S

ŒUVRES COMPLÈTES

DE

BERNARD PALISSY.

PARIS, IMPRIMÉ PAR BÉTHUNE ET PLON.

OEUVRES COMPLÈTES

DE

BERNARD PALISSY,

ÉDITION

CONFORME AUX TEXTES ORIGINAUX

IMPRIMÉS DU VIVANT DE L'AUTEUR;

AVEC

DES NOTES ET UNE NOTICE HISTORIQUE

PAR PAUL-ANTOINE CAP.

PARIS,

J.-J. DUBOCHET ET Cⁱᵉ, ÉDITEURS,
RUE DE SEINE, 33.

1844.

A MONSIEUR

ALEXANDRE BRONGNIART,

MEMBRE DE L'INSTITUT,
DIRECTEUR DE LA MANUFACTURE ROYALE DE PORCELAINE DE SÈVRES,
PROFESSEUR AU MUSÉUM D'HISTOIRE NATURELLE, etc.

Monsieur,

En préparant une nouvelle édition des *OEuvres de* Bernard Palissy, j'ai eu surtout pour objet de rendre plus populaire le nom et les écrits de l'un des hommes dont la France a le plus à se glorifier. En plaçant cette édition sous vos auspices, j'ai pensé à réunir deux noms chers aux sciences comme aux beaux arts, et auxquels la céramique moderne doit ses plus larges développements. Permettez-moi d'ajouter, Monsieur, que j'y ai vu aussi l'heureuse occasion de vous offrir un témoignage public de ma haute estime et de mon profond respect.

P.-A. Cap.

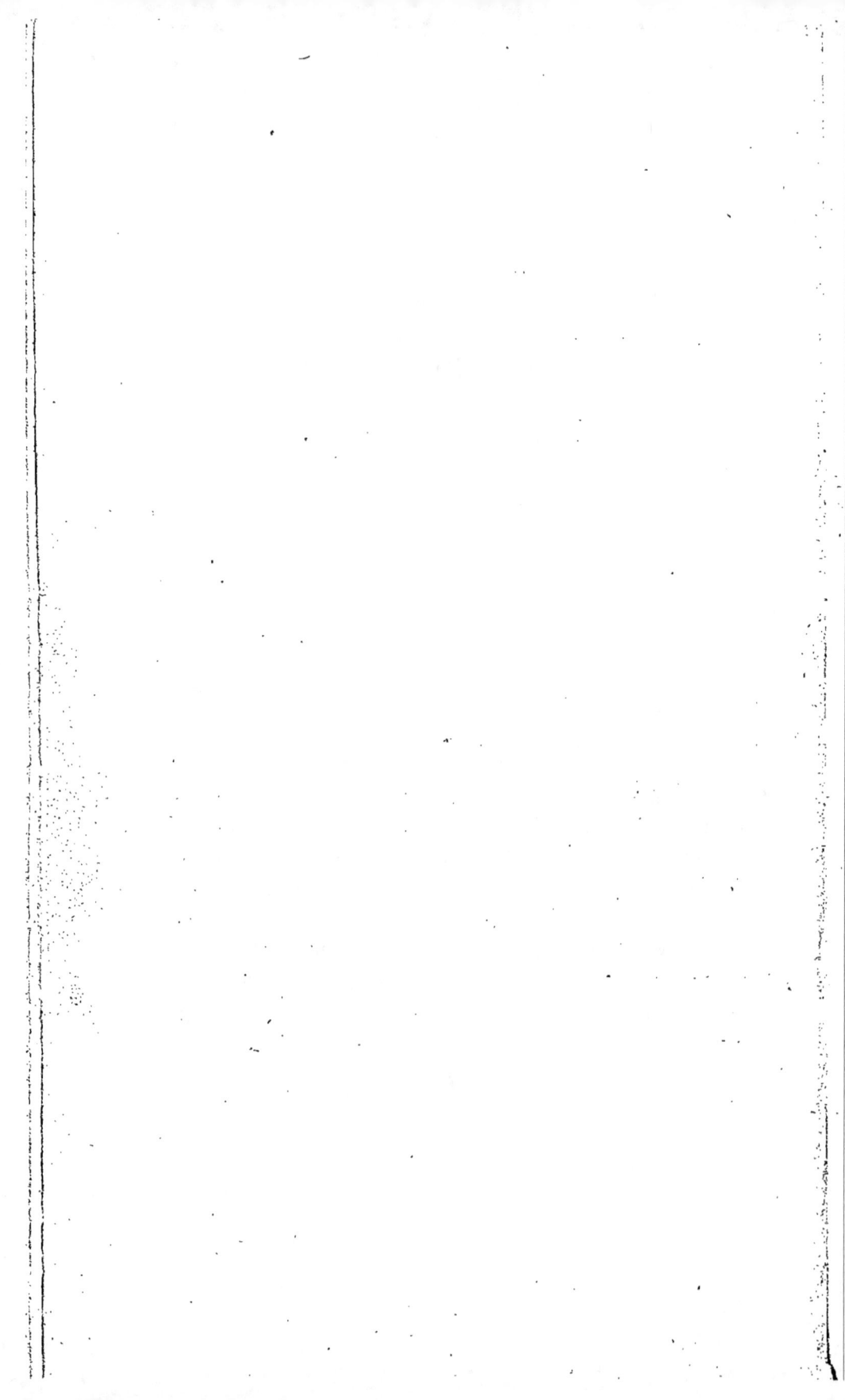

NOTICE HISTORIQUE

sur

LA VIE ET LES OUVRAGES DE BERNARD PALISSY.

Le nom de Bernard Palissy est vaguement empreint dans la mémoire de toutes les personnes qui s'occupent de sciences naturelles, d'agriculture, de physique, de chimie, ou qui ont étudié l'histoire des arts. On sait en général qu'il vécut au seizième siècle, qu'il était potier de terre, et qu'il découvrit le vernis des faïences. On sait que l'ardeur qu'il mit à cette recherche le retint long-temps dans la misère la plus profonde; mais qu'il finit par atteindre son but, et qu'il fut l'inventeur de ces *rustiques figulines* auxquelles les amateurs attachent aujourd'hui un assez haut prix. Ce que l'on sait moins généralement, c'est que cet homme, sans éducation première, sans aucune notion de littérature, sans connaissance de l'antiquité, sans secours d'aucune espèce, à l'aide des seuls efforts de son génie et de l'observation attentive de la nature, posa les bases de la plupart des doctrines modernes sur les sciences et les arts; qu'il émit, sur une foule de hautes questions scientifiques, les idées les plus hardies et les mieux fondées; qu'il professa le premier en France l'histoire naturelle et la géologie; qu'il fut l'un de ceux qui contribuèrent le plus puissamment à renverser le culte aveugle du moyen âge pour les

doctrines de l'antiquité; que cet ouvrier, sans culture et sans lettres, a laissé des écrits remarquables par la clarté, l'énergie, le coloris du style; qu'enfin cet homme, simple et pur, mais puissant par le génie, fournit l'exemple de l'un des plus beaux caractères de son époque, et qu'il expia par la captivité et la mort sa persévérance courageuse et sa fermeté dans ses croyances.

Il est beau sans doute de voir l'artiste, aux prises avec les difficultés de son art, ou avec les obstacles matériels qui s'opposent à la production de sa pensée, sortir victorieux de cette lutte, après une longue période d'efforts, de misère et de souffrances; mais il ne l'est pas moins de voir l'homme d'une origine obscure, dépourvu des secours de l'instruction et de l'étude, jeter sur tout ce qui l'entoure le coup d'œil de l'observateur et du philosophe, pénétrer les mystères de la nature, saisir les principes des vérités éternelles, renverser les erreurs accréditées de son époque, et pressentir la plupart des découvertes qui feront l'avenir et la gloire des siècles plus éclairés. C'est avec ce double mérite que Palissy se présente aux regards de la postérité. Les événements de sa vie, dont quelques-uns furent racontés par lui-même, montrent tout ce que peut le génie fécondé par une âme ferme, un esprit droit et un cœur pur. Leur simple récit nous semble le moyen le plus naturel d'appeler sur ses travaux l'intérêt dont ils sont si dignes, et sur sa personne le respect, l'admiration que commande toujours un beau caractère uni aux plus précieux talents.

Un pauvre village du Périgord, situé à peu de distance de la petite ville de Biron, entre le Lot et la Dordogne, donna naissance à Bernard Palissy. Ce village, appelé La Chapelle-Biron, renferme encore, dit-on, une famille qui descend de cet homme célèbre; et une tuilerie fort ancienne, établie dans le même lieu, portait encore naguère le nom de *Tuilerie de Palissy*. Des documents, assez peu d'accord entre eux, font remonter sa naissance au commencement du seizième siècle.

Ainsi d'Aubigné prétend qu'à sa mort, arrivée en 1589, il était âgé de quatre-vingt-dix ans, tandis que, selon Lacroix du Maine, il florissait à Paris en 1575, âgé de soixante ans et plus. En rapprochant diverses circonstances parmi celles que Palissy rapporte lui-même, la version la plus vraisemblable et la plus généralement adoptée rapporterait la date de sa naissance à l'année 1510.

On ne possède aucun détail sur ses parents ni sur sa première éducation. Il paraît que, dès son enfance, il travaillait à la vitrerie, qui comprenait alors la préparation, l'assemblage des vitraux colorés, ainsi que la peinture sur verre. Doué d'une aptitude particulière aux arts du dessin, il conçut de bonne heure la pensée d'élever ses travaux d'artisan à la hauteur des œuvres d'un artiste. Aussi, tout en *peindant des images*, comme il dit, pour exister, il étudiait les grands maîtres de cette belle école italienne, qui, dès le siècle précédent, avait donné à la renaissance des arts une si vigoureuse impulsion. Il s'exerçait en même temps à l'architecture, et pratiquait la géométrie. « On pensoit, dit-il, que je fusse plus » sçavant en l'art de peinture que je n'estois, qui causoit que » j'estois souvent appelé pour faire des figures (des plans) » dans les procès. » C'était une nouvelle ressource un peu plus profitable que l'art de composer des vitraux.

Cependant, pour l'homme qui se sent capable de fournir une large carrière, le pays natal ne saurait long-temps suffire ; Palissy se mit donc à voyager. Il alla d'abord dans les Pyrénées, et s'arrêta quelque temps à Tarbes. Les accidents naturels de ce beau pays le frappèrent vivement, et peut-être est-ce là le point de départ de son goût ardent pour la géologie et les sciences naturelles. Il parcourut ensuite quelques autres provinces de France, puis la Flandre, les Pays-Bas, les Ardennes et les bords du Rhin, en ouvrier nomade, exerçant à la fois la vitrerie, la *pourtraiture* et l'arpentage ; mais aussi observant partout la topographie, les accidents du sol, les curiosités naturelles ; parcourant les montagnes, les forêts,

a.

les rives des fleuves; visitant les carrières et les mines, les grottes et les cavernes; en un mot, demandant partout à la nature elle-même le secret des merveilles qu'elle offrait à son admiration et à son étude. L'éducation scientifique de Palissy, au lieu de commencer par les livres, partait ainsi des bases les plus certaines, les plus fécondes : l'expérience et l'observation.

Ses voyages étaient terminés en 1539. De retour dans son pays natal, Palissy alla se fixer à Saintes, et s'y maria. Quelques années plus tard, déjà surchargé de famille et luttant contre la misère, le hasard fit tomber entre ses mains une coupe de terre émaillée d'une grande beauté. Aussitôt il conçoit la pensée d'imiter ce travail, et de se livrer à un art entièrement nouveau pour lui. On sait qu'à cette époque la poterie n'était point recouverte de vernis, ou du moins que cet art, déjà pratiqué en Italie, à Faenza et à Castel-Durante, n'était point encore connu en France. Palissy vient à penser que, s'il parvenait à découvrir le secret de cet émail, il pourrait élever l'art de la poterie à un degré de perfection inconnu jusqu'alors. Le voilà donc livré à cette recherche, mais en aveugle, « comme un homme qui taste en ténèbres, » attendu qu'il n'avait aucune connaissance ni des matières ni des procédés. C'est dans son traité de *l'Art de Terre* (pag. 309-324) qu'il faut lire l'admirable récit de ses tentatives, des difficultés qu'il eut à vaincre, et des maux qu'il eut à souffrir pendant le cours de seize années, avant d'avoir réussi à donner toute la perfection désirable aux ouvrages sortis de ses mains. Ce n'est pas sans une admiration mêlée d'attendrissement qu'on peut lire les pages sublimes dans lesquelles il raconte avec autant de simplicité que de grandeur la longue série de ses efforts et de ses misères. Forcé de préluder à la recherche de son nouvel art par la connaissance des terres argileuses, la construction des fourneaux, l'art du modeleur, du potier, du mouleur, et l'étude de la chimie, qu'il fut obligé, comme il dit, « d'apprendre avec les dents, » c'est-à-dire en s'imposant les plus

dures, les plus cruelles privations, il faut le voir poursuivre sa pensée avec une ardeur, une constance à toute épreuve; consacrant ses veilles, ses économies, sa santé, et jusqu'aux choses nécessaires à sa subsistance, à ses recherches incessantes; déçu à chaque instant dans son espoir, mais retrouvant tout son courage à la moindre lueur de succès, et dans cette lutte de l'intelligence, de la volonté, contre les obstacles matériels, parvenir enfin à lasser la mauvaise fortune et à faire triompher sa pensée créatrice.

Cependant il lui fallait subvenir aux besoins d'une nombreuse famille, soutenir les reproches des siens, les représentations de ses amis, les sarcasmes de ses voisins, et continuer à exercer ses talents ordinaires, afin « d'eschapper le temps » qu'il employait à la recherche de son nouvel art. En 1543, des commissaires chargés d'établir la gabelle en Saintonge l'appelèrent pour lever le plan des îles et des marais salants de la province. « Cette commission parachevée, dit-il, je me trou-
» vay muny d'un peu d'argent, et je reprins l'affection de
» poursuyure à la recherche desdits emaux. » Le voici donc de nouveau livré à des essais innombrables; il passe les nuits et les jours à rassembler, à combiner toutes les substances qu'il croit propres à son objet; il pulvérise, broie, mélange ces drogues dans toutes les proportions; il en couvre des fragments de poterie, il les soumet à toutes les épreuves, à tous les degrés de cuisson. Mécontent des fours ordinaires à poterie, il construit de ses propres mains des fourneaux semblables à ceux des verriers; il va chercher la brique, l'apporte sur ses épaules, pétrit la terre, maçonne lui-même ses fourneaux, les emplit de ses ouvrages, allume le feu, et attend le résultat. Mais, ô déception! tantôt le feu est trop faible, tantôt il est trop ardent; ici l'émail est à peine fondu, là il se trouve brûlé; les pièces sont déformées, brisées, ou bien elles sont couvertes de cendre. A chaque difficulté nouvelle, il faut trouver un expédient, un remède; et il en trouve de si ingénieux, de si efficaces, que l'art les a adoptés pour toujours. Mais des obsta-

cles d'une autre nature viennent s'ajouter aux premiers : c'est le manque d'argent, de bois et de matières. Il imagine de nouvelles ressources, il redouble d'ardeur, il réunit tous ses moyens, et déjà, plus assuré de sa réussite, il entreprend une nouvelle fournée mieux entendue et plus considérable que les précédentes, car il avait employé huit mois à exécuter les ouvrages dont elle devait se composer, et consacré plus d'un mois, jour et nuit, à la préparation de ses émaux. Cela fait, il met le feu à sa fournée, et l'entretient pendant six jours et six nuits, au bout desquels l'émail n'était pas encore fondu. Désespéré, il craint de s'être trompé dans les proportions des matières, et il se met à refaire de nouveaux mélanges, mais sans laisser refroidir son appareil. Il pile, broie, combine ses ingrédients, et les applique sur de nouvelles épreuves, en même temps qu'il pousse et active la flamme en jetant du bois par les deux gueules du fourneau. C'est alors qu'un nouveau revers, le plus grand de tous, vient l'atteindre : il s'aperçoit que le bois va lui manquer. Il n'hésite pas : il commence par brûler les étais qui soutiennent les tailles de son jardin ; puis il jette dans la fournaise ses tables, ses meubles, et jusqu'aux planchers de sa maison. L'artiste était ruiné, mais il avait réussi !

Cependant des chagrins contre lesquels l'âme la plus ferme ne trouve pas toujours des armes venaient incessamment l'assaillir. Accablé de dettes, chargé d'enfants, persécuté par ceux-là même qui l'eussent dû secourir, il sent un moment fléchir son courage ; mais aussitôt, faisant un appel à son âme, il retrouve sa force, et se remet à l'œuvre avec une nouvelle ardeur. Telle était alors sa détresse qu'ayant pris un ouvrier pour l'aider dans ses travaux les plus pénibles, il se vit au bout de quelques mois dans l'impossibilité de le nourrir. Bien qu'il fût sur le point d'entreprendre une nouvelle fournée, il fallut renvoyer son aide, et, faute d'argent pour le payer, il se dépouilla de ses vêtements et les lui donna pour son salaire.

A travers tant et de si cruelles épreuves, Palissy s'appro-

chait incessamment du but qu'il s'était proposé. Ses belles poteries, ses pièces rustiques, ses statuettes charmantes étaient fort goûtées ; ses ouvrages commençaient à être recherchés des grands seigneurs, et la variété de ses talents lui avait déjà valu quelques hautes protections. Le connétable de Montmorency ayant été chargé, en 1548, d'aller réprimer la révolte de Saintonge, eut occasion de voir et d'admirer les ouvrages de Palissy. Il se prit d'affection pour sa personne, et le chargea de travaux importants. Quelques années plus tard l'artiste devait presque la vie à son illustre protecteur.

Le calvinisme commençait alors à se propager dans les provinces du midi. Palissy, homme religieux et d'une grande sévérité de mœurs, fut frappé des vertus et de la conduite austère des premiers propagateurs de la nouvelle secte. L'ardeur et la générosité de son âme le rangèrent parmi les partisans des nouvelles doctrines, et lui firent adopter, avec un certain enthousiasme, une réforme qui semblait s'appliquer à la morale plus qu'aux dogmes, et aux pratiques extérieures plus qu'aux principes fondamentaux du christianisme. Il s'associa avec quelques autres artisans pour former à Saintes une église, dans laquelle chacun d'eux expliquait à son tour les maximes de l'Évangile. Doué d'une éloquence naturelle, plein de la Bible et des prophètes, l'énergie et la constance de son caractère devaient en faire un apôtre rempli de zèle : aussi il paraît qu'il s'acquit dans la prédication une certaine célébrité, et l'on peut remarquer, surtout dans ses premiers écrits, que son style est souvent empreint des formes et des images bibliques. Cependant la sécurité des nouveaux prosélytes ne tarda pas à être troublée. L'édit de 1559, qui punissait de mort le crime d'hérésie et défendait aux juges de modérer la peine, commença à jeter l'alarme parmi les protestants. En 1562, le parlement de Bordeaux en ordonna l'exécution dans son ressort. Palissy, qui avait obtenu du duc de Montpensier une sauvegarde, se montra le courageux défenseur de ses coreli-

gionnaires, et se dévoua plus d'une fois pour les sauver. Le comte de La Rochefoucauld, général de l'armée royale en Saintonge, déclara son atelier un lieu de franchise. C'était, dit un de ses biographes, une sorte de droit d'asile accordé au génie; mais ce privilége ne fut pas long-temps respecté. Malgré la protection de MM. de Burie, de Ponts et de Jarnac, Palissy fut enlevé pendant la nuit par les officiers de justice, et conduit dans les prisons de Bordeaux. Son atelier fut démoli, et le grand artiste eût été infailliblement envoyé au supplice sans l'intervention du Connétable, qui, tout-puissant auprès de Catherine, obtint du roi, par l'entremise de sa mère, qu'il fût rendu à la liberté. On lui accorda en même temps le brevet d'inventeur des rustiques figulines du roi. Ce titre, en l'arrachant à la juridiction du parlement de Bordeaux, attribuait au grand conseil la connaissance de sa cause, ce qui équivalait à un ajournement indéfini.

L'année suivante, en 1563, Palissy publiait à La Rochelle son ouvrage intitulé : RECEPTE VÉRITABLE, *par laquelle tous les hommes de la France pourront apprendre à multiplier et à augmenter leurs thrésors.* C'est sans doute pendant les tristes jours de sa captivité, et tandis que son atelier renversé ne lui permettait plus de se livrer à ses travaux ordinaires, que fut composé ce petit volume, d'un intérêt si piquant, si varié, et qui semble résumer toutes les pensées, tout le caractère de son auteur. Son âme naïve, mais énergique, son coup d'œil droit et plein de sagacité, son génie artistique, ses goûts, ses opinions, ses connaissances, et jusqu'aux promesses qu'il fait à l'avenir, tout s'y révèle et s'y retrouve à la fois. Et que l'on ne fasse pas à cet ouvrage le reproche d'être sans ordre et sans liaison dans les idées; Palissy ne composait pas un livre, un traité dogmatique, comme l'entendent de nos jours les hommes de science; il ne faisait qu'émettre ses pensées, ses observations, ses *receptes*, ainsi qu'il les appelle, dans l'ordre où tout cela se succédait dans son esprit ou dans sa mémoire; à la vérité, sans plan arrêté à l'avance, sans préten-

tion didactique, mais suivant l'enchaînement le plus simple et le plus naturel. Il touche à tous les sujets, il les effleure successivement, il semble se livrer à de continuelles digressions; mais, quelque disparates qu'elles paraissent au premier aspect, il est facile de voir que, dans son esprit, toutes ces idées sont intimement liées entre elles et se subordonnent à une pensée primordiale. Son premier objet, dit-il, est de se montrer reconnaissant envers ses bienfaiteurs ; or, dans l'impossibilité de leur offrir un meilleur témoignage de sa gratitude, il leur adresse les résultats de ses méditations et de sa longue expérience. Il veut, en mettant en lumière des *secrets* qu'il croit propres à multiplier les biens et les vertus des hommes, obéir à ce divin précepte : « Que chacun ait à manger » son pain au labeur de son corps, et à répandre les talents » que Dieu lui a donnés. » Il faut peu d'efforts, selon nous, pour saisir la suite naturelle des idées qu'il développe dans ce petit livre, et pour montrer leur rapport avec la pensée principale qui le préoccupait en l'écrivant.

Ainsi il annonce, en débutant, qu'il cherche un lieu propre à établir un jardin, qui serait destiné à récréer son esprit fatigué du spectacle des maux publics, et à servir de retraite dans les jours de persécution. En se promenant au bord de la Charente, il s'imagine entendre des chœurs de jeunes vierges chantant le psaume 104e du Roi-Prophète, et il songe d'abord à reproduire dans un vaste tableau les admirables descriptions de ce psaume. Puis il vient à penser qu'il vaudrait mieux représenter en nature toutes ces merveilles, et faire de ce délicieux jardin comme un lieu de refuge en temps de calamités publiques. Il s'étend à cette occasion sur l'utilité de l'agriculture, et regrette que la terre soit généralement cultivée avec si peu d'intelligence. Il montre que la philosophie, c'est-à-dire l'observation attentive de la nature, est indispensable à ceux qui s'en occupent, et il donne en passant quelques bons préceptes à ce sujet, fruits de ses remarques particulières. C'est là entre autres qu'il place sa théorie chimique des

engrais, et qu'il recommande à l'égard des fumiers une pratique excellente trop long-temps ignorée ou négligée par les agriculteurs. Il prescrit le meilleur mode de couper les bois et la saison la plus propre à cette opération ; il examine les causes de la configuration du sol, la variété des terrains, les différentes formes des pierres, des gemmes, des cristaux ; il émet sur la théorie des sels une idée neuve et hardie, et en généralise la définition plus qu'aucun chimiste ne l'avait fait avant lui. Il explique l'origine des fontaines, la manière dont les pierres précieuses et les métaux sont engendrés dans le sein de la terre. Enfin, revenant à son sujet primitif, il donne le dessin, l'ordonnance générale du jardin et de l'agréable retraite qu'il se propose d'édifier. C'est alors que, laissant toute carrière à son imagination capricieuse et poétique, il décrit non-seulement les dispositions générales de ce lieu de délices, mais aussi la construction des *cabinets* qu'il place dans ses divers compartiments. Il ne manque pas de les orner d'ouvrages en terre cuite, peinte, émaillée, et de toutes ces pièces qu'il nomme *rustiques,* parce qu'elles représentaient de petits monuments champêtres, des rochers, des fontaines, des bosquets, des animaux et des coquillages. Il n'avait garde de négliger d'y réunir les beaux effets de l'architecture monumentale aux dispositions naturelles des plantes et des arbres. Ne perdant jamais de vue la pensée morale et religieuse, il orne toutes ses constructions de maximes tirées de l'Écriture, afin qu'au milieu des riantes délices de ce lieu enchanteur l'homme ne puisse jamais oublier son origine, ses devoirs, et la Providence, auteur de tous ces biens. Chemin faisant, il s'égaie par d'excellents traits de satire sur les fourbes, les simoniaques, les sinécures ecclésiastiques, l'avarice et la cupidité. C'est pour fuir tous ces maux, tous ces vices, qu'il veut se retirer dans l'asile, objet de son rêve poétique, et que, dans son illusion, il regarde comme déjà créé. Alors, dans une sorte d'extase, il peint les merveilles de la végétation, il admire l'instinct des animaux, il assiste à

leurs jeux, il jouit avec ravissement des scènes agrestes que son imagination lui représente, et il s'écrie que l'homme est bien fou de méconnaître les charmes de la vie des champs. Il se prend de pitié pour ces laboureurs qui, dédaignant l'art auquel ils doivent leur fortune, élèvent leurs fils pour d'autres conditions et s'exposent ainsi eux-mêmes au mépris de leurs enfants, tandis que la culture de la terre est abandonnée aux plus ignorants et aux plus incapables. Pour lui, il estime les moindres bourgeons des plantes au-dessus des mines d'or et d'argent; il souffre de voir que l'on abatte les forêts sans en replanter d'autres, tandis qu'en bonne pratique c'est le contraire qu'il faudrait ordonner. Il plaint l'aveuglement des grands seigneurs qui n'estiment les forêts que pour le plaisir de la chasse, ou les revenus qu'elles rapportent, et qui s'appliquent à inventer de nouvelles armes de guerre, de destruction, au lieu de perfectionner les outils d'agriculture, en général si négligés, si mal appropriés à leur emploi. Et pourquoi n'apporterait-on pas au perfectionnement des ustensiles d'agriculture le même soin qu'à ceux des autres arts, tandis qu'il faudrait y faire servir les instruments les plus ingénieux, et jusqu'à ceux qu'emploient l'architecture et la géométrie? Là-dessus, notre artiste-poète aborde une digression aussi spirituelle que piquante. Après avoir énuméré les principaux instruments de la géométrie et des arts, il suppose qu'il s'élève entre eux un débat touchant leur prééminence. Le compas veut l'emporter sur la règle, qui, à son tour, est rabaissée par l'aplomb, lequel voit son rang contesté par la fausse équerre, le niveau et l'astrolabe. Palissy veut leur faire entendre que, quel que soit leur mérite respectif, ils sont tous subordonnés au génie, à la volonté de l'homme, qui les a inventés. Les outils soutiennent qu'ils sont loin de devoir obéissance et soumission à un être qui lui-même n'est composé que de méchanceté et de folie. Pour le prouver, ils prient leur juge de se servir d'eux afin de mesurer la tête de quelques hommes parmi ceux qui semblent les

b

plus dignes de respect. Palissy se livre à cet examen, qui donne lieu à des remarques pleines de verve satirique et d'une philosophie aussi profonde qu'ingénieuse. Voyant ses mesures constamment en défaut, et ne pouvant reconnaître par ce moyen la cause des bizarreries contenues dans les têtes qu'il examine, il a recours à la *philosophie alchimistale*. Il les soumet au creuset, à l'alambic, à la coupelle, et finit par y découvrir, « d'une part la cholère noire et pernicieuse, l'am- » bition et la superbité de l'autre. » Enfin, ayant examiné de plus près, il trouve que « c'est l'avarice et l'ambition qui » rendent tous les hommes fous, après leur avoir pourri la cer- » velle. » Comme la dernière tête qu'il analyse est celle d'un conseiller de Parlement, coupable à ses yeux d'avoir sévi contre ses coreligionnaires, il en prend occasion de faire l'histoire de l'établissement à Saintes de l'église protestante, et des persécutions qui en furent la suite ; ce qui le ramène naturellement à son premier objet : la fondation d'une cité de refuge en cas « d'esmotions, de guerres civiles ou de malheurs publics. » Cette cité est une forteresse dont il trace le plan, après en avoir emprunté l'idée à certains coquillages dont la forme met l'animal qui en est revêtu à l'abri des attaques de tous les autres animaux.

N'est-il pas évident que tous ces détails, pour n'être point liés par un plan systématique, n'en présentent pas moins une série assez naturelle de réflexions et d'idées ? La forme du dialogue montre, d'ailleurs, que l'auteur n'avait en vue qu'une sorte de conversation, avec toute la liberté qu'elle comporte dans l'ordre des pensées. C'est une mosaïque qui se prêtait merveilleusement à l'exposition de ses sentiments, de ses méditations, de ses vues, où pouvait se déployer toute la richesse de son imagination et la singularité de son esprit. C'est un terrain encore vierge où il déposait le germe des sujets dont l'étude devait le préoccuper dans tout le cours de sa vie.

Presque immédiatement après cette publication, Palissy quitta la Saintonge et vint s'établir à Paris. C'est à partir de

cette époque que, devenu maître de son art, il donna à ses ouvrages tous les développements, toute la perfection que lui inspirèrent son goût et son génie. On sait quels efforts avait faits François 1er, pour naturaliser en France les arts de l'Italie qui, dès le siècle précédent, s'étaient élevés à une si prodigieuse hauteur. L'école française avait répondu par de nobles efforts à l'appel, aux encouragements de son souverain. Jean Goujon, Pierre Lescot, Germain Pilon, Cousin, Bullant, Ducerceau et une foule d'autres s'étaient montrés les dignes élèves, puis les heureux émules de Léonard de Vinci, de Fra Jocondo, d'André del Sarto, de Primaticcio, de Cellini et des différents maîtres qui s'étaient succédé en France, sous le patronage de ce monarque ami des arts. Palissy, né dans une province éloignée, n'avait point été élevé à cette grande école, qu'il ne put connaître qu'à l'époque de ses voyages. Mais dès qu'il fut à portée d'en apprécier l'heureuse direction, il se rangea aussitôt parmi les disciples de ces illustres maîtres : aussi remarque-t-on qu'il s'inspira partout des chefs-d'œuvre de l'art italien, et retrouve-t-on dans la plupart de ses ouvrages l'élégance, la pureté des formes et la richesse des ornements qui caractérisent ceux du Primatice, du Rosso et surtout de Benvenuto Cellini. Les plus importants de ces ouvrages, ou du moins ceux de la plus grande dimension, servaient à la décoration des jardins, des pièces d'eau, des grottes, des fontaines, ou à l'ornement des habitations somptueuses. C'est à ceux-là surtout que Palissy donnait le nom de *rustiques figulines*, parce qu'ils représentaient des objets rustiques, des rochers, des grottes, des arbres, des animaux et quelquefois des personnages ; le tout en relief ou en ronde-bosse et recouvert d'un émail coloré. Il reste à peine aujourd'hui quelques traces des pièces de cette classe. Elles ornaient dans le temps les châteaux de Chaulnes (1) et de Nesle en Picardie, de Reux en Norman-

(1) Le parc de Chaulnes avait été exécuté sur un plan analogue à celui que Palissy avait décrit dans son premier ouvrage, sous le nom de *jardin*

die, de Madrid au bois de Boulogne, et surtout le château d'É-
couen, où Palissy avait déployé toutes les richesses de son art,
pour embellir l'habitation de son protecteur, le connétable de
Montmorency (1). A peu près à la même époque, il travailla à la
décoration des jardins du palais des Tuileries, que Catherine
de Médicis venait de faire construire (2), et c'est probable-

délectable. C'est dans ce parc que Gresset composa sa *Chartreuse* et son
épître au père Bougeant.

(1) Le château d'Écouen fut construit au commencement du seizième siè-
cle par l'architecte Jean Bullant. Les sculptures de la chapelle sont de Jean
Goujon. De tous les ouvrages dont Palissy avait décoré cette habitation, on
n'y voit plus aujourd'hui que le pavé de faïence peinte, à compartiments,
de la chapelle et des galeries. On attribuait également à Palissy une mar-
queterie en faïence, appliquée sur les parois de la Chapelle, représentant
les actes des Apôtres, la passion de Jésus-Christ, en seize tableaux réunis
en un seul cadre, d'après Albert Durer, et les vitraux de la galerie, repré-
sentant l'histoire de Psyché, d'après les dessins de Raphaël. Ces derniers
ont été gravés, et M. Lenoir en a publié la suite, en quarante-cinq estampes,
dans le tome VI du *Musée des monuments français*.

(2) Un terrain assez étendu, situé au delà des fossés du Louvre, et sur lequel
était établie une fabrique de TUILES, fut acheté, en 1518, par François 1er,
qui le donna à sa mère, Marie-Louise de Savoie.

En 1564, Catherine de Médicis ne voulant point habiter le Louvre, ni le
palais des Tournelles, qui allait être démoli, acheta quelques bâtiments
qui avoisinaient les *Tuileries*, et fit jeter les fondements de cet édifice, dont
la première pierre fut posée par Charles IX le 11 janvier 1566. Catherine
ne l'habita pas long-temps, car en 1572 elle quitta cette résidence pour
l'hôtel de Soissons, qu'elle venait d'acheter.

On trouve dans un manuscrit de la Bibliothèque royale, intitulé : *Des-
penses de la reyne Catherine de Médicis*, plusieurs pièces qui se rapportent
à des payements faits dans le cours de l'année 1570, à *Bernard*, *Nicolas* et
Mathurin PALISSYS (sic), « pour les ouvrages en terre cuite, esmaillée, qui
» restent à faire pour achever les *quatre ponts* (ce mot, difficile à lire dans
» le manuscrit, laisse quelque incertitude sur la nature des travaux), au
» pourtour de la grotte encommencée par la Reyne, en son palais, à Paris,
» suivant le marché fait avec eux, etc. »

Ce document expliquerait le motif de la résidence de Palissy dans l'en-
ceinte du château, ainsi que le surnom de *Bernard des Tuileries*, qui a
suggéré à quelques biographes la singulière supposition qu'il était gouver-
neur de ce palais. Palissy avait, sans nul doute, placé son atelier près de la
tuilerie déjà établie dans le même lieu, et qui y subsista encore long-temps;
car, suivant les plans manuscrits de l'époque, au commencement du règne
de Louis XIV on voyait encore dans les cours du château les chantiers de
bois et les fours qui servaient à la fabrication des tuiles et des briques.

On peut tirer du même document cette autre conséquence, que Bernard
Palissy était alors secondé dans ses travaux par deux de ses fils, Nicolas
et Mathurin. Cette hypothèse, d'ailleurs si naturelle, permettrait, en outre

ment à cette circonstance qu'il dut le bonheur d'échapper aux massacres de la Saint-Barthélemy.

Ses ouvrages de moyenne et de petite dimension ornaient les appartements et figuraient sur les dressoirs, les buffets, les tables et les consoles. Ce sont des vases, des aiguières avec leurs bassins, des statuettes, des groupes pleins de grâce et de mouvement, des coupes, des vidercomes, des salières, des écritoires, des flambeaux, des corbeilles, de grands et de petits plats sculptés, enfin des *bassins rustiques* chargés de fruits, de coquillages, de poissons et de reptiles, représentés avec une vérité de formes et de coloris qui font l'admiration des hommes de l'art. D'autres plats présentent des bas-reliefs d'un fini remarquable, des sujets tirés de la mythologie ou de l'histoire sainte. Les ouvrages de cette série sont moins rares que les précédents. Le musée de Paris, le musée céramique de Sèvres, et les collections particulières de quelques amateurs éclairés, en renferment de très-belles épreuves (1). Toutes ces pièces sont remarquables par l'harmonie des sujets, l'élégance des formes, le fini de l'exécution, et sont enrichies d'ornements pleins d'imagination et de goût. Leur rareté n'ajoute donc rien à leur mérite réel, qui justifie seul l'empressement avec lequel elles sont recherchées.

A travers les rudes épreuves qu'il avait eu à subir et les travaux incessants que les difficultés de l'art ou les rigueurs de la fortune lui avaient imposés, Palissy n'avait pas pour cela négligé ses études chéries. L'histoire naturelle, l'agriculture, la physique du globe et la chimie n'avaient jamais

de penser que ceux-ci, qui ne soutinrent point la réputation de leur père, continuèrent néanmoins d'exercer la même industrie, et qu'ayant conservé les moules de Bernard ils livrèrent à la circulation des pièces dont la date est évidemment postérieure à celle de sa mort. Tel est un plat fort connu dont le fond représente Henri IV et sa famille, mais dont les bords appartiennent sans aucun doute à Bernard Palissy.

(1) On doit citer, comme l'une des plus remarquables, parmi ces collections, celle de M. Ch. Sauvageot, qui, à force de soins et de recherches intelligentes, a réussi à former une suite à peu près complète des ouvrages de Palissy. Cette suite figure au milieu d'une réunion extrêmement riche des meilleures productions artistiques du seizième siècle.

b.

cessé d'être les sujets de ses expériences et de ses méditations. Riche des faits nombreux qu'il avait observés et recueillis, il songeait depuis long-temps à les rendre publics ; mais ne sachant pas, grâce à son ignorance des langues anciennes, si les philosophes de l'antiquité avaient eu sur les mêmes sujets des opinions analogues ou contraires aux siennes, il résolut de faire la démonstration publique de ses théories et d'appeler à ses leçons les hommes les plus éclairés de l'époque. C'était une sorte d'expédient à l'aide duquel il voulait s'assurer si ses vues étaient fondées, en provoquant à leur sujet la critique et les objections des érudits. Cependant, il avait rassemblé tous les objets naturels propres à confirmer ses idées à l'égard de certains phénomènes physiques, particulièrement sur la formation des cristaux, les pétrifications et les principes de la géologie. Ce cabinet d'histoire naturelle, le premier qui eût été formé à Paris, était disposé, non d'après une méthode générale, systématique, mais dans l'ordre des démonstrations qui faisaient l'objet de son cours. Ces leçons étaient également les premières conférences publiques qui avaient lieu sur les sciences physiques et naturelles. Et n'est-ce pas un tableau digne du plus haut intérêt que celui d'un simple potier de terre, d'un homme sans culture, sans connaissance de l'antiquité, venant exposer les résultats de ses découvertes en présence de tout ce que la capitale renfermait alors de savants, provoquer la critique, les argumentations sur les sujets les plus ardus ; et tout cela, non dans l'intérêt de sa gloire, mais dans celui de la science et de la vérité ! sorte d'académie, de congrès scientifique, où chacun avait le droit de relever les fautes de l'orateur, mais où l'on ne vit jamais s'élever la moindre contradiction. On peut juger de la hardiesse, de la singularité d'une telle entreprise, en voyant la plupart des savants de son époque, et même des siècles qui l'ont suivie, s'étonner avant tout que l'on pût posséder quelque science, quelque talent, sans avoir appris le latin et le grec. Palissy s'en étonna d'abord lui-même et

essaya parfois de s'en excuser, puis il en prit son parti et alla même jusqu'à montrer à ce sujet un dédain assez piquant. C'est ainsi que dans l'un de ses dialogues, *Practique*, suivant son habitude, après avoir harcelé *Théorique*, pulvérisé ses faux raisonnements et renversé ses systèmes préconçus, finit par lui lancer cette apostrophe : « Or, vas quérir à présent tes philo- » sophes latins, pour me donner argument contraire, lequel » soit aussi aisé à connoistre comme ce que je mets avant. »

C'est pendant le carême de 1575 que Palissy ouvrit pour la première fois ces conférences, qui furent continuées jusqu'en 1584. Mais déjà il songeait à résumer les principales données, fruits de ses longues investigations, dans un ouvrage qui est devenu son plus beau titre de gloire aux yeux des hommes de science. Cet ouvrage parut, en 1580, sous le titre de Discours admirables *de la nature des eaux et fontaines, tant naturelles qu'artificielles ; des métaux, des sels et salines, des pierres, des terres, du feu et des émaux ; avec plusieurs autres excellents secrets des choses naturelles*, etc. C'est dans ce livre que l'on peut juger des pas immenses qu'eussent pu faire les sciences physiques et naturelles sous l'influence du génie d'un seul homme, si le nom de cet homme eût eu plus d'autorité et si les enseignements qu'il livrait à son siècle eussent eu plus de retentissement. Il ne s'agit plus ici, comme dans la *Recepte véritable*, d'une sorte de causerie éparpillée sur mille sujets divers, d'ailleurs peu approfondis ; mais bien d'une réunion de traités *ex professo* sur des points déterminés de physique générale, de chimie, de géologie et d'histoire naturelle, auxquels l'auteur joignait d'excellents préceptes sur son Art de terre, point de départ de tous ses travaux, et où venaient finalement aboutir toutes ses méditations et ses études. Ce n'est plus l'artisan obscur et illettré essayant de payer la dette de la reconnaissance à l'aide de quelques *receptes* sur les secrets de son art, de quelques vues modestes sur les sujets ordinaires de ses rêveries ; c'est le véritable savant, riche des connaissances qu'il a acquises par quarante ans de

travaux et de recherches, le professeur fier d'avoir expliqué les phénomènes de la nature et les principes des sciences aux hommes les plus éclairés de son époque, et qui en écrit le résumé didactique dans toute la maturité de l'âge, de la réflexion et de l'expérience. Ce ne sont plus enfin des hypothèses, des aperçus ingénieux, des théories plus ou moins spécieuses ; mais des faits positifs, des démonstrations appuyées sur des exemples palpables, des vues larges et hardies sur les points les plus importants des hautes sciences ; sortes de révélations du génie qui, pour la plupart, ont été confirmées par la science plus réfléchie et plus analytique des siècles postérieurs (1).

C'est surtout dans le *Traité des eaux et fontaines* que Palissy a traité avec une supériorité remarquable plusieurs hautes questions de physique générale. Après avoir jeté un coup d'œil sur les eaux de puits, de mare, de citerne et de source ordinaires, il parle des moyens de conduire les eaux d'un point à un autre à l'aide des pompes, des tuyaux ou des aqueducs, et il compare ces différents moyens. Il remarque que les eaux de source sont fréquemment altérées par les matières salines, bitumineuses ou minérales contenues dans le sol qu'elles traversent, et qui les rendent parfois efficaces dans certaines maladies. A l'égard des eaux thermales, il attribue leur chaleur à un feu continuel placé au sein de la terre. Il regarde la force combinée de ce feu central et de l'eau réduite en vapeur comme la cause des volcans et des tremblements de terre. Il ajoute que cette force, capable de renverser des montagnes, n'est point encore connue des hommes ; et cependant il s'était rendu compte de son extrême puis-

(1) Lorsqu'on apprécie les travaux d'un savant d'une époque éloignée, on ne saurait procéder de la même manière que lorsqu'on analyse ceux d'un auteur contemporain. Il est évident qu'il faut surtout s'attacher à signaler les points de la science qu'il a fait avancer, ses découvertes, ses prévisions, son influence, et non à relever ses erreurs, qui furent celles de son siècle, et qui montrent uniquement qu'il n'a pas appliqué à tous les sujets sa sagacité ordinaire, et la rectitude habituelle de ses méditations.

sance, non en l'étudiant, comme il le dit, « dans le livre des philosophes », mais en faisant bouillir de l'eau dans un chaudron, en appliquant le feu à ses ouvrages de terre, et en observant une pomme d'airain contenant un peu d'eau, « et es-» chauffée sur les charbons. »

Plus loin, il combat l'opinion alors générale que les fontaines étaient produites, soit par l'infiltration des eaux de la mer, soit par l'évaporation et la condensation des eaux contenues dans des cavernes au sein des montagnes ; hypothèse que, cinquante ans plus tard, Bacon soutenait encore. Palissy prouve que les eaux de source proviennent de l'infiltration des eaux des pluies, lesquelles tendent à descendre dans l'intérieur de la terre jusqu'à ce qu'elles rencontrent un fond de roc ou d'argile imperméable, qui les contraigne de s'arrêter et de se faire jour à la partie la plus déclive du terrain qu'elles ont traversé. Il ajoute que ce serait là le moyen d'établir des fontaines artificielles, « à l'imitation et le plus près approchant de » la nature, en ensuyvant le formulaire du souverain fontai-» nier..., et ce d'autant qu'il est impossible d'imiter nature en » quoi que ce soit, que premièrement l'on ne contemple les ef-» fets d'icelle, la prenant pour patron et exemplaire. » Et il décrit ce procédé avec une précision et une clarté parfaites. Il explique enfin les fontaines jaillissantes en déclarant que ce phénomène n'a lieu qu'à la condition que les eaux proviennent d'un point plus élevé que celui où elles se montrent, et par contre que « les eaux ne s'élèvent jamais plus haut que les sources d'où elles procèdent. » C'est ainsi que ce physicien naturel saisissait d'un seul coup d'œil l'ensemble du phénomène de la circulation des eaux à la surface comme à l'intérieur du globe, en même temps que le système des lois auxquelles obéissent les liquides, et qui forment aujourd'hui les bases fondamentales de l'hydrostatique.

Mais ces questions élevées de physique n'étaient pas les seules qui le préoccupaient. Quelques savants ayant avancé que les glaces ne se formaient pas à la surface, mais au fond

des rivières, Palissy, à l'aide d'arguments très-probables, montra que la première supposition était seule admissible. C'est là, du reste, une question encore controversée, et sur laquelle la science moderne ne paraît pas avoir dit son dernier mot. Ailleurs il démontre la porosité des corps, en se fondant sur des exemples ingénieux, des observations neuves et qui lui sont propres. Il remarque la tendance qu'ont certaines substances à se rapprocher lorsqu'elles sont abandonnées à elles-mêmes, et il donne à la force qui les réunit le nom d'*attraction*. Enfin, en cherchant la cause des couleurs irisées que présentent certains coquillages, il annonce, pour la première fois, que l'arc-en-ciel ne se produit que lorsque « le so-» leil passe directement au travers des pluies qui lui sont op-» posites. » N'était-ce pas pressentir la décomposition de la lumière avant Dominis, Descartes, Newton, et rapporter, avant Galilée, à des causes naturelles certains phénomènes que l'ignorance avait fait jusque-là regarder comme des prodiges ?...

Voilà le physicien ; essayons d'apprécier le chimiste, et n'oublions pas que nous sommes au siècle où, sous l'influence de Paracelse, d'Agricola, et des nombreux sectateurs de leur école, l'alchimie préoccupait les meilleurs esprits, les uns sérieux et de bonne foi, les autres avides et fascinés par l'espoir de parvenir à un immense résultat. Or, si le nombre des adeptes était grand, celui des dupes l'était encore davantage. Palissy combattit cette grande erreur, d'abord parce qu'à l'aide de son jugement droit et pénétrant il en avait reconnu toute la vanité ; mais aussi parce que, esprit sévère et consciencieux, il croyait de son devoir de stigmatiser les fourbes et de venir en aide à la faiblesse des hommes simples et crédules. Il montra que la recherche du *grand-œuvre* reposait avant tout sur un principe honteux d'avarice et de paresse. Il dévoila les supercheries des alchimistes jongleurs ; il jeta un blâme sévère sur les hommes qui ne cherchent dans la science que l'occasion de s'enrichir, et qui se disent philo-

sophes, « c'est-à-dire amateurs de sapience, » en faisant preuve de cupidité et de mauvaise foi (1). Il cherche à prouver, par le raisonnement, que la génération des métaux est un de ces secrets que Dieu s'est réservés à lui-même, « comme de » donner aux plantes le croistre, la saveur et la couleur; » et qu'enfin la découverte de la transmutation, fût-elle possible, entraînerait les plus funestes conséquences, en arrachant les hommes « au cultivement de la terre, à l'industrie, à l'étude et aux arts. »

Ce n'était point assez de détourner la science de la fausse voie dans laquelle l'engageaient les alchimistes, il fallait encore la ramener dans celle de la vérité, en enseignant les saines méthodes d'observation et les sujets vraiment utiles sur lesquels elle avait à s'exercer. C'est ainsi que, tout en s'élevant contre les fripons ou les fous qui poursuivaient le *grand-œuvre*, il conseillait aux médecins de s'occuper de chimie afin de mieux connaître les choses naturelles; il appelait l'attention des minéralogistes sur la manière dont se forment les sels, les cristaux, et posait les premiers principes de la cristallographie. Remarquant l'analogie qui existe entre certaines pétrifications et les minéraux cristallisés, il cherchait à expliquer les unes et les autres par une même théorie. Il émettait les vues les plus neuves sur l'*affinité*, qui réunit les corps de nature étrangère, et sur l'*attraction*, qu'il appelle « une ma- » tière supresme qui attire les choses de mesme nature. » L'aimant, dit-il, n'est pas seul qui ait le pouvoir d'attirer les choses qu'il *aime*. Le jayet et l'ambre n'attirent-ils pas le fétu? L'huile jetée sur l'eau ne se rassemble-t-elle pas en une masse, et les sels dissous au sein d'un liquide ne savent-ils pas se réunir pour se former en cristaux? Enfin, il va jusqu'à trouver des phénomènes analogues parmi les plantes et même les animaux; comme si, dans ses prévisions instinctives, il

(1) « Ie m'esmerveille comment un tas de faux monnoyeurs, lesquels ne » s'estudient qu'à tromperies et malices, n'ont honte de se mettre au rang » des philosophes. » (V. p. 210.)

eût déjà pressenti le système universel des attractions et des répulsions, des sympathies et des antagonismes ?

Cependant Palissy avait entrevu dans les combinaisons chimiques un ordre de phénomènes dont il avait de la peine à se rendre compte, mais qui lui semblait si général, qu'il fallait absolument le rapporter à une cause de premier ordre : aussi n'hésite-t-il pas à y voir un *cinquième élément*. Comme cette cause s'appliquait surtout d'une manière notable à la formation des sels, il l'avait d'abord confondue avec les sels eux-mêmes. Il se la représentait donc comme une matière soluble dans l'eau, douée de saveur, d'odeur et de propriétés diverses, parfois occultes, et se prêtant facilement à toute sorte de combinaisons. Il la regardait comme la base des substances minérales, le principe de la végétation, et même de la reproduction chez les êtres organisés. Bien que ce nouvel élément ne puisse pénétrer les corps qu'à l'état de dissolution, il doit, pour agir sur eux, se séparer de l'eau dans laquelle il est dissous, et que Palissy appelle eau *exhalative*, par opposition avec l'eau retenue par le sel, et qu'il nomme *germinative* ou *congélative* (de cristallisation). En généralisant cette pensée, il donne au mot *sel* une acception plus étendue, et l'applique à tous les corps doués de propriétés occultes, de quelque faculté de combinaison (1). Que si cette extension dépassait les véritables limites, il faut bien convenir qu'une définition plus rigoureuse eût été un pas trop gigantesque pour l'époque, et surtout pour un chimiste qui n'avait d'autre guide que les inspirations de son génie ; mais on ne saurait nier qu'il y eût là une pensée, une vue scientifique de premier ordre ; et que ce principe, cet *élément* qu'il ne pouvait encore se représenter que sous la forme d'un corps palpable, fût autre chose que la force qui préside aux combinaisons chimiques, qu'on lui donne le nom d'affinité, de force chimico-électrique, de puissance catalytique, ou toute autre dénomination.

(1) C'est dans le même sens que les anciens chimistes l'étendaient jusqu'à la classe des acides.

Cette donnée une fois admise et représentée par le titre de *Cinquième élément*, Palissy s'en servait avec habileté pour rendre compte d'une foule de phénomènes de la nature ou des arts. La présence des sels dans la cendre des végétaux, dans l'écorce des arbres, dans les eaux salpêtrées, lui servait à expliquer la théorie du blanchiment, la fabrication du nitre, le tanage des cuirs, l'action des engrais, des fumiers, la pratique de l'écobuage... Ne dirait-on pas que la science a retrouvé hier ces théories lumineuses long-temps égarées, et qu'elle ne fait que les reproduire en les traduisant dans son langage moderne, et en les accordant avec l'expérience des siècles écoulés depuis leur première émission?

Du reste, ce n'est pas seulement comme théoricien que Palissy doit occuper une place éminente parmi les chimistes de son époque, c'est surtout comme chimiste pratique. Bien qu'il ait émis des idées fort judicieuses sur le développement des espèces minérales au sein de la terre, qu'il assimile aux cristallisations, ce qui le range au nombre des premiers instigateurs de la doctrine du neptunisme, sur la nature des métaux, qui, selon lui, « ne peuvent ni s'accroître ni se multi- » plier », ce qui les place nécessairement parmi les corps élémentaires, et sur une foule d'autres points importants de théorie, hâtons-nous de dire que l'art lui doit encore plus que la science. Etranger aux recherches de l'alchimie, qu'il traite avec tant de mépris, il dirige ses études sur des sujets plus sérieux et d'une application plus directe. Il ne fait pas pendant quinze ans des mélanges et des épreuves en aveugle et au hasard; mais, tandis qu'il affronte une à une et dans toutes les proportions les substances les plus diverses, il pénètre dans tous les détails de la minéralogie, de la géologie, il étudie les pierres, les terres, les sels de toute nature, il constate leurs propriétés, il les range en catégories, et les réunit par des rapports généraux. C'est ainsi qu'il reconnut les propriétés de la soude comme fondant, de l'alun pour fixer les couleurs, la composition des pierres précieuses; qu'il perfec-

tionna la fabrication du salpêtre, l'extraction du sel commun, et qu'il créa cet art tout nouveau d'émailler la poterie, qu'il sut élever de ses premiers éléments jusqu'à son plus haut degré de perfection.

A cette époque les arts possédaient déjà de nombreux procédés, *des secrets*, comme on les appelait, et avec raison, car ils étaient conservés et cachés avec beaucoup de mystère. Le moment où ces secrets passèrent de l'atelier de l'artisan dans le domaine de la science fut sans contredit une grande époque; car si les arts gagnèrent beaucoup à être éclairés par le raisonnement, les sciences ne trouvèrent pas moins d'avantages à être enrichies par l'expérience. Palissy fut l'un de ceux qui contribuèrent le plus efficacement à cette heureuse transition. Artiste, il demanda à la science la cause des phénomènes qu'il observait avec une sagacité rare dans un homme de pratique; puis, devenu savant, il rapporta aux arts les fruits de ses méditations éclairées.

On ne pouvait, à coup sûr, se placer d'une manière plus heureuse au milieu du vaste champ de la science. On dirait que Palissy s'était imposé la mission d'en parcourir successivement toutes les voies, et d'appliquer à tous les sujets cette justesse de coup d'œil, cette sagacité dans l'observation et dans l'expérience qui caractérisent à la fois le savant et l'homme pratique. Après le chimiste et le physicien, on trouve en lui le géologue, l'agronome, et chaque branche de la science lui fournit des données applicables à l'industrie ou aux arts : « Matières, comme il dit, si bien *concaténées* ensem- » ble que l'une donne l'intelligence de l'autre », et qu'elles se servent mutuellement de transition, de lien et d'appui.

C'est dans le *Traité des pierres* et dans celui *de la marne* que Palissy a réuni ses remarques les plus importantes relatives à l'agriculture et à la géologie. Là sont consignés des vues et des faits si nombreux qu'une simple notice doit se borner à les énumérer d'une manière succincte et générale. On s'étonne de la nouveauté, de la variété de ses observa-

tions sur la constitution des montagnes et des différents sols, sur l'origine des espèces minérales, sur la formation et le mode d'accroissement des pierres, qu'il examine sous leurs divers rapports de forme, de couleur, de cohésion, de poids et de densité. Les cristallisations, les statactites, les bois pétrifiés, les fossiles, la marne, les faluns, rien n'échappe à ses recherches, et, fidèle à sa méthode habituelle d'investigation, il rattache tous les faits recueillis à quelque vue générale, qui presque toujours est la plus directe et la plus féconde. C'est ainsi qu'il distingue la cristallisation des sels de la congélation des liquides (1), qu'il assimile les pétrifications aux cristallisations, en ce sens que les unes et les autres s'opèrent par l'intermède de l'eau. Après avoir fait justice de l'opinion de quelques physiciens qui regardaient les empreintes de coquillages que l'on remarque dans certaines pierres comme un jeu de la nature, il attribue la formation des faluns, non à des coquilles portées par le déluge sur les plus hautes montagnes, comme le pensaient d'autres géologues, mais à des amas de poissons engendrés sur les lieux mêmes, et qui y sont restés « à mesure que l'eau leur a défailly et que la vase » où ils habitoient s'est elle-même pétrifiée. » Il va même jusqu'à prouver, par l'intégrité des parties molles de ces coquilles, qu'elles n'ont pu être transportées par une inondation au lieu où on les découvre, et que, par conséquent, la mer a dû recouvrir les points du globe qui les recèle actuellement (2).

(1) Bacon croyait encore, dans le siècle suivant, que le cristal de roche n'était autre chose que de l'eau si fortement congelée qu'elle ne pouvait plus revenir à l'état liquide.

(2) « C'est là, comme on voit, le commencement, l'embryon de la géologie moderne. On avait bien antérieurement, dans différents ouvrages sur les pierres, soit anciens, soit du moyen âge, soit d'une époque plus récente, traité des questions de physique relatives à chaque masse pierreuse, à la formation des cristaux et à celle des cailloux ; mais la question générale de savoir comment se sont superposées ces immenses croûtes qui constituent aujourd'hui les parties solides du continent, n'avait pas encore été agitée. Elle ne commença à l'être que lorsqu'on se fut demandé d'où provenait cette quantité immense de corps organiques et surtout ces milliers de coquilles qui existent dans quelques parties superficielles du globe. Des hommes pré-

Un petit nombre de pages du *Traité de la Marne* contiennent en outre plusieurs idées aussi remarquables par leur nouveauté que par la portée immense de leurs applications. Ainsi, après avoir exposé de la manière la plus claire, et pour la première fois dans les annales de la géologie, le meilleur procédé à employer pour le sondage des terres, il se sert de ce procédé pour montrer que le sol est formé de plusieurs couches ou bancs superposés de terre, de sable, de chaux, de craie ou d'argile, et enfin de roc. « En perçant ce roc, dit-
» il, à l'aide d'une tarière torcière, on peut encore trouver au
» dessous des terres de marne, *voire des eaux pour faire puits,*
» *lesquelles bien souvent pourroient monter plus haut que le*
» *lieu où la pointe de la tarière les aura trouvées; et cela se*
» *pourra faire, moyennant qu'elles viennent de plus haut que*
» *le fond du trou que tu auras fait.* » Pouvait-on prophétiser d'une manière plus formelle les beaux résultats auxquels est parvenu de nos jours l'art de creuser des puits artésiens ?

Mais où le génie et l'âme puissante, énergique de Palissy se révèlent de la manière la plus complète, c'est sans contredit dans le *Traité de l'art de Terre*. Déjà, dans un précédent chapitre, il avait donné d'excellents préceptes sur le choix des terres à poterie, l'art de les mettre en œuvre, l'application du feu, les précautions à prendre et les accidents à éviter : dans le traité suivant, ce n'est plus l'ouvrier de terre, c'est le grand artiste qui prend la parole, et qui, par un artifice ingénieux, comme par son propre exemple, montre à quel ensemble de difficultés morales et matérielles doit s'attendre celui qui, dans son art, a résolu de s'élever au premier rang. D'abord, un long débat dans lequel *Practique* se décide avec peine à révéler à *Théorique* ce qu'elle a appris par une longue expérience ; puis, après y avoir consenti, elle veut l'avertir des

tendaient, dans le quinzième et le seizième siècle, que c'était un résultat des jeux de la nature, un produit de ses forces naturelles, des aberrations de sa puissance vivifiante : Palissy expulsa ces erreurs du domaine de la science. » (G. Cuvier, *Histoire des sciences naturelles*, t. II, p. 231.)

obstacles sans nombre qui l'attendent dans la carrière. C'est là que l'auteur a placé l'admirable tableau de ses propres misères et des longues souffrances qu'il a endurées en poursuivant la recherche de son art. A Dieu ne plaise que nous affaiblissions par quelques citations incomplètes l'effet saisissant de ses paroles. C'est dans le texte même qu'il faut lire ce récit où, dans un style à la fois naïf, pittoresque et énergique, il rend compte de la lutte qu'il eut à supporter pendant seize années contre la misère, les obstacles de toute nature, les obsessions de sa famille ou de ses amis. De quelle simplicité, de quelle modestie sont empreintes ces pages sublimes! Et, en même temps, quelle force d'âme, que de constance et de résignation! Dévoré des soucis les plus amers, réduit aux plus cruelles privations, pauvre, épuisé, malade, et, pour comble de maux, blâmé, tourné en ridicule, regardé par les siens comme un fou ou comme un malfaiteur, mais toujours soutenu par sa confiance en lui-même, par une volonté ferme et persévérante et par le pressentiment du succès. Après avoir plaint et admiré le grand artiste aux prises avec le malheur, on se prend à suivre avec anxiété les chances de sa fortune, et c'est avec une sorte d'orgueil et de joie qu'on le voit enfin sortir triomphant de tant d'épreuves, et atteindre glorieusement au plus haut période de son art.

Mais une pensée d'une haute portée philosophique ressort en même temps de cet éloquent tableau : c'est la toute-puissance du travail, de la volonté agissante, la supériorité des recherches pratiques sur les spéculations passives; c'est, en un mot, le triomphe de la méthode expérimentale, dont, après Palissy, Bacon, Robert Boyle et, plus tard, Francklin ont si bien développé la suprématie sur les théories scientifiques et les rêves brillants de l'imagination. « La science se manifeste » à qui la cherche! » s'écrie-t-il ; mais il faut avant tout, pour y réussir, « être veuillant, agile, portatif, laborieux. » Palissy montre par son exemple qu'il faut encore être persévérant, courageux et surtout résigné.

c.

XXX

Mais tandis que, soit par le professorat, soit par ses travaux ou ses écrits, il enrichissait son siècle des fruits de ses fécondes méditations, la France continuait d'être plongée dans les horreurs de la guerre civile, et, bien qu'il vécût tout à fait en dehors des passions de son époque, les haines religieuses et les persécutions, devenues plus violentes, ne pouvaient manquer de l'atteindre, lui, toujours fidèle à ses croyances, toujours inébranlable dans ses convictions. En 1588, affaibli par l'âge, presque octogénaire, il fut arrêté, enfermé à la Bastille, et menacé du dernier supplice. Matthieu de Launay, ancien ministre et alors l'un des Seize, insistait pour qu'on le conduisît au *spectacle public*, c'est-à-dire à la mort ; mais le duc de Mayenne, qui le protégeait, fit traîner son procès en longueur. On lit dans l'Histoire universelle de d'Aubigné et dans la confession de Sancy, du même auteur, que le roi Henri III, étant allé le voir dans sa prison, lui dit ces paroles : « Mon bon homme, il y a quarante-cinq ans que
» vous êtes au service de ma mère et de moi. Nous avons en-
» duré que vous ayez vescu en vostre religion parmi les feux
» et les massacres : maintenant je suis tellement pressé par
» ceux de Guise et mon peuple, que *je suis contraint* de vous
» laisser entre les mains de mes ennemis, et que demain vous
» serez bruslé, si vous ne vous convertissez. — Sire, répond
» Bernard, je suis prest à donner ma vie pour la gloire de
» Dieu. Vous m'avez dit plusieurs fois que vous aviez pitié
» de moi ; et moi j'ai pitié de vous, qui avez prononcé ces
» mots : *Je suis contraint!* Ce n'est pas parler en roi, sire ; et
» c'est ce que vous-mesme, ceux qui vous contraignent, les
» Guisards et tout votre peuple ne pourrez jamais sur moi ; car
» je sais mourir (1). » Palissy mourut en effet, mais de sa mort naturelle, à la Bastille, en 1589. Ainsi se termina une carrière honorée par tant de talents et de si rares vertus.

(1) « Voyez l'impudence de ce bélistre! ajoute d'Aubigné ; vous diriez qu'il auroit lu ce vers de Sénèque : On ne peut contraindre celui qui sait mourir : *Qui mori scit, cogi nescit.* »

XXXI

Pourquoi faut-il que l'une des plus belles époques de l'histoire de l'esprit humain, celle du plus vaste essor qu'aient pris à la fois les sciences, les lettres et les arts, soit ainsi souillée par des actes d'intolérance qui s'adressaient à la pensée, et cherchaient à contraindre par la violence une force qui échappe à toutes les entraves et ne tient aucun compte des obstacles qu'on lui oppose! La renaissance du goût, des talents et de la philosophie naturelle eût été en même temps celle de la civilisation tout entière, si la persécution n'en eût pas comprimé les élans généreux, et si des scènes de barbarie n'eussent pas été mêlées aux brillants combats que des esprits supérieurs livraient à l'ignorance et aux préjugés d'un autre âge. Palissy, comme après lui Galilée et Descartes, figurait parmi ceux qui n'hésitèrent pas à soutenir cette glorieuse lutte, comme à en subir les conséquences. Il porta les premiers coups au respect servile de l'antiquité, et réduisit à leur juste valeur ces vaines questions, ou plutôt ces principes jurés sur la parole du maître, qui faisaient la base de la scolastique du moyen âge. Que l'on ne fasse donc pas à Bacon tout l'honneur de cette heureuse révolution dans la marche de l'esprit humain; car, un demi-siècle avant lui, un homme sans lettres et sans études proclamait hautement que le livre de la nature était le seul dans lequel il eût cherché à lire, et qu'un chaudron rempli d'eau et placé sur le feu lui avait appris plus de physique que tous les livres des philosophes (1). Provoquer une pareille réforme, en plein seizième siècle, n'était pas seulement un trait de génie, c'était encore un acte de courage. Il y avait toute une révolution dans la pensée de faire revenir les esprits de leur culte aveugle pour une philosophie surannée. Pour rompre en visière à des idées accrédi-

(1) « Prends garde d'enyvrer ton esprit des sciences escriptes aux cabinets » par une théorique imaginative ou crochetée de quelque livre escrit par » imagination de ceux qui n'ont rien pratiqué; et te donnes garde de croire » les opinions de ceux qui disent et soutiennent que théorique a engendré » la practique. » (V. p. 132.)

tées par les siècles et soutenues par un parti tout-puissant, il fallait se résoudre à affronter la persécution et la mort. C'est ce que savait fort bien Palissy sans l'avoir appris de Sénèque. Tel était le prix qu'il devait attendre, et qu'il reçut en effet des services qu'il rendait à son siècle et à son pays.

Né dans une condition obscure, mais largement doué des qualités qui constituent le génie, Palissy prouva qu'un tel ensemble de facultés n'a pas toujours besoin du secours de l'étude. Bien que dans ses travaux d'art il se soit montré l'émule des grands maîtres de l'art italien, on ne sait à quelle école il en puisa les principes. Physicien, géologue, chimiste, nul ne peut dire quels furent ses premiers maîtres, pas plus qu'il n'est possible de retrouver la source de son élocution facile et originale. Si l'éducation ne lui vint point en aide, elle ne contraria pas non plus ses dispositions naturelles, et peut-être faut-il attribuer à cette circonstance ce qui, dans ses vues scientifiques, nous frappe par la nouveauté, et dans ses écrits par la singularité du style. Artiste, savant, philosophe, il posséda cette variété de talents que l'on retrouve dans la plupart des hommes supérieurs qui, poursuivant une pensée primordiale, voulurent en saisir les rapports avec toutes les branches des connaissances humaines (1). Personne mieux que lui ne prouva cette vérité, que chaque art renferme une science tout entière, pour quiconque veut l'approfondir dans tous ses détails.

Parmi tant de talents divers, celui auquel Palissy attachait le moins d'importance et dont il eût fait meilleur marché, c'est à coup sûr son talent d'écrivain. Ce n'est point une fausse

(1) Léonard de Vinci était peintre, sculpteur, architecte, poète, chimiste et musicien. Michel-Ange était peintre, architecte, mathématicien, anatomiste; Cellini, graveur, orfèvre, sculpteur, musicien, guerrier; Bramante, peintre, ingénieur, architecte, musicien, poète. On sait que Haller s'occupait à la fois de sciences, d'administration, de médecine, de poésie, et que Robert Boyle était en même temps physicien, géologue, philosophe et moraliste.

modestie qui le porte à s'excuser partout de son peu d'habileté, et de ce qu'il écrit « en un language rustique et mal » plaisant. Je ne suis, dit-il, ne grec, ne hébrieu, ne poëte, ne » réthoricien, ains un simple artisan bien pauvrement instruit » aux lettres, » et toutefois la postérité en a jugé bien différemment. S'il est vrai que le style soit l'homme même, c'est surtout lorsque l'auteur n'a point eu la prétention d'écrire, et qu'il n'a pris la plume que pour développer des principes qu'il ne croit pas suffisamment établis par son exemple ou par ses œuvres. Palissy obéissait encore à une autre pensée : « On » ne doit pas, dit-il, abuser des dons de Dieu, et cacher ses » talents en la terre; car il est écrit que le fol cachant sa folie » vaut mieux que le sage celant son savoir. » A ses propres yeux, il ne fut donc pas écrivain, et cependant combien d'hommes d'étude pourraient lui envier les éminentes qualités qui caractérisent son style! Clair, précis, méthodique lorsqu'il décrit les procédés des arts, simple et naturel quand il exprime ses vœux ou ses pensées intimes, noble et énergique quand il aborde des sujets plus relevés, il se distingue toujours par une lucidité parfaite et une logique irréprochable. Si, dans l'exposé de certaines théories, on trouve parfois du vague et de l'obscurité, il faut se souvenir qu'à cette époque la langue de la science n'était point encore formée, et que les vues de Palissy n'étaient point assez arrêtées elles-mêmes pour qu'il pût les formuler avec netteté et précision.

Un esprit aussi remarquable par la sagacité et la rectitude devait apporter dans la discussion une dialectique d'autant plus pressante qu'elle reposait avant tout sur une profonde conviction. La forme de dialogue y jetait de la variété, du mouvement, et faisait place aux objections que l'auteur y semait avec adresse, tout en se réservant de les combattre victorieusement. Ainsi *Théorique*, qui représente la scolastique de l'époque, est un pédagogue fort ignorant, fort indocile, très-confiant en lui-même, dont *Practique* renverse à plaisir tous les raisonnements et s'amuse à combattre les opinions

fagotées à l'avance. Une fois placée sur son terrain, Practique pousse l'argument avec habileté, manie le sarcasme avec finesse, et ne laisse plus aucun repos à son interlocuteur. Quelques-uns de ces dialogues peuvent être regardés comme des thèses complètes et comme de véritables modèles d'argumentation.

On a comparé le style de Palissy à celui de Montaigne. Son expression, en effet, est presque toujours vive, pittoresque, prime-sautière, comme celle du célèbre sceptique. Il l'égale souvent par son tour ingénieux, par une certaine verve de logique, par une liberté de pensée et de langage qui n'exclut pas la finesse et la malice; d'autres fois il le surpasse par le piquant et la nouveauté des formes, par l'élévation des idées, par une éloquence vive et naturelle qui prend sa source dans la fermeté de son caractère et dans la sincérité de ses croyances. Alors son style se remplit d'images, et atteint à une hauteur toute poétique; c'est l'élan d'un cœur pur, honnête, religieux; c'est le reflet de la candeur et de l'énergie de son âme, comme parfois on y retrouve les caractères de son talent d'artiste et les qualités qui distinguent ses ouvrages d'art, c'est-à-dire l'originalité, le relief et le coloris.

En jetant un dernier regard sur cette nature si puissante et dotée si richement des facultés les plus variées, on se demande si Palissy fut heureux. Il le fut, sans doute, en ce sens qu'il atteignit le but spécial de ses labeurs; mais la gloire, cet autre but de l'ambition de toute âme élevée, l'obtint-il de la justice de ses contemporains? Malheureusement, non. Ses écrits furent à peine connus de son vivant; ses ouvrages d'art ne furent jamais populaires. Peu compris de son siècle, qui ne vit en lui qu'un potier de terre, parce qu'il ne rechercha point d'autre titre, apprécié seulement par un petit nombre de gens de goût, il en tira peu de parti pour sa gloire contemporaine, et encore moins pour sa fortune. Il se crut ignorant pour n'avoir point lu les livres des philosophes, tandis qu'il avait « anatomizé la » matrice de la terre » et étudié le grand livre de la nature : il

se dit étranger aux lettres, et ses écrits sont étonnants de profondeur, brillants d'imagination, d'esprit et de génie. Sa modestie n'en fut pas moins prise au mot ; et cependant, quand on considère cette intelligence supérieure qui s'applique à tous les sujets, qui saisit partout le point de vue le plus droit et le plus fécond, on se demande ce qu'est la science de tant d'hommes qui passent pour des savants !

Soit que les malheurs de l'époque eussent attristé son âme, soit par l'effet de son austérité naturelle, Palissy était porté à la mélancolie ; il aimait la retraite et la solitude, aussi son nom ne se trouve-t-il mêlé à aucun incident historique de son temps. Lorsqu'on s'est bien pénétré de la nature de son caractère, on se le représente, non comme un de ces artistes fougueux de la renaissance, dévorés d'orgueil et d'envie, pour lesquels la poursuite de leur art ne fut qu'un long combat, tout rempli de passions violentes et haineuses; mais comme un penseur grave, sévère, religieux, toujours appliqué à la méditation, se promenant le front baissé pour interroger la nature, et ne relevant la tête que pour admirer ou bénir la Providence. C'est une de ces imposantes figures qui répandent sur leur époque un caractère austère et solennel, un des membres de cette illustre phalange qui sépara le moyen âge des temps modernes; phares de l'intelligence, élevés au milieu d'un siècle de ténèbres, comme pour rappeler l'esprit humain à ses nobles destinées, et le guider désormais dans la carrière du perfectionnement.

P.-A. CAP.

Décembre 1843.

NOTE

SUR LES PRÉCÉDENTES ÉDITIONS DES ŒUVRES DE BERNARD PALISSY.

Le premier ouvrage authentique de Bernard Palissy fut publié à La Rochelle, sous ce titre : « RECEPTE VÉRITABLE, *par* » *laquelle tous les hommes de France pourront apprendre à mul-* » *tiplier et à augmenter leurs thrésors*. Item, ceux qui n'ont » jamais eu cognoissance des lettres, pourront apprendre une » philosophie nécessaire à tous les habitants de la terre. Item, » en ce livre est contenu le dessein d'un iardin autant délec- » table et d'utile invention, qu'il en fut oncques veu. Item, le » dessein et ordonnance d'une ville de forteresse, la plus im- » prenable qu'homme ouyt iamais parler ; composé par mais- » tre BERNARD PALISSY, ouurier de terre, et inventeur des » rustiques figulines du Roy, et de monseigneur le duc de » Montmorency, pair et connestable de France ; demeurant en » la ville de Xaintes. La Rochelle, de l'imprimerie de Barthé- » lemy Berton. 1563. » Le seul exemplaire que nous connais- sions de cet ouvrage appartient à la Bibliothèque royale. C'est sur lui qu'a été imprimé et corrigé le texte qui fait partie de la présente édition.

En 1580, Palissy publia son ouvrage intitulé : « DISCOURS » ADMIRABLES *de la nature des eaux et fontaines, tant natu-* » *relles qu'artificielles, des métaux, des sels et salines, des pier-* » *res, des terres, du feu et des émaux* ; avec plusieurs autres » excellents secrets des choses naturelles. Plus, un traité de la » marne, fort utile et nécessaire à ceux qui se mellent de l'a- » griculture. Le tout dressé par dialogues, ès quels sont intro-

» duits la théorique et la practique. Par M⁰ Bernard Palissy,
» inventeur des rustiques figulines du Roy, et de la Royne sa
» mère. Un volume in-8, à Paris, chez Martin le jeune, à
» l'enseigne du Serpent, devant le collége de Cambray. 1580. »
Les exemplaires de ce volume sont devenus très-rares, et sont
par conséquent d'un prix assez élevé.

Ces deux ouvrages furent réunis en deux volumes in-8, publiés en 1636, sous ce titre : « Le Moyen de devenir riche,
» *et la manière véritable par laquelle tous les hommes de la*
» *France pourront apprendre à multiplier leurs thrésors et*
» *possessions*; avec plusieurs autres excellents secrets des choses naturelles, desquels jusques à présent l'on n'a ouï. Paris,
» Robert Fouet, libraire. 1636. » Le second volume est intitulé : « Seconde partie du Moyen de devenir riche, contenant les Discours admirables *de la nature des eaux et fontaines*, etc., par M⁰ Bernard Palissy, inventeur des rustiques figulines du Roy. »

Cette édition est peu estimée, parce qu'elle est loin d'être conforme aux textes originaux publiés du vivant de l'auteur. Le libraire est inexcusable, non-seulement pour avoir donné à l'œuvre de Palissy un titre ridicule, mais encore pour l'avoir tronquée et mutilée, en supprimant tous les passages qui, au seizième siècle, lui paraissaient de nature à soulever la susceptibilité du clergé, comme en la dénaturant par certaines additions. C'est ainsi, par exemple, que l'on trouve, au commencement du premier volume, une épître dédicatoire au peuple français, qui évidemment n'est point sortie de la plume de Palissy.

Les œuvres du potier de Xaintes, long-temps oubliées, ne reprirent quelque lustre que dans la seconde moitié du siècle suivant. Mais la rareté des exemplaires ne permettait encore au public de les connaître que d'après les citations et les éloges de quelques savants empressés de relever la gloire de l'un des hommes les plus capables d'honorer sa patrie.

En 1777, MM. Faujas de Saint-Fond et Gobet donnèrent une édition nouvelle des *OEuvres de Bernard Palissy*. Cette édition, qui forme un beau volume in-4°, est accompagnée de notes instructives, de documents nombreux, et doit être regardée comme un digne hommage rendu à notre illustre compatriote. Toutefois, l'envie de la rendre le plus complète pos-

sible nous semble avoir entraîné trop loin les deux savants éditeurs. Un passage de la *Recepte veritable* leur ayant paru indiquer que Palissy avait, avant 1563, publié un premier ouvrage, dont il ne donne d'ailleurs ni le titre ni la date, Faujas et Gobet s'efforcèrent de découvrir cet écrit, et crurent l'avoir rencontré dans un opuscule pseudonyme publié à Lyon, en 1557, sous le nom de Pierre Braillier, et ils n'hésitèrent pas à l'insérer dans leur édition. Bien que nous ne puissions admettre leurs arguments à ce sujet, nous avons cru devoir réimprimer cet opuscule sous la forme d'APPENDICE (1), afin que notre édition ne parût pas moins complète que la précédente, et aussi pour que le public fût appelé à décider entre l'opinion des deux savants éditeurs et la nôtre.

Nous avons d'ailleurs un autre reproche à faire à l'édition de 1777 : c'est d'avoir complétement interverti l'ordre des divers traités dont se composent les œuvres authentiques de Palissy. Cette interversion dans l'ordre chronologique a non-seulement pour résultat d'empêcher le lecteur de suivre le développement progressif des idées de l'auteur, mais aussi de présenter en seconde ligne des opinions, des systèmes qu'il a modifiés avec le temps, en sorte que la rectification précède partout la théorie primitive. Enfin, Faujas de Saint-Fond et Gobet, tout en blâmant l'éditeur de 1636 de quelques altérations qu'il avait fait subir au texte original, ont aussi fait quelques sacrifices aux opinions dominantes de l'époque. Nous n'avons pas besoin de dire que tous les passages supprimés ou altérés ont été scrupuleusement rétablis dans notre édition, la seule exactement conforme à celles publiées du vivant de l'auteur.

La destinée des ouvrages de Palissy, et par conséquent celle de sa gloire, ont été soumises à de singulières alternatives. Son nom eut peu de retentissement pendant sa vie. Oublié après sa mort, pendant un demi siècle, il fut réhabilité, d'une manière assez maladroite, dans l'édition du libraire Fouët. Dans le siècle suivant, il devint, de la part de Voltaire, l'objet de quelques plaisanteries qui montrèrent uniquement la faiblesse de leur auteur sur les questions de Physique du globe. Vers la fin du même siècle, Fontenelle, Buffon, Rouelle,

(1) V. p. 383.

Guettard, Venel et plusieurs autres savants lui rendirent une justice tardive, mais éclatante, et rappelèrent avec admiration ses divers titres scientifiques, tandis que Faujas et Gobet, dans leur belle édition in-4°, élevaient à sa gloire un véritable monument. Plus tard, Cuvier et tous ceux qui s'occupèrent de l'histoire de la science, lui rendirent le même hommage. Enfin, tout récemment, Palissy a été très-dignement apprécié dans une notice de M. Miel, lue, en 1835, à la Société libre des Beaux-Arts, et dans un excellent article de M. Eug. Piot, inséré dans le *Cabinet de l'Amateur*, 2ᵉ livraison, mars 1842.

TABLE SOMMAIRE.

Notice historique sur la vie et les ouvrages de Bernard Palissy. III
Note sur les précédentes éditions des œuvres de Bernard Palissy. XXXVI

I. RECEPTE VÉRITABLE par laquelle tous les hommes de la France pourront apprendre à multiplier leurs thrésors.. 1
 A Monseigneur le mareschal de Montmorancy, chevalier de l'Ordre du Roi, etc. 3
 A ma très chère et honorée dame, Madame la Royne mère. 6
 A Monseigneur le duc de Montmorancy, pair et connestable de France. 8
 RECEPTE VÉRITABLE, etc. 13
 De la ville de forteresse. 113

II. DISCOURS ADMIRABLES de la Nature des eaux et fontaines, etc. 127
 A très haut et très puissant sieur le sire Anthoine de Ponts. 129
 Advertissement aux lecteurs. 132
 Des Eaux et fontaines. 136
 Du Mascaret qui s'engendre au fleuve de Dourdougne. 184
 Traité des Métaux et alchimie. 190
 Traité de l'Or potable. 224
 Du Mitridat ou Thériaque. 231
 Des Glaces. 236
 Des Sels divers. 241
 Du Sel commun. 251
 Des Pierres. 261
 Des Terres d'argile. 298
 De l'Art de terre, de son utilité : des esmaux et du feu. 306
 Pour trouver et connoistre la terre nommée marne, etc. 325
 Coppie des escrits qui sont mis au dessouz des choses merveilleuses que l'auteur a mises par ordre en son cabinet, etc. 358
 Extrait des sentences principales contenues au présent livre. 367
 Explication des mots plus difficiles. 377

III. APPENDICE. 383
 Avertissement de l'éditeur. 385
 A noble seigneur Claude de Gouffier, comte de Caruasz, etc. 391
 Espitre au lecteur. 393
 Déclaration des abus et ignorances des médecins. 399
 Table alphabétique des matières. 433

RECEPTE VÉRITABLE,

PAR LAQUELLE TOUS LES HOMMES DE LA FRANCE

POURRONT APPRENDRE A MULTIPLIER

ET AUGMENTER LEURS THRÉSORS.

Item, ceux qui n'ont jamais eu cognoissance des lettres, pourront apprendre une philosophie nécessaire à tous les habitans de la terre.

Item, en ce liure est contenu le dessein d'un jardin autant délectable et d'utile inuention, qu'il en fut oncques veu.

Item, le dessein et ordonnance d'une ville de forteresse, la plus imprenable qu'homme ouyt iamais parler, composé par maistre Bernard PALISSY, ouurier de terre, et inuenteur des rustiques figulines du Roy, et de Monseigneur le duc de Montmorancy, pair et connestable de France, demeurant en la ville de Xaintes.

FB. (1) A. M. BERNARD PALISSY,

son singulier et parfait ami, salut.

Si le malin vulgaire, ami Bernard,
Mesdit souuent de ce qui est louable,
Craindras-tu point, veu mesme ton propre art,
Luy diuulguer ce liure profitable ?
Non, si me crois : car il m'est agreable,
Quoy que voudroyent enuieux mal parler :
Les ignorans, de l'art tant admirable,
Par ton moyen y pourront profiter.

AV LECTEVR, salut.

En petit corps gist souuent grand puissance,
Ce qu'entendras, lecteur, lisant ce liure,
Qui de nouueau est mis en euidence,
Pour d'aucuns sots, l'erreur ne faire viure :
Car il demonstre à l'œil, ce qu'il faut suiure,
Ou reietter, en ses dits admirables :
En recitant maints propos veritables,
Tend à ce but, qu'art imitant nature,
Peut accomplir, que maints estiment fables,
Gens sans raison, et d'inique censure.

(1) Probablement François Béroalde de Verville, son contemporain, auteur du *Moyen de parvenir*.

A MONSEIGNEUR LE MARESCHAL

DE MONTMORANCY, CHEVALIER DE L'ORDRE DU ROI,

CAPITAINE DE CINQUANTE LANCES, GOUVERNEUR DE PARIS

ET DE L'ISLE DE FRANCE (1).

Monseigneur, combien qu'aucuns ne voudroyent jamais ouir parler des Escritures Sainctes, si est-ce que je n'ay trouvé rien meilleur que suivre le conseil de Dieu, ses esdits, statuts et ordonnances : et en regardant quel estoit son vouloir, j'ay trouvé que, par testament dernier, il a commandé à ses héritiers qu'ils eussent à manger le pain au labeur de leurs corps, et qu'ils eussent à multiplier les talens qu'il leur auoit laissez par son testament. Quoi considéré, ie n'ay voulu cacher en terre les talens qu'il lui a pleu me distribuer : ains pour les faire profiter et augmenter, suiuant son commandement, je les ay voulu exhiber à un chacun, et singulièrement à Vostre Seigneurie, sachant bien que par vous ne seront mesprisez, combien qu'ils soyent prouenus d'une bien pauure thésorerie, estant portée par une personne fort abjecte et de basse condition. Ce néantmoins, puisqu'il a pleu à Monseigneur le Connestable vostre père, me faire l'honneur de m'employer à son service, à l'édification d'une admirable Grotte rustique de nouvelle inuention, ie n'ay craint à vous adresser partie des talens que i'ay receus de celui qui en a en abondance. Monseignevr, les talens que je vous enuoye, sont en premiers lieu plusieurs beaux secrets de nature, et de l'agriculture, lesquels i'ay mis en un liure, tendant à inciter tous les hommes de la terre, à les rendre amateurs de vertu et iuste labeur, et singulièrement en l'art d'agriculture, sans lequel nous ne saurions vivre. Et parce que je voy que la terre est cultiuée le plus souuent par gens ignorans, qui ne la font qu'auorter, i'ay mis plusieurs enseignemens en ce liure, qui pourront estre le moyen qu'il se pourra cueillir plus de

(1) Fils du Connétable.

quatre millions de boisseaux de grain, par chacun an, en la France, plus que de coustume, pouruen qu'on veuille suiure mon conseil : ce que i'espère que vos sujets feront, après avoir receu l'aduertissement que i'ay donné en ce liure. Item, parce que vous estes un Seigneur puissant et magnanime, et de bon iugement, i'ai trouué bon de vous désigner l'ordonnance d'un iardin autant beau qu'il en fut iamais au monde, horsmis celuy du Paradis terrestre, lequel dessein de iardin, je m'asseure que trouuerez de bonne inuention.

Item, en ce liure est contenu le dessein et ordonnance d'une ville de forteresse, telle que iusques ici on n'a point ouy parler de semblable. Il y a audit liure plusieurs autres choses fructueuses que ie laisseray dire à ceux qui en les lisant les retiendront et vous en feront le récit. Je n'ay point mis le portrait dudit iardin en ce liure, pour cause que plusieurs sont indignes de le veoir, et singulièrement les ennemis de vertu et de bon engin : aussi que mon indigence et occupation de mon art ne l'a voulu permettre. Je say qu'aucuns ignorans, ennemis de vertu et calomniateurs diront que le dessein de ce iardin est un songe seulement, et le voudront peut estre comparer au songe de Polyphile, ou bien voudront dire qu'il seroit de trop grande despence, et qu'on ne pourroit trouuer lieu commode pour l'edification dudit iardin, iouxte le dessein. A ce je responds, qu'il se trouuera plus de quatre mille maisons nobles en France auprés desquelles se trouueront plusieurs lieux commodes pour édifier ledit iardin, iouxte la teneur de mon dessein. Et quant à la despence, il y a en France plusieurs iardins qui ont plus cousté qu'icelui ne cousteroit. Quand il vous plaira me faire l'honneur de m'employer à cest affaire, ie ne faudray à vous en faire soudain un pourtrait, et mesmes le mettray en exécution, s'il vous venoit à gré de ce faire. Et quand est du dessein et ordonnance de la ville forteresse, ie say qu'aucuns diront qu'il ne se faut arrester à mon dire, d'autant que ie n'ay point exercé l'estat militaire, et qu'il est impossible de savoir faire ces choses sans avoir veu premièrement plusieurs batteries et assaux de villes. A ce ie responds, que l'œuure que i'ai commencée pour Monseigneur le Connestable rend assez de tesmoignage du don que Dieu m'a donné pour leur clore la bouche : car s'ils font inquisition, ils trouueront que telle besongne n'a oncque

esté veuë. Item, ayant fait une plus ample inquisition, ils trouueront que nul homme ne m'a apprins de sauoir faire la besongne susdite. Si donques il a pleu à Dieu de me distribuer ses dons en l'art de terre, qui voudra nier qu'il ne soit aussi puissant de me donner d'entendre quelque chose en l'art militaire, lequel est plus apprins par nature, ou sens naturel, que non pas par pratique? La fortification d'une ville consiste principalement en traits et lignes de géométrie, et on sait bien que, grâces à Dieu, je ne suis point du tout despourveu de ces choses. J'ay prins la hardiesse de vous proposer ces argumens, à fin d'obvier aux détractions qu'aucuns vous pourroyent persuader, en vous disant que la chose est impossible : toutesfois ie me soumets à receuoir honteuse mort, quand je ne feray apparoir la vérité estre telle toutesfois et quantes il vous plaira m'employer à cest affaire. Si ces choses ne sont escrites à telle dextérité que Vostre Grandeur le mérite, il vous plaira me pardonner : ce que j'espère que ferez, veu que je ne suis ne Grec, ne Hébrieu, ne Poëte, ne Rhétoricien, ains un simple artisan bien pauurement instruit aux lettres : ce néantmoins, pour ces causes, la chose de soy n'a pas moins de vertu que si elle estoit tirée d'un homme plus éloquent. J'aime mieux dire la vérité en mon langage rustique, que mensonge, en un langage rhétorique. Suyvant quoi, Monseigneur, i'espère que receurez ce petit œuvre d'aussi bonne volonté que ie desire qu'il vous soit agréable. Et en cest endroit, je prierai le Seigneur Dieu, Monseigneur, vous donner, en parfaite santé, bonne et longue vie.

Votre très-affectionné et très-humble serviteur,

BERNARD PALISSY.

A MA TRÈS-CHÈRE ET HONORÉE DAME,

MADAME LA ROINE MÈRE (1).

MADAME, quelque temps après que, par vostre moyen et faveur, à la requeste de Monseigneur le Connestable, ie fus déliuré des mains de mes plus cruels ennemis, i'entray en un débat d'esprit sur le fait de l'ingratitude des hommes : sachant bien que la cause pour laquelle ils me vouloyent liurer à la mort, n'estoit si non pour leur auoir pourchassé leur bien, voire le plus grand bien qui leur pourroit iamais advenir. Quoy considéré, i'entray en moy-mesme, pour fouiller les secrets de mon cœur et entrer en ma conscience, pour savoir s'il y auoit en moi quelque ingratitude, comme celle de ceux qui m'auoient livré au péril de la mort. Lors me vint à souvenir du bien qu'il vous a pleu me faire, quand de vostre grâce vous employastes l'authorité du Roy pour ma déliurance. Quoy voyant, ie trouvay que ce seroit en moy une grande ingratitude, si ie ne recognoissois un tel bien : ce neantmoins, mon indigence n'a voulu permettre que ie me transportasse iusques en vostre présence pour vous remercier d'un tel bien, qui est la moindre récompense que ie pourrois faire. Et combien que Dieu m'aye donné plusieurs inuentions desquelles ie pourrois vous faire service, ce néantmoins ie n'ay eu moyen vous le faire entendre, qui m'a causé mettre en récompense de ce, plusieurs secrets en lumière contenus en ce liure, lesquels tendent à fin de multiplier les biens et vertus de tous les habitans du Royaume. Ma petitesse n'a osé desdier mon œuure au Roy, sachant bien qu'aucuns voudroyent dire que i'aurais ce fait, tendant à fin d'estre recompensé : quand ainsi seroit, ce ne seroit rien de nouueau. Madame, il ne fut iamais que les bonnes inuentions ne fussent recompensées par les Roys; ce néantmoins, que i'ay espérance que cest œuure sera plus utile au Roy que pour nul autre : toutes fois, à cause de ma petitesse, ie l'ay desdié à Monseigneur de

(1) Catherine de Médicis.

Montmorancy, bon et fidèle seruiteur du Roy, lequel j'espère
qu'il saura très bien faire entendre à son souuerain Prince et
Roy. Il y a des choses escrites en ce liure qui pourront beau‑
coup seruir à l'édification de vostre iardin de Chenonceaux :
et quand il vous plaira me commander vous y faire seruice,
ie ne faudray m'y employer. Et s'il vous venoit à gré
de ce faire, il feray des choses que nul autre
n'a fait encores iusques ici. Qui sera l'en‑
droit, Madame, où ie prieray le
Seigneur Dieu vous don‑
ner, en parfaite
santé, longue
et heu‑
reuse
vie.

Vostre très humble et très affectionné seruiteur,

BERNARD PALISSY.

A MONSEIGNEUR LE DUC DE MONTMORANCY,

PAIR ET CONNESTABLE DE FRANCE.

ONSEIGNEUR, ie croy que vous ne trouuerez mauvais de ce que ne vous ay esté remercier, lors qu'il vous pleut d'employer la Roine mère, pour me tirer hors des mains de mes ennemis mortels et capitaux. Vous savez que l'occasion de vostre œuvre, ensemble mon indigence, ne l'a voulu permettre : ie cuide que n'eussiez trouvé bon que i'eusse laissé vostre œuvre, pour vous apporter un grand merci. Jesus Christ nous a laissé un conseil escrit en Sainct Matthieu, chapitre 7, par lequel il nous desfend de semer les marguerites devant les pourceaux, de peur que, se retournant contre nous, ils ne nous deschirent : si j'eusse creu ce conseil, ie n'eusse été en peine vous prier pour ma déliurance, vous asseurant, à la vérité, que mes haineux n'ont eu occasion contre moy, sinon pour ce que ie leur auois remonstré plusieurs fois certains passages des Escritures Sainctes, où il est escrit que celuy est malheureux et maudit, qui boit le laict, et vestist la laine de la brebis, sans lui donner pasture. Et combien que cela les deust inciter à m'aimer, ils ont par là prins occasion de me vouloir faire destruire comme malfaicteur : et est chose véritable que si ie me fusse confessé ès juges de cette ville, qu'ils m'eussent fait mourir avant i'eusse sceu obtenir de vous aucun secours. Et l'occasion qui mouuoit aucuns Juges à estre un corps et une ame, et une même volonté auec le Doyen et Chapitre, mes parties, c'estoit parce qu'aucuns desdits Juges estoyent parens dudit Doyen et Chapitre, et possèdent quelque morceau de benefice, lequel ils craignent perdre, parce que les laboureurs commencent à gronder en payant les dixmes à ceux qui les reçoyvent sans les mériter. Je me fusse très bien donné garde de tomber entre leurs mains sanguinaires, n'eust esté que i'auois esperance qu'ils auroyent esgard à vostre œuure; et à l'incitation de Monseigneur le Duc de Montpensier, lequel me donna une sauue garde, leur interdisant de

non cognoistre ni entreprendre sur moy, ni sur ma maison, sachant bien que nul homme ne pourroit acheuer vostre œuvre que moy. Aussi estant entre leurs mains prisonnier, le Seigneur de Burie, et le Seigneur de Jarnac et le Seigneur de Ponts prindrent bonne peine pour me faire déliurer, tendant à fin que vostre œuure fust parachevée. Quoy voyant mes haineux, m'envoyerent de nuit à Bourdeaux, par voyes obliques, sans avoir esgard, ni à vostre grandeur, ni à vostre œuure. Ce que ie trouvay fort estrange, veu que Monsieur le Comte de la Roche-Foucaut, combien que pour lors il tenoit le parti de vos aduersaires, ce néantmoins, il porta tel honneur à vostre grandeur qu'il ne voulut iamais qu'aucune ouuerture fust faite à mon hastelier, en cause de vostre œuure; mais les susdits de ceste ville ne firent pas ainsi, ains au contraire, soudain que je fus prisonnier, ils firent ouuerture et lieu public de partie de mon hastelier, et avoyent conclu en leur maison de ville de jetter mon hastelier à bas, lequel a esté partie érigé à vos despens; et eust esté exécutée une telle délibération, n'eust esté le Seigneur et Dame de Ponts qui prierent les susdits de n'executer leur intention.

Je vous ay escrit toutes ces choses, à fin que n'eussiez opinion que i'eusse esté prisonnier comme un larron ou meurtrier. Je say combien il vous saura très bien souuenir de ces choses en temps et lieu, et combien que vostre œuure vous coustera beaucoup davantage, pour le tort qu'ils vous ont fait en ma personne; toutesfois i'espere, que suivant le conseil de Dieu, vous leur rendrez bien pour mal, ce que ie desire : et
de ma part, de mon pouuoir ie tascheray à recognoistre
le bien qu'il vous a pleu me faire. Qui est l'endroit, où je prieray le Seigneur Dieu,
Monseigneur, vous donner en parfaite santé, longue et
heureuse
vie.

Vostre très humble et très affectionné seruiteur,

BERNARD PALISSY.

AU LECTEUR, salut.

AMI LECTEUR, puisqu'il a pleu à Dieu que cest escrit soit tombé entre tes mains, ie te prie ne sois si paresseux ou temeraire de te contenter de la lecture du commencement ou partie d'icelui : mais à fin d'en apporter quelque fruit prens peine de lire le tout, sans auoir esgard à la petitesse et abjecte condition de l'autheur, ni aussi à son langage rustique et mal orné, t'asseurant que tu ne trouueras rien à cet escrit qui ne te profite, ou peu ou prou : et les choses qui au commencement te sembleront impossibles, tu les trouueras en fin véritables et aisées à croire : sur toutes choses, ie te prie te souvenir d'un passage qui est en l'Escriture Saincte, là où sainct Paul dit : qu'un chacun selon qu'il aura receu des dons de Dieu, qu'il en distribue aux autres. Suivant quoy, ie te prie instruire les laboureurs, qui ne sont literez, à ce qu'ils ayent soigneusement à s'estudier en la philosophie naturelle, suivant mon conseil : et singulièrement, que ce secret et enseignement des fumiers, que i'ai mis en ce liure, leur soit diuulgué et manifesté : et ce iusqu'à tant qu'ils l'ayent en aussi grande estime, comme la chose le merite : comme ainsi soit que nul homme ne sauroit estimer combien le profit sera grand en la France, si en cest endroit ils veulent suiure mon conseil. Il y a en certaines parties de la Gascongne et aucuns autres pays de France, un genre de terre qu'on appelle merle (*marne*), de laquelle les laboureurs fument leurs champs, et disent qu'elle vaut mieux que fumier : aussi, disent-ils que, quand un champ sera fumé de la dite terre, que ce sera assez pour dix années. Si ie voy qu'on ne mesprise point mes escrits, et qu'ils soyent mis en exécution, ie prendray peine de cercher de la dite merle en ce pays de Xaintonge, et ferai un troisième liure, par lequel i'apprendray toutes gens à cognoistre ladite merle, et mesme la manière de l'appliquer aux champs, selon la méthode de ceux qui en usent ordinairement. Ie say que mes haineux ne voudront ap-

prouuer mon œuure, ni aussi les malicieux et ignorans, car ils sont ennemis de toute vertu ; mais pour estre iustifié de leurs calomnies, enuies et détractions, i'appelleray à tesmoin tous les plus gentils esprits de France, philosophes, gens bien viuans, pleins de vertus et de bonnes mœurs, lesquels ie say qu'ils auront mon œuure en estime, combien qu'elle soit escrite en langage rustique et mal poli : et s'il y a quelque faute, ils sauront bien excuser la condition de l'autheur. Ie say qu'aucuns ignorans diront qu'il faudroit la puissance d'un Roy pour faire un iardin, iouxte le dessein que i'ay mis en ce liure ; mais à ce ie respons que la despense ne seroit si grande, comme aucuns pourroyent penser. Et puis il faut entendre que tout ainsi qu'à un liure de médecine. il y a diuers remedes, selon les maladies diuerses, et un chacun prend selon ce qui luy fait besoin, selon la diversité du mal : aussi en cas pareil, au dessein de mon iardin, aucuns pourront tirer selon leurs portées et commoditez des lieux où ils habiteront. Voilà pourquoy nul ne pourra iustement calomnier le dessein de mon iardin. Ie say aussi que plusieurs se moqueront du dessein de la ville de forteresse que i'ay mis en ce liure, et diront que c'est resverie ; mais à ce ie respons que, s'il y a quelque Seigneur chevalier de l'ordre ou autres capitaines qui soyent tant curieux d'en savoir la vérité, qu'ils pensent de n'être si sujets ni captifs sous la puissance de leur argent que, pour le contentement de leur esprit, ils ne m'en départent quelque peu pour leur faire entendre par pourtrait et modelle la vérité de la chose. Ie say qu'ils trouueront estrange que ie n'ay point mis en ce liure le pourtrait du iardin, ni aussi de la ville de forteresse ; mais à ce ie respons que mon indigence et l'occupation de mon art ne l'a voulu permettre. I'ay aussi trouué une telle ingratitude en plusieurs personnes, que cela m'a causé me restraindre de trop grande libéralité : toutefois le desir que i'ay du bien public et de faire seruice à la noblesse de France, m'incitera quelque jour de prendre le temps pour faire le pourtrait du iardin, iouxte la teneur et dessein escrits en ce liure ; mais ie voudrois prier la noblesse de France, ausquels le pourtrait pourroit beaucoup seruir, qu'après que i'auray employé mon temps pour leur faire seruice, qu'il leur plaise ne me rendre mal pour bien, comme ont fait les Ecclesiastiques Romains de cette ville, les-

quels m'ont voulu faire pendre pour leur avoir pourchassé le
plus grand bien que iamais leur pourroit aduenir, qui est pour
les avoir voulu inciter à paistre leurs troupeaux suivant le
commandement de Dieu. Et sauroit-on dire que iamais ie leur
eusse fait aucun tort? Mais parce que ie leur auois remonstré
leur perdition au dix-huitième de l'Apocalypse, tendant à fin de
les amender, et que plusieurs fois aussi ie leur auois monstré
une authorité escrite au prophete Ieremie, où il dit : Malediction
sur vous, Pasteurs, qui mangez le lait et vestissez la laine, et
laissez mes brebis esparses par les montagnes! Ie les rede-
manderay de uostre main. Eux voyans telle chose, au lieu de
s'amender, ils se sont endurcis, et se sont bandez contre la
lumière, à fin de cheminer le surplus de leurs iours en tene-
bres, et ensuyvans leurs voluptez et desirs charnels accous-
tumez. Ie n'eusse iamais pensé que par là ils eussent voulu
prendre occasion de me faire mourir. Dieu m'est tesmoin que
le mal qu'ils m'ont fait n'a esté pour autre occasion que pour
la susdite. Ce neantmoins, ie prie Dieu qu'il les veuille amen-
der. Qui sera l'endroit où ie prieray un chacun qui verra ce
liure de se rendre amateur de l'agriculture, suiuant mon pre-
mier propos, qui est un juste labeur et digne d'estre prisé et
honoré. Aussi, comme i'ay dit ci-dessus, que les simples
soyent instruits par les doctes, afin que nous ne soyons redar-
guez à la grande iournée d'auoir caché les talens en
terre, comme bien sauez que ceux qui les
auront ainsi cachez seront bannis du
règne éternel, de deuant la face
de celuy qui vit et regne
éternellement au
siècle des
siècles.
Amen.

POUR auoir plus facile intelligence du present discours, nous le traiterons en forme de Dialogue, auquel nous introduirons deux Personnes, l'une demandera, l'autre respondra comme s'ensuit.

Puisque nous sommes sur les propos des honnestes delices et plaisirs, ie te puis asseurer, qu'il y a plusieurs iours que i'ay commencé à tracasser d'vn costé et d'autre, pour trouuer quelque lieu montueux, propre et conuenable pour edifier vn iardin pour me retirer, et recreer mon esprit en temps de diuorces, pestes, epidimies, et autres tribulations, desquelles nous sommes à ce iourd'huy grandement troublez.

Demande.

Ie ne puis clairement entendre ton dessein, parce que tu dis que tu cerches vn lieu montueux, pour faire vn iardin delectable. C'est vne opinion contraire à celle de tous les Antiques et Modernes; car ie sçay qu'on cerche communement les lieux planiers, pour edifier iardins : aussi sçay-je bien que plusieurs ayans des bosses et terriers en leurs iardins, se sont constituez en grands fraits pour les applanir. Quoy considere, ie te prie me dire la cause qui t'a meu de cercher vn lieu montueux pour edifier ton iardin.

Responce.

Quelques iours apres que les esmotions et guerres ciuiles furent appaisees, et qu'il eut pleu à Dieu nous enuoyer sa paix, i'estois vn iour me pourmenant le long de la prairie de ceste ville de Xaintes, pres du fleuue de Charante : et ainsi que ie contemplois les horribles dangers, desquels Dieu m'auoit garenti au temps des tumultes et horribles troubles passez, i'ouy la voix de certaines vierges, qui estoyent assises sous certaines aubarees (1), et chantoyent le Pseaume cent quatriesme. Et parce que leur voix estoit douce et bien accordante, cela me fit oublier mes premieres pensees, et m'estant arresté pour escouter ledit Pseaume, ie laissay le plaisir des voix, et entray en contemplation sur le sens dudit Pseaume, et ayant noté

(1) Plantations d'aubiers (*alburnum*).

les poincts d'iceluy, ie fus tout confus en admiration, sur la sagesse du Prophete Royal, en disant à moy-mesme, O diuine et admirable bonté de Dieu! A la miene volonté, que nous eussions les œuures de tes mains en telle reuerence, comme le Prophete nous enseigne en ce Pseaume! Et deslors ie pensay de figurer en quelque grand tableau les beaux paysages que le Prophete descrit au Pseaume susdit : mais bien tost apres, mon courage fut changé, veu que les peintures sont de peu de duree, et pensay de trouuer vn lieu convenable, pour edifier vn jardin iouxte le dessein, ornement, et excellente beauté, ou partie de ce que le Prophete a descrit en son Pseaume, et ayant desia figuré en mon esprit ledit iardin, ie trouuay que tout par vn moyen, ie pourrois aupres dudit iardin edifier vn Palais, ou amphitheatre de refuge pour receuoir les Chrestiens exilez en temps de persecution, qui seroit vne saincte delectation, et honneste occupation de corps et d'esprit.

Demande.

Ie te trouue fort eslongué de toute opinion commune en deux instances : la premiere est, parce que tu dis qu'il est requis trouuer un lieu montueux pour edifier vn jardin delectable : et l'autre, parce que tu dis que tu voudrois aussi edifier vn amphitheatre de refuge pour les Chrestiens exilés : ce que ne puis prendre à la bonne part, consideré que nous auons la Paix. Aussi que nous espérons que de brief on aura la liberté de prescher par toute la France, et non seulement en France, mais aussi par tout le monde : car il est escrit en saint Matthieu, chapitre XXIIII, là où le Seigneur dit que l'Évangile du Royaume sera presché en l'universel monde, en tesmoignage à toutes gens. Voilà qui me fait dire et asseurer, qu'il n'est plus de besoin de cercher des Citez de refuge pour les Chrestiens.

Responce.

Tu as fort mal consideré les sentences du Nouveau-Testament : car il est escrit que les enfans et esleus de Dieu seront persecutez jusqu'à la fin, et chassez et moquez, bannis et exilez ; et quant à la sentence que tu as amenée escrite en sainct Matthieu, vrai est qu'il est escrit, que l'Evangile du Royaume sera presché à l'universel monde ; mais il ne dit pas qu'il sera receu de tous, mais bien dit, qu'il sera en tes-

moignage à tous, savoir est, pour iustifier les croyans, et pour condemner iustement les infideles. Suyvant quoy, il est à conclurre que les pervers et iniques, symoniaques, avaricieux et toutes especes de gens meschans, seront tousjours prests à persecuter ceux qui par lignes directes voudront suivre les statuts et ordonnances de nostre Seigneur.

Demande.

Quant au premier poinct, ie te le donne gagné; mais quant est de ce que tu dis, qu'il est requis vn lieu montueux pour edifier iardins, ie ne puis à ce accorder.

Responce.

Ie sçay que toute folie accoustumee est prinse comme par vne loy et vertu : mais à ce ie ne m'arreste, et ne veux aucunement estre imitateur de mes predecesseurs, sinon en ce qu'ils auront bien fait selon l'ordonnance de Dieu. Ie voy de si grands abus et ignorances en tous les arts, qu'il semble que tout ordre soit la plus grand part peruerti, et qu'vn chacun laboure la terre sans aucune Philosophie, et vont tousiours le trot accoustumé, en ensuiuant la trace de leurs predecesseurs, sans considerer les natures, ny causes principales de l'agriculture

Demande.

Tu me fais à ce coup plus esbahir de tes propos, que ie ne fus oncques. Il semble à t'ouyr parler, qu'il est requis quelque Philosophie aux laboureurs, chose que ie trouue estrange.

Responce.

Ie te dis qu'il n'est nul art au monde, auquel soit requis vne plus grande Philosophie qu'à l'agriculture, et te dis, que si l'agriculture est conduite sans Philosophie, que c'est autant que iournellement violer la terre, et les choses qu'elle produit; et m'esmerueille, que la terre et natures produites en icelle, ne crient vengeance contre certains meurtrisseurs, ignorans, et ingrats, qui iournellement ne font que gaster et dissiper les arbres et plantes, sans aucune consideration. Ie t'ose aussi bien dire, que si la terre estoit cultiuée à son deuoir, qu'vn journaut produiroit plus de fruit, que non pas deux, en la sorte qu'elle est cultiuee iournellement. Te souuient-il point auoir leu vne histoire, qu'il y auoit vn certain personnage agriculteur, qui estoit si tres bon Philosophe, et subtil inge-

nieux, que par son labeur et industrie, il faisoit qu'un peu de terre qu'il auoit, luy rendoit plus de fruict, que non pas vne grande quantité de celles de ses voisins, dont s'en ensuiuit vne enuie : car ses voisins voyans telles choses, furent marris de son bien, et l'accuserent qu'il estoit sorcier, et que par sa sorcelerie, il faisoit que sa terre portoit plus de fruict que non pas celles de ses voisins. Quoy voyant les Iuges de la Cité, le feirent conuenir, pour luy faire declarer, qui estoit la cause que ses terres apportoyent si grande abondance de fruicts : quoy voyant le bon homme, print ses enfans, et seruiteurs, son chariot et hastelage, et auec ce plusieurs outils d'agriculture, lesquels il alla exhiber deuant les Iuges, en leur remonstrant, que la sorcelerie de laquelle il vsoit en ses terres, estoit le propre labeur de ses mains, et des mains de ses enfants et seruiteurs, et les diuers outils qu'il auoit inuentez, dont le bon homme fut grandement loué, et renuoyé en son labourage : et par tel moyen l'enuie de ses voisins fut amplement cognuë (1).

Demande.

Ie te prie, di moy en quoy est-ce qu'il est besoin que les laboureurs ayent quelque Philosophie : car ie sçay que plusieurs se moqueront d'une telle opinion mesme, ie sçay que S. Paul le defend aux Colossiens, chapitre II, disant : Donnez vous garde d'estre seduits par vaines Philosophies.

Responce.

Tu t'abuses, en m'allegant ce passage de sainct Paul en cest endroit, d'autant qu'il ne fait rien contre moy : car quand sainct Paul dit, Donnez vous garde d'estre seduits par Philosophie, il adiouste vaine, mais celle dont ie te parle n'est point vaine : Parquoy, ie conclus, que cela ne fait rien contre mon opinion. Comment cuides-tu qu'vn laboureur cognoistra les saisons de labourer, planter ou semer, sans Philosophie? Ie t'ose bien dire, qu'on pourra labourer la terre en telle saison, que cela luy causera plus de dommage, que de profit.

(1) Ce trait, rapporté par Pline (*Hist. nat.*, l. XVII), est attribué à l'affranchi C. F. Ctesinus, lequel *in invidia magna erat, ceu fruges alienas pelliceret veneficiis*. Il se présenta à l'édile Post. Albinus, avec sa famille et ses instruments d'agriculture, et dit : *Veneficia mea, Quirites, hæc sunt, nec vobis possum ostendere, aut in forum adducere lucubrationes meas, vigiliasque et sudores.*

Item, comment cognoistra vn laboureur la différence des terres, sans Philosophie? Les vnes sont propres pour les fromens, les autres pour les pois, et autres pour les febues. Les febues creuës en vn champ sont cuisantes, et, tout auprès d'icelles, y aura vn autre champ, duquel les febues qui y seront produites, ne seront iamais cuisantes : pareillement en est-il de toutes especes de legumes. Aussi il y a des eaux, desquelles les legumes ne pourront cuire, et il y a d'autres eaux, desquelles les légumes seront cuisans. Brief, il est impossible de te pouuoir reciter, combien la Philosophie naturelle est requise aux agriculteurs. Et ce n'est sans cause, que ie t'ay mis ces propos en auant : car les actes ignorans que ie voy tous les iours commettre en l'art d'agriculture, m'ont causé plusieurs fois me tourmenter en mon esprit, et me cholerer en ma seule pensée, parce que ie voy qu'vn chacun tasche à s'agrandir, et cerche des moyens pour succer la substance de la terre, sans y trauailler, et cependant on laisse les pauures ignares pour le cultiuement de la terre, dont s'en ensuit, que la terre et ce qu'elle produit est souvent adulterée, et est commise grande violence ès bestes bouines, que Dieu a créées pour le soulagement de l'homme.

Demande.

Ie te prie me monstrer quelque faute commise en l'agriculture, à fin de me faire croire ce que tu dis.

Responce.

Quand tu iras par les villages, considere vn peu les fumiers des laboureurs, et tu verras qu'ils les mettent hors de leurs estables, tantost en lieu haut, et tantost en lieu bas, sans aucune consideration, mais qu'il soit appilé, il leur suffit : et puis, pren garde au temps des pluyes, et tu verras que les eaux qui tombent sur lesdits, emportent vne teinture noire, en passant par ledit fumier, et trouuant le bas, pente, ou inclinaison du lieu où les fumiers seront mis, les eaux qui passeront par lesdits fumiers, emporteront ladite teinture, qui est la principale, et le total de la substance du fumier. Parquoy, le fumier ainsi laué, ne peut seruir, sinon de parade : mais estant porté au champ, il n'y fait aucun profit. Voila pas doncques vne ignorance manifeste, qui est grandement à regretter?

Demande.

Ie ne croy rien de cela, si tu ne me donnes autre raison.

Responce.

Tu dois entendre premierement la cause pourquoy on porte le fumier au champ, et ayant entendu la cause, tu croiras aisement ce que ie t'ay dit. Il faut que tu me confesses, que quand tu apportes le fumier au champ, que c'est pour luy rebailler vne partie de ce qui luy a esté osté : car il est ainsi qu'en semant le blé, on a esperance qu'vn grain en apportera plusieurs : or cela ne peut estre sans prendre quelque substance de la terre, et si le champ a esté semé plusieurs annees, sa substance est emportee auec les pailles et grains. Parquoy, il est besoin de rapporter les fumiers, bouës et immondicitez, et mesme les excremens et ordures, tant des hommes que des bestes, si possible estoit, à fin de rapporter au lieu la mesme substance qui luy aura esté ostee. Et voila pourquoy ie dis, que les fumiers ne doiuent estre mis à la merci des pluyes, parce que les pluyes en passant par lesdits fumiers, emportent le sel, qui est la principale substance et vertu du fumier.

Demande.

Tu m'as dit à present vn propos, qui me fait plus resuer que tous les autres, et sçay que plusieurs se mocqueront de toy, parce que tu dis, qu'il y a du sel ès fumiers : ie te prie donne moy quelque raison apparente, pour me le faire croire.

Responce.

Par cy deuant tu trouuois estrange que ie te disois qu'il est requis aux laboureurs quelque Philosophie, et à present tu me demandes vne raison, qui est assez despendante de mon premier propos, ie te la diray, mais ie te prie l'auoir en tel estime, comme elle le requiert de soy : en entendant icelle, tu entendras plusieurs choses que par cy deuant tu as ignoré. Note doncques, qu'il n'est aucune semence tant bonne que mauuaise, qui n'apporte en soy quelque espece de sel, et quand les pailles, foins, et autres herbes, sont putrefiees, les eaux qui passent à trauers, emportent le sel qui estoit esdites pailles, et autres herbes, ou foins : et tout ainsi comme tu vois qu'vn merlu salé, ou autre poisson, qui auroit long temps trempé, perdroit en fin toute sa substance salsitiue, et en fin n'auroit aucun goust, en cas pareil te faut croire, que les fu-

miers perdent leur sel, quand ils sont lauez des pluyes. Et quant est de ce que tu me pourrois alleguer, en disant, que le fumier demeure fumier, et qu'estant porté en la terre, il pourra encore beaucoup seruir, ie te donneray vn exemple contraire. Ne sçais-tu pas bien que ceux qui tirent les essences des herbes et espiceries, ils tireront la substance de la canelle, sans desfaire aucunement la forme? toutesfois tu trouueras qu'en la liqueur qu'ils ont tiré de la canelle, ils auront emporté de ladite canelle la saueur, la senteur, et entièrement la vertu d'icelle, ce neantmoins, la canelle demeurera en sa forme, et aura apparence de canelle comme auparauant : mais si tu en manges tu n'y trouueras ni senteur, ni saueur, ni vertu. Voila un exemple qui doit suffire pour te faire croire ce que dessus.

Demande.

Quand tu m'aurois presché l'espace de cent ans si est-ce que tu ne me sçaurois faire à croire qu'il y eust du sel és fumiers, ny à toutes especes de plantes, comme tu me veux faire croire.

Responce.

Ie te donneray à present des arguments, qui te feront croire ce que tu ignores, ou bien il faudroit que tu eusses la teste d'vn asne sur tes espaules. En premier lieu, il faut que tu me confesses que le salicor est vne herbe qui croist communément és terres des marais de Narbonne et de Xaintonge. Or ladite herbe estant bruslée, se reduit en pierre de sel, lequel sel les Apoticaires et Philosophes Alchimistes appellent *sal alcaly*, brief, c'est vn sel prouenu d'vne herbe.

Item, la fougere aussi est vne herbe, et estant bruslée, se reduit en pierre de sel, tesmoins les verriers, qui se seruent dudit sel à faire leurs verres, auec autres choses que nous dirons quand le propos se presentera, en traittant des pierres. Item, considere vn peu les cannes desquelles on fait le sucre, c'est vne herbe noüée, et creuse comme vne jambe de seigle, faite en façon de roseau : ce neantmoins, d'icelle herbe le sucre est tiré, qui n'est autre chose que sel. Vray est, que tous les sels n'ont pas vne mesme saueur, ny vne mesme vertu, et ne font vne mesme action, neantmoins, ie te puis asseurer, qu'il y a un nombre infini d'especes de sels sur la terre. Si elles n'ont vne mesme saueur, et vne mesme apparence, et

vne mesme action, cela n'empesche toutesfois qu'elles ne soyent sel, et l'ose bien dire derechef, et soustenir hardiment, qu'il n'est aucune plante, ny espece d'herbe sur la terre, qu'elle n'aye en soy quelque espece de sel, et te dis encore, qu'il n'est nul arbre de quelque genre que ce soit, qu'il n'en aye consequemment les vns plus, et les autres moins. Et qui plus est, ie t'ose dire que, s'il n'y avoit du sel és fruits, qu'ils n'auroient ne saueur, ny vertu, ne odeur, et ne pourroit-on empescher qu'ils ne fussent putrefiez : et afin que tu ne dises que ie parle sans raison, ie te baille en premier lieu le principal fruit qui est à nostre vsage, à sçavoir le fruit de la vigne. Il est chose certaine, que la lie estant bruslée, elle se reduit en sel, que nous appellons sel de tartare (*tartre*) : or ce sel est grandement mordicatif, et corrosif. Quand il est mis en lieu humide, il se reduit en huile de tartare, et plusieurs guerissent les enderces (1) dudit huile, par ce qu'il est corrosif. Le sel de l'herbe salicor, quand il est tenu en lieu humide, il est ainsi oligineux comme celuy de tartare. Voila des raisons, qui te doiuent faire croire, qu'il y a du sel aux arbres et plantes. Qui me demanderoit combien il y a d'especes de sel, ie voudrois respondre, qu'il y en a d'autant d'especes que de diuerses saueurs. Il est donc à conclure, que le sel du poiure et de la maniguette est plus corrosif, que celui de la canelle, et que de tant plus les vins sont forts et puissans, de tant plus il y a abondance de sel, qui cause la force et vertu dudit vin. Qu'ainsi ne soit, contemple vn peu les vins de Montpellier, ils ont vne puissance et force admirable, tellement que les rapes de leurs raisins bruslent et calcinent les lamines d'airain, et les reduisent en vert de gris : et si quelqu'vn ose dire, que cela ne se fait par la vertu du sel qui est ausdites rapes, mon dire est aisé à verifier, par ce que c'est chose certaine, que si on met du sel commun, ou du sel de tartare dedans vne poele d'airain, elle deuiendra verde en moins de vingt et quatre heures, pourueu que le sel soit dissout, et cela se fera à cause de son acreté. Voila vn argument qui te doit suffire pour le tout, toutesfois pour mieux te faire entendre ces choses, ie te veux apprendre à present de tirer du sel de toutes especes d'arbres, herbes et plantes, et si te le feray entendre presentement, sans mettre la main à l'œuure. Tu me confesseras

(1) *Anders*, dartres laiteuses des veaux.

aisément, que toutes cendres sont aptes à la buee (*lessive*), aussi tu me confesseras qu'elles ne peuuent seruir qu'vne fois en ladite buee, si tu me confesses cela, c'est assez : car par là tu dois entendre, que le sel qui estoit aux cendres, s'est dissout et meslé parmi la lessiue, et cela a causé d'emporter les saletez et ordures des linges, à cause de sa mordication : dont s'ensuit, que la lessiue est teinte et oligineuse dudit sel, qui est dissout parmi, et la lessiue estant venuë en sa perfection, elle a emporté tout le sel qui estoit ausdites cendres, d'où vient que les cendres demeurent alterees, et inutiles, et la lessiue qui a emporté le sel desdites cendres, a tousiours quelque vertu de nettoyer. Si tu ne veux croire ces raisons, pren vn chauderon de lessiue, et le fay bouillir iusques à ce que l'humide soit tout éuaporé, et lors tu trouueras le sel au fons de la chaudiere. Si les argumens susdits ne sont suffisans, pren garde à la fumee du bois : car il est ainsi, que les fumees de toute espece de bois, font cuire les yeux, et endommagent la veuë, et ce, pour cause de certaine salsitude, qu'elle attire du bois, lors que les autres humeurs sont exhallees par la vehemence du feu, qui chasse les matieres haineuses et humides. Et qu'ainsi ne soit, tu le cognoistras, lors que tu feras bouillir l'eau dans quelque chaudiere, parce que la fumee de ladite eau ne te nuira aucunement à la veuë, combien que tu presentes les yeux sur ladite fumee. Et pour mieux encore et prouuer qu'il y a du sel és bois et plantes, considere l'escorce, de laquelle les Taneurs courrayent leurs peaux : si elle est sechee, et puluerisee, elle endurcist et garde de putrefier les peaux des bœufs et autres bestes. Cuides-tu que les escorces de chesne eussent vertu d'empescher la putrefaction desdites peaux, sans qu'il y eust du sel esdites escorces ? Non pour vray, et si ainsi estoit que l'escorce eust ceste vertu, elle pourroit seruir plusieurs fois, mais dés qu'elle a serui vne fois, l'humidité de la peau a fait attraction, et a dissout le sel qui estoit en l'escorce, et l'a prins et attiré à soy, pour se fortifier et endurcir. Et ainsi, ladite escorce ne sert plus de rien que de mettre au feu, apres qu'elle a serui vne fois seulement.

Autre exemple. Il me souuient auoir veu certaines pierres, qui estoient faites de pailles bruslees, ce qui ne peut estre fait, sans que lesdites pailles tiennent en soy grande quantité

de sel (1). Item, le feu se print vne fois a vne grange pleine de foin, le feu fut si grand, que ledit foin en fin fut reduit en pierre, de la maniere que ie t'ay conté du salicor et de la fougere : mais parce qu'en iceluy foin il y a moins de sel qu'au salicor et au tartare, lesdites pierres de foin et de paille ne sont suiettes à dissolution, ains endurent l'iniure du temps, comme pourroit faire un lopin d'excrement de fer. Ie sçay aussi que plusieurs verriers de ceux qui font les verres des vitres, se seruent de la cendre du bois de fayan (2) en lieu de salicor, qui vaut autant à dire, que la cendre dudit fayan n'est autre chose que sel : car autrement elle ne pourroit seruir à cest affaire. Quand ie voudrois mettre par escrit tous les exemples que ie pourrois trouuer, il me faudroit vn bien long temps : mais pour conclusion, ie te dis, comme dessus, qu'il y a vn nombre infini d'especes de sel, voire autant d'especes diuerses, que de diuerses saueurs. La couppe rose, et vitriol, ne sont que sel, le bourras (*borax*) n'est que sel, l'alun sel, le salpestre sel, et le nitre sel. Ie te dis, que sans qu'il y eust du sel en toutes choses, elles ne pourroient se soustenir, ains soudain seroyent putrefiees et annichilees. Le sel affermit, et garde de putrefier les lards, et autres chairs, tesmoins les Égyptiens, qui faisoient de grandes pyramides, pour garder les corps de leurs Roys trespassez : et pour empescher la putrefaction desdits corps, il les poudroyent de nitre, qui est vn sel, comme i'ay dit, et de certaines espiceries, qui tiennent en soy grande quantité de sel. Et par tels moyens leurs corps estoient conseruez sans putrefaction : mesme iusques à ce iourd'huy, on en trouue encore esdites pyramides, qui ont esté si bien conseruez, que la chair desdits morts sert auiourd'hui d'vne medecine, qu'on appelle Momie. Ie te demande, As-tu pas veu certains laboureurs, que quand ils veulent semer vne terre deux annees suiuantes, ils font brusler le gleu, ou paille restée du blé, qui aura esté couppé, et en la cendre de ladite paille, sera trouué le sel que la paille auoit attiré de la terre, lequel sel demeurant dans le champ, aidera derechef à la terre ? Et ainsi la paille estant bruslee

(1) Il s'agit sans doute ici de quelques matières terreuses mises en fusion par une extrême chaleur et vitrifiées à l'aide de la potasse contenue dans la paille brûlée.

(2) Fayard, hêtre (*fagus*).

dedans le champ, elle seruira d'autant de fumier, parce qu'elle laissera la mesme substance qu'elle auoit attiree de la terre. Il est temps que ie face fin à ce propos : car si tu ne veux croire les raisons susdites, ce seroit grand folie de te donner autres exemples : toutesfois, parce que nostre propos a esté dés le commencement, pour te remonstrer que les pluyes emportent le sel des fumiers qui sont au descouuert, ie te donneray encore pour conclurre mon propos, vn exemple, qui te suffira pour le tout. Pren garde au temps de semailles, et tu verras que les laboureurs apporteront leurs fumiers aux champs, quelque temps auparauant semer la terre, ils mettront iceluy fumier par monceaux ou pilots dans le champ, et quelque temps apres, ils le viendront espandre par tout le champ : mais au lieu où ledit pilot de fumier aura reposé quelque temps, ils n'y laisseront rien dudit fumier, ains le ietteront deçà et delà, mais au lieu où il aura reposé quelque temps, tu verras qu'apres que le blé qui aura esté semé sera grand, il sera en cest endroit plus espes, plus haut, plus verd, et plus droit. Par là tu peux aisement cognoistre, que ce n'est pas le fumier qui a causé cela, car le laboureur le iette autre part : mais c'est que quand ledit fumier estoit au champ par pilots, les pluyes qui sont suruenues, ont passé à trauers desdits pilots, et sont descendu à trauers du fumier iusqu'à la terre, et en passant, ont dissout et emporté certaines parties du sel qui estoit audit fumier (1). Tout ainsi que tu vois que les eaux qui passent à trauers des terres salpestreuses, emportent auec elles le salpestre, et apres que les eaux ont passé par lesdites terres, lesdites terres ne peuuent plus seruir à faire salpestre, car les eaux qui ont passé, ont emporté tout le sel : autant en est-il des cendres, desquelles les Salpestreurs se seruent, et semblablement de celles qui seruent aux buees : et voyla pourquoy elles sont apres inutiles, qui est le poinct qui te doit faire croire ce que ie t'ay dit dés le commencement : c'est à

(1) Voilà une théorie singulièrement avancée pour le siècle où elle était émise, et qui dénote dans l'auteur un admirable esprit d'observation, « Trois » cents ans nous séparent bientôt de B. Palissy, et l'expérience de nos jours » a parfaitement confirmé ces idées. Il est évident que ce sont les sels, et no- » tamment les sels ammoniacaux (sulfate, carbonate et chlorhydrate), qui » jouent le rôle le plus important dans l'action des engrais. » (Hoëfer, Hist. de la Chimie, t. II, p. 91.)

sçauoir que les eaux qui passent par les fumiers, emportent tout le sel et rendent le fumier inutile, qui est vne ignorance de tres-grand poids. Et si elle estoit corrigee, on ne sçauroit estimer combien le profit seroit grand. A la mienne volonté, qu'vn chacun qui verra ce secret, soit aussi soigneux à le garder, comme de soy il le merite.

DEMANDE.

Dy moy, comment donc pourrois-ie garder de gaster mon fumier ?

RESPONCE.

Si tu veux que ton fumier te serue à plein et à outrance, il faut que tu creuses vne fosse en quelque lieu conuenable, pres de tes estables, et icelle fosse creusee en maniere d'vn claune, ou d'vn abruuoir, faut que tu paues de cailloux, ou de pierres, ou de briques ledit claune ou fosse, et iceluy bien paué auec du mortier de chaux et de sable, tu porteras tes fumiers pour garder en ladite fosse, iusques au temps qu'il le faudra porter aux champs. Et afin que ledit fumier ne soit gasté par les pluyes, ni par le soleil, tu feras quelque maniere de loge pour couurir ledit fumier : et quand il viendra au temps des semailles, tu porteras ledit fumier dans le champ, auec toute sa substance, et tu trouueras que le paué de la fosse, ou receptacle, aura gardé toute la liqueur du fumier, qui autrement se fust perdue, la terre eust sucé partie de la substance dudit fumier : et te faut icy noter, que si au fons de la fosse, ou receptacle dudit fumier, se trouue quelque matiere claire, qui sera descenduë des fumiers, et que ladite matiere ne se puisse porter dans des paniers, il faut que tu prenes des basses (1), qui puissent tenir l'eau, comme si tu voulois porter de la vendange, et lors tu porteras ladite matiere claire, soit vrine des bestes, ou ce que voudras. Ie t'asseure que c'est le meilleur du fumier, voire le plus salé (2) : et si tu le fais ainsi, tu rapporteras à la terre la mesme chose qui luy auoit esté ostee par les accroissemens des semences, et les

(1) Sorte de banc, ou *bassin* de bois.
(2) Cette pratique excellente a été préconisée récemment comme une invention toute nouvelle, et a fait un certain honneur à l'agronome qui l'a propagée. Il est vraiment inconceuable qu'énoncée en termes si clairs et si formels par B. Palissy, elle soit restée ignorée pendant trois siècles, ou du moins qu'elle n'ait pas été adoptée plus tôt par tous les agriculteurs intelligents.

semences que tu y mettras apres, reprendront la mesme chose que tu y auras porté. Voila comment il faut qu'vn chacun mette peine d'entendre son art, et pourquoy il est requis, que les laboureurs ayent quelque Philosophie : ou autrement, ils ne font qu'auorter la terre, et meurtrir les arbres. Les abus qu'ils commettent tous les iours és arbres, me contraignent en parler ainsi d'affection.

Demande.

Tu fais icy semblant que des arbres ce sont des hommes, et semble qu'ils te font grand pitié : tu dis que les laboureurs les meurtrissent, voila vn propos qui me donne occasion de rire.

Responce.

C'est le naturel des fols et des ennemis de science : toutesfois, ie sçay bien ce que ie dis, car en passant par les taillis, i'ay contemplé plusieurs fois la maniere de coupper les bois, et ay veu que les buscherons de ce pays, en couppant leurs taillis, laissoient la seppe ou tronc qui demeuroit en terre tout fendu, brisé, et esclatté, ne se souciant du tronc, pourueu qu'ils eussent le bois qui est produit dudit tronc, combien qu'ils esperassent que toutes les cinq annees les troncs en produiroyent encores autant. Ie m'esmerueille que le bois ne crie d'estre ainsi vilainement meurtry. Penses-tu que la seppe qui est ainsi fendue et esclattee en plusieurs lieux, qu'elle ne se ressente de la fraction, et extorsion qui luy aura esté faicte ? Ne sçais-tu pas bien que les vents et pluyes apporteront certaines poussieres dans les fentes de ladite seppe, qui causera que la seppe se pourrira au milieu, et ne se pourra resoudre, et sera à tout iamais malade de l'extorsion qui luy aura esté faicte ? Et pour mieux te faire entendre ces choses, contemple vn peu les aubiers, lesquels sur un mesme degré produisent plusieurs branches, qui croissent directement en haut en peu de temps, et icelles paruenues à la grosseur ou enuiron du bras d'vn homme, on les vient à coupper, et la mesme annee que lesdites branches auront esté couppees, pres et ioignant la couppe d'icelles, il sortira un nombre de gittes, qui derechef viendront à la mesme grosseur que les susdites : et par tel moyen la teste de l'aubier s'engrossira en cest endroit, apres que plusieurs annees on luy aura couppé ses branches, desquelles aucuns font des cercles, et des paux (1) pour sous-

(1) Pluriel du mot pal (*palus*), pieu, échalas.

tenir les seps des vignes : dont s'en ensuiura, que les couppes de la multitude des branches qui auront esté couppees sur la teste dudit aubier, feront vn receptacle d'eau sur ladite teste, laquelle eau estant ainsi retenue entrera petit à petit dans le centre et moile de l'aubier, et pourrira la iambe et tronc, comme tu peux apperceuoir en plusieurs aubiers, lesquels tu trouueras communement pourris par le dedans : et s'ils estoient couppez par science, ce mal seroit obuié par la prudence de l'homme. Veux-tu que ie te produise tesmoignage de mon dire? Va à vn Chirurgien, et luy fay vn interrogatoire ; en disant ainsi, Maistre, il est aduenu à ce iourd'huy, que deux hommes ont eu chacun d'eux vn bras couppé, et y en a vn d'iceux à qui on l'a couppé d'vn glaiue tranchant, du beau premier coup tout nettement, à cause que le glaiue estoit bien esguisé : mais à l'autre, on luy a couppé d'vne serpe toute esbrechee, en telle sorte qu'il luy a falu donner plusieurs coups, deuant que le bras fust couppé : dont s'ensuit que les os sont froissez, et la chair meurtrie, et lambineuse, ou serpilleuse à l'endroit où le bras a esté couppé. Ie vous prie me dire, lequel des deux bras sera le plus aisé à guerir. Si le Chirurgien entend son art, il te dira soudain, que celuy qui a eu le bras couppé nettement par le glaiue tranchant, est beaucoup plus aisé à guerir que l'autre. Semblablement ie te puis asseurer, qu'vne branche d'arbre couppee par science, la playe de l'arbre sera beaucoup plustost guerie, que non pas celle qui par violence et inconsiderement sera froissee. Voila pourquoy ie voudrois que les laboureurs et buscherons eussent ceste consideration, quand ils couperont les branches des arbres, en esperance que la seppe apporte encore branches, qu'ils eussent esgard de faire la couppe nettement, et en pente, à fin que les eaux, ni aucune chose, ne se peust retenir sur ladite couppe. Et sur toutes choses, qu'on se donnast bien garde de les froisser, ni fendre en les couppant. Veux-tu ouyr vn bel exemple? Il y auoit deux laboureurs, qui auoyent arresté vne terre nouuelle, et pour icelle clorre, ils auoyent fait vn fossé, par égale portion : et sur le bord dudit fossé, ils auoyent planté des espines vn mesme iour l'vn et l'autre : quelque temps apres que les espines furent grandes, et bonnes à faire fagots, pour chauffer les fours, ils vont ensemble accorder, qu'il faloit estaucer (*tailler*) leur palice ou

haye, à fin que les espines produisissent de rechef multitude de gittes et branches : cela fait et accordé, au iour determiné l'vn d'iceux print vn volant, qui est vn ferrement comme vne serpe : mais il est emmanché au bout d'un baston, et ainsi, celuy qui auoit le volant, couppoit ses espines de bien loin, à grands coups, craignant s'espiner, et en les couppant, faisoit plusieurs fautes et fractions aux seppes et racines desdites espines : mais son compagnon plus sage que luy, monstra qu'il auoit quelque Philosophie en son esprit : car il prist vne sie, et ayant des gans aux mains, il sia toutes les branches de ses espines, auec ladite sie, en telle sorte, qu'il ne fut fait aucune fraction : mais plusieurs se moquoyent de luy, dont à fin, ils furent moquez : car la partie de la haye qui auoit esté siee ainsi sagement, elle se trouua auoir produit derechef ses branches en deux annees plus grosses et plus grandes, que non pas celles de son compagnon en cinq annees : voila vn tesmoignage, qui te doit donner occasion de premediter et philosopher les choses deuant que les commencer. Ce n'est donc pas sans cause, que ie t'ay dit, qu'il est requis vne grande Philosophie en l'art d'agriculture.

Demande.

Tu m'as dit, que les aubiers estoyent creux, et pourris au dedans du cœur, à cause des eaux qui sont retenues sur la teste, pour la faute, ou imprudence de ceux qui couppent les branches, toutesfois, i'ay veu plusieurs Chesnes és forests, qui auoyent la iambe creuse, et n'auoyent iamais esté estaucez ou couppez.

Response.

Cela n'empesche pas que ma raison ne soit legitime, mais en cest endroit tu dois entendre, que plusieurs arbres ont des carrefours sur la rencontre des fourches, et plusieurs branches, qui ont prins leur accroissement en vn mesme endroit, et en se dilatant l'vne deçà, et l'autre delà, elles font vn certain receptacle entre lesdites branches, sur lesdits carrefours : et en temps de pluyes, les eaux qui descoulent le long des branches sont retenues sur lesdits carrefours ; et ainsi, par succession de temps, elles percent, et penetrent la iambe de l'arbre iusques à la racine, parce que le naturel de l'eau est de tirer tousiours en bas, voila qui cause que lesdits arbres sont creux dedans le corps. Veux-tu bien claire-

ment entendre ces choses? pren garde au bois de Noyer, et tu trouueras que quand il est vieux, le bois est madré, ou figuré, et de couleur noire par le dedans du tronc : et pour coste cause, les vieux Noyers, sont plus estimez à faire menuserie, que non pas les ieunes : car le bois des ieunes est blanc, et n'y a aucune figure. Cela te doit asseurer, que les eaux qui distillent le long des branches, se retienent et arrestent sur les carrefours desdits Noyers, et petit à petit lesdites eaux entrent par les porres dudit Noyer. Et si tu ne veux croire que le bois de Noyer soit porreux, va chez vn menusier, et tu trouueras, que quand il rabote quelque table, ou membrure dudit Noyer, il se fait des escoupeaux longs, et terues (*minces*) comme papier : pren vn desdits escoupeaux, et le regarde contre le iour, et tu verras là vn nombre infini de petits pertuis, qui est la cause que ledit bois est fort espongieux, et suiet à s'enfler, soudain qu'il reçoit quelque humidité. Ie te donneray encore vn exemple fort aisé ; il faut que tu me confesses, que le bois d'Érable est plus madré, figuré, et damasquiné que nul autre bois, et pour ceste cause, les Flamans en font des tables merueilleusement belles : car ayans vn bois bien damasquiné, ils le sieront bien terue, et l'enchasseront dans quelque autre table de moindre estime en ioignant et assemblant plusieurs desdites tables ensemble : ils cercheront le racord des figures de la damasquine, tellement qu'il semblera que toutes lesdites tables iointes ensemble, ne sont qu'vne mesme piece, à cause que le racord des figures, empesche la cognoissance de l'assemblage. Veux-tu sçauoir à present qui est la cause que ledit bois se trouue ainsi figuré ? Note qu'il est tout branchu, depuis la racine iusques aux branches, et parce qu'il ne produit aucun fruit profitable, on couppe souuent les branches, et on laisse le tronc, lors les branches estant couppees, la teste du tronc se renforce d'escorce, et de gittes, et fait vn receptacle, sur lequel sont retenues quantités d'eaux és temps des pluyes, ainsi que ie l'ay dit cy dessus. L'eau a son naturel de percer tousiours en bas, et passant par les porres le long du tronc, en tirant en bas, elle trouue qu'à l'endroit des branches de la iambe, le bois est plus dur, et moins porreux, parce que les nœuds desdites branches prennent leur origine dés le centre du tronc. Et ainsi que ladite eau descend en bas, et qu'elle trouue le dur

de la naissance, et la branche, elle est contrainte se desuier par autre voye en tenant lignes obliques, et tant plus il y a de branches audit tronc, d'autant plus se trouuent diuerses figures au bois d'Érable. Et pour bien cognoistre cela, va à vn ruisseau où il n'y a gueres d'eau et mets plusieurs pierres dedans le cours de l'eau, enuiron distantes de quatre doits l'vne de l'autre : si les pierres sont vn peu plus hautes que l'eau, tu verras que les pierres feront diuertir l'eau en la maniere que dessus. Si ce secret estoit cogneu de tous les bois d'Erable, ils ne seroyent bruslez, ains seroyent gardez precieusement, desquels on pourroit faire de belles colonnes, et autres telles choses. Puis que nous sommes sur le propos des arbres, et des abus que les ignorans commettent au gouuernement d'iceux, combien penses tu qu'il y ait de gens, qui regardent le temps et saison conuenable pour coupper les bois de haute futee? De ma part, ie pense qu'il y en a bien peu : vray est que communement ils ne les couppent pas en esté, parce qu'ils ont d'autres affaires, qui les pressent : et parce qu'ils n'ont rien à faire en hyuer, et qu'il fait bon trauailler pour s'eschauffer, ils couppent communement leurs bois en hyuer : car en esté ils ne pouroient finer de iournalliers, par quoy sont contrains d'attendre l'hiuer : mais il faut philosopher plus outre, car si les bois sont coupez és iours que le vent est au Sus, ou au Ouëst, ce sont les vents humides, lesquels par leurs actions font enfler les bois, et remplir les porres d'humidité : et estans ainsi enflez, humectez, et abreuuez, s'ils sont couppez en tel estat, l'humeur qui est dedans les porres s'eschauffera, et engendrera quelques cossons, ou vermines, qui quelque temps apres gasteront le bois. Quoy qu'il en soit, la charpante d'vn bois couppé en la saison susdite sera de petite duree : mais si le bois est couppé en temps de froidures, et que le vent soit au Nord, les porres desdits bois sont resserez en telle sorte, que comme l'homme est plus sain et plus fort en temps de froidure, que non pas au temps que par sueur les humeurs sont dilatees, et les porres ouuerts, semblablement le bois qui est couppé au temps que le vent est au Nord, il est plus halis et plus fort que non pas en esté. Et te faut aussi noter que nulle nature ne produit son fruit sans extreme trauail, voire et douleur : ie dis autant bien les natures vegetatiues, comme les sensibles et raisonnables. Si la

3.

Poule deuient maigre, pour espellir (*expellere*) ses poulets, et la Chienne souffre en produisant ses petits, et consequemment toutes especes et genres, et mesme la Vipere, qui meurt en produisant son semblable (1), ie te puis aussi asseurer, que les natures vegetatiues et insensibles souffrent, en produisant leurs fruicts. I'estois quelque fois és Isles de Xaintonge, où i'apperceu vne vigne plus chargee de fruits que toutes les autres, et m'enquerant de la raison, on me respondit qu'elle estoit chargee à la mort : lors ayant demandé l'interpretation de cela, on me dist, qu'on lui auoit laissé plus de rameaux que de coustume, parce qu'on la vouloit arracher apres la cueillie, et qu'autrement on n'eust voulu permettre, qu'elle eust chargé si abondamment, ce qui vaut autant dire, que si on laissoit faire ausdites vignes ce qu'elles voudroyent, qu'elles se tueroyent, à cause de l'abondance des fruits, qu'elles s'efforceroyent de produire. I'ay contemplé plusieurs fois des arbres et plantes, qui par secheresse, ou autre accident se mouroyent : toutesfois, deuant que mourir, ils se hastoyent de fleurir et produire graines et fruits deuant le temps accoustumé. Or si ainsi est, que les arbres et autres vegetatifs trauaillent, et sont malades en produisant, il faut conclurre, que si tu couppes tes arbres au temps des fruits, des fleurs, et des feuilles, tu les couppes en leur maladie, dont la foiblesse de ladite maladie demeurera audits arbres, et la charpente qui sera faite desdits arbres ne sera iamais si forte, ni de si grande duree, que celle qui sera faite des arbres qui seront couppez au temps d'hyuer et froidures seches, comme i'ay dit cy dessus. Si tu es homme de bon iugement, tu peus à present cognoistre par les argumens susdits, que ce n'est pas sans cause, que i'ay dit, qu'il est requis quelque Philosophie à ceux qui exercent l'art d'agriculture, et si tu eusses entendu ce qu'vn bon laboureur deuroit entendre, tu n'eusses trouué estrange ce propos que ie t'ay dit au commencement, c'est à sçavoir, que ie cerchois un lieu montueux, pour edifier un iardin excellent et de grand reuenu.

DEMANDE.

A la verité, i'ay trouué cela fort estrange, et ne puis encore entendre la cause : parquoy, ie te prie, me la dire à fin de m'oster de ceste fantasie.

(1) C'est une ancienne erreur, fort accréditée du temps de Palissy.

Responce.

Tu dois entendre, que les terres des lieux montueux sont plus salees, que non pas celles des vallees : et pour ceste cause, les arbres fruitiers qui croissent sur les hauts terriers produisent leurs fruits plus salez, et de meilleur goust, que ceux des vallees : voila vne raison qui te doit suffire pour le tout.

Demande.

Cuides-tu que ie te croye, de ce que tu dis à present, qu'il y aye du sel en la terre, et mesme en toutes especes ?

Responce.

Veritablement tu as vn pauure iugement : ie t'ay prouué cy deuant que, en toutes especes d'arbres, herbes, et plantes, il y auoit du sel, et à present tu veux ignorer qu'il y en aye en toutes terres. Et où penses-tu que les arbres, herbes, et plantes prennent leur sel, s'ils ne le tirent de la terre ? Tu trouuerois bien estrange, si ie te disois, qu'il y a aussi du sel en toutes especes de pierres, et non seulement és especes de pierres, mais ie te dis aussi, qu'il y en a en toutes espèces de metaux : car n'y en ayant point, nulle chose ne se pourroit tenir en son estre ; ains se reduiroit soudain en cendre.

Demande.

Si de ces choses tu ne me donnes des raisons bien apparentes, ie ne croiray rien de tout ce que tu m'en as dit.

Responce.

Il te faut icy entendre, que la cause qui tient la forme et bosse des montagnes, n'est autre chose que les rochers qui y sont, tout ainsi comme les os d'vn homme tiennent la forme de la chair, de laquelle ils sont reuestus. Et tout ainsi que si l'homme auoit les os froissez et escachez, la forme du corps se viendroit à encliner, perdre et rabaisser son estre : semblablement, si les pierres qui sont és montagnes se venoyent à reduire en terre, lesdites montagnes perdroyent leur forme : car les eaux qui descendent des nues, emmeneroyent les terres desdites montagnes aux vallees, et ainsi il n'y auroit plus de montagnes, mais les pierres, comme ie t'ay dit, tiennent ladite forme. Et parce qu'esdites pierres il y a plus de sel, que non pas en la terre, les terres qui sont sur les rochers, se ressentent du sel desdites pierres : car, tout ainsi que ie t'ay dit que l'acreté de la fumee du bois estoit tesmoignage qu'elle

portoit en soy quelque salsitude, qui faisoit cuire et gaster les yeux, semblablement la vapeur qui sort des rochers desdites montagnes apporte quelque salsitude és terres qui sont dessus, qui causent que les fruits qui y croissent sont plus salez, et de meilleur goust, et ne sont si sujets à putrefaction et pourriture, comme ceux qui sont produits és vallees, et ceux des vallees sont communement plus fades, et de mauuaises saueur, et sujets à pourriture. Et ce, pour cause que les terres des vallees sont suiettes à receuoir et donner passage és eaux qui descendent des montagnes, lesquelles eaux font dissoudre, et emportent le sel des terres desdites vallees, qui causent que les fruits ne sont guere salez. Item, les arbres qui sont plantez és vallees, ne peuuent porter si grande abondance de fruits, que ceux des montagnes, ou terriers hauts : et la cause est, parce que les arbres des vallees sont trop guais, à cause de l'abondance d'humeur, qui fait qu'ils employent leur temps et force à produire grande quantité de bois et branches, et cerchent le Soleil, et deuiennent plus hauts et plus droits, que ceux qui sont aux terriers hauts : aussi lesdits arbres des vallees en cas pareil n'ont point si grande quantité d'huile en leur bois, comme ceux des hauts terriers et montagnes. Voila aussi pourquoy ils ne bruslent pas si bien que ceux des hauts lieux, et ne sont lesdits arbres de si longue durée. Et si tu ne veux croire qu'il y aye du sel és fruits, contemple vn peu quelque arbre de Serisier, Pommier, ou Prunier ; si tu vois vne annee qu'il n'aye guere de fruit, et que le temps se porte sec, tu trouueras ce fruit là d'vne excellente saueur : et s'il aduient vne annee fort mouillee, et que ledit arbre aye grande quantité de fruit, tu trouueras que ledit fruit sera fade, et de mauuaise saueur, et de peu de garde. Et cela aduiendra pour deux causes : la premiere est, parce que le tronc et branches dudit arbre n'ont pas assez de sel, pour en distribuer abondamment, à si grande quantité de fruit : l'autre, parce que l'annee a esté pluuieuse, et que les pluyes ont emporté partie du sel dudit fruit, comme il seroit d'vn poisson salé, qui seroit pendu à vne branche dudit arbre.

Demande.

Quant est de ces raisons que tu m'as donnees des fruits, elles sont aisees à croire : mais de croire qu'il y aye du sel

aux pierres et métaux, il n'y a homme qui me le sçeust faire accroire.

RESPONCE.

Tu trouues bien estrange, que ie dise qu'il y a du sel en toutes especes de pierres et métaux : tu t'esbahiras donc beaucoup plus, quand je te diray, qu'aucunes pierres sont presque toutes de sel, et je te prouueray par bonnes raisons, qu'il y a certains métaux, qui ne sont autre chose que sel : et à fin que n'ayes occasion de t'en aller mal édifié de mes propos, commençons du mineur au maieur. Tu me confesseras, en premier lieu, que les pierres de chaux empeschent la putrefaction, et endurcissent et mondifient les peaux des bestes mortes : ou autrement, elles ne pourroyent seruir aux Corrayeurs. Tu es bien asne, si tu penses que la pierre de chaux aye ceste vertu, sans qu'il y eust du sel. Passons outre, ie te demande, pourquoy est-ce que les Corrayeurs iettent ladite chaux apres qu'elle a serui vne fois? N'est-ce pas, parce que son sel s'est dissout, et estant dissout, a salé lesdites peaux, et le residu de la pierre est demeuré inutile? Car autrement ladite chaux pourroit seruir plusieurs fois. Je t'ay donné cy dessus vn exemple du sel de l'écorce du bois, duquel se seruent les Tanneurs : l'vne raison te doit assez suffire, pour te faire croire l'autre. Si tu tastes de la chaux dissoute sur le bout de la langue, tu trouueras vne mordication salsitive beaucoup plus poignante que celle du sel commun. Item, tout ainsi que le sel du vin qu'on appelle cendre gravelee, nettoye les draps, et est bonne à la buee, aussi fait le sel, qui est aux cendres du bois. Semblablement le sel de la pierre de chaux, est bon à la buee, quelque chose qu'on die, qu'il brusle les draps : cela ne peut estre, si ce n'estoit que dedans vn peu d'eau, on mist vne grande quantité de ladite chaux : mais si vne moyenne quantité de chaux est mise et dissoute dedans assez bonne quantité d'eau, et que ladite chaux aye trempé quelque temps dedans ladite eau, le sel qui y est, se viendra à dissoudre et mesler parmi l'eau : lors ladite eau, estant salee du sel de la chaux, sera fort apte pour seruir à la buee, comme ie t'ay dit cy deuant, que l'eau qui distille des fumiers, est presque le total de ce qui deust estre porté en la terre. Voila les raisons qui te doiuent faire croire le total, toutesfois ie te donneray encore certains exemples, qui te

feront croire ce que tu ignores à present. Considere vn peu certaines pierres qu'on appelle gelices ou venteuses, et tu verras qu'elles se consomment iournellement, et se reduisent en cendre, ou menue poussière. Veux-tu sçauoir la cause de cela? C'est parce qu'il n'y a pas long temps, que ladite pierre a esté faite, et a esté tirée de sa racine, deuant que sa discretion fust parachevee : dont s'ensuit que l'humidité de l'air, et pluyes qui donnent contre, font dissoudre le sel qui est en ladite pierre, et le sel estant ainsi dissout et reduit en eau, il laisse ses autres parties ausquelles il s'estoit ioint : et de là vient, que ladite pierre se reduit de rechef en terre, comme elle estoit premierement, et estant reduite en terre, elle n'est iamais oisiuue : car si on ne luy donne quelque semence, elle se trauaillera à produire espines et chardons, ou autres especes d'herbes, arbres ou plantes, ou bien quand la saison sera conuenable, elle se reduira de rechef en pierre. Pour bien cognoistre ces choses, quand tu passeras pres des murailles qui sont gastées par l'iniure du temps, taste sur la langue, de la poussiere qui tombe desdites pierres, et tu trouueras qu'elle sera salée, et que certains rochers, qui sont descouuers, combien qu'ils soyent encore au lieu de leur essence, ils sont sujets à l'iniure du temps : et dois icy noter, que les murailles et rochers qui sont ainsi incisez par l'injure du temps, le sont beaucoup plus deuers la partie du Sus, et du Ouëst, que non pas du Nord, qui est attestation de mon dire, c'est à sçauoir, que l'humidité fait dissoudre le sel, qui estoit la cause de la tenance, forme, et discretion de la pierre : et mesme tu vois que le sel commun, estant dedans les maisons, se dissout de soy-mesme en temps de pluyes, qui sont agitées par lesdits vents du Ouëst et Sus.

DEMANDE.

L'opinion que tu m'as dite à present, est la plus menteuse, que i'ouys iamais parler : car tu dis, que la pierre qui depuis peu de temps a esté faite, est suiette à se dissoudre, à cause de l'injure du temps, et ie sçay que dés le commencement que Dieu fit le Ciel et la terre, il fit aussi toutes les pierres, et n'en fut fait onques depuis. Et mesme le Pseaume, sur lequel tu veux édifier ton iardin, rend tesmoignage que le tout a esté fait dés le commencement de la création du monde.

Responce.

Ie ne vis onques homme de si dure ceruelle que toy : ie sçay bien qu'il est escrit au liure de Genese, que Dieu crea toutes choses en six iours, et qu'il se reposa le septiesme : mais pourtant, Dieu ne crea pas ces choses pour les laisser oisifues, ains chacune fait son deuoir, selon le commandement qui luy est donné de Dieu. Les astres et planetes ne sont pas oisifues, la mer se pourmeine d'vn costé et d'autre, et se trauaille à produire choses profitables, la terre semblablement n'est iamais oisifue : ce qui se consomme naturellement en elle, elle le renouuelle et le reforme de rechef, si ce n'est en vne sorte, elle le refait en vne autre. Et voila pourquoy tu dois porter les fumiers en terre, afin que de rechef, la terre prenne la mesme substance qu'elle luy auoit donnee. Or faut icy noter que, tout ainsi que l'extérieur de la terre se trauaille pour enfanter quelque chose : pareillement le dedans et matrice de la terre se trauaille aussi à produire : en aucuns lieux elle produit du charbon fort utile, en d'autres lieux, elle conçoit et engendre du fer, de l'argent, du plomb, de l'estain, de l'or, du marbre, du iaspe, et de toutes especes de mineraux, et especes de terres argileuses, et en plusieurs lieux elle engendre et produit du bitume, qui est une espèce de gomme oligineuse, qui brusle comme résine : et aduient souuent que, dedans la matrice de la terre, s'allumera du feu par quelque compression, et quand le feu trouue quelque miniere de bitume, ou de souffre, ou de charbon de terre, ledit feu se nourrist, et entretient ainsi sous la terre : et aduient souuent, que par un long espace de temps, aucunes montagnes deuiendront vallées par vn tremblement de terre, ou grande vehemence que ledit feu engendrera, ou bien, que les pierres, metaux, et autres mineraux qui tenoyent la bosse de la montagne se brusleront, et en se consommant par feu, ladite montagne se pourra encliner et baisser petit à petit : aussi autres montagnes se pourront manifester et esleuer, pour l'accroissement des roches et minéraux, qui croissent en icelles, ou bien il aduiendra, qu'vne contree de pays sera abysmee, ou abaissee par un tremblement de terre, et alors, ce qui restera, sera trouvé montueux : et ainsi, la terre trouuera touiours dequoy se trauailler, tant és parties intérieures, qu'extérieures. Et quant est de ce que tu te mocques, que ie

t'ay dit, que les pierres croissent en terre, il n'y a aucune occasion, ni raison de se mocquer de moy : mais ceux qui s'en mocqueront, se declareront ignorans deuant les Doctes : car il est certain, que si depuis la creation du monde, il n'estoit creu aucune pierre en la terre, il seroit difficile d'en trouuer auiourd'huy une charge de cheual en tout vn Royaume, sinon en quelques montagnes et deserts, ou autres lieux non habitez, et donneray à present à cognoistre, qu'il est ainsi que ie t'ay dit. Considere vn peu combien de millions de pippes de pierres, sont iournellement gastees, à faire de la chaux. Item, considere vn peu les chemins, tu trouueras qu'un nombre infiny de pierres, sont reduites en poussiere, par les chariots et cheuaux, qui passent iournellement par lesdits chemins. Item, regarde vn peu trauailler les Massons, quand ils feront quelque bastiment de pierre de taille, et tu verras qu'vne bien grande partie de ladite pierre est gastée, et mise en poussiere, ou en farine par lesdits Massons. Il n'y a homme au monde ny esprit si subtil qui sçeust nombrer la grande quantité de pierres qui sont iournellement dissoutes et puluerisees par l'effet des gelees, non comprins vn nombre infini d'autres accidens, qui iournellement gastent, consument, et reduisent les pierres en terre. Parquoy, ie puis asseurement conclurre que, si les pierres n'eussent esté aucunement formees, creuës, et augmentees depuis la premiere creation escrite au liure de Genese, qu'il seroit auiourd'huy difficile d'en pouuoir trouuer vne seule, sinon, comme i'ay dit cy deuant, és hautes montagnes et lieux deserts et non habitez, et sera bien gros d'esprit, celuy qui ne le croira ainsi, s'il a esgard és choses susdites.

Demande.

Donne moy donc quelque raison, qui me face entendre, comment les pierres croissent iournellement entre nous, et lors ie ne t'importuneray plus.

Response.

Sur toutes les choses qui m'ont fait croire et entendre, que la terre produisoit ordinairement des pierres, ç'a esté, parce que i'ay trouué plusieurs fois des pierres, qu'en quelque part qu'on les eust peu rompre, il se trouuoit des coquilles, lesquelles coquilles estoyent de pierre plus dure que non pas le residu, qui a esté la cause, que ie me suis tourmenté et de-

batu en mon esprit l'espace de plusieurs iours, pour admirer et contempler, qui pouuoit estre le moyen et cause de cela. Et quelque iour ainsi que i'estois és Isles de Xaintonge, en allant de Marepnes à la Rochelle, i'ay apperceu vn fossé creusé de nouueau, duquel on auoit tiré plus de cent charetées de pierres, lesquelles en quelque lieu ou endroit qu'on les sçeust casser, elles se trouuoient pleines de coquilles, ie dis si pres à pres, qu'on n'eust sçeu mettre vn dos de cousteau entre elles sans les toucher : et deslors ie commençay à baisser la teste, le long de mon chemin, à fin de ne voir rien qui m'empeschast d'imaginer qui pourroit estre la cause de cela : et estant en ce trauail d'esprit, ie pensay deslors, chose que ie crois encore a present, et m'asseure qui est veritable, que pres dudit fossé il y a eu d'autres fois quelque habitation, et ceux qui pour lors y habitoient, apres qu'ils auoient mangé le poisson qui estoit dedans la coquille, ils iettoyent lesdites coquilles dedans cette vallée, où estoit ledit fossé, et par succession de temps, lesdites coquilles s'estoient dissoutes en la terre, et aussi la terre de ce bourbier s'estoit mondifiee, et les saletez pourries, et reduites en terre fine, comme terre argileuse : et ainsi que lesdites coquilles se venoient à dissoudre et liquefier, et la substance et vertu du sel desdites coquilles faisoient attraction de la terre prochaine, et la reduisoyent en pierre avec soy, toutesfois, parce que lesdites coquilles tenoient plus de sel en soy, qu'elles n'en donnoient à la terre, elles se congeloient d'vne congelation beaucoup plus dure, que non pas la terre : mais l'vn et l'autre se reduisoyent en pierre, sans que lesdites coquilles perdissent leur forme (1). Voila la cause, qui depuis ce temps là, me fit imaginer, et repaistre mon esprit de plusieurs secrets de nature, desquels ie t'en monstreray aucuns. Item, vne autre fois je me pourmenois le long des rochers de cette ville de Xaintes, et en contemplant les natures, i'apperceu en vn rocher certaines pierres, qui estoyent faites en façon d'vne corne de mouton (2), non pas si

(1) Cette première opinion de Palissy sur l'origine des coquilles pétrifiées est celle qu'adopta Voltaire, mais Palissy ne pouvait rester long-temps dans une pareille erreur ; aussi, en observateur habile, ne tarda-t-il point à en revenir et à reconnaître la véritable théorie de cette formation, comme on le verra plus loin au *Traité des pierres*.

(2) C'est ce que l'on connaît aujourd'hui sous le nom d'*ammonites*, ou *cornes d'Ammon*.

longues, ny si courbees, mais communement estoient arquees et auoyent environ demi-pied de long. Ie fus l'espace de plusieurs annees, deuant que ie cogneusse qui pouuoit estre la cause que ces pierres estoyent formees en telle sorte : mais il aduint vn jour, qu'vn nommé Pierre Guoy, Bourgeois et Escheuin de cette ville de Xaintes, trouua en sa Mestairie vne desdites pierres, qui estoit ouuerte par la moitié, et auoit certaines denteleures, qui se ioignoyent admirablement l'vne dans l'autre : et parce que ledit Guoy sçauoit que i'estois curieux de telles choses, il me fit un present de ladite pierre, dont ie fus grandement resiouy, et deslors ie cogneu, que ladite pierre auoit esté d'autres fois vne coquille de poisson duquel nous n'en voyons plus. Et faut estimer et croire, que ce genre de poisson a d'autres fois frequenté à la mer de Xaintonge : car il se trouue grand nombre desdites pierres, mais le genre du poisson s'est perdu, à cause qu'on l'a pesché par trop souuent, comme aussi le genre des Saumons se commence à perdre en plusieurs contrees des bras de mer, parce que sans cesse on cerche à le prendre, à cause de sa bonté. I'estois quelque fois à Sainct-Denis d'Olleron, qui est la fin d'une isle de Xaintonge, où ie prins une vingtaine de femmes et enfans, pour me venir aider à cercher sur les roches maritimes, certaines coquilles, desquelles i'avois necessairement affaire, et m'estant rendu sur vn rocher, qui estoit iournellement couuert de l'eau de la mer, il me fut monstré vn grand nombre de poisson armé, qui estoit fait en forme d'vn pellon de chastagne, plat par dessous, et vn trou bien petit, duquel il s'attachoit à la roche, et prenoit nourriture par ledit trou : or ledit poisson n'a aucune forme, ains est vne liqueur semblable à l'huitre, toutesfois elle remplist toute sa coquille (1). Le dehors et dessus de sa coquille, est tout garny d'vn poil dur, et poignant, comme celui d'vn herisson, aussi ledit poisson s'appelle herisson. Ie fus fort aise de l'auoir trouué, et en ayant prins et emporté vne douzaine en ma maison, ie fus grandement deceu : car quand le dedans de la coquil'e fut osté, la racine du poil qui tenoit contre la coquille, se putrefia en peu de iours, et ledit poil tomba : et apres que le poil fut tombé, la coquille demeura toute nette, et à l'endroit de la racine de chacun poil, se trouua vne bossette, lesquelles bossettes sont mises par vn si bel ordre, qu'el-

(1) Ce sont des oursins (*echinus*).

les rendent la coquille plaisante et admirable. Or quelque temps apres, il y eut vn Aduocat, homme fameux, et amateur des lettres et des arts, qui en disputant de quelque art, il me monstra deux pierres toutes semblables de forme ausdites coquilles d'herisson qui toutesfois estoyent toutes massiues : et soustenoit ledit Aduocat nommé Babaud, que lesdites pierres auoyent esté ainsi taillees par la main de quelque Ouurier, et fut fort estonné, quand ie lui maintins, que lesdites pierres estoyent naturelles, et trouua fort estrange, que ie disois, que ie sçauois bien la cause pourquoy elles auoyent prins vne telle forme en la terre : car i'auois desja considero, que c'estoit de ces coquilles d'herisson, qui à succession de temps s'estoyent liquifiees, et en fin reduites en pierre, voire que la salsitude de ladite coquille auoit ainsi congelé et reduit en pierre, la terre qui estoit entree dans ladite coquille : or ay-ie recouuert depuis ce temps-là plusieurs desdites coquilles, qui sont conuerties en pierre. Voila qui te doit faire croire, que iournellement la terre produit des pierres, et qu'en plusieurs lieux la terre se reduit en pierre par l'action du sel, qui fait le principal de la congelation, comme tu peux cognoistre, que pour cause que les coquilles sont salees, elles attirent à soy ce qui leur est propre, pour se reduire en pierre Item, ay trouué plusieurs coquilles de sourdon, qui estoyent reduites en pierres : toutesfois elles estoyent massiues, combien qu'elles fussent iointes, comme si le poisson eust esté dedans. Et que diras-tu de ceux qui ont trouué des os d'hommes enclos dedans des pierres, et autres ont trouué des monnoyes antiques? N'est-ce pas bien attestation, que les pierres augmentent en la terre? Veux tu encore vn bel exemple? Il y a certaines pierrieres, desquelles la pierre a vn nombre infini de fins, combien qu'elles se tiennent en vne masse, si est-ce qu'en mettant des coins par dessous, elle se fendra aisement, et se leuera en sus. Veux tu sçauoir comme on la tire, sçache que parce que les veines ou fins (1) de ladite pierre sont en trauersant, Vitruue dit qu'en couppant ladite pierre il faut marquer son lict : car si les Massons mettoyent la pierre qui estoit couchee en son lict debout, le bout qui estoit de trauers, cela causeroit que ladite pierre se fendroit, et s'esclatteroit, pour la pesanteur de celles qui seroyent mises dessus. Toutes pier-

(1) Ou plutôt *sins, sinus*.

rieres ne sont pas ainsi, il y en a aucunes, qui n'ont ne long, ne trauers ; mais sont si bien congelees, qu'on ne regarde pas du costé qu'on les met. Venons à present à la cause, qu'aucunes pierres ont si grand nombre de veines, lesquelles sont aisees à fendre, et pourquoy c'est que les veines ne sont aussi bien descendantes d'en haut, comme elles vont en trauersant. La cause de cela, est, parce qu'au dessus de la pierriere, il y a vne grande espesseur de terres : il est bien vray, que quand la pierre se faisoit, l'eau qui tomboit des pluyes, passant à trauers de ladite terre, prenoit auec soy quelque espece de sel et l'eau estant descendue iusques à la profondeur du lieu où elle s'arrestoit, ladite eau ainsi salee, conuertissoit et congeloit la terre où elle estoit arrestee, en pierre : et pour ce coup se formoit une couche, ou lict, de ladite pierre, et estant endurcie, elle seruoit apres de receptacle pour les autres eaux qui tomboyent apres, et passoyent à trauers des terres, iusques audit receptacle, et ayant prins encores un coup quelque sel en passant par les terres, il se formoit vne autre couche, ou lict, qui se formoit et se ioignoit auec le premier ; et ainsi à diuerses fois, annees, et saisons, plusieurs minieres de pierres ont esté augmentees, et augmentent iournellement en la matrice de la terre. Et il aduient quelque fois qu'un lict et couche de pierre aura par dessus quelque couche de terre glueuse, qui causera quelque saleté au dessus du terrier ou lict : les autres eaux qui se congeleront auec la terre, qui est dessus ledit lict, ne se pourroyent ioindre ou souder ensemble, à cause de la saleté contraire. Dont se commencera un lict à part, et se trouuera vne separation en ladite roche, que les pierreurs appellent vne fin.

Demande.

Penses-tu me trouuer si beste, que ie croye à present une telle folie, que tu m'as icy proposé ? Ne sçay-ie pas bien, si ainsi estoit, que de puis la creation du monde, toutes les eaux et la terre seroyent conuerties en pierre, et qu'à present les poissons seroyent à sec ?

Response.

Ie t'asseure, que ie ne cogneus onques vne si grande beste que toy ; i'ay perdu mon temps de tout ce que ie t'ay dit cy deuant : car tu n'as rien conceu. T'ay-ie pas dit, que tout ainsi, que iournellement les pierres estoyent augmentees d'vne

part, qu'en cas pareil, elles estoyent diminuees d'vne autre part; et en se diminuant par fractions, brisures, et dissolutions des vents, pluyes, et gelees, lors qu'elles sont dissoutes, elles rendent l'eau, le sel, et la terre, de laquelle elles auoyent prins leur essence?

DEMANDE.

Voire, mais ie voy bien souuent des pierres qui sont fort blanches, et toutesfois la terre qui est dessus, est noire : s'il y auoit de ladite terre, comme tu dis, la pierre ne seroit ainsi blanche, ains seroit de la couleur de la terre qui est dessus, puis qu'elle a esté formee de partie d'icelle.

RESPONCE.

Si tu auois quelque Philosophie, tu n'eusses ainsi argumenté : car c'est chose certaine, que le sel blanchist la terre en la congelation, et non seulement la terre, mais plusieurs autres choses, tesmoins les experts Alchimistes, qui souuentesfois prendront du sel de tartare, ou du sel de salicor, ou quelque autre espece de sel, pour blanchir le cuiure, et le faire ressembler argent. Le plomb aussi qui est noir, quand il est calciné par la vapeur salsitive du vinaigre, il se reduit en blanc de plomb dequoy la ceruse est faite, et blanc rasis, qui est la plus blanche de toutes les drogues. Et quant est de ce que tu as allegué, que depuis le commencement du monde, toutes les eaux eussent esté conuerties en pierre, s'il estoit ainsi comme ie t'ay dit, tu as fort mal entendu ce poinct : car ie ne t'ay point dit, que toute l'eau qui passoit à trauers des terres, se conuertissoit en pierre, mais seulement vne partie : et qu'ainsi ne soit, qu'il n'y aye de l'eau dedans les pierres, considere celles qu'on fait cuire pour faire la chaux, et tu trouueras, qu'elles sont pesantes deuant qu'estre cuites, et apres qu'elles sont cuites, elles sont legeres. N'est-ce pas attestation, que l'eau qui estoit iointe auec le sel de la terre, s'est euaporé par la vehemence du feu, et les autres parties sont demeurees alterees, qui cause que soudain qu'on met de l'eau dessus lesdites pierres de chaux, se trouuans alterees, emboiuent si tres violemment que cela les cause soudain reduire en farine? et te faut icy noter, que les pierres qui sont faites d'vn bien long-temps, l'eau et les autres parties se sont si bien vnies, qu'elles ne peuuent estre propres à faire la chaux, à cause que leur congelation est plus parfaite, comme

ie te feray bien entendre, en te parlant des cailloux : mais les pierres bonnes à faire chaux, il n'y a pas long temps qu'elles sont congelees et fermees : et si autrement estoit, qu'ainsi que ie te dis, toutes pierres seroyent bonnes à faire chaux. Et quant est de l'autre poinct, que l'eau qui passe à trauers des terres se reduit en pierre, et que ie t'ay dit, que cela ne s'entendoit pas du tout, ains d'vne partie, considere vn peu la maniere de faire le salpestre. On fera bouillir l'eau qui aura passé par la terre salpestreuse, et par les cendres : est-ce pourtant à dire que toute ladite eau se conuertisse en salpestre? Non. Pareillement, toute l'eau qui passe à trauers des terres, ne se conuertist pas en pierre, mais vne partie : et ainsi, il y a bien peu d'endroits en la terre, qui ne soyent foncez de pierre, ou d'vne espece, ou d'autre : car autrement il seroit difficile de trouuer une seule fontaine.

Demande.

Ie te prie, laisse pour cette heure le propos des pierres, et me fay une petite enarration de ces fontaines, puis que le propos s'y presente.

Responce.

Ie t'ay dit cy deuant, qu'il y a bien peu de terre, qui ne soit foncee par dessous de pierres, ou de mines de metaux, ou de terre argileuse, voire bien souuent foncee de toutes les trois especes : dont s'ensuit, que quand les eaux des pluyes tombent de l'air sur la terre, elles sont retenues sur lesdits rochers, et lesdits rochers seruent de vaisseau et receptacle, pour lesdites eaux : car autrement, les eaux descendroyent iusques aux abysmes, ou au centre de la terre : mais estans ainsi retenues sur les rochers, elles trouuent quelque fois des iointures et veines esdits rochers, et ayans trouué tant peu soit-il d'aspiration, soit terue, ou fente, ou quoy que ce soit, lesdites eaux prendront leurs cours deuers la partie pendante, pourueu qu'elles trouuent tant peu soit-il d'ouuerture : et de là vient le plus souuent, que des rochers et lieux montueux sortent plusieurs belles fontaines : et de tant plus elles viennent de loin, sortans et passans par des bonnes terres, d'autant plus lesdites eaux seront saines et purifiees, et de bonne saueur. Aussi communement les eaux qui sortent desdits rochers, sont plus salees, et de meilleur goust que les autres,

parce qu'elles font tousiours quelque peu d'attraction du sel qui est esdits rochers.

DEMANDE.

Tu reuiens tousiours au propos de ce sel, et on ne te sçauroit oster de la teste, qu'il n'y aye du sel aux pierres.

RESPONCE.

Ie ne t'ay pas dit, aux pierres seulement, mais aussi aux cailloux, et en toutes choses.

DEMANDE.

Ie te nie à present qu'il y aye aucun sel aux cailloux, et te prouueray le contraire, par certains argumens, que tu m'as cy deuant baillez. Tu m'as dit, que les pierres qu'on appelloit gelices ou venteuses, se dissoluoyent à l'humidité du temps, à cause du sel qui estoit en elles : aussi tu m'as dit que, des pierres à faire chaux, l'humide s'euaporoit, pour la vehemence du feu : or est-il chose certaine, que les cailloux ne sont suiets à nuls de ces accidens : car ie n'en vis iamais dissoudre par l'iniure du temps, aussi le feu ne chasse aucunement l'humeur desdits cailloux : te voila donc vaincu par tes mesmes raisons.

RESPONCE.

Ie veux à present prouuer mon dire veritable, par les mesmes raisons que tu prens, pour le rendre menteur. Tu dis qu'aux cailloux, il n'y a aucune espece de sel, parce qu'ils ne sont suiets à se dissoudre, ne par eau, ne par feu : cela n'empesche point qu'il n'y en aye, voire beaucoup plus abondamment, que non pas és pierres tendres, bonnes à massonner : et qu'ainsi ne soit, as-tu iamais veu faire verre, qu'il n'y eust du sel? As-tu aussi iamais veu aucun, qui sceust faire fondre, ou liquifier les cailloux, sans sel? Il faut necessairement, que pour faire liquifier les cailloux, qu'on y mette quelque espece de sel : or le plus apte pour cest affaire est le salicor, et apres cestuy là, le sel de tartare y est fort propre, car il a pouuoir de contraindre les autres choses à se liquifier, combien que d'elles-mesmes soyent liquifiables. Tu m'as dit, que les cailloux n'estoyent suiets à nulle dissolution par humidité, ne par feu : et par là tu as voulu prouuer, qu'ils ne tenoyent point de sel en leur nature, mais tu n'as pas dit ce qui est du caillou : car veritablement, quand il est mis en vne fournaise extremement chaude, comme les fournaises à

faire chaux ou verre, ou autres telles fournaises, esquelles le feu est extremement violent, lesdits cailloux se viennent à vitrifier d'eux-mesmes, sans aucune mixtion, ce qui est vne attestation bien notoire, que les cailloux ont en eux grande quantité de sel, qui leur cause se vitrifier, voire que le sel qui est en soy, tient si bien fixes les autres especes, que lesdits cailloux ont retenu leur humeur, en telle sorte qu'ils ne se peuuent iamais exhaller, ains toutes les matieres desdits cailloux sont fixes et inseparables : et qu'ainsi ne soit, pren vn certain poids de verre, qui aura esté fait desdits cailloux et du salicor, fay le chauffer le plus violemment que tu pourras, si est-ce que tu trouueras encore son poids. Par cy deuant ie t'auois bien dit, que l'humidité de la pierre de chaux s'exhalloit au feu, mais quant est du sel qui est en ladite pierre, ie ne t'auois pas dit, qu'il fust suiet à exhallation, mais bien à se dissoudre. Voila vne raison qui te doit faire croire, que tant plus il y a de sel en vne pierre, d'autant plus elle est fixe. I'ay encore vn exemple, pour te le mieux prouuer. Il est ainsi, que le verre le plus beau, est fait de sel et de cailloux : or est-il fixe autant que matiere de ce monde, comme ie t'ay dit : toutesfois, il est transparent, qui est signe et apparence euidente, qu'il n'y a guere de terre. Il s'ensuit donc, qu'il y en a bien peu au caillou, et au salicor. Que dirons-nous donc que c'est de ces matieres ainsi diaphanees? Nous pourrons dire, qu'il n'y a guere autre chose que de l'eau, et du sel ; et bien peu de terre : car la terre n'est pas diaphane de soy, et s'il y en auoit quantité, le verre ne pourroit estre transparent : suiuant quoy, que pourrons nous dire du caillou, sinon qu'il est engendré de semblables matieres que le verre ? Et ce, d'autant qu'il est diaphane comme le verre, et aussi suiet à se vitrifier de soy-mesme, sans aucun aide, et la vitrification ne se pourroit faire sans sel. Parquoy, il est à conclurre, que esdits cailloux, il y a vne bonne portion de sel.

DEMANDE

Tu m'as cy deuant dit, qui estoit cause que la pierre s'augmentoit assiduellement és minieres, mais quant est des cailloux, qui sont faits de petites pieces, tu ne m'as pas dit la cause, ne l'origine de l'essence.

RESPONCE.

En ce pays de Xaintonge nous auons grande quantité de

terres vareneuses (1), ausquelles se trouue vn nombre de cailloux, qui se forment annuellement en la terre, qui sont fort cornus, et raboteux, et mal plaisans par le dehors : mais par le dedans, ils sont blancs et cristalins, fort plaisans, et propres à faire verres et pierreries artificielles (2). La cause que lesdits cailloux sont ainsi cornus et raboteux par le dehors, c'est à cause de la place et lieu où ils ont esté formez, qui est, que quelque temps apres que les herbes et pailles dudit champ ont esté pourries, et qu'il aura demeuré long temps sans pleuuoir, il viendra quelque temps apres, qu'il fera vne certaine pluye, qui prendra le sel de la terre et des herbes qui auoyent esté pourries dans le champ : et ainsi que l'eau courra le long du seillon du champ, elle trouuera quelque trou de taupe, ou de souris, ou autre animal, et l'eau ayant entré dedans le trou, le sel qu'elle aura amené prendra de la terre et de l'eau ce qu'il luy en faut, et selon la grosseur du trou et de la matiere, il se congelera (cristallisera) vne pierre, ou caillou tel que ie t'ay dit cy dessus, qui sera bossu, raboteux, et mal plaisant, selon la forme de la place où il aura esté congelé. Veux-tu que ie te donne des raisons, qui m'ont fait cognoistre qu'il est ainsi? Quelquefois ie cerchois des cailloux, pour faire de l'esmail, et des pierres artificielles : or apres auoir assemblé vn grand nombre desdits cailloux, en les voulant piler, i'en trouuay vne quantité qui estoyent creux dedans, où il y auoit certaines pointes, comme celles de diamant, luisantes, transparentes, et fort belles : alors ie me commençay à tormenter, pour sçauoir qui estoit la cause de cela, et ne la pouuant entendre par Theorique, ne Philosophie naturelle, il me print desir de l'entendre par pratique, et ayant prins vne bonne quantité de salpestre, ie le fis dissoudre dans vne chaudiere auec de l'eau, laquelle ie fis bouillir : et estant ainsi bouillie et dissoute, ie la mis refroidir, et l'eau estant froide, i'apperceu que le salpestre s'estoit congelé aux extremitez de la chaudiere, et lors ie vuiday l'eau de ladite chaudiere, et trouuay que les glaçons du salpestre estoient formez par quadratures et pointes fort plaisantes. Quoy consideré deslors en mon esprit, ie vi, que les cailloux dont ie t'ay parlé, estoient aussi congelez : mais ceux qui se trou-

(1) Terres incultes auprès des marais salants.
(2) Ce sont des géodes.

ucrent massifs, c'est signe et euidente preuue qu'il y auoit assez de matiere pour remplir la fosse, et ceux qui estoient creux, c'est qu'il y auoit vne superfluité d'eau, laquelle s'estoit dessechee, pendant que la congelation se faisoit aux extremes parties : et quand l'humidité du milieu se dessechoit, les matieres propres pour le caillou, demeuroient fermes et congelees par le dedans, comme petites pointes de diamant. Ie ne te dis chose, que ie ne te monstre de quoy, si tu veux venir en mon cabinet, car ie te monstreray de toutes especes de pierres, que ie t'ay parlé. I'ay trouué quelques especes de cailloux, qui ont vn trou ou canal, qui passe tout à trauers desdits cailloux, cela m'a faict asseurement croire, que l'eau qui apportoit les matieres du caillou, passoit tout à trauers, pendant que ledit caillou se congeloit : et parce que le cours de l'eau ne trouuoit aucune fermure qui l'arrestast, elle a tousiours passé à trauers dudit caillou, et en passant en ceste sorte, la vistesse de l'eau a empesché qu'il ne se fist congelation au milieu dudit caillou : dont s'en est ensuiui, que le caillou est demeuré creux comme vne canelle tout à trauers. Tu peus prendre cest exemple par les ruisseaux courans au temps des gelees, lesquels se congelent aux extremitez, mais non pas au cours principal, à cause de la vistesse de l'eau. Il y a vn autre exemple, qui m'a fait croire, que les pierres ont esté congelees de certaine liqueur, par la vertu du sel. Quelquefois ainsi que i'allois de Xaintes à Marepnes, passant par les brandes (1) de sainct Sorlin, ie vy certains manouuriers, qui tiroient de la terre d'argile, pour faire de la thuile : et ainsi que i'estois arresté, pour contempler la nature de la terre susdite i'apperceu vn grand nombre de petits tourteaux de marcacite (pyrites), qui se trouuoient parmy ladite terre : et ayant contemplé plus outre, ie cogneus que lesdites pierres de marcacite auoient vne forme telle, comme si quelqu'vn auoit coulé de la cire fondue petit à petit auec vne cuillere : car lesdite marcacites estoient faites par rotonditez conglacees, la premiere plus euasee que la seconde, et la seconde plus que la tierce, et consequemment toutes les circulations et rotonditez estoyent faites en appetissant, en montant en haut, et en fin de ladite pierre, il y auoit vne pointe, qui me faisoit naturellement cognoistre, que c'estoit la fin et derniere goutte

(1) Bruyères, terres incultes.

de la liqueur, qui auoit distillé lors que lesdites marcacites se congeloyent : si de cela tu ne me veux croire, va t'en ausdits terriers, et tu trouueras quantité desdites marcacites, et si tu les gardes long temps, tu trouueras qu'elles chaumeniront (durciront), et taste au bout de la langue, et tu trouueras qu'elles sont salees, qui te fera croire, que les metaux ont en eux du sel, aussi bien comme les pierres : car les marcacites ne sont autre chose, que commencement de quelque metal : et qu'ainsi ne soit, pren deux desdites pierres, et les frotte l'vne contre l'autre, et tu trouueras qu'elles sentiront comme le souffre, et mesme si tu les frappes, il en sortira du feu, comme fait des autres mines de metaux. Ie te veux alleguer encore un exemple de la congelation des cailloux. Quelque fois que i'estois à Tours durant les grands iours de Paris, qui estoyent lors audit Tours, il y eut vn grand Vicaire dudit Tours, Abbé de Turpenay, et maistre des requestes de la Royne de Nauarre, homme Philosophe et amateur des lettres, et des bonnes inuentions, il me monstra en son cabinet plusieurs et diuerses pierres : mais entre toutes les plus admirables, il me monstra vne grande quantité de cailloux blancs, formez à la propre semblance de dragees de diuerses façons, et en faisoit ledit Abbé plusieurs presens, comme de chose admirable : quelques iours apres, il me mena en son Abbaye de Turpenay, et en passant par vn village, qui est le long de la riuiere de Loire, il me monstra vne grande cauerne, par laquelle on alloit bien auant sous terre, par le dessous des rochers : et me dist, qu'au dedans de ladite cauerne, il y auoit un rocher, duquel tomboit de l'eau par petites gouttes, bien lentement : et en distillant, elle se congeloit, et se reduisoit en vne masse de caillou blanc, et me dit, qu'on mettoit par dessous l'eau qui distilloit de la paille, à fin que les gouttes qui distilleroyent, se congelassent sur ladite paille, pour faire des dragees (stalactites) de diuerses façons, et m'asseura ledit Abbé, que la dragee qu'il m'auoit monstree, auoit esté prinse en ce lieu là, et qu'elle auoit esté faite par le moyen susdit : aussi plusieurs gens dudit village m'attesterent la chose estre telle. Tu peux bien donc croire à present, que l'eau des pluyes qui passe à trauers des terres, qui sont au dessus du rocher, apporte quelque espece de sel, qui cause la congelation de ces pierres, qui est le propos que ie t'ay tousiours tenu. Cela

se peut encores auiourd'huy verifier : nous pouuons aussi iuger par là, que le cristal, et autres pierres transparentes, sont congelees la plus grand part d'eau et de sel.

Demande.

Par quel argument me voudrois-tu faire croire, que le cristal soit fait d'vne eau congelee ?

Responce.

J'avois vne fois vne boule de cristal, qui estoit bien nette, ronde, et bien polie : quand ie la regardois en l'air, i'apperceuois certaines estincelles à trauers dudit cristal, apres, ie prenois vne phiole pleine d'eau claire, et voyois aussi des bluettes ou estincelles semblables à celles du cristal. Je prenois aussi une piece de glace, et la regardois en l'air, et en cas pareil, j'apperceuois des petites bluettes et estincelles comme dessus : et me sembloit, que les trois choses susdites se ressembloyent de couleur, de pesanteur, et de froidure. Voila qui me donna occasion d'entendre et cognoistre, que toutes les pierres transparentes, sont la pluspart de matiere haineuse, et de tant plus elles sont haineuses, elles resistent plus vaillamment au feu, et de tant plus qu'elles sont de nature froide, de tant plus elles se cassent en se froidissant, quand elles sont vne fois eschauffees.

Demande.

Entre toutes les choses que tu m'as conté de la croissance des pierres, ie ne trouue rien si estrange, que ce que tu m'as dit des varaines : car tu dis qu'en ceste terre là, il y a quelque espece de sel, qui cause la congelation desdites pierres.

Responce.

Veux-tu que de cela ie te donne presentement vn bon argument ? Va t'en à un four à chaux, duquel le mortier sera fait de ladite varaine, si ledit four a chauffé deux ou trois fois, tu verras que son mortier se sera vitrifié. J'en ay veu aucuns duquel le mortier estoit si fort vitrifié, qu'il y avoit plusieurs tetines de verre, qui pendoyent és voutes dudit fourneau. Penses-tu que la terre se fust ainsi vitrifiee, s'il n'y auoit quelque espece de sel ? Tu trouuerois bien estrange, si quelqu'vn te disoit, qu'il y a du bois, qui se reduist en pierre : il te fascheroit beaucoup de le croire, toutesfois ie croy qu'il est ainsi, et sçay bien les causes pourquoy cela se fait. Il y a vn Gentilhomme pres de Peyrehourade, qui est l'habitation et Ville

du Viscomte d'Orto, cinq lieux distante de Bayonne, lequel Gentil-homme est Seigneur de la Mothe, et Secretaire du Roy de Nauarre, homme fort curieux et amateur de vertu : il se trouva quelquefois à la Cour, en la compagnie du feu Roy de Nauarre, auquel il fut apporté audit Roy, vne piece de bois, qui estoit reduite en pierre, dont plusieurs furent esmerueillez : et apres que ledit Sieur, eust reçeu ladite pierre, il commanda à vn quidam de ses seruiteurs, de la luy serrer auec ses autres richesses : lors le Seigneur de la Mothe, Secretaire susdit, pria ledit quidam de luy en donner vn petit morceau, ce qu'il fit, et ledit de la Mothe, passant par ceste ville de Xaintes, m'en fit vn present, sçachant bien à la vérité, que i'estois curieux de telles choses. Cela te peut estre dur à croire : mais de ma part, ie sçay à la vérité, qu'il est ainsi, et depuis, ie me suis enquis, d'où c'estoit que le bois reduit en pierre, auoit esté apporté : il me fut dit, qu'il y auoit vne certaine forest de Fayan, qui estoit vne partie marescageuse, dont je conclus en mon esprit, que le bois de Fayan, tient en soy plus de sel, que nulle autre espece de bois : parquoy il faut croire, que quand ledit bois est pourri, et que son sel est humecté, il reduit le bois, qui est desja pourri, en espece de fumier, ou terre, et deslors, le sel qui est dissout dudit bois, endurcist l'humeur pourrie du bois, et la reduist en pierre, qui est la mesme raison, que ie t'ay dit des coquilles, c'est, que pour se mollifier et reduire en pierre, elles ne perdent aucunement leur forme : semblablement, le bois estant reduit en pierre, tient encore la forme du bois, tout ainsi comme les coquilles. Et voila comment nature n'est pas si tost destruite d'vn effet, qu'elle ne recommence soudain vn autre, qui est ce que ie t'ay tousiours dit, que la terre et autres elemens ne sont iamais oisifs. Sçais-tu ce qui me fait croire, que le bois de Fayan est plus apte à reduire en pierre, que non pas les autres bois? C'est parce qu'il a en soy vne si grande quantité de sel, qu'il y a aucunes verrieres de verre de vitre, où apres qu'ils ont chauffé leur fourneau dudit Fayan, ils prennent la cendre, pour se seruir à faire verres de vitres, en lieu de salicor, ou de fougere. Il ne faut donc trouuer estrange, si ledit bois estant pourri, est propre pour se reduire en pierre, attendu qu'il est propre et vtile à faire verres : car tout bien consideré, le verre n'est autre

chose qu'une pierre. Pourquoy est-ce que tu trouves estrange, que ie dis, que les pierres s'engendrent annuellement en la terre, veu qu'elles s'engendrent bien dedans le corps des hommes, et dedans la teste des bestes? Il n'est pas iusques aux limaces rouges, qui n'en ayent. Les Medecins disent, que les poissons portans coquilles, sont dangereux d'engendrer la pierre, c'est vne attestation, de tout ce que i'ay dit cy deuant, que si le poisson qui porte coquille engendre la pierre, la coquille a esté formee de la propre substance du poisson : et ainsi, ils sont d'vne mesme nature. Je finiray donc mon propos, en concluant, que tout ce que i'ai dit cy dessus, contient vérité. Combien que i'eusse cy devant conclu, ce que ie pretendois traitter de l'essence des pierres, et de l'action du sel, si est-ce, qu'à fin que le secret que i'ay donné des fumiers, serue à l'vniuersel, et qu'on ne meprise en cest endroit mon conseil, pour tousiours mieux asseurer, que le sel a affinité auec toutes choses, et que sans iceluy, toutes choses se putrefieroyent soudain, i'ay voulu encore t'aduertir, que i'ay leu quelque historien, qui dit, qu'en Arabie se trouue quelques Contrees de pierre de sel, desquelles on bastist les maisons. Tu ne dois donc trouuer estrange, si ie t'ay dit, que les cailloux, qui sont transparens comme verres, sont congelez par le sel. Et quant à ce que ie t'ay dit, qu'aucunes pierres se consomment à l'humidité de l'air, ie te dis à present, non seulement les pierres, mais aussi le verre, auquel il y a grande quantité de sel : et qu'ainsi ne soit, tu trouueras és temples de Poitou, et de Bretagne, vn nombre infini de vitres, qui sont incisees par le dehors, par l'iniure du temps, et les vitriers disent, que la Lune a ce fait, mais ils me pardonneront : car c'est l'humidité des pluyes, qui a fait dissoudre quelque partie du sel dudit verre (1) : ie te dis derechef, que le sel fait des congelations merueilleuses. Les Alchimistes en ont senti quelque chose : car ils se tourmentent fort apres ces sels preparez. Il me souuient auoir veu vn potier, qui faisoit broier du plomb calciné à vn moulin à bras : et ainsi qu'on lui annonça l'heure du disner, il envoya ses seruiteurs deuant, et print vne poignee de sel commun, et le mesla

(1) Cette explication est la véritable. Le verre est un silicate qui, dans certaines conditions, est susceptible de s'altérer au contact de la chaleur et de l'humidité.

parmi sondit plomb, qui estoit destrampé clair comme eau, et l'ayant meslé, il donna deux ou trois tours à son moulin, à fin que ses seruiteurs n'apperceussent le beau secret, qui luy auoit esté apprins, de mettre du sel dedans son plomb, pour faire la couleur plus belle, mais au retour du disner, ce fut vne fort belle risee : car il trouua que le sel, le plomb, et l'eau s'estoyent si bien endurcis, et congelez, par la vertu du sel, qu'il ne fut possible de plus virer les meules, et estoit le dessus et le dessous si bien prins l'vn à l'autre, qu'il fut difficile de les separer. Voila une histoire, que ie t'ay voulu dire, pour mieux t'asseurer, que le sel a vertu de congeler et les metaux, et les pierres.

DEMANDE.

Puis que tu as cerché la maniere de cognoistre ainsi les pierres et cailloux, et l'effet de leur essence, me sçaurois-tu donner quelque raison, des douze pierres rares, lesquelles Sainct Iean en son Apocalypse prend comme par vne figure des douze fondemens de la Saincte Cité de Ierusalem ? Car il faut entendre, que les douze pierres sont dures et indissolubles, puis que Sainct Iean les prend par figure d'vn perpetuel bastiment.

RESPONSE.

Le Iaspe, qui est vne desdites pierres, est vne eau qui a passé par beaucoup de terres, et en passant, elle a prins la substance salsitiue, et est tombee sur vn certain receptacle; et estant ainsi cheute, deuant qu'estre congelee, sont tombees autres gouttes d'eau, qui en passant à trauers des terres, ont trouué quelque espece de marcacites, ou metaux parfaicts, et ayant prins teinture és choses susdites, les gouttes d'eau, qui estoyent ainsi teintes, sont cheutes sur l'autre eau : et ainsi, l'eau teinte tombant sur la blanche, a fait plusieurs figures, idees, ou damasquinees en ladite pierre de iaspe. Et parce qu'vne partie de l'eau a apporté auec soy vne substance de sel metallique, la congelation de la pierre s'est faite merueilleusement dure, et sa dureté est cause, que quand ladite pierre est polie, le polissement est merueilleusement beau, et ses figures fort plaisantes.

Quant est du Calcidoine, ie t'en dis en cas pareil.

La Thopasse est vne eau, qui aussi a passé par quelque miniere de fer, où elle a prins sa teinture iaune, et de là vient

que la substance metallique lui donne quelque dureté d'auantage.

L'Esmeraude est vne eau fort nette, qui a passé à trauers des minieres d'airain, ou de coupe-rose, de laquelle l'airain est fait, et là a prins sa teinture de verre, et le sel qui a causé sa congelation : car ladite coupe-rose n'est autre chose que sel, qui est tousjours tesmoignage de ce que ie t'ay dit cy deuant.

La Turquoise est aussi vne eau, qui a distillé et passé par certaines veines des minieres d'airain et de saphre (1), et de là vient, qu'elle tient aucunement couleur des deux especes des mineraux, et y a parmy lesdites especes quelque quantité de terre, qui cause que ladite pierre n'a point de transparence, comme l'Esmeraude.

Le Saphyr, est comme dessus, vne eau bien pure, mais parce qu'elle a passé par quelque miniere de saphre, elle tient vn peu de la couleur et teinture dudit saphre.

Le Diamant n'est autre chose qu'vne eau, comme le cristal, mais il est congelé par quelque rare espece de sel, pur et munde, lequel est tellement endurci en sa congelation, qu'il est plus dur que mille des autres pierres ; et faut icy noter, que son excellente beauté procede en partie de sa dureté, et ce, d'autant que le polissement est plus beau, de tant plus la pierre est dure. Les Lapidaires disent ainsi, voila vn Diamant qui a vne belle eau, ils parlent bien, mais il y a du cristal, que s'il estoit ainsi dur qu'est le Diamant, il se trouueroit aussi lumineux et excellent en beauté, comme le Diamant, et ne cognoistroit-on aucunement la difference de l'vn avec l'autre.

Demande.

Iusques icy tu as tousiours persisté, en disant, qu'en toutes especes de pierres il y auoit du sel, i'en ay rompu plusieurs, et principalement certains cailloux, qui auoyent la propre semblance de sel : toutesfois, quand ie tastais à la langue, ie n'y trouuois aucune saueur.

Response.

Cela n'empesche point, qu'il n'y aye du sel : si tu tastes à la langue une pesle d'airain, tu n'y trouueras aucun goust,

(1) Mine de cobalt arsenifère oxydée par le grillage.

toutesfois l'airain est venu de couppe-roze, qui n'est autre chose que sel. Veux-tu bien sçauoir la cause pourquoy en tastant à la langue, tu n'aperçois aucun goust de sel? La cause est, parce que les matieres sont si bien fixes, qu'elles ne se peuuent dissoudre par l'humidité de la langue, comme fait le sel commun. Le sel commun, la coupe-roze, le vitriol, l'alun, le sel armoniac, et le sel de tartare, toutes ces especes, soudain qu'elles sont tant peu soit-il humectees du bout de la langue, elles se dissoudent, et lors la langue trouue aisement le goust, parce que l'humidité de ladite langue fait attraction, et dilate les parties de toutes ces especes de sel : mais quand vn sel est bien fixe auec l'eau, et la terre, ou autres choses à luy iointes, lors il ne se peut dissoudre, que par bonne Philosophie, ou par le moyen et pratique de Philosophie. Exemple. Le verre est la plus grande partie de sel et d'eau; ie dis de sel, à cause du salicor, qui est un sel d'herbe : apres, ie dis d'eau, parce que les cailloux ou sable ioints au sel de salicor, sont partie d'eau et de sel. Or est-il ainsi, que si tu tastes vn verre à la langue, tu n'as garde de le trouuer salé, combien que ce ne soit la plus grande partie que sel : Qui est donc la cause que l'humidité de la langue ne peut faire attraction de la saueur dudit sel? C'est pour la mesme cause que i'ay dit, que les matieres terrestres, aineuses et salsitiues, sont si bien jointes ensemble, qu'elles ne se peuuent dissoudre, sinon par industrie et pratique. Un iour vn Alchimiste trouua fort estrange, que ie luy dis, que ie tirerois du sel d'vn verre, il pensoit estre bon Philosophe, mais il n'auoit pas encore pratiqué iusques là, combien que la chose fust assez aisee. Ie ne te parleray plus de ces choses, sçachant bien, que si tu ne reçois les raisons que ie t'ay donnees, ce seroit folie de t'en monstrer d'auantage.

DEMANDE.

Ie ne t'en feray aussi plus de question : mais ie voudrois que tu m'eusses dit quelque chose de l'essence des métaux.

RESPONCE.

C'est vne regle bien accordee entre les Philosophes, que les metaux sont engendrez de souphre et d'argent vif, ce que ie leur accorde : ce neantmoins, il y a quelque espece de sel qui aide à la congelation. Nous ne pouuons nier, que l'argent,

l'estain, le plomb, et le fer, ne tiennent la plus grant part de la couleur et du poids de l'argent vif. Item, nous sçauons, qu'auparauant que les metaux soyent purifiez, ils sentent le souphre, et toutesfois ie ne puis accorder, que le souphre qui estoit à la minière d'argent, soit fixe auec ledit argent, parce que les Orpheures disent, que le souphre empesche de souder l'argent, et est grandement ennemy de la forge d'argent. Bien croiray-je, que ledit souphre aye aidé à la discrétion dudit argent, et qu'ainsi que la miniere estoit à la fournaise, le souphre se soit exhalé. Quant est de l'or, les Philosophes disent, qu'il est engendré de souphre rouge, et de vif argent, voulans dire par là, que le souphre rouge a donné la teinture à l'or. Quant est de moy, ie ne vy oncques souphre rouge, mais quand ainsi seroit, qu'il s'en trouueroit quantité, si ne pourrois-ie accorder, que l'or print sa teinture dudit souphre : car il faut necessairement, que ce qui a teint ledit or, soit de plus haute couleur que rouge, car vn rouge ne peut augmenter vn autre rouge, sans se palesir. Ie crois plustost, que la teinture de l'or seroit venue de l'antimoine que non pas du souphre : et ce, à cause que sa teinture iaune, est de si haute couleur, qu'vne liure d'antimoine pourra teindre vn grand nombre de liures d'argent vif, ou autre metal blanc. Ie suis fort esmerueillé, comment on peut croire, que l'or puisse seruir à restaurer les personnes, sans estre dissout, c'est pour les mesmes causes, que ie t'ay dit, que tu ne peux trouuer le goust du sel, si premierement il ne se dissout : et si ainsi est qu'on ne trouue point de saueur és pierres salees, ausquelles le sel est fixe parfaitement, combien moins de goust trouuera vn malade en l'or, s'il n'est dissout ? Or il est ainsi, qu'il n'y a rien plus fixe que l'or : tu l'as beau tremper et bouillir, tu n'as garde de le dissoudre. Il me semble que la nourriture de l'homme, est en ce que son estomac cuist et dissout les choses qu'il prend par la bouche ; et puis la substance se depart par toutes les parties du corps, et voila vne nourriture et restaurant : mais comment l'estomac d'un homme debile, et quasi mort, pourra-t-il dissoudre l'or, et le departir par toutes les parties de son corps, veu que les fournaises, voire mesme eschauffees d'vne chaleur plus que violente, ne le peuuent consommer ? Il faudroit que l'estomac de l'homme malade fust plus chaud que les fournaises, ou ie n'y entens rien. Vray est,

qu'aucuns Philosophes Alchimistes, disent sçauoir rendre l'or en eau par quelque dissolution : veritablement s'ils le peuuent dissoudre, il est potable : or venons à present à sçauoir, si estant potable, il peut seruir de nourriture. Les Philosophes disent qu'il est de souphre et d'argent vif, estant donc dissout, ce sera du souphre et de l'argent vif, que tu donneras à boire aux malades, autre chose n'en peux-tu tirer, que ce qui y a esté mis ; et toutesfois tu dis, que le vif argent est vn poison: Veux-tu donc nourrir le malade de poison, pour le restaurer ? Ie ne puis entendre autrement c'est affaire : parquoy, ie m'en tairay pour le present, et le laisseray disputer à ceux qui le croyent autrement que moy.

Demande.

Comment oses-tu tenir vn tel propos, contre la commune opinion de tous les medecins ? Car il ne fut oncques, qu'on ne fist du restaurant d'or.

Responce.

Ie ne t'ay pas dit mal des Medecins, i'en serois bien marry : car il y en a en ceste Ville, à qui ie suis grandement tenu, et singulierement à Monsieur l'Amoureux, lequel m'a secouru de ses biens, et du labeur de son art : toutesfois, comme par vne maniere de dispute, ils ne doiuent trouver mauuais, si ie dis ce qu'il m'en semble. Ie sçay bien que plusieurs Medecins et Apothicaires ont fait bouillir de l'or dans les ventres des chapons gras, pour restaurer les malades, et disoyent que l'or se diminuoit, ce qu'on n'a garde de me faire croire : tu l'as beau bouillir et fricasser, tu n'as garde de le faire amoindrir de poids. Si le sel, ou graisse du pot fait trouuer sa couleur plus pale sur la superficie seulement, cela ne fait rien contre mon opinion. Si l'or se pouuoit diminuer en bouillant, les Alchimistes auroyent gagné le prix, et ne se faudroit tant trauailler pour dissoudre l'or : car apres qu'ils en auroyent fait bouillir vne grande quantité, ils prendroyent l'eau où ledit or auroit esté bouilli, et ayant fait euaporer l'humide, ils trouueroyent l'or au fonds de leur vaisseau, duquel ils se seruiroyent, à ce qu'ils pretendent. Ie te demande, Sais-tu que c'est à dire restaurant ? N'est-ce pas à dire nourriture et reparation de nature ? Veux-tu vn peu penser l'effet et le naturel des choses, qui restaurent les corps des humains ? Consideré vn peu toutes les choses qui sont bonnes à manger et à

restaurer, et tu trouueras, que soudain qu'elles sont sur la langue, elles se commencent à dissoudre : car autrement, la langue ne pourroit iuger de la saueur de la chose : et si la langue ne reçoit aucune saueur, ni goust bon, ne mauuais de ce qui luy est presenté, tu peux par là aisement iuger, que le ventre, ne l'estomac ne pourront aussi receuoir quelque saueur de ce qui leur sera presenté. Considere aussi que nulle chose n'est bonne pour nourriture, que d'elle-mesme ne soit suiecte à s'eschauffer, corrompre, et putrefier : c'est vn argument bien notable, pour soustenir mon propos. Or il est ainsi, que l'or n'est suiet à nul de ces accidens : tu as beau appiler des escus ensemble, ils n'ont garde de s'eschauffer, ne putrefier, comme font les choses bonnes à manger. Que diras-tu là? As-tu quelque chose, pour legitimement contredire à ce propos? Peut estre que tu diras, qu'il faut croire les Doctes et Anciens, qui ont escrit ces choses, il y a vn bien long temps, qu'il ne se faut arrester à mon dire, d'autant que ie ne suis ne Grec, ne Latin, et que ie n'ay rien veu des liures des Medecins. A ce ie respons, que les Anciens estoyent aussi bien hommes comme les Modernes, et qu'ils peuuent aussi bien auoir failli comme nous : et qu'ainsi ne soit, regarde vn peu les œuures d'Ysidore, et du Lapidaire, et de Dioscorides, et plusieurs autres autheurs anciens : quand ils parlent des pierres rares, ils disent, que les vnes ont vertu contre les diables, et les autres contre les sorciers, et les autres, pour rendre l'homme constant, plaisant, beau et victorieux en bataille, et plus d'vn millier d'autres vertus, qu'ils attribuent ausdites pierres. Ie te demande, N'est-ce pas vne fausse opinion, et directement contre les authoritez de l'Escriture Saincte? Si ainsi est, que ces Docteurs anciens, et tant excellens ayent erré en parlant des pierres, pourquoy est-ce que tu voudrois me nier, qu'ils ne puissent avoir erré, en parlant de l'or? Si tu dis, que peut estre que l'or estant dans le corps a pouuoir d'attirer à soy les mauuaises humeurs, comme l'emant tire le fer, ie te demande, Pourquoy est-ce donc, que tu le separes en tant de parties? Car les vns le mangent estant limé, et les autres battu par fueilles, et d'espece bien menu : or si l'emant estoit ainsi puluerisé, il n'auroit pouuoir d'attirer le fer, comme il a, estant ioint en vne masse. Parquoy, ie conclus, que si on ne me donne meilleure raison, que celles

que i'ay alleguees, ie ne sçaurois croire que l'or sçeust restaurer vn malade, non plus que feroit du sable dedans l'estomac, et ce d'autant qu'il est impossible à nul estomac le pouuoir dissoudre.

DEMANDE.

Dés le premier commencement de nostre propos, tu m'as dit, que tu cerchois vn lieu montueux, pour edifier vn iardin de plaisance : tu sçais que i'ay trouué fort estrange vne telle opinion : et toutesfois, tu ne m'as aucunement contenté, comme des autres choses, que nous auons parlé. Ie voudrois te prier, de m'en donner quelque raison.

RESPONCE.

Es-tu encore si ignorant, que tu ne sçaches qu'il ne fut iamais montagne, qu'au pied d'icelle n'y eust une vallee? Quand ie t'ay dit, que ie cerchois vn lieu montueux, pour edifier mon iardin, ie ne t'ay pas dit, que ie voulois faire le iardin sur la montagne : mais pour auoir la commodité du iardin, il faut necessairement, qu'il y aye des montagnes aupres d'iceluy.

DEMANDE.

Ie te prie, me faire vn discours de l'ordonnance du iardin que tu veux edifier.

RESPONCE.

Le propos sera bien prolixe, mais toutesfois ie te le feray assez bien entendre. Il est impossible d'auoir un lieu propre pour faire vn iardin, qu'il n'y aye quelque fontaine ou ruisseau, qui passe par le iardin : et pour ceste cause, ie veux eslire vn lieu planier au bas de quelque montagne ou haut terrier, à fin de prendre quelque source d'eau dudit terrier, pour la faire dilater à mon plaisir par toutes les parties de mon iardin, et alors ayant trouué telle commodité, ie designeray et ordonneray mon iardin de telle inuention, que iamais homme n'a veu le semblable. Et m'asseure, qu'ayant trouué ce lieu, ie feray vn autant beau iardin, qu'il en fut iamais sous le ciel, hors-mis le iardin de Paradis terrestre.

DEMANDE.

Et où penses-tu trouuer vn haut terrier, où il y aye quelque source d'eau, et vne plaine au bas de la montagne, comme tu demandes?

Response.

Il y à en France plus de quatre mille maisons nobles, où ladite commodité se pourroit aisement trouuer, et singulierement le long des fleuues, comme tu dirois le long de la riuiere de Loire, le long de la Gironde, de la Garonne, du Lot, du Tar, et presque le long des autres fleuues. Cela n'est point impossible quant à la commodité : ie penserois trouuer bien tost vn lieu commode le long d'vne riuiere.

Demande.

Dy moy donc comment tu pretens orner ton iardin, apres que tu auras acheté la place.

Responce.

En premier lieu, ie marqueray la quadrature de mon iardin, de telle longueur et largeur que i'auiseray estre requise, et feray ladite quadrature en quelque plaine, qui soit enuironnee de montagnes, terriers, ou rochers; deuers le costé du vent de Nord, et du vent d'Ouest, à fin que lesdites montagne, terriers, ou rochers, me seruent és choses que ie te diray cy apres. I'auiseray aussi de situer mon iardin au dessous de quelque source d'eau, sortant desdits rochers, et venant de lieu haut, et ce fait, ie feray madite quadrature : mais quoy qu'il soit, ie veux edifier mon iardin en vn lieu, où il y ayt vne pree par dessous, pour sortir aucunesfois dudit iardin en la pree : et ce, pour les causes qui seront desduites cy apres, et ayant ainsi fermé la situation du iardin, ie viendray lors à le diuiser en quatre parties esgales, et pour la separation desdites parties, il y aura vne grande hallee, qui croisera ledit iardin, et aux quatre bouts de ladite croisee, il y aura vn amphitheatre tel que ie te diray cy apres, aux quatre angles dudit iardin. Il y aura en chacune vn cabinet, qui sont en nombre huit cabinets, et un amphitheatre, qui seront edifiez au iardin : mais tu dois entendre que tous les huit cabinets seront diuersement estoffez, et de telle inuention, qu'on n'en a encore jamais veu, ni ouy parler. Voila pourquoy, ie veux eriger mon iardin sur le Pseaume cent quatre, là où le Prophete descrit les œuures excellentes, et merueilleuses de Dieu, et en les contemplant, il s'humilie deuant luy, et commande à son ame de louër le Seigneur en toutes ses merueilles. Ie veux aussi edifier ce iardin admirable, à fin de donner occasion aux hommes de se rendre amateurs du cultiuement de la

terre, et de laisser toutes occupations, ou delices vicieux, et mauuais trafics, pour s'amuser au cultiuement de la terre.

Demande.

Ie te prie me designer, ou me faire vn discours de ces beaux cabinets, que tu pretends ainsi eriger.

Responce.

En premier lieu, tu dois entendre, que ie feray venir la source d'eau, ou partie d'icelle, du rocher, aux huict cabinets susdits. Ce qui me sera assez aisé à faire : car ainsi que l'eau distillera de la montagne, ou rocher, ie prendray sa source, et la meneray par toutes les parties de mon iardin, où bon me semblera : et en donneray à chacun cabinet une portion, ainsi que ie verray estre necessaire, et edifieray mes cabinets de telle inuention, que de chacun d'eux sortira plus de cent pisseures d'eau : et ce, par les moyens que ie te feray entendre, en te faisant le discours de la beauté des cabinets. Venons donc au discours de tous mes cabinets l'vn apres l'autre.

Du premier Cabinet.

Le premier cabinet, qui sera deuers le vent du Nord, au coin et anglet du iardin, au bas, et ioignant le pied de la montagne ou rocher, ie le bastiray de briques cuites, mais elles seront formees de telle sorte, que ledit cabinet se trouuera ressembler la forme d'vn rocher, qu'on auroit creusé sur le lieu mesme, ayant par le dedans plusieurs sieges concaves au dedans de la muraille, et entre deux d'vn chacun des sieges, il y aura une colomne, et au dessous d'icelle, vn piedestal, et au dessus des testes des chapiteaux des colomnes, il y aura un architraue, frise et corniche, qui regnera autour dudit cabinet : et au long de la frise, il y aura certaines lettres antiques pour orner ladite frise, et aussi au long de ladite frise, y aura en escrit, *Dieu n'a prins plaisir en rien, sinon en l'homme, auquel habite Sapience* : et ainsi, mon cabinet aura ses fenestres deuers le costé du Midi, et seront lesdites fenestres, et entree dudit cabinet, en maniere d'vn rocher : aussi ledit cabinet sera du costé du Nord, et du costé du Ouëst, massonné contre les terriers, ou rochers, en telle sorte, qu'en descendant du haut terrier, on se pourra rendre sur ledit cabinet, sans cognoistre qu'il y aye aucun bastiment dessous ; et à fin de rendre ledit cabinet plus

plaisant, ie feray planter sur la voute d'iceluy plusieurs arbrisseaux portans fruits, bons pour la nourriture des oiseaux, et aussi certaines herbes, desquelles ils sont amateurs de la graine, à fin d'accoustumer lesdits oiseaux à se venir reposer et dire leurs chansonnettes sur lesdits arbrisseaux, pour donner plaisir à ceux qui seront au dedans dudit cabinet et iardin, et le dehors dudit cabinet sera massonné de grosses pierres de rochers, sans estre polies, ni incisees, à fin que le dehors dudit cabinet n'aye en soi aucune forme de bastiment: et en massonnant le dehors dudit cabinet, i'ameneray vn canal d'eau, lequel ie feray passer au dedans de la muraille, et estant ainsi massonné dans le mur, ie le dilateray en plusieurs parties de pisseures, qui sortiront par le dehors dudit cabinet, en telle sorte que ledit cabinet ressemblant vn rocher, on pensera que lesdites pisseures sortent dudit cabinet, sans aucun artifice, à cause que le dehors d'iceluy cabinet semblera vn rocher, et lesdites pisseures estans cheutes, se rendront à vn certain lieu, que ie te diray cy apres : mais ie te veux premierement discourir la beauté du polissement du dedans du cabinet. Quand le cabinet sera ainsi massonné, ie le viendray couurir de plusieurs couleurs d'esmails, depuis le sommet des voutes, iusques au pied et paué d'iceluy : quoy fait, ie viendray faire vn grand feu dedans le cabinet susdit : et ce iusques à temps que lesdits esmails soient fondus ou liquifiez sur ladite massonnerie : et ainsi, les esmails en se liquefiant, couleront, et en se coulant s'entremesleront, et en s'entremeslant, ils feront des figures et idees fort plaisantes, et le feu estant osté dudit cabinet, on trouuera que lesdits esmails auront couuert la iointure des briques, desquelles le cabinet sera massonné : et en telle sorte, que ledit cabinet semblera par le dedans estre tout d'vne piece, parce qu'il n'y aura aucune apparition de iointures : et si sera ledit cabinet luisant d'vn tel polissement, que les lezars et langrottes qui entreront dedans se verront comme en vn miroir, et admireront les statues : que si quelqu'vn les surprend, elles ne pourront monter au long de la muraille dudit cabinet, à cause de son polissement, et par tel moyen, ledit cabinet durera à iamais, et n'y faudra aucune tapisserie : car sa parure sera d'vne telle beauté, comme si elle estoit d'vn iaspe, ou porphire, ou calcidoine bien poli.

Du second Cabinet.

Le second Cabinet, qui sera en l'autre coin ou anglet, qui aura aussi son regard deuers la partie meridionale, sera par le dehors de semblable ornement et parure que le premier : aussi par dessus sa voute, il y aura certains arbrisseaux plantez, ainsi que ie l'ay dit du premier : aussi le dedans dudit cabinet sera tout massonné de briques, mais lesdites briques, seront massonnees et façonnees d'vne telle industrie, qu'il y aura au dedans du bastiment plusieurs figures de termes, qui seruiront de colomnes, et seront posez lesdits termes sur vn certain embassement, qui seruira de siege, pour ceux qui seront assis dedans ledit cabinet, et au dessus desdites figures de termes, il y aura vn architraue, frise et corniche, qui regnera à l'entour du dessus desdites figures, et au dedans de la frise y aura plusieurs grandes lettres antiques, et y aura en escrit, *La crainte de Dieu, est le commencement de Sapience* : lesdits termes qui feront gestes et grimaces estranges, seront esmaillez de plusieurs et diuerses couleurs, qui seroyent trop longues à desduire : aussi tout le residu dudit cabinet sera esmaillé de diuerses couleurs d'esmails, et tout ainsi que ie t'ay dit, que les esmails du premier cabinet seroient fondus sur le lieu mesme, ainsi en sera fait de cestuy second, et ce, à fin que les iointures, et la massonnerie ne soit apperceuë, et que le tout luise comme une pierre cristaline.

Du troisiesme Cabinet.

Le troisiesme cabinet, qui sera à l'autre coin, deuers la partie du midy, du costé de la prairie, sera vouté et couuert des terres et arbres, en telle forme que le premier : aussi sortiront du dehors du cabinet plusieurs pisseures d'eau, comme du premier, et le dedans sera aussi massonné de briques, mais sa façon sera differente aux autres : car il sera tout rustique, comme si vn rocher auoit esté creusé à grands coups de marteaux : toutesfois, il y aura tout à l'entour dudit cabinet, certaines concauitez creusees dedans la muraille, qui seruiront de sieges, et au dessus, il y aura espece ou maniere d'architraue, frise et corniche, non pas proprement insculpees, mais comme qui se mocqueroit, en les formant, et les insculpant à grands coups de marteaux : toutesfois elles auront quelque apparence, et seront grauees certaines lettres antiques au

long de ladite frise, qui denoteront, que *la Sapience n'habitera point au corps sujet à péché, ny en l'ame mal affectionnée*: or ce cabinet sera couuert d'vn esmail blanc maderé, moucheté, et iaspé de diuerses couleurs par dessus ledit blanc, de telle sorte, que lesdits esmails et diuersitez de couleurs, couuriront les iointures des briques, et de la massonnerie ; et ainsi ledit cabinet apparoistra estre tout d'vne mesme piece, comme le premier, et ses esmails seront luisans et plaisans, comme ceux du premier et second.

Du quatriesme Cabinet.

Le quatriesme cabinet sera massonné de briques comme les trois susdits : mais la façon sera fort differente des trois premiers : car il sera massonné par le dedans d'vne telle industrie, qu'il semblera proprement que ce soit vn rocher, qui auroit esté caué, pour tirer la pierre du dedans : or ledit cabinet sera tortu, bossu, ayant plusieurs bosses et concauitez biaises, ne tenant aucune apparence ny forme d'art d'insculpture, ny labeur de main d'homme : et seront les voutes tortues de telle sorte, qu'elles auront quelque apparence de vouloir tomber, à cause qu'il y aura plusieurs bosses pendantes : toutesfois, parce qu'aux trois susdits, il y a à chacun d'iceux vne authorité notable escrite, et prinse en la Sapience, en ce quatriesme cy sera escrit, *sans Sapience, est impossible de plaire à Dieu*. Et ledit cabinet sera comme d'vn esmail de couleur d'vn calcidoine, iaspe maderé, et moucheté d'vn esmail blanc, qui en se fondant, ou liquifiant, fera plusieurs veines, figures, et idees estranges, en se dilatant et dissoudant d'en haut au bas dudit cabinet : et en ce faisant, il couurira les iointures des briques, desquelles ledit cabinet sera massonné, en telle sorte, qu'il semblera qu'il soit d'vne mesme piece comme les trois susdits, et par le dehors sera massonné de grosses pierres, telles comme elles seront prinses au rocher, sans estre aucunement taillees ny façonnees, à fin que le dehors dudit cabinet ressemble proprement vn rocher naturel : et parce que ledit cabinet sera erigé ioignant le pied de la montagne, qui est deuers le costé du Ouëst, en l'anglet qui est deuers le Midy, iceluy cabinet estant dessus couuert de terre, et ayant plusieurs arbres plantez sur ladite terre, il y aura bien peu d'apparence de bastiment, parce qu'en descendant du terrier haut, on pourra marcher sur la voute dudit cabinet, sans apperceuoir

qu'il y aye aucune forme de bastiment : et tout ainsi que ie t'ay dit, qu'au premier cabinet il y auroit plusieurs pisseures d'eau, qui sortiront de la muraille par le dehors, aussi en ce quatriesme en sortira abondamment, qui sera chose de grande recreation : et ainsi qu'au premier cabinet, ie t'ay dit, qu'il y auroit certains arbres portans fruits, pour les oiseaux, il y en aura aussi à ce quatriesme cy. Aussi les fenestres seront de telle monstruosité que les premieres : voila le discours des quatre cabinets.

Des Cabinets qui seront aux quatre bouts de la croisee, qui trauersera le milieu du iardin du trauers et du long.

Quant est de ces quatre cabinets cy, ils seront faits de certains hommeaux (ormeaux), que ie planteray tout à l'entour de la circonference de la place que i'auray pourtraite, pour la grandeur de mes cabinets susdits, et combien qu'au commencement de mon propos, tu pourras, peut estre, iuger en toy-mesme, que ce n'est rien de nouueau, que de faire des cabinets d'hommeaux, ou autres arbres, toutesfois, si tu veux ouyr patiemment mon propos, ie te feray bien entendre, que ce sera vne grandissime chose, voire telle, qu'homme n'a veu la semblable : ayes donc patience, et ne me redargue point de prolixité. Au premier des quatre cabinets, qui seront ainsi faits d'hommeaux, y aura au dedans et dessous la couuerture des branches desdits cabinets, à chacun vn rocher, qui sera massonné auec la muraille de la closture du iardin. Ce premier rocher donc, qui sera au cabinet du costé du vent de Nord, sera fait de terre cuite, insculpee et esmaillee en façon d'vn rocher tortu, bossu, et de diuerses couleurs estranges, ainsi que ie fay la Grotte de Monseigneur le Connestable, non pas proprement d'vne telle ordonnance, parce que ce n'est pas aussi vn œuvre semblable. Note donc qu'au bas et pied du rocher, il y aura vn fossé naturel, ou receptacle d'eau, qui tiendra autant en longueur comme ledit rocher. Pour ceste cause, ie feray plusieurs bosses en mon rocher, le long dudit fossé ; sur lesquelles bosses ie mettray plusieurs grenouilles, tortues, chancres, escreuisses, et vn grand nombre de coquilles de toutes especes, à fin de mieux imiter les rochers. Aussi y aura plusieurs branches de corail, duquel les racines seront tout au pied du rocher, à fin que lesdits couraux ayent

apparence d'auoir creu dedans ledit fossé. Item, vn peu plus haut dudit rocher, y aura plusieurs trous et concauitez, sur lesquelles y aura plusieurs serpents, aspics et viperes, qui seront couchees et entortillees sur lesdites bosses, et au dedans des trous : et tout le residu du haut du rocher, sera ainsi biais, tortu, bossu, ayant un nombre d'espece d'herbes, et de mousses insculpees, qui coustumierement croissent és rochers et lieux humides, comme sont scolopendre, capilli Veneris, adianthe, politricon, et autres telles especes d'herbes, et au dessus desdites mousses et herbes, il y aura vn grand nombre de serpents, aspics, viperes, langotres et lezars, qui ramperont le long du rocher, les vns en haut, les autres de trauers, et les autres descendans en bas, tenans et faisans plusieurs gestes, et plaisans contournemens, et tous lesdits animaux seront insculpez et esmaillez si pres de la nature, que les autres lezars naturels et serpents, les viendront souuent admirer, comme tu vois qu'il y a vn chien en mon bastelier de l'art de terre, que plusieurs autres chiens se sont prins à gronder à l'encontre, pensans qu'il fust naturel : et dudit rocher distillera vn grand nombre de pisseures d'eau, qui tomberont dedans le fossé, qui sera dans ledit cabinet, auquel fossé y aura vn grand nombre de poissons naturels, et des grenouilles et tortues. Et par ce que sur le terrier ioignant ledit fossé, il y aura plusieurs poissons et grenouilles insculpees de mon art de terre, ceux qui iront voir ledit cabinet, cuideront que lesdits poissons, tortues, et grenouilles soyent naturelles, et qu'elles soyent sorties dudit fossé, d'autant qu'audit fossé il y en aura de naturelles : Aussi audit rocher sera formé quelque espèce de buffet, pour tenir les verres et coupes de ceux qui banqueteront dans le cabinet. Et par un mesme moyen, seront formez audit rocher certains parquets, et petits receptacles, pour faire rafraischir le vin, pendant l'heure du repas, lesquels receptacles auront tousiours l'eau froide, à cause que quand ils seront pleins à la mesure ordonnee de leur grandeur, la superfluité de l'eau tombera dedans le fossé, et ainsi l'eau sera tousiours viue dedans lesdits receptacles : aussi audit cabinet y aura vne table de semblable estoffe que le rocher, laquelle sera assise aussi sur vn rocher, et sera ladite table en façon ouale, estant esmaillee, enrichie, et coloree de diuerses couleurs d'esmail, qui luiront comme

vn cristallin. Et ceux qui seront assis pour banqueter en ladite table, pourront mettre de l'eau viue en leur vin, sans sortir dudit cabinet, ains la prendront és pisseures des fontaines dudit rocher.

Et quant est à present des hommeaux, qui feront la closture et couuerture dudit cabinet, ils seront mis et dressez par vn tel ordre, que les iambes des hommeaux seruiront de colomnes, et les branches feront vn architraue, frise et corniche, et tympane, et frontispice, en obseruant l'ordonnance de la massonnerie.

Demande.

Veritablement ie pense que tu es insensé, de vouloir obseruer les reigles d'architecture és bastimens faits d'arbres, et tu sçais que les arbres croissent tous les iours, et qu'ils ne peuuent tenir longuement quelque mesure que tu leur sçaurois donner : et nous sçauons que les anciens Architectes n'ont rien fait qu'auec certaines mesures, et grandes considerations, tesmoins Victruue, et Sebastiane, qui ont fait certains livres d'architecture.

Responce.

Tu te deuois bien effrayer, et esleuer contre moy : tu as allegué de belles raisons, pour me prouuer d'estre insensé, et mespriser l'inuention de mon iardin, veu que c'est vne chose de si grande estime. Si tu as leu les liures que tu dis d'architecture, tu trouueras que les anciens inuenteurs des excellens edifices, ont prins leurs pourtraits et exemplaires de leurs colomnes, és arbres et formes humaines, et qu'ainsi ne soit, mesure vn peu leurs colomnes, et tu trouueras qu'elles sont plus grosses par le bas de la iambe, que non pas en haut, qui est vne des raisons qu'ils ont prins en formant leurs colomnes : et aussi les colomnes faites d'arbres seront trouuees tousiours plus rares et excellentes, que non pas celles des pierres : et si tu veux tant honorer celles des pierres, que tu les vueilles preferer à celles qui seront faites de iambes d'arbres, ie te diray, que c'est contre toute disposition du droit Diuin et humain : car les œuures du Souuerain et premier edificateur, doiuent estre en plus grand honneur, que non pas celle des edificateurs humains. Item, tu sçais qu'vne pourtraiture qui aura esté contrefaite à l'exemple d'vne autre pourtraiture, la contrefacture ou pourtraiture qui aura esté faite,

ne sera iamais tant estimée comme l'original, sur lequel on aura prins le pourtrait. Parquoy, les colomnes de pierre ne se peuuent glorifier contre celles de bois, ne dire, nous sommes plus parfaites, et ce, d'autant que celles de bois ont engendré, ou pour le moins ont aprins à faire celles de pierre. Et puis que le Souuerain Geometrien, et premier edificateur y a mis la main, il les faut plus estimer que celles des pierres, quelques rares qu'elles soyent, hors-mis qu'elles fussent de pierre de iaspe, ou d'autres pierres rares.

Demande.

Voire, mais les colomnes des pierres qui ont esté insculpees par nos anciens edificateurs, ont chacune vn chapiteau, pour imiter la teste de l'humaine nature : Aussi les anciens edificateurs ont insculpé au pied d'vne chacune desdites colomnes, vne base, qui signifie le pied de l'homme. Et quand ceux de Corinthe inuenterent leurs genres de colomnes, desquelles ils edifierent le Temple de la grand Diane, qui estoit un merueilleux bastiment; ils firent au corps de leurs colomnes certains canaux, et voyes creuses, qui denotoyent les plis et froncis des robes et cotes de leur Deesse Diane : Aussi au chapiteau de leurs colomnes, ils mirent certains rouleaux, façonnez en maniere d'vne ligne aspiralle, lesquels entortillemens signifioyent les cheueux et coiffure de ladite Diane. Voila comment nos anciens edificateurs n'ont rien fait sans grande consideration, et raison bien asseuree : mais toy, quelle raison, mesure, ni ordre pourrois-tu tenir à ton bastiment fait de pieds et branches d'hommeaux, veu que lesdits hommeaux augmentent tous les iours en grosseur et hauteur ?

Responce.

Pour vray, ie pense que tu as vne teste sans ceruelle : n'as-tu point considéré tant de beaux iardins, qui sont en France, ausquels les iardiniers ont tondu les romarins, lizos, et plusieurs autres especes d'herbes, les vnes auront la forme d'vne grue, les autres la forme d'vn coq, les autres la forme d'vne oye, et consequemment de plusieurs autres especes d'animaux : et mesme, i'ay veu en certains iardins, qu'on a fait certains gens-d'armes à cheual et à pied, et grand nombre de diuerses armoiries, lettres, et deuises : mais toutes ces choses sont de peu de duree, et les faut refaçonner souuent

Si ainsi est, que les choses qui sont de peu de profit, et de petite duree soyent tant estimees, combien penses-tu que le bastiment de mes cabinets meritera d'estre estimé, veu que la chose sera de longue duree, et aisee à entretenir; utile, et profitable? voire si profitable, que quand par vieillesse elle sera inutile au bastiment, et closture desdits cabinets, si est ce qu'encore les colomnes auront grandement profité, à cause du bois qu'elles rendront à son possesseur. Et quant est de l'entretien, tant il s'en faut, qu'il ne soit de si grands frais que celuy des petites herbes sus escrites : Car ces petites herbes ne sçauroyent tenir leur forme guere long temps, sans estre tondues : mais les colomnes de mes cabinets dureront pour le moins la vie d'vn homme, ou de deux, sans y faire aucune reparation. Quant est des branches il les faudra estaucer et arranger vne fois ou deux l'annee, c'est pour le plus, cognois tu pas par là, que mon bastiment ainsi fait de pieds d'hommeaux, sera grandement vtile, excellent et louable ?

Demande.

Voire; mais ie ne puis entendre l'ordre, que tu pretens tenir au bastiment et edification de ton cabinet. Fay m'en presentement quelque discours, par lequel ie le puisse aisement entendre.

Responce.

Apres que les hommeaux seront plantés, iouxte la quadrature et circonference de mon cabinet, et que ie seray asseure que lesdits hommeaux auront prins racine, ie couperay toutes les branches iusques à la hauteur des colomnes : et ce fait, ie marqueray ou inciseray le pied de l'hommeau à l'endroit où ie voudray faire la base de la colomne : semblablement à l'endroit de là où ie voudray faire le chapiteau, ie feray quelque incision, marque ou concussion, et lors, nature se trouuant greuee en ces deux parties, elle enuoyera secours et abondance de saueur, et humeur, pour renforcer et guerir lesdites playes : et de là aduiendra, qu'en ces parties blessees s'engendrera vne superfluité de bois, qui causera la forme du chapiteau et base de la colomne, et ainsi que les colomnes croistront, et augmenteront, la forme aussi du chapiteau et base augmentera. Voila comment les iambes des hommeaux auront tousiours vne chacune la forme d'vne colomne, et les branches qui auront leur naissance sur le bout dudit chapiteau, ie les

ployeray de trauers, pour se rendre directement depuis la naissance, qui sera sur ledit chapiteau, iusques au dessous du chapiteau de l'autre prochaine colomne, et les branches, ou partie d'icelles, qui seront en la colomne circonuoisine, ie les feray directement coucher, pour se rendre sur le chapiteau de la premiere colomne : toutesfois ie laisseray tousiours une quantité de branches pour faire les autres membres despendans de la massonnerie et architecture dudit cabinet. Et par tel moyen, les premieres branches ainsi couchees d'vne colomne à autre, feront directement vne forme d'architraue, parce que ie leur donneray quelque auancement, en les couchant l'vne sur l'autre, pour former les mollures de l'architraue. Et quant est de la frise qui s'ensuit apres, ie ne l'occuperay d'aucunes branches trauersantes, mais ie prendray premierement certaines branches de celles que i'auray laissé debout, et les ayans couchees de la maniere des autres, i'en feray la forme de la corniche, en telle sorte que ie t'ay dit de l'architraue : car ie feray auancer les branches par degrez, mesurees par art de Geometrie et Architecture, à fin de faire trouuer et apparoistre les mollures de ladite corniche, de la mesure que lesdites mollures doiuent auoir. Et ainsi, l'architraue et la corniche estans formez à leur raison, la frise demeurera vuide, et pour l'ornement et excellence de ladite frise, ie plieray certaines gittes, qui procederont de l'architraue, et de la corniche : et en les pliant et arrangeant au dedans de ladite frise, ie feray tenir à vne chacune gitte, ou branche, vne forme de lettre antique bien proportionnee. Et à fin que l'ingratitude ne soit redarguee mesme par les choses insensibles et vegetatiues, il y aura en escrit en ladite frise vne authorité prinse au liure de Sapience, où il est escrit, Que lorsque les fols periront, ils appelleront la Sapience et elle se moquera d'eux, parce qu'ils n'ont tenu comte d'elle lorsqu'elle les appelloit par les carrefours, rues, lieux, assemblees, et sermons publics. Voila qui sera escrit en ladite frise, à fin que les hommes qui reietteront Sapience, discipline, et doctrine soyent mesme condamnez par les tesmoignages des ames vegetatiues et insensibles : quoy fait, ie prendray le residu des branches, et en formeray vn frontispice en chacune face dudit cabinet, et seront les mollures dudit frontispice formees des branches qui resteront, qui sera la fin et total des

branches, et de la massonnerie. Et parce qu'en ce faisant, les tympanes se trouueront vides et percez à iour : ie mettrai à vn chacun desdits tympanes vne deuise de lettres antiques et romaines, lesquelles lettres seront formees de petites gittes, qui procederont des branches de la corniche, et du frontispice : et ainsi, lesdits tympanes seront enrichis de deuises aussi bien que la frise. Et quant est des deuises qui y seront, ie te les mettray par ordre cy apres. Pour conclusion, sçaches que le cabinet estant ainsi fait, les branches qui croistront au dessus des frontispices et sommité du bastiment, ie les feray coucher l'vne sur l'autre d'vne telle inuention, qu'il ne pleuura aucunement dedans ledit cabinet, non plus que s'il estoit couuert d'ardoise. Voila toute l'edification du premier des quatre cabinets verds.

Du second Cabinet verd.

Le second cabinet verd, qui sera du costé du vent de Est, sera erigé et construit d'hommeaux, en la propre forme que les susdits : mais le rocher du dedans, qui sera ioint auec la muraille de la cloison et fermure du iardin, sera d'vne autre inuention : car il sera massonné de certains cailloux blancs et diaphanes, lesquels i'ay amassez en plusieurs et diuers champs, rochers, et montagnes : et seront lesdits cailloux arrangez, et massonnez en ladite muraille d'vn si bel ordre, qu'il y aura plusieurs riches concauitez et retraittes, qui seruiront d'autant de sieges, pour reposer ceux qui iront audit cabinet : et d'iceluy rocher sortira vn nombre infini de pisseures d'eau, qui feront mouuoir certains moulinets, et les moulinets feront iouer certains soufflets, et les soufflets ietteront leur vent dedans certains flaiols (1), qui seront dedans vn ruisseau, qui sera au pied du rocher, en telle sorte que les soufflets contraindront les flaiols rendre leur voix, eux estans dedans l'eau : dont s'en ensuiuront plusieurs voix de flaiols gargouillantes, qui en leurs gargouillemens imiteront de bien pres les chants de diuers oiseaux, et singulierement, le chant du Rossignol : or ledit rocher sera tenu luisant et net, à cause des eaux qui iournellement distilleront dessus. Et quant est de la deuise, qui sera en la frise dudit cabinet, il y aura en escrit; *Les enfans de Sapience, sont l'Eglise des Iustes*. Eccles. 3.

(1) Flutes, flageolets.

Et à celle qui sera aux tympanes, dedans le tympane de la premiere face, y aura en escrit, *Les cogitations peruerses se separent de Dieu. Sapience 1.*

Et au tympane de la seconde face, il y aura en escrit, *En l'ame mal affectionnee, n'entrera point de Sapience. Sapience 1.*

Et au tympane de la troisiesme, y aura en escrit, *Celuy est malheureux, qui reiette Sapience. Sapience 3.*

Dv troisiesme Cabinet verd.

Le troisiesme Cabinet sera erigé comme les deux premiers, et n'y aura rien à dire qu'ils ne se ressemblent, hors-mis le rocher du dedans et fons dudit cabinet : car parce que ce cabinet cy sera au bout de l'allee deuers le costé du vent d'Oüest, au pied de la montagne, le rocher dudit cabinet sera taillé de la mesme piece de la montagne, et en le formant et taillant, les secrets des canaux et pisseures d'eau, seront encloses, fermees et massonnees au dedans dudit rocher, à fin qu'il semble que les eaux sortent naturellement de ce rocher : mais pour rendre ledit rocher plus admirable, ie feray enchasser dedans ledit rocher plusieurs couraux, tels qu'ils viennent de leur nature, sans estre polis, à fin qu'il semble qu'ils ayent creu audit rocher. Aussi dans iceluy rocher, ie feray enchasser plusieurs pierres rares, que ie feray apporter de diuers pays et contrees, comme sont Calcidoines, Iaspes, Porfires, Marbres, Cristals, et autres cailloux riches et plaisans à la veuë, et seront lesdites pierres enchassees en la roche, sans aucun polissement, et seront si bien iointes dedans l'incision qu'on fera en ladite roche, qu'il n'y aura aucune apparence d'artifice, ains semblera que lesdites choses soyent ainsi venues de sa propre nature, et d'iceluy rocher sortiront plusieurs pisseures d'eau, comme des trois susdits, et dedans ce cabinet cy, il y aura vne table de quelque pierre rare, laquelle sera assise sur vn rocher propre pour cest affaire, auquel rocher seront ainsi enchassees plusieurs et diuerses especes de pierres rares comme dessus, et en la frise dudit cabinet sera escrit, *Le fruit des bons labeurs, est glorieux. Sapience 3.*

Et au tympane de la premiere face, sera escrit, *Desir de Sapience meine au Regne Eternel. Sapience 6.*

Et au tympane de la seconde face, sera escrit, *Dieu*

n'aime personne, que celuy qui habite auec Sapience. Sapience 7.

Et au troisiesme et dernier tympane, il y aura en escrit, *Par Sapience l'homme aura immortalité. Sapience* 8.

Et y aura audit cabinet à dextre et à senestre, plusieurs sieges entre les colomnes, lesquels seront faits de certaines gittes, que les racines des hommeaux et colomnes auront produites en bas, car c'est chose certaine, que les hommeaux ont en eux ce naturel, de produire plusieurs gittes de la racine.

Du dernier Cabinet verd.

Le dernier Cabinet, qui sera au bout de l'allee, deuers le vent de Sus, il sera de la semblable forme que les trois susdits, sçauoir est d'hommeaux : mais le rocher qui sera ioignant la muraille de la closture, sera fort estrange et plaisant : car ie feray cercher plusieurs pierres et diuers cailloux. Ils se trouvent souvent és ports et haures de ceste mer Oceane, plusieurs pierres diuerses, que les marchands d'estrange pays apportent au fonds de leurs nauires, pour garder qu'il ne soit trop leger : car autrement le nauire estant vuide verseroit soudain, par la violence des vents. Et quand ils sont arriuez, ils iettent lesdites pierres sur le bord de la mer. Il s'en trouue bien souuent, qui sont toutes semees de petites estincelles ressemblantes argent, et de plusieurs diuerses couleurs. Au pays de Poictou, s'en trouue de toutes grosseurs, qui sont si blanches, qu'estans rompues, elles ont couleur d'vn sel tres blanc, ou de sucre fin : et en ay veu d'aussi grosses que barriques. En ce pays de Xaintonge, és parties limitrofes de la mer, s'en trouue grande quantité, qui en quelque part ou endroit qu'on les puisse rompre, elles sont toutes pleines de coquilles, qui sont formees en la mesme pierre. Ayant donc amassé vn grand nombre de toutes ces diuerses pierres, ie massonneray mon rocher plus estrangement que les susdits. Ie les formeray en telle sorte, qu'il y aura par dessus plusieurs voutes, et en icelles y aura plusieurs grandes pierres pendantes : et pour donner grace audit rocher, il y aura plusieurs piliers, qui seront conduits par lignes obliques, et indirectes. Ce rocher sera trouué fort estrange, parce qu'auparauant le massonner, ie tailleray plusieurs serpents, aspics, et viperes, où par le derriere d'iceux, y aura vne languette, ou queuë de

la mesme estoffe, sçauoir est, de terre : et ayant cuit et esmaillé lesdits animaux, ie les massonneray parmy les cailloux, pierres et rocher, en telle sorte, qu'il semblera proprement qu'ils soyent en vie, et qu'ils rampent au long dudit rocher. Aussi de mon art de terre, ie formeray certaines pierres, qui seront esmaillees de couleur de turquoise, lesquelles pierres, ayans une queuë par derriere, seront liees et massonnees auec ledit rocher : et en iceluy rocher ie formeray quelque maniere d'architraue, frise et corniche, toutesfois sans aucunement tailler les pierres, ains seront massonnees en la propre forme qu'on les trouuera : et à fin de mieux enrichir ledit rocher, ie feray que le champ de la frise sera d'vne mesme couleur de pierre, et en massonnant ladite frise, ie l'enrichiray de certaines lettres antiques, qui seront formees de petits cailloux, ou pierres, d'autre couleur que ladite frise: et en ce faisant, i'escriray une sentence prise en Esaie le Prophete, chap. 55, qui dit ainsi, *Vous tous ayans soif, venez, et buuez pour neant de l'eau de la fontaine viue.* Et ladite deuise sera conuenable en ce lieu, parce que dudit rocher sortira grand nombre de pisseures d'eau, qui tomberont dedans vn fossé, qui sera paué, orné, enrichi, et muraillé desdites pierres et cailloux estranges. Et sur le bord dudit fossé, il y aura vne certaine plate-forme, pour mettre les vases, coupes et verres, pour le seruice dudit cabinet. Et y aura audit cabinet vne table sur vn pilier, et rocher de semblable parure que ledit rocher. Et entre les colomnes et pieds desdits hommeaux, qui feront la cloison et couuerture dudit cabinet, y aura plusieurs sieges de semblable parure et estoffe que le rocher : et en la frise qui sera faite de branche d'hommeau, y aura plusieurs lettres, comme és autres susdites, et en cestuy-cy y aura en escrit, *La fontaine de Sapience, est la parole de Dieu. Ecclesiast.* 1.

Aussi semblablement y aura des lettres dedans les trois tympanes, faites par branches d'hommeaux. Au tympane de la premiere face, sera escrit, *Dilection du Seigneur, est Sapience honorable. Ecclesiast.* 1.

Au tympane de la seconde face, sera escrit, *Le commencement de Sapience, est la crainte du Seigneur. Ecclesiast.* 1.

Item, au tympane de la troisiesme face, sera escrit, *La crainte du Seigneur, est la couronne de Sapience. Ecclesiast.* 1

Voila ce que ie te diray pour le present, des huit cabinets qui seront en mon iardin.

Du Rocher ou Montagne.

I'ay à present à te faire le discours d'vne commodité, qu'il y aura en mon iardin merueilleusement vtile, belle, et plaisante. Et quand ie te l'auray contee, tu cognoistras que ce n'est pas sans cause, que i'ay cherché de faire mon iardin ioignant les rochers.

Les deux costez de mon iardin, sçauoir est, deuers le vent du Nord et du Ouëst, qui seront circuits, clos, et enuironnez des rochers et montagnes, me causeront de faire mon iardin merueilleusement delectable : car tout le long des deux costez de la montagne, ie feray croiser vn grand nombre de chambres dedans lesdits rochers, lesquelles chambres, les vnes seruiront à serrer les plantes et herbes, qui sont suiettes és gelees et nuitees d'hyuer, lesquelles plantes, les vnes seront portees dedans les vaisseaux de terre, les autres sur certains engins faits en forme de boyards ou brouëttes : aucunes sur certains vaisseaux de bois, dressees sur certaines roues : aucunes desdites chambres seruiront aussi pour retirer les graines qui sont encore en leurs plantes : aucunes autres seruiront pour serrer grande quantité de perches, pau-fourches, vismes (osiers), et toutes telles choses requises, pour le seruice du dit iardin : aucunes desdites chambres, seruiront pour retirer les iardiniers au temps des pluyes, et lors qu'il faudra aiguiser leurs pau-fourches, estaipes (pieus), et perches : aussi aucunes seruiront pour serrer les outils d'agriculture, autres pour serrer pour quelque temps les naueaux, aulx, oignons, noix, chastagnes, glans, et autres telles choses necessaires et requises à vn pere de famille.

Item, au dessus desdites chambres le rocher sera couppé, pour seruir d'vne grande allee en maniere d'vne plate-forme : mais il te faut noter, qu'à present ie te vay discourir vne chose fort vtile et plaisante, qui est, qu'au dessus desdites chambres, ie feray aussi croiser dedans ledit rocher vn nombre de chambres hautes tout le long de l'allee, qui sera ainsi faite sur lesdites chambres basses, et icelles chambres hautes estans ainsi formees dedans la montagne et rocher, elles seront fort vtiles et plaisantes : car l'vne sera toute taillee en façon de popitres, pour seruir de librairie et estude : l'autre sera toute

taillee par autre maniere de popitres, pour tenir les eaux distillees, et diuers vinaigres, l'autre sera faite par petites armoires, pour tenir et garder la diuersité des graines. Il y en aura vne autre, qui sera toute faite en maniere de rayons de marchans, pour tenir diuersité de fruits meslez, comme pruneaux, cerises, guignes, et autres telles espèces. Il y en aura aussi vne qui sera fort vtile, pour dresser certains fourneaux, à tirer les eaux et essences des herbes de bonne senteur : et y aura d'autres chambres qui seront fort vtiles, pour garder les fruits, et toutes especes de legumes, comme feues, pois, nentilles, et autres telles choses semblables. Toutes ces chambres seront à ce vtiles, parce qu'elles seront en vn lieu chaud moderement, et bien aëré, mais voici à present la cause pourquoy lesdites chambres et montagnes seront fort vtiles, plaisantes et belles.

En premier lieu, il te faut noter, qu'au deuant desdites chambres, il y aura vne grande et spatieuse allee, qui sera au dessus des chambres basses, qui seront erigees pour la commodité des iardiniers, comme ie t'ay dit cy-dessus, laquelle allee seruira comme d'vne gallerie, au deuant desdites chambres hautes. Et pour mieux la faire ressembler à vne gallerie, ie feray vne muraille tout du long sur le deuant de l'allee, deuers les deux costez du iardin, qui sera à fleur du deuant, et entre les chambres basses, laquelle muraille sera plate par dessus, pour seruir d'accotoüer à ceux qui se pourmeneront au deuant desdites chambres hautes, sur ladite allee, plate-forme, et gallerie. Et à fin de rendre la chose plus plaisante et admirable, ie planteray au dessus des portes et fenestres des chambres hautes, tout le long du terrier vn grand nombre d'aubepins, et autres arbrisseaux, portans bons fruits, pour la nourriture des oiseaux, lesquels aubepins, et autres arbrisseaux, seruiront comme d'vn pauillon au dessus des portes et fenestres desdites chambres hautes, voire et couuriront tout du long de l'allee ladite plateforme ou gallerie : et par tel moyen, ceux qui seront esdites chambres hautes, et ceux qui se pourmeneront au deuant d'icelles, auront ordinairement le plaisir de diuerses chansonnettes, qui par les oiseaux seront dites sur lesdits arbrisseaux. Il y a deux causes, qui rendront les oiseaux amateurs de dire leurs chansonnettes en ce lieu. La premiere cause, est le Soleil, qui dés le matin iettera ses rayons sur lesdits arbrisseaux : la seconde

raison est, parce que lesdits oisillons trouueront ordinairement quelque chose à se repaistre ausdits arbrisseaux : aussi pour mieux les accoustumer en ce lieu, ie ietteray en temps d'hyuer des graines de plusieurs semences sur l'allee, gallerie, et plate-forme susdite, à fin que les oiseaux trouuent quelque chose à manger en ce lieu, lors que l'hyuer aura rendu les arbres steriles. Voila comment en tout temps lesdites chambres hautes insculpees dedans les rochers, seront vtiles et de grande recreation. Et outre ces choses, les accotouër qui seront erigez deuers le costé du iardin, seront grandement vtiles à faire meler les pruneaux, guignes, serises, et autres tels fruits qu'on a accoustumé faire meler au Soleil, parce que ce lieu sera orienté en telle sorte, que le Soleil y enuoyera ses rayons tout le long du iour : car le regard desdits rochers, chambres, et galleries seront vers le costé du vent d'Es et Sus. Et voila comment ceux qui auront affaire à estudier, distiller, ou autres labeurs esdites chambres hautes, quand ils voudront se recreer, ils sortiront sur ladite plate-forme et gallerie, et en se pourmenant, ils auront les arbrisseaux, et les oiselets au dessus de leurs testes. Et apres, voulans regarder toute la beauté du iardin, ils se viendront appuyer sur l'accotouër, qui sera fait exprés, et propre pour cest affaire, et estans la accotez, ils verront entierement toute la beauté du iardin, et ce qui s'y fera : Aussi ils auront la senteur de certains damas, violettes, marjolaines, basilics, et autres telles especes d'herbes, qui seront sur ledit accotouër, plantees dedans certains vases de terre, esmaillez de diuerses couleurs, lesquels vases, ainsi mis par ordre, et esgalles portions, decoreront et orneront grandement la beauté du iardin et gallerie susdite. Aussi au dessus desdits accotouërs, il y aura certaines figures feintes, insculpees de terre cuite, et seront esmaillees si pres de la nature, que ceux qui de nouueau seront venus au iardin, se descouuriront, faisans reuerence ausdites statues, qui sembleront, ou apparoistront certains personnages appuyez contre l'accotouër de ladite gallerie et plate-forme : or pour monter sur ladite plate-forme il y aura deux escaliers, l'vn deuers le costé du vent de Nord, et l'autre deuers le costé du vent de Sus, et seront lesdits escaliers taillez de la mesme roche, et sur le mesme lieu, qui sera vne beauté

et commodité cent fois plus grande, que ie ne te sçaurois desduire. Si tu es un homme de bon iugement, tu pourras assez aisément entendre, combien la chose sera plaisante, estant erigee en la forme que ie t'ay dit : venons à present au cabinet, qui sera au milieu du iardin.

Du Cabinet du milieu.

Pour eriger le cabinet du milieu, à telle dexterité que le dessein de mon esprit l'a conceu, tu dois entendre, que la source de l'eau de laquelle ie me seruiray és fontaines de mes cabinets, ou rochers d'iceux, sera prise vn peu plus haut que le iardin, deuers le costé du Nord, et en prenant l'eau pour dilater à mes cabinets et fontaines, tout par un moyen ie feray du residu de la source, vn ruisseau, lequel passera tout à trauers dudit iardin, en tirant vers le costé du vent de Sus. Et quand il sera à l'endroit du milieu, ie separeray le cours dudit ruisseau en deux parties, l'une à dextre, et l'autre à senestre, en ensuiuant le traict d'vne rotondité que i'auray formee au compas : et apres qu'vne chacune des deux parties aura circuit la moitié de ladite rotondité, lors les deux parties du ruisseau, se viendront rassembler à vn mesme cours, comme dessus, et en telle sorte se trouuera au milieu du iardin une petite isle, à l'entour de laquelle ie planteray certains pibles ou populiers (peupliers), qui en peu de iours seront creus d'vne bien grande hauteur, lesquels populiers ou pibles ie formeray, sçauoir est, les iambes en maniere de colomnes, par les moyens que ie t'ay dit cy-dessus, en te parlant des cabinets des hommeaux : aussi au dessus des testes desdites colomnes, il y aura architraue, frise et corniche, qui seront erigees des branches des mesmes arbres, comme ie t'ay conté des hommeaux : et en ceste sorte, lesdits populiers et pibles, feront la cloison d'vn cabinet rond, lequel cabinet sera fait en forme pyramidale. Et combien qu'il sera fait à peu de frais, toutesfois, il ne sera moins à estimer que les pyramides d'Egypte, combien qu'elles coustassent tant de millions d'or : et te diray à present, comment ie formeray mon cabinet en forme de pyramide. Depuis la racine des arbres iusques à la corniche, le tout sera à plomb, en ensuiuant les regles de nos anciens architectes : mais depuis la corniche tirant en haut, i'ameneray lesdits arbres pres l'vn de l'autre petit à petit, iusques à ce que tous ensemble se reduisent en vne pointe,

au bout de laquelle pointe y aura vn engin attaché auec les pointes de tous les arbres, lequel engin aura vn entonnoir pour receuoir le vent, et au bout de l'entonnoir plusieurs flaiols, se rendant en vn mesme trou, en telle sorte, que le vent estant enfermé dans ledit entonnoir, fera sonner lesdits flaiols, qui seront de diuerses grosseurs, à fin de tenir et ensuiure la mesure de la musique, et en quelque part, ou endroit que le vent se vire, l'entonnoir aussi se virera : et ainsi les flaiols ioueront à tous vents. Il y aura aussi plusieurs lettres en la frise, qui seront formees des mesmes branches des arbres, comme ie t'ay dit des hommeaux, et y aura en escrit en la deuise de ladite frise, *Malediction à ceux qui rejettent Sapience*. Et ainsi, le dessous de ladite pyramide sera vn cabinet rond, merueilleusement frais et plaisant, à cause que le ruisseau sera tout à l'entour de la petite Isle dudit cabinet, et les pieds des colomnes ou arbres de ladite pyramide, seront plantez sur le bord du ruisseau, qui causera que ledit ruisseau en passant, grondera, et murmurera à l'entour de ladite petite Isle, en laquelle il faudra certaines planches pour y entrer, et y aura au milieu de la petite Isle vne table ronde, et à l'entre-deux des colomnes, qui seront lesdits pieds des pibles, il y aura certains vismes doux, qui seront tissus, entrelassez, et arrangez, en telle sorte, qu'ils seruiront de cloison, chaires, et doussiers entre lesdites colomnes, et le dessus de la voute desdites chaires et doussiers d'icelle, sera tissu en façon plate, sur laquelle plate-forme seront arrangez plusieurs vaisseaux et vases, pour le seruice dudit cabinet. Voila comment lesdits populiers formeront vne pyramide excellemment belle au milieu dudit iardin, laquelle pyramide seruira par le dessous d'vn cabinet rond merueilleusement vtile, auquel cabinet y aura quatre portes correspondantes aux quatre allees de la croisee du iardin, et par le dehors dudit cabinet, vn peu au delà du terrier et bord du fossé du dehors dudit cabinet, ou pyramide, seront plantez plusieurs aubiers, qui formeront vne autre rotondité, enuiron cinq pieds distante de la pyramide susdite, et si seront lesdits aubiers tous clissez d'vne chemise de fil d'archal : aussi depuis la sommité desdits aubiers, iusques aux colomnes de la pyramide, en cas pareil : pareillement, entre lesdites colomnes iusques à l'endroit susdit de la sommité des aubiers. Et sera ledit fil d'archal tissu par

diuerses cloisons, parcelles et moyens, au dedans desquels moyens, il y aura vn grand nombre d'oiseaux, grands et petits, de diuerses especes, tant de ceux qui se plaisent en l'air, que de ceux qui se plaisent és arbres, et en la terre. Et par tel moyen, ceux qui banqueteront au dessous et dedans de ladite pyramide, ils auront le plaisir du chant des oiseaux, du coax des grenouilles, qui seront au ruisseau, le murmurement de l'eau, qui passera contre les pieds et iambes des colomnes qui soustiendront ladite pyramide, la frescheur du ruisseau, et des arbres qui seront à l'entour, la freschure du doux vent, qui sera engendré par le mouuement des feuilles desdits pibles ou populiers. On aura aussi le plaisir de la Musique, qui sera sur la sommité et pointe de ladite pyramide, laquelle Musique se iouëra au soufflement du vent, comme ie t'ay dit cy dessus : voila à present le dessein de tous les cabinets de mon iardin.

Quant est à present des tonnelles qui pourront estre à l'entour de la circonference du iardin, et autres membres semblables, ie ne t'en parleray point : mais ie veux à present que tu confesses, que sans les montagnes, terriers et rochers, il me seroit impossible d'eriger vn iardin, qui eust ses commoditez requises. Tu as veu ci dessus en combien de sortes lesdits rochers me seruent à cest affaire, et à present te faut noter, que tous mes arbres et plantes qui seront suiets aux gelees, seront plantez du long, et au pied du bas desdites montagnes. Et ce, pour cause que lesdites montagnes les garentiront des froidures du vent de Nord et Ouëst, qui sont les vents les plus fascheux qui regnent en ce pays de Xaintonge, ie dis de Xaintonge, parce qu'il y a aucuns Astrologues, qui disent, que les vents qui sont icy les pires, sont les meilleurs en aucunes autres contrees de pays. Les herbes, plantes, et arbres qui seront au pied, et ioignant lesdits rochers et montagnes, seront garentis desdits vents, parce que lesdites montagnes, terriers et rochers, leur seruiront de pauillon et defense contre lesdits vents. Item, ils se ressentiront la nuict de de la chaleur qu'ils auront receu le iour, parce que lesdites montagnes auront leur regard deuers Es et Sus, en telle sorte, que lesdites montagnes auront tout le iour l'aspect des rayons du Soleil, tellement que les arbres et plantes qui seront au pied desdites montagnes, seront eschauffees par le Soleil, et aussi

par la reuerberation d'iceluy mesme, qui frappera contre les terriers, et rochers. Item, la liqueur et l'humidité qui descendra desdits terriers et montagnes, sera plus salee que non pas celle des autres parties du iardin, qui causera, que les fruits des arbres qui seront au pied des montagnes, seront plus sauoureux, et de meilleure garde, que non pas les autres, comme tu peux auoir entendu dés le commencement de mon propos, quand ie t'ay parlé des fumiers : et ainsi, chacune espece d'arbre et plante sera plantee selon ce qu'on cognoistra estre requis, sçauoir est, celles qui demandent les lieux hauts, secs et montueux, aux lieux montueux, et celles qui demandent l'humidité, seront plantees le long du ruisseau, qui passera à trauers du iardin. Item, au iardin y aura plusieurs petites isles, qui seront enuironnees de petits ruisseaux, qui distilleront d'vn chacun des rochers des cabinets, et seront amenez les cours desdits ruisseaux droit au grand ruisseau, qui sera par le milieu du iardin. Et par tel moyen, ie feray que lesdits ruisseaux feront en eux en allant au grand ruisseau certaines circulations, qui causeront des petites isles fort plaisantes, et propres pour arrouser les herbes qui seront plantees esdites petites isles. Ie dresseray aussi vn autre petit moyen, pour arrouser les parties du iardin, d'aussi peu de frais qu'il est possible d'ouyr parler : Et ledit moyen est tel, que ie feray percer vn grand nombre de bois de Seu (Sureau), ou autre, que ie verray estre conuenable, et propre pour cest affaire, et apres en auoir percé plusieurs pieces, ie feray qu'elles entreront, et s'assembleront le bout de l'vne au dedans du bout de l'autre : et ainsi consequemment toutes les autres. Et quand ie voudray arrouser quelques plantes ou semences de mon iardin, ie presenteray vn bout desdits bois percez contre l'vne des pisseures des fontaines, et ladite eau de la pisseure entrera dedans le canal ou bois percé, et dedans le bout d'iceluy bois, i'emmancheray vne autre piece de chenelle ou autre bois percé, et selon la distance du lieu que ie voudray arrouser, i'en assembleray plusieurs ainsi, bout à bout l'vne de l'autre, et pour soustenir lesdites chenelles, i'auray certaines fourchettes que ie piqueray en terre, tout le long de la voye où ie voudray aller, lesquelles fourchettes et piquets soustiendront et conduiront mesdites chenelles iusques au lieu que ie voudray arrouser : mais à fin que la chose soit arrou-

see amiablement sans fouler la terre, le derrière de mes chenelles sera fermé au bout d'vn tapon, qui aura vn nombre infiny de petits trous, et par tel moyen, le canal distillera l'eau, comme une amiable rosee, sans faire aucun dommage ny aux plantes, ny à la terre. Et par tel moyen, ie tourneray mes chenelles et bois percez d'vn costé et d'autre, par toutes les parties de mon iardin, et lieux que ie voudray arrouser. Et quant est des engins qu'aucuns ont fait cy deuant, sçauoir est, certaines trapes, desquelles ils trompent les nouueaux venus au iardin, et les font tomber dedans l'eau, pour auoir leur passe-temps, ie ne voudrois estre leurs imitateurs en cest endroit : mais bien voudrois-ie faire certaines statues, qui auroient quelque vase en vne des mains, et en l'autre quelque escriteau, et ainsi que quelqu'vn voudroit venir pour lire ladite escriture, il y auroit vn engin, qui causeroit que ladite statue verseroit le vase d'eau sur la teste de celuy qui voudroit lire ledit Epitaphe. Item, ie voudrois aussi faire d'autres statues, qui auroient vne certaine boucle, ou anneau pendu en vne main, à fin que quand les Pages courroyent la lance contre ladite boucle, ainsi qu'ils frapperoyent ledit anneau, la statue leur viendroit bailler vn grand coup sur la teste d'vne esponge abruuee d'eau, en telle sorte, que ladite esponge rendra grande quantité d'eau, à cause de la compression, et du grand coup qu'elle frappera. Si ie voulois te desduire entierement le dessein de mon iardin, ie n'aurois iamais fait, parquoy, ne t'en diray plus rien : mais venons à present és confrontations d'iceluy.

Des Confrontations.

Les confrontations du iardin deuers le costé du vent de Sus, seront prairies, ainsi que ie t'ay dit cy dessus, et au milieu desdites prairies passeront les mesmes ruisseaux qui passent au iardin. A dextre et à senestre dudit ruisseau, seront plantez plusieurs belles aubarees, et tout à l'entour, et le long des deux extremitez de la prairie, seront plantez nombre d'aubepins, qui seruiront de closture et muraille, pour la defense de ladite pree, et au long de ladite haye, et bord de la pree, vn sentier et allee fort plaisante et de recreation, pour les causes que ie te diray cy apres, et la confrontation du iardin deuers le vent d'Es, seront certains champs, plantez par esgales parcelles, de diuerses especes d'arbres fructiers, qui se

ront de grand reuenu ; sçauoir est, vn champ de noyers, un autre de chastagners, et vn autre de nousillers (noisetiers), poiriers, pommiers, brief, de toutes especes de fruits : et du costé du vent de Nord, seront les mottes pour les cherues (chanvre), lins, et aubiers doux, et certains vimiers, pour seruir à la ligature du iardin, et deuers le costé du vent d'Ouëst, seront les bois, montagnes, et rochers que ie t'ay dit cy dessus. Voila à present l'ordonnance de mon iardin, avec ses confrontations.

Demande.

Veritablement tu m'en as bien conté, et de bien piteuses : et où cuiderois-tu trouuer vn lieu commode selon ton dessein ? Serois-tu bien si fol, de faire si grand despence, pour auoir vn beau iardin ?

Responce.

Ie t'ay dit cy dessus, qu'il se trouuera plus de quatre mille mestairies, ou maisons nobles en France, aupres desquelles on trouuera la commodité requise, pour eriger le iardin susdit, et de ce ne faut douter. et quant est de la despence, que tu dis estre excessiue, il se trouuera plus de mille iardins en France, qui ont couté plus que cestuy ne coutera : et puis, regardes-tu au coust pour auoir vne telle delectation et reuenu de grandes loüanges ?

Demande.

Voire, mais on auroit plus grand plaisir, et vaudroit mieux acheter de bons cheuaux, et de bonnes armures, pour paruenir à quelque degré et charge de l'art militaire, et lors en passant pays, plusieurs viendroyent au deuant te presenter logis, viures, et tapisseries : l'vn te donneroit un mulet, et l'autre vn cheual, qui ne te cousteroit qu'à souffler : et ainsi, tu receurois beaucoup plus de plaisir, que non pas à ton iardin. Aussi tu attraperois quelque benefice, que tu ferois tenir par quelque cuisinier de prestre, et tu prendrois le reuenu : car ie say plusieurs qui, par tels moyens, ayant acheté estat de seneschal de robe longue, sont paruenus à avoir estat de seneschal de robe courte, qui a été le moyen qu'ils ont esté prisez et honorez, crains et redoutez. Et par tels moyens ont rempli leurs bources de butin : et mesme en ces troubles passez, tu sais comme aucuns d'iceux ont reçu de grands présens pour favoriser aux huguenots, lesquels n'epargnoient rien pour sauuer leurs vies, lesquelles on cerchoit de bien près.

Responce.

Tu m'as allegué des raisons fort meschantes, et mal à propos : tu sçais bien que dés le commencement ie t'ay dit que ie voulois eriger mon iardin pour m'en seruir, comme pour une cité de refuge, pour me retirer és iours perilleux et mauuais : et ce, à fin de fuyr les iniquitez et malices des hommes, pour seruir à Dieu, et à present tu me viens tenter d'une execrable auarice, et meschante inuention. Et cuides tu que si un homme a acheté un office de seneschal, soit de robe courte, ou de robe longue, et qu'il aie ce fait par avarice et ambition, qu'il soit homme de bien en ce faisant? Ie say bien qu'aucuns ont acheté les grandeurs susdites pour se faire craindre et se venger, et pour emplir leurs bources de présens. Est-ce pourtant à dire que telles gens soient gens de bien? Et tant il s'en faut. Tu sais bien que saint Paul dit qu'il n'y a rien de plus méchant que l'auaricieux. Item, il dit que l'auarice est la racine de tous maux : comment me prouueras tu que telles gens puissent viure en repos de conscience? Item, on sait bien, qu'en plusieurs lieux des escritures sainctes, il est défendu aux Juges de prendre présens, parce que les présens corrompent le iugement : et ainsi, ie puis conclurre qu'il n'y a rien de bon au conseil que tu m'as donné. Item, tu m'as dit que si i'avois acheté quelque authorité, ou office de seneschal, ou autre, que ie pourrois crocheter quelque benefice que ie ferois tenir par un cuisinier de prestre : tu me conseilles donc d'estre meschant symoniaque et larron, et tu sais que le reuenu des benefices ne doit estre donné, sinon à ceux qui fidélement administreront la parole de Dieu : et quant est des autres qui iouiront du reuenu, ils sont maudits, damnés et perdus : et ie te le puis asseurement dire, puisqu'il est escrit au prophete Ezechiel. chap. 34 : Malediction sur vous, Pasteurs, qui mangez le laict et vestissez la laine, et laissez mes brebis esparses par les montagnes, ie les demanderai de vostre main. Ne voilà pas une sentence qui deust faire trembler ces symoniaques? et à la vérité, ils sont cause des troubles que nous auons auiourd'hui en la France : car s'ils ne craignoient de perdre leur reuenu ecclesiastique, ils accorderoient aisément tous les points de l'Escriture saincte : mais je puis aisement iuger par leurs manières de faire, qu'ils aiment mieux, et ont en plus grande reuerence leur propre ventre, que non pas la diuine

Maiesté de Dieu, deuant lequel il faudra qu'ils rendent conte au iour de son aduenement, et lors desireront de mourir, et la mort s'enfuira d'eux, et diront lors aux montagnes, Montagnes, tombez sur nous, et nous cachez de la face de ce grand Dieu viuant, comme il est escrit en l'Apocalypse. Or, regarde maintenant, si tu m'as donné vn bon conseil, ouy bien pour me damner. Item, penses-tu que ces paures miserables ayent quelque repos en leur conscience? I'ose dire, qu'eux et leurs complices, quoy qu'il soit, ils ont tousiours quelque remords en leurs consciences, et qu'ils craignent plus de mourir, que non pas ceux qui n'ont point leurs consciences cauterisees : toutesfois, ils ne sont iamais rassasiez ne de biens, ne d'honneurs : mais si quelqu'vn les desobeyst, ils creueront, iusques à tant qu'ils en soyent vengez : et ainsi, les paures miserables n'ont repos, ny en leurs esprits, ny en leurs corps, quelque grasse cuisine qu'ils puissent auoir. Pour lesquelles causes ie n'ay trouué rien meilleur, que de fuyr le voisinage, et accointance de telles gens, et me retirer au labeur de la terre, qui est chose iuste deuant Dieu, et de grande recreation à ceux qui admirablement veulent contempler les œuures merueilleuses de nature : mais ie n'ay trouué en ce monde vne plus grande delectation, que d'auoir vn beau iardin : aussi Dieu ayant creé la terre pour le seruice de l'homme, il le colloqua dans vn iardin, auquel y auoit plusieurs especes de fruits, qui fut cause, qu'en contemplant le sens du Pseaume cent quatriesme, comme ie t'ay dit cy dessus, il me prit deslors vne affection si grande d'edifier mondit iardin, que depuis ce temps-là ie n'ay fait que resuer apres l'edification d'iceluy : et bien souuent en dormant, il me sembloit que i'estois apres, tellement qu'il m'aduint la semaine passee, que comme i'estois en mon lict endormy, il me sembloit, que mon iardin estoit desia fait, en la mesme forme que ie t'ay dit cy dessus, et que ie commençois desia à manger des fruits, et me recreer en iceluy, et me sembloit qu'en passant au matin par ledit iardin, ie venois à considerer les merueilleuses actions que le Souuerain a commandé de faire à nature, et entre les autres choses, ie contemplois les rameaux des vignes, des pois, et des coyes (courges), lesquelles sembloyent qu'elles eussent quelque sentiment et cognoissance de leur debile nature car ne se pouuans soustenir d'elles-mesmes, elles iettoyent certains

petits bras, comme filets en l'air, et trouuans quelque petite branche, ou rameau, se venoyent lier et attacher, sans plus partir de là, à fin de soustenir les parties de leur debilé nature. Et quelque fois en passant par le iardin, ie voyois vn nombre desdits rameaux, qui n'auoyent rien à quoy s'appuyer, et iettoyent leurs petits bras en l'air, pensans empoigner quelque chose, pour soustenir la partie de leurdit corps, lors ie venois leur presenter certaines branches et rameaux, pour aider à leur debile nature : et ayant ce fait au matin, ie trouuois au soir que les choses susdites auoyent jetté, et entortillé plusieurs de leurs bras à l'entour desdits rameaux: lors tout esmerueillé de la prouidence de Dieu, ie venois à contempler vne authorité, qui est en sáint Matthieu, où le Seigneur dit, que *les oiseaux mesmes ne tomberont point sans son vouloir*, et ayant passé plus outre, i'apperceu certaines branches et gittes d'aubelon (houblon), lequel combien qu'il n'eust ny veuë, ny ouye, ny sentiment, ce neantmoins, Dieu luy a donné cognoissance de la debilité de sa nature, et le moyen de se soustenir, tellement que ie vis, que lesdites gittes dudit aubelon s'estoyent liees et entortillees plusieurs ensemble, et estans ainsi fortifiees et accompagnees l'vne de l'autre, elles se dilatoyent au long de certaines branches, pour se consolider encore toutes ensemble, et s'attacher auxdites branches : lorsque i'eu apperceu et contemplé vne telle chose, ie ne trouvay rien meilleur, que de s'employer en l'art d'agriculture, et de glorifier Dieu, et se recognoistre en ses merueilles: et ayans passé plus outre, i'apperceu certains arbres fruictiers, qu'il sembloit qu'ils eussent quelque cognoissance : car ils estoyent soigneux de garder leurs fruits, comme la femme son petit enfant, et entre les autres, i'apperceu la vigne, les concombres, et poupons (mélons, *pepo*), qui s'estoyent faits certaines fueilles, desquelles ils couuroyent leurs fruits, craignans que le chaud ne les endommageast, ie vis aussi les rosiers et gruseliers, qui à fin de defendre ceux qui voudroyent rauir leurs fruits, ils s'estoyent faits des armures et espines piquantes au deuant desdits fruits. I'apperceu aussi le froment, et autres bleds, ausquels le Souuerain auoit donné sapience de vestir leur fruit si excellemment, voire plus excellemment, que Salomon ne fut oncques si iustement vestu auec toute sa sapience. Ie consideray aussi, que le Souuerain auoit donné au chas-

tagner de sçauoir armer et vestir son fruit d'vne industrie et merueilleuse robe : semblablement le noyer, allemandier, et plusieurs autres especes d'arbres fructiers, lesquelles choses me donnoyent occasion de tomber sur ma face, et adorer le viuant des vivans, qui a fait telles choses pour l'vtilité et seruice de l'homme : lors aussi cela me donnoit occasion de considerer nostre miserable ingratitude, et mauuaistié peruerse, et de tant plus i'entrois en contemplation en ces choses, d'autant plus i'estois affectionné de suiure l'art d'agriculture, et mespriser ces grandeurs et gains deshonnestes, lesquels à la fin, faut qu'ils soyent recompensez selon leurs merites ou demerites. Et estant en vn tel rauissement d'esprit, il me sembloit que i'estois proprement audit iardin, et que ie iouyssois de tous les plaisirs contenus en iceluy, et non seulement d'iceluy iardin, mais aussi des confrontations et lieux circonuoisins : car il me sembloit proprement, que ie sortois du iardin, pour m'aller pourmener à la pree, qui estoit du costé du Sus, et qu'y estant ie voyois iouër, gambader, et penader certains agneaux, moutons, brebis, cheures et cheureaux, en ruant et sautelant, en faisant plusieurs gestes et mines estranges, et mesmement me sembloit, que ie prenois grand plaisir à voir certaines brebis vieilles et morueuses, lesquelles sentens le temps nouueau, et ayans laissé leurs vieilles robbes, elles faisoyent mille sauts et gambades en ladite pree, qui estoit vne chose fort plaisante, et de grande recreation. Il me sembloit aussi, que ie voyois certains moutons, qui se reculoyent bien loin l'vn de l'autre, et puis courans d'vne vistesse et grande roideur, ils se venoyent frapper des cornes l'vn contre l'autre. Ie voyois aussi les cheures, qui se leuans des deux pieds de derrière, se frappoyent des cornes d'vne grande violence : aussi ie voyois les petits poulains, et les petits veaux, qui se iouoyent et penadoyent auprès de leurs meres. Toutes ces choses me donnoyent vn si grand plaisir, que ie disois en moy-mesme, que les hommes estoyent bien fols, d'ainsi mespriser les lieux champestres, et l'art d'agriculture, lequel nos peres anciens, gens de bien, et Prophetes ont bien voulu eux-mesmes exercer, et mesme garder les troupeaux. Il me sembloit aussi, que pour me recreer, ie me pourmenois le long des aubarees, et en me pourmenant sous la couuerture d'icelles, i'entendois vn peu murmurer les eaux

du ruisseau, qui passoit au pied desdites aubarees, et d'autre part i'entendois la voix des oiselets, qui estoyent sur lesdits aubiers : et lors me venoit à souuenir du Pseaume cent quatriesme, sur lequel i'auois edifié mon iardin, auquel le Prophete dit, *Que les ruisseaux passent et murmurent aux vallees et bas des montagnes* : aussi dit-il, Que les oiselets font resonner leurs voix sur les arbrisseaux, plantez sur les bords des ruisseaux courans. Il me sembloit aussi, que quand ie fus las de pourmener en ladite prairie, ie me tournay deuers le costé du vent d'Ouëst, où sont les bois et montagnes, et lors me sembloit, que i'apperceu plusieurs choses, qui sont deduites et narrees au Pseaume susdit : car ie voyois les conils (1) iouans, sautans, et penadans le long de la montagne, pres de certaines fosses, trous et habitations, que le Souuerain Architecte leur auoit erigé, et soudain que les animaux apperceuoyent quelqu'vn de leurs ennemis, ils sçauoyent fort bien se retirer au lieu qui leur auoit esté ordonné pour leur demeurance. Ie voyois aussi le renard, qui se ralloit le long des buissons, le ventre contre terre, pour attrapper quelqu'vne de ces petites bestes, à fin de contenter le desir de son ventre. Brief, il me sembloit que i'auois les plaisirs de voir cheures, dains, bisches, et cheureaux le long desdites montagnes, en la mesme sorte, ou bien pres du deuis que le Prophete David nous descrit en ce Pseaume cent quatrieme. Item, m'estoit auis, que i'entendois la voix de plusieurs vierges, qui gardoyent leurs troupeaux : pareillement me sembloit, que i'oyois certains bergers iouans melodieusement de leurs flaiols : et lors me sembloit, que ie disois en moy-mesme, ie m'esmerueille d'vn tas de fols laboureurs, que soudain qu'ils ont vn peu de bien, qu'ils auront gagné avec grand labeur en leur ieunesse, ils auront apres honte de faire leurs enfans de leur estat de labourage, ains les feront du premier iour plus grands qu'eux-mesmes, les faisans communement de la pratique, et ce que le pauure homme aura gagné à grande peine et labeur, il en despendra vne grand' partie à faire son fils Monsieur, lequel Monsieur aura en fin honte de se trouuer en la compagnie de son pere, et sera desplaisant qu'on dira qu'il est fils d'vn laboureur. Et si de cas fortuit, le bon homme a

(1) Lapins, *Cuniculus.*

certains autres enfans, ce sera ce Monsieur là, qui mangera les autres, et aura la meilleure part, sans auoir esgard qu'il a beaucoup cousté aux escholes pendant que ses autres freres cultiuoient la terre auec leur pere. Et en cependant, voila qui cause que la terre est le plus souuent auortee, et mal cultiuee, parce que le mal-heur est tel, qu'vn chacun ne demande que viure de son reuenu, et faire cultiuer la terre par les plus ignorans, chose malheureuse. A la mienne volonté, disois-je lors, que les hommes eussent aussi grand zele, et fussent aussi affectionnez au labeur de la terre, comme ils sont affectionnez pour acheter les offices, benefices, et grandeurs, et lors la terre seroit benite, et le labeur de celuy qui la cultiueroit, et lors elle produiroit ses fruits en sa saison. Ayant contemplé toutes ces choses, ie m'en allay pourmener deuers le costé du vent d'Est, et en me pourmenant pardessous les arbres fructiers, i'y receu vn grand contentement, et plusieurs ioyeux plaisirs : car ie voyois les Escurieux (écureuils) cueillans les fruits, et sautans de branche en branche, faisans plusieurs belles mines et gestes. Ie voyois d'autre part cueillir les noix aux groles (corneilles), qui se resiouyssoient, en prenant leur repas et disner sur lesdits Noyers. D'autre part, ie trouuois sous les Pommiers certains herissons, qui s'estoyent roulez en forme ronde, et auoyent fait piquer leurs poils, ou aiguillons sur lesdites pommes, et s'en alloyent ainsi chargez. Ie voyois aussi la sagesse du renard, lequel se trouuant persecuté des puces, prenoit vn bouchon de mousse dedans sa bouche, et s'en alloit à vn ruisseau, et s'estant culé dedans ledit ruisseau, il entroit petit à petit pour faire fuyr toutes les puces du corps en sa teste : et quand elles s'en estoyent fuyes iusques à la teste, le renard se plongeoit encore tousiours, iusques à ce qu'elles fussent toutes sur le museau, et quand elles estoyent sur le museau il se plongeait jusqu'à ce qu'elles fussent sur la mousse, qu'il auoit mise en sa gueule, et quand elles estoyent sur la mousse, il se plongeait tout à vn coup, et s'en alloit sortir au dessus du courant de l'eau : et ainsi, il laissoit ses puces sur ladite mousse, laquelle mousse leur seruoit de bateau pour s'en aller d'vn autre costé. I'apperceu aussi vne finesse que le renard fit en ma présence la plus fine et subtile que i'ouys oncques parler : car iceluy se trouuant desnué de viures, et voyant que l'heure du disner s'approchoit, et qu'il n'auoit

encore rien de prest, il s'en alla coucher en vn champ, pres et ioignant l'aile d'vn bois, et estant là couché, il dilata les iambes en sus, et ferma les yeux, et estant ainsi couché à la renuerse faisant du mort, et tirant son membre : dont aduint qu'vne grole n'ayant aussi rien à disner, pensant que le dit renard fust mort, se va poser sur son ventre, pensant de son membre que ce fust quelque chair desia commencee à détailler : mais la grole fut bien affinee, car dés le premier coup de bec qu'elle commença à donner sur ledit membre, le renard d'vne vistesse soudaine empongna la grole, laquelle ne sceut tenir aucune contenance, sinon de faire coüa : et voila comment le fin renard print son disner aux despens de celle qui le vouloit manger.

Toutes ces choses m'ont rendu si amateur de l'agriculture, qu'il me semble, qu'il n'y a thresor au monde si precieux, ni qui deust estre en si grande estime, que les petites gittes des arbres et plantes, voire les plus mesprisees. Ie les ay en plus grande estime que non les minieres d'or et d'argent. Et quand ie considere la valeur des plus moindres gittes des arbres ou espines, ie suis tout esmerueillé de la grande ignorance des hommes, lesquels il semble qu'auiourd'huy ils ne s'estudient qu'à rompre, couper, et deschirer les belles forests que leurs predecesseurs auoyent si precieusement gardees. Ie ne trouueray pas mauuais qu'ils coupassent les forests, pourueu qu'ils en plantassent apres quelque partie : mais ils ne se soucient aucunement du temps à venir, ne considerans point le grand dommage qu'ils font à leurs enfans à l'aduenir.

Demande.

Et pourquoy trouues-tu si mauuais, qu'on coupe ainsi les forests? il y a plusieurs Euesques, Cardinaux, Prieurs et Abbez, Moineries, et Chapitres, qui en coupant les forests, ils ont fait trois profits. Le premier, ils ont eu de l'argent de bois et en ont donné quelque partie aux femmes, filles et hommes aussi. Item, ils ont baillé la sole desdites forests à rente : dont ils ont eu beaucoup d'argent des entrees. Et apres les laboureurs ont semé du bled et sement tous les ans, duquel bled ils en ont encore vne bonne portion. Voila comment les terres valent plus de reuenu, qu'elles ne faisoyent auparauant. Parquoy ie ne puis penser, que cela doiue estre trouué mauuais.

Responce.

Ie ne puis assez detester vne telle chose, et ne la puis appeller faute : mais vne malediction, et vn mal-heur à toute la France, parce qu'apres que tous les bois seront coupez, il faut que tous les arts cessent, et que les artisans s'en aillent paistre l'herbe, comme fit Nabuchodonozor. Ie voulu quelquesfois mettre par estat les arts qui cesseroyent, lorsqu'il n'y auroit plus de bois : mais quand i'en eu escrit vn grand nombre, ie ne sceu jamais trouuer fin à mon escrit, et ayant tout consideré ie trouvay qu'il n'y en auoit pas vn seul, qui se peust exercer sans bois, et que quand il n'y auroit plus de bois, qu'il faudroit que toutes les nauigations et pescheries cessassent, et que mesme les oiseaux et plusieurs especes de bestes, lesquelles se nourrissent de fruits, s'en allassent en vn autre Roiaume, et que les bœufs, ni les vaches, ni autres bestes bouines ne seruiroyent de rien au pays où il n'y auroit point de bois. Ie me fusse estudié à te donner vn millier de raisons : mais c'est vne Philosophie, que quand les chambrieres y auront pensé, elles iugeront, que sans bois, il est impossible d'exercer aucun art, et mesme faudroit, s'il n'y auoit point de bois, que l'office des dents fust vaquant, et là où il n'y a point de bois, ils n'ont besoin d'aucun froment, ni d'autre semence à faire pain. Ie trouue vne chose fort estrange, que beaucoup de Seigneurs ne contraignent leurs suiets de semer quelque partie de leurs terres de glans, et autres parties de chastagners, et autres parties de noyers, qui seroit vn bien public, et vn reuenu qui viendroit en dormant. Cela seroit fort propre en beaucoup de pays, là où ils sont contraints d'amasser les excremens des bœufs et vaches pour se chauffer, et en autres contrees, ils sont contraints de se chauffer et faire bouillir leurs pots de paille : n'est-ce pas vne faute, et ignorance publique? Quand ie serois Seigneur de telles terres ainsi steriles de bois, ie contraindrois mes tenanciers, pour le moins d'en semer quelque partie. Ils sont bien miserables, c'est un reuenu qui vient en dormant, et apres qu'ils auroient mangé les fruits de leurs arbres, ils se chaufferoyent des branches et troncs. Ie louë grandement vn Duc Italien, qui quelques iours apres que sa femme fut accouchee d'vne fille, il philosopha en soy-mesme, que le bois estoit vn reuenu qui venoit en dormant : parquoy, il commanda

à ses seruiteurs de planter en ses terres le nombre de cent mille pieds d'arbres, disant ainsi, que lesdits arbres pourroyent valoir chacun vingt sols auparauant que sa fille fust bonne à marier : et ainsi, lesdits arbres vaudroyent cent mille liures, qui estoit le prix qu'il pretendoit donner à sa fille. Voila vne prudence grandement louable : à la mienne volonté, qu'il y en eust plusieurs en France, qui fissent le semblable. Il y en a plusieurs qui aiment le plaisir de la chasse, et la frequentation des bois : mais cependant ils prennent ce qu'ils trouuent, sans se soucier de l'aduenir. Plusieurs mangent leurs reuenus à la suite de la Cour en brauades, despences superflues, tant en accoustrement, qu'autres choses : il leur seroit beaucoup plus vtile de manger des oignons auec leurs tenanciers, et les instruire à bien viure, monstrer bon exemple, les accorder de leurs différens, les empescher de se ruyner en procés, planter, edifier, fossoyer, nourrir, entretenir, et en temps requis, et necessaire, se tenir prests à faire seruice à son Prince, pour defendre la patrie. Ie m'esmerueille de l'ignorance des hommes, en contemplant leurs outils d'agriculture, lesquels on deust auoir en plus grande recommandation, que non pas les precieuses armures : toutesfois, il semble à certains Iuuenceaux, que s'ils auoient manié vn outil d'agriculture, qu'ils en seroient deshonnorez, et vn Gentilhomme tant pauure qu'il soit et endetté iusques aux aureilles, s'il auoit vn peu manié vn ferrement d'agriculture, il luy sembleroit estre vilain. A la mienne volonté, que le Roy eust erigé certains offices, estats et honneurs à tous ceux qui inuenteroient quelque bel engin, et subtil pour l'agriculture. Si ainsi estoit, tout le monde se ietteroit apres, à qui mieux mieux, pour paruenir. Iamais ingenieux ne furent plus empressez à l'assaut d'vne ville, qu'aucuns s'empresseroient : et tout ainsi que tu vois qu'ils mesprisent les anciennes façons d'habillemens, ils mespriseroient aussi les anciens outils de l'agriculture, et à la vérité, ils en inuenteroient de meilleurs. Les armuriers changent souuent les façons des hallebardes, d'espees et autres arnois : mais l'ignorance de l'agriculture est si grande, qu'elle demeure tousiours à vne mode accoustumee : et si leurs ferremens estoient lourds au commencement qu'ils furent inuentez, ils les entretiennent tousiours en leur lourdeté : en vn pays, vne mode accoustumee sans changer, en vn autre pays vne autre

aussi sans iamais changer. Il n'y a pas long-temps, que i'estois au pays de Béarn, et de Bigorre, mais en passant par les champs, ie ne pouuois regarder les laboureurs, sans me cholerer en moy-mesme, voyant la lourdeté de leurs ferremens : et pourquoy est-ce qu'il ne se trouue quelque enfant de bonne maison, qui s'estudie aussi bien à inuenter des ferremens vtiles pour le labourage, comme ils sçauent estudier à se faire decouper du drap en diuerses sortes estranges? Ie ne puis me tenir de dire ces choses, considerant la folie et ignorance des hommes.

DEMANDE.

Quels outils faudroit-il pour edifier un tel iardin, que tu m'as cy dessus designé?

RESPONCE.

Il faudroit de toutes les especes d'outils seruans à l'agriculture : et parce qu'il y a des colomnes, et autres membres d'architecture, il faudroit de toutes les especes d'outils propres à la Geometrie.

DEMANDE.

Ie te prie me les nommer icy par rang l'vn apres l'autre.

RESPONCE.

Nous auons le Compas,
La Reigle,
L'Escarre (équerre),
Le Plomb (l'à-plomb),
Le Niueau,
La Sauterelle (fausse équerre),
Et l'Astrolabe.

Voila les outils par lesquels on conduit la Geometrie et l'Architecture.

Puis que nous sommes sur le propos de Geometrie, il aduint la semaine passee, qu'estant en mon repos sur l'heure de minuict, il m'estoit auis, que mes outils de Geometrie s'estoient esleuez l'vn contre l'autre, et qu'ils se debatoient à qui appartenoit l'honneur d'aller le premier, et estant en ce debat, le compas disoit, Il m'appartient l'honneur : car c'est moy qui conduis et mesure toutes choses : aussi quand on veut reprouuer un homme de sa despence superflue, on l'admoneste de viure par compas. Voila comment l'honneur m'appartient d'aller le premier. La reigle disoit au compas, Tu ne sçais que tu dis, tu ne sçaurois rien faire qu'vn rond seule-

ment; mais moy, ie conduis toutes choses directement, et de long, et de trauers, et en quelque sorte que ce soit, ie fay tout marcher droit deuant moy : aussi quand un homme est mal-viuant, on dit qu'il vit desreiglement, qui est autant à dire, que sans moy, il ne peut viure droitement. Voila pourquoy l'honneur m'appartient d'aller deuant. Lors l'Escarre dist, C'est à moy à qui l'honneur appartient : car pour vn besoin, on trouuera deux reigles en moy : aussi c'est moy, qui conduis les pierres angulaires et principales du coin, sans lesquelles nul bastiment ne pourroit tenir. Lors le plomb se vinst à esleuer, disant, Ie dois estre honoré par dessus tous : car c'est moy qui ameine et conduis toute massonnerie directement en haut, et sans moy on ne sçauroit faire aucune muraille droite, qui seroit cause, que les bastimens tomberoyent soudain : aussi, bien souuent, ie fay l'office d'vne reigle : parquoy faut conclurre, que l'honneur m'appartient. Ce fait, le Niueau s'esleua, et dist : O ces belistres et coquins, c'est à moy que l'honneur appartient. Ne sçait-on pas, que tous les soumiers, poutres, et trauerses ne pourroyent estre assises à leur deuoir sans moy? Ne sçait-on pas bien, que ie conduis toutes places et pauemens comme ie veux? Ne sçait-on pas bien, que plusieurs ingenieux se sont seruis de moy, en faisant leurs mines, tranchees, et en braquant leurs furieux canons? et que sans moy ils ne pourroyent paruenir à leur dessein? Voila pourquoy faut arrester et conclurre que l'honneur me doit demeurer : et soudain que le niueau eut fini son propos, voicy la sauterelle, qui d'vne grande vistesse se va esleuer, en disant, Deuant, devant, vous ne sçauez que vous dites, c'est à moy à qui appartient l'honneur : car ie fay des actes que nul ne sçauroit faire, et ie vous demande, sçauriez-vous conduire un bastiment en vne place biaise? Et on sçait bien que non, et vous ne seruez, ni ne sçauez rien faire sinon un mestier : mais moy, ie vay, ie viens, ie fay de la petite, ie fay de la grande, brief, ie fay des choses que nul de vous ne sçauroit faire. Parquoy il est aisé à iuger, que l'honneur m'appartient. Adonc l'Astrolabe vint à s'esleuer avec vne constance et grauité canonique, et dist ainsi, Me voulez-vous oster l'honneur qui m'appartient? car c'est moy qui monte plus haut que tous tant que vous estes, et mon Regne et Empire s'estend iusques aux nues. N'est-ce pas moy, qui mesure

les astres, et que par moy les temps et saisons sont cogneuës aux hommes, fertilité ou stérilité? et qu'est ceci à dire? Me sçauroit-on nier, que ce que ie dis ne soit vray? Et ainsi que i'entendis le bruit de leurs disputes, ie m'escueillay, et soudain m'en allay voir que c'estoit : dont soudain qu'ils m'eurent apperceu, ils me vont eslire iuge, pour iuger de leur different : lors ie leur dis, Ne vous abusez point, il ne vous appartient ny honneur, ni aucune preeminence : l'honneur appartient à l'homme, qui vous a formez. Parquoy, il faut que vous luy seruiez et l'honoriez. Comment, dirent-ils, à l'homme, et faut-il que nous obeyssions et seruions à l'homme qui est si meschant et plein de folie? lors ie voulus excuser l'homme, en disant, qu'il n'estoit pas ainsi : ils s'escrierent tous, en disant, Permettez nous mesurer la teste de l'homme, et vous seruez de nous en cest affaire, et vous cognoistrez, que l'homme n'a aucune ligne directe, ni mesure certaine en toutes ses parties, quelque chose que Victruue, et Sebastiane et autres Architectes ayent sçeu dire, et monstrer par leurs figures. Quoy voyant, il me print enuie de mesurer la teste d'vn homme, pour sçauoir directement ses mesures, et me sembla, que la sauterelle, la reigle, et le compas me seroient fort propres pour cest affaire : mais quoy qu'il en soit, ie n'y sceu iamais trouuer vne mesure asseuree, parce que les folies qui estoient en ladite teste luy faisoient changer ses mesures. Adonc ie fus confus, parce que ie trouuois ladite teste tantost d'une sorte, et tantost d'vne autre, et combien qu'aucunes fois il y eust quelque apparence de lignes directes, ainsi que i'apprestois mes outils pour les figurer, soudain, et en vn moment, ie trouuois que les lignes directes s'estoient renduës obliques, dont ie fus fort estonné, voyant qu'il n'y auoit aucune ligne directe en la teste de l'homme, à cause que sa folie les faisoit toutes fleschir, et les rendoit obliques. Lors ie voulus sçauoir, quelles especes de folies estoyent en l'homme, qui le rendoit ainsi difforme, et mal proportionné: mais ne le pouuant sçauoir ni cognoistre par l'art de Geometrie, ie m'auisay de l'examiner par vne Philosophie Alchimistale, qui fut le moyen, que ie vins soudain eriger plusieurs fourneaux propres à cest affaire : les vns pour putrefier, les autres pour calciner, aucuns autres pour examiner, et aucuns pour sublimer, et d'autres pour distiller. Quoy faict, ie prins

la teste d'vn homme, et ayant tiré son essence par calcinations, et distillations, sublimations et autres examens faits par matrats, cornues, et bainmaries, et ayant separé toutes les parties terrestres de la matiere exhallatiue, ie trouuay, que veritablement, en l'homme il y auoit vn nombre infini de folies, que quand ie les eu apperceuës, ie tombay quasi en arriere comme pasmé, à cause du grand nombre des folies, que i'auois apperceu en ladite teste. Lors me print soudain vne curiosité et enuie, de sçauoir qui estoit la cause de ses grandes folies, et ayant examiné de bien pres mon affaire, ie trouuay que l'auarice et ambition auoit rendu presque tous les hommes fols, et leur auoit quasi pourri toute la ceruelle : lors que i'eu apperceu vne telle chose, ie fus plus desireux de veoir les malices des hommes, que ie n'estois au parauant, qui fut cause, que ie prins la teste d'vn Limosin, et l'ayant mise à l'examen, ie trouuay qu'il auoit sa teste pleine de folies, et grand mixtionneur et augmentateur de drogues, tellement qu'il se trouua, qu'il auoit acheté trente cinq sols la liure du bon poiure à la Rochelle, et puis le bailloit à dix sept sols à la foire de Niord, et gagnoit encore beaucoup, à cause de la tromperie qu'il auoit adioustee audit poiure. Lors ie luy demanday, pourquoy il estoit ainsi fol, et sans entendement, de tromper ainsi meschamment les marchands : mais sans aucune honte, ce meschant soustenoit, que la folie qu'il faisoit, estoit vne sagesse, et ie luy remonstray lors qu'il se damnoit, et qu'il valoit mieux estre pauure que non pas d'estre damné : mais cest insensé disoit, que les pauures n'estoyent en rien prisez, et qu'il ne vouloit estre pauure, quoy qu'il en deust aduenir : dont ie fus contraint de le laisser en sa folie. Apres i'empoignay la teste d'vn ieune homme, sans auoir esgard de quel estat il estoit, et ayant mis la teste à l'examen, ie trouuay, que la plus part d'icelle n'estoit que folie, et ayant vn peu contemplé le personnage, i'entray en dispute auec luy, en luy demandant, Frere, qui t'a meu ainsi de couper ce bon drap, que tu portes en tes chausses, et autres habillemens? sçais-tu pas bien, que c'est vne folie? mais c'est insensé me vouloit faire accroire, que les chausses ainsi coupees, dureroyent plus que les autres, ce que ne pouuois croire. Lors ie luy dis, Mon ami, asseure toy de cela, n'en doute point, que le premier qui fit decouper ses chausses, es-

toit naturellement fol : et quand au demeurant tu serois le plus sage du monde, si est-ce qu'en cest endroit, tu es imitateur, et suis l'exemple d'vn fol. Vray est qu'vne folie de longue main entretenue, est estimee sagesse : mais de ma part, ie ne puis accorder, que telle chose ne soit vne directe folie. Apres cestuy, ie vous empoignay la teste d'vne croteuse femme d'vn officier royal, sçauoir est de robe-longue, et l'ayant mise à l'examen, et auoir separé l'esprit d'auec le terrestre, ie trouuay la susdite grandement pleine de folie en sa teste, lors pensant faire deuoir de Chrestien, ie luy dis, Mamie, pourquoy est-ce que vous contrefaites ainsi vos habillemens? Ne sçauez vous pas bien, que les robes ne sont faites en Esté, que pour couurir la dissolution de la chair? et en Hyuer, pour cela mesme, et pour les froidures? et vous sçauez que tant plus les habillemens sont proches de la chair, d'autant plus ils tiennent la chaleur, aussi de tant mieux ils couurent les parties honteuses : Mais au contraire, vous auez prins vne verdugale, pour dilater vos robes, en telle sorte que peu s'en faut, que vous ne monstriez vos honteuses parties : apres luy auoir fait vne telle remonstrance, en lieu de me remercier, la sotte m'appella Huguenot : quoy voyant, ie la laissay, et prins la teste de son mary, et l'ayant examinee comme les autres, ie trouuay de grandes folies et larrecins : lors ie luy dis, Pourquoy est-ce que tu es ainsi fol, de chicaner et piller les vns et les autres? il me dist que cestoit pour entretenir ses estats, et qu'il ne pourroit auoir patience auec sa femme, s'il ne lui donnoit souuent des accoustremens nouueaux; et qu'il falloit desrober pour entretenir ses estats et honneurs. O fol, di-je, lors ta femme te fera elle mordre en la pomme, comme fit celle de nostre premier pere? il te vaudroit mieux auoir espousé vne bergere : tu n'auras point d'excuse sur ta femme, quand il faudra comparoistre deuant le siege iudicial de Dieu. Aprés cestuy, je prins la teste d'un Chanoine, et ayant fait examen de ses parties, comme dessus, ie trouuay qu'il y auoit plus de folies qu'en tous les autres. Ie luy demanday lors, Pourquoi est-ce que tu es si grand ennemi de ceux qui parlent des authoritez de l'Escriture saincte? mais iceluy respondant, dist que ne seroit qu'on le vouloit contraindre d'aller prescher en ses benefices, qu'il tiendroit la partie des protestans : mais à cause qu'il n'auoit aprins à

prescher, et qu'il auoit accoustumé auoir ses aises dés sa jeunesse, cela lui coutoit de soustenir l'Eglise Romaine : Et ie dis lors, tu es bien meschant, et tu fais de l'hypocrite deuant tes freres les autres Chanoines, qui pensent que tu soutiens, et que tu croyes directement les statuts de l'Eglise Romaine. Non, non, dit-il, il n'y en a pas un de mes compagnons qui ne confesse la verité, ne seroit la crainte de perdre leur reuenu : et qu'ainsi ne soit, il n'y a celui qui ne mange de la chair en caresme aussi bien comme moy, et quelque mine qu'ils facent, ils ne vont à la messe sinon pour conserver la cuisine, et de ce n'en faut douter : et quand n'eut esté que les bonnes gens nous vouloyent contraindre d'aller prescher, nous eussions aisément souffert les ministres, mais nostre reuenu est cause que nous faisons nos esforts pour les banir. Adonc ie pensay que ça seroit folie à moy de le vouloir admonester, attendu la response qu'il auoit faite. Lors pour sauoir si son dire contenoit vérité, i'empoignay la teste d'un Président de Chapitre, mais elle estoit terrible : car elle ne vouloit iamais endurer la coupelle, ni permettre qu'on feist aucun examen de ses affaires ; il regimboit, il batoit, il penadoit, il entroit dans une noire cholére vindicative. Quoy voyant, ie me despitay comme luy, et bon gré malgré qu'il en eust, ie le mis à l'examen et vins à séparer ses parties, savoir est, la cholere noire et pernicieuse d'un costé, l'ambition et superbité de l'autre, ie mis d'autre costé le meurtre intestin qu'il portoit contre ses haineux : brief, ie separay ainsi toutes ses parties, comme un bon alchimiste separe les matieres des metaux, et lui demanday, Ne veux-tu point laisser tes folies? Est-il pas temps de se conuertir? Quoy, dit-il, folies, il n'y a homme en ceste paroisse plus sage que moy. Ie suis, disoit-il, de la nouuelle religion quand ie veux, et entens la vérité aussi bien qu'un autre, mais ie suis sage, ie chemine selon le temps, et fais plaisir à ceux que i'aime, et me venge de ceux que ie hais : Voire, dis je, mais ce n'est pas une vie Chrestienne : car on sait bien que les prestres ne doiuent point estre paillards. Quoy, paillards, dit il, il est vray que i'ay une femme à laquelle i'ay fait plusieurs enfans, mais elle n'est point paillarde, elle est ma femme; nous sommes tous deux espousez secretement. Et ie lui dis lors, Pourquoi est-ce donc que tu persecutes et taches à faire mourir les Chrestiens?

Quoy, mourir, dit-il, i'en ai sauué plusieurs : vráy est que ceux que ie hayssois, ie n'ay espargné de les poursuiure. Quelque chose que ie peusse dire, ni faire, iamais ie ne sceus faire accroire à ce Président, qu'il ne fust homme de bien, et sage, combien que ie voyois de merueilleuses manuaisetiez en ses parties, lesquelles i'auois mises à l'examen. Après cestuy là, ie prins la teste d'un Iuge Présidial, qui se disoit estre bon seruiteur du Roy, lequel auoit grandement persécuté aucuns Chrestiens, et favorisé beaucoup de vicieux, et ayant mis sa teste à l'examen, et avoir séparé ses parties, ie trouuay qu'il s'estoit une partie engraissé d'un morceau de benefice qu'il possedoit : lors ie cogneu directement que cela estoit la cause qu'il faisoit la guerre à l'Evangile, ou à ceux qui la vouloyent exposer en lumiére. Quoy voyant, ie le laissay là comme un fol, sachant bien que je n'eusse eu aucune raison de luy, puisque sa cuisine estoit engraissée d'un tel potage. Adonc ie vins à examiner la teste et tout le corps d'un Conseiller de Parlement, le plus fin gantier qu'on eut sceu iamais voir, et ayant mis ses parties en la coupelle et fourneau d'examen, ie trouuay que dedans son ventre il y auoit plusieurs morceaux de benefice qui l'auoyent tellement engraissé que son ventre ne pouuoit plus tenir dedans ses chausses. Quand i'eus apperceu une telle chose, i'entray en dispute auec luy, en luy disant, Viens çà, es-tu pas fol ? Est-il pas ainsi, que le profit de tes bénéfices causoyent que tu faisois le procés des Chrestiens ? confesse par là que tu es un fol, ie dis plus fol que non pas Esaü, qui donna l'héritage de sa progeniture pour vne escuelle de legumes : il ne donna qu'un bien temporel, mais tu donnes un regne eternel, et prens peines eternelles pour le plaisir et délectation de ton ventre. Confesse donc que ta folie est sans comparaison plus grande que non pas celle d'Esaü. Esaü pleura son péché, ce neantmoins, il ne fut point exaucé : ie ne veux pas dire par là que si tu confesses ton iniquité, tu ne sois pardonné, mais i'ai grand peur que tu n'en feras rien, attendu que tu batailles directement contre la vérité de Dieu, que tu cognois bien. Ie n'eus pas si tost fini mon propos, que ce fol et insensé ne se mist à ses esforts de me rendre honteux et vaincu ès propos que ie luy auois tenus, et me dist à haute voix : Et en estes-vous encore là ? Si ainsi estoit que ie fusse fol pour tenir des benefices, le nombre des fols seroit bien

9

grand. Lors ie luy dis tout doucement que tous ceux qui boiuent le laict et vestissent la laine des brebis, sans les repaistre, sont maudits : et lui alleguay le passage qui est escrit en Ieremie le Prophete, Chapitre 34. Adonc il s'esleua d'une brauade et furie merueilleusement superbe, en disant : Quoy? selon ton dire, il y en auroit un bien grand nombre de damnez et maudits de Dieu : car ie say qu'en nostre Cour souueraine, et en toutes les Cours de la France, il y a bien peu de Conseillers et Présidens qui ne possédent quelque morceau de bénéfice qui aide à entretenir les dorures et accoustremens, banquets et menus plaisirs de la maison, voire pour acquester auec le temps quelque place noble, ou office de plus grand honneur et authorité. Appelles-tu cela folie ? C'est une grandissime sagesse, disoit-il : mais c'est une grand' folie que de se faire pendre ou bruler, pour soustenir les authoritez de la Bible. Item, disoit-il, ie say qu'il y a plusieurs grands Seigneurs en France, qui prennent le reuenu des benefices, toutesfois, ils ne sont pas fols, mais grandement sages : car cela aide beaucoup à entretenir leurs estats, honneurs et grasses cuisines : et par tel moyen, ils ont de bons cheuaux pour le seruice de la guerre. Quand i'eus entendu le propos de ce miserable symoniaque inueteré en sa malice, ie fus tout confus, et m'escriay en mon esprit, en esleuant les yeux en haut, et disant, O pauures Chrestiens, où en estes-vous? vous pensiez abbatre l'idolatrie et avoir gagné la partie, ie cognois à present que vous n'auiez garde de ce faire : car selon le dire de cestuy Conseiller, vous auez toutes les Cours de Parlement contre vous : et s'il est ainsi, qu'il m'a dit, vous auez aussi plusieurs grands seigneurs qui prennent profit du reuenu des benefices, et tandis qu'ils sont repus d'un tel bruuage, il faut que vous esperiez qu'ils seront touiours vos ennemis capitaux et mortels. Parquoy, je suis d'avis que vous retourniez à vostre premiere simplicité, vous asseurant que vous aurez des ennemis et serez persecuté tout le temps de vostre vie, si par lignes directes, vous voulez suiure et soustenir la querelle de Dieu : car telles sont les promesses originalement escrites au vieux et nouueau testament. Ayez donc vostre refuge à vostre chef, protecteur, et capitaine notre seigneur Jésus Christ, lequel en temps et lieu, saura trés bien venger l'iniure qui luy aura esté faite, et en cas pareil la vostre.

L'Histoire.

Apres que i'eu apperceu les folies et malices des hommes, et consideré les horribles esmotions et guerres, qui ont esté cette annee par tout le Royaume de France, ie pensay en moy-mesme de faire le dessein de quelque Ville ou Cité de refuge, pour se retirer és temps des guerres et troubles, à fin d'obuier à la malice de plusieurs horribles et insensez saccageurs, ausquels i'ay par cy deuant veu executer leurs rages furieuses, contre vne grande multitude de familles, sans auoir esgard à la cause iuste ou iniuste, et mesme sans aucune commission ne mandement.

Demande.

Il semble à t'ouyr parler, que tu ne t'asseures pas de la paix qu'il a pleu à Dieu nous enuoyer, et que tu as encore quelque crainte d'vne esmotion populaire.

Responce.

Ie prie à Dieu, qu'il luy plaise nous donner sa paix, mais si tu auois veu les horribles desbordemens des hommes, que i'ay veu durant ces troubles, tu n'as cheueux en la teste, qui n'eussent tremblé, craignant de tomber à la mercy de la malice des hommes. Et celuy qui n'a veu ces choses, il ne sçauroit iamais penser, combien la guerre est grande et horrible. Ie ne m'esmerueille pas, si le Prophete Dauid aima mieux eslire la peste, que non pas la famine et la guerre, en disant, que s'il auoit la peste, il seroit à la mercy de Dieu, mais qu'en la guerre, il seroit à la mercy des hommes, qui fut la cause, que Dieu estendit ses verges seulement sur son peuple, et non pas sur luy, parce qu'il estoit submis sous sa misericorde, et auoit directement confessé sa faute. Voila pourquoy ie te puis asseurer, que c'est vne chose horriblement à craindre, que de tomber sous la mercy des hommes pernicieux et meschans.

Demande.

Ie te prie, me dire comment aduint ce divorce en ce pays de Xaintonge : car il me semble, qu'il seroit bon de le mettre par escrit, à fin qu'il en demeurast vne perpetuelle memoire, pour seruir à ceux qui viendront apres nous.

Responce.

Tu sais qu'il y aura plusieurs historiens, qui s'employeront à cest affaire, toutesfois pour mieux descrire la verité, ie trouuerois bon, qu'en chacune Ville, il y eust personnes deputees,

pour escrire fidelement les actes qui ont esté faits durant ces troubles : et par tel moyen, la verité pourroit estre réduite en vn volume, et pour ceste cause, ie m'en vay commencer à t'en faire un bien petit narré, non pas du tout, mais d'vne partie du commencement de l'Eglise reformee.

Tu dois entendre, que tout ainsi que l'Eglise primitiue fut erigee d'vn bien petit commencement, et auec plusieurs perils, dangers et grandes tribulations, aussi sur ces derniers iours, la difficulté et dangers, peines, trauaux et afflictions ont esté grandes en ce pays de Xaintonge. Ie dis de Xaintonge, parce que ie laisseray és habitans d'vn autre Diocese, d'en escrire ce qu'ils en sauent à la verité. Il aduint l'an 1546, qu'aucuns Moines ayans esté quelques iours és parties d'Allemagne, ou bien ayans leu quelques liures de leur doctrine, et se trouuans abusez, ils prindrent la hardiesse assez couuertement, de descouurir quelques abus, mais soudain que les Prestres et beneficiers entendirent qu'ils detractoyent de leurs coquilles, ils inciterent les iuges de leur courir sus : ce qu'ils faisoyent de bien bonne volonté, à cause qu'aucuns d'eux possedoyent quelque morceau de benefice, qui aidoit à faire bouillir le pot. Par ce moyen, aucuns desdits Moines estoyent contrains s'en fuyr, s'exiler, et se desfroquer, craignans qu'on les feist mourir de chaud. Les vns se faisoyent de mestier, les autres regentoyent en quelque village, et parce que les isles d'Olleron, de Marepnes, et d'Alleuert, sont loin des chemins publics, il se retira en ces isles là quelque nombre desdits moines, ayans trouué diuers moyens de viure, sans estre cogneus : et ainsi qu'ils frequentoyent les personnes, ils se hazardoyent de parler couuertement, iusques à ce qu'ils fussent bien asseurez qu'on n'en diroit rien. Et apres que par tel moyen ils eurent reduit quelque quantité de personnes, ils trouuerent moyen d'obtenir la chaire, parce qu'en ces iours là, il y auoit un grand Vicaire, qui les fauorisoit tacitement : dont s'en ensuiuit, que petit à petit en ces pays et isles de Xaintonge, plusieurs eurent les yeux ouuers, et cogneurent beaucoup d'abus qu'ils auoyent auparauant ignorez, qui fut cause, que plusieurs eurent en grande estime lesdits Predicateurs, combien que pour lors ils descouuroyent les abus assez maigrement. Il y eut en ces iours là vn nommé Collardeau, Procureur fiscal, homme peruers, et de mauuaise vie,

qui trouua moyen d'aduertir l'Euesque de Xaintes, qui estoit pour lors à la Cour, luy faisant entendre que tout estoit plein de Lutheriens, et qu'il luy donnast charge et commission pour les extirper, et non seulement luy escrivit plusieurs fois, mais aussi se transporta iusques audit lieu. Il feit tant par ces moyens, qu'il obtint vne commission de l'Euesque, et du Parlement de Bourdeaux, auec vne bonne somme de deniers, qui lui furent taxez par ladite Cour. Cela faisoit-il pour le guain, et non pour le zele de la Religion. Quoy fait, il pratiqua certains iuges, tant en l'isle d'Olleron, que d'Alleuert, et pareillement à Gimosac, et ayant aposté ces iuges, il feit prendre le Prescheur de saint Denis, qui est au bout de l'isle d'Olleron, nommé frere Robin, et tout par vn moyen, le feit passer en l'isle d'Alleuert, où il en print vn autre nommé Nicole, et quelques iours apres, il print aussi celuy de Gimosac, qui tenoit eschole, et preschoit les Dimanches, estant fort aimé des habitans : et combien que ie pense qu'ils soyent escrits au liure des Martyrs, ce neantmoins, parce que ie say la verité de certains faicts insinuez, i'ay trouué bon les escrire, qui est, qu'eux ayans bien disputé, et soustenu leur Religion en la presence d'vn Nauieres, Theologien, Chanoine de Xaintes, qui autresfois auoit commencé à descouurir les abus, toutesfois, parce que le ventre l'auoit gagné, il soustenoit du contraire, comme très-bien les pauures captifs luy sauoyent reprocher en son visage. Quoy qu'il en fut, ces pauures gens furent condamnez à estre desgraduez, et vestus d'accoustremens verds, à fin que le peuple les estimast fols ou insensez : et qui plus est, parce qu'ils soustenoyent virilement la querelle de Dieu, ils furent bridez comme cheuaux par ledit Collardeau, auparauant que d'estre menez sur l'eschafaut, esquelles brides y avoit en chacune vne pomme de fer, qui leur emplissoit tout le dedans de leurs bouches, chose fort hideuse à voir : et estans ainsi desgraduez, ils les retournerent en prison, pour les mener à Bourdeaux, à fin de les condamner à mourir : mais entre les deux, il aduint un cas admirable, sauoir est, que celuy à qui on vouloit le plus de mal, lequel on pensoit faire mourir le plus cruellement, ce fut celuy qui leur eschappa, et sortit des prisons par vn moyen admirable : car pour se donner garde de de luy, ils auoyent mis vn certain personnage sur les degrez

d'vne auiz près des prisons, pour escouter s'il se feroit quelque brisure : aussi on auoit eu des grans chiens des villages qu'vn grand Vicaire auoit amené, ausquels on auoit donné le large de la court de l'Euesché, à fin qu'ils abboyassent, si les prisonniers venoyent à sortir. Nonobstant toutes ces choses, frere Robin lima les fers qu'il auoit aux iambes, et les ayans limez, il bailla les limes à ses compagnons : et ce fait, il perça les murailles qui estoyent de bonne massonnerie, mais il aduint vn cas estrange, c'est que d'auenture il y auoit plusieurs barriques appilees l'vne sur l'autre, au deuant de ladite muraille, lesquelles barriques estans poussees à bas, menerent vn grand bruit, qui furent cause, que le portier se leua, et ayant long temps escouté, s'en retourna coucher : et ainsi ledit frere Robin sortit en la court, à la merci des chiens, toutesfois Dieu l'auoit inspiré d'auoir prins du pain, et quand il fut en la court, il le ietta ausdits chiens, qui eurent la gueule close, comme les Lions de Daniel. Or il faut noter, que ledit Robin n'auoit iamais esté en ceste Ville cy de Xaintes : pour ceste cause, estant en la court de l'Euesché, il estoit encore enfermé, mais Dieu voulut qu'il trouua une porte ouuerte, qui se rendoit au iardin, auquel il entra, et se trouuant de rechef enfermé de certaines murailles bien hautes, il apperceut à la clarté de la lune vn certain Poirier, qui estoit assez pres de ladite muraille, et estant monté audit Poirier, il apperceut par le dehors de ladite muraille vn fumier, sur lequel il pouuait assez aisement sauter. Quoy voyant, il s'en retourna és prison, pour sauoir si quelqu'vn de ses compagnons auroit limé ses fers : mais voyant que non, il les consola, et exhorta à batailler virilement, et à prendre patiemment la mort, et en les embrassant, print congé d'eux, et s'en alla derechef monter sur le Poirier et de là sauta sur les fumiers de la rue, mais ce fut vne chose tres merueilleuse, procedante de la prouidence Diuine, comment ledit Robin peut eschapper le second danger : car parce qu'il n'auoit iamais esté en la Ville, il ne sauoit à qui se retirer : mais parce qu'il auoit esté malade d'vne pleuresie és prisons, et qu'on luy auoit donné vn Medecin, et vn Apoticaire, ledit Robin couroit par les rues, en s'enquerant dudit Medecin et Apoticaire, desquels il auoit retenu le nom : mais en ce faisant, il alla tabourner en plusieurs portes des plus grands de ses ennemis, et entre les au-

tres, à la porte d'vn Conseiller, qui fit diligence le lendemain pour sauoir de ses nouuelles, et promettoit cinquante escus de la part du grand Vicaire nommé Selliere, à celuy qui donneroit moyen de prendre ledit Robin. Iceluy donc frappant par les portes à l'heure de minuict, auoit diuinement pourueu à son affaire : car il auoit troussé son habit sur ses espaules, et auoit attaché son enferge (sa chaine) en vne de ses iambes, et par tel moyen, ceux qui sortoyent aux fenestres, pensoyent que ce fust vn laquay. Il fit si bien, qu'il se sauua en quelque maison, et de là fut en mesme heure conduit hors la Ville, ce qui aduint au mois d'Aoust dudit an : mais ses deux compagnons furent bruslez, l'vn en ceste Ville de Xaintes, et l'autre à Libourne, à cause que le Parlement de Bourdeaux s'en estoit là fuy, pour raison de la peste, qui estoit lors en la ville de Bourdeaux, et moururent les susdits maistre Nicole et ses compagnons l'an 1546. au mois d'Aoust, endurans la mort fort constamment. L'Euesque, ou ses Conseillers, s'auisèrent en ce temps-là d'vne ruse et finesse grandement subtile : car ayans obtenu quelque mandement du Roy, pour couper vn grand nombre de forests, qui estoyent à l'entour de ceste Ville, toustefois, parce que plusieurs auoyent leur iouyssance des bois et pasturages esdites forets, ils ne vouloyent permettre qu'elles fussent abatues : mais ceux-cy, suiuans les ruses Mahometistes, s'auiserent de gagner le cœur du peuple par predications et presens faits au gens du Roy, et enuoyerent en ceste ville de Xaintes, et autres Villes du Diocese certains moines Sorbonistes, qui escumoyent, bauoyent, se tormentoyent et viroyent, faisans gestes et grimaces estranges, et tous leurs propos n'estoyent que crier contre ces Chrestiens nouueaux, et aucunesfois ils exaltoyent leur Euesque, en disant qu'il estoit descendu du precieux sang de Monseigneur sainct Louys (1), et par tel moyen, le pauure peuple souffroit patiemment que tous leurs bois fussent coupez : et les bois estans ainsi coupez, il n'y eut plus de Predicateurs : voila comment le peuple fut deceu en ses biens, et pareillement en ses esprits. Par là tu peux aisement iuger, quel pouuoit estre l'estat de l'Eglise reformee, laquelle n'auoit encore aucune apparence d'Eglise,

(1) Cet évêque était, en effet, Charles, cardinal de Bourbon, frère d'Antoine, Roi de Navarre, que les Ligueurs reconnurent un moment Roi de France, sous le nom de Charles X.

sinon aucuns, qui tacitement, et auec crainte detractoyent de la Papauté. Il y eut quelque temps apres, l'an 1557. qu'vn nommé maistre Philebert Hamelin, qui auoit esté autresfois prisonnier en ceste Ville, et prins par le même Collardeau, se transporta derechef en ceste Ville de Xaintes, et parce qu'il auoit demeuré à Geneue vn bien long temps depuis son emprisonnement, et ayant augmenté audit Geneue de Foy et de doctrine, il auoit tousiours un remords de conscience, de ce qu'il auoit dissimulé en sa confession faite en ceste Ville, et voulant reparer sa faute, il s'efforçoit partout où il passoit d'inciter les hommes d'auoir des Ministres, et de dresser quelque forme d'Eglise, et s'en alloit ainsi par le pays de France, ayant quelques seruiteurs qui vendoyent des Bibles, et autres liures imprimez en son Imprimerie : car il s'estoit desprestré et fait Imprimeur. En ce faisant, il passoit quelque fois par ceste ville, et alloit aussi en Alleuert. Or il estoit si iuste, et d'vn si grand zele, que combien qu'il fust homme assez mal portatif, il ne voulut iamais prendre de cheuaux, encore que plusieurs l'en requeroyent d'vne bonne affection. Et combien qu'il eust bien de quoy moyennement, si est-ce qu'il n'auoit aucune espee à sa ceinture : ains seulement vn simple baston en la main, et s'en alloit ainsi tout seul, sans aucune crainte. Or aduint un iour, apres qu'il eut fait quelques prieres et petites exhortations en ceste ville, ayant au plus sept ou huit auditeurs, il print son chemin, pour aller en Alleuert, et deuant que partir, il pria le petit troupeau de l'assemblee, de se congreger, de prier et s'exhorter l'vn l'autre : et ainsi, s'en alla en Alleuert, tendant à fin de gagner le peuple à Dieu, et là estant recueilli benignement, par la plus grand' partie du peuple, fit certains presches au son de la cloche, et baptisa vn enfant. Quoy voyant les Magistrats de ceste ville, contraindrent l'Euesque d'exhiber deniers, pour faire la suite (poursuivre) dudit Philebert, auec cheuaux, gens-d'armes, cuisiniers et viuandiers. L'Euesque et certains Magistrats de ceste ville se transporterent au lieu d'Alleuert, là où ils firent rebaptiser l'enfant qui auoit esté baptisé par ledit Philebert, et ne le pouuans là attraper, ils le suiuirent à la trace, iusques à ce qu'ils l'eurent trouué en la maison d'vn Gentil-homme, et ainsi, l'amenerent en ceste ville comme mal-faicteur, és prisons criminelles, combien que ses œuures rendent certain tesmoignage

qu'il estoit enfant de Dieu, et directement esleu. Il estoit si parfait en ses œuures, que ses ennemis estoyent contraints de confesser qu'il estoit d'vne vie saincte, toutesfois sans approuuer sa doctrine. Ie suis tout esmerueillé, comment les hommes ont osé assoir iugement de mort sur luy, veu qu'ils sauoyent bien, et auoyent entendu sa saincte conuersation : car ie suis asseuré, et le puis dire à la verité, que deslors qu'il fut amené és prisons de Xaintes, ie prins la hardiesse (combien que les iours fussent perilleux en ce temps là) d'aller remonstrer à six des principaux Iuges et Magistrats de ceste ville de Xaintes, qu'ils auoyent emprisonné vn Prophete, ou Ange de Dieu, enuoyé pour annoncer sa Parole, et iugement de condamnation aux hommes sur le dernier temps, leur asseurant, qu'il y auoit onze ans, que ie cognoissois ledit Philebert Hamelin d'vne si saincte vie, qu'il me sembloit, que les autres hommes estoyent diables au regard de luy. Il est certain, que les Iuges vserent d'humanité en mon endroit, et m'escouterent benignement : aussi parlois-ie à vn chacun d'eux estant en sa maison. Finalement ils traitterent assez benignement ledit maistre Philebert, toutesfois ils ne se peuuent excuser qu'ils ne soyent coulpables de sa mort. Vray est qu'ils ne le tuerent pas non plus que Pilate et Iudas Iesus Christ, mais ils le liurerent entre les mains de ceux qu'ils sauoyent bien qu'ils le feroyent mourir. Et pour mieux paruenir à un laue-main, pour s'en descharger, ils s'auiserent qu'il auoit esté Prestre en l'Eglise Romaine, parquoy l'enuoyerent à Bourdeaux auec bonne et seure garde par vn Preuost des Mareschaux : veux-tu bien cognoistre comment ledit Philebert estoit de saincte vie ? on luy donnoit liberté d'estre en la chambre du Geolier, et de boire et manger à sa table, ce qu'il fit, pendant qu'il estoit en ceste Ville : mais apres que par plusieurs iours il eut travaillé, et prins peine de reprimer les ieux et blasphemes qui se commettoyent en la chambre du Geolier, il fut si desplaisant, voyant qu'ils ne se vouloyent corriger, que pour obuier à entendre un tel mal, soudain qu'il auoit disné, il se faisoit mener en vne chambre criminelle, et estoit là tout le long du iour tout seul, pour obuier les compagnies mauuaises. Item, veux-tu encore mieux sauoir, combien il cheminoit droitement ? Luy estant en prison suruint un Aduocat du pays de France, de quelque lieu où il auoit erigé vne petite Eglise, lequel Aduocat apporta trois

cents liures, qu'il presenta au Geolier, pourueu qu'il voulust de nuict mettre ledit Philebert hors des prisons. Quoy voyant le Geolier, fut presque incité à ce faire, toutesfois il demanda conseil audit maistre Philebert, lequel respondant, luy dist, qu'il valoit mieux qu'il mourust par la main de l'executeur, que de le mettre en peine pour luy. Quoy sachant ledit Aduocat, rapporta son argent : ie te demande, Qui est celuy de nous, qui voudroit faire le semblable, estant à la merci des hommes ennemis, comme il estoit? Les Iuges de ceste Ville sauoient bien qu'il estoit de saincte vie, toutesfois ils l'ont fait pour crainte de perdre leurs offices, ainsi le faut-il entendre. Ie fus bien aduerti, que cependant que ledit Philebert estoit és prisons de ceste Ville, qu'il y eut vn personnage, qui parlant dudit Philebert, dist à vn Conseiller de Bourdeaux : On vous amenera vn de ces iours vn prisonnier de Xaintes, qui parlera bien à vous, Messieurs : mais le Conseiller en blasphemant le nom de Dieu, iura qu'il ne parleroit pas à luy, et qu'il se donneroit bien garde d'assister à son iugement. Ie te demande, ce Conseiller se disoit estre Chrestien, il ne vouloit pas condamner le Iuste ; toutesfois, puisqu'il estoit constitué Iuge, il n'aura point d'excuse : car puis qu'il sauoit que l'autre estoit homme de bien, il deuoit de son pouuoir s'opposer au iugement de ceux qui par ignorance, ou par malice le condamnerent, liurerent, et firent pendre comme vn larron, le 18. d'Auril de l'an susdit. Quelque temps auparauant la prise dudit Philebert, il y eut en ceste Ville vn certain artisan, pauure et indigent à merueilles, lequel auoit vn si grand desir de l'auancement de l'Euangile, qu'il le demonstra quelque iour à vn autre artisan aussi pauure que luy, et d'aussi peu de sauoir, car tous deux n'en sauoyent guere : toutesfois le premier remonstra à l'autre, que s'il vouloit s'employer à faire quelque forme d'exhortation, ce seroit la cause d'vn grand fruit : et combien que le second se sentoit totalement desnué de sauoir, cela luy donna courage : et quelques iours apres, il assembla vn Dimanche au matin neuf ou dix personnes, et parce qu'il estoit mal instruit és lettres, il auoit tiré quelques passages du vieux et nouueau Testament, les ayans mis par escrit. Et quand ils furent assemblez, il leur lisoit les passages ou authoritez, en disant, Qu'vn chacun selon ce qu'il a receu de dons, qu'il faut qu'il les distribue aux autres, et que tout arbre

qui ne fera point de fruit, sera coupé et ietté au feu : aussi il lisoit vne autre authorité prise au Deuteronome, là où il est dit, Vous annoncerez ma Loy en allant, en venant, en buuant, en mangeant, en vous couchant, en vous leuant, et estant assis en la voye : il leur proposoit aussi la similitude des talens, et vn grand nombre de telles authoritez, et ce faisoit-il tendant à deux bonnes fins, la premiere estoit, pour monstrer qu'il appartient à toutes gens de parler des statuts et ordonnances de Dieu, et à fin qu'on ne mesprisast sa doctrine, à cause de son abiection : la seconde fin, estoit à fin d'inciter certains auditeurs, de faire le semblable : car en ceste mesme heure, ils conuindrent ensemble, que six d'entr'eux exhorteroyent par hebdomade, sauoir est, vn chacun de six en six semaines, les Dimanches seulement. Et parce qu'ils entreprenoyent vn affaire, auquel ils n'auoyent jamais été instruits, il fut dit, qu'ils mettroyent leurs exhortations par escrit, et les liroyent deuant l'assemblee : or toutes ces choses furent faites par le bon exemple, conseil et doctrine de maistre Philebert Hamelin. Voila le commencement de l'Eglise reformee de la ville de Xaintes. Ie m'asseure, qu'il y a eu au commencement telle assemblee, que le nombre n'estoit que de cinq seulement, et pendant que l'Eglise estoit ainsi petite, et que ledit maistre Philebert estoit en prison, il arriua en ceste Ville vn Ministre nommé de la Place, lequel auoit esté enuoyé, pour aller prescher en Alleuert : mais ce mesme iour, le Procureur dudit Alleuert se trouua en ceste Ville, qui certifia, qu'il y seroit fort mal venu, à cause de ce Baptesme, que maistre Philebert auoit fait, parce qu'on auoit condamné plusieurs assistans à fort grandes amendes, qui fut le moyen, que nous priasmes ledit de la Place, de nous administrer la Parole de Dieu, et fut receu pour nostre Ministre, et demeura iusques à ce que nous eusmes Monsieur de la Boissiere, qui est celuy que nous auons encore à present : mais c'estoit vne chose pitoyable, car nous auions bon vouloir, mais le pouuoir d'entretenir les Ministres n'y estoit pas, veu que de la Place pendant le temps que nous l'eusmes, il fut entretenu vne partie aux despens des Gentilshommes, qui l'appeloyent souuent, mais craignans que cela ne fust le moyen de corrompre nos ministres, on conseilla à Monsieur de la Boissiere de ne partir de la Ville sans congé, pour seruir à la noblesse, veu qu'aussi il y eut vrgent affaire. Par tel

moyen, le pauure homme estoit reclos comme vn prisonnier, et bien souuent mangeoit des pommes, et buuoit de l'eau à son disner, et par faute de nape, il mettoit bien souuent son disner sur vne chemise, parce qu'il y auoit bien peu de riches qui fussent de nostre assemblee, et si n'auions pas de quoy luy payer ses gages. Voila comment nostre Eglise a esté erigee au commencement par gens mesprisez : et alors que les ennemis d'icelle la vindrent saccager et persecuter, elle auoit si bien profité en peu d'annees, que desia les ieux, danses, ballades, banquets et superfluitez de coiffures et dorures, auoyent presque toutes cessé : il n'y auoit plus guere de paroles scandaleuses, ni de meurtres. Les proces commençoyent grandement à diminuer : car soudain que deux hommes de la Religion estoyent en proces, on trouuoit moyen de les accorder : et mesme bien souuent, deuant que commencer aucun proces, vn homme n'y eust point mis vn autre, que premierement il ne l'eust fait exhorter à ceux de la Religion. Quand le temps s'approchoit de faire ses Pasques, plusieurs haines, dissensions et querelles estoyent accordees : il n'estoit question que de Pseaumes, Prieres, Cantiques et Chansons spirituelles, et n'estoit plus question de Chansons dissolues ni lubriques. L'Eglise auoit si bien profité, que mesme les Magistrats auoyent policé plusieurs choses mauuaises, qui dependoyent de leurs authoritez. Il estoit defendu aux Hosteliers de ne tenir ieux, ni de donner à boire et à manger à gens domiciliez, à fin que les hommes desbauchez se retirassent en leurs familles. Vous eussiez veu en ces iours là és Dimanches, les compagnons de mestier se pourmener par les prairies, boscages, ou autres lieux plaisans, chantans par troupes Pseaumes, Cantiques et Chansons spirituelles, lisans et s'instruisans les vns les autres. Vous eussiez aussi veu les filles et vierges assises par troupes és iardins et autres lieux, qui en cas pareil se délectoyent à chanter toutes choses sainctes : d'autre part, vous eussiez veu les pedagogues, qui auoyent si bien instruit la ieunesse, que les enfans estoyent tellement enseignez, que mesme il n'y auoit plus de geste puerile, ains une constance virile. Ces choses auoyent si bien profité, que les personnes auoyent changé leurs manieres de faire, mesme iusques à leurs contenances. L'Eglise fut erigee au commencement auec grande difficulté et eminens perils : nous estions blasmez et vituperez de calomnies peruerses

et meschantes. Les vns disoyent, si leur doctrine estoit bonne, ils prescheroyent publiquement : les autres disoyent, que nous nous assemblions pour paillarder, et qu'en nos assemblees, les femmes estoyent communes : les autres disoyent, que nous allions baiser le cul au diable, auec de la chandelle de rosine. Nonobstant toutes ces choses, Dieu fauorisa si bien nostre affaire, que combien que nos assemblees fussent le plus souuent à plein minuit, et que nos ennemis nous entendoyent souuent passer par la ruë, si est-ce que Dieu leur tenoit la bride serree en telle sorte, que nous fusmes conseruez sous sa protection, et lors que Dieu voulut que son Eglise fut manifestee publiquement, et en plein iour, il fit en nostre ville vn œuure admirable, car il fut enuoyé à Tolose deux des principaux chefs, lesquels n'eussent voulu permettre nos assemblees estre publiques, qui fut la cause, que nous eusmes la hardiesse de prendre la halle. Ce que nous n'eussions seu faire, sans grands scandales, si lesdits chefs eussent esté en la ville. Et qu'ainsi ne soit, tu ne peus nier, que depuis ces troubles, ils ne se soyent totalement appliquez à rabaisser, ruyner, et anichiler, enfoncer et abysmer la petite nasselle de l'Eglise reformee. Par là, ie puis aisement iuger, que Dieu les a tenus l'espace de deux annees, ou enuiron à Tolose, à fin qu'ils ne nuisissent à son Eglise, durant le temps qu'il la vouloit manifester publiquement : combien que l'Eglise eut de grans ennemis, toutesfois elle fleurit en telle sorte en peu d'annees, que mesme les ennemis d'icelle, à leur tres-grand regret estoyent contraints de dire bien de nos ministres, et singulierement de Monsieur de la Boissiere, parce que sa vie les redarguoit, et rendoit bon tesmoignage de sa doctrine. Or aucuns Prestres commençoyent d'assister aux assemblees, à estudier, et prendre conseil de l'Eglise : mais quand quelqu'vn de l'Eglise faisoit quelque faute, ou tort à quelqu'vn des aduersaires, ils sauoyent tres-bien dire, Vostre ministre ne vous a pas conseillé de faire ce mal : et ainsi, les ennemis de l'Euangile auoyent la bouche close, et combien qu'ils eussent en haine les ministres, ils n'osoyent mesdire d'eux, à cause de leur bonne vie. En ces iours là, les prestres et moines furent blasmez du commun : sauoir est, des ennemis de la Religion, et disoyent ainsi, les Ministres font des prieres, que nous ne pouuons nier qu'elles ne soyent bonnes : pourquoy est-ce que vous ne fai-

tes le semblable? Quoy voyant Monsieur le Theologien du Chapitre se print à faire les prieres, comme les Ministres: aussi firent les moines qu'ils auoyent à gages pour leur Predication : car s'il y auoit vn fin frere, mauuais garçon, et subtil argumentateur de moine en tout le pays, il faloit l'auoir en l'Eglise Cathedrale. Voila comment en ces iours là, il y auoit prieres en la ville de Xaintes tous les iours d'vne part et d'autre. Veux-tu bien cognoistre, comment les Ecclesiastiques Romains faisoyent lesdites prieres par hypocrisie et malice? Regarde vn peu, ils n'en font plus à present, ni n'en faisoyent au parauant la venue des Ministres : Est-il pas aisé à iuger, que ce qu'ils en faisoyent, estoit seulement pour dire, ie say faire cela aussi bien comme les autres? Quoy qu'il en soit, l'Eglise profita si bien alors, que les fruits d'icelle demeureront a iamais : et ceux qui ont esperance de voir l'Eglise abbatue et anichilee, seront confus, car puis que Dieu l'a garentie lors qu'ils n'estoyent que trois ou quatre pauures gens mesprisez, combien plus auiourd'huy aura-t-il soin d'vn grand nombre? Ie ne doute pas qu'elle ne soit tormentee : cela nous doit estre tout resolu, puis qu'il est escrit: mais ce ne sera pas selon la mesure et desir de ses ennemis. Plusieurs gens des villages en ces iours là demandoyent des Ministres à leurs Curez ou fermiers, ou autrement, ils disoyent qu'ils n'auroyent point de dismes : cela faschoit plus les prestres, que nulle autre chose, et leur estoit fort estrange. En ce temps là furent faits des actes assez dignes de faire rire et pleurer tout à vn coup : car aucuns fermiers ennemis de la Religion, voyans telles nouuelles, s'en alloyent aux Ministres, pour les prier de venir exhorter le peuple, d'où il estoyent fermiers : et ce, à fin d'estre payez des dismes. Quand ils ne pouuoyent finir de Ministres, ils demandoyent des anciens. Ie ne ris iamais de si bon courage, toutesfois en pleurand, quand i'ouy dire, que le Procureur qui estoit Greffier criminel, lors qu'on faisoit les proces de ceux de la Religion, auoit luy-mesme fait les prieres vn peu au parauant le saccagement de l'Eglise en la Parroisse d'où il estoit fermier : à sauoir si lors qu'il faisoit luy-mesme les prieres, il estoit meilleur Chrestien, que quand il escriuoit les proces contre ceux de la Religion : certes autant bon Chrestien estoit-il, lorsqu'il escriuoit les proces, comme quand il faisoit les prieres, attendu

qu'il ne les faisoit, que pour auoir les gerbes et fruits des laboureurs. Le fruit de nostre petite Eglise auoit si bien profité, qu'ils auoyent contraint les meschans d'estre gens de bien : toutesfois leur hypocrisie a esté depuis amplement manifestee et cogneuë : car lors qu'ils ont eu liberté de mal faire, ils ont monstré exterieurement ce qu'ils tenoyent caché dedans leurs miserables poitrines : ils ont fait des actes si miserables, que i'ay horreur seulement de m'en souuenir, au temps qu'ils s'esleuerent pour dissiper, abysmer, perdre et destruire ceux de l'Eglise reformee. Pour obuier à leurs tyrannies horribles et execrables, ie me retiray secretement en ma maison, pour ne voir les meurtres, reniemens, et destroussemens qui se faisoyent és lieux champestres : et estant retiré en ma maison l'espace de deux mois, il m'estoit auis, que l'enfer auoit esté desfonsé, et qué tous les esprits diaboliques estoyent entrez en la ville de Xaintes : car au lieu que i'entendois vn peu au parauant Pseaumes, Cantiques, et toutes paroles honnestes d'edification et bon exemple, ie n'entendois que blasphemes, bateries, menaces, tumultes, toutes paroles miserables, dissolution, chansons lubriques et detestables, en telle sorte, qu'il me sembloit que toute la vertu et saincteté de la terre estoit estouffee et esteinte : car il sortit certains diabletons du Chasteau de Taillebourg, qui faisoyent plus de mal, que non pas ceux qui estoyent diables d'ancieneté. Eux entrans en la ville, accompagnez de certains prestres, ayans l'espee nue au poing, crioyent, Où sont-ils? il faut couper gorge tout à main, et faisoyent ainsi des mouuans, sachans bien, qu'il n'y auoit aucune resistance : car ceux de l'Eglise reformee s'estoyent tous absentez : toutesfois pour faire des mauuais, ils trouuerent vn Parisien en la rue, qui auoit bruit d'auoir de l'argent : ils le tuerent, sans auoir aucune resistance, et en vsant de leur mestier accoustumé, le mirent en chemise deuant qu'il fust acheué de mourir. Apres cela, ils s'en allerent de maison en maison, prendre, piller, saccager, gourmander, rire, moquer et gaudir auec toutes dissolutions, et paroles de blasphemes contre Dieu et les hommes : et ne se contentoyent pas seulement de se moquer des hommes, mais aussi se moquoyent de Dieu : car ils disoyent, que Agimus auoit gagné Pere eternel. En ce iour là, il y auoit certains personnages és prisons, que quand les pages des Chanoines passoyent par de-

uant lesdites prisons, ils disoyent en se moquant, Le Seigneur vous assistera, et luy disoyent encore, or dites à present, Reuenge moy, pren la querelle : et plusieurs autres en frapant d'vn baston, disoyent, Le Seigneur vous bénie. Ie fus grandement espouuanté l'espace de deux mois, voyant que les portefaix, et belistreaux estoyent deuenus seigneurs aux despens de ceux de l'Eglise reformee : ie n'auois tous les iours autre chose que rapports des cas espouuantables qui de iour en iour s'y commettoyent, et de tout ce que ie fus le plus desplaisant en moy-mesme, ce fut de certains petis enfans de la Ville, qui se venoyent iournellement assembler en vne place pres du lieu où i'estois caché (m'exerçant toutesfois à faire quelqu'œuure de mon art), qui se diuisans en deux bandes, et iettans des pierres les vns contre les autres, iuroyent et blasphemoyent le plus execrablement, que iamais homme ouyt parler : car ils disoyent, par le sang, mort, teste, double teste, triple teste, et des blasphemes si horribles, que i'ay quasi horreur de les escrire : or cela dura assez long temps, sans que les peres ni meres, y missent aucune police. Il me prenoit souuent enuie de hazarder ma vie, pour en faire la punition ; mais ie disois en mon cœur le pseaume 79, qui se commence, Les gens entrez sont en ton heritage. Ie say que plusieurs Historiens descriront les choses plus au long, toutesfois, i'ay bien voulu dire ceci en passant, parce que durant ces iours mauuais, il y auoit bien peu de gens de l'Eglise reformee en ceste Ville.

DE LA VILLE DE FORTERESSE (1).

Quelque temps apres que i'eu consideré les horribles dangers de la guerre, desquels Dieu m'auoit merueilleusement deliuré, il me print enuie de designer et pourtraire l'ordonnance de quelque Ville, en laquelle on peust estre asseuré au temps de guerre : mais considerant les furieuses batteries, desquelles auiourd'huy les hommes s'aident, i'estois presque hors d'esperance, et estois tous les iours la teste baissee, craignant de voir quelque chose, qui me fist oublier les choses que ie voulois penser : car mon esprit voltigeoit tantost en vne Ville, et tantost en l'autre, en me trauaillant, pour rememorer les forces d'icelles, et sçauoir, si ie me pourrois aider en partie de l'ordonnance d'icelles, pour seruir à mon dessein : mais ie trouuay en toutes, vne maniere de faire fort contraire à mon opinion : car les habitans les fortifient, en rompant les maisons, qui sont ioignant les murailles de la cloison de la Ville, et font de grandes allees entre les maisons et lesdites murailles : et cela, disent-ils, estre necessaire, pour batailler, defendre et trainer toute espece d'engin et artillerie : mais ie trouuay aussi, que c'estoit pour faire tuer beaucoup d'hommes, et n'ay iamais sceu persuader en mon esprit, qu'vne telle inuention fust bonne : et m'asseure, que si du temps que les colomnes furent inuentees, l'artillerie eust regné comme elle fait à present, que nos anciens edificateurs n'eussent point edifié les Villes auec separation des maisons aux mu-

(1) C'était avant l'usage des bombes et des mines, que Palissy imagina sa ville imprenable ; c'est-à-dire avant les Stevin, les Pagan, les Vauban et les Cohorn. Son génie, relatif aux circonstances de son siècle, suppose, dans l'homme qui traça ce plan, de ces dispositions qui rendent les grands génies supérieurs à leurs contemporains, et qui, dans tous les temps, auraient profité des découvertes nouvelles pour appartenir à tous les siècles. Les ingénieurs remarqueront ce qu'était leur art, en 1563, pour juger Palissy. (G.)

railles. Et quoy? en temps de Paix les murailles sont inutiles, quelques grands thresors et labeurs qui y ayent esté employez. Ayant donc consideré ces choses, ie trouuay, que lesdites Villes ne me pouuoient seruir d'aucun exemplaire, veu que quand les murailles sont gagnees, la ville est contrainte se rendre. Voila bien vn pauure corps de Ville quand les membres ne se peuuent consolider, et aider l'vn l'autre. Brief, toutes telles Villes sont mal designees, attendu que les membres ne sont point concathenez auec le corps principal. Il est fort aisé de battre le corps, si les membres ne donnent aucun secours. Quoy voyant, i'ostay mon esperance de prendre aucun exemplaire és Villes qui sont edifiees à present, ains transportay mon esprit, pour contempler les pourtraits des compartimens, et autres figures qui ont esté faites par maistre Iaques du Cerseau, et plusieurs autres pourtrayeurs. Ie regarday aussi les plans et figures de Victruue et Sebastiane, et autres Architectes, pour voir si ie pourrois trouuer en leurs pourtraits quelque chose, qui me peust seruir, pour inuenter ladite Ville de forteresse : mais iamais il ne me fut possible de trouuer aucun pourtrait, qui me sçeust aider à cest affaire. Quoy voyant, ie m'en allay comme vn homme transporté de son esprit, la teste baissee, sans saluer ny regarder personne, à cause de mon affection, qui estoit occupee à ladite Ville; et m'en allant, ainsi faisant, visiter tous les iardins les plus excellens qu'il me fut possible de trouuer (et ce, à fin de voir s'il y auoit quelque figure de labyrinthe inuentee par Dedalus, ou quelque parterre, qui me peust seruir à mon dessein), il ne me fust possible de trouuer rien, qui contentast mon esprit. Alors ie commençay d'aller par les bois, montagnes, et vallees, pour voir si ie trouuerois quelque industrieux animal, qui eust fait quelque maison industrieuse : ce que cerchant i'en vis vn tres-grand nombre, qui me rendit tout estonné de la grande industrie que Dieu leur auoit donnee : et entre les autres, ie fus fort esmerueillé d'vne forteresse, que l'oriou (1) auoit faite, pour la sauue-garde de ses petis, car ladite forteresse estoit pendue en l'air, par vne admirable industrie: toutesfois, ie ne peu là rien profiter pour mon affaire. Ie vi aussi vne ieune limace, qui bastissoit sa maison et forteresse

(1) Le Loriot, *Oriolus Galbula*, L.

de sa propre saliue : et cela faisoit-elle petit à petit par diuers iours : car ayans prins ladite limace, ie trouuay que le bord de son bastiment estoit encore liquide, et le surplus dur, et cogneus lors, qu'il falloit quelque temps, pour endurcir la saliue de laquelle elle bastissoit son fort. Adonc ie prins grande occasion de glorifier Dieu en toutes ses merueilles, et trouuay que cela me pourroit quelque peu aider à mon affaire : pour le moins, cela m'encouragea, et me tint en esperance de paruenir à mon dessein : alors bien ioyeux, ie me pourmenay deçà delà, d'vn costé et d'autre, pour voir si ie pourrois encore apprendre quelque industrie sur les bastimens des animaux, ce qui dura l'espace de plusieurs mois, en exerçant toutesfois tousiours mon art de terre, pour nourrir ma famille. Apres que plusieurs iours i'eu demeuré en ce debat d'esprit, i'auisay de me transporter sur le riuage, et rochers de la mer Oceane, où i'apperceu tant de diuerses especes de maisons et forteresses, que certains petits poissons auoyent faites de leur propre liqueur et saliue, que deslors ie commençay à penser, que ie pourrois trouuer là quelque chose de bon, pour mon affaire. Adonc, ie commençay à contempler l'industrie de toutes ces especes de poissons, pour apprendre quelque chose d'eux, en commençant des plus grands aux plus petits : ie trouuay des choses qui me rendoyent tout confus, à cause de la merueilleuse prouidence Diuine, qui auoit eu ainsi soin de ces creatures, tellement que ie trouuay, que celles qui sont de moindre estime, Dieu les a pourueuës de la plus grande industrie, que non pas les autres : car pensant trouuer quelque grande industrie et excellente sapience és gros poissons, ie n'y trouuay rien d'industrieux, ce qui me fit considerer qu'ils estoyent assez armez, craints et redoutez, à cause de leur grandeur, et qu'ils n'auoyent besoin d'autres armures : mais quant est des foibles, ie trouuay que Dieu leur auoit donné industrie, de sçauoir faire des forteresses merueilleusement excellentes à l'encontre des brigues de leurs ennemis : i'apperceu aussi, que les batailles et brigueries de la mer, estoyent sans comparaison plus grandes esdits animaux, que non pas celles de la terre, et vis que la luxure de la mer estoit plus grande que celle de la terre, et que sans comparaison, elle produit plus de fruit. Ayant donc prins affection de contempler de bien pres ces choses, ie prins garde, qu'il y auoit vn nombre infini de

poissons, qui estoyent si faibles de leur nature, qu'il n'y auoit aucune apparence de vie, fors qu'vne forme de liqueur baueuse, comme sont les huitres, les moucles (moules), les sourdons, les petoncles, les auaillons, les palourdes (pelorides), les dailles (pholades), les hourmeaux, les gembles, et vn nombre infiny de burgaux (limaçons) de diuerses especes et grandeurs. Tous ces poissons susdits sont foibles, comme ie t'ay cy deuant dit : mais quoy ? voicy à present vne chose admirable, qui est, que Dieu a eu si grand soin d'eux, qu'il leur a donné industrie de se sçauoir faire à chacun d'eux vne maison, construite et niuelee par vne telle Geometrie et Architecture, que iamais Salomon en toute sa Sapience ne sceut faire chose semblable : et quand mesme tous les esprits des humains seroient assemblez en vn, ils n'en sçauroient auoir fait le plus moindre traict. Quand i'eu contemplé toutes ces choses, ie tombay sur ma face, et en adorant Dieu, me prins à escrier en mon esprit, en disant, O bon Dieu ! ie puis à present dire, comme le Prophete Dauid ton seruiteur : Et qu'est-ce que de l'homme, que tu as eu souuenance de luy ? et que mesme tu as fait toutes ces choses pour son seruice et commodité ? toutesfois, Seigneur, il n'a honte de s'esleuer contre toy, pour destruire et mettre à neant ceux que tu as enuoyez en la terre, pour annoncer ta iustice et iugement aux hommes. O bon Dieu, et qui sera celuy qui ne s'esmerueillera de ta patience merueilleuse ? Iusques à quand laisseras-tu souffrir et endurer les Prophetes et esleus que tu as mis à la mercy de ceux qui ne cessent de les tormenter ? Ce fait, ie me pourmenay sur les rochers pour contempler de plus pres les excellentes merueilles de Dieu, et ayant trouué certains gembles, qu'on appelle autrement œils de bouc, i'apperceu qu'ils estoyent armez par vne grande industrie : car n'ayans qu'vne coquille sur le dos, ils s'attachoyent contre les rochers, en telle sorte, que ie pense qu'il n'y a nul poisson en la mer, tant soit-il furieux, qui le sceust arracher de ladite roche. Et quand on veut arracher ledit poisson, qui n'est que baue, ou vne liqueur endurcie, si on faille du premier coup de l'arracher, en mettant vn couteau entre la roche et luy, il se viendra si fort resserrer et ioindre à la roche, qu'il n'est pas possible de l'arracher, qui est chose admirable, veu la foiblesse de son estre. L'hourmeau, et plusieurs autres especes s'attachent en cas pareil : car autrement leurs ennemis

les deuoreroyent soudain. N'est-ce pas aussi chose admirable de l'herisson de mer? lequel par ce que sa coquille est assez foible, Dieu luy a donné moyen de sçauoir faire plusieurs espines piquantes, par dessus son halecret (sa cuirasse) et forteresse, tellement qu'estant attaché sur la roche, on ne le sçauroit prendre sans se piquer. N'est-ce pas vne chose admirable, de voir les poissons qui sont armez de deux coquilles? Si tu consideres les petoncles, et les sourdons, et plusieurs autres especes, tu trouueras une industrie telle, qu'elle te donnera occasion de rabaisser ta gloire. As-tu iamais veu chose faite de main d'homme, qui se peust rassembler si iustement, que font les deux coquilles et harnois desdits sourdons et petoncles? Certes il est impossible aux hommes de faire le semblable. Penses-tu que ces petites concauitez et neruures, qui sont auxdites coquilles, soyent faites seulement par ornement, et beauté? Non, non : il y a quelque chose d'auantage : Cela augmente en telle sorte la force de ladite forteresse, comme feroyent certains arcboutans appuyez contre vne muraille, pour la consolider : et de ce n'en faut douter, i'en croiray tousiours les Architectes de bon iugement. Penses-tu que les poissons qui erigent leurs forteresses par lignes aspirales, ou en forme de limace, que ce soit sans quelque raison? Non, ce n'est pas pour la beauté seulement, il y a bien autre chose. Tu dois entendre, qu'il y a plusieurs poissons, qui ont le museau si pointu, qu'ils mangeroyent la plus part des susdits poissons, si leur maison estoit droicte : mais quand ils sont assaillis par leurs ennemis à la porte, en se retirant au dedans, ils se retirent en vironnant, et suiuant le traict de la ligne aspirale : et par tel moyen, leurs ennemis ne leur peuuent nuire. Quoy consideré, ce n'est pas donc pour la beauté que ces choses sont ainsi faites, ains pour la force. Qui sera l'homme si ingrat, qui n'adorera le souuerain Architecte, en contemplant les choses susdites? Me pourmenant ainsi sur les rochers, ie voyois des merueilles, qui me donnoyent occasion de crier, en ensuiuant le Prophete : Non pas à nous, Seigneur, non pas à nous : mais à ton Nom donne gloire et honneur, et commençay à penser en moy-mesme, que ie ne pourrois trouuer aucune chose de meilleur conseil, pour faire le dessein de ma Ville de forteresse : lors ie me mis à regarder, lequel de tous les poissons seroit trouué le plus industrieux en

l'Architecture, à fin de prendre quelque conseil de son industrie. Or en ce temps-là, vn Bourgeois de la Rochelle nommé l'Hermite, m'auoit fait present de deux coquilles bien grosses, sçauoir est, de la coquille d'vn pourpre (*Murex* L.), et l'autre d'vn buxine (buccin), lesquelles auoyent esté apportees de la Guinée, et estoyent toutes deux faites en façon de limace, et ligne aspirale : mais celle du buxine estoit plus forte, et plus grande que l'autre, toutesfois veu le propos que i'ay tenu cy dessus, c'est que Dieu a donné plus d'industrie és choses foibles, que non pas aux fortes, ie m'arrestay à contempler de plus pres la coquille du pourpre, que non pas celle du buxine, parce que ie m'asseurois, que Dieu luy auroit donné quelque chose d'auantage, pour recompenser, sa foiblesse. Et ainsi, estant long-temps arresté sur ces pensees i'auisay en la coquille du pourpre, qu'il y auoit un nombre de pointes assez grosses qui estoyent à l'entour de ladite coquille : ie m'asseuray deslors, que, non sans cause, lesdites cornes auoyent esté formees, et que cela estoit autant de ballouars (boulevards) et defenses, pour la forteresse et retraitte dudit pourpre. Quoy voyant, ne trouuay rien meilleur, pour edifier ma Ville de forteresse, que de prendre exemple sur la forteresse dudit pourpre, et pris quant et quant vn compas, reigle, et autres outils necessaires, pour faire mon pourtrait. Premierement, ie fis la figure d'vne grande place quarree, à l'entour de laquelle ie fis le plan d'vn grand nombre de maisons, ausquelles ie mis les fenestres, portes et boutiques, ayans toutes leur regard deuers la partie exterieure du plan et ruës de la Ville, et aupres d'vn des anglets de ladite place, ie fis le plan d'vn grand portal, sur lequel ie marquay le plan de la maison, ou demeurance du principal Gouuerneur de ladite Ville, à fin que nul n'entrast en ladite place, sans le congé du Gouuerneur, et à l'entour de ladite place, ie fis le plan de certains auuans, ou basses galleries, pour tenir l'artillerie à couuert, et fis le plan en telle sorte, que les murailles du deuant de la gallerie seruiront de defense et de batterie, y ayant plusieurs canonnieres tout autour, qui auront toutes leur regard au centre de ladite place, à fin que si les ennemis entroyent par mine en ladite place, que tout en vn moment, on eust moyen de les exterminer : quoy fait, ie commençay vn bout de ruë, à l'issue dudit portail, enuironnant le plan des maisons que i'auois marquees, à

l'endroit de ladite place, voulant edifier ma Ville en forme et ligne aspirale, et ensuiuant la forme et industrie du pourpre : mais quand i'eu vn peu pensé à mon affaire, i'apperceus que le deuoir du canon, est de iouër par lignes directes, et que si ma Ville estoit, totalement edifiee, suiuant la ligne aspirale, que le canon ne pourroit iouër par les ruës, parquoy, ie m'auisay deslors de suiure l'industrie dudit pourpre, seulement en ce qu'il me pouuoit seruir, et ie commençay à marquer le plan de la premiere ruë, pres de la place, environnant à l'entour, en forme quarree : et ce fait, ie marquay les habitations à l'entour de ladite ruë, ayans toutes le regard, entrees et issues deuers le centre de ladite place : et ainsi, se trouua vne ruë, ayant quatre faces à l'entour du premier rang, qui est à l'entour du milieu, et en uironnant, suiuant la coquille du pourpre : et ce toutesfois, par lignes directes. Ie vins derechef marquer vne ruë à l'entour de la premiere, aussi en vironnant : et apres que ces deux ruës furent pourtraites, auec les maisons necessaires à l'entour, ie commençay à suiure le mesme trait, pour pourtraire la troisieme rue : mais parce que la place, et les deux ruës d'alentour d'icelle auoyent grandement eslongné le trait, ie trouuay bon de bailler huit faces à la seconde rue : et ce, pour plusieurs raisons. Quand la troisieme ruë fut ainsi pourtraite, auec les maisons requises à l'entour, ie trouuay mon inuention fort bonne et vtile, et vins encore à marquer et pourtraire vne autre ruë semblable à la troisieme, sçauoir est, à huit faces, et tousiours en vironnant. Ce fait, ie trouuay que ladite Ville estoit assez spacieuse, et vins à marquer les maisons à l'entour de ladite ruë, ioignant les murailles de la Ville, lesquelles murailles i'allay pourtraire iointes auec les maisons de la ruë prochaine d'icelles. Lors ayant ainsi fait mon dessein, il me sembla que ma Ville se moquoit de toutes les autres : parce que toutes les murailles des autres Villes sont inutiles en temps de Paix, et celles que ie fais seruiront en tout temps, pour habitation à ceux mesmes qui exerceront plusieurs arts, en gardant ladite Ville. Item, ayant fait mon pourtrait, ie trouuay, que les murailles de toutes les maisons seruoyent d'autant d'esperons, et de quelque costé que le canon sçeust frapper contre ladite Ville, qu'il trouueroit tousiours les murailles par le long : or en la Ville, il n'y aura qu'vne rue, et vne entree, qui ira

tousiours en vironnant, et ce, par lignes directes, d'anglet en anglet, iusques à la place, qui est au milieu de la Ville: et en chacun coin et anglet des faces desdites rues, y aura vn portal double, et vosté (voûté), et au dessus de chacun d'iceux, vne haute batterie, ou plate-forme, tellement qu'aux deux anglets de chacune face, on pourra battre en tout temps de coin en coin à couuert, par le moyen desdits portaux vostez: et ce, sans que les Canonniers puissent aucunement estre offensez. Ayant ainsi fait mon pourtrait, et estant bien asseuré, que mon inuention estoit bonne, ie dis en mon esprit : Ie me puis bien vanter à present, que si le Roy vouloit edifier vne Ville de forteresse en quelque partie de son Royaume, que ie luy donneray vn pourtrait, plan et modelle d'vne Ville la plus imprenable, qui soit auiourd'huy entre les hommes : c'est à sçauoir, en ce qui consiste en l'art de Geometrie et Architecture, exceptez les lieux que Dieu a fortifiez par nature.

Et premierement, si vne Ville est edifiee iouxte le modelle et pourtrait que i'ay fait, elle sera imprenable

Par multitude de gens,
Par multitude de coups de canon,
Par feu,
Par mine,
Par eschelles,
Par famine,
Par trahison,
Par sapes.

Exposition d'avcvns Articles.

Aucuns trouueront estrange l'article de la trahison, mais il est ainsi, que quand les dix ou douze parts de la Ville, et mesme les Gouuerneurs d'icelle auroient fait complot auec les ennemis, pour liurer la Ville, il n'est en leur puissance de la liurer, pourueu qu'il y ait vne petite partie de la Ville, qui vueille resister, parce que l'ordre des bastimens sera si bien concathené, qu'il faudroit necessairement, que tous les habitans fussent consentans à la trahison, deuant qu'elle peust estre liuree, et la coniuration generale ne se pourroit iamais faire, que le Prince ne fust aduerty.

Item, on s'esbahira de ce que ie dis, qu'elle sera par sa mine imprenable : Ie le dis, parce qu'elle se pourra garder

bien peu de gens : Ie dis à bien peu, car quand bien peu de gens auroient du biscuit pour certaines annees, il n'y aura si furieux Canonniers, ny si subtils ingenieux, qui ne soyent contraints de leuer le siege de deuant vne telle Ville, voire à leur confusion.

Item, on s'estonnera de ce que ie dis, qu'elle seroit imprenable par sapes, mais ie dis d'auantage, que quand les ennemis auroient sapé et emporté les fondemens de tout le circuit de la Ville, et qu'ils les eussent iettez aux abysmes de la mer, si est-ce que par tel moyen les habitans n'auront occasion de s'estonner, parce que les murailles demeureront encore debout comme auparauant. Et quand il aduiendroit, que les ennemis se fussent opiniastrez d'auantage, et qu'ils eussent rué tout à l'entour du circuit des murailles, autant de coups de canons qu'il pourroit tomber de gouttes d'eau durant les pluyes de quinze iours, et que par tel moyen, ils eussent mis tout le circuit des murailles à petits morceaux comme chapple, c'est à dire, mis les murailles à bas et en friche, si est-ce que pour cela, la Ville ne seroit aucunement perduë, ny les habitans blessez en leurs personnes.

Et qui plus est, quand les ennemis se seroyent encore plus opiniastrez et qu'ils eussent brisé vne carriere tout à trauers de la Ville, et qu'ils peussent passer et repasser à trauers de ladite Ville iusques au nombre de quarante de front, trainans auec eux toutes especes d'engins et artillerie, si est-ce qu'ils n'auroient pas encore gagné la Ville : ce que ie sçay qui sera trouué fort estrange.

Ie dis aussi, que quand les ennemis auroient trouué le moyen par vne subtile mine, de sortir en vne place, qui sera au milieu de la Ville, et qu'ils seroient entrez en ladite Ville, en si grand nombre d'hommes et artillerie, que toute ladite place fust pleine de gens bien armez, si est-ce que par tel moyen ils n'auront gagné aucune chose, sinon l'accourcissement de leurs iours.

Et quand il aduiendroit, que les ennemis auroient fait vne telle approche, que par multitude de gens ils eussent fait des montagnes, qui fussent si hautes, que les ennemis peussent auoir veuë iusques au paué des ruës prochaines des murailles, pour ietter boulets et toutes especes d'engins et feux estranges, par tel moyen les habitans ne receuront aucun dom-

mage, sinon seulement la peur, et l'empoisonnement des mauuaises fumees, qui pourroient estre iettees en la ruë prochaine des murailles, et non és autres.

Item, l'ordre de la Ville sera edifié d'vne telle subtilité et inuention, que mesme les enfans au dessus de six ans pourront aider à la défendre le iour des assaux, voire sans desplacer aucun de sa place et demeurance, et sans se mettre en aucun danger de leurs personnes.

Ie scay bien, qu'aucuns se voudront moquer, toutesfois ie m'asseure de tout ce qui est dit cy-dessus, et suis prest à exposer ma vie, quand ie n'en feray apparoir la verité par Modelle, auquel seront demonstrees les vtilitez et secrets de ladite forteresse, tellement que par ledit Modelle, vn chacun cognoistra la verité, tout ainsi comme si la Ville estoit edifiee.

Demande.

Tu fais cy dessus vne promesse bien temeraire, de dire que par pourtrait et plan, tu feras aisement entendre, que ce que tu as dit de la Ville de forteresse contient verité. Pourquoy est-ce donc, que tu n'as mis en ce liure le pourtrait et plan de ladite Ville? car par là on eust peu iuger si ton dire contient verité.

Responce.

Tu as bien mal retenu mon propos : car ie ne t'ay pas dit que par le plan et pourtrait on peust iuger le total, mais auec le plan et pourtrait, i'ay adiousté qu'il estoit requis faire vn Modelle, veu qu'il n'y auroit aucune raison de le faire à mes despens. Ie t'ay assez dit, que la chose meritoit recompense : parquoy, c'est vne chose iuste, que le labeur dudit Modelle soit payé aux despens de ceux qui le voudront auoir. Or si tu sçais quelqu'vn qui aye vouloir d'auoir vn Modelle de mon inuention, tu me le pourras addresser, ce que i'espere que feras. Et en cest endroit, ie prieray le Seigneur Dieu, te tenir en sa garde.

Quant au reste, si ie cognois ce mien second liure estre approuué par gens à ce cognoissans, ie mettray en lumiere le troisiesme liure que ie feray cy apres, lequel traittera du Palais et plate-forme de refuge, de diuerses especes de terres, tant des argileuses, que des autres : aussi sera parlé de la

Merle (Marne), qui sert à fumer les autres terres. Item, sera parlé de la mesure des vaisseaux antiques, aussi des esmails, des feux, des accidens qui suruiennent par le feu, de la maniere de calciner et sublimer par diuers moyens, dont les fourneaux seront figurez audit liure.

Apres que i'auray érigé mes fourneaux Alchimistals, ie prendray la ceruelle de plusieurs qualitez de personnes, pour examiner, et sçauoir la cause d'vn si grand nombre de folies qu'ils ont en la teste, à fin de faire vn troisiesme liure, auquel seront contenus les remedes et receptes pour guerir leurs pernicieuses folies.

FIN.

A MAISTRE BERNARD PALISSY,

PIERRE SANXAY DIT

Salut.

PAn tous les siècles passez,
Nature mere des choses,
De ses thresors amassez,
Les portes a tenu closes.

L'homme comme vn ieune enfant
Sans grace et intelligence,
N'a fait geste triomphant,
N'œuure beau par excellence.

Hercules, ou comme on dit,
Les neueux du premier homme,
De dresser ont eu credit
Vne, et vne autre colomne.

La Grece a receu l'honneur
De quelques Cariatides :
L'Egypte, pour la grandeur
De ses hautes Pyramides.

Du sepulchre Carien,
N'est esteinte la memoire :
L'amphitheatre ancien
Couronne Cesar de gloire.

Mais cela n'approche point
Des rustiques Figulines,
Que tant et tant bien à poinct,
Et dextrement imagines.

A chacun œuure il faloit
Mille milliers de personnes :
Mais le plus beau n'esgaloit
Celuy que seul tu façonnes.

Le plus beau a bien esté
Enrichi par eloquence :
Le tien a plus de beauté,
Que la langue d'elegance.

Les anciens, qui nombroyent
Sept merueilles en ce monde,
La tiene veuë, ils diroyent
Que nulle ne la seconde.

Appelles a eu le pris
En bien peindant sur Parrhase,
Parrhase sur Xeuzis :
Ton pinceau le leur surpasse.

Le rocher haut et espais
Ne distille l'eau tant claire,
Que celuy là que tu fais,
Iettra l'eau de sa riuiere.

Un Architas Tarentin
Fit la colombe volante :
Tu fais en cours argentin
Troupe de poissons nageante.

Les ranes (grenouilles) en vn estang,
Ne sont point plus infinies :
Mais leur coax on n'entend,
Car elles sont seriphies.

Megere au chef tant hydeux
Portoit les serpens nuisantes :
Mais toy non moins hazardeux,
Les fais par tout reluisantes.

Le lizard sur le buisson
N'a point vn plus nayf lustre,

11.

Que les tiens en ta maison
D'œuure nouueau tout illustre.

Les herbes ne sont point mieux
Par les champs et verdes prees,
D'vn esmail plus precieux,
Que les tienes diaprees.

Le froid, l'humide, le chaud,
Fait flestrir tout autre herbage :
Tout ce qui tombe d'en haut,
Le tien de rien n'endommage.

Je me tairay donc, disant,
Que ta meilleure nature,
D'vn thresor riche à present
Nous donne en toy ouuerture.

A Dieu.

DISCOURS ADMIRABLES,

DE LA NATURE DES EAUX ET FONTAINES,
tant naturelles qu'artificielles,

Des Métaux, des Sels et Salines, des Pierres, des Terres, du Feu et des Emaux.

AVEC PLUSIEURS AUTRES EXCELLENTS SECRETS des choses naturelles.

PLUS, UN TRAITÉ DE LA MARNE, fort utile et nécessaire pour ceux qui se mellent de l'agriculture.

LE TOUT DRESSÉ PAR DIALOGUES, esquels sont introduits la théorique et la practique,

PAR M. BERNARD PALISSY,
Inventeur des rustiques figulines du Roy, et de la Royne sa mère.

A TRES HAUT ET TRES PUISSANT SIEUR

Le sire Anthoine de Ponts, chevalier des ordres du Roy, Capitaine des cents gentilshommes, et conseiller tres fidele de Sa Maiesté.

A TRES HAUT ET TRES PUISSANT SIEUR

LE SIRE ANTHOINE DE PONTS, CHEUALIER DES ORDRES

DU ROY, CAPITAINE DES CENTS GENTILS-HOMMES,

ET CONSEILLER TRES FIDELE DE SA MAIESTÉ.

Le nombre de mes ans m'a incité de prendre la hardiesse de vous dire qu'vn de ces iours ie considerois la couleur de ma barbe, qui me causa penser au peu de jours qui me restent, pour finir ma course : et cela m'a fait admirer les lis et bleds des campagnes, et plusieurs especes de plantes, lesquelles changent leurs couleurs verdes en blanches, lors qu'elles sont prestes de rendre leurs fruits. Aussi plusieurs arbres se hâtent de fleurir quand ils sentent cesser leur vertu vegetatiue et naturelle, vne telle considération m'a fait souuenir qu'il est escrit : que l'on se donne garde d'abuser des dons de Dieu, et de cacher le talent en terre : aussi est escrit que le fol cedant sa folie vaut mieux que le sage celant son sçauoir. C'est donques chose iuste et raisonnable que chascun s'efforce de multiplier le talent qu'il a receu de Dieu, suyuant son commandement. Parquoy ie me suis efforcé de mettre en lumiere les choses qu'il a pleu à Dieu me faire entendre, selon la mesure qu'il luy a plu me departir, afin de profiter à la postérité. Et par ce que plusieurs souz un beau Latin, ou autre langage bien poli, ont laissé plusieurs talents pernicieux pour abuser et faire perdre le temps à la ieunesse : qu'ainsi ne soit, vn Geber, un Roman de la Roze, et un Raimond Lule, et aucuns disciples de Paracelse, et plusieurs autres alchimistes ont laissé des liures à l'estude desquels plusieurs ont perdu

et leurs temps et leurs biens. Tels liures pernicieux m'ont causé gratter la terre l'espace de quarante ans, et foüiller les entrailles d'icelle, à fin de connoistre les choses qu'elle produit dans soy, et par tel moyen i'ay trouué grace deuant Dieu, qui m'a fait connoistre des secrets qui ont esté iusques à present inconnuz aux hommes, voire aux plus doctes, comme l'on pourra connoistre par mes escrits contenuz en ce liure. Ie sçay bien qu'aucuns se moqueront, en disant qu'il est impossible qu'vn homme destitué de la langue Latine puisse auoir intelligence des choses naturelles; et diront que c'est à moy vne grande temerité d'escrire contre l'opinion de tant de Philosophes fameux et anciens, lesquels ont escrit des effects naturels, et rempli toute la terre de sagesse. Ie sçay aussi qu'autres iugeront selon l'exterieur, disans que ie ne suis qu'vn pauure artisan : et par tels propos voudront faire trouuer mauuais mes escrits. A la verité il y a des choses en mon liure qui seront difficiles à croire aux ignorans. Nonobstant toutes ces considerations, ie n'ay laissé de poursuyure mon entreprise, et pour couper broche à toutes calomnies et embusches, i'ay dressé vn cabinet auquel i'ay mis plusieurs choses admirables et monstrueuses, que i'ay tirees de la matrice de la terre, lesquelles rendent tesmoignage certain de ce que ie dis ; et ne se trouuera homme qui ne soit contraint confesser iceux veritables, apres qu'il aura veu les choses que i'ay preparé en mon cabinet, pour rendre certains tous ceux qui ne voudroyent autrement adiouster foy à mes escrits. S'il venoit d'auenture quelque grosse teste, qui voulut ignorer les preuues mises en mon cabinet, ie ne demanderois autre iugement que le vostre, lequel est suffisant pour conuaincre et renuerser toutes les opinions de ceux qui y voudroyent contredire. Ie le dis en verité, et sans aucune flatterie : car combien que i'eusse bon tesmoignage de l'excellence de vostre esprit, dès le temps que retournastes de Ferrare, en vostre chateau de Pons, si est ce que en ces derniers iours ausquels il vous pleut me parler de sciences diuerses, asçauoir de la Philosophie, Astrologie, et autres arts tirez des Mathematiques. Cela di-

m'a causé doubler l'asseurance et suffisance de vostre merueilleux esprit, et combien que le nombre des iours de plusieurs diminue leur mémoire, si est-ce que i'ay trouué la vostre plus augmentée que diminuée. Ce que i'ay connu par les propos qu'il vous a pleu me tenir. Et pour ces causes i'ay pensé qu'il n'y a seigneur en ce monde auquel mon œuure puisse mieux estre dedié qu'à vous, sçachant bien qu'au lieu qu'il pourroit estre estimé d'aucuns comme vne fable pleine de mensonges, qu'en vostre endroit il sera prisé et estimé chose rare. Et s'il y a quelque chose mal polie, ou mal ordonnée, vous sçaurez très-bien tirer la substance de la matiere, et excuser le trop rude langage de l'aucteur, et souz telle esperance, ie vous supplieray treshumblement de me faire cest honneur de le receuoir comme de la main de l'vn de vos treshumbles seruiteurs.

ADVERTISEMENT
AUX LECTEURS.

AMI lecteur, le desir que i'ay que tu profites à la lecture de ce liure, m'a incité de t'aduertir que tu te donnes garde de enyurer ton esprit de sciences escriptes aux cabinets par vne theorique imaginatiue, ou crochetee de quelque liure escrit par imagination de ceux qui n'ont rien practiqué, et te donnes garde de croire les opinions de ceux qui disent et soustiennent que theorique a engendré la practique. Ceux qui enseignent telle doctrine prennent argument mal fondé, disans qu'il faut imaginer et figurer la chose que l'on veut faire en son esprit, deuant que mettre la main à sa besongne. Si l'homme pouuoit executer ses imaginations, ie tiendrois leur party et opinion : mais tant s'en faut, si les choses conceües aux esprits se pouvoyent executer, les souffleurs d'alchimie feroyent de belles choses, et ne s'amuseroyent à chercher l'espace de cinquante ans, comme plusieurs ont fait. Si la theorique figuree aux esprits des chefs de guerre se pouuoit executer, ils ne perdroyent iamais bataille. I'ose dire à la confusion de ceux qui tiennent telle opinion, qu'ils ne sçauroyent faire un soulier, non pas mesmes un talon de chausse, quand ils auroyent toutes les theoriques du monde. Ie demanderois à ceux qui tiennent telle opinion, quand ils auroyent estudié cinquante ans aux liures de Cosmographie et nauigation de la mer, et qu'ils auroyent les cartes de toutes régions et le cadran de la mer, le compas et les instruments astronomiques, voudroyent ils pourtant entreprendre de conduire vn nauire

par tout pays, comme fera un homme bien exp ert et practicien ils n'ont garde de se mettre en danger, quelque theorique qu'ils ayent apprise : et quand ils auront bien disputé, il faudra qu'ils confessent que la practique a engendré la theorique. I'ay mis ce propos en auant, pour clorre la bouche à ceux qui disent, comment est il possible qu'vn homme puisse sçauoir quelque chose et parler des effects naturels, sans auoir veu les liures Latins des philosophes ? Un tel propos peut auoir lieu en mon endroit, puis que par practique ie prouue en plusieurs endroits la theorique de plusieurs philosophes fausse, mesmes des plus renommez et plus anciens, comme chascun pourra voir, et entendre en moins de deux heures, moyennant qu'il vueille prendre la peine de venir voir mon cabinet, auquel l'on verra des choses merueilleuses qui sont mises pour tesmoignage et preuue de mes escrits, attachez par ordre et par estages, auec certains escriteaux au dessouz, afin qu'vn chacun se puisse instruire soy mesme : te pouuant asseurer (lecteur) qu'en bien peu d'heures, voire dans la premiere iournee, tu apprendras plus de philosophie naturelle sur les faits des choses contenues en ce liure, que tu ne sçaurois apprendre en cinquante ans, en lisant les theoriques et opinions des philosophes anciens. Aucuns ennemis de science se mocqueront des astrologues : en disant, où est l'eschelle par où ils sont montez au ciel, pour connoistre l'assiette des astres ? Mais en cest endroit ie suis exempt de telle moquerie ; par ce qu'en prouuant mes raisons escrittes, ie contente la veuë, l'ouye et l'atouchement : à raison dequoy les calomniateurs n'auront point de lieu en mon endroit : comme tu verras lors que tu me viendras voir en ma petite Academie.

 Bien te soit.

D EPUIS que le liure a esté commencé de mettre suz la presse, plusieurs personnages m'ont requis d'en faire lecture, afin d'auoir plus certaine connoissance des choses difficiles, qui m'a incité d'escrire ce qui s'ensuit : à sçavoir que si aprés l'impression dudit liure, il se presente quelqu'un qui ne se contente d'avoir veu les choses par escrit en son priué, et qu'il desire auoir vne ample interpretation, qu'il se retire par deuers l'imprimeur, et il lui dira le lieu de ma demeurance, auquel on me trouuera touiours prest à faire lecture et desmonstration des choses contenues en icelui.

Aussi si quelqu'vn vouloit edifier vne fontaine, selon le dessein y contenu, et qu'il ne puisse entendre clerement l'intention de l'aucteur, ie luy feray un modelle, par lequel il pourra facilement entendre ce que dessus.

LES PRINCIPAVX POINTS

TRAITEZ EN CE LIURE.

1. Des eaux des fleuues, fontaines, puits, cisternes, estangs, marez et autres eaux douces : de leur origine, bonté, mauuaistié, et autres qualitez : auec le moyen de faire des fontaines en tous lieux.
2. De l'Alchimie : des metaux, de leur generation et nature.
3. De l'or potable.
4. Du mitridat.
5. Des glaces.
6. Des diuerses sortes des sels vegetatifs ou generatifs, et soustenans les formes, en la generation de ces corps terrestres, de leur nature et merueilleux effects.
7. Du sel commun, la maniere de le faire auec la description des marez salans.
8. Des pierres tant communes que precieuses : des causes de leur generation : des diuerses formes, couleur, pesanteur, dureté, transparence, et autres qualitez d'icelles.
9. Des diuerses terres d'argille, natures et effects d'icelles.
10. De l'art de terre, de son vtilité : des esmaux et du feu.
11. De la marne, de son vtilité, avec le moyen de la connoistre et en trouver en toutes provinces.

DES EAUX ET FONTAINES.

THEORIQUE COMMENCE.

IE me trouuay ces iours passez (allant par les champs) fort alteré, et passant par quelque village ie demanday où ie pourrois trouuer quelque bonne fontaine, afin de me rafraichir et desalterer, à quoy me fut respondu qu'il n'y en auoit point audit lieu, et que leurs puits estoient tous taris, à cause de la secheresse, et qu'il n'y auoit qu'vn peu d'eau bourbeuse au fond desdits puits. Ce qui me causa grande fascherie, et fus fort estonné de la peine où estoient les habitans de ce village, à cause de l'indigence d'eau. Et lors me souuint d'vne promesse que tu m'as faite long temps y a, de me monstrer à faire des fontaines aux lieux les plus stériles d'eaux. Or puis que nous sommes de loisir, ie te prie (suyuant ta promesse) de m'apprendre ceste science qui me sera fort vtile : Car i'ay vn heritage où il n'y a point de fontaines, et n'y a qu'vn puits qui est suiet à tarir aussi bien que les autres.

PRACTIQUE.

Ie le feray volontiers : Mais auant que parler des fontaines de mon inuention, ie suis d'auis de te faire petit vn discours de la cause des bonnes ou mauuaises eaux, et de l'imprudence d'aucuns fontainiers modernes : Aussi des naissances des sources naturelles. Et pour cest effect il faut regarder à l'invention moderne, pour connoistre son vtilité et longue duree. Plusieurs desdits modernes, n'ayants nul moyen de trouuer sources ne fontaines viues, ont creusé les terres pour faire des puits, et pour obuier au grand labeur de tirer l'eau ils ont contemplé les pompes des nauires, et combien qu'elles soyent inuentees par nos antiques, aucuns artisans (desirans de gaigner, et se mettre en credit, aussi pour croistre leurs

renommees) ont conseillé à plusieurs seigneurs et autres de faire des pompes à leurs puits, non comme inuention vieille, mais comme premiers inuenteurs, et s'en font beaucoup valoir, et plusieurs ont fait de grandes despences esdites pompes, lesquelles ont encores à present grand regne : Toutesfois ie sçay à la verité, tant par Practique que Theorique, que lesdites pompes auront bien peu de duree, à cause de la violence des mouuemens desdites pompes, qu'ils endurent, tant par la subtilité des eaux, que par les vents qui s'entonnent dedans les tuyaux : Et faut conclure que toutes choses violentes ne peuuent durer.

Theorique.

Comment est-ce que tu oses mespriser vne inuention si ingenieuse, et tant vtile, veu que toy mesmes confesse qu'elle est inuentee par les anciens, et de tout temps l'on en a vsé pour la conseruation des navires : car sans lesdites pompes ils periroyent bien souuent : aussi l'on sçait bien qu'en plusieurs minieres de metaux l'on se sert desdites pompes : car autrement les eaux les submergeroyent à tous les coups.

Practique.

Ie ne mesprise point l'inuention des pompes : mais au contraire ie l'estime beaucoup, et quiconques l'a inuentée a eu vne grande considération, et n'a pas esté sans auoir consideré l'anatomie de nature humaine. Car ie sçay bien que l'eau qui est montée le long des canaux n'est montée sinon par vne attraction d'halene causee par la souspape, laquelle ayant donné lieu à l'aspiration, ou sucement du vent qui est amené par le baston de la pompe, et que par l'attraction et haussement tant de la souspape que du baston, estant entré vne quantité d'eau au dedans du tuyau, ladite souspape estant remise en son lieu enferme l'eau et le vent, qui sont enclos dedans la pompe, estant demeuree et poussee par le mouuement dudit baston, lequel contrainct l'eau de monter en haut, et cela ne se peut faire sans grande violence : Comme tu vois qu'vn homme ne peut cracher sans premierement attirer à soy du vent ou de l'air, et cela ne se peut faire que la souspape de la gorge de l'homme (que les chirurgiens appellent la luette) ne ioüe comme celle des pompes. Et combien que i'estime l'inuention desdites pompes merueilleusement grande, et que ie sçay qu'elles seront tousiours de re-

12.

queste, et vtiles tant aux nauires que minieres, si est ce que pour les puits domestiques elles seront bien peu de requeste : par ce qu'il faut tousiours des ouuriers apres, à cause des fractions engendrees par les violences : et qu'il se trouue bien peu d'hommes qui les sçachent reparer. Voila pourquoy ie parle hardiment, comme estant bien asseuré que plusieurs dedans Paris et ailleurs ont fait faire desdites pompes auec grand fraiz, qui à la fin les ont délaissees à cause des reparations qu'il y falloit souuent faire. Aussi ie sçay qu'il y a eu de nostre temps vn architecte François, qui se faisoit quasi appeller le dieu des maçons ou architectes (1), et d'autant qu'il possedoit vint mil en benefices, et qu'il se sçauoit bien accommoder à la cour, il aduint quelquefois qu'il se venta de faire monter l'eau tant haut qu'il voudroit, par le moyen des pompes ou machines, et par telle iactance incita vn grand seigneur à vouloir faire monter l'eau d'vne riuiere en vn haut iardin qu'il auoit pres ladite riuiere. Il commanda que deniers fussent deliurez pour faire les frais : ce qu'estant accordé, ledit architecte feit faire grande quantité de tuyaux de plomb, et certaines rouës dedans la riuiere, pour causer les mouuements des maillets, qui font iouër les souspapes : mais quand ce vint à faire monter l'eau, il n'y auoit tuyau qui ne creuast, à cause de la violence de l'air enclos auec l'eau : dont ayant veu que le plomb estoit trop foible, ledit architecte commanda en diligence de fondre des tuyaux d'airain, pour lesquels fut employé vn grand nombre de fondeurs, tellement que la despence de ces choses fust si grande, que l'on a trouué par les papiers des contrôleurs, qu'elle montoit à quarante mil francs, combien que la chose ne valust iamais rien : Et à ce propos i'ay veu plusieurs pompes, qui ont amené par le mouuement de la souspape vne si grande quantité de sable qu'en fin il failloit rompre les tuyaux, pour oster le sable qui estoit dedans.

THEORIQUE.

Ie ne sçay comment cela que tu dis se peut faire : car i'ay veu vn millier de modelles de pompes, qui iettoyent l'eau aussi naturellement que si c'eust esté vne source.

(1) G. pense que ce *dieu des maçons* était Philibert Delorme, et que le *haut jardin* que désigne Palissy était celui de Meudon, construit pour le cardinal Charles de Lorraine, et modifié depuis par Mansard et Le Nôtre.

PRACTIQUE.

Tu t'abuses en m'allegant les modelles : car ils ont trompé vn million d'hommes tant és bastiments que plateformes, batteries, pontages et desuoyements de riuieres, chaussees, leuees, ou paissieres, et singulierement aux eleuations des eaux. Car plusieurs ayants approuué l'esleuation et vuidange des eaux par modelles de pompes, ont fait de grandes entreprises, pour fonder des piliers dedans les riuieres, cuidans qu'apres que l'eau seroit remparee alentour du lieu destiné pour le fondement des piliers il seroit bien aisé de la vuider par les pompes, ont fait faire de grandes pompes suyuant les modelles qu'ils auoyent trouué veritables, en quoy ils ont estez deceus, et se sont ruinez : d'autant qu'ils n'ont sçeu faire en grand volume ce qu'ils faisoyent en petit. Autant en est-il aduenu à plusieurs sur les desuoyemens des cours des riuieres. Si inquisition estoit faite de ces choses l'on en trouueroit quelque tesmoignage à Tholouse, en l'edification d'vn pont assis sur la Garonne ; parquoy faut conclure que les pompes sont vtiles et necessaires és nauires et en quelques minieres : mais pour en faire estat pour les puits, l'on en est bien tost las, pour les causes que i'ay dites cy dessus : parquoy ie ne t'en parleray d'auantage.

THEORIQUE.

Et quant à l'eau des puits, que t'en semble? la treuues tu bonne ou mauuaise?

PRACTIQUE.

Ie ne puis autre chose dire des eaux des puits sinon qu'elles sont toutes froides et croupies, les vnes plus, les autres moins ; et ne faut pas que tu penses que les eaux des puits procedent de quelque source : car si c'estoit de quelque source continuelle, les puits s'empliroyent soudain : parquoy est à noter qu'elles ne viennent de gueres loing : et n'est seulement que les esgouts des pluyes qui tombent à l'entour des puits : et ceux qui sont dedans les villes sont suiets à receuoir plusieurs vrines, et s'il y a des priuez circonuoisins il ne faut douter que l'eau desdits puits ne s'en resente : et ne peut-on autrement conclure, sinon que les eaux des puits sont esgouts continuels des pluyes, qui se rendent petit à petit en bas au trauers des autres. Et ce qui fait qu'aucuns puits sont meilleurs les vns que les autres, et n'est autre chose sinon que les terres

circonuoisines sont nettes de tous mineraux, salpestres et autre substance que les eaux pourroyent prendre en passant par les terres. Toutesfois depuis que les eaux sont entrées dedans les puits elles croupissent, et sont aisees à empoisonner, par ce qu'elles n'ont point de cours. Si tu auois leu l'histoire de Iehan Sleidan, tu connoistrois que les eaux des puits et cisternes sont suiettes aux poisons. Il raconte que durant la guerre que l'empereur Charles cinquiesme fit contre les protestans, il fut empoisonné plusieurs puits et eaux dormantes, et qu'il fut pris vn homme qui confessa estre venu de lointain pays, expres pour faire ce mauuais effect, et ce par le commandement de deux grands personnages que ie ne veux nommer (1). Au grand marché de Meaux en Brie, en la maison des Gillets, l'on voulut curer vn puits, et pour ce faire, le premier qui y descendit mourut soudain au fonds dudit puits, et fut enuoyé vn autre pour sçauoir la cause, pourquoy iceluy ne disoit aucune chose, et mourut comme l'autre : il en fut renuoyé encore vn qui descendit iusques au milieu : mais là estant, se print à crier pour se faire tirer diligemment, ce que fut fait, et estant dehors, se trouua si malade qu'il trauailla beaucoup à sauuer sa vie (2).

Item, vne autre histoire racompte qu'il y eut iadis vn Medecin qui se voyant destitué d'argent et de practiques, s'auisa de ietter quelques drogues dans les puits de la ville de son habi-

(1) Voici le passage de Sleidan : « Vers le même temps, l'électeur de Saxe et le landgrave de Hesse publièrent un écrit où ils disoient qu'ils avoient appris de gens dignes de foi, que le Pape qui étoit l'Antechrist Romain, l'organe de Satan, et l'auteur de cette guerre, et qui quelques années auparavant avoit envoyé des incendiaires en Saxe qui y avoient causé de grands dommages, y avoit fait présentement passer des empoisonneurs pour empoisonner les puits et les étangs, afin de faire périr par le poison ceux qu'ils n'avoient pu détruire par le fer et les armes » (Histoire de la Réformation, ou Mémoire de Jean Sleidan sur l'état de la religion et de la république sous l'empire de Charles-Quint; 1767, t. II, p. 360). Une note de le Courrayer, traducteur de Sleidan, relative à ce passage, montre l'absurdité des soupçons populaires à ce sujet. « La quantité de poison qui serait nécessaire, dit-il, pour le succès d'une telle scélératesse, rend la chose incroyable lors même qu'il y aurait des gens assez méchants pour donner une telle commission ou pour s'en charger. » Cette croyance n'en était pas moins très-répandue parmi le peuple à l'époque des guerres de religion.

(2) Les accidents d'asphyxie causés par l'accumulation de gaz délétères au fond de certains puits, passaient alors pour l'effet d'un poison dont chaque parti accusait l'autre d'avoir infecté les eaux potables.

tation, qui fut cause que tous ceux qui beuuoyent de l'eau estoyent pris d'vn flux de ventre, qui les tormentoit à merueilles, et les faisoit courir apres le Medecin, lequel estant ioyeux de l'operation de ladite medecine, consoloit hardiment les malades, et feindant leur bailler des medecines bien cheres, il leur bailloit de bon vin à boire, leur defendant de boire de l'eau, et par tel moyen la malice de l'eau s'en alloit, et la nourriture du vin demeuroit, et le medecin gaignoit beaucoup. Il y a aussi quelques puits voisins des riuieres, desquels l'eau qui y est ne vient que de la riuiere circonuoisine : et cela est conneu d'autant que quand les riuieres sont grosses il y a beaucoup d'eau dedans lesdits puits, et quand les riuieres sont basses aussi sont les eaux desdits puits : et cela nous donne à connoistre qu'il y a certaines veines qui vont des puits iusques aux riuieres, par lesquelles les eaux se viennent rendre audits puits. Aucuns de ceux qui ont besongné à la congelation du sel qui se fait en Lorraine, m'ont attesté que l'eau de laquelle ils font ledit sel, se prend dedans des puits : et quand les riuieres sont grandes il entre de l'eau douce dedans lesdits puits, qui cause qu'ils sont arrestez iusques à ce que les riuieres soyent remises dedans leurs limites, partant ie conclus qu'aucuns puits sont entretenus des eaux des fleuues circonuoisins.

THEORIQUE.

Puis que nous sommes sur le propos des eaux, que te semble de l'eau des mares? desquelles, en plusieurs pays, ils sont contraints se seruir, tant pour leur vsage, que pour l'vsage de leurs bestes.

PRACTIQUE.

Il y a plusieurs especes de mares : plusieurs les appellent claunes : en quelques lieux ce n'est qu'vne fosse gueres profonde, mise en quelque place inclinee d'vn costé, afin que les eaux des pluyes se rendent dans laditte fosse ou mare, et que les bœufs, vaches et autre bestail puissent aisement entrer et sortir pour y boire, et icelles ne sont creusees que deuers la partie pendante. A la verité telles eaux ne peuuent estre bonnes ny pour les hommes ny pour les bestes. Car elles sont eschauffees par l'air et par le soleil, et par ce moyen engendrent et produisent plusieurs especes d'animaux, et d'autant qu'il y a tousiours grande quantité de grenouilles, les serpens,

aspics et viperes se tiennent pres desdites claunes : affin de se repaistre desdites grenouilles. Il y a aussi communement des sangsues, que si les bœufs ou vaches demeurent quelque temps dedans les dites mares, ils ne faudront d'estre piquez par les sangsues. I'ay veu plusieurs fois des aspics et serpens, couchez et entortillez au fond des eaux desdites mares : parquoy ie dis que lesdites eaux ainsi aërees et eschauffees ne peuuent estre bonnes ; et bien souuent il meurt des bœufs, vaches et autre bestail, qui peuuent avoir prins leurs maladies és abreuuoirs ainsi infectez. Si les hommes qui verront les enseignemens que ie donneray cy apres, me vouloyent croire, ils auroyent tousiours des eaux pures et nettes, tant pour eux que pour leurs bestes.

Theorique.

Que veux tu dire des mares qui sont plus basses, desquelles on se sert en plusieurs endroits de la Normandie et autre pays, pour le seruice de la maison ?

Practique.

Que veux tu que ie te die, sinon que c'est une eau croupie mais d'autant qu'elle est plus froide, elle ne peut produire aucun animal, d'autant qu'il ne se fait iamais de generation tant des choses animees, que des vegetatiues sans qu'il y a vne humeur eschauffee. Mais si au dessus desdites eaux mares il y a seulement du limon verd, c'est un signe de putrefaction et commencement de generation de quelque chose et plus y apparoist et s'y engendre de putrefaction, et plus l'vsage en est pernicieux.

Theorique.

Di moy qu'il te semble des cisternes que nos predecesseurs ont eu en vsage, comme nous voyons tant par leurs vestiges que par tesmoignage des escritures.

Practique.

Les eaux des cisternes prouiennent des pluyes, comme celles des claunes : mais d'autant qu'elles sont closes, fermees, bien maçonnees, et au dessouz pauees, il ne peut estre qu'elles ne soyent sans comparaison meilleures que celles des mares : à cause qu'elles ne peuuent rien produire, pour la froidure et le peu d'air qu'elles ont : toutesfois toutes ces eaux ne sont point naturellement bonnes, comme celles que i'ay entrepris te monstrer cy apres. Ie me tairay donc à present

parler des eaux croupies, et parleray de celles des fontaines naturelles, qui sont à present en nostre vsage.

Theorique.

Et que sçaurois tu dire des fontaines naturelles? puis qu'elles sont naturelles tu n'y sçaurois trouuer à redire, comme tu as faict sur les mares et pompes et puits : que si tu entreprens de parler contre les fontaines naturelles, tu entreprens contre Dieu, qui les a faites.

Practique.

Tu me reprens deuant que i'aye parlé; ie sçay bien que les sources des fontaines naturelles sont faites de la main de Dieu : parquoy ie n'y sçaurois rien reprendre des fautes qui se commettent pour conduire les eaux des sources naturelles : mais d'autant que les fontainiers qui amenent les sources par tuyaux, canaux et aqueducs, depuis la source iusques aux maisons, villes et chasteaux peuuent commettre de grandes fautes, voila dequoy i'entens parler : d'autant que la vie de l'homme est si brefue qu'il est impossible qu'en l'espace de si peu d'annees vn homme puisse connoistre les effects des eaux, et ne les connoissant point il est impossible de les conduire et amener vn long chemin, qu'il n'y ait quelque faute, et si on l'amene de deux ou trois lieuës loin, enclose et enfermee par tuyaux elle sera de bien peu de duree, et y faudra souuent mettre la main. Voila pourquoy ie te veux bien dire que l'eau et le feu ioints auec l'air ont vn effect si tressubtil et vehement, que iamais homme ne l'a directement conneu, comme tu pourras entendre, lorsque ie parleray des tremblemens de terre : et si tu veux vn peu contempler les vestiges et antiquitez de nos predecesseurs, tu trouueras grand nombre de pyramides antiques, construites, tant par les Empereurs Romains, que par les Roys d'Egypte, tu trouueras aussi grand nombre d'arcs triomphans construits du temps des Césars, comme tu as veu en la ville de Xaintes deux arcs triomphans, que combien qu'ils soyent fondez dedans l'eau, si est ce qu'ils sont encores de bout, et ne peut on nier qu'ils ne soyent du temps des Cesars, l'escriture qui y est inscrite en fait foy. Ie t'ay mis ce propos en auant pour te monstrer que combien que nos predecesseurs ayent aussi fait de grands despens pour les aqueducs, tuyaux et beauté de fontaines, si est-ce que tu ne me sçaurois monstrer vne seule fontaine antique, comme

les bastimens des arcs triomphans, palais et amphitheatres : et ne faut pourtant penser que nos predecesseurs antiques ne se soyent estudiez et employez à grands despens aussi bien és fontaines que és autres bastiments, et qu'ainsi ne soit, quelqu'vn m'a asseuré auoir veu en Italie des aqueducs contenans cinquante lieuës de long (chose incroyable toutesfois) lesquels ont estez faits pour amener les eaux d'vn lieu à l'autre. Nos antiques montrent par là qu'ils auoient bien conneu que les eaux amenees par les aqueducs venoient plus à leur aise que non pas celles qui viennent encloses dedans des tuyaux. Il est certain qu'à Xaintes (qui est ville antique, en laquelle se trouue encores des vestiges d'vn amphitheatre, et plusieurs antiquitez, pareillement grande quantité de monnoye des Empereurs) il y auoit vn aqueduc duquel les vestiges y sont encores, par lequel ils faisoient venir l'eau de deux grandes lieuës distant de ladite ville, et toutesfois la ruine s'en est ensuiuie en telle sorte qu'à present il y a bien peu d'hommes qui ayent connoissance des vestiges de l'aqueduc susdit. Voyla pourquoy i'ay dit que combien que les antiques ayent besongné de meilleures estofes que les modernes, et qu'ils ayent moins regardé aux frais, si est ce que l'on ne treuue aucunes fontaines antiques. Ie ne dy pas pourtant que les sources soyent perdues : car l'on sçait bien que la source antique de la ville de Xaintes est encores au lieu d'où elle procedoit : pour laquelle voir, le Chancelier de l'hospital se destourna de son chemin (reuenant du voyage de Bayonne) pour voir l'excellence de ladite source. Il y a encores en certaines vallees entre la ville et la source, quelques arcades sur lesquelles l'on faisoit passer les eaux de ladite source : toutesfois la cause desdites arcades est inconnue au vulgaire. Et si tu veux sçauoir pourquoy ie te mets deuant les yeux ces arcades aux vallees, c'est pour te monstrer l'ignorance des modernes. Car si les antiques eussent amené les tuyaux de leurs cours de fontaines par dessous la terre il eust fallu monter et puis descendre, et encores monter autant de fois qu'il y eust eu de montagnes et vallees, et eust fallu accommoder les tuyaux à toutes ces passions ; et comme ie t'ay dit en plusieurs endroits l'eau qui est ainsi contrainte, ioints les vents subtils entremeslez auec elle, font des efforts tels que nul homme n'a iamais eu la parfaite connoissance de la violence desdites eaux.

vne chose merueilleuse des effects des eaux enserrées; il y a bien peu d'hommes qui voulussent croire que l'eau qui remplist et occupe vn tuyau de deux poulces de diametre, estant violemment poussée par les vents ou autres eaux elle se resserrera en telle sorte qu'elle passera par vn canal d'vn poulce de diametre : et par ce que les vents, qui sont enclos dedans lesdits tuyaux, ou canaux occupent autant de place que les eaux, les fontainiers sont bien souuent trompez en leurs entreprises : mesmement aux tuyaux enclos souz terre : car quelquefois lesdits tuyaux sont occupez par des racines qui s'engendrent et veiettent dedans, ayants quelque bout racinal entre les ioinctures : autres sont occupez et engorgez par les eaux congelatiues, qui se lapifient au dedans desdits tuyaux. C'est pourquoy les antiques faisoient les aqueducs aërez auec grande despence, afin d'amener les eaux sans violence, et euiter tous ces accidens susdits. Toutesfois ie suis certain que quand les eaux se viennent à congeler soit en cristal ou autrement, elles sont contraintes de se reserrer en leur congelation, et ne se fait nulle congelation sans compression. Le semblable se trouue en la violence du feu, qui se trouuant enclos dedans les montaignes engendre vne vapeur aqueuse et vn vent si impetueux qu'il fait trembler la terre et renuerser les montaignes, et bien souuent les villes et villages, c'est la cause pourquoy les antiques faisoyent venir leurs sources d'eaux par aqueducs, et pour donner pente legitime à leurs eaux ils faisoyent des arcades aux vallees, pour s'accommoder aux montaignes. Je ne demande point de meilleur tesmoignage que le pont du Gua (Gard), qui est en Languedoc, lequel a esté fait expressement pour porter l'aqueduc qui trauersoit la vallee entre deux montaignes, afin d'amener l'eau de dix lieües distant de la ville de Nimes : et ce pour obuier aux compressions et violences que les eaux eussent engendrees si on les eut voulu faire suyure les montaignes et vallees. Ledit pont est vne œuure admirable : car pour venir depuis le bas des montaignes iusques à la sommité d'icelles, il a fallu edilier trois rangs d'arcades l'vne sur l'autre, et sont lesdites arcades d'vne hauteur extraordinaire, et construites de pierres de merueilleuse grandeur. De là nous pouuons tirer que Nimes (ville antique, en laquelle se trouue tesmoignage tant par l'amphitheatre que par autres vestiges) estoit vne ville en la-

quelle les anciens Empereurs Romains et leurs proconsuls auoient faict de grandes et superbes despenses, pour l'embellir et enrichir, et y auoient employé des gens de sçauoir, des plus grands qui fussent en l'Empire Romain, comme l'ouurage en fait encores foy. Si tu auois esté à Rome tu pourrois aisément iuger combien les modernes sont esloignez des inuentions de nos predecesseurs sur le fait des fontaines : car il y a bien peu de bonnes maisons dedans Rome ausquelles il n'y ait des fontaines prouenantes des aqueducs construits en l'air, et qu'ainsi ne soit, regarde vn peu vn pourtraict de ladite ville de Rome qui a esté nouuellement imprimé, tu verras en iceluy vn receptacle d'eau, haut esleué, d'vne grandeur assez superbe, lequel receptacle contient si grande quantité d'eau, qu'il fournit la plus grande part de ladite ville de Rome, car il y a audit receptacle plusieurs acqueducs diuisez par branches amenez et conduits de rue en rue, pour fournir les palais et grandes maisons de la ville, et sont lesdits acqueducs amenez et conduits sur certaines arcades assez pres l'vne de l'autre et toutes-fois autant esleuées en l'air que les maisons de laditte ville. Et te faut notter qu'il y a vn grand acqueduc principal venant de bien loin qui fournit le grand receptacle duquel procedent tous les autres acqueducs. Or si les fontaines des fontainiers antiques, faites auec si grande despense, n'ont peu durer iusques à present, combien moins de durée peut on esperer de celles que les fontainiers modernes font passer par monts et vaux auec des tuyaux de plomb soudez et cachez trois ou quatre pieds dans terre. Si monsieur l'architecte de la Royne (1), qui auoit hanté l'Italie, et qui auoit gaigné vne auctorité et commandement sur tous les artisans de ladite Dame, eust eu tant soit peu de philosophie seulement naturelle, sans aucunes lettres, il eust fait faire quelque muraille et arcade à la vallee de saint Cloud, et de là faire venir son eau tout doucement, depuis le pont de sainct Cloud iusques aux murailles du parc, et puis renforcer ladite muraille de la closture dudit parc pour faire passer l'eau par dessus, et au bout de l'angle et coing dudit parc faire certaines arcades, en diminuant petit à petit iusques au dedans, et lors la fontaine

(1) Il s'agit encore de Philibert Delorme, architecte et intendant des bâtiments de Catherine de Médicis.

eust peu durer, et n'y eust fallu faire tant de regards (1).

THEORIQUE.

Puis que tu trouues tant d'imperfections és eaux des mares, puits et és conduits ou tuyaux des fontaines, ie te veux à present faire vne demande, asçauoir qui est la cause que les sources des fontaines naturelles sont meilleures les vnes que les autres.

PRACTIQUE.

Vn homme qui a hanté les minieres, fossez et tranchées, et qui a consideré les diuerses especes des terres argileuses, et qui a voulu connoistre les diuerses especes de sels et autres choses fossiles, il peut aysément iuger de la cause de la bonté ou mauuaistié des eaux prouenans des sources naturelles. Et pour en donner iugement certain, il faut premierement considerer qu'il n'y a aucune partie en la terre qui ne soit remplie de quelque espece de sel, qui cause la generation de plusieurs choses, soit pierre, ardoise, ou quelque espece de metal ou mineral, et est chose certaine que les parties interieures de la terre ne sont non plus oysiues que les exterieures, qui produisent iournellement arbres, buissons, ronces, espines et toutes especes de vegetatif. Il faut donc conclure qu'il est impossible que le cours des fontaines puisse passer par les veines de la terre sans mener auec soy quelque espece de sel, lequel estant dissoult dedans l'eau est inconneu et hors du iugement des hommes : et selon que le sel sera veneneux, il rendra l'eau veneneuse ; comme celles qui passent par les minieres d'airain, elles amenent auec soy vn sel de vitriol ou coperoze fort pernicieux : Celles qui passent par des veines alumineuses ou salpestreuses, ne peuuent amener sinon la substance salsitiue par où elles passent : et si aucunes sources passent par des bois ou troncs pourriz dedans terre, telles eaux ne peuuent estre mauuaises, par ce que le sel des bois pourriz n'est veneneux comme celuy de la coperose. Ie ne dy pas qu'il n'y aye quelque arbre, et consequemment des plantes, desquelles

(1) Palissy jette ici le blâme sur les travaux exécutés à Saint-Cloud par Nicolas Wasser-Hun, Jean de Sponde et Paul de La Treille, privilégiés par lettres patentes de Henri III, du 7 mars 1585. Ce privilége, assez curieux par les projets qu'annonçaient les inventeurs, fut imprimé chez Frédéric Morel, in-12, 1585. Il est rapporté par Gobet, dans l'édition de 1777, p. 675.

le sel peut estre veneneux ; et ne faut penser que toutes eaux bonnes à boire soyent exemptes de venin : mais vn peu de venin en vne grande quantité d'eau n'a pas puissance d'actionner sa nature mauuaise : comme les eaux qui passent par des veines où il y a du sel commun, ne peuuent estre mauuaises. Celles qui passent dedans les canaux des rochers ne peuuent amener autre chose que du genre de sel qui a causé la congelation desdits Rochers : et ledit sel est conneu en la calcination extraite des pierres desdits Rochers, et lors que telles pierres sont calcinees l'on trouue au goust de la langue la mordication et acuité dudit sel, lequel estant dedans l'eau peut aussi bien congeler des pierres au corps de l'homme comme il fait en la terre, n'estoit la raison que i'ay alleguée cy dessus ; que la grande quantité d'eau efface le pouuoir d'vn peu de venin (1). C'est chose certaine qu'il y a des fontaines qui donnent les fieures à ceux qui en boyuent. Ie n'ay iamais veu venir estranger au pays de Bigorre pour y habiter, que bien tost apres n'ayt pris les fieures : l'on voit audit pays grand nombre d'hommes et femmes qui ont la gorge grosse comme les deux poings ; et est chose toute certaine que les eaux leur causent ce mal, soit par la froidure des eaux ou par les mineraux par où elles ont passé. Pline raconte au trentiesme liure de son histoire naturelle, chap. 16, qu'il y a vne fontaine en Arcadie, de laquelle l'eau est d'vne nature si pernicieuse qu'elle dissipe tous les vaisseaux ausquels elle est mise : Et ne peut on trouuer aucun vaisseau qui la puisse contenir. Sur ce propos ie diray ce qu'en escrit Plutarque en la vie d'Alexandre le Grand (2), c'est qu'aucuns ont pensé qu'Aristote enseigna à Antipater le moyen de pouuoir recueillir de ceste eau, à sçauoir dans l'ongle d'vn asne, et qu'Alexandre fut ainsi empoisonné. C'est vne chose toute certaine que tout ainsi qu'il y a diuerses especes de sels en la terre, qu'il y a aussi diuerses huiles, tesmoin l'huile de petrolle, qui sort des rochers : et faut croire que le bitumen n'est autre chose qu'huile

(1) On ne peut mieux raisonner sur cette matière ; et c'est là la véritable manière d'envisager les eaux de source, qui sont toutes plus ou moins minéralisées par les substances répandues au milieu des terrains qu'elles traversent.

(2) Traduct. d'Amyot, CXXIII.

au parauant qu'il soit congelé. Et tout ainsi comme les eaux sousternees apportent auec elles quelques especes de sels par où elles passent, semblablement si elles treuuent des huiles elles les ameneront auec elles, et en beuuant telles eaux nous beuuons souuent et de l'huile et du sel. N'as-tu pas leu quelques historiens, qui disent qu'il y a vn fleuue et quelquelques fontaines d'où il sort grande quantité de bitumen, lequel est recueilli par les habitans du pays, lesquels en font grand trafic, le faisant transporter en pays estranges? Et pour l'asseurance et tesmoignage de ce que i'ay dit, que les huiles et sels peuuent rendre les eaux mauuaises et pernicieuses : ceux qui ont escrit des fontaines et des fleuues, rendent tesmoignage que telles eaux sont pernicieuses, et que mesme les oyseaux meurent de la senteur d'icelles. Les sources qui passent au trauers des mines des terres argilleuses, ne peuuent qu'elles n'amenent quelque salsitude mauuaise : d'autant qu'il se treuue bien peu de terre argileuse, où il n'y ait quelques marcassites sulphurees et commencement de metaux : aussi qu'il y a bien peu de terres argilleuses, qui ne soyent de diuerses couleurs, comme de blanc, rouge, iaune, noir, ou gris, entremeslees des couleurs susdites, lesquelles couleurs sont causees par les mineraux sulphurez qui sont dedans icelle : comme nous sçauons à la verité, que le fer, le plomb, l'argent, l'anthimoine, et plusieurs autres mineraux ont en eux vne teinture iaune, dont les terres iaunes ont pris leur couleur. Voyla donc vn tesmoignage inexpugnable que les eaux qui passent par les terres argilleuses amenent auec elles du sel semblable à celuy qui est esdites terres : lesquelles terres ne pourroyent iamais s'endurcir, cuire, colliger ny se fixer si ce n'estoit la vertu du sel, qui est esdites terres, et par le moyen dudit sel elles sont bonnes à faire briques, tuilles et toutes especes de vaisseaux pour le seruice de l'homme, comme ie donneray plus clairement à entendre parlant des terres argilleuses et des pierres : et feray fin au propos de la bonté ou malice des eaux, si ce que i'en ay dit t'a suffisamment contenté.

THEORIQUE.

Ie me contente plus que suffisamment de ce que tu m'en as discouru : toutesfois iusques icy ie n'ay rien entendu de toy de la cause des eaux chaudes, qui sont en plusieurs pays, et

150 DES EAUX

mesmes en France, au lieu de Cauterets, Bauieres (Bagnères), et en plusieurs autres lieux.

PRACTIQUE.

Ie ne te puis asseurer d'autre chose, qui puisse causer la chaleur des eaux, que les quatre matieres cy dessus nommees, sçauoir le souphre, le charbon de terre, les mottes de terre, et le bitumen : mais nulle de ces choses ne peut eschaufer les eaux si premierement le feu n'est ietté ou esprins au dedans de l'vne de ces quatre matieres. Tu me diras qui est ce qui auroit mis le feu soubs terre pour brusler ces choses? A ce ie responds, qu'il ne faut qu'vne pierre de rocher tomber ou s'encliner contre vne autre, pour engendrer certaines estincelles, lesquelles seront suffisantes pour allumer quelque veine sulphurée : et de là le feu pourra suiure l'vne des quatre matieres susdites : en telle sorte que le feu ne s'esteindra iamais, tant qu'il trouuera matiere pour se nourrir; et quand l'vne de ces quatre est allumée, les eaux qui sont encloses dedans les Rochers descendantes continuellement de degré en degré, iusques à ce qu'elles soyent au lieu où lesdites matieres sont allumees, ne peuuent passer qu'elles ne s'eschauffent, et cela ne se peut faire qu'il n'y ait vn merueilleux tourment engendré du feu et de l'eau : et quelque chose que les Philosophes ayent dit des tremblements de terre, ie ne confesseray iamais qu'aucun tremblement de terre se puisse faire sans feu : bien leur confesseray-ie que les eaux seules auec les vents enclos dedans icelles, peuuent abysmer chasteaux, villes et montaignes, tant par l'effect du vent enclos dedans les cauernes, que par la compression des eaux desbordees, qui par leur subtilité et vehemence peuuent pousser, demolir et ruyner ce que dessus : et ce par le moyen d'auoir chassé les terres sur lesquelles ces choses seront assises, et ayant concaué par dessouz les fondements, icelles choses peuuent tomber dedans cest abisme, sans aucune ayde ny action ignee. Mais les tremblements de terre ne peuuent estre engendrez que premierement il n'y ait le feu, l'eau et l'aër ioincts ensemble. Quelques historiens racontent qu'en certains pays il y a des tremblements de terre, qui ont duré l'espace de deux annees (chose fort aisee à croire) et cela ne se peut faire par autre moyen que par celuy que i'ay mis cy dessus. faut qu'au parauant que la terre tremble il y ait grande quan

tité de l'vne de ces quatre matieres (que i'ay nommees cy deuant) allumee, et estant allumee qu'elle aye trouué en sa voye quelques receptacles d'eaux dedans les rochers, et que le feu soit si grand qu'il aye puissance de faire bouillir les eaux encloses dedans les rochers, et alors par le feu, les eaux et l'aër enclos, s'engendrera vne vapeur qui viendra souleuer par sa puissance les rochers, terres et maisons qui seront au dessus. Et d'autant que la violence du feu, de l'eau et de l'aër, ne pourra ietter d'vn costé ny d'autre vne si grande masse, elle la fera trembler, et en tremblant il se fera quelques subtiles ouuertures qui donneront quelque peu d'aër au feu, à l'eau et aux vents, et par tel moyen la violence qui autrement eut tout renuersé est pacifiée; que si les trois matieres qui font trembler, ne prenoyent quelque peu d'aër en faisant leur action, il n'y a si puissante montaigne qui ne fut soudain renuersée, comme il est aduenu en plusieurs lieux, que plusieurs montaignes ont esté conuerties en vallees, par tremblements de terre, et plusieurs vallees en montaignes par vne mesme action. Et lors que lesdits tremblements ont ietté bas villes, chasteaux et montaignes, ç'a esté lors que les trois matieres susdites estant en leur grand combat ne pouuoyent auoir aucune haleine. Or il falloit necessairement, ou que les choses qui estoyent dessus ces trois elements vainquissent, et qu'elles estoufassent lesdits elements, ou bien que les elements ioints ensemble en leur superbe grandeur vainquissent, se donnant ouuerture pour viure. Veux tu que ie te die le liure des Philosophes, où i'ay appris ces beaux secrets? ce n'a esté qu'vn chauderon à demy plein d'eau, lequel en bouillant quand l'eau estoit vn peu asprement poussée par la chaleur du cul du chauderon, elle se sousleuoit iusques par dessus ledit chauderon : et cela ne se pouuoit faire qu'il n'y eust quelque vent engendré dedans l'eau par la vertu du feu : d'autant que le chauderon n'estoit qu'à demy plein d'eau quand elle estoit froide, et estoit plein quand elle estoit chaude (1). Les fourneaux ausquels ie cuis ma besongne, m'ont donné beaucoup à

(1) On voit par ce passage remarquable combien Palissy, en observant tous ces faits, se trouvait près de la théorie de l'ébullition, de l'augmentation du volume des liquides par la chaleur, de la dilatation des gaz par la température, et enfin de la puissance de la vapeur.

connoistre la violence du feu : mais entre les autres choses qui m'ont fait connoistre la force des elements, qui engendrent les tremblements de terre, i'ay consideré vne pomme d'airain qu'il n'y aura qu'vn petit d'eau dedans, et estant eschauffee sur les charbons, elle poussera vn vent tres-vehement (1), qu'elle fera brusler le bois au feu, ores qu'il ne fut coupé que du iour mesme (2).

THEORIQUE.

Tu es pris à ce coup par tes mesmes paroles : car tu as dit cy dessus que les eaux et l'aër poussez et courroucez par la violence du feu, qui est leur contraire, ne pouuoyent subsister ensemble, qui causoit les tremblements de terre, et renuersements des villes et chasteaux, comme feroyent plusieurs caques de poudre à canon emflambez. Et à present ie prouue le contraire, par le recueil de tes paroles. Car tu dis que les eaux chaudes (desquelles on fait les bains, tant à Aignescaudes (Chaudes-aigues), Cauterets, Bauieres, qu'à Aix en Alemagne, Sauoye et Prouence, et autres lieux) sont eschauffees par le feu qui est continuel sous la terre, ou par le souphre, le charbon et mottes de terre, ou par le bitumen. Et ce neantmoins ie sçay bien qu'il y a long temps que lesdites fontaines chaudes ont duré, et durent encores en mesme estat, voire si long temps que la memoire en est perdue. Et si ainsi estoit que tu dis, le feu, l'aër et l'eau n'eussent ils pas long temps y a ruyné et despecé et fait sauter à dextre et à senestre les canaux et voutes, par lesquelles lesdites eaux passent ? ou pour le moins elles engendreroyent (selon que tu dis) vn continuel tremblement de terre.

PRACTIQUE.

Tu as fort mal entendu mes propos : car quand ie t'ay parlé des tremblements de terre, ie t'ay dit qu'en tremblant par la

(1) Palissy avait probablement appris ce phénomène dans Vitruve. « La force du souffle (de l'air), dit celui-ci, est en raison de la chaleur. C'est ce que nous apprend l'expérience des *éolipyles* : boules d'airain, ayant un très-petit orifice par lequel on les remplit d'eau. On place ces éolipyles pleins d'eau, auprès du feu ; tant qu'ils ne sont pas chauds on n'observe rien, mais dès qu'ils commencent à s'échauffer ils émettent un souffle véhément. » (Vitruv. archit., 1, 6.)

(2) Dans le siècle suivant, R. Boyle mit à profit cette remarque de Palissy pour activer la combustion du charbon.

force des trois elements enclos dessouz, qu'il se faisoit quelques subtiles ouuertures, par lesquelles sortoit vne partie de la force et haleine de la vapeur desdits elements, et qu'autrement lesdits elements tourneroyent cul sur pointe, toutes les voutes de dessus les canaux où se fait le mouuement, et d'autant que tu m'as dit que cela se deuroit faire dedans les voutes, par lesquelles les eaux des bains sont eschauffees, par le mesme effect que celles qui causent le tremblement de terre, à ce ie respon que la cause pourquoy la terre ne peut estre esbranlee, ny agitee par lesdits feux, est par ce qu'il y a un canal par lequel les eaux passent et sortent hors, qui appaise la violence desdits elements. Car iceux prennent haleine, et aspirent par le canal par où l'eau sort. Et tout ainsi comme l'homme ne pourroit viure ayant le col serré et l'aër enclos dedans le corps, aussi le feu ne sçauroit viure sans aër. Et tout ainsi que l'homme et la beste à qui l'on estouperoit les conduits de l'haleine feroyent de grands efforts pour eschapper, ainsi le feu se trouuant occupé de trop grande abondance d'aër, que luy mesme a causé, esmouuant l'humide, se trouuant dy-ie ainsi opprimé, et ne voulant point mourir, alors il renuerse les montaignes, pour auoir haleine, tendant afin de viure, et c'est vne conclusion si asseurée, qu'il n'y a Philosophe qui la sçeut impugner par raisons legitimes, ie laisseray à dire le surplus iusques à ce que nous parlions de l'Alquimie.

Theorique.

Puis que nous sommes sur le propos des eaux chaudes, di moy la cause pourquoy tant de personnes se vont baigner esdites eaux, tant en France qu'en Alemagne. As-tu quelque iugement qu'elles puissent seruir à guerir toutes maladies? Si tu en as quelque connoissance, ie te prie me le dire.

Practique.

Tout ce que ie puis connoistre de ces choses, c'est que comme le poisson, le lard et autres chairs sont fortifiees et endurcies par l'action du sel, il peut estre que les sels qui sont meslez parmy les eaux chaudes pourroyent endurcir quelques lasches humeurs putrifiées au corps de ceux qui se baignent : mais pour t'asseurer ny croire qu'elles puissent seruir à toutes maladies, ie suis logé bien loing d'vne telle opinion. Ie me suis tenu quelques années à Tarbe, principale

ville de Bigorre, et ay veu plusieurs malades aller ausdits bains qui sont reuenuz autant malades qu'ils estoyent auparauant : D'autre part si le feu est ceste année en vn endroit où il y aura quelque espece de mineral, et qu'iceluy aye vertu de guerir quelque maladie, peut estre que l'annee qui vient le feu trouuera vn autre mineral, duquel le sel ne pourra faire la mesme action que la premiere.

Voila pourquoy ie dy que les choses sont incertaines, d'autant que les eaux viennent de lieux inconnuz.

Theorique.

Et des eaux de Spa au pays de Liege, veux tu aussi dire, que la guarison d'icelles soit incertaine? N'y a il pas iournellement des personnes malades de diuerses maladies, qui vont demeurer quelque temps audit lieu, pour boire de ladite eau, et s'en trouuent bien? il n'est pas iusques aux femmes steriles qu'elles n'y aillent, afin de conceuoir.

Practique.

Ta demande n'est pas à propos, par ce que les eaux de Spa ne sont pas chaudes : toutesfois, afin de respondre à ta demande, ie te di que si les eaux de Spa pouuoient causer vne conception aux femmes, elles feroient de beaux miracles. Je sçay bien que plusieurs y sont allees boire de ladite eau, qui eussent eu plus de proufit de boire du vin. Ie ne dis pas que ladite eau ne soit vtile contre la grauelle, par ce que plusieurs s'en sont bien trouuez : et la cause de ce est d'autant qu'elle prouoque à vriner, et ne demeurant gueres à passer par les parties ordinaires, les matieres qui causent la pierre n'ont pas le loisir de s'assembler pour s'endurcir et lapifier. Aucuns medecins et autres personnes tiennent pour certain que lesdites eaux passent par des minieres de fer, et prennent cet argument de ce que la gueule de la source est tainte en iaune. L'argument est fort bien fondé comme tu l'entendras par les preuues que ie te diray cy apres. Il se trouue en plusieurs villages du pays de Liege des fontaines qui ont la mesme vertu: Mais les habitans de Spa ont publié la leur des premiers, dont il leur reuient vn grand proufit. Si ainsi est que la mine de fer ait telle vertu, il se trouuera au pays des Ardennes grand nombre de fontaines autant bonnes que les susdites : par ce que les terres du pays sont pleines de mines de fer, les terres argilleuses iaunes qui y sont, en rendent tesmoignage.

Theorique.

Tu m'as cy deuant fait entendre que si les eaux des bains de Bauieres, Cauterets, Argelais et Aix, auoient quelque vertu de guarir les maladies, que cela se faisoit par la vertu des sels, et à présent tu dis que la mine de fer cause la vertu de l'eau de Spa.

Practique.

Quand tu auras bien entendu tout mon discours, tu connoistras que le fer n'est engendré d'autre chose que de sel. Mais par ce que ce propos se trouuera mieux à point en prouuant qu'il y a du sel en toutes choses, ie l'y reserveray.

Theorique.

Si ainsi est nous ne mangerions point de beurre frais. Ie ne vis iamais vn plus arresté, sur ces sels. Mais me penserois tu faire croire qu'il y eust du sel souz la terre, et que les eaux le puissent amener pour causer les effects de la medecine?

Practique.

Tu n'es guere sage de faire une telle demande, as tu point ouy dire à ceux qui sont venus de Polongne que la miniere de sel est merueilleusement basse dedans terre? n'as tu pas aussi ouy dire qu'il y a des puits salez en Lorraine? Il me semble l'auoir dit cy dessus. Ne sçait on pas qu'en Bearn il y a des fontaines salees, desquelles l'on fait le sel qui fournist la pluspart dudit pays, et de Bigorre? Ce n'est pas encores assez: car quand il n'y auroit point de sel commun és terres et canaux où le feu est allumé, par où les eaux chaudes passent, il y en aura de plusieurs autres especes : par ce que si le feu qui est embrazé dedans les parties sousternées trouue du marbre, ou autre espece de pierre, de laquelle l'humeur ne soit fixe, le feu les calcinera, et estant reduites en chaux, les eaux qui passent par laditte chaux dissoudront le sel qui estoit au marbre, et autres pierres imparfaites; i'appelle pierres imparfaites celles qui sont suiettes à se calciner. Les parfaites ne se calcinent iamais, ains se vitrifient. Item, si le feu qui est allumé, et qui a causé la chaleur des eaux s'est attaché és mottes de terre, qui sont pleines de petites racines, ce qui les fait brusler, les mottes et racines estant bruslees, laisseront le sel qui est en elles, et l'ayant laissé dedans les cendres, et les eaux passant au trauers d'icelles ne faudront iamais d'emporter le sel dissout en icelles : autant s'en pourra faire des

cendres du souphre et du charbon de terre. Et encores que les eaux ne peussent estre salées par les moyens que ie dis (ce qui ne peut estre autrement) encores seroyent elles salées du sel qui degoutte continuellement auec les eaux qui passent au trauers des terres pour se rendre iusques au lieu là où lesdits feux sont allumez. Il faut donc conclure que dedans lesdites eaux chaudes, il y peut auoir plusieurs et diuerses especes de sels tout en vn mesme temps : ie dis et sel commun, sel de vitriol, sel d'alun, et de coperoze, et de toutes especes de mineraux. Et outre ce que ie dis il y peut auoir plusieurs especes de sels, qui seront entremeslez auec du sable ou cailloux, en telle sorte que la violence du feu les aura contrains se vitrifier : comme ainsi soit que cela soit aduenu par accident à ceux qui premièrement ont inuenté le verre. Aucuns disent que les enfans d'Israël ayant mis le feu en quelque boys, le feu fut si grand qu'il eschauffa le nitre auec le sable iusques à le faire couler et distiler le long des montagnes, et que deslors on chercha l'inuention de faire artificiellement ce qui auoit esté fait par accident, pour faire les verres. Autres disent que l'exemple fut pris sur le riuage de la mer, là où quelques pirates estoyent descendus à bord, et voulant faire bouillir leur marmitte, et n'ayans aucuns chenets ou landiers, prindrent des pierres de nitre, sur lesquelles ils mirent des grosses buches, et grande quantité de bois, qui causa vn si grand feu, que lesdites pierres se vindrent à liquifier, et estant liquifiees, descoulerent sur le sablon ; qui fut cause que ledit sablon estant entremeslé auec le nitre fut vitrifié comme le nitre, et le tout fit vne matiere diaphane et vitreuse. Aussi ie te di, qui pourroit voir le lieu où les feux sont allumez dessouz les terres et montagnes, que l'on trouueroit plusieurs matieres vitrifiees de diuerses couleurs. Aussi trouueroit on or et argent fondu, et autres metaux et mineraux ; car tout ainsi que i'ay dit vne autrefois, que l'exterieur de la terre est tout plein de plantes diuerses, aussi l'interieur se trauaille iournellement à produire choses diuerses, et par ce que i'ay dit cy dessus, que les feux qui sont enclos soubs la terre ne peuuent engendrer tremblement, sinon quand ils ne peuuent aspirer, et que l'haleine est reserrée. Pour tesmoignage de mon dire i'ay esté adverti par plusieurs dignes de foy, que aux lieux où il y a de terres sulphurees, l'on voit de nuit

grand nombre de petis trous au trauers de la terre, par lesquels sortent des flambes de feu procedantes du souphre qui est allumé par dessouz la terre, et disent que les trouz ne sont pas plus grands que trouz de vers, et au tour de l'entree desdis trouz l'on trouue du souphre, que les flambes du feu ont esleué de dessouz la terre, et cesdits feux n'aparoissent que de nuit. Tu peux connoistre par là que le feu prenant aspiration par lesdits trouz brusle sans faire aucune violence ny tremblement en la terre. Autant en est il de celuy qui eschauffe les eaux des bains par ce qu'il prend haleine par le canal desdites eaux. Iusques à present i'ay pris peine de te faire entendre la cause des bontez ou malices des eaux, tant de celles des sources naturelles, que des puits, mares et autres receptacles, et tout cela tendant afin que tu connoisses mieux la bonté de l'eau des fontaines, que ie te veux apprendre à faire és lieux les plus steriles d'eaux. Ie laisseray donc tous autres propos pour venir à la cause des sources naturelles : Et ce d'autant qu'il est impossible d'imiter nature en quelque chose que ce soit, que premierement l'on ne contemple les effects d'icelle, la prenant pour patron et exemplaire, car il n'y a chose en ce monde où il y ait perfection, qu'és œuures du souuerain. En prenant donc exemple à ces beaux formulaires qu'il nous a laissez, nous viendrons à l'imitation d'iceux.

Quand i'ay eu bien long temps et de pres consideré la cause des sources des fontaines naturelles, et le lieu de là où elles pouuoyent sortir, en fin i'ai conneu directement qu'elles ne procedoyent et n'estoyent engendrees sinon des pluyes (1). Voila qui m'a meu d'entreprendre de faire des recueils des pluyes, à l'imitation et le plus pres approchans de la nature, qu'il me sera possible; et en ensuyuant le formulaire du souuerain fontenier, ie me tiens tout asseuré que ie pourray faire des fontaines desquelles l'eau sera autant bonne, pure et nette, que de celles qui sont naturelles.

THEORIQUE.

Apres que i'ai entendu ton propos ie suis contraint de dire que tu es vn grand fol. Me cuides tu si ignorant que ie veuille adiouster plus de foy à ce que tu dis, qu'à vn si grand nombre

(1) Palissy est évidemment le premier qui, par suite de ses observations, ait été amené à attribuer l'origine des eaux de source aux infiltrations des eaux de pluie.

de Philosophes, qui disent que toutes les eaux viennent de la mer, et qu'elles y retournent? Il n'y a pas iusques aux vieilles qui ne tiennent vn tel langage, et de tout temps nous l'auons tous creu. C'est à toy vne grande outrecuidance de nous vouloir faire croire vne doctrine toute nouuelle, comme si tu estois le plus habile Philosophe.

Practique.

Si ie n'estois bien asseuré en mon opinion, tu me ferois grand honte : mais ie ne m'estonne pas pour tes iniures ny pour ton beau langage : car ie suis tout certain que ic le gagneray contre toy et contre tous ceux qui sont de ton opinion, fut ce Aristote et tous les plus excellents Philosophes qui furent iamais : car ie suis tout asseuré que mon opinion est véritable.

Theorique.

Venons donques à la preuue : baille moi quelques raisons par lesquelles ie puisse connoistre qu'il y a quelque apparence de verité en ton opinion.

Practique.

Ma raison est telle, c'est que Dieu a constitué les limites de la mer, lesquelles elle ne passera point : ainsi qu'il est escrit és Prophetes. Nous voyons par les effets cela estre veritable, car combien que la mer en plusieurs lieux soit plus haute que la terre, toutesfois elle tient quelque hauteur au milieu : mais aux extremitez elle tient vne mesure, par le commandement de Dieu, afin qu'elle ne vienne submerger la terre. Nous auons de fort bons tesmoings de ces choses, et entre les œuures de Dieu, ceste la est grandement merueilleuse, car si tu auois pris garde aux terribles effects de la mer, tu dirois qu'il semble qu'elle vienne de vingtquatre heures en vingtquatre heures deux fois combatre la terre, pour la vouloir perdre et submerger. Et semble sa venue à vne grande armee qui viendroit contre la terre, pour la combatre : et la pointe, comme la pointe d'vne bataille, vient hurter impetueusement contre les rochers et limites de la terre, menant vn bruit si furieux qu'il semble qu'elle veuille tout destruire. Et pource qu'il y a certains canaux sur les limites de la mer és terres circonuoisines, aucuns ont edifié des moulins sur lesdits canaux, ausquels l'on a fait plusieurs portes pour laisser entrer l'eau dedans le canal, à la venue de la mer : afin qu'en venant elle face moudre lesdits moulins, et quand elle vient pour entrer dedans le

canal, elle trouue la porte fermée, et ne trouuant seruiteur plus propre qu'elle mesme, elle ouure la porte et fait moudre le moulin pour sa bien venuë. Et quand elle s'en veut retourner, comme vne bonne seruante elle mesme ferme la porte du canal, afin de le laisser plein d'eau, laquelle eau l'on fait passer apres par vn destroit : afin qu'elle face tousiours moudre le moulin. Et s'il estoit ainsi que tu dis, suyuant l'opinion des Philosophes, que les sources des fontaines vinssent de la mer, il faudroit necessairement que les eaux fussent salees, comme celles de la mer, et qui plus est, il faudroit que la mer fust plus haute que non pas les plus hautes montaignes, ce qui n'est pas.

Item, tout ainsi que l'eau qui est entrée au dedans des canaux, et fait moudre les moulins, et qui amene les bateaux en plusieurs et diuers canaux, pour charger le sel, bois et autres choses limitrofes de la mer, est suiette à suivre la grande armée de mer, qui est venue escarmoucher la terre. En cas pareil ie di qu'il faudroit que les fontaines, fleuues et ruisseaux, s'en retournassent auec elle : et faudroit aussi qu'ils fussent taris pendant l'absence de la mer, tout ainsi que les canaux sont emplis par la venuë de la mer, et tarissent en son absence. Regarde à present si tes beaux Philosophes ont quelque raison suffisante pour conuaincre la mienne. C'est chose bien certaine que quand la mer s'en est allée, elle descouure en plusieurs lieux plus de deux grands lieuës de sable, où l'on peut marcher à sec, et faut croire que quand elle s'en retourne, les poissons s'enfuyent auec elle. Il y a quelque genre de poissons portant quilles, comme les moulles, sourdons, petoncles, auaillons, huitres et plusieurs especes de burgaus, lesquels sont faits en forme de limace, qui ne daignent suiure la mer, mais se fiant en leurs armures, ceux qui n'ont qu'vne coquille s'attachent contre les rochers, et les autres qui en ont deux demeurent sur le sable. Aucuns genres d'iceux, lesquels sont formez comme vn manche de couteau ayant enuiron demy pied de long, se tiennent cachez dedans le sable bien auant, et alors les pescheurs les vont querir. C'est vne chose admirable que les huitres estant apportees à dix ou douze lieuës de la mer, elles sentent l'heure qu'elle reuient, et approchent des lieux où elles faisoient leurs demeurances, et d'elles mesmes s'ouurent, pour receuoir aliment de la mer, comme si elles y estoyent encores. Et à cause

qu'elles ont ce naturel, le cancre sçachant bien qu'elles se viendront presenter, portes ouuertes, quand la mer retournera en ses limites, se tient pres de leurs habitations, et ainsi que l'huitre aura ses deux coquilles ouuertes, ledit cancre pour tromper l'huitre prend vne petite pierre, laquelle il met entre les deux coquilles, afin qu'elles ne se puissent clorre, et ce fait, il a moyen de se repaistre de laditte huitre. Mais les souris n'ont pas conneu la cause pourquoy les huitres auoient deux coquilles : car il est aduenu en plusieurs lieux bien distans de la mer, lors que les huitres sentoyent l'heure de la marée, et qu'elles se venoient à ouurir, comme i'ay dit cy dessus, les souris les trouuans ouuertes, les vouloyent manger, et l'huitre sentant la douleur de la morsure venoit à clorre et resserrer ses deux coquilles, et par ce moyen plusieurs souris ont esté prises : car elles n'auoyent pas mis de pierre entre deux, comme le cancre. Quant est des gros poissons, les pescheurs des isles de Xaintonge ont inuenté vne belle chose pour les tromper : car ils ont planté en certains lieux dedans la mer, plusieurs grandes et grosses perches, et en icelles ont mis des poulies, ausquelles ils attachent les cordes de leurs rets ou filets, et quand la mer s'en est allée, ils laissent couler leurs filets dessus le sable, laissans toutesfois la corde où ils sont attachez, tenant des deux bouts ausdittes poulies. Et quand la mer s'en reuient, les poissons viennent auec elle, et cherchent pasture d'vn costé et d'autre, ne se donnant point de difficulté des filets qui sont sur le sable, par ce qu'ils nagent au dessus : et quand les pescheurs voyent que la mer est preste de s'en retourner, ils leuent leurs filets iusques à la hauteur de l'eau, et les ayant attachez auditez perches, le bas desdits filets est compressé de plusieurs pierres, de plomb, qui les tient roides par le bas. Les mariniers ayants tendu leurs rets et esleuez en telle sorte, attendent que la mer s'en soit allée, et comme la mer s'en veut aller, les poissons la veulent suyure, comme ils ont accoustumé : mais ils se trouuent deceus d'autant que les filets les arrestent, et par ce moyen sont pris par les pescheurs, quand la mer s'en est allée.

Et afin de ne sortir hors de nostre propos ie te donneray vn autre exemple. Il faut tenir pour chose certaine que la mer est aussi haute en esté comme en hyuer, et quand ie diroi

plus, ie ne mentirois point, par ce que les marées les plus hautes sont en la pleine lune du mois de Mars, et à celle du mois de Iullet : auquel temps elle couure plus de terre és parties maritimes des insulaires Xaintoniques, que non pas en nulle autre saison. Si ainsi estoit que les sources des fontaines vinssent de la mer, comment pourroient elles tarir en esté, veu que la mer n'est en rien moindre qu'en hyuer, prens garde à ce propos, et tu connoistras que si la mer alaictoit de ses tetines les fontaines de l'vnivers, elles ne pourroient iamais tarir és mois de Iullet, Aoust et Septembre, auquel temps vn nombre infiny de puits se tarissent. Il faut que ie dispute encores contre toy et tes Philosophes Latins, parce que tu ne trouues rien de bon s'il ne vient des Latins. Ie te di pour vne regle generale et certaine, que les eaux ne montent iamais plus haut que les sources d'où elles procedent (1). Ne sçais tu pas bien qu'il y a plus de fontaines és montagnes que non pas aux vallées : et quant ainsi seroit que la mer fust aussi haute que la plus haute montagne, encores seroit il impossible que les fontaines des montagnes vinssent de la mer : et la raison est, par ce que pour amener l'eau d'vn lieu plus haut pour la faire monter en vn autre lieu aussi haut, il faut necessairement que le canal par où l'eau passe soit si bien clos qu'il ne puisse rien passer au trauers : autrement l'eau estant descenduë en la vallée elle ne remonteroit iamais és lieux hauts, mais sortiroit au prochain trou qu'elle trouueroit. A present donc ie veux conclure que quand la mer seroit aussi haute que les montagnes, les eaux d'icelle ne pourroient aller iusques aux parties hautes des montaignes, d'où les sources procedent. Car la terre est pleine en plusieurs lieux de trouz, fentes, et abysmes, par lesquels l'eau qui viendroit de la mer sortiroit en la plaine, par les premiers trouz, sources ou abysmes qu'elle trouueroit, et au parauant qu'elle montast iusques au sommet des montagnes, toutes les plaines seroyent abysmées et couuertes d'eau : et qu'ainsi ne soit que la terre soit percée, les feux continuels, qui sortent des abysmes amenent auec soy des vapeurs sulphurees, qui en rendent tesmoignage, et ne faudroit qu'vn seul trou, ou vne seule

(1) On reconnaît ici, et dans ce qui va suivre, les bases de la théorie de nos jaillissements artésiens.

14.

fente, pour submerger toutes les plaines. Or va querir à present tes Philosophes Latins pour me donner argument contraire, lequel soit aussi aisé à connoistre, comme ce que ie mets en auant.

Theorique.

Tu dis que si les sources des fontaines venoyent de la mer, que les eaux en seroyent salées, comme celles de la mer, et toutesfois l'opinion generale et commune est que les eaux se dessalent en passant par les veines de la terre.

Practique.

Ceux qui soustiennent une telle opinion n'y entendent rien: parce qu'il est plustost à croire que le sel de la mer vient de la terre, y estant porté tant par les eaux des riuieres qui se rendent en icelle, que par les flots impetueux, qui frappent violemment contre les rochers et terres salées. Car il te faut notter qu'en plusieurs pays il y a des rochers de sel. Il y a quelque autheur qui a mis en ses œuures qu'il y a un païs où les maisons sont faites de pierres de sel; quoy consideré il te faut chercher arguments plus legitimes, pour me faire croire que les eaux des fontaines et riuieres procedent de la mer.

Theorique.

Et ie te prie fay moy donc bien entendre ton opinion, et d'où tu cuides qu'elles peuuent venir, si elles ne viennent de la mer.

Practique.

Il faut que tu croyes fermement que toutes les eaux qui sont, seront et ont esté, sont creées des le commencement du monde: Et Dieu ne voulant rien laisser en oysiueté, leur commande aller et venir et produire. Ce qu'elles font sans cesse, comme i'ay dit que la mer ne cesse d'aller et venir. Pareillement les eaux des pluyes qui tombent en hyuer remontent en esté pour retourner encores en hyuer, et les eaux et la reuerberation du Soleil et la siccité des vents frappans contre terre fait esleuer grande quantité d'eau: laquelle estant rassemblée en l'aër et formée en nuées, sont parties d'vn costé et d'autre comme les herauts enuoyez de Dieu (1). Et les vents poussant lesdittes vapeurs, les eaux retombent par toutes les

(1) Expression biblique. On reconnaît souvent dans le langage de Palissy le prédicateur évangéliste.

parties de la terre, et quand il plaist à Dieu que ces nuees (qui ne sont autre chose qu'vn amas d'eau) se viennent à dissoudre, lesdittes vapeurs sont conuerties en pluies qui tombent sur la terre.

Theorique.

Veritablement ie connois à ce coup que tu es vn grand menteur, et si ainsi estoit que les eaux de la mer fussent esleuées en l'aër, et tombassent apres sur la terre, ce seroit des eaux salees, te voyla donc pris par tes paroles mesme.

Practique.

C'est fort mal theoriqué à toy : me cuides tu surprendre par ce poinct? tu es bien loing de ton compte. Si tu auois consideré la maniere comment se fait le sel commun, tu n'eusses mis vn tel argument en auant, et s'il estoit ainsi que tu dis, l'on ne pourroit iamais faire de sel. Mais il te faut entendre que quand les sauniers ont mis l'eau de la mer dedans leurs parquetages, pour la faire congeler à la chaleur du soleil et du vent, elle ne se congeleroit iamais n'estoit la chaleur et le vent, qui esleue en haut l'eau douce, qui est entremêlée parmy la salée. Et quand l'eau douce est exalée, la salée se vient à craimer et congeler. Voyla comment ie preuue que les nuées esleuées de l'eau de la mer ne sont point salées. Car si le soleil et le vent exaloyent l'eau salée de la mer, ils pourroyent aussi exaler celle de quoy l'on fait le sel, et par ce moyen il seroit impossible de faire du sel. Voila tes argumens vaincuz.

Theorique.

Et que deuiendra donc l'opinion de tant de Philosophes qui disent que les fontaines, fleuues ou riuieres sont engendrees d'vn aër espois, qui sort du dessous des montaignes, de certaines cauernes, qui sont dans lesdittes montaignes, et disent qu'iceluy aër vient à s'espoissir, et quelque temps apres se dissoult et conuertit en eau, qui cause la source des fontaines et riuieres.

Practique.

Entends-tu bien ce que tu dis; que c'est vn aër qui s'espoissit contre les voutes des cauernes, rochers, et que cela se vient à dissoudre en eau? pose le cas que cela soit : toutesfois il me semble que la maniere de parler est mal propre. Tu dis que c'est un aër espoissy, et puis qu'il se dissout en eau : c'es-

toit donc de l'eau conforme à celle que ie dy qui est esleuée, que l'on appelle nuées, lesquelles s'approchant pres de la terre obscurcissent l'aër par vne compression qu'elles apportent, et font que ledit aër est tellement esmeu par compression des eaux assemblées en forme de nuées. Et qu'ainsi ne soit, prens garde quand lesdites nuées sont dissoutes et reduites en pluyes, tu connoistras que les vents ne sont autre chose qu'vne compression d'aër, engendrée par la descente des eaux : d'autant qu'apres que les eaux sont tombées en bas, les vents sont soudain pacifiez : et de là est venu le prouerbe que l'on dit, petite pluye abat grand vent. Ainsi donc la pluye auoit causé lesdits vents, lesquels estant pacifiez par la cheute de la pluye, deslors l'aër, qui estoit obscurcy, commence à s'esclaircir. C'est pour te faire entendre que ie ne nie pas que les eaux encloses dedans les cauernes et gouffres des montagnes ne se puissent exaller contre les rochers et voutes, qui sont au dessouz desdits gouffres : mais ie nie que ce soit la cause totale des sources des fontaines : tant s'en faut, car si tu veus considerer que depuis la creation du monde, il est sorti continuellement des fontaines, fleuues et ruisseaux desdites montagnes, tu connoistras bien qu'il est impossible que lesdites cauernes peussent fournir d'eau pour vne année, non pas pour vn mois, autant de fleuues qui descoulent iournellement. Il faut donc conclure que les eaux qui sortent desdittes cauernes ne viennent ny de la mer ny des abysmes : car ie sçay à la verité que desdits creux des rochers il sort vne merueilleuse quantité d'eau : et en plusieurs montagnes on la void sortir comme vne grosse fumée espesse, qui en s'esleuant en haut obscurcit l'aër en se dilatant parmi iceluy d'vne part et d'autre, et quand laditte vapeur vient à se dissoudre ce n'est autre chose que pluye. I'ay veu plusieurs fois sortir de telles espoisses vapeurs au pays d'Ardenne, et ceux qui les voyoyent sortir comme moy disoyent que dans peu de temps nous aurions de la pluye, estans bien asseurez que lesdittes vapeurs se dissoudroyent en eau. I'ay veu aux montagnes Pyrenées, plusieurs fois sortir de telles vapeurs, qui estant esleuées en haut se conglaçoyent en neiges, et bien tost apres lesdittes neiges couuroyent toute la terre. Ie ne nie donc pas que les vapeurs aqueuses des cauernes souzternees ne puissent contenir grande quantité d'eaux : mais il faut nécessai-

rement qu'elle y aye esté mise et portee par les postes et mes-
sagers de Dieu, sçauoir est, les vents, pluyes, orages et
tempestes, comme il est escrit que ce sont les herauts de la
iustice de Dieu. Or donc les eaux des cauernes y ont esté
mises par les pluyes engendrees tant des eaux qui sont esle-
uées de la mer, que de la terre et de toutes les choses humi-
des, lesquelles en dessechant les vapeurs aqueuses, sont es-
leuées en haut pour tomber de rechef. Voila comment les
eaux ne cessent de monter et descendre ; comme le Soleil et
la Lune n'ont en eux nul repos, semblablement les eaux ne
cessent de trauailler à engendrer, produire, aller et venir ainsi
que Dieu leur a commandé.

Theorique.

Tu as cy deuant conclud comme par vn arrest definitif, que
toutes les sources des fontaines et fleuues ne procedent d'autre
chose que des eaux de pluyes, chose fort esloignée de toute
opinion commune ; ie te prie donne moy quelque raison qui
aye apparence de verité, pour me faire croyre que ton dire
soit fondé sur quelque preuue legitime.

Practique.

Au parauant que venir aux raisons, il te faut considerer la
cause des montagnes, et conséquemment des vallées, et ayant
consideré de bien pres ces choses, tu entendras directement
la raison pourquoy en certaines contrées l'on ne peut trou-
uer aucune source d'eau, non pas mesme souz la terre, pour
faire des puits : Et quand tu auras entendu ces choses, il te
sera aisé à croire que toutes fontaines ne procedent que des
sources prouenantes des pluyes. Venons donc à la connois-
sance des montagnes, pourquoy c'est qu'elles sont plus hau-
tes que la terre; Il n'y a autre raison que celle de la forme
de l'homme : car tout ainsi que l'homme est soustenu en sa
hauteur et grandeur à cause des os, et sans iceux l'homme
seroit plus acroupy qu'vne bouze de vache; en cas pareil si
ce n'estoit les pierres et les mineraux qui sont les os de la
forme des montagnes, elles seroyent soudain conuerties en
vallees, ou pour le moins tous pays seroyent plats et à ni-
ueau, par les faits des eaux, qui descendroyent auec elles
des terres et montagnes droit aux valees. Ayant mis en ta
memoire une telle consideration, tu pourras connoistre la
cause pourquoy il y a plus de fontaines et riuieres proce-

dentes des montagnes que non par du surplus de la terre, qui n'est autre chose sinon que les roches et montagnes retiennent les eaux des pluyes comme feroit un vaisseau d'airain. Et lesdittes eaux tombantes sur lesdittes montagnes au travers des terres et fentes, descendent tousjours, et n'ont aucun arrest iusques à ce qu'elles ayent trouué quelque lieu foncé de pierre ou rocher bien contigu ou condencé; Et lors elles se reposent sur vn tel fond, et ayant trouué quelque canal ou autre ouuerture, elles sortent en fontaines ou en ruisseaux et fleuues, selon que l'ouuerture et les receptacles sont grands: et d'autant qu'vne telle source ne se peut ietter (contre sa nature) au montagnes, elle descend aux valées. Et combien que les commencements desdittes sources venant des montagnes ne soyent gueres grandes, il leur vient du secours de toutes parts, pour les agrandir et augmenter : et singulierement des terres et montagnes qui sont à dextre et à senestre du cours desdittes sources. Voyla en peu de paroles la cause des sources des fontaines, fleuues et ruisseaux : et ne le faut chercher nulle autre raison que celle-là. Si les Philosophes ont escrit que les sources estoyent engendrées d'vn air espais sourdant du bas des montagnes, et que cedit air estant dissout en eau, causoit les fontaines : c'estoit donc de l'eau auparauant provenant des pluyes, estans tombees auant que remonter (1).

Venons à present à la cause pourquoy il n'y a aussi bien des sources és plats pays et campagnes comme és montagnes. Tu dois entendre que si toute la terre estoit sableuze, déliée ou spongieuse, comme les terres labourables, l'on ne trouueroit iamais source de fontaines en quelque lieu que ce fust. Car les eaux des pluyes, qui tomberoyent sur lesdittes terres, s'en iroyent tousiours en bas iusques au centre, et ne se pourroyent iamais arrester pour faire puits ny fontaines. La cause donc pourquoy les eaux se trouuent tant és sources qu'és puits, n'est autre qu'elles ont trouué vn fond de pierre ou terre argileuse, laquelle peut tenir l'eau autant bien comme la pierre ; et si quelqu'vn cherche de l'eau dedans des terres sableuses, il n'en trouuera iamais si ce n'est qu'il y aye

(1) Cette théorie, qui est la véritable, est aussi ingénieuse que clairement exposée.

dessous de l'eau quelque terre argileuse, pierre, ou ardoize, ou mineral, qui retiennent les eaux des pluyes quand elles auront passé au trauers des terres; tu me pourras mettre en auant que tu as veu plusieurs sources sortant des terres sableuses, voire dedans les sables mesmes : A quoy ie respons, comme dessus, qu'il y a dessouz quelque fond de pierre, et que si la source monte plus hault que les sables, elle vient aussi de plus haut : et ne t'abuses point en ta seule opinion : car tu ne trouueras iamais raisons plus certaines que celle que ie t'ay mis en plusieurs endroits de ce discours, et si tu ne me veux croire, c'est à moy grande folie de t'en parler d'auantage. Parquoy ie feray fin de la cause des sources de fontaines.

Theorique.

A la verité il y a longtemps que nous sommes sur ce propos, et i'ay esté bien deçeu : par ce que dés le commencement tu m'as promis de me monstrer à faire des fontaines és lieux steriles d'eau, et en quelque part que ie voudrois ; mais iusques icy tu ne m'en as pas dit encores vn seul mot.

Practique.

Tu n'es gueres sage; ne crois tu pas que le Medecin prudent, n'ordonnera iamais vne medecine à vn malade, si premierement il ne connoist la cause de la maladie? en cas pareil ne faloit il point que, au parauant que t'apprendre à faire des fontaines, ie te montrasse la cause de celles qui se font naturellement? Ne sçais-tu pas que ie t'ay promis dés le commencement de t'apprendre à faire des fontaines à l'imitation de celles du souuerain fontenier? et comment cela se pourroit il faire sans premierement contempler les natures? voila pourquoy ie t'ay voulu inciter à te faire entrer en vne telle contemplation. Et combien que cy deuant ie t'aye beaucoup parlé de l'essence des sources, si est ce que ie te veux encore faire entendre qu'il est impossible qu'elles puissent proceder de la mer, pour vne cause que i'ay oublié à dire cy deuant, qui est qu'il n'y a rien de vuide sous le ciel, et que lors que la mer se retire des canaux, concauitez, trous ou voyes où elle estoit entrée quand elle estoit haute, les eaux n'ont pas si tost laissé lesdits trous ou canaux vuides, qu'ils ne soyent remplis d'aër, et si l'eau retournant de la mer vient à enclorre et enfermer l'aër qui aura pris possession en son absence dans

lesdits trous, iceluy y fera obstacle à l'eau s'il ne trouue quelque subtile aspiration, pour luy ceder place : et si cela se fait en vne fiole de verre tant soit elle petite ou grande, combien cuides tu que cela se peut faire plus asseurement en vn canal d'eau qui iroit depuis la mer iusques aux montagnes d'Auuergne ? si tu dis que entre les montaignes et la mer il y peut avoir quelques subtiles aspirations par lesquelles l'aër s'en pourra fuir au deuant de l'eau, ie respons que si l'ëar y passe, l'eau passera aussi : et est certain que l'eau de la mer vient d'vne telle vitesse, que quand il y auroit vn canal bien clos depuis la mer iusques aux montaignes, et qu'elle fut aussi haute que les montaignes, si est ce que l'eau ne pourroit venir iusques ausdites montaignes, qu'elle ne fît creuer le canal, à cause de la grande distance et de l'aër enclos auec elle. Et comme i'ay dit vne autrefois, si cela se pouuoit faire, les riuieres, fontaines et sources des montagnes, tariroyent quand la mer s'en seroit allée, qui est vne regle aussi certaine que celle que i'ay dit cy dessus, asçauoir que si les fontaines et riuieres venoyent de la mer, les eaux seroyent salées. I'ay encores vne exemple singuliere, pour la derniere de ce propos, qui est qu'aux pays et isles de Xaintonge limitrophes de la mer, il y a en plusieurs bourgs et villages, des puits doux et des puits salez, l'on peut connoistre clairement par là que les puits dont les eaux sont salees, sont abreuuez de l'eau de la mer, et les puits d'eau douce, qui sont pres des salées, et aussi pres de la mer, sont abreuuez des esgouts des pluyes qui viennent de la part contraire de la mer. Et qui plus est, et bien à noter, il y a plusieurs petites isles, enuironnées et entourées d'eau de mer, mesme quelques vnes qui ne contiennent pas un arpent de terre ferme, esquelles il y a des puits d'eau douce ; qui donne clairement à connoistre que lesdites eaux douces ne prouiennent ny de source ny de la mer : ains des esgouts des pluyes, trauersant les terres iusques à ce qu'elles ayent trouué fond, ainsi que ie t'ay desia dit. Apres que i'eus conneu sans nulle doute que les eaux des fontaines naturelles estoyent causées et engendrées par les pluyes, i'ay pensé que c'estoit vne grande ignorance à ceux qui possedent heritages steriles d'eaux, qu'ils n'auisoyent les moyens de faire des fontaines : veu et entendu que Dieu enuoye des eaux autant

sur les terres sableuses que sur les autres, et qu'il faut bien peu de science pour la sçauoir recueillir. Si les antiques n'eussent autrement contemplé les œuures de Dieu, ils se fussent nourris de la pasture des bestes, ils eussent seulement pris les fruits des champs tels qu'ils fussent venus sans labeur : mais ils se sont voulus sagement exercer à planter, semer et cultiuer, pour aider à nature, c'est pourquoy les premiers inuenteurs de quelque chose de bon, pour aider à nature, ont esté tant estimez par nos predecesseurs, qu'ils les ont reputez estre participans de l'esprit de Dieu. Ceres laquelle s'aduisa de semer et cultiuer le bled, a esté appelée deesse ; Bachus homme de bien (non point yurongne comme les Peintres le font) fut exalté parce qu'il s'auisa de planter et cultiuer la vigne : Priapus en cas pareil, pour auoir inuenté le partage des terres, afin que chacun cultiuast sa part : Neptune pour auoir inuenté la nauigation, et consequemment tous inuenteurs des choses vtiles, ont esté estimez estre participans des dons de Dieu. Bachus auoit bien trouué des raisins sauuages, Ceres auoit bien trouué du bled sauuage ; mais cela ne suffisoit pas pour les nourrir suauement, comme quand les choses furent transplantées. Nous connoissons par là que Dieu veut que l'on trauaille, pour aider à nature, comme ainsi soit que toutes choses transplantées sont beaucoup plus suaves que non pas les sauuages : et veu que Dieu nous enuoye de l'eau pure et nette, iusques à nos portes, qui ne couste rien qu'à luy preparer lieu pour recueillir : ne sera ce pas à nous vne grande paresse, apres auoir veu une bonne inuention pour recueillir les eaux que Dieu nous enuoye, de croupir en nostre paresse, sans daigner receuoir vne telle benediction ? or ie feray mon deuoir suyuant la promesse que ie t'ay faicte, protestant que si tu la mesprises tu és indigne de iamais ioüir du benefice des eaux de fontaines ; ie di partant que tu ayes quelque heritage auquel tu puisses recueillir des eaux, ainsi que ie te feray entendre.

Theorique.

Ie te prie donc ne me faire plus languir, mais me monstrer promptement le moyen d'y proceder.

Practique.

Ie ne te puis sagement instruire, que ie n'aye entendu de toy si le lieu où tu veux faire ta fontaine est montueux ou plat :

par ce que selon la commodité du lieu, il faut que la chose soit dessignée, ou autrement l'on trauailleroit en vain.

Theorique.

I'ay vne maison champestre aupres de laquelle y a vne montaigne assez roide, et ma maison est pres du pied de laditte montaigne.

Practique.

Si ainsi est, tu as vne grande commodité pour construire ta fontaine à peu de frais, et te diray comment; il n'est point de montaigne qui ne soit foncée de rochers, comme ie t'ay dit plusieurs fois. Tu te peux donc asseurer que si tu prens garde qu'il n'y ait quelque trou ou fente le long de la montagne, tu pourras recueillir grande quantité d'eau, et la faire descendre iusques aupres de ta maison. Prens donc garde qu'il n'y aye quelque ouuerture, par laquelle ton eau se puisse perdre, et s'il y en a, ferme la de pierres et de terre, et puis rempares la circonference à dextre et à senestre du lieu que tu auras destiné pour receuoir les eaux des pluyes : Et ayant ainsi fait vn rempart en manière de chaussée, toute l'eau qui tombera dedans ton enclos se viendra rendre au lieu que tu luy auras préparé : Et ce fait, tu feras deux receptacles, l'vn apres l'autre : le second sera plus bas que le premier : afin que l'eau du premier, estant desia purifiée, se vienne rendre au second. Et pour purifier les eaux, faut qu'elles passent au trauers d'vne quantité de sable, que tu auras mis au deuant du premier receptacle, et faut maçonner les pierres du premier receptacle sans mortier, afin que les eaux puissent passer iusques au second, ou bien faire quelque grille d'airain, ou une platine percée de petits trous, afin qu'il ne passe rien que l'eau: et ainsi quand elle aura passé au trauers le sable, et par le premier receptacle, elle sera bien affinée quand elle se rendra au second ; et au bas d'iceluy, pource que le premier receptacle sera grand, et descouuert en l'air comme vn estang, il faudra faire un troisiesme degré plus bas que les deux autres, duquel sortiront les eaux pour l'vsage de la maison : si tu veux enrichir la face du receptacle du costé que tu tires l'eau, tu le pourras enrichir de telle beauté que bon te semblera, soit en façon de roc ou autrement ; et si tu pourras planter des arbres à dextre et à senestre que tu feras cou-

ber en forme de tonnelle ou cabinet, pour donner beauté à ta fontaine.

THÉORIQUE.

Voyre : mais si ma maison estoit un Chasteau entouré de fossez, cela ne me pourroit seruir.

PRACTIQUE.

Si ainsi estoit, il faudroit amener l'eau du receptacle par tuyaux iusques au dedans du chasteau, tout ainsi que tu vois les fontaines de Paris, et celles de la Royne, que l'on fait passer au trauers les fossez, par dedans certaines pieces de bois, qui sont creusees pour cest effect, et sont couuertes par dessus, et y a dedans vn tuyau de plomb par où l'eau desdittes fontaines passe.

THÉORIQUE.

Ie connois à ce coup qu'il y a quelque apparence de verité en ton dire : toutesfois quand i'aurois fait tout ce que tu dis, ie n'aurois rien fait sinon vne cisterne ; ie me tiens tout asseuré que tous ceux qui verroyent ma fontaine ne l'appelleroyent point autrement.

PRACTIQUE.

Mais pensés-tu conoistre la verité ny le poids de mes paroles, si tu n'as souuenance de ce que i'ay dit au parauant, de la cause des sources naturelles ? Il est bien certain que si tu ne retiens qu'vne partie de tout ce que ie di tu n'entendras rien : Mais toute personne qui entendra les beaux exemples et preuues singulieres que ie t'ay dites cy deuant, il confessera tousiours que la fontaine que ie te veux monstrer à faire ne peut estre appellée cisterne : Ains à bon droit elle sera appellée fontaine naturelle ; d'autant que l'eau qu'elle iettera procede du mesme tresor que les autres fontaines. Et n'y a nulle difference sinon deux points ; le premier est que l'on a aydé à recueillir, ou pour mieux dire receuoir le bien qui nous est presenté : Mais qu'est ce que ie di ; n'y a il point de peine ? et ne fait on point de frais pour amener les sources naturelles dedans les villes et chasteaux ? ne faut il pas aussi bien de la maçonnerie comme à celle que ie te monstre à faire ? et qui est celuy qui la pourra legitimement appeller cisterne ? veu qu'elle n'a rien moins que les fontaines naturelles : Ie t'ai dit qu'elle estoit toute semblable aux naturelles, excepté deux points : le premier est, comme i'ay dit, que l'on a aidé à na-

ture : tout ainsi que semer le bled, tailler et labourer la vigne, n'est autre chose qu'aider à nature : Le second est de grand poids, et ne peut estre entendu si tu n'as bien retenu le commencement de mes propos, et l'ayant bien entendu tu pourras iuger par les preuves que i'ay alleguées, que nulle des fontaines naturelles ne sçauroyent produire eaux desquelles on puisse estre asseuré qu'elles soyent bonnes, comme de celle que ie te monstre à faire. La raison est, comme tu peux auoir entendu, que toute la terre est pleine de diuerses especes de sels et de mineraux, et qu'il est impossible que les eaux passans par les conduits des rochers et veines de la terre, n'amenent auec elles quelque sel ou mineral veneneux, ce que ne peut estre en l'eau de la fontaine que ie t'apprens à faire. Item, tu sçais bien que c'est vne regle generale, que les eaux les plus legeres sont les meilleures : ie te demande, y a il des eaux plus legeres que celles des pluyes ? ie t'ay dit par cy deuant qu'elles sont montées au parauant que descendre, et cela a esté fait par la vertu d'vne chaude exalation : or les eaux qui sont montées ne peuuent porter en elles que bien peu de substance terrestre, et encores moins de substance minerale. Et ceste eau, qui est ainsi legerement montée par exalation, redescend sur les terres, lesquelles tu sçais bien qui sont nettes de tous mineraux et autres choses qui peuuent rendre les eaux mauuaises. Voila pourquoy ie puis conclure que les eaux des fontaines faites selon mon dessein, seront plus asseurement bonnes, que non pas les naturelles, et ne deuront point estre appellees autrement que fontaines naturelles : et tout ainsi que les arbres fruitiers ne peuuent changer de nom pour estre entez et transplantez, aussi mes fontaines ne peuuent changer de nom pour estre meilleures que les autres, et s'il estoit loisible de leur changer de nom, il faudroit appeller les sources naturelles sauuages au regard de celles que ie te monstre : Tout ainsi que les arbres fruitiers qui croissent naturellement és bois, sont appellez sauuages : et estant transplantez on les appelle francs. Et pour te faire mieux connoistre que les eaux des pluyes sont les plus legeres, et par consequent les meilleures, interroge vn peu les teinturiers et les affineurs de sucre, ils diront que les eaux des pluyes sont les meilleures pour leurs affaires, et pour plusieurs autres choses. Si tu ne veux croire tant de belles preuues

que ie t'ay amenees, ie te renuoye voir le grand Victruue, qui est celuy de tous ceux qui ont parlé des eaux, qui en parle le plus sainement : il preuue dans son liure, par raisons suffisantes, que l'eau des pluyes est la meilleure et la plus saine.

Theorique.

Ie connois à present que ce que tu dis est fort aisé à faire, et que les eaux de telles fontaines seront asseurement bonnes. Mais ie crain vne difficulté, qui est que quand il pleut asprement de pluye d'orage, les eaux qui descendent violemment du haut de la montaigne ne viennent à amener grande quantité de terres, sables et autres choses, qui empeschent le cours de la fontaine, ou bien des eaux qui se pourroyent rendre en icelle.

Practique.

Pour vray ie connois à ce coup que tu n'es pas aliené de iugement, et par ce que ie voy que tu es attentif à mes paroles, ie te feray cy apres vn pourtrait ou dessein conuenable pour la place ou lieu que tu m'as fait entendre, pour faire ta fontaine. Et pour obvier à la malice des grandes eaux qui se pourroyent assembler en peu d'heures par quelque tempeste, il faut qu'apres que tu auras designé ton parterre pour receuoir les eaux, tu mettes des grosses pierres au trauers des plus profonds canaux qui viennent en ton parterre. Et par tel moyen, la violence des eaux et rauines sera amortie, et ton eau se rendra paisiblement dans tes receptacles.

Theorique.

Ie te demande si le long de la montaigne que ie veux choisir pour le parterre, il y a des arbres, faudra il les couper ?

Practique.

Nenny de par Dieu, donne t'en bien garde : car lesdits arbres te seruiront beaucoup en cest affaire. Il se treuue en plusieurs parties de la France, et singulierement à Nantes, des ponts de bois, que pour desrompre la violence des eaux et glaces qui pourroyent offenser les pilliers desdits ponts, l'on a mis grande quantité de bois debout, au deuant desdits pilliers : par ce que sans cela ils seroyent de peu de duree. Semblablement les arbres qui sont plantez le long de la montaigne, où tu veux faire ton parterre, seruiront beaucoup

pour abattre la trop grande violence des eaux, et tant s'en faut que ie te conseille de les coupper, que s'il n'y en auoit point ie te conseillerois d'y en planter : car ils te seruiroyent pour empescher que les eaux ne puissent concauer la terre : et par tel moyen l'herbage sera conserué, au long duquel herbage les eaux descendront fort doucement droit à ton receptacle : Et te faut noter vn poinct singulier, lequel n'est conneu que de peu de gens, qui est que les fueilles des arbres qui tomberont dedans le parterre et les herbes croissantes au dessouz, et singulierement les fruicts, s'il y en a aux arbres, estant putrifiées, les eaux du parterre attireront le sel desdits fruicts, fueilles et herbages, lequel rendra beaucoup meilleure l'eau de tes fontaines, et empeschera toute putrefaction. Quand nous parlerons des sels tu pourras plus clairement connoistre ce poinct : parquoy ie ne t'en diray plus.

Theorique.

I'ay vne autre maison champestre : mais la montagne est bien à demy quart de lieüe à costé de ma maison : n'y auroit il point de moyen d'y faire venir la fontaine? car quand les eaux descendent, elles s'en vont tomber dedans des prairies assez loing de ma maison.

Practique.

N'as tu pas moyen de remparer les eaux au pied de la montagne, et leur faire prendre le chemin vers le costé de ton heritage? et quand tu les auras amenées jusques à la plaine, deuers le costé de ta maison, il te les faudra amener le surplus du chemin par tuyaux de plomb, de terre, ou de bois : tu feras bien cela; c'est chose bien aisée.

Theorique.

Et si ie voulois faire vne fontaine en vn lieu champestre, que la terre fut à niueau, comme l'on voit communement aux campagnes, y auroit il quelque moyen d'en faire?

Practique.

Ouy bien : mais c'est à plus grand frais que non pas és montagnes : d'autant que là où la place est droicte, il luy faut donner pente à force d'hommes.

Theorique.

Comment est il possible de luy donner pente si elle n'y est de nature?

PRACTIQUE.

Encores n'est ce pas le pis : car il est bien aisé de donner pente à force d'hommes : Mais le pis est qu'estant haussée d'vn costé et abaissée de l'autre, il la faut necessairement pauer : car autrement tout ne vaudroit rien.

THEORIQUE.

Il faut donc conclure tout en vn coup que cela ne se peut faire : parquoy il n'en faut plus parler.

PRACTIQUE.

Si fait, si fait : et la chose est bien aysée, moyennant que l'on veuille employer du temps et de l'argent.

THEORIQUE.

Ie te prie me dire comment tu y voudrois proceder.

PRACTIQUE.

Ie voudrois, en premier lieu, choisir vn champ bien pres de la maison, et selon la grandeur de ma famille ie voudrois faire mon parterre, et ayant tendu mes cordeaux, i'aurois vn nombre de mercenaires, ausquels ie ferois oster la terre du bout prochain de la maison où ie voudrois faire les receptacles, et la ferois porter à l'autre bout de mon parterre, et par ce moyen ie n'aurois pas si tost baissé la partie prochaine de la maison de deux pieds, que l'autre partie ne se trouuast plus haute de quatre pieds, qui seroit vne hauteur assez capable pour amener toutes les eaux des pluyes qui tomberoyent dedans ton parterre, les frais de cela ne sont pas si grands qu'ils vaillent le disputer. Mais quant aux frais du paué, il pourroit couster plus ou moins, selon la commodité des estoffes qui se trouueront pres du lieu.

THEORIQUE.

Et quel besoing est il de pauer ce parterre?

PRACTIQUE.

Par ce que tu m'as dit que c'est vn pays plat, et que tu as tasché à y faire des puits, où tes prédecesseurs et toy auez beaucoup despendu, et si n'auez sçeu trouuer d'eau, ie t'ay dit cy deuant que si toutes terres estoyent sableuses et spongieuses, que les eaux des pluyes passeroyent soudain, qu'elles seroyent cheutes : et que si toutes terres estoyent ainsi, que iamais ne pourroit y auoir source de fontaine, et que les fontaines ne sont causées que de ce que les terres sont foncées de

pierre, ou de quelque mineral. Pour ces causes quand tu aurois fait apporter les terres du bout de ton parterre à l'autre, et qu'il seroit tout preparé à receuoir les pluyes, cela ne te seruiroit de rien : parce qu'elles ne trouueroyent rien qui les peut arrester : voyla pourquoy ie t'ay dit qu'il faut necessairement que ton parterre soit paué, afin qu'il puisse contenir l'eau. Ie n'entens pas qu'il faille que ce soit vn paué taillé ny choisi de pierres dures, comme celuy des villes, ny assis auec du sable, s'il ne se trouue sur le lieu, ains les poser toutes cornues auec de la terre simplement (1). Voyla comment ie l'entends : afin que tu ne penses que la despence soit si grande ; et s'il se trouue de la pierre plate, comme l'on voit en plusieurs contrées, il les faut mettre de plat, afin qu'elles tiennent plus de place ; pourueu qu'elles puissent empescher que les terres ne boyuent l'eau, c'est tout vn, comment elles seront mises.

THEORIQUE.

Et si ie veux eriger ma fontaine en quelque lieu où il n'y aye point de pierre ?

PRACTIQUE.

S'il n'y a point de pierre, fonce la de brique.

THEORIQUE.

Et s'il n'y a ny pierre ny brique ?

PRACTIQUE.

Fonce la de terre argileuse.

THEORIQUE.

Et comment ? la terre argileuse ne boira elle point l'eau comme l'autre terre ?

PRACTIQUE.

Non : car si les eaux pouuoyent passer au trauers des terres argileuses l'on ne pourroit iamais faire du sel à la chaleur du Soleil. Qu'ainsi ne soit, les champs et parquetages des maraiz salans, sont foncez de terre argileuse, et par ce moyen l'eau de la mer, qui est enclose dedans lesdits parquetages, est contenue pour estre congelée et reduite en sel. Mais il te

(1) Ces principes, que Palissy avait déjà présentés dans son premier ouvrage (voy. p 42), furent plusieurs fois mis en pratique et avec succès. On lit dans l'éloge de Couplet, par Fontenelle, des détails fort curieux sur l'application qui en fut faite à Coulanges-la-Vineuse, à Auxerre et à Courson. (*Éloges des Savants.*)

faut noter que les terres argileuses de quoy l'on se sert pour tenir lesdites eaux, faut qu'elles soyent conroyees, comme ie te diray le moyen duquel ceux des isles vsent pour la conroyer. Premierement, ils ont vn nombre de cheuaux attachez à la queue l'vn de l'autre tout d'vn rang, et au premier cheual, pour la conduite d'iceux, y a vn homme qui tient la bride d'vne main, et de l'autre les touche tout à coup d'vn fouët, les faisant pourmener tout le long de la place, iusques à ce qu'elle soit bien conroyée : apres ils l'applanissent, et la mettent en telle forme qu'elle leur puisse seruir à tenir les eaux. Et pource ie t'ay dit que tu pourrois foncer ton parterre de terre argileuse, par faute de pierre, ou de brique, ie te parleray plus amplement de cecy en traitant du sel commun.

THEORIQUE.

Et si mon parterre estoit paué de pierre, de brique, ou de terre d'argile, mon champ ne me pourroit scruir sinon pour receuoir les eaux, et ce seroit grand dommage à vn pauure homme, qui n'auroit qu'vn peu de terre, de l'employer en vne fontaine seulement.

PRACTIQUE.

Si tu me veux croire, ledit parterre te portera grand profit et vtilité; à sçauoir en y plantant grand nombre d'arbres fruitiers de toutes especes, et les planter par lignes directes, et puis paueras ton parterre, et à l'endroit d'vn chacun arbre, tu laisseras trois ou quatre pouces de terre sans estre paué, afin que ledit paué n'empesche l'accroissement des arbres. Et quand cela sera fait tu pourras faire apporter sur ledit paué, de la terre iusques à vn pied de haut et d'auantage; apres tu pourras semer telle espece de legumes que tu voudras, et par ce moyen les arbres croistront, et la terre fructifiera, et te portera plusieurs fruits, et mesme du bois pour te chauffer; et n'y aura piece de terre de si grand reuenu, parce qu'elle seruira à plusieurs choses. Premierement pour les fontaines, secondement pour les fruits, tiercement pour le bois, quartement pour les choses que tu semeras audit parterre : que si tu n'y veux rien semer de ce que nous auons dit, semes y du foing lequel seruira de pasturage : et pour la fin, ce sera vn pourmenoir fort delectable, or voyla vne piece de terre qui portera cinq belles commoditez.

Theorique.

Voire mais si ie couure ledit parterre paué de terre, et que ie seme quelque chose dessus, les eaux qui passeront submergeront les semences que i'y auray semées.

Practique.

Tu as fort mal retenu le propos que ie t'ay dit plusieurs fois, que les terres spongieuses et labourées ne peuuent contenir l'eau, parquoy tu dois entendre que les pluyes qui tomberont dedans ton parterre descendront à trauers des terres iusques sur le paué, et trouuant la pente d'icelluy, descendront iusques au sable qui sera ioignant les receptacles, et en continuant passeront à trauers des sables pour se rendre iusques au premier. Cela te doit bien faire considerer que les eaux des pluyes qui tombent par les montagnes, terriers et toutes places qui ont inclination vers le costé des riuieres ou fontaines, ne s'y rendent pas si soudain. Car si ainsi estoit toutes sources tariroyent en Esté : mais par ce que les eaux qui sont tombees durant l'Hyuer sur les terres ne peuuent passer promptement, mais petit à petit descendent iusques à ce qu'elles ayent trouué la terre foncée de quelque chose, et quand elles ont trouué le roc elles suyuent la partie inclinée, se rendant és riuieres, de là vient qu'au dessouz desdites riuieres, il y a plusieurs sources continuelles : et par ainsi, ne pouuant passer que peu à peu, toutes sources sont entretenues depuis la fin d'vn hyuer iusques à l'autre.

Theorique.

Tu m'as donné le desseing de trois fontaines, deux és montaignes et vne en plat pays : mais d'autant que celle du plat pays ne se peut faire sans frais, et tous n'ont pas la commodité des montagnes, ne me sçaurois tu donner quelque inuention, de laquelle les laboureurs se puissent aider en plat pays, sans estre contrains de pauer la sole? parce que tous n'ont pas la puissance d'auoir du paué : mesme qu'il y a plusieurs campagnes où l'on ne sçauroit trouuer ny pierre, ny brique, ny terre argileuse.

Practique.

Si i'estois homme de village, et que mon habitation fut en plaine campagne, i'aurois espoir de trouuer moyen de faire quelque fontaine pour la prouision de ma famille.

Theorique.

Ie te prie me dire comment tu voudrois faire.

Practique.

I'eslirois quelque piece de terre prochaine de ma maison, et l'ayant haussée d'vn bout, comme i'ay dit cy deuant, ie voudrois auoir certains maillets de bois, et battrois la terre fort vnie : et estant ainsi battue et bien dressée, ie ferois les deux receptacles que i'ay dit cy dessus, et chercherois en quelque part, soit prez ou bois, quelque terre qui fut bien espoisse d'herbe, et d'icelles ie ferois vn si grand nombre de gazons, que i'en aurois pour foncer tout le dedans de mon parterre, et afin que les racines des herbes entrassent d'vn gazon à l'autre ie remplirois toutes les iointures de terre fine, et par tel moyen les racines des gazons passeroient de l'vne à l'autre, et lors ce seroit vn paué de pré qui ameneroit les eaux iusques au receptacle, par le moyen de son inclination.

Theorique.

Et cuides tu que les eaux des pluyes ne puissent passer au trauers desdits gazons, ou pour mieux dire, que les terres les boiroyent sans leur donner le loisir de se rendre au receptacle ?

Practique.

Et penses tu que ie te baille vn tel conseil sans auoir premierement contemplé les prées naturelles. I'en ay veu pres d'vn millier qui n'auoyent pas trois pieds de pente, ou toutesfois les eaux des pluyes se rendoyent en la partie basse de la prée, et demeuroyent là vn bien long temps au parauant que la terre les eut succes. Car la quantité des herbes et racines empesche que la terre ne puisse succer l'eau comme les terres labourees, ie ne di pas que les fentes qui suruiennent en esté à cause de la siccité ne puissent boire une partie des eaux, quand les terres sont alterées : mais l'inclination ou pente du parterre, cause que la plus grand part des eaux qui tombent se rendent soudain entre les sables qui sont au dessus du premier receptacle. Si tu auois seulement bordé ton parterre de plusieurs especes d'arbres, cela donneroit ombrage audit parterre : afin que le soleil ne fit fendre lesdits gazons. Item, ie voudrois laisser croistre l'herbe desdits gazons, sans la couper, et les pluyes descendantes du haut du parterre en bas, feroyent coucher ton herbage, et lors elle seruiroit de cou-

uerture aux fentes de la terre. Et quand lesdites herbes se putreficroyent, leur sel seroit amené par les eaux dedans le receptacle qui causeroit vne bonté és eaux, comme i'ay dit.

Theorique.

Tu m'as donné tant de raisons que ie suis contraint de confesser que les fontaines naturelles ne procedent que des eaux des pluyes, toutesfois i'ay veu de si grandes sources qu'elles faisoyent moudre des moulins, et d'autres qui estoyent commencement de riuieres, et cela ne se peut faire qu'il n'y aye quelque autre cause que les pluyes.

Practique.

Tu t'abuses; par ce que tu n'entends pas que celles des grandes sources viennent de bien loing, à cause qu'elles trouuent la continuation des rochers fort grande, et ayant trouué vn canal naturel, lequel les eaux mesmes auront fait par longue espace de temps, tout ainsi que tu vois que dans les grandes riuieres il se rend plusieurs petites riuieres : ce qui se fait en cas pareil dedans la matrice des montagnes : ayant des canaux principaux qui amenent les sources, ausquels s'en rendent plusieurs autres. Cela se fait, di-ie, aussi bien dans les montaignes interieurement comme il se fait visiblement à toutes riuieres. Et ne cherche plus la cause de la grandeur ou petitesse des sources ; car tu ne trouueras nul qui t'en puisse donner d'autre plus veritable.

Theorique.

Et si le champ lequel i'aurois mis en parterre pour recueillir les eaux à fournir ma fontaine, ne suffit pour toute l'annee, et qu'elles viennent à tarir aux grandes chaleurs, par quel moyen pourroy-ie obuier au defaut desdites eaux?

Practique.

Le moyen est fort aisé, et ne faut pas grand esprit pour la connoistre. Si ton parterre ne suffit, aioustes y encores vne piece de champ : et le paue en cas pareil que ie t'ay dit : et par tel moyen tu n'auras iamais faute d'eau.

Theorique.

Ie n'ay pas encores entendu vn poinct principal, à sçauoir si ceste fontaine sourdera continuellement ou bien si l'eau se doit tirer par un Robinet.

ET FONTAINES.

Practique.

Ie t'ay dit cy deuant qu'en la face de ta fontaine tu mettrois telle beauté ou enrichissement que bon te sembleroit, et qu'il faudroit vn robinet en ladite face.

Theorique.

Et si ainsi est, il me faudra tirer l'eau comme le vin d'vn tonneau, et pour ceste cause ne se pourra appeller fontaine. Car les fontaines naturelles sourdent tousiours.

Practique.

Si iamais ie n'auois veu de fontaines tu me ferois accroire beaucoup de choses : et ne sçait on pas bien que celles de Paris et vn millier d'autres se tirent par robinets?

Theorique.

Voire, mais tu m'as dit que les fontaines que tu m'apprens à faire seruiront pour moy et pour mes bestes ; veux-tu qu'elles aillent tendre la gueule au dessouz du robinet?

Practique.

Ie ne sçay comment tu oses faire une telle demande. Ne sçaurois tu faire quelque receptacle à costé, hors le chemin de la fontaine, pour retirer de l'eau afin d'en abreuuer ton bestail? ie ferois vn robinet à part sur le coing de la fontaine, et quand il faudroit abreuuer le bestail il le faudroit ouurir et le laisser descouler dedans l'abreuuoir, et alors tes bestes boiroyent de l'eau fresche, pure et nette.

Theorique.

Voire, mais ce seroit dommage d'employer tant de terre pour seruir seulement en fontaine.

Practique.

Ie ne connus iamais homme de si peu d'esprit : estimes tu si peu de chose l'vtilité des fontaines? y a-il quelque chose en ce monde plus necessaire? ne sçais tu pas que l'eau est l'vn des elements, voire le premier entre tous, sans lequel nulle chose ne pourroit prendre commencement? ie dy nulle chose animee, ny vegetatiue, ny minerale, ne mesmes les pierres, comme ie te feray entendre en parlant d'icelles.

Item, ie t'ay dit que tu pourras planter toutes especes d'arbres dedans le parterre : et si ainsi est, estimes tu vne terre inutile de produire arbres fruictiers ou autres? il faut à present que ie te face vn long discours de ton ignorance, et de cent mil autres, laquelle ie ne puis assez detester, et mon es-

prit n'est pas capable de crier assez contre vne telle ignorance. Premierement regarde que c'est que ie t'ay dit, que l'homme ny la beste ne sçauroyent viure sans eau. Aussi dis-ie qu'ils ne sçauroyent viure sans feu : voila pourquoy ie di que quand ton parterre ne seruiroit que d'apporter du bois, ce seroit la plus belle chose que tu sçaurois auoir en ton heritage. Ie t'ay dit cy dessus que tu pourras recueillir du bois, des fruits, et de toutes especes de pasturages dans ton parterre, sans que les eaux en soyent aucunement desbauchées. Cuides tu que ce soit peu de chose à l'homme prudent, qui considerera l'utilité du bois, et qui sur toutes choses s'estudiera d'en auoir en son heritage? que sçaurois-tu faire sans bois? feras tu cuire ton disner au soleil? ie te prie, considere vn peu si tu trouveras quelqu'vn de quelque estat que ce soit qui s'en puisse passer. Regarde qu'il y a peu d'artisans qui ne gaignent leur vie par le moyen du bois. Si tu veux bastir des maisons il faut du bois tant pour les poutres, soliues, que cheurons, pour cuire la chaux, pour faire la massonnerie; s'il est question de faire outils et instruments pour trauailler de quelque estat que ce soit, il faut du charbon pour les forger. S'il est question de nauiger pour trafiquer en pays estranges, il faut du bois pour faire les nauires, s'il est question d'auoir des armes de defence, il les faut monter de bois. Il faut du bois pour faire les chariots et charettes, les mareschaux, serruriers, orfeures, et tous ceux qui besongnent de charbon, quel estat prendront ils pour se passer de bois? Bref, s'il est question de faire des moulins, de conroyer les cuirs, de faire les teintures, de faire des tonneaux à mettre du vin et autres choses, desquelles on ne se peut passer, pour toutes ces choses il faut necessairement du bois. Quand est des fruits, comme poires, pommes, cerises, chastaignes, prunes, et autres especes, d'où les recueillera on si on ne plante des arbres? Si ie voulois mestre par escrit combien la necessité du bois est grande, et comme il est impossible de s'en passer, ie n'aurois iamais fait.

ADVERTISSEMENT AV GOVVERNEVR ET

habitans de Iaques Pauly (Jacopolis), autrement nommé Broüage [1].

En poursuiuant le discours des fontaines, i'ay trouué bon d'aduertir par cest escrit le gouuerneur de Broüage, du beau moyen et utilité qui est audit lieu, pour faire vne fontaine selon mon desseing, et à peu de frais, d'autant qu'audit lieu il y a commencement des bois des pompes tout percé qui ne reste qu'à les emboister l'vn dans l'autre, depuis les bois d'Yers iusques au lieu de Iaques Pauly, autrement Broüage; la pente du lieu est si commode que l'on pourroit faire pisser vne fontaine plus d'vne lance haute audit lieu de Iaques Pauly, et cela di-ie pour auoir entendu la grande indigence d'eau que l'on a eu audit lieu durant vn siege qui a esté fait de nostre temps de-uant laditte ville.

[1] Le Brouage est une sorte de havre, assez bien défendu, situé au milieu des marais salants de Saintonge.

DV MASCARET QVI S'ENGENDRE AV

fleuve de Dourdongne, en la Guienne [1].

THEORIQUE.

Tu m'as fait cy deuant vn bien long discours, des effects des eaux, des feux et des tremblemens de terre : mais tu ne m'as rien dit de la cause de l'essence du Mascaret.

PRACTIQUE.

Et qu'est ce que tu appelles mascaret ? car ie n'ouis jamais parler de mascaret, ny ne sçay que ce peut estre, si tu ne me le dis.

THEORIQUE.

L'on appelle mascaret vne grande montaigne d'eau qui se fait en la riuiere de Dourdongne, vers les contrees de Libourne, et ladite montagne ne se fait sinon au temps d'esté : mesme és saisons les plus paisibles, et lors que les eaux sont les plus tranquilles, et tout en vn moment, en vne saison inconneue, la montaigne d'eau se forme en vn instant et fait une course quelquefois bien longue, le long de l'eau, et quelquefois plus courte : et lors que la montaigne fait son cours, elle renuerse tous les bateaux qu'elle trouue en son chemin : parquoy les habitans limitrophes de la riuiere, quand ils voyent le mascaret en sa formation, ils se prennent soudain à crier de toutes parts : garde le mascaret, garde le mascaret, et les bateliers qui pour lors sont en la riuiere s'enfuyent és riuages pour sauuer leurs vies, qui autrement seroyent près de leur fin.

PRACTIQUE.

Et qu'en disent les hommes du pays où se forme ledit mascaret ?

(1) Le *mascaret* n'est autre chose qu'une espèce de *barre* occasionnée par le reflux ou la marée montante. Ce phénomène ne se montre ordinairement qu'en automne.

DV MASCARET.

THEORIQUE.

Ils ne sont pas tous d'vne opinion. Car les vns disent d'vn et les autres disent d'autre. Toutesfois les Bordelois, Libournois et Guitroys tiennent pour certain que la cause de ce, n'est autre que la venuë du montant de la mer, qui rencontre le descendant de la riuiere, et veulent conclure par là que le combat des deux eaux cause d'engendrer celle grande montaigne. Voila l'opinion plus certaine et commune des habitans du pays.

PRACTIQUE.

Et à toy que t'en semble il de la cause de cet effect?

THEORIQUE.

Ie suis de l'opinion des autres.

PRACTIQUE.

Ny toy ny eux n'y entendez rien : car si ainsi estoit que le montant de la mer et la descente de la Dourdongne causast le mascaret, il se formeroit aussi bien des mascarets en la Garonne comme en la Dourdongne, voire à la Charente, et en la riuiere de Loyre, voire pour mieux dire tout en vn coup en toutes les riuieres qui descendent dedans la mer, et toutesfois nous n'auons iamais entendu qu'és mois d'autonne et és iours tranquilles il se trouuast mascaret sinon en ladite riuiere de Dourdongne : parquoy il faut chercher autre cause que la susditte, pour venir à la connoissance de cest effect.

THEORIQUE.

Ie t'en prie, dy moy donc quelle peut estre la cause de ce.

PRACTIQUE.

Ie ne puis penser ny croire que ce soit autre chose qu'un aër enclos au dedans de quelque canal qui est souz terre, trauersant depuis le fleuue de Garonne iusques au dessouz du fleuue de la Dourdongne, et est bien croyable, voire que cela ne se peut faire que par un aër enclos sous les eaux, toutesfois l'aër ne le pourroit faire pour cause de sa foiblesse s'il n'estoit poussé par accident, il faut doncques penser et croire que quand il vient au descendant de la mer, que la riuiere de Garonne est basse pour l'absence de la mer, que lors il y a quelques canaux vuides, lesquels se remplissent d'aër, depuis la Dordongne iusques à la Garonne ; estant ainsi rempli d'aër, quand la mer retourne elle fait enfler et augmenter la riuiere de Garonne, et estant ainsi enflee elle vient à entrer dedans

les canaux qu'elle auoit laissé vuides en sa descente et de là vient que l'aër qui est dedans les canaux se trouuant enclos entre les deux fleuues, et estant viuement poussé par les eaux de la Garonne, il s'enfuit au deuant desdites eaux et en s'enfuyant ils se trouue enclos souz la riuiere de Dordongne, et se trouuant enclos il esleue les eaux comme vne montagne, et ne les pouuant si tost percer, il les meine ainsi en leur hauteur, sans se desformer ny se laisser, iusques à ce que par quelque mouuement les eaux ainsi montees se trouuent plus foible en quelque endroit, et lors l'aër enclos les vient à esclater aux parties plus foibles, et les ayant esclatées ledit aër s'enfuit et les eaux s'abbaissent tout en vn coup, et la riuiere reuient en la premiere tranquillité : et ne faut que tu cherches autre raison pour connoistre la cause du mascaret.

Theorique.

Ie trouue en ton dire vne opinion contraire à la verité : car nous sçauons qu'il se fait ordinairement des vagues dedans la mer, aussi hautes que les montagnes, et mesmes és passages de Maumusson, lesquelles vagues sont si grandes que les nauires n'y peuuent passer sans estre en peril de naufrage, et s'en perd grand nombre audit passage.

Practique.

Cela ne fait rien contre mon dire. Car iamais les vagues de la mer ne sont formées sinon par l'action des vents qui cause ainsi esleuer les eaux de la mer : et la cause pourquoy elles sont plus enflées et esleuées au passage de Maumusson, c'est parce qu'il y a des rochers contre lesquels les eaux de la mer, estants poussées par les vents, viennent frapper impetueusement, qui cause vne grande eleuation és eaux, ie dis vne eleuation si grande que le bruit est entendu de plus de sept lieües loing. Et quand la mer est ainsi esmeüe, les nauires se donnent bien garde d'y passer : par ce que les vagues les ietteroyent contre les rochers et seroyent soudain froissés. Toutesfois cela ne contrarie en rien à mon dire touchant le mascaret. Car ie te di que le mascaret se forme au temps de l'automne és iours les plus tranquilles, et lors que les eaux des fleuues sont basses, et si ledit mascaret estoit causé par les vents, comme les vagues de la mer, il apparoistroit et se formeroit plus souuent en hyuer que non pas en esté. Mais iamais homme ne l'

veu en hyuer : aussi sçais-ie bien que la terre qui fait diuision entre la Dourdongne et la Garonne, fait vne pointe entre Bordeaux et Blaye, là où les deux riuieres se rencontrent, laquelle pointe, viz à viz de Bourg, l'on appelle le bec d'Ambez. Ie me suis trouué quelquefois en laditte pointe où il y a plusieurs maisons ou metairies, lesquelles sont fondees sur la terre, parce que s'ils creusoyent pour faire fondement, ils trouueroyent l'eau qui les empescheroit de bastir, et ne faut douter qu'il n'y aye un grand pays de ladite pointe qui est soutenu par les eaux d'vn bout, et de l'autre bout elle est arrestée par les terres fermes deuers le costé du haut pays : cela ay-ie conneu, par ce qu'en me secoüant sur lesdittes terres ie faisois bransler tout alentour de moy, comme si c'eust esté vn plancher : ie voyois aussi qu'au mois d'Aoust et de Septembre, les terres de laditte pointe sont fendues de fentes si grandes que bien souuent la iambe d'un homme y pourroit entrer : cela me fait croire et assurer que le mascaret n'est causé sinon de l'aër enclos, ce que i'ay aussi conneu par autres exemples des pluyes qui tombent des couuertures des maisons és ruisseaux, et forment par les vents vne vessie ronde, laquelle se creue quand le vent en est sorty. I'ay aussi plusieurs fois contemplé les sources naturelles, lesquelles amenent en cas pareil des vents enclos formés en globe, qui tiennent leurs formes rondes iusques à ce que l'aër les ait creuées : puis que tu vois que l'aër estant poussé par la pesanteur des eaux, a puissance d'esleuer vne si grande quantité desdites eaux, tu peux connoistre par là que telles choses ou semblables peuuent engendrer vn tremblement de terre, non pas si grand comme les trois matieres desquelles i'ay traité au discours escrit en ce liure, sur les faits des causes du tremblement.

AV LECTEVR.

AMI lecteur, le grand nombre de mes iours et la diuersité des hommes m'a fait connoistre les diuerses affections et opinions indicibles qui sont en l'vniuers : entre lesquelles i'ay trouué l'opinion de la multiplication, generation et augmentation des metaux, plus inueteree en la ceruelle de plusieurs hommes que nulle des autres opinions. Et par ce que ie sçay que plusieurs cherchent ladite science sans pensée en fraude ny malice, ains pour vne asseurance qu'ils ont que la chose est possible : cela m'a causé protester par cest escrit que ie n'entens aucunement blasmer trois manieres de personnes. Sçauoir est les seigneurs, qui pour occuper leurs esprits et par maniere de recreation, sans estre menez d'affection de gaing illegitime. Les seconds sont toutes especes de physiciens ausquels est requis de connoistre les natures. Les troisiémes sont ceux qui ont le pouuoir, et qui croyent la chose estre possible, et qui pour rien ne voudroyent en abuser. Et parce que i'ay entrepris de parler contre vn milier d'autres qui sont indignes d'vne telle science, et totalement incapables, à cause de leur ignorance et peu d'experience. Aussi parce qu'ils n'ont le pouuoir de supporter les pertes des fautes qui suruiennent, ils sont contraincts abuser de teintures exterieures et sophistications de metaux. Pour ces causes ay-ie entrepris de parler viuement, auec preuues inuincibles, ie dis inuincibles fa ceux desquels ie parle, et s'il y a quelqu'vn qui aye tant fait par son labeur qu'il ait esmeu la charité de Dieu à luy reueler un tel secret, ie n'entend parler de tels personnages : Mais au contraire, d'autant que la capacité de mon esprit ne peut s'accommoder à croire que telle chose se puisse faire, lors que ie verray le contraire, et que la verité me redarguera, ie confesseray qu'il n'y a rien plus ennemy de science que les ignorans, entre lesquels ie n'auray point de honte de me mettre au premier rang, en ce qui consiste la generation des mé

taux. Et s'il y a quelqu'vn à qui Dieu aye distribué ce don, qu'il excuse mon ignorance : car suyuant ce que i'en croy ie m'en vay mettre la main à la plume, pour poursuyure ce que i'en pense, ou pour mieux dire, ce que i'en ay apris auec vn bien grand labeur, et non pas en peu de iours, ny en la lecture de diuers liures : Ains en anatomizant la matrice de la terre, comme l'on pourra voir par mon discours cy apres.

TRAITÉ DES METAVX ET ALCHIMIE.

THEORIQUE.

IL me semble que tu as assez parlé des fontaines : ie voudrois que suyuant ta promesse tu m'eusses donné quelque connoissance du fait des metaux. Car ie sçay qu'il y a vn grand nombre d'hommes en France, qui se trauaillent tous les iours à l'œuure de l'Alchimie, et plusieurs font de grands proufits, ayants trouué de beaux secrets, tant pour augmenter l'or et l'argent, qu'autres effects : choses que ie voudrois bien sçauoir et entendre.

PRACTIQUE.

Par là tu peux connoistre combien l'insatiable auarice des hommes amene de maux en ce bas siecle. Il n'est abus entre les hommes qui cause plus de larcins et tromperies que l'auarice, ainsi qu'il est escrit, que l'auarice est racine de tous maux. Il est certain que plusieurs desirans d'estre riches se sont enuelopez en plusieurs douleurs : suyuant quoy ie ne puis mieux connoistre que tu veux estre compris au rang des auaricieux, que de ce que tu desire sçauoir, faire ou augmenter l'or ou l'argent. Car plusieurs des auaricieux se peuuent cacher par hypocrisie. Mais quant est de ceux qui veulent faire l'or et l'argent, leur auarice ne se peut cacher, et leurs intentions ne peuuent estre mises en autre rang qu'en celuy des conuoiteux et ventres paresseux, qui pour obuier à trauailler à quelque art vtile et iuste, voudroyent sçauoir faire de l'or et de l'argent, afin de viure à leur aise, et se faire grands à peu de labeur : et estants menez d'vne telle conuoitise, ne pouuant paruenir à faire ce qu'ils cherchent, ils vsent de ce qu'ils peuuent, iuste ou iniuste. Voila vn point que tout homme de bon esprit auroit honte de me le nier : parquoy si tu m'en veux croire tu ne mettras iamais ton affection à ces choses.

Theorique.

Tu me donnes ici de terribles traits, tu me veux quasi accuser d'vn mal que ie n'ay pas encores fait : d'autre part, me veux tu faire croire que ce soit mal fait de prendre de l'huile d'antimoine ou de l'huile d'or, et auec lesdites huiles par vn art philosophal puisse teindre l'argent en couleur d'or? est-ce mal fait de conuertir l'argent en or? Si ie prens du fin cuyure et que ie vienne à luy oster son flegme, ou teincture rouge, et que ie le puisse reduire en couleur d'argent, ie dis en telle sorte qu'il endurera la coupelle et tous autres examens, quel mal est ce si ie le puis faire, moyennant que ce soit bon argent?

Practique.

Tu as beau faire; et trauaille tant que tu voudras, et consomme tes iours et tes biens comme tant de milliers d'autres ont fait, tu n'y paruiendras iamais.

Theorique.

Et ne sçay-ie pas bien que plusieurs par cy deuant sont paruenus à ce que ie di? n'auons nous pas tant de beaux liures qu'ils nous ont laissé par escrit; entre autres vn Gebert, vn Arnault de Villeneufue, le Roman de la Rose, et tant d'autres : mesmes que quelqu'vns de nos anciens ont fait autrefois vne pierre Philosophale, laquelle en mettant vn certain poids dedans l'or elle l'augmentoit de cent fois autant, et c'est ce que plusieurs cherchent auiourd'huy, sçachant bien que cela a esté fait autre fois, et cela s'appelle le grand œuure.

Practique.

Et vray Dieu! és tu encores si ignorant de croire cela? cuides tu que les hommes du temps passé n'eussent en eux quelque mensonge, pour sçauoir attirer l'argent par fallace, aussi bien que ceux du iourd'huy? sçais-tu pas ce que dit Dauid de son temps : Seigneur aide nous : car nous sommes tous desnuez d'hommes droits. Les hommes (dit-il) sont tous pleins de flaterie, et parlent tout au contraire de leurs pensées. Et Salomon dit que l'iniquité est si grande qu'il n'y a pas vn artisan qui ne soit enuieux contre son semblable. Cuides tu que ie vueille croire vn Gebert (1), vn Arnauld de Ville-

(1) Geber ou Yeber, Arabe d'origine, vivait au commencement du IX^e siè-

neufue, ou vn Roman de la Rose, en cé qu'ils auront parlé contre les œuures de Dieu? Et cuides tu que ie sois si mal instruit, que ie ne sçache bien que l'or et l'argent et tous autres metaux sont vne œuure diuine, et que c'est temerairement entrepris contre la gloire de Dieu, de vouloir vsurper sur ce qui est de son estat. Or tout ce qui est donné à l'homme de pouuoir faire enuers les metaux, c'est d'en tirer les excremens, et les purifier et examiner, et en former telles especes de vaisseaux ou monnoyes que bon luy semblera ; et est chose semblable aux cueillettes et cultiuement des semences. Car c'est à l'homme seulement de trier le grain d'auec la paille, le son d'auec la farine, et de la farine en faire du pain, et de pressurer les grappes pour en tirer le vin : Mais c'est à Dieu de leur donner le croistre, la saueur et couleur : ie di qu'ainsi que l'homme ne peut rien en cest endroit, aussi ne peut-il enuers les metaux.

THEORIQUE.

Comment? tu parles icy de semer ; comme si les metaux venoyent de semence, comme le bled ou autres vegetatifs.

PRACTIQUE.

Ie n'ay pas entrepris un tel propos, ny mis vn tel argument en auant sans quelque raison. Ne sçay-ie pas bien que tous ces conuoiteurs de richesses, qui taschent de sçauoir faire l'or et l'argent, quand on leur dit qu'il y a long-temps qu'ils sont apres, et que l'on ne voit aucune experience, ils disent que tout en cas pareil que le laboureur attend patiemment le temps et saison de la cueillette, apres auoir semé : aussi faut qu'ils attendent, et que cela ne se peut faire qu'auec la generation qu'ils ont conclud faire dedans leurs vaisseaux, qu'ils

cle. Il écrivit beaucoup sur la science hermétique, mais il insista peu sur la transmutation des métaux. Geber était l'oracle des alchimistes.

Arnaud de Bachuone, ou *de Villeneuve*, florissait au commencement du XIII^e siècle. On lui attribue à tort la découverte de la distillation, déjà connue, et décrite dans les ouvrages des chimistes des III^e et IV^e siècles de notre ère. Arnaud de Villeneuve n'était autre qu'un charlatan, et l'un des meilleurs types des alchimistes-jongleurs du moyen âge.

Le *Roman de la Rose*, l'un des plus anciens poèmes de notre langue, commencé vers la fin du XIII^e siècle par Guillaume de Lorris, et achevé par *Jean de Méun* (Jehan de Meung), surnommé *Clopinel* ou le Boiteux, favori de Philippe-le-Bel. Il renferme deux écrits alchimiques en vers. Quant au *Miroir d'alchimie*, c'est un ouvrage supposé et attribué faussement à Jean de Méun.

ont destinez à besongner et seruir comme vne matrice à la generation des metaux. Et cela, disent ils, a esté bien considéré et preueu par les Philosophes antiques : car tout ainsi que l'on iette la semence du bled pour causer l'augmentation en sa seconde generation : aussi (disent ils) qu'apres qu'ils ont separé par calcinations, distillations ou autres manieres de faire, les matieres l'vne de l'autre, ils mettent couuer ou generer selon leurs desseings, leurs matieres, par poids et mesure, telle qu'ils ont imaginee, et ce fait ils mettent lesdites choses en vn feu fort lent, voulant imiter la matrice de la femme ou de la beste : sçachant bien que la generation se fait par vne lente chaleur · et afin d'auoir tousiours vn feu continuel et d'vne mesme sorte, ils se sont aduisez de faire vne lampe auec vne mesche toute d'vne grosseur, et leurs matieres estans dedans la matrice, ils les font chaufer de la chaleur de la lampe, et attendent ainsi long-temps à couuer les œufs : ie di aucuns ont attendu plusieurs annees, tesmoing le magnifique Maigret, homme docte et fort experimenté en ces choses, qui toutesfois ne pouuant venir à son desseing, se venta que si les guerres n'eussent esteint sa lampe deuant le temps, qu'il auoit trouué la féue. Autres font des fourneaux que le feu vient d'vn degré assez loing de là où l'on a mis couuer les œufs : Mais afin qu'il continuë tousiours à vne chaleur lente et de mesure, ils font quelques portes de fer, lesquelles ils ouurent selon le degré qu'ils veulent donner à leur feu. Telles gens ne dorment gueres et ont beaucoup de pensées en leurs poitrines, et tourments d'esprit, languissans apres le temps de la visitation de la couuée. Voila l'vn des points par lequel ie preuue que les Alchimistes vsent (abusent) de ce mot de semence et autres termes. Ce n'est pas sans cause que i'ay dit que c'est l'œuure de Dieu que de semer la matiere des metaux et leur donner l'accroissement, et aux hommes de les recueillir, purifier et examiner, fondre et mallier, pour les mettre en telle forme que bon leur semblera, pour leur seruice (1).

THEORIQUE.

Voila vn propos qui est assez long, et toutesfois ie ne le

(1) Palissy est un des premiers savants qui, par la seule force de son génie, ait compris la vanité et le ridicule de certaines recherches alchimiques. Son Traité des métaux date de 1580, et deux cent cinquante ans après il y avait encore des hommes qui se livraient à ces folies.

puis entendre : d'autant que ie sçay qu'il est permis à l'homme de semer de toutes especes de semences, et ce pendant tu appelles les metaux semences diuines, et tu me veux empescher de les semer.

Practique.

Tu as beaucoup mieux dit que tu ne pensois, que les matieres des metaux sont semences diuines. Ie di tellement diuines qu'elles sont inconnuës aux hommes, voire inuisibles : et de ce n'en faut douter, et croy que si me mets apres pour te le prouuer, ie te le monstreray si clairement que tu seras contraint d'accorder mes fins et conclusions.

Theorique.

Ie te prie donc de m'en faire le discours tout au long, par lequel ie puisse connoistre ton dire estre veritable.

Practique.

Il faut donc que tu tiennes pour chose certaine, que toutes les eaux qui sont au monde qui ont esté et seront, furent toutes creées en vn mesme iour, et si ainsi est des eaux, ie te di que les semences des metaux et de tous mineraux et de toutes pierres ont esté creées aussi en vn mesme iour : autant en est il de la terre, de l'air et du feu, car le souuerain createur n'a rien laissé de vuide, et comme il est parfaict, il n'a rien laissé d'imparfait. Mais (comme ie t'ay dit tant de fois, en te parlant des fontaines) il a commandé à nature de trauailler, produire et engendrer, consommer et dissiper ; comme tu vois que le feu consomme plusieurs choses, aussi il nourrit et soustient plusieurs choses ; les eaux desbordees dissipent et gastent plusieurs choses, et toutesfois sans elles nulle chose ne pourroit dire ie suis. Et tout ainsi que l'eau et le feu dissipent d'vne part, ils engendrent et produisent d'autre. Suyuant quoy ie ne puis dire autre chose des metaux, sinon que la matiere d'iceux est vn sel dissoult et liquifié parmy les eaux communes, lequel sel est inconneu aux hommes : d'autant qu'iceluy estant entremeslé parmi les eaux, estant de la mesme couleur que les eaux liquides et diafanes ou transparentes, il est indistinguible et inconnu à tous : n'ayant aucun signe apparent, par lequel les hommes le puissent distinguer d'auec les eaux communes. Voila vn trait singulier, lequel (comme ie pense) est caché et inconneu à beaucoup d'hommes qui pensent estre bons ph[ilosophes]

losophes : et te souuienne de ce point, et le garde pour t'en seruir contre tous ceux qui te voudront faire accroire que la generation des metaux se peut faire par œuure manuelle. Car quand tu n'aurois que ce seul poinct, il suffira pour conuaincre toutes les opinions des alchimistes.

THEORIQUE.

Voire! mais comment les pourroy-ie vaincre par ce point? ie ne voy point que pour cela ils puissent estre vaincus.

PRACTIQUE.

Ie me romps la teste en vain. Ie te demande, di moy par quel moyen les alchimistes besongnent à la generation, multiplication ou augmentation des metaux, et quand tu me l'auras dit, ie te montreray que tu n'as pas bien entendu le principe que ie t'ay baillé.

THEORIQUE.

Les Alchimistes besongnent par feux de reuerberation, calcination, distillation, putrefaction, et infusion.

PRACTIQUE.

Et pourquoy vsent ils de tant de sortes de feux?

THEORIQUE.

Parce qu'ils en font aucuns pour destruire le cuyure, l'or et l'argent, et autres metaux : et quand ils les ont destruits, calcinez et pulverisez, ils font un amas de plusieurs desdites matieres : Et par ce que le vif argent duquel ils vsent volontiers, s'exaleroit à vn grand feu, il est requis qu'ils vsent de feux gueres chauds, et ayant enclos le vif argent, qu'ils appellent Mercure, dedans des vaisseaux bien lutez et fermez, ils taschent à le fixer petit à petit, et le captiuer à vn petit feu, pour le contraindre de se congeler (fixer, cristalliser); afin que puis apres il puisse endurer vn plus grand feu. C'est pourquoy ils ont beaucoup de sortes de vaisseaux, et diuerses especes de fourneaux.

PRACTIQUE.

Ie ne demande autre preuue que celle que tu m'as alleguée pour te monstrer, et par ta confession mesme, que autant qu'il y a d'Alchimistes en France cherchent la generation des metaux par feu, et toutesfois ie t'ay dit pour regle certaine et methode asseuree, que les metaux sont engendrez d'vne eau, à sçauoir d'eau salee, ou pour mieux dire d'vn sel dissout, et si ainsi est (comme la vérité est telle), tous les Alchimistes

cherchent à edifier par le destructeur. Le feu est destructeur de l'eau, et en quelque part qu'il entre, il faut qu'il chasse l'eau, ou s'il ne la chasse, elle le fera mourir : puis qu'ainsi est que le feu et l'eau sont contraires, c'est donc vne pure folie de vouloir generer les metaux par feu : veu qu'il est ennemy et destructeur d'iceux.

Theorique.

I'ay bien entendu que tu m'as dit que les metaux estoyent engendrez d'vn sel liquifié : Mais cela ne fait rien contre mes propos ; ains au contraire il me iustifie. La raison est telle, que ce sel qui est dissout parmy les eaux de la mer est inconneu, comme sont les sels metalliques : et toutesfois il se congele et distingue d'auec les eaux par feu.

Practique.

Tu t'abuses. Toutes congelations faites par froidure se dissoudent par chaleur ; et toutes congelations faites par chaleur se dissoudent par humidité : comme le sel que tu as allegué, il se congele par chaleur et se dissout par humidité. Or les metaux se dissoudent tous par chaleur, il s'ensuit donc qu'ils sont engendrez et congelez par humidité. Te voila forclos de deffences à la mode des practiciens.

Theorique.

Tu me la bailles belle, de me vouloir faire croire que les metaux soyent engendrez ou congelez en humidité.

Practique.

Et si tu ne le veux croire, va voir les minieres où l'on tire l'or et l'argent, et autres metaux, et tu trouueras dedans la pluspart d'icelles qu'il faut espuizer l'eau nuit et iour, pour auoir le metal qui est dans icelles. Vn iour Antoine, Roy de Nauarre commanda de poursuyure la veine de quelques minnes d'argent qui auoyent esté trouuees aux montagnes Pyrenées. Mais quand l'on en eut tiré quelque quantité, les eaux qui y estoyent contraignirent les maistres des minieres à quitter tout. Et l'on sçait bien que plusieurs minieres ont esté delaissées par tel moyen. Tu trouueras donc bien estrange quand ie te prouueray cy apres que nulle pierre ne peut estre congelée ny formée sans eau, et s'il y a de l'eau, c'est donc par humidité, chose directement contraire à ceux qui cherchent la generation des metaux par feu. Ie t'en dirois beaucoup de preuues fort propres pour soustenir mon propos : Mais

d'autant qu'il se trouuera beaucoup meilleur en parlant de l'essence, matiere et congelation de toutes pierres : ie laisseray le reste de mes preuues pour ce temps la.

THEORIQUE.

Tu diras ce que tu voudras : mais i'ay veu vn Philosophe qui augmenta vn teston deuant moy : et affin qu'il n'y eust tromperie il me la fit faire à moy mesme.

PRACTIQUE.

Et comment?

THEORIQUE.

Il me fit peser un teston et autant de vif argent, et me fit mettre le tout dedans vn creuset, lequel ayant mis dedans le feu, il me bailla d'vne poudre pour mesler, laquelle auoit vertu d'arrester le vif argent : Et puis me fit soufler iusques à ce que le tout fut fondu ensemble, et estant fondu il se trouua le poids de deux testons de bon argent : car le vif argent s'estoit fixé par la vertu de la poudre qu'il m'auoit baillée, et moy-mesme auois mis toutes choses : parquoy n'y auoit nulle tromperie.

PRACTIQUE.

Dy moy vn peu comment c'est que tu faisois?

THEORIQUE.

Pendant que les matieres fondoyent ie les remuois d'vn baston.

PRACTIQUE.

Où auois tu pris ce baston là?

THEORIQUE.

En vn coing, le premier que ie trouuay à la main.

PRACTIQUE.

Ie sçauois bien que l'on t'auoit trompé. Car ce maistre Philosophe auoit mis ce baston aupres de toy, sçachant bien qu'il te le feroit prendre pour mesler les matieres : et voila comment il te trompa, car il auoit mis de l'argent au bout du baston, et pendant que tu remuois les matieres dedans le creuset, la cire, de laquelle il auoit fermé l'argent au bout du baston, se fondit, et l'argent tomba dedans le creuset, et le vif argent et la poudre s'en alloit en fumée : et par tel moyen ne demeuroit rien dans le creuset sinon l'argent du teston, et autant poisant d'argent qu'il auoit mis au bout du baston : Voila comment il augmenta ton teston de moytié.

DES METAVX

Theorique.

Est il bien possible qu'il se fut aduisé de me tromper par ce moyen?

Practique.

Et, mon amy, c'est la moindre des finesses desquelles ils trompent les hommes : si ie voulois dire toutes les tromperies qu'ils sçauent faire, et dont i'ay esté aduerty, ie n'aurois iamais fait. Si par tel moyen il n'eut mis l'argent dans le creuset, il t'eust baillé d'une poudre d'argent, laquelle t'eust esté inconnue, et t'eust fait acroire que ladite poudre auroit aresté le vif argent : et ceste poudre eut pesé autant comme il eut voulu faire l'augmentation : ou s'il n'eust mis l'augmentation par vn tel moyen, il eut mis l'argent en cachette de toy, dedans vn grand charbon, duquel il t'eut fait courir ton creuset, et le charbon et l'argent fut tombé dans ton creuset : par ainsi tu ne pouuois eschaper la tromperie. Di moy ie te prie, te monstra il à faire la multiplication de l'argent?

Theorique.

Non.

Practique.

Et pourquoy faisoit il donc cela en ta presence?

Theorique.

C'estoit qu'il me le vouloit monstrer pour de l'argent.

Practique.

T'ay-ie pas bien dit que ce n'estoit que tromperie? Car si la science estoit veritable il n'auroit garde de te la monstrer : mais il tendoit ses filets pour attraper ton argent. Et quand tu eusses esté afronté, tu n'eusses eu garde de t'en venter. Car il n'en eust esté autre chose, sinon que tu eusses esté assez moqué ; ie sçay bien qu'il y en a en France plus de deux mil, qui ont esté afrontez pour cest affaire, que iamais l'on en vist vn qui ait intenté procés pour recouurer son argent.

Theorique.

Et tu estimes donc qu'il y a beaucoup de gens qui se meslent d'affronter les hommes par tels moyens?

Practique.

Ie ne di pas tels moyens seulement; car ie say qu'ils ont vn millier d'autres moyens plus subtils, desquels ils afrontent les plus fins, et ceux mesme qui se pensent mieux don-

ner de garde. Le sieur de Courlange, valet de chambre du Roy, sçauoit beaucoup de telles finesses, s'il en eut voulu vser. Car quelque iour venant à disputer de ces choses deuant le Roy Charles neufieme, il se venta par maniere de facetie, qu'il luy apprendroit à faire l'or et l'argent, pour laquelle chose experimenter, il commanda audit de Courlange qu'il eut à besongner promptement : ce qui fut fait, et au iour de l'experience ledit de Courlange apporta deux phioles plaines d'eau claire comme eau de fontaine, laquelle estoit si bien accoustrée que mettant vne esguille ou autre piece de fer tremper dans l'vne desdites phioles, elle deuenoit soudain de couleur d'or, et le fer estant trempé dans l'autre phiole, venoit de couleur d'argent (1) : puis fut mis du vif argent dedans lesdites phioles, qui soudain se congela ; celuy de l'vne des phioles, en couleur d'or, et celuy de l'autre en couleur d'argent : dont le Roy print les deux lingots et s'alla vanter à sa mere, qu'il auoit appris à faire de l'or et de l'argent Et toutesfois c'estoit vne tromperie, comme ledit de Courlange me l'a dit de sa propre bouche. Voila pourquoy ie t'ay dit que la tromperie de laquelle l'autre te vouloit empoigner, estoit des plus grossieres.

THEORIQUE.

Or di ce que tu voudras : mais ie sçay que plusieurs alchimistes ont trouué de sçauoir faire vn medium d'argent et vn tiercelet d'or, desquels ils besongnent ordinairement : car i'en suis tout asseuré.

PRACTIQUE.

Et moy ie suis tout asseuré que si leur medium d'argent et tiercelet d'or estoit mis à la coupelle, il ne s'y trouueroit rien de bon que ce qui y auroit esté mis de naturel, et le surplus de ce qui y auroit este adiousté seroit connu estre faux : et ie sçay bien que toute les additions et sophistiqueries, qu'ils sçauent faire, ont causé vn millier de faux monnoyeurs : par ce qu'ils ne se peuuent deffaire de leur marchandise sinon en monnoye, car s'ils la vendoyent en lingots la fausseté se trouueroit à la fonte. Mais ils se desfont aisément de monnoye à toutes gens. C'est pourquoy quand ils ont bien trauaillé et ne

(1) Il semblerait que l'ont eût déjà connu à cette époque le moyen de dorer et d'argenter par la voie humide.

se peuuent releuer de leurs pertes, ils sont contraints se ietter sur la monnoye. Il fut pris vn faux monnoyeur (Bearnois) au diocese de Xaintonge, auquel fut trouué quatre cents testons prets à marquer, que s'ils eussent esté marquez, il n'y auoit orfeure n'y autre qui ne les eut pris pour bons. Car ils enduroyent le mail, la touche, la fonte, et le ton; tout semblable aux bons. Mais quand ils furent mis a la coupelle, la fausseté fut descouuerte. En ce temps là il y auoit vn preuost à Xaintes, nommé Grimaut, qui m'asseura qu'en faisant le proces à vn faux monnoyeur, iceluy luy bailla le nom et surnom de huit vints hommes, qui se mesloyent de son mestier, ensemble leurs aages, qualitez et demeurances et autres enseignements asseurez. Et quant ie dis audit preuost pourquoy il ne faisoit prendre lesdits monnoyeurs nommez en son rolle, il me respondit qu'il n'oseroit l'entreprendre : par ce qu'au nombre d'iceux il y auoit plusieurs Iuges et Magistrats, tant du Bordellois, Perigord, que de Limosin : et que s'il auoit entrepris de les fascher, qu'ils trouueroyent moyen de le faire mourir. Quand l'iniquité est entre les grands, et entre ceux qui doiuent punir les autres, c'est vn si grand feu allumé qu'il n'est possible de l'esteindre par forces d'hommes. Si ie voulois dire tous les abus qui se commettent sous ombre de iuste labeur, ie n'aurois iamais fait. Ie t'ay donné seulement cet exemple, afin qu'il ne te prenne iamais enuie de chercher generation, augmentation n'y congelation des metaux : par ce aussi que c'est vne œuure qui se fait par le commandement de Dieu, inuisiblement et par vne nature si tres-occulte qu'il ne fut iamais donné à homme de le connoistre.

THEORIQUE.

Tu m'as beau prescher, car ie sçay qu'il y a plusieurs gens de bien et grands personnages, qui cherchent tous les iours ces choses, et qui pour rien du monde ne se voudroyent attacher à la monnoye : aussi qu'ils ont bien le moyen de s'en passer.

PRACTIQUE.

Ie confesse qu'il y a plusieurs Seigneurs, gens de bien et grands personnages, qui s'occupent à l'alchimie, et y despendent beaucoup. Laisse les faire : cela les garentist d'vn plus grand vice : et puis ils ont du reuenu pour approuuer ces choses. Quant aux medecins, en cherchant l'alchymie ils

prendront à connoistre les natures : et cela leur seruira en leur art : et en ce faisant ils connoistront l'impossibilité de la chose. J'ay recouuert certaines pierres transparentes comme cristal, sans nulle couleur ni tache, ce neantmoins par examen l'on peut faire apparoir directement qu'il y a du metal parmy lesdites pierres, combien qu'elles soyent aussi claires, nettes et transparentes, que lors qu'elles estoyent encor en eau.

Theorique.

Tu dis tousiours qu'il est impossible : et ton opinion veut surmonter celles de plusieurs milliers d'hommes, qui sont plus doctes sans comparaison que toy, lesquels te feroyent rougir, si tu auois entrepris de disputer contre eux : Car tu n'as pas beaucoup de raisons, et ils t'en ameneroyent vn milier, ausquelles tu ne sçaurois contredire.

Practique.

S'il n'estoit question que de raisons, i'en ay vn grand nombre, que la moindre suffira pour vaincre toutes celles qu'ils me sçauroyent amener.

Theorique.

Ie te prie donc donne moy vne de ces belles raisons que tu dis.

Practique.

Quand les alchimistes veulent faire de l'or ou de l'argent ils calcinent et puluerisent leurs metaux, et les ayans puluerisez par calcinations, ils se trauaillent pour faire regenerer lesdites matieres. Or si par ce moyen ils peuuent faire nouuelle generation des metaux hors la matrice ou ils ont esté faits premierement, il leur serait beaucoup plus aisé de faire regenerer vne noix, vne poire, ou vne pomme, qu'ils auroyent mise en poudre. Di donc au plus braue d'iceux qu'il pile vne noix, i'entens la coquille et le noyau, et l'ayant puluerisée qu'il la mette dedans son vaisseau alchymistal, et s'il fait rassembler les matières d'vne noix, ou d'vne chastaigne pilée, les remettant au mesme estat qu'elles estoyent auparauant, ie diray lors qu'ils pourront faire l'or et l'argent, voire mais ie m'abuse, car ores qu'ils peussent rassembler et regenerer vne noix ou une chastaigne, encore ne seroit ce pas la multiplier ny augmenter de cent parties, comme ils disent que s'ils auoyent trouué la pierre des Philosophes, chascun poix d'icel-

es augmenteroit de cent. Or ie sçay qu'ils feront aussi bien l'vn que l'autre.

THEORIQUE.

Pourquoy est ce que tu m'allegues des noix, des chastaignes et autres fruits? veu que ce sont ames vegetatiues, ne pouant estre formées sinon auec vn long temps, et faut que premierement elles soyent venues de semences. Mais quant aux metaux, il n'y à nulle raison de les accomparager aux fruicts, d'autant que leurs corps et leur effect est insensible.

PRACTIQUE.

A ce ie respond qu'il est beaucoup plus aisé de contrefaire vne chose visible, que non pas celle qui est inuisible, les fruits sont formez visiblement et toutesfois il est impossible de les contrefaire : mais encores est-il plus aisé que non pas les metaux. Et quant est de ce que tu dis que les fruits se forment par vne action vegetatiue, et que les metaux sont corps morts et insensibles, en cest endroit ie te veux reueler un secret que tu n'entends pas. Sçache donc que deslors que Dieu crea la terre, il mist en icelle toutes les substances qui y sont et qui y seront : car autrement nulle chose ne pourroit vegeter, n'y prendre forme : et faut croire que les arbres plantez et semencés, ont pris accroissement des le commencement de leur nature par le commandement de Dieu, et depuis (comme i'ay dit en parlant des fontaines) les hommes ayans des semences sauuages les ont semees, cultiuees, transplantees. Mais lesdites semences ne pourroyent prendre accroissement si la matière de l'accroissement n'estoit en terre. Il faut donc conclure que deslors que la terre fust creée, qu'auec elle furent creées toutes matieres vegetatiues, toutes douceurs et amertumes, toutes couleurs, senteurs et vertus, et de là vient, que chacune des semences estant iettee en terre, attire à soy odeurs et vertus. Aucunes attirent des matieres veneneuses et pernicieuses, prenant toutes ces choses en la terre.

THEORIQUE.

Tout ce que tu m'as allegué cy dessus ne fait rien contre mon opinion.

PRACTIQUE.

Si fait : car tout ainsi que ie t'ay dit que les semences ou matieres de toutes choses vegetatiues, estoyent creées des le commencement du monde auec la terre : Aussi t'ay ie dit que

toutes les matieres minerales (que tu appelles corps morts) furent aussi creées comme les vegetatiues, et se trauaillent à produire semences pour engendrer d'autres. Aussi les minerales ne sont pas tellement mortes qu'elles n'enfantent et produisent de degré en degré choses plus excellentes, et pour mieux te le faire entendre, les matieres minerales sont entremeslees et inconnues parmy les eaux, en la matrice de la terre, ainsi que toute humaine creature et brutale est engendree sous espece d'eau en sa formation : et estant entremeslees parmy les eaux, il y a quelque matiere supresme, qui attire les autres qui sont de sa nature pour se former. Et ne faut penser qu'au parauant leur formation et congelation, leur couleur fust connuë parmy les eaux. Mais comme tu vois que les chastaignes sont blanches en leur premiere formation, et noires en leur maturité : les pommes noires au commencement, et rouges en leur maturité : les raisins verds en leur premiere essence, et noirs en leur maturité : Semblablement les metaux en leur premier estre n'ont aucune couleur que d'eau seulement : et cela ay-ie connu auecques vn grand trauail; protestant que iamais ie n'en ay rien cherché en intention de pretendre au fait de l'alchimie. Car i'ay tousiours estimé la chose impossible : ie dis si fort impossible, qu'il n'y à homme qui me sçeust donner raisons legitimes, que cela se puisse faire. Quand i'ai contemplé les diuerses œuures et le bel ordre que Dieu a mis en la terre, ie me suis tout esmerueillé de l'outrecuidance des hommes; car ie voy qu'il y a plusieurs coquilles de poissons, lesquelles ont vn si beau polissement qu'il n'y a perle au monde si belle. Entre les autres y en a vne au cabinet de monsieur Rasce, qui a vn tel lustre, qu'elle semble vne escarboucle, à cause de son beau polissement, et voyant telles choses ie dy en moy-mesme, pourquoy est ce que ceux qui disent sçauoir faire l'or ne puluerisent vn nombre desdites coquilles et en faire de la paste pour en former quelque belle coupe? ie suis asseuré qu'vne coupe bien faitte de telle matiere seroit plus precieuse que l'or. Ou bien que ne regardent ils dequoy le poisson à formé ceste belle maison, et prendre de semblables matieres, pour faire quelque beau vaisseau. Le poisson qui fait sadite coquille n'est si glorieux que l'homme, c'est vn animal qui a bien peu de forme, et toutesfois il sçait faire ce que l'homme ne sçauroit faire. En quelque partie de la mer Oceane

se trouue vne grande quantité de poissons portans chascun vne coquille sur le dos, lequel s'atache contre le roc, et par ce qu'il est couuert de sa coquille, il forme au dessus d'icelle six trous, pour auoir air, ou pour receuoir nourriture ; et ainsi qu'il augmente sa coquille il fait vn nouueau trou, et en ferme un autre ; La plus grande desdites coquilles n'est pas plus grande que la main de l'homme : Le dedans de ladite coquille est de couleur de perle, et plus beau : par ce qu'il tient des couleurs de l'arc celeste, comme la pierre que l'on appelle opale : Le dessus de ladite coquille est assez rude et mal plaisant, à cause de l'eau de la mer qui donne dessus : Mais quant la croute en est ostée, le dessus de ladite coquille est aussi beau que le dedans. Ledit poisson n'a aucune forme, et toutesfois il sçait faire ce que les alchymistes ne sçauroyent faire. Il y a vne isle en laquelle se trouve si grande quantité dudit poisson, que les habitans d'icelle en engraissent les pourceaux, et pour les arracher de leurs coquilles, ils les font bouillir, et font brusler lesdites coquilles, pour faire de la chaux.

Theorique.

Pourquoy est ce que tu me fais vn si long discours d'vne coquille, veu que nostre propos n'est autre que du fait de l'alchimie ?

Practique.

C'est pour vaincre ton erreur et de tous ceux qui sont de ton opinion, que i'ay mis en auant vn poisson le plus difforme que l'on sçauroit trouuer en toutes les parties maritimes, lequel sçait faire vne maison peinte d'vne telle beauté que tous les alchimistes du monde n'en sçauroyent faire vne semblable. I'ay plusieurs fois admiré les couleurs qui sont esdites coquilles, et n'ay peu comprendre la cause d'icelles : toutefois enfin i'ay considéré que la cause de l'arc celeste n'estoit sinon d'autant que le Soleil passe directement au trauers des pluyes qui sont opposites de l'aspect du Soleil : car l'on ne vist iamais l'arc celeste que le Soleil ne luy fust opposite : Aussi ne vist on iamais l'arc celeste que la pluye ne tombast deuers la partie de sa formation : Suyuant quoy i'ay pensé que quand ledit poisson fait sa maison, il se met sur quelque roche, à l'endroit de laquelle l'eau de la mer n'a pas beaucoup d'espoisseur, et que pendant le temps que ledit poisson forme sa maison, le Soleil donne au trauers de l'eau et cause les

couleurs de l'arc celeste en laditte eau, et les matieres desdites coquilles estant aqueuses et liquides en leur formation et congelation retiennent les couleurs actionnées par la reverberation du Soleil passant au trauers desdites eaux. Voila comment il y a temps et saison aussi bien pour les hommes que pour les bestes, les vegetatifs qui n'ont aucun sentiment nous donnent enseignement de ces choses, i'ai veu plusieurs fois besongner les limaces à bastir leurs maisons; mais, iamais homme ne les vist bastir en temps d'hyuer. Les abeilles ou mouches à miel et autres animaux ne le font pas aussi, parquoy il est aisé à conclure que les metaux et tous mineraux ont quelque saison pour leur formation, qui nous est inconnue. Nous pouuons connoistre en ces choses, la folie de ceux qui veulent entreprendre de generer l'or et l'argent hors la matrice de la terre, et qui plus est, les veulent engendrer sans connoistre les matieres propres à leur essence : et (encore piz) veulent faire par feu ce qui est naturellement fait par eau. Et (comme i'ai dit cy dessus) les matieres des metaux sont en telle sorte cachées, qu'il est impossible à l'homme de les connoistre auparavant qu'elles soyent congelées, non plus qu'vne eau en laquelle l'on auroit fait dissoudre du sel, nul ne sçauroit dire qu'elle fust salée sans la taster à la langue.

Theorique.

Et comment sçais tu ces choses, et sur quoy te fondes tu, pour entreprendre de parler à l'encontre de tant de sçauans Philosophes, qui ont fait de si beaux liures d'alchimie? veu que tu n'es ny Grec ny Latin, ny gueres bon François.

Practique.

Ie te le diray. Il aduint vn iour que ie fis bouillir et dissoudre vne liure de salpetre dedans vn chauderon plein d'eau, et puis ie la mis refroidir, et quand elle fust froide, ie trouuay le salpetre qui en se conglaçant s'estoit attaché audit chauderon par glaçons longs, ayant forme quadrangulaire. Quelque temps apres i'achetay du cristal qui auoit esté apporté d'Espaigne, qui estoit formé, ainsi que le salpestre que i'auois fait dissoudre. Ie connuz lors que combien que les metaux soyent corps morts (comme tu as dit) toutesfois le cristal n'est pas tellement mort qu'il ne luy soit donné de se sçauoir separer des autres eaux, et au milieu d'icelles se former par angles et pointes de diamants : et comme il est donné au cris-

tal, salpestre et sel commun, de se sçauoir congeler et faire vn corps à part au milieu de l'eau commune, il est donné aussi aux matieres minerales de faire le semblable, comme ie prouue par vne ardoise que tu vois icy, en laquelle sont plusieurs marcassites formees. Et non sans cause t'ay-ie mis en auant le propos de ceste ardoise : car elle me donne à connoistre la conclusion de ce que i'ay allegué cy dessus. Tu vois que les marcassites metalliques qui sont en icelles sont quarrees par faces semblables à un dé. Si ie te demande lequel des deux a esté formé le premier, ou l'ardoise ou la marcassite, tu ne me sçaurois respondre; ie seray donc le prestre Martin, ie me respondray moy mesme, prenant pour argument les coquilles, lesquelles ie preuue estre formées dedans l'eau qui depuis ont esté petrifiees, et l'eau et les vases où elles habitoyent. Et tout ainsi comme les coquilles estoient formées au parauant qu'estre petrifiees, et le lieu où elles habitoyent : semblablement les marcassites qui sont en ceste ardoise estoyent formees au parauant l'ardoise, et est chose certaine que quand elles se formoyent elles estoyent couuertes d'eau meslee de terre, laquelle depuis s'est reduite en ardoise, et les marcassites ont demeuré en leurs propres formes enchassées dedans laditte ardoise, comme les coquilles se trouuent enchassees dedans la pierre. Conclus donc que lesdites marcassites sont formees d'vne matiere qui (au parauant sa formation) estoit inconnue dedans les eaux, et par vn ordre que Dieu a mis en nature, les matieres, qui au parauant estoyent vagantes, se sont formees en telle sorte, que les hommes deuroyent grandement s'esmerueiller des œuures de Dieu, et connoistre que c'est vne grande folie de le penser imiter en telle chose. Quelque temps apres que i'eus pris garde à ce que dessus, ie m'en allois par les champs, la teste baissee, pour contempler les œuures de nature : lors ie trouuay certains mercenaires qui tiroyent de la mine de fer, assez bas dans la terre, et laditte mine estoit en pierres d'enuiron la grosseur d'un œuf, ie nomme la grosseur par ce qu'és Ardennes la mine de fer y est fort menue. Or celle que lesdits mercenaires tiroyent n'auoit aucune forme, les vnes pierres estoient longues et les autres rondes, bicornues, selon le lieu où la matiere s'estoit arrestée au temps de sa congelation. Quelque temps apres i'en trouuay certaines pierres asses grosses, que toute la superficie estoit formée à

pointes de diamants, ie fus plusieurs ans à songer qui pourroit estre la cause de la forme desdites pointes, et ne pouuant entendre la cause, ie la mis quelque temps à nonchaloir, ne m'en souciant plus. Et comme vne autre fois ie cherchois la cause de la formation de toutes pierres, qui d'vn costé estoyent formees à pointes de diamants, et estoyent lesdittes pointes pures, nettes, candides, et transparantes comme cristal, et de l'autre costé elles estoyent tenebreuses, rudes, et mal plaisantes. Or d'autant qu'elles auoyent esté congelees en ce mesme lieu, i'ay conneu que la partie diaphane estoit formée d'eau pure, et la partie tenebreuse d'vne eau trouble meslee de terre : Mais quant aux pointes de diamants, ie n'en sçeus encores pour lors entendre la cause, il aduint vn iour que quelqu'un me monstra de la mine d'estain qui estoit ainsi formee par pointes, vne autre fois me fust monstré de la mine d'argent tenant encores auec la roche, ou les matieres dudit argent auoyent esté congelees, laquelle mine estoit aussi formée en pointe de diamans. Quand i'ay eu consideré toutes ces choses i'ay conneu que toutes pierres et especes de sels, marcassites et autres mineraux, desquels la congelation est faitte dans l'eau, apportent en soy quelque forme triangulaire, ou quadrangulaire, ou pentagone, et le costé qui est en terre et contre le roc, ne peut porter autre forme que celle de l'assiete du lieu où elle reposoit au temps de sa congelation. Voila qui suffira pour renuerser les opinions de tous ceux qui cherchent à faire l'or et l'argent par son contraire. Car puis qu'il y a des formes de pointes de diamant és minieres d'or, d'argent, de plomb, d'estain et autres metaux, tu te peux asseurer que la principale matiere d'iceux n'est autre chose qu'vn sel dissoult, lequel habitant auec les autres eaux se separe d'auec icelles, attirant à soy les choses qu'il aime, pour les congeler et reduire en metal. Et combien que tous les Philosophes ayent conclud que l'or est fait de souphre, et d'argent vif, ie maintiens que le souphre que nous voyons, ne se sçauroit mesler auec les matieres minerales ou semences d'icelles; bien confesseray-ie que parmy les eaux il y a quelque genre d'huile, lequel estant meslé auec l'eau et le sel mineral, ayde à la generation des metaux, et les metaux estans paruenuz en leur parfaite decoction, l'huile est lors congelée parmy le metal, et prend le nom de souphre. Il y a des secrets si fort cachez et

inconneuz en toutes natures, que de tant plus vn homme sera sçauant en philosophie, de tant plus il craindra les hazards qui suruiennent ordinairement en toutes entreprises fusibles, metalliques, et vulcanistes. N'est ce pas chose estrange et de grande consideration qu'il y a à Montpelier certaines eaux où l'on reduit le cuyure en verd de griz, et tout auprez d'icelle, il y a autres eaux où l'on n'en sçauroit faire? N'y a il pas aussi des eaux qui sont bonnes aux teintures et à cuire legumes, et autres eaux bien pres d'icelles n'y vaudront rien. I'ai veu du temps que les vitriers auoyent grand vogue, à cause qu'ils faisoyent des figures és vitraux des temples, que ceux qui peignoyent lesdittes figures n'eussent osé manger aux, ny oignons. Car s'ils en eussent mangé la peinture n'eust pas tenu sur le verre. I'en ay connu vn nommé Iean de Connet, par ce qu'il auoit l'alene punaise, toute la peinture qu'il faisoit sur le verre ne pouuoit tenir aucunement, combien qu'il fust sçauant en son art. Les historiens disent que s'il y a vne palme plantée sur le bord d'vn fleuue, et vne autre de l'autre costé dudit fleuue, que les racines iront de l'vn à l'autre par dessous ledit fleuue, à cause de l'amitié ou affinité qu'elles ont ensemble (1). Il est certain aussi que les femmes alaictantes, estans loing de leurs enfans endormis, sentent à leurs mammelles quand ils crient estant esueillez. I'ay veu vne femme pudique, saige et honorable, que quand son mary estoit aux champs, elle sentoit par quelque mouuement secret, le iour que son mary deuoit arriuer. Tels mouuemens ne sont pas seulement aux creatures humaines et brutales, mais aussi aux vegetatiues et metalliques. Et tout ainsi comme les matieres animées se servent de choses alimentaires, et en ayant pris la substance nutritiue, enuoyent le demeurant és vaisseaux excrementaires, semblablement les metaux engendrent quelques excrements inutiles apres leur formation. Ie prens donc le souphre comme vne colofaigne (colophane) ou excrement qui a servi à la generation, laquelle estant perfaite les excrements n'y seruent plus de rien, et si cela aduient és creatures humaines et brutales, aussi fait il à tous vegetatifs. Et qu'ainsi ne soit,

(1) Il est peut-être inutile de remarquer qu'il s'agit ici d'un phénomène interprété, à cette époque, à l'aide d'une supposition erronée, mais aujourd'hui parfaitement expliqué par le transport du pollen de la plante mâle à la plante femelle par l'intermédiaire des vents.

tu vois les noix et les chastaignes qui ont vne robbe excrementale, et deslors qu'elles viennent à leur perfection elles iettent en bas leurs robbes comme vn excrement inutile. Ainsi toutes semences ou plantes vegetatiues, produisent quelque chose pour leur aider et seruir pour vn temps seulement. Semblablement ceux qui affinent les mines des metaux, separent le souphre d'auec le metal, comme chose inutile, tout ainsi comme le laboureur separe le bled d'auec la paille. Voila pourquoy ie te di que le souphre vulgaire n'est pas tel comme lors qu'il a generé les metaux, et qu'au parauant ce ne pouuoit estre qu'vne huile inconnue ; tout ainsi que tu vois que la gomme n'est qu'vne eau quand elle est au dedans de l'arbre, et quand elle est sortie, et qu'elle decoule le long de l'arbre elle se desseche et endurcist, et lors elle prend le nom de gomme. La terebentine est vne huile qui distille des piniers, et quand elle est cuitte elle s'endurcist, et puis s'appelle poix rasine. Voila comment il faut que tu entendes que la generation des metaux est faite par matieres et vertus incognues aux hommes. Et ne pense pas que le vif argent soit autre chose qu'vn commencement de metal, fait ou commencé par vne matiere aqueuse et salsitive. Ie ne dis pas de sel commun : car ie sçay que le nombre des especes de sels est infiny à nostre connoissance, comme ie te feray entendre cy apres en parlant des sels.

Theorique.

Tu es terriblement prompt à detracter des Philosophes, et c'est la plus belle chose du monde que la Philosophie, car par Philosophie l'on fait des distillations les plus vtiles pour la medecine que chose que l'on sçauroit trouuer : mesme l'on tire par Philosophie toutes senteurs, vertus et saueurs, tant des espiceries que de toutes choses odoriferantes.

Practique.

Tu te moques bien de moy, de dire que i'ay en haine la Philosophie, et tu sçais bien que ie n'ay rien en plus grande recommandation, et que ie la cherche tous les iours, et ce que i'en parle n'est pas contre les Philosophes actuels et dignes de ce nom. Mais ie parle contre ceux qui meritent plus d'estre appellez antiphilosophes que Philosophes. Car ie louë grandement les distillateurs et tireurs d'essences, et estime cette science grandement vtile et proufitable. Ie n'entens parler si-

18.

non contre ceux qui veulent vsurper (pour viure à leur aise) vn secret que Dieu a reserué à soy, aussi bien comme la puissance de faire vegeter et croistre toutes plantes et toutes choses. Car c'est Dieu luy mesme qui a ietté la semence des metaux en la terre. Et ils veulent entreprendre de faire vne œuure qui se fait occultement dans la terre, de laquelle ils ne connoissent ny le moyen ny les matieres, ny par quelle vertu ny comment, ny en combien de temps la chose peut paruenir à sa perfection. L'on a quelque connoissance du temps qu'il fault pour la maturité des bleds et autres semences : Mais quant est de la semence des metaux, ils n'en ont aucun tesmoignage, ny connoissance de la vertu par laquelle les matieres se lient et congelent. Ie sçay bien que ces choses ont quelque vertu d'attirer l'vn et l'autre, comme l'aimant tire le fer. Aussi sçay-ie bien que quelque fois i'ay pris vne pierre de matiere fusible, qu'apres l'auoir pilée et broyée aussi finement que fumée, et l'ayant ainsi puluerisée ie la meslay parmy de la terre d'argile, et quelques iours apres quand ie vouluz besongner de ladite terre, ie trouuay que ladite pierre s'estoit commencée à rassembler, combien qu'elle fust meslée si subtilement parmy la terre, que nul homme n'en eust sçeu trouuer vne pierre aussi grosse que les petits atomes que l'on void dedans les rayons du soleil, entrant dans la chambre, chose que i'ay trouuée merueilleusement admirable. Cela te doit faire croire que les matieres des metaux se rassemblent et congelent admirablement, suyuant l'ordre et vertu admirable que Dieu leur a ordonné.

THEORIQUE.

Tu as beau parler contre l'alchimie, toutefois i'ay veu plusieurs Philosophes, qui m'ont baillé de grandes raisons du fait de la generation de l'or et autres metaux.

PRACTIQUE.

Ie me doute que ceux que tu appelles Philosophes, ne soyent les plus grands ennemis de Philosophie. Car si tu sçauois que c'est que Philosophie tu connoistrois que ceux qui cherchent à faire l'or et l'argent, ne meritent pas ce titre : par ce que Philosophe veut dire amateur de sapience. Or Dieu est sapience : l'on ne peut donc aimer sapience sans aymer Dieu. Et ie m'emerueille comment vn tas de faux monnoyeurs, lesquels ne s'estudient qu'à tromperies et malices, n'ont honte de se mettre

au rang des Philosophes. Or comme i'ay dit dés le commencement, l'auarice est racine de tous maux, et ceux qui cherchent à faire l'or et l'argent, ne peuuent estre exemps du titre d'auaricieux, et estants auaricieux, ne peuuent estre dits Philosophes ny compris au nombre de ceux qui aiment sapience. I'ay mis ce propos en auant par ce que tous ceux qui cherchent à faire l'or et l'argent, ont tousiours ce mot en la bouche, que les secrets de sçauoir faire les metaux n'appartiennent sinon aux enfans de Philosophie, et non seulement le disent de bouche, mais le mettent és liures imprimez : comme ainsi soit qu'il fut imprimé à Lyon vn liure de l'or potable, du temps que le Roy Henry troisieme y estoit à son retour de Polongne, auquel liure est clairement escrit, que l'alchimie ne doit estre reuelée sinon aux enfans de Philosophie : S'ils sont enfans de Philosophie, ils sont enfans de Sapience, et consequemment enfans de Dieu. Si ainsi estoit il seroit bon que nous fussions tous de la religion des Alchimistes.

THEORIQUE.

Tu m'as allegué cy dessus des chastaignes, des noix, et autres fruits : Mais cela ne fait rien contre moy, parce que les metaux sont vn et les fruits sont vn autre.

PRACTIQUE.

I'ay grand honte que ce propos dure si longuement : toutesfois à cause de ton opiniatrise ie parleray encores de ce fait. Que ne consideres tu le fait de l'aimant, qui par vne vertu singuliere attire à soy le fer : combien qu'il n'ait nulle ame vegetatiue : et si ainsi est hors de la matrice de la terre, combien cuides tu qu'il aye plus grande vertu en la terre, quand il est encores en matiere liquide? l'aimant n'est pas seul qui ait pouuoir d'attirer à soy les choses qu'il aime : Ne vois tu pas le Iayet et l'Ambre, lesquels attirent le festu? Item, de l'huille estant iettée dedans l'eau se ramasse à part de laditte eau, veux tu meilleures preuues que du sel commun, du salpestre, de l'alun, de la coperoze, et de toutes especes de sels, lesquels estans dissouz dedans l'eau se sçauent bien separer et faire vn corps à part distingué et separé d'auec l'eau? et en confirmant ce que i'ay dit cy dessus, ie te di encores, que la semence des metaux est liquide et inconnue aux hommes : Et tout ainsi que ie t'ay dit que la semence du sel liquide se sçait separer de l'eau commune, pour se conge-

ler, autant en est il des matieres metalliques. Et te faut icy philosopher encores de plus pres : regarde les semences quand on les iette en terre, elles n'ont qu'vne seule couleur, et venant à leur croissance et maturité elles se forment plusieurs couleurs : les fleurs, les branches, les feuilles et les boutons, ce seront toutes couleurs diuerses, et mesme en vne seule fleur il y aura diuerses couleurs. Semblablement tu trouueras des serpens, des chenilles, et papillons, qui seront de plusieurs belles couleurs. Venons à present à philosopher plus outre, tu me confesseras que d'autant que toutes ces choses prennent nourriture en la terre, que leur couleur procede aussi de la terre : Et ie te diray par quel moyen? et qui en est la cause? Si tu peux attirer de la terre par art alchimistal, les couleurs diuerses comme font ces petits animaux, ie t'accorderay que tu peux aussi attirer les matieres metalliques et les rassembler pour faire l'or et l'argent. Mais (comme ie t'ay dit tant de fois) tu y procedes tout au contraire de la nature. Tu as entendu par mes arguments que toutes matieres metalliques sont aqueuses et se forment dedans l'eau, et cependant tu les veux former par le feu, qui est son contraire. Ne t'ay-ie pas monstré euidemment par vne ardoise remplie de marcassites, que les matieres metalliques estant encores fluides dedans les eaux, elles s'atirent l'vne à l'autre pour se reduire en corps : et comme i'ay tousiours dit, elles sont inconnues et indistinguibles des autres eaux, iusques à leur congelation (1).

THEORIQUE.

Ie trouue fort estrange que tu dis que les matieres metalliques sont inconnues dedans les eaux, et toutesfois l'on void le contraire, car tous tant qu'il y a de Philosophes disent que tous metaux sont composez de souphre et de vif argent. S'il est ainsi pourquoy croiray-ie qu'ils ne se peuuent connoistre dedans l'eau? car ie suis certain que s'il y en auoit dedans l'eau ie les connoistrois bien.

PRACTIQUE.

Et comment n'as tu point de souuenance que ie t'ay allegué

(1) Il est facile de reconnaître aujourd'hui à quel point les idées de Palissy ont dû influer, deux siècles après lui, sur celles de Werner et de l'école des Neptunistes.

le sel commun et autres, pour te faire entendre que tout ainsi que le sel n'a aucune couleur estant liquide dedans l'eau, que aussi les matieres metalliques n'ont aucune couleur, iusques à leur congelation. Mais ils la prennent en se r'assemblant et congelant : tout ainsi que toutes especes de fruits changent de couleur en leur croissance et maturité. Si ie voulois alleguer les semences humaines et brutales, y trouuera on quelque couleur au parauant leur formation ? non, non plus qu'aux metaux. Ie t'ay desia dit-cy dessus que tu n'as iamais veu souphre, ne vif argent, qui ne fut congelé, et qu'au parauant ils n'estoyent pas de la couleur qui sont à present, et qu'ils estoyent inconnus, comme le sel est inconnu dedans l'eau de la mer. Il y a long temps que ie pensois faire fin au propos de l'alchimie, estimant qu'en parlant des pierres tu pourrois connoistre la verité de mes preuues : Mais par ce que ie te trouue de dure ceruelle et par trop arresté en ton opinion, ie suis contraint pour conclure à ce que dessus, te dire qu'il ne se peut entendre autre chose des metaux, sinon ce que les natures humaines, brutales et vegetatiues me donnent à connoistre : Qui est, que quand la chastaigne, la noix et tous autres fruits, sont semez en terre, en iceux sont enclos les racines, les branches, les feuilles, et toutes les parties, vertus, senteurs et couleurs, que l'arbre sçauroit produire quand il sera né. Aussi qu'en la semence des natures humaines et brutales, les os, la chair, le sang et toutes les autres parties sont comprises en laditte semence. Et tout ainsi que tu vois que nulle de ces choses ne demeure en sa premiere couleur : mais en la croissance d'iceux ils changent de couleur, et en vne mesme chose y a plusieurs couleurs : En cas pareil te faut croire que les semences des metaux (qui sont matieres liquides et aqueuses) changent de couleur, pesanteur et dureté. La premiere connoissance que i'ay eu de ces choses, fut à vne miniere de terre argileuse, qui estoit à vne tuilerie pres saint Sorlin de Marennes és isles de Xaintonge, là où ie trouuay parmy laditte terre vn grand nombre de marcassites de diuerses grandeurs et pesanteurs, toutes lesquelles estoyent formees de telle sorte que l'on pouuoit iuger, que la matiere de leur formation estoit liquide, et qu'elle estoit cheute du haut en bas, és iours de sa congelation, tout ainsi que si l'on

auoit laissé tomber de la cire fondue petit à petit pour la faire congeler.

Theorique.

I'ay bien entendu tes raisons. Mais ne seroit ce pas vn grand bien en France, s'il y auoit cinq ou six hommes qui fusseut paruenuz à leur fin, touchant la pierre des anciens Philosophes? Car i'ay entendu par le dire de plusieurs alchimistes que s'ils y estoyent paruenuz, ils feroyent assez d'or, pour faire la guerre contre tous aduersaires, et mesme contre le Turc.

Practique.

Entre tous les propos que tu as dit par cy deuant, il n'y en a pas vn si esloigné de sapience que celuy que tu viens de dire : Mais ie di au contraire qu'il vaudroit mieux vne peste, vne guerre, et vne famine en France, que non pas six hommes qui sceussent faire l'or en si grande abondance que tu dis. Car apres que l'on seroit asseuré que la chose se pourroit faire, tout le monde mespriseroit le cultiuement de la terre, et s'estudieroit à chercher de faire de l'or, et par ce moyen la terre demeureroit en friche, et toutes les forests de la France ne sçauroyent fournir de charbon tous les alchimistes l'espace de six ans. Ceux qui ont veu les histoires disent qu'vn Roy ayant trouué quelques mines d'or en son Royaume, employa la plus grande partie de ses suiets pour tirer et affiner ladite mine, qui causa que les terres demeuroyent en frische, et la famine commença audit Royaume. Mais la Royne (comme prudente et esmeüe de charité enuers ses suiets) fist faire secretement des chapons, poulets, pigeons, et autres viandes de pur or, et quand le Roy voulust disner, elle le fist seruir desdittes viandes, dont il fust ioyeux, n'entendant pas à quoy la Royne tendoit : mais voyant qu'on ne luy apportoit point d'autres viandes, commença à se fascher, quoy voyant la Royne le supplia de considerer que l'or n'estoit pas nourriture, et qu'il valoit mieux employer ses suiets à cultiuer la terre que non pas à chercher les mines d'or. Si tu ne te veux arrester à vn si bel exemple, entre en toy mesmes, et t'asseure que s'il y auoit six hommes en France, comme tu dis, qui sceussent faire l'or, ils en feroyent si grande quantité que le moindre d'eux se voudroit faire monarque, et ils se feroyent la guerre entr'eux.

et apres que la science seroit diuulguee, il se feroit si grande quantité d'or qu'il viendroit à tel mespris, que nul n'en voudroit bailler pain ne vin pour eschange. Ie ne di pas que ce ne soit chose iuste que les princes commettent gens és minieres, mesmes des forfaires criminels, pour extraire lesdites mines, afin de s'en ayder, tant pour le commerce que pour les instruments necessaires, que l'on forme desdits metaux.

Theorique.

Tu m'as cy dessus donné beaucoup d'arguments contre ceux qui veulent generer les metaux par chaleur, et mesme t'es vanté de prouuer vn cinquiesme element : desquelles choses ie ne puis me contenter, si ie n'ay vne conclusion plus certaine.

Practique.

Ie ne puis conclure autre chose sur le fait des metaux, sinon la mesme chose que i'ay dit cy dessus : que toutes matieres metalliques sont liquides, fluides, et diafanes, et inconneues parmy les eaux communes, iusques à leur congelation, et quand est du cinquiesme element, ie ne puis donner autre preuue que celle que i'ay donné publiquement deuant mes auditeurs, où tu estois present, dont la preuue a esté faite par vne pierre, que tu vois icy.

Ne te souuient il pas qu'en faisant la demonstration de ceste pierre, que ie disois que toutes pierres ayans forme triangulaire, ou pentagonne, ou quadrangulaire, ou à pointes de diamants, estoyent formees dedans l'eau, et qu'autrement elles ne pouuoyent prendre les formes susdittes : ayant donc resolu vn tel argument, ie leur monstrois laditte pierre, laquelle est composee de trois matieres diuerses, sçauoir est, le dessus de laditte pierre est de cristal pur et net, formé en la superficie superieure en pointes de diamants, et l'autre partie suyuante au dessouz d'icelle, est de mine d'argent : et la troisiesme partie est d'vne pierre commune, qui donne clairement à entendre que celle que i'appelle commune, qu'aucuns appellent tuf, semblable à celle des carrieres, estoit formee la premiere, et depuis sa formation la matiere d'argent descendant d'en haut auparauant sa congelation, s'est arrestée sur la carriere de laditte pierre, et quelque temps apres s'est congelee en mine d'argent, et en vn autre temps, la matiere cristaline s'est arrestée sur laditte mine, et s'est congelee et

formée en pointes de diamants, et ce durant le temps que les eaux communes estoyent plus hautes que lesdittes matieres : car autrement iamais le cristal ne se fust formé par pointes. Tu sçais bien que tous ceux à qui i'ay fait demonstration de laditte pierre ont approuué mes arguments, sans aucune contradiction. Et pour venir à la preuue du cinquiesme clement, ladite pierre m'a aussi serui de preuue : par ce que leur ay prouué que iamais ne se forma cristal ny autres pierres à pointes ou à faces, qu'elles ne fussent dedans les eaux communes, et que la vérité est telle, que le cristal, le diamant, et toutes pierres diaphanes ne sont formees que de matieres aqueuses, et puis que le cristal et autres pierres diaphanes se forment au milieu des eaux communes, ne voulant avoir aucune affinité auec elles en leur congelation, non plus que le suif, la graisse, les huiles, la poix-rasine et autres telles matieres, lesquelles se separent des eaux communes : Il faut conclure donc que l'eau de laquelle le cristal est formé, est d'vn autre genre que non pas les eaux communes : et si elle est d'vn autre genre, nous pouuons donques asseurer qu'il y a deux eaux, l'vne est exalatiue et l'autre essenciue, congelatiue et generatiue, lesquelles deux eaux sont entre-meslees l'vne parmi l'autre, en telle sorte qu'il est impossible les distinguer au parauant que l'vne des deux soit congelée (1).

Theorique.

Si tu mets vn tel propos en auant l'on se moquera de toy, par ce que les Philosophes tiennent pour chose certaine qu'il n'y a que quatre elements : et s'il y auoit deux genres d'eau, comme tu dis, il y en auroit cinq.

Practique.

Ie te l'ay assez fait entendre par le cristal, lequel quand il se veut congeler le plus souuent dedans les neiges, il se se-

(1) Palissy donne une trop grande extension à une idée d'ailleurs ingénieuse et qui n'est pas sans quelque fondement. L'eau qui entre dans la composition intime des végétaux et de certains minéraux ne diffère pas de celle que la chaleur peut en séparer ; de même que le calorique retenu par les corps, dans leurs divers états, ne diffère point de celui que l'on peut apprécier par le thermomètre. Néanmoins, pour montrer que, sans changer de nature, l'une et l'autre se trouvent dans des états différents, on nomme la première : *eau de végétation*, de *cristallisation*, comme on distingue le calorique *latent* du calorique *sensible*.

pare des autres eaux, et les eaux communes qui sont demeurées en neiges, se dissoluent, et le cristal ne se peut dissoudre, ny au soleil ny au feu : qui est vn argument bien certain que les eaux communes ne font qu'aller et venir, monter et descendre, comme i'ay dit en parlant des fontaines, et t'ose dire encores, que les eaux congelatiues sont aussi euaporatiues et exalatiues, et leur habitation et demeure est parmy l'eau commune, iusques à leur congelation.

Theorique.

Il y a bien peu d'hommes qui veulent croire ce que tu dis : par ce qu'ils voudront s'arrester aux Philosophes antiques.

Practique.

Tu diras ce que tu voudras : Mais si est ce, que quand tu auras bien examiné toutes choses par les effets du feu, tu trouueras mon dire veritable, et me confesseras que le commencement et origine de toutes choses naturelles est eau : l'eau generatiue de la semence humaine et brutale n'est pas eau commune; l'eau qui cause la germination de tous arbres et plantes, n'est pas eau commune, et combien que nul arbre, ny plante, ny nature humaine, ny brutale, ne sçauroit viure sans l'ayde de l'eau commune, si est ce que parmy icelle, il y en a vne autre germinatiue, congelatiue, sans laquelle nulle chose ne pourroit dire ie suis : c'est celle qui germine tous arbres et plantes, et qui soustient et entretient leur formation iusques à la fin : et mesme quand la fin et consommation d'iceux est suruenue par feu, icelle eau generatiue se trouue és cendres, desquelles l'on peut faire du verre semblable à l'eau de laquelle le cristal est formé, et ne faut que tu penses que autrement les bleds et autres plantes seiches se puissent soustenir : par ce que l'eau exalatiue qui estoit auparauant leur maturité, s'est exalee par l'attraction du Soleil : Mais l'eau congelatiue a tousiours soustenu la forme de la paille. En ce cas pareil te faut croire que combien que l'homme ne boiue que de l'eau commune en apparence, si est ce qu'en beuuant et mangeant il attire de ladite eau generatiue, ce qui est en toutes matieres nutritiues : et selon l'effect de nature, la dureté des os est causee par l'action de l'eau congelatiue, et pour ces causes, il y a plusieurs especes d'os qui endurent plus grand feu que non pas les pierres naturelles. Il te sera

plus aisé de consumer au feu vne pierre naturelle, que non pas les os d'vn pied de mouton, ou les coquilles d'œufs. Tu peux par là connoistre que l'eau cristaline, qui cause la veuë, à quelque affinité auec l'eau generatiue, de laquelle les lunettes, le cristal et miroir sont faits.

Theorique.

Il me semble que tu te contredis en parlant de ceste eau generatiue : par ce qu'en parlant des sels tu dis qu'il y a du sel en toutes choses, et que sans iceluy nulle chose ne pourroit estre.

Practique.

Tu ne trouueras point de contradiction en mes propos. Veux tu que i'appelle l'eau de la mer sel, tandis qu'elle sera vagante parmy les eaux communes? ie ne puis appeler les choses fluides et liquides ou aqueuses (pendant qu'elles sont inconneues parmy les eaux communes) sinon eau. Non pas mesme les metaux au parauant leur congelation : par ce que ie t'ay dit que les matieres metalliques n'ont aucune couleur sinon d'eau, iusques à leur congelation.

Theorique.

Tu m'as tant de fois dit que les matieres metalliques costoyent liquides comme l'eau commune, au parauant leur congelation, toutesfois ie ne puis comprendre comment cela peut estre veritable, si tu ne me donnes preuues plus intelligibles.

Practique.

Ie ne te sçaurois donner preuues plus suffisantes que celles que i'ay monstré euidemment en ta presence à mes disciples, qui est (comme tu sçais) vn grand nombre de bois reduit en metal. Ne te souuient il pas que quand ie faisois monstre desdits bois, ie leur disois, comment seroit-il possible que le bois se fust reduit en metal, s'il n'eut premierement long temps reposé dans les eaux metalliques entremeslees parmy les eaux communes? et si les eaux metalliques n'eussent esté autant liquides et subtiles comme les communes, comment eussent elles peu entrer dans le bois et l'embiber par toutes ses parties, sans luy oster aucunement sa forme premiere? c'est vn point que tous ceux qui le considerent seront contrains con descendre à mon opinion : et te diray encores vne autre preuue plus asseurée, pour te monstrer combien il faut que les

matieres metalliques soyent subtiles pour actioner et reduire en metal, sans les desformer, les choses desquelles ie te veux parler. Premierement il se treuue grand nombre de coquilles de poisson qui pour auoir croupi quelque temps dans les eaux metalliques sont reduites en metal sans perdre leur forme, desquelles coquilles i'en ay veu quelque quantité au cabinet de Monsieur de Roisi. De ma part i'en ay vne que i'ay monstré au maistre Maçon des fortifications de Brest, en basse Bretaigne, qui m'a attesté qu'il s'en trouuoit grande quantité en icelle contrée. Au cabinet de Monsieur Race, Chirurgien fameux de ceste ville de Paris, y a vne pierre de mine d'airain, où il y auoit vn poisson de mesme matiere. Au pays de Mansfeld se trouue grande quantité de poissons reduits en metal, et cela est trouué fort estrange à ceux qui viuent sans Philosophie : Et ne peuuent iamais paruenir à la connaissance de la cause ; combien qu'elle soit assez facile, comme ie feray entendre cy apres : mais premierement il faut que i'anticipe sur le discours que i'ay à te faire de la cause des coquilles et bois petrifiez, qui est que les coquilles sont formees d'vne matiere alise, serree et fort compacte, et bien fort dure : et toutesfois quand lesdites coquilles ont long temps crouppi dedans les eaux communes, elles font atraction d'vne eau cristaline generatiue, de laquelle i'ay tant parlé, laquelle les rend de matieres de coquilles en matiere de pierre, sans rien changer de leur forme. Ie n'en demande autre tesmoing que toy, qui as esté present quand i'ay monstré à mes auditeurs vn grand nombre de coquilles de diuerses especes reduites en pierre, et non seulement les coquilles, mais aussi les poissons : aussi plusieurs pieces de bois. Il est donques aisé à conclure que les poissons qui sont reduits en metal ont esté viuants dans certaines eaux et estangs, esquelles eaux se sont entremeslées autres eaux metalliques, qui depuis se sont congelées en miniere d'airain, et ont congelé le poisson et le vase, et les eaux communes se sont exalées suiuant l'ordre commun, qui leur est ordonné, comme ie t'ay dit cy dessus ; et si lors que les eaux se sont congelées en metal il y eut eu en icelles quelque corps mort, soit d'homme ou de beste, il se fut aussi reduit en metal : et de ce n'en faut aucunement douter. Et tout ainsi que tu vois que les eaux communes descendantes amenent auec elles plusieurs incommoditez, comme

terres, sables, et autres ordures, aussi les eaux metalliques estans impures en leur congelation, elles congellent toutes choses qui sont en icelles : parquoy les affineurs ont grand peine à separer le pur d'avec l'impur, comme tu pourras plus clairement entendre en la conclusion que ie feray sur le traitté des pierres. Tu sçais bien que la cause qui m'a meu de te remonstrer ces choses, n'est autre sinon afin que iamais ne te prenne enuie de t'associer auec ceux qui veulent generer les metaux. Car par les instructions que ie t'ay donné tu peux aisément connoistre qu'ils s'abusent, de vouloir faire par feu ce qui se fait par eau. Ie te puis asseurer auoir connu vn grand nombre des cercheurs susdits qui sont si ignorants qu'ils pensent retenir les esprits enfermez dans des vaisseaux de terre, chose à eux impossible.

THEORIQUE.

Et qu'est ce qu'ils appellent esprits?

PRACTIQUE.

Ils appellent esprits toutes matieres exalatiues, et singulierement le vif argent, qui est vne eau qui s'exale comme l'eau commune, quand elle est pressée du feu, et ils ont opinion que s'ils pouuoyent trouuer quelque terre, de laquelle ils pussent faire des vaisseaux pour faire chauffer le vif argent, estant enclos dedans iceux, qu'iceluy se congeleroit en argent, et seroit rendu maleable. Mais les pauures gens s'abusent si lourdement que i'ay honte de le dire. Car quand le vaisseau auroit cent toises d'espoisseur, il seroit impossible de le garder de creuer, s'il estoit tout clos, partant qu'il y eut au dedans tant peu soit d'humidité : comme ie t'ay fait entendre en parlant des tremblements de terre, que les matieres humides estans touchées par le feu font de merueilleux efforts, et ne peuuent endurer estre encloses sans aër, comme tu as entendu par vne pomme d'airain ; et mesme les œufs, les chastaignes, les pommes, et autres fruits sont contrains se creuer, quand l'humeur est eschauffée : et voyla pourquoy l'on est contraint de creuer la peau des chastaignes, afin que l'humeur eschauffée ne les face petter : si ces bonnes gens consideroyent ces effects, ils ne chercheroyent point de terre pour retenir les esprits.

THEORIQUE.

Tu m'as allegué cy dessus des chastaignes, des noix et au-

tres fruits, contre mon opinion de l'alchimie : mais cela ne fait rien contre moy : par ce que les metaux sont vn, et les fruits sont vn autre.

Practique (1).

I'ay grand honte que ce propos dure si longuement : toutes fois à cause de ton opiniatrise ie suis contraint de parler encores de ce fait. Es tu si grand' beste que tu ne consideres le fait de l'aymant, qui par vne vertu singuliere attire à soy le fer, combien qu'il n'ait aucun ame vegetatiue, et si ainsi est hors de la matrice de la terre, combien cuides tu qu'il y aye plus de vertu estant en la terre, quand il est encores en matiere liquide? Et cuides tu que l'aymant soit seul qui ait pouuoir d'attirer à soy les choses qu'il aime? ne voy tu pas bien que le Iayet et l'Ambre attirent à eux le festu? Item, ne voy tu pas bien que l'huile estant ietté dedans l'eau se ramasse à part de l'eau? Veux tu meilleure preuue que du sel commun, du salpestre, de l'alun, de la coperoze, et de toutes especes de sels, qui estans dissoulz dedans l'eau se sçauent tres-bien separer et faire vn corps à part, distingué et separé d'auec l'eau? En confirmant ce que ie t'ay dit cy dessus, ie te dy encores que la semence des metaux est liquide et inconnue aux hommes, tout ainsi comme le sel dissoult, ne se peut connoistre parmy l'eau commune iusques à sa parfaite congelation : Aussi pour tout certain la semence des metaux ne se peut connoistre estant en matiere liquide entremeslée parmi les eaux, iusques à sa congelation : Et tout ainsi que ie t'ay dit que la semence du sel liquide se sçait separer de l'eau commune pour se congeler, autant en est-il des matieres metalliques. Et te faut ici philosopher encores de plus pres. Regarde les semences, quand tu les iettes en terre, elles n'ont qu'vne seule couleur, et en venant à leur croissance et maturité elles se forment plusieurs couleurs, la fleur, les fueilles, les branches, les rameaux et les boutons, seront toutes couleurs diuerses, et mesme à vne seule fleur il y aura diuerses couleurs. Semblablement tu trouueras des serpens, des chenilles et des papillons, qui seront figurez de merueilleuses

(1) Quoique ce passage soit la répétition presque littérale de ce qui a été rapporté ci-dessus, page 211, nous avons crû devoir le reproduire, comme les précédents éditeurs, et conserver religieusement le texte, tel qu'il fut publié du vivant de l'auteur.

couleurs, voire par vn labeur tel que nul peintre ny brodeur ne sçauroit imiter leurs beaux ouurages. Venons à present à philosopher plus outre : tu me confesseras, que d'autant que toutes ces choses prennent nourriture en la terre, que leur couleur procede aussi de la terre : et ie te diray par quel moyen, et qui en est la cause? Si tu me donnes raisons apparentes de ce que dessus, et que tu puisses attirer de la terre par ton art alchimistal, les couleurs diuerses, comme font ces petits animaux, ie te confesseray que tu peux aussi attirer les matieres metalliques, et les rassembler, pour faire l'or et l'argent. Mais quoy! ie t'ay dit tant de fois que tu y procedes tout au contraire de la nature, et tu vois bien par mes arguments que les matieres metalliques sont toutes aqueuses, et se forment dedans l'eau, et tu les veux former par le feu, qui est son contraire. Ne t'ay-ie pas monstré euidemment cy dessus par vne ardoise remplie de marcassites et autres pierres et mineraux, que les matieres metalliques estant encores fluides dedans les eaux, elles s'attirent l'vne à l'autre pour se reduire en corps metallique et (comme i'ay tousiours dit) elles sont inconnues et indistinguibles des autres eaux, iusques à leur congelation.

Theorique.

Ie trouue fort estrange que tu dis que les matieres metalliques sont inconnues dedans les eaux, et toutesfois on voit le contraire : car autant qu'il y a de Philosophes disent, que tous metaux sont composez de souphre et de vif argent. S'il est ainsi, me veux tu faire croire que le souphre et l'argent vif ne se peuuent connoistre dedans l'eau? Ie me tiens pour certain que s'il y auoit du souphre et du vif argent dedans l'eau, ie le connoistrois.

Practique.

Ie voy bien que ie pers mon temps : Tu es aussi grand beste auiourd'huy comme hier. Et n'as tu point de souuenance que ie t'ay allegué le sel commun et autres : pour te faire entendre que tout ainsi que le sel n'a aucune couleur cependant qu'il est liquide dedans l'eau, que aussi les matieres metalliques n'ont aucune couleur iusques à leur congelation, mais prennent leur couleur en se rassemblant et congelant : tout ainsi que tu vois toutes especes de fruits changer de couleur en leurs croissances et maturitez. Si ie voulois alleguer les

semences des natures humaines et brutales, y trouueroit on quelque couleur au parauant leur formation non plus qu'aux metaux? T'ay ie pas dit cy dessus que tu ne sçaurois dire iamais auoir veu souphre ne vif argent qui ne fut congelé? penses tu que le vif argent que tu vois et le souphre ayent esté dés le commencement des couleurs qu'ils sont à present? ie sçay bien que non, et qu'au parauant ils estoyent inconnuz, comme le sel est inconnu dedans l'eau de la mer.

D'AUTANT que i'ay reprouué par le discours precedent, la medecine alchimistale sur l'effet de la generation, augmentation et fixation, sur le fait des metaux: i'ay trouué bon et à propos de reprouuer aussi les effects de l'or potable, lequel i'estime ennemy de la nourriture corporelle des humains.

TRAITÉ

DE L'OR POTABLE.

Theorique.

QUAND tu m'alleguerois toutes les plus belles raisons du monde, si est ce, que tu ne me sçaurois faire mespriser l'alchimie : car ie sçay que plusieurs font de belles choses, et quasi des miracles en la medecine, par le moyen d'icelle, tesmoing l'or potable que les alchimistes ont inuenté : chose de grand poids et digne de louange. Car il fait quasi resusciter les morts : il guarist toutes maladies, il entretient la beauté, il prolonge la vie, et tient l'homme ioyeux : que sçaurois tu contredire à cela ?

Practique.

Et comment es tu encores en ces resueries? n'as tu point veu vn petit liure que ie fis imprimer durant les premiers troubles, par lequel i'ay suffisamment prouué que l'or ne peut seruir de restaurant, ains plustost de poison (1) ; dont plusieurs docteurs en medecine ayant veu mes raisons furent de mon party : tellement que depuis quelque temps il y a eu vn certain medecin docteur et regent en la faculté de medecine, lequel estant à Paris en la chaire, a confirmé mes propos, les pro-

(1) Ce petit livre est évidemment la *Recepte véritable*, publiée en 1563, et dans laquelle se trouvent, en effet (de la page 54 à la page 57 de cette édition), la plupart des arguments reproduits ici avec quelque extension. C'est donc à tort que Gobet affirme qu'*il n'est pas question d'or potable* dans le livre imprimé, en 1563, à La Rochelle. Quant à la conformité qu'il trouve entre cette dissertation et ce qu'on lit à ce sujet dans la *Déclaration des abus et ignorances des médecins*, qu'il lui attribue, on verra que cette analogie est loin de justifier l'opinion que Palissy soit l'auteur de ce dernier opuscule.

posant à ses disciples comme doctrine bien asseurée (1). Quand il n'y auroit que cela, c'est assez pour te rendre confus en tes arguments.

Theorique.

Et comment oses tu tenir vn tel propos? veu que tant de milliers de medecins ont de si long temps ordonné de l'or pour seruir de restaurant aux malades, et mesmes les medecins Arabes en vsoyent, qui estoyent les plus excellens de tous les autres.

Practique.

Ie t'accorde qu'il y a vn nombre infini de medecins qui ont fait bouillir des pieces d'or dedans des ventres de chapons, et puis faisoyent boire le bouillon aux malades, et disoyent que le bouillon auoit retenu quelque substance de l'or, par ce que lesdittes pieces estoyent vn peu blanchies sur la superficie à cause du sel et de la graisse : Ce qui estoit faux, et s'ils eussent poisé lesdittes pieces, apres les auoir bouilli, ils les eussent trouué aussi poisantes que deuant. Autres faisoyent limer lesdites pieces d'or, et faisoyent manger la limeure aux malades, parmy quelque viande : ce qui estoit pire que s'ils eussent mangé du sable. Autres prenoyent de l'or en feuille de quoy vsent les peintres : mais tout cela seruoit autant d'vne sorte que d'autre.

Theorique.

Encores que l'or ne serue rien aux malades en la sorte que tu dis, tu ne peux nier qu'il ne leur serue quand il est potable. Car les alchimistes qui le rendent potable le calcinent en poudre fort subtile, et quand il est meslé parmy quelque liqueur, il s'incorpore aussi bien comme pourroit faire la graisse de chapon parmy le bouillon. Voila comment et par quel moyen l'or peut seruir à restaurer et nourrir le malade.

Practique.

Tu n'entens pas bien ce que tu dis. Car tu sçais bien que les fournaises de feu ne peuuent consommer l'or pur ; comment seroit il donc possible que l'estomac d'vn malade le peut

(1) Gobet assure que ce médecin était Germain Courtin, qui publia un livre sous ce titre: *Germani Courtini, medici Parisiensis, adversùs Paracelsi de tribus principiis, auro potabili, totáque pyrotechniá portentosas opiniones, disputatio.* In-4°, Parisiis, 1579.

consommer? attendu qu'il est desia si debile qu'il ne sçauroit digerer vne pomme cuitte.

Theorique.

Et tu te moques bien de moy ; l'or n'est il pas desia consommé quand il est potable ? l'alchimiste qui l'a rendu potable l'a rendu aussi liquide que de l'eau claire.

Practique.

Tu t'abuses, et n'entens rien de tous mes propos, ou bien tu fais semblant de n'en vouloir rien entendre : Car quand tous les alchimistes auroyent mis l'or en potage plus subtil que la fine essence ou quinte distilation de vin, encores dirois ie qu'ils n'ont rien fait à ce qu'il puisse seruir de nourriture. Vray est que s'ils pouuoyent dissoudre l'or sans aucune addition, alors ie serois de leur party, moyennant aussi qu'il se peust dissoudre à vne chaleur du tout semblable à celle de l'estomac : Car autrement quel proufit pourroit faire vne matiere à l'estomac si la chaleur naturelle n'est capable de la dissoudre, comme elle fait les viandes qui luy sont donnees pour nourriture ? Mais quoy! ils ne font qu'adulterer, calciner et pulueriser, et puis mettent autres liqueurs pour le faire boire. Ne sçay ie pas bien que toutes choses dures, seiches et alterees, estant puluerisées se peuuent boire auec autres liqueurs ? ce n'est pas à dire pourtant qu'elles puissent seruir de nourriture : tu pourras bien boire du sable et autres poussieres ; diras tu pourtant que cela te soit nourriture ? l'on sçait bien que non.

Theorique.

Ce n'est pas tout vn : car on prend l'or pour restaurant, comme le plus parfait de tous les alimens, et dit on qu'vn homme qui se nourriroit d'or seroit immortel, ainsi que l'or ne se peut consommer, et dure à iamais.

Practique.

Vrayement tu as bien dit à ce coup : car si vn homme se pouuoit nourrir d'or, ô que ce seroit vn bel idole ! Ie m'esmerueille que tu n'as honte de mettre vn tel propos en auant: d'autant que ce propos est suffisant pour vaincre toutes tes disputes. Tu dis que l'or est eternel selon le cours de ce siecle. Or s'il est eternel, l'estomac de l'homme n'aura donc garde de le consommer, puis que le temps, la terre, l'air ny le feu ne le peuuent consommer, par quel moyen sera il donc con-

DE L'OR POTABLE.

sommé en l'estomac? car l'effect de l'estomac de l'homme est de cuire et consommer ce qui luy est donné : et ce qui est bon pour la nourriture est enuoyé par tous les membres, pour augmenter la chair et le sang et tout ce qui est en l'homme, et le surplus il l'enuoye hors aux excrements. Or ie te demande, vn homme qui seroit nourri d'or sans manger autre chose, pourroit il engendrer quelque excrement? si tu dis qu'ouy, l'or n'est donc pas eternel : si tu dis que non, il ne faudra pas de priuez, ny de chaires percées, pour ceux qui seroyent nourris d'or potable.

Theorique.

Il est impossible de vaincre tes opinions : toutefois plusieurs ont escrit que l'or potable a des vertus merueilleuses. N'as tu pas veu vn liure imprimé depuis n'agueres (1), qui dit que le Paracelse, medecin Alemand, medecinalement a guari vn nombre de ladres (lépreux) par le moyen de l'or potable. Et toy qui n'es qu'vn tarracier desnué de toutes langues, sinon de celle que ta mere t'a apris, oses tu bien parler contre vn tel personnage, qui a composé plus de cinquante liures de medecine, lequel est estimé vnique, voire monarque entre les medecins?

Practique.

Quand le Paracelse et tous les medecins qui furent iamais m'auroyent presché, ie diray tousiours que si l'or potable estoit mis dedans vn creuset, et soudé, que la liqueur qui auroit esté mise auec l'or se viendroit à exaller, brusler et consommer, l'or qui auroit esté potagé se rendroit en vn lingot, et si l'estomac de l'homme estoit aussi chaud qu'vne fournaise, il feroit aussi venir cest or potable en vne masse ou lingot : et s'il estoit autrement, l'or ne pourroit estre appellé fixe ou eternel, comme tu dis.

Theorique.

Et que deuiendra donc le dire du Paracelse qui en a guari tant de ladres?

Practique.

Ie me doute que le Paracelse est plus fin que toy ny moy :

(1) Il s'agit de l'ouvrage de Roch Le Baillif, publié en 1580, intitulé : *Traité de l'homme, de ses maladies, médecine et absolus remèdes, ès teintures d'or, corail et antimoine, magistère de perles, etc.* Le Baillif, qui devint par la suite médecin de Henri IV, était un zélé partisan de Paracelse.

Car peut estre qu'apres qu'il a eu trouué quelque rare medecine, par le moyen des metaux imparfaits, marcassites, ou autres simples, il fait accroire que c'est or potable, pour la faire trouuer meilleure, et s'en faire mieux payer. C'est la moindre finesse de quoy il se pourroit aduiser : l'en ay bien veu de plus fines en vne petite ville de Poitou, où il y auoit vn medecin aussi peu sçauant qu'il y en eut en tout le pays, et toutesfois par vne seule finesse il se faisoit quasi adorer (1). Il auoit vne estude secrete bien pres de la porte de sa maison, et par vn petit trou voyoit venir ceux qui luy apportoyent des vrines, et estants entrez en la court, sa femme bien instruite se venoit assoir sur vn bois, pres de l'estude où il y auoit vne fenestre fermée de chassis, et interrogeoit le porteur d'vrines d'où il estoit, et que son mari estoit en la ville, mais qu'il viendroit bien tost, et les faisant assoir auprés d'elle les interrogeoit du iour que la maladie print au malade, et en quelle partie du corps estoit son mal, et consequemment de tous les effects et signes de la maladie ; et pendant que le messager respondoit aux interrogations, Monsieur le Medecin escoutoit tout, et puis sortoit par vne porte de derriere, et rentroit par la porte de deuant, par où le messager le voyoit venir, lors la dame luy disoit : voyla mon mari, parlez à luy. Ledit porteur n'auoit pas si tost presenté l'vrine, que Monsieur le Medecin ne la regardast auec fort belle contenance, et apres il faisoit vn discours de la maladie, suyuant ce qu'il auoit entendu du messager par son estude : Et quand ledit messager estoit retourné au logis du malade, il contoit comme par vn grand miracle le grand sçauoir de ce Medecin, qui auoit conneu toute la maladie soudain qu'il auoit veu l'vrine, et par ce moyen le bruit de ce Medecin augmentoit de iour à autre. Voyla pourquoy ie t'ay dit que peut estre Para-

(1) Gobet pense que Palissy a voulu désigner Sébastien Colin, médecin de Fontenay-le-Comte, en Poitou, auteur du livre intitulé : *Déclaration des abus et tromperies que font les apothicaires*. Tours (Poitiers), 1553, plusieurs fois réimprimé sous le pseudonyme de *Lisset Benancio*, anagramme de son nom. C'est à cet ouvrage de S. Colin que répondait l'opuscule ayant pour titre : *Déclaration des abus et ignorance des médecins*, Lyon, 1557, que le même éditeur s'efforce d'attribuer à Palissy, et sur l'origine duquel nous exprimons ailleurs nos doutes. S. Colin, outre quelques traductions, avait publié un livre intitulé : *Bref dialogue contenant les causes, jugemens, couleurs et hypostases des urines*, etc. Poitiers, 1558, in-8°.

celse faisoit à croire que sa medecine estoit d'or potable, et qu'il n'en vsa iamais.

Theorique.

Ie ne sçay comment tu l'entends : tu as dit cy dessus que peut-estre le Paracelse faisoit quelque medecine pour la lepre, de quelques metaux ou autres simples, et puis faisoit à croire que c'estoit or potable, afin d'estre payé. Puis qu'il peut faire medecine de metaux, pourquoy l'or ne pourra il aussi bien seruir à la medecine comme les autres metaux ?

Practique.

Tu te trompes : le desir que tu as de faire trouuer ta cause bonne, t'empesche d'entendre mon propos. Car ie ne t'ay pas dit que le Paracelse prenoit des metaux, mais bien des metaux imparfaits, ou quelques marcassites, ou autre mineral, comme pourroit estre l'anthimoine, duquel plusieurs font estat en la medecine.

Theorique.

Te voyla pris par ta propre bouche : car puis que tu confesses que l'anthimoine peut seruir en la medecine, ie di que l'or y peut aussi bien seruir, car l'antimoine est vn metal, partant la victoire me demeure, et faut que tu confesses estre vaincu.

Practique.

Te voila aussi sage qu'au parauant, de dire que l'anthimoine est vn metal, et qu'il sert en medecine. Et tu sçais bien que toute nostre dispute n'est que sur le fait du restaurant, qui vaut autant à dire comme reparation de nature : en premier lieu tu parles fort mal de dire que l'anthimoine est vn metal ; car il est certain que ce n'est qu'vne espece de marcassite, ou bien commencement de metal : d'autre part tu dis que i'ay dit qu'il sert en medecine : ouy bien : mais non pas de restaurant. Car s'il pouuoit seruir de restaurant, l'on en pourroit manger comme d'vne autre viande. Mais tant s'en faut : car l'homme qui en prendra plus de quatre ou six grains se met en hazard de mourir. Or ceux qui veulent faire valoir l'or potable disent qu'vn malade en peut prendre deux fois par chacun iour : parquoy l'anthimoine n'est pas à propos pour prouuer le restaurant d'or. Car vn metal parfait ne se peut mouuoir à la chaleur de l'estomac. Mais il n'est pas ainsi de l'anthimoine.

Car son action est veneneuse, et par sa venenosité il esmeut toutes les parties de l'estomac, du ventre, et de tout le corps, et cela se fait par une exalation qui est causée de luy mesme, par ce qu'il est imparfait, et qu'il a esté tiré de la miniere auparauant que sa decoction fut venue en sa perfection : comme ainsi soit que les metaux parfaits ne pourroyent esmouuoir aucune vapeur en l'estomac comme fait l'anthimoine. Voila comment il faut parler des choses auecques preuues fondées sur quelque raison, non pas aller chercher les corps celestes, comme aucuns qui, pour prouuer le restaurant d'or, montent iusques au ciel, et vont chercher vn sol, luna, mercure, et autres planettes, iusques au nombre de sept : disans qu'elles ont domination sur les metaux et sur les corps humains : ie n'entends rien en l'Astrologie, mais bien sçay-ie que le corps humain ne peut estre nourry que de choses suiettes à putrefaction : et d'autant que l'or ne se peut putrifier ny consommer au corps de l'homme, ie dy et maintiens qu'il ne peut seruir de medecine, ny de restaurant; et que toutes choses desquelles la langue ne peut faire attraction de saueur, ne peuuent seruir à la nourriture. Car Dieu a mis la langue pour sonder les choses qui sont vtiles, pour les autres parties du corps, et faut noter que quand vn homme est fort malade, on lui baille des viandes les plus tendres : si on luy baille du fruit, on le fait cuire afin qu'il soit plutost mis en putrefaction : Autrement l'estomac debile ne les pourroit consommer pour enuoyer la liqueur nutritiue à toutes les parties du corps, et le marc aux parties excrementales. Si ainsi est qu'vn estomac debile trauaille beaucoup à digerer vne pomme cuitte, comment peus-tu croire qu'il peut consommer l'or? et veu que le corps ne peut rien consommer sinon les choses desquelles la langue puisse tirer quelque saueur auparauant qu'elles aillent plus outre, comment pourra il consommer l'or? tu l'as beau taster à la langue, tu n'as garde d'en tirer aucune saueur. Veux tu que ie te die vn beau trait auant que finir mon propos? Si la langue pouuoit tirer quelque saueur d'vne piece d'or, ie te puis asseurer qu'elle amoindriroit de poids, d'autant que la langue en auroit attiré. Aussi ie di que quelque fleur que tu flaires auec le nez, que tu diminues sa vertu, d'autant que tu en prends auec le nez. Et note encores ce poinct, que toutes les choses que tu presentes à la langue, et que tu en tires

quelque saueur, ladite saueur n'est autre chose que le sel qui est en la chose que tu tastes. Car le sel est de telle nature qu'il se dissoult à l'humidité et quand l'humidité est chaude il se dissoult plus promptement. Or la langue apporte auec soy vne humeur chaude, qui cause soudain faire attraction de quelque peu de sel de la chose qui luy est presentée. Voyla pourquoy ie di que si la langue pouuoit tirer quelque saueur de l'or ce seroit du sel, et l'or diminueroit, d'autant que la langue en auroit attiré, et n'en pouuant rien tirer comme des alimens nutritifs, il est aisé à conclure que l'or ne peut seruir de nourriture.

DV MITRIDAT, OV THERIAQUE.

O<small>N</small> ayant desconfit vne erreur de si long temps inueterée, touchant le restaurant d'or, il m'est pris enuie de parler vn peu du Mitridat, auant que de parler des sels.

T<small>HEORIQUE</small>.

Et as-tu quelque chose à dire contre le Mitridat?

P<small>RACTIQUE</small>.

Ouy bien : mais afin de ne rendre mal contents les medecins, et que par là ils ne prennent occasion de detracter de mes autres œuures, ie n'en parleray sinon par maniere de dispute, prenant mon argument sur ce que aucuns disent qu'il faut de trois cents sortes de drogues pour le composer, ce que ie trouue bien fort eslongné de ma capacité, et ne puis penser, que tant de sortes de simples puissent loger ensemble dans vn estomac, sans faire ennuy l'vn à l'autre.

T<small>HEORIQUE</small>.

Si tu mets vn tel propos en auant tu te feras hayr de beaucoup de gens, voudrois tu bien entreprendre de contredire à

tant de notables medecins, qui ont plusieurs fois examiné diligemment vne telle matiere, et a esté disputé plusieurs fois aux vniuersitez et escoles de medecine? ie sçay qu'en vne ville d'Alemaigne fut commandé aux medecins dudit lieu, par les magistrats, de s'assembler pour aduiser ensemble de donner quelque moyen contre le venin de la peste, qui estoit pour lors en ladite ville. Suyuant quoy les medecins ne trouuerent rien meilleur que le Mitridat qu'ils ordonnerent, et fut composé du nombre des simples susdits. Voyla pourquoy ie te di que si tu parles contre tant de sçauans hommes, l'on t'estimera fol.

PRACTIQUE.

Mais n'est il pas aussi possible que les medecins se puissent tromper en la composition du Mitridat, comme ils se sont trompez, adherant à l'opinion des Arabes, touchant le restaurant d'or? Car tu as bien entendu cy dessus que c'est vn abus manifeste, les medecins sages n'auront garde de trouuer mauuais ce que i'en dis : par ce que c'est par maniere de dispute, et cela les incitera à penser s'il y a quelques raisons en mes arguments.

THEORIQUE.

Et quels sont tes arguments?

PRACTIQUE.

Ils sont bien notables, et entre les autres i'en ay trois singuliers : le premier est la consideration d'vn bouquet composé de plusieurs fleurs ; iamais la senteur dudit bouquet ne sera si amiable comme s'il estoit d'vne fleur seulement, et par là tu connoistras que les senteurs meslées ensemble font vne confusion telle que tu ne sçaurois iuger laquelle est la supreme et meilleure d'icelles. Item, si tu prens vn chapon, vne perdrix, vne becasse, vn pigeon et de toutes sortes de chairs, le tout bien cuit et preparé, puis que tu les mettes dans un mortier et les pilles ensemble pour les manger, elles seront bonnes ; mais y trouueras tu aussi bon goust comme si tu les mangeois particulierement? l'on sçait bien que non. Item, si tu prens de l'azur, du vermillon, du massicot et de toutes autres couleurs, et que tu les broyes toutes ensemble, et en fact un meslinge, tu connoistras que la moindre de toutes est plus belle à part soy, qu'elles ne sont toutes meslées ensemble. Cela me fait penser que tant de simples ensemble ne peuuent estre qu'ils n'effacent et destruisent la vertu l'vn de

DU MITRIDAT. 233

l'autre : tout ainsi que les senteurs, saueurs et couleurs (1). Ie te prie aussi considere vn peu quel accord pourroit estre en vne musique de trois cens musiciens chantans tous ensemble. Depuis quelques iours i'ay veu vn liure duquel les Apotiquaires se seruent pour les compositions de leurs drogues, et ayant demandé à l'Apotiquaire qu'il me dit en François les drogues du Mitridat, il le fit volontiers, entre autres il me nomma le gif (gypse) et l'alebastre : Ce qui me fait parler plus asseurement, par ce que ie sçay que l'vn et l'autre sont indigest : Et quand ils sont calcinez ce n'est autre chose que plastre. I'ay veu quelque liure ancien qui dit que le plastre est mortel : par ce (dit il) qu'il estoupe les conduits, par là ie connois que plusieurs escriuent des choses qu'ils n'entendent pas. Car par ce qu'ils ont veu quelques fois fermer des trous de murailles auec du plastre, ils ont pensé qu'il pourroit faire le semblable dans le corps de l'homme, chose fort mal entendue : car le plastre ne durcist iamais quand il est rendu potable, et si l'on y met de l'eau plus qu'il n'en faut, il perd toute sa force. L'argument est donc mal fondé, de dire que le plastre estoupe les conduits. Ie croy qu'il est aussi bon au Mitridat comme à autre medecine. Si ie voulois composer vn electoire ou medecine de pierreries, ie voudrois premierement connoistre deux choses : l'vne de quelle matiere les pierres sont formées, et l'autre, si l'estomac est capable de les digerer. Or puis que les pierres verdes sont teintes par la couperose elles ne peuuent estre qu'ennemies de nature.

THEORIQUE.

Or ça, pour les mesmes causes que tu dis, l'on met plusieurs simples ensemble, par ce qu'aucuns sont trop rudes, mordicatifs, corrosifs, et laxatifs : et mesmes aucuns pernicieux, estants pris particulierement : mais pour les corriger l'on y mesle des matieres douces.

PRACTIQUE.

En cela ie trouue une difficulté bien grande, qui est telle,

(1) Le simple raisonnement avait appris à un homme étranger jusqu'à certain point aux connaissances médicales, que ces mélanges monstrueux des anciennes pharmacopées ne pouvaient avoir qu'une action complexe, et par conséquent douteuse, lorsqu'elle n'était pas nuisible. Ce qui n'a point empêché ces compositions bizarres de figurer jusqu'à nos jours dans les dispensaires pharmaceutiques, tant une vieille erreur est difficile à déraciner.

20.

que ie sçay qu'vne composition de trois cents simples ne peut estre qu'il n'y en ait plusieurs d'iceux de plus dure digestion que les autres, qui me fait penser qu'estans dans l'estomac, les plutost cuittes sont enuoyées les premieres en nourriture, suyuant l'ordre naturel; tout ainsi que ie t'ay montré par certaines marcassites, que les matieres, qui ont quelque affinité, se sçauent separer et ioindre ensemble en la matrice de la terre; cela, dis-ie, se peut aussi bien faire dans l'estomac, sçauoir est que les matieres nutritiues seront dispersées par les membres, et les ennemies de la nature seront envoyés aux excremens, et si entre tant de simples il y en a quelqu'vn que l'estomac ne puisse digerer, comment pouuons nous esperer qu'il puisse seruir? Aussi ie trouue fort estrange des electoires, qui est vne medecine faite de pierres pilées, lesquelles ie sçay qu'il y en a aucunes si fixes, qu'il est impossible à l'estomac de les digerer. Or une matiere indigeste ne peut seruir à vn estomac.

Theorique.

Comment oses-tu reprouuer le Mitridat? lequel de si long temps a esté approuué, et plusieurs en ayans mangé à ieun, ont esté garantis de poison, et mesme que le Roy Mitridates fut mort, l'on trouua en son cabinet la recepte dudit Mitridat au milieu de ses besongnes les plus precieuses, et parce qu'il en prenoit tous les matins, il ne peut estre empoisonné.

Practique.

Ce propos ne fait rien contre moy : parce que le contrepoison de Mitridates n'estoit composé que de quatre simples, sçauoir est, de noix, de figues, de rue et de sel ; c'est bien loing de trois cens (1). Pour connoistre si vne matiere peut seruir contre le poison, il faut premierement sçauoir que c'est que poison. Quelqu'vn a mis en ses escrits qu'il y en a de trois cens sortes. Si ainsi est, qui sera celuy qui dira qu'vn Mitridat puisse seruir à toutes especes de poison? Quant est du contre poison de Mitridates, il y a quelque grande raison par laquelle

(1) L'électuaire inventé par Mithridate était en effet composé de cinquante quatre substances. Pompée en trouva la formule dans les papiers de ce prince après sa défaite et sa mort. Il en découvrit aussi une seconde, qui était composée seulement de sel, de figues, d'amandes de noix et de feuilles de rue. C'est cette derniere que l'on regarda comme le contre-poison dont Mithridate prenait une certaine dose chaque matin.

l'on peut iuger de son vtilité, et pour en donner quelque iugement, il faut auoir esgard à ce que le sublimé qui est le plus commun poison, n'est pas de matiere oleagineuse, ains d'vne matiere aqueuse, et les matieres oleagineuses n'ont aucune affinité auec les aqueuses : il faut donc croire que celuy qui composa le contrepoison du Mitridat de quatre simples, eut esgard à ce que le sublimé et aucuns autres poisons, estans dans l'estomac, ou boyaux, s'attachent et incisent la partie où ils reposent, et par tel moyen leur action est pernicieuse et mortelle : et pour obuier à vn tel effet il estoit de besoin que ledit contrepoison fut composé de matieres oleagineuses et bonnes à manger, afin que l'estomac ne les abominast. Nous ne pouuons nier que les noix ne soyent oleagineuses et plaisantes à manger, les figues consequemment ont vn sel en elles si fort corrosif et dissolutif, qu'au pays d'Agenés et lieux circonuoisins, où il y a grande quantité de figuiers, ceux qui mangent les figues auant qu'elles soyent meures ont les leures fenduës, à cause de la mordication du laict desdittes figues. Le laict desdittes figues a grande vertu de dissoudre les choses visqueuses : quand les peintres se veulent seruir de blanc d'œuf pour destremper leurs couleurs, ils y mettent des petites figues decoupées, ou bien des gittes des branches de figuier, et soudain que cela est remué parmy ledit blanc d'œuf, il se vient à dissoudre, et se rend aussi clair qu'eau de fontaine, sans aucune visquosité. Ie dis cecy pour donner à entendre que le Mitridat composé de ces quatre choses pouuoit engraisser l'estomac et les boyaux, par la vertu oleagineuse des noix, et dissoudre le poison par la vertu des figues et de la rue : quant est du sel, c'est une chose certaine qu'il est contraire au venin, comme ie te diray en parlant des sels. Voila comment le Mitridat ne peut estre mauuais : non pas qu'il soit vtile pour tous poisons ou venins. Si ie connoissois la cause i'en pourrois parler. Le venin de la peste est inuisible. Il va de iour et nuit ainsi que Dieu luy a commandé. Aucuns disent que les causes de la verole, de la peste, et de la lepre sont inconnues. Ie sçay que toutes maladies se guarissent par leurs contraires : et si ie ne connois la maladie, comment connoistray-ie son contraire ? il ne faut point douter qu'il n'y ait aucunes choses qui sont mortelles par leur frigidité, et autres par leur grande chaleur et mordication ex-

tremc, et autres qui estoufent les esprits vitaux, se rangeant communement au cerueau, s'esleuant en quelque vapeur aërée. En la mer Oceane, enuiron le temps de Pasques, il se prend vn grand nombre de poissons, qui sont grands comme enfans, que l'on nomme maigres (1), desquels les pescheurs font grand argent. I'ay veu plusieurs fois des hommes et des femmes, qui ont pelé par le corps, les mains et le visage, pour auoir mangé du foye desdits poissons, et dit on que cela se fait quand ledit poisson se prend lors qu'il est en chaleur. Or parce que les natures des diuers venins sont si mal aisées à connoistre, i'ay dit par maniere de dispute, que ie ne puis croire qu'vne composition de trois cents simples puisse estre si bonne comme celle de Mitridates, qui n'est composée que de quatre seulement.

DES GLACES.

THEORIQUE.

Ie ne vis iamais homme si opiniastre que toy : car depuis que tu as quelque chose en ta teste, il est impossible de te faire croire le contraire. Cela me fait souuenir d'un iour que tu estois au long de la riuiere de Seinne, vis à vis des tuileries, où plusieurs personnes, mesme des bateliers, disoyent et soustenoyent que les glaces qui courent sur la riuiere, quand il gele fort, sortoyent du fond d'icelle, toutefois tu soustenois le contraire par ton opiniastreté.

PRACTIQUE.

Appelles tu opiniastreté de soustenir la verité?

THEORIQUE.

Et quoy persistes tu encores en ta folle opinion?

(1) C'est le maigne, fégaro, ou aigle de mer, *sciæna aquila*, C.

PRACTIQUE.

J'y persiste et y persisteray tant que ie viuray : car ie sçay que mon dire est veritable, que l'eau ne se peut geler au fond de la riuiere que premierement toute la superficie ne soit gelee, et qu'elle n'aye entierement perdu son cours : et suis fort aise que tu m'as reproché vn tel propos : par ce qu'il me seruira d'argument pour prouuer que si en vne chose visible et aisee à connoistre vne si grande multitude d'hommes soustiennent le contraire de verité, disans que les glaçons que la riuiere porte ont esté gelez au fond d'icelle, combien plus se peuuent ils estre abusez és choses interieures, comme ils ont fait du restaurant d'or, qui m'a incité à disputer du Mitridat.

THEORIQUE.

Ne sçais tu pas que plusieurs t'ont maintenu en barbe qu'en temps de gelee ils voyent ordinairement monter les glaçons du fond de l'eau ? Ne sçais-tu pas aussi que plusieurs gens doctes t'ont maintenu par raisons philosophiques (que tu n'as sçeu conuaincre) que cela estoit veritable?

PRACTIQUE.

Tant plus tu veux confondre mon dire, et plus ie suis asseuré en mon opinion, et n'y a homme en ce monde qui m'en sceut faire rougir, car ie sçay qu'il est impossible que les glaces puissent estre formees au fond de l'eau.

THEORIQUE.

Mais puis que tes contraires t'alleguent raisons naturelles tu deusses aussi produire les tiennes en auant : afin que l'on conneùt si elles sont meilleures que les leurs.

PRACTIQUE.

Si ie me voulois estudier à chercher les raisons, i'en trouuerois vn millier de plus suffisantes que non pas celles que mes contredisants alleguent. Premierement il faut tenir pour chose certaine que si les riuieres se glaçoyent au fond, comme ils disent, que tous les poissons qui sont en l'eau mourroyent, et de cela n'en faut douter. Il ne se trouueroit glaçon montant de l'eau qui ne fut tout lardé de poissons. Ie croy que tu ne connois pas quels sont les effects mortels des glaces : leur action pernicieuse est telle que comme l'eau se conglace, elle fait vne compression si grande, que les choses qui sont meslées parmy icelle ne la peuuent endurer, mesmement les cho-

ses animees, faut qu'elles rendent l'esprit, quelques puissantes qu'elles soyent. Regarde les bleds quand ils sont gelez, tu ne connoistras point qu'ils soyent perdus iusques au desgel. Mais quand il sera desgelé, tu connoistras que la compression de la gelee aura coupé la iambe du bled, et qu'il n'y a autre cause qui l'ay fait mourir. Si tu pensois me faire croire que les poissons fussent plus durs à la gelee que les pierres, tu t'abuserois. Ie sçay que les pierres des montaignes d'Ardenne sont plus dures que le marbre : et ce neantmoins les habitans du pays ne tirent point desdites pierres en hyuer : à cause qu'elles sont suiettes à la gelee : et plusieurs fois l'on a veu les rochers tomber au parauant qu'estre coupez : dont plusieurs personnes en ont esté tuees, au temps que lesdites roches desgeloyent. Tu sçais bien que l'eau des puits est plus chaude en hyuer qu'en esté : car l'air, qui est chaud en tems d'esté, se retire en temps de froidure, pour fuir son contraire, et qu'ainsi ne soit, te souvient il point quand nous allasmes dans les carrieres de saint Marceau, au dedans desquelles i'estois tout degoustant de sueur, combien que dehors l'air estoit fort froid ; et si c'eust esté en temps de chaleurs, nous eussions trouué le dedans desdittes carrieres froid. Aucuns disent que pour ces causes l'homme mange mieux en hyuer qu'en esté : par ce que la chaleur naturelle se tient serrée au dedans, aidant à la concoction de l'estomac. Voicy à present vne autre exemple, qui te deura suffire pour toutes preuues. Lors que les riuieres se gelent, elles commencent aux extremes parties et sur la superficie, et quand elles ont gelé vne nuit le cours principal et le residu de l'eau qui n'est point gelée se baisse, et quand elle est vn peu baissee, et qu'elle a laissé ses glaçons attachez contre les terres des extremitez, il aduient qu'ils tombent dedans l'eau, emportans auec eux grande quantité de terre et de pierre, qui causent enfoncer lesdits glaçons, et les glaçons estans au dedans de l'eau, et trouuant la chaleur du fond, se viennent à dissoudre, et ainsi qu'ils commencent à eschauffer, la terre et pierre qui les auoyent contraints d'aller au fonds tombent et laschent lesdits glaçons, et eux estant allegés, s'esleuent en haut sur la superficie ; et quand il y en a grande quantité, l'eau les amene iusques à ce qu'ils ayent trouué quelque retour ou obstacle, pour les arrester ; et ayant trouué arrest, ils se soudent l'vn

contre l'autre, et par tel moyen les riuieres se glacent tout au trauers. Voila la cause qui les trompe, et qui leur fait soustenir que la riuiere se glace au fond (1). Si ainsi estoit, où est ce que les poissons habiteroyent, quand les riuieres seroyent gelees? C'est vne chose toute certaine que plusieurs poissons maritimes se retirent au fond de la mer durant les grandes froidures : Ce qui se peut verifier par les pescheurs Xaintoniques, qui en temps d'esté peschent des maigres et des seiches en si grand nombre, qu'il y a tel homme qui en fait saler et secher pour plus de cinq cents liures tous les ans : desquels ne s'en pesche pas vn en hyuer : et si ainsi est des poissons de la mer, combien plus de ceux des riuieres? il n'est pas iusques aux grenouilles qu'elles ne se plongent au fond de l'eau, mesme dans les vases, pour conseruer leur vie durant le froid. Car autrement tous les poissons mourroyent; aucuns ayans frequenté en Moscouie, Prusse et Pologne, disent qu'en temps d'hyuer, les pescheurs de ces pays là prennent grand peine à rompre les glaces de certaines riuieres, ou lacs : et ayant fait vn trou d'vn costé et vn d'vn autre il mettent les filets a l'vn des trous, et par l'autre ils chassent le poisson, et par ce moyen prennent vne grande quantité de poissons. Brouille et fagotte à present tes opinions, tu n'as garde de me faire croire que la riuiere soit aussi gelée au fond, et que l'habitation des poissons soit entre deux glaces. Autre exemple, consideres vn peu la forme des glaçons lorsque la riuiere commence à glacer, ils n'ont autre forme que platte, comme le verre duquel les vitriers besongnent, et s'ils ne sont ainsi à niueau, les formes bossues y sont venues à la seconde gelation, par l'empeschement des premiers glaçons, qui causent faire quelques sauts és eaux qui donent contre, et apres vient plus grande quantité de glaçons qui sont contrains par le poussement de l'eau, de se ietter l'vn sur l'autre. Or si lesdits glaçons estoyent formez au fond de la riuiere, il faudroit qu'ils tinssent necessairement la forme

(1) La question de l'origine des glaces flottantes n'était point encore entièrement résolue, il y a peu d'années, comme on le voit par la notice que M. Arago a donnée à ce sujet dans l'un des annuaires du bureau des longitudes. Quelque opinion que l'on accepte relativement à la congélation des eaux courantes, les réflexions de Palissy n'en sont pas moins d'un bon espri et d'un habile observateur.

des fosses et concauitez du fond de la riuiere : et outre cela, il ne se pourroit faire qu'ils n'apportassent auec eux de la terre ou sable du lieu où ils se formeroyent : et si ainsi estoit que les eaux se gelassent au fond, il faudroit que les froidures vinssent du dessous de la terre : ce qui seroit contre verité. Car si elles venoyent du fond de terre il faudroit que toutes les sources des fontaines gelassent les premieres, et consequemment les puits, et les vins qui sont dans les caves : et si la froidure vient de l'air (comme la verité est telle) et qu'elle causast geler les eaux au fond, il faudroit que la riuiere fut plus spongieuse que nulle chose de ce monde, encores geleroit elle dessus le premier, puis qu'ainsi est que la froidure vient de l'air. Mais tant s'en faut qu'elle soit spongieuse, que ie ne trouue rien plus allié qu'elle est : et qu'ainsi ne soit, tu le peux connoistre par elle mesme, quand elle est glacee : car il n'y a ny trou, ny veine, ny artere : tu le peux aussi connoistre par les diamans, qui sont d'vne eau pure congelee : que s'ils estoyent tant peu soit poreux, ils ne prendroyent nul polissement. Il faut donc conclure que la froidure vient de l'air, et que la riuiere est alize ou condensee comme le cristal, et que la froidure de l'air vient dessus, et ne sçauroit passer iusques au fond de l'eau, et qu'il y a vne chaleur naturelle au fonds d'icelle, aidee en partie par plusieurs petites sources, qui procedent du fond de la terre, qui causent que les poissons conseruent leur vie au plus profond des eaux.

THEORIQUE.

Pose le cas qu'ainsi soit : toutesfois il me semble qu'il n'estoit pas besoin d'en faire si long discours, et que le temps seroit bien mieux employé à parler des autres choses, dont tu m'as fait promesse.

DES SELS DIVERS.

Practique.

J'avois bien pensé qu'apres l'or potable et le Mitridat, ie te parlerois des sels : mais toi-mesme m'as interrompu, en me reprochant la dispute que i'auois euë autresfois des glaces. Or venons donc en propos : Car ie te veux montrer qu'il n'est nulle chose sans sel. Si tu es homme d'esprit (comme ie l'estime) tu connoistras plusieurs secrets en parlant desdits sels, qui te pourront mieux asseurer de l'impossibilité de la generation des metaux : et ce d'autant que les sels seruent beaucoup à ceux qui se meslent d'adulterer, augmenter et sophistiquer les metaux.

Theorique.

Et comment? tu dis des sels, comme s'il y en auoit de plusieurs sortes.

Practique.

Ie te di qu'il y en a vn si grand nombre qu'il est impossible à nul homme de les pouuoir nommer, et te dis d'auantage, qu'il n'y a nulle chose en ce monde, qu'il n'y aye du sel, soit en l'homme, la beste, les arbres, plantes, ou autres especes de vegetatif : voire mesme és metaux : et di encores plus, que nulles choses vegetatiues ne pourroient vegeter sans l'action du sel, qui est és semences; qui plus est, si le sel estoit osté du corps de l'homme, il tomberoit en poudre en moins d'vn clin d'œil. Si le sel estoit séparé des pierres qui sont és bastiments, elles tomberoyent soudain en poudre. Si le sel estoit extrait des poutres, soliues et cheurons, le tout tomberoit en poudre. Autant en dis-ie du fer, de l'acier, de l'or et de l'argent, et de tous metaux. Qui me demanderoit combien il y a diverses especes sels, ie respondrois qu'il y en a autant que de diuerses especes de saueurs et senteurs.

DES SELS DIVERS.

THEORIQUE.

Si tu veux que ie croye ce que tu dis, nommes en donc quelques vnes.

PRACTIQUE.

La coperose est un sel, le nitre est vn sel, le vitriol est vn sel, l'alun est sel, le borras est sel, le sucre est sel, le sublimé, le salpestre, le sel gemme, le salicor, le tartre, le sel armoniac, tout cela sont sels diuers. Si ie les voulois nommer tous, ie n'aurois iamais fait. Le sel que les alchimistes appellent salis Alkali, est extrait d'vne herbe qui croit és marez salans des isles de Xaintonge. Le sel de Tartare n'est autre chose que le sel des raisins, qui donne goust et saueur au vin, et empesche la putrefaction d'iceluy, partant ie dis encores, que la saueur de toutes choses est par le sel, lequel mesmes a causé la vegetation, perfection, maturité, et la totalle bonté de la chose alimentaire (1). Et combien qu'il y ait beaucoup d'arbres et d'especes de vegetatifs, desquels le sel est plus fixe et de plus dure dissolution que celuy de la vigne et du salicor, si est ce qu'il y en a en tous les arbres et plantes, ie di autant ou peu s'en faut qu'aux susdites. Et autrement plusieurs especes de cendres ne vaudroyent rien à blanchir le linge; en l'effect desdites cendres, tu peux connoistre qu'il y a du sel en toutes choses. Et ne faut que tu penses que les cendres ayent pouuoir de blanchir sinon par la vertu du sel, autrement elles pourroyent servir plusieurs fois. Mais d'autant que le sel qui est dedans lesdites cendres, se vient à dissoudre en l'eau que l'on met dans le cuuier, il passe au trauers du linge, et par sa vertu et acuité, ou mordication, les ordures du linge sont dissipées, mollifiées et emmenées en bas auecques l'eau, laquelle apres se nomme lexiue, à cause qu'en icelle demeure le sel qui estoit aux cendres, estant dissout par l'action de l'eau, et les cendres estant ainsi dessalées n'ont aucune vertu de plus blanchir le linge, et on les iette comme inutiles. Autre exemple. Quand les salpestreux font attraction du salpestre qui est en terre, ils le font par une telle maniere que

(1) Le mot de *sel* n'avait pas encore été aussi généralisé. Il résulterait de ce passage que Palissy donnait le nom de sel à toute substance soluble dans l'eau, pourvue d'une saveur ou d'une odeur quelconque. La définition qu'il en donne à la fin de ce chapitre, bien qu'un peu embarrassée, rentre néanmoins dans ce sens général.

lexiue, et quand ils ont tiré le salpestre, les cendres et la terre duquel ils ont extrait le sel, sont inutiles : par ce que le sel qui causoit l'operation n'y est plus. Si tu n'as assez d'exemples pour croire qu'il y a du sel en tous les bois et plantes, considere les Tanneurs de cuirs, il prennent de l'escorce de chesne? et l'ayant seichée et puluerisée, ils la meslent entre les cuirs qu'ils font tanner dans un certain receptacle : et quand le cuir a demeuré le temps préordonné parmy ladite escorce, le tanneur prend son cuir et iette l'escorce hors, comme chose inutile : vray est qu'és lieux où le bois est cher, l'on fait des mottes de ladite escorce, en forme de fromage, lesquelles on fait secher pour les brusler à faute de bois : mais les cendres n'en valent rien : à cause que le sel est en dehors. Ne peux-tu pas connoistre par là que ce n'est pas l'escorce qui a endurcy et tanné le cuir, mais que c'est le sel qui estoit en icelle? Car autrement l'escorce pourroit seruir plusieurs fois : mais d'autant que le sel est dissout, il s'est mis dedans le cuir, à cause de son humidité, et en a fait attraction, pour seruir à soy mesmes. Il faut que tu nottes qu'en toutes especes de bois le sel est presque tout à l'escorce : aussi le bois sans escorce ne produit jamais bonnes cendres. Monsieur Sifly, medecin du Duc de Montpensier, me montra quelque fois vne verge de balsamum, ou de canelle, la quelle contenoit enuiron quatre pieds en longueur et en grosseur vn pouce ou enuiron : il me fit gouster de l'escorce, qui auoit saveur naturelle de fine canelle : mais quant au reste du bois, il n'avoit non plus de saueur qu'vne pierre. Voila pourquoy les tanneurs ne se seruent que de l'escorce : par ce que le sel y est, autrement le surplus du bois estant puluerisé pourroit aussi bien seruir que l'escorce. Et en continuant mes preuues, qu'il y a du sel en toutes choses : Les Egyptiens auoyent de coustume de saler les corps de leurs Roys et Princes, ce que nous appelons embaumer. Les histoires disent qu'ils les embaumoyent de nitre et d'espiceries aromatiques. Il te faut noter que le nitre est vn sel conseruatif, et qui empesche la putrefaction : toutesfois il n'eust sçeu empescher la putrefaction par tant de mil années, n'eust esté lesdites espiceries aromatiques, desquelles le sel a causé l'incorruption desdits corps, qui en estoyent embaumez. Et outre, la chair desdits corps est appellée mommye, à cause desdites espiceries, dont ils estoyent pou-

drez. Les Princes Egyptiens gardent ladite mommye pour leur seruir en leurs maladies. Ie croiray plustot qu'une telle manducation seroit plus vtile que l'or potable. Quelques modernes ont voulu imiter les anciens, voulants faire de la mommye de quelques pendus ou decapitez : Mais qui la mettroit vn peu tremper, on la feroit retourner en puante charogne : par ce qu'elle n'a pas esté confitte d'espiceries ayant telle vertu que celles des anciens Egyptiens. Aussi dit on communement que les odeurs et Rubarbes, gommes et espiceries aromatiques, sont toutes adulterées au parauant qu'elles soyent venues iusques à nous. Et le sel commun n'a pas la vertu de conseruer comme les aromatiques qui viennent de l'Arabie heureuse et autres pays chauds. Et par ce que nostre propos est de prouver qu'il y a du sel en toutes choses, ie mettray ce poinct en auant, qui est que l'on peut faire du verre de toutes cendres : combien que les vnes sont plus dures à la fonte que non pas les autres : et s'il n'y auoit du sel és bois et és herbes, il seroit impossible d'en pouuoir faire verre.

C'est assez prouué qu'il y a du sel en toutes choses : parlons de leurs vertus, qui sont si grandes que nul homme ne les connut iamais parfaictement. Le sel blanchist toutes choses : le sel endurcist toutes choses : il conserue toutes choses : il donne saueur à toutes choses ; c'est vn mastic qui lie et mastique toutes choses : il rassemble et lie les matieres minerales : et de plusieurs milliers de pieces il en fait vne masse. Le sel donne son à toutes choses : sans le sel nul metal ne rendroit sa voix. Le sel resiouyst les humains : il blanchist la chair, donnant beauté aux créatures raisonnables : il entretient l'amitié entre le male et la femelle, à cause de la vigueur qu'il donne és parties genitalles : il aide à la generation : il donne voix aux creatures comme aux metaux. Le sel fait que plusieurs cailloux puluerisez subtilement, se rendent en vne masse pour former verres et toutes especes de vaisseaux : par le sel on peut rendre toutes choses en corps diafane. Le sel fait vegeter et croistre toutes semences : Et combien qu'il y ait bien peu de personnes qui sçachent la cause pourquoy le fumier sert aux semences et qu'ils l'apportent seulement par coustume et non pas par philosophie ; Si est ce, que le fumier que l'on porte aux champs ne serviroit de rien, si ce n'estoit le sel que les pailles et foins y ont laissé en se pourrissant, parquoy ceux qui laissent leurs

fumiers à la mercy des pluyes, sont fort mauuais mesnagers, et n'ont guere de philosophie acquise ny naturelle (1). Car les pluyes qui tombent sur les fumiers, decoulant en quelque valee emmeinent auec elles le sel dudit fumier, qui se sera dissout à l'humidité, et par ce moyen il ne seruira plus de rien, estant porté aux champs : la chose est assez aisée à croire : et si tu ne le veux croire, regarde quand le laboureur aura porté du fumier en son champ, il le mettra (en deschargeant) par petites pilles, et quelques iours apres il le viendra espandre parmi le champ, et ne laissera rien à l'endroit desdites pilles : et toutesfois apres qu'vn champ sera semé de bled, tu trouueras que le bled sera plus beau, plus verd et plus espois à l'endroit où lesdites pilles auront reposé que non pas en autre lieu, et cela aduient par ce que les pluyes qui sont tombees sur lesdits pilots, ont prins le sel en passant au trauers et descendant en terre. Par là tu peux connoistre que ce n'est pas le fumier qui est cause de la generation : ains le sel que les semences auoyent pris en la terre. Encores que i'aye deduit autrefois ce propos des fumiers, en vn petit liure que ie t'ay dit que ie fis imprimer dès les premiers troubles (2), si est ce qu'il me semble qu'il n'est point superflu en cest endroit : car par là tu entendras aussi la cause pourquoy tous excrements peuuent aider à la generation des semences. Ie di tous excrements, soit de l'homme ou de la beste. C'est touiours confirmation d'vn propos que i'ay repeté plusieurs fois en parlant de l'alchimie, que quand Dieu forma la terre il la remplist de toutes especes de semences : Mais si quelqu'vn seme vn champ par plusieurs années sans le fumer, les semences tireront le sel de la terre pour leur accroissement, et la terre par ce moyen se trouuera desnuée de sel et ne pourra plus produire : parquoy la faudra fumer, ou la laisser reposer quelques années, afin qu'elle reprenne quelque salsitude, prouenant des pluyes ou nuées. Car toutes terres sont terres : mais elles sont

(1) Palissy rappelle ici sa théorie des fumiers, déjà émise dans la *Recepte véritable* (voy. p. 23, 24).

(2) Il est évident, par cette citation, que le livre de Palissy, imprimé *dès les premiers troubles,* n'est autre chose que la *Recepte véritable*, publiée à La Rochelle en 1563, quoi qu'en disent Faujas de Saint-Fond et Gobet. L'opuscule des *Abus et ignorances des médecins* ne contient pas un mot sur la théorie des sels ni des engrais.

bien plus salées les vnes que les autres. Ie ne parle pas d'vn sel commun seulement, mais ie parle des sels vegetatifs. Aucuns disent qu'il n'y a rien plus ennemy des semences que le sel, et pour ces causes, quand quelqu'vn a commis quelque grand crime, on le condamne que sa maison soit rasée et la solle labourée et semée de sel afin qu'elle ne produise iamais semence. Je ne sçay s'il y a quelque pays où le sel soit ennemy des semences : Mais bien sçay-ie que sur les bossis des marez sallants de Xaintonge, l'on y cueille du bled autant beau qu'en lieu où ie fus iamais : et toutesfois lesdits bossis sont formez des vuidanges desdits marez : ie di des vuidanges du fond du champ des marez, lesquelles vuidanges et fanges sont aussi salées que l'eau de la mer : toutes-fois les semences y viennent autant bien qu'en nulle terre que i'aye iamais veuë : ie ne sçay pas où c'est que nos iuges ont pris occasion de faire semer du sel en vne terre en signe de malediction, si ce n'est qu'il y aye quelque contrée où le sel soit ennemi des semences.

THEORIQUE.

Peut estre que les iuges ne le font pas pour l'occasion que le sel soit ennemi des semences, mais ils le font plustot par ce que le sel est vne semence qui ne vegete point.

PRACTIQUE.

Tu diras ce que tu voudras, mais ie sçay bien que plusieurs medecins et autres personnes, m'ont voulu maintenir que le sel estoit ennemy des semences : Et c'est pourquoy i'ay mis ce propos en auant, afin de parler amplement des sels. Et en continuant encores mon propos, pour te monstrer que le sel n'est pas ennemi des natures vegetatiues, ny sensibles, les vignes du pays de Xaintonge, plantées au milieu des marez salans, apportent d'vn genre de raisins noirs, qu'ils appellent chauchetz, desquels on fait du vin qui n'est pas moins à estimer que hyppocras, et y fait on des rosties tout ainsi qu'à l'hyppocras. Et lesdites vignes sont si fertiles qu'vne plante de vigne apporte plus de fruit que non pas six de celles de Paris. Voila pourquoy ie dis que tant s'en faut que le sel soit ennemy des natures, qu'au contraire il aide à la bonté, douceur et maturité, generation et conseruation desdits vins. Et non seulement le sel aide à ces choses, mais aussi l'air duquel les exalations sont salées. Ausdites isles et parmy les

marez sallans, on y cueille de l'herbe salée, de laquelle on fait les plus beaux verres, laquelle on appelle salicor : aussi on y cueille de l'absinte appelée Xaintonnique, à cause du pays de Xaintonge. Ladite herbe a telle vertu que quand on la fait boullir, et prenant de sa decoction, on en destrempe de la farine pour en faire des bignets fricassez en sein (graisse) de porc ou en beurre, et que l'on mange desdits bignets, ils chassent et mettent hors tous les vers qui sont dans le corps, tant des hommes que des enfans. Au parauant que i'eusse la connoissance de ladite herbe, les vers m'ont fait mourir six enfans, comme nous l'auons connu tant pour les auoir fait ouurir, que par ce qu'ils en rendaient souuent par la bouche ; et quand il estoyent pres de la mort, les vers sortoyent par les nasaux. Les pays de Xaintonge, Gascogne, Agenès, Quercy, et le pays deuers Toloze, sont fort suiets ausdits vers, et y a peu d'enfans qui en soyent exempts : à cause que les fruits desdits pays sont fort doux. Ie le di parce que les medecins de Paris m'ont attesté que c'estoit chose rare de trouuer des vers és enfans dudit lieu : toutesfois és pays des Ardennes ils y sont fort suiets. Ie ne sçay si c'est à cause de la biere, ou des laitages. Ie ne puis rendre tesmoignage sinon des pays que i'ay frequentez. Dans les rochers des isles de Xaintonge l'on y cueille aussi de la criste-marine, autrement appellée perce-pierre, laquelle a vne merveilleuse bonté et senteur, à cause de la vapeur de la mer ; quand elle est fraische, les sallades en sont fort bonnes, et plusieurs en font confire pour toute l'année. A Paris quelques vns ont planté de ladite criste-marine : mais n'a garde d'auoir la bonté de celle qui vient naturellement sur les rochers limitrophes de la mer. Ie ne veux pas prouver par là que le sel commun soit plaisant à toutes especes de plantes : Mais ie sçay bien que les terres salées de Xaintonge portent de toutes especes de fruits qui y sont plantez, lesquels ont vne telle douceur et autant suaue qu'en lieu là où i'aye iamais esté. Les herbes sauuages, espines et chardons y croissent autant gaillardes qu'en nuls autres pays. C'est tousiours confirmation de mon argument, contre ceux qui disent que le sel est ennemy des plantes. S'il estoit ennemi des plantes, il seroit ennemi des natures humaines. Les Bourgongnons ne le diront pas : car s'ils eussent connu que le sel fut ennemi de nature humaine, ils n'eussent ordonné de mettre du sel en la bouche

des petits enfans quand on les baptise, et on ne les appelleroit pas Bourgongnons salez, comme l'on fait. Les natures brutales ne diront pas que le sel leur soit ennemi : car les cheures en mangeront autant qu'on leur en sçauroit bailler, et mesmes vont cherchant les murailles pisseuses, pour les lecher, à cause du sel des vrines; les pigeons ne pouuans trouuer du sel à leur commodité, quand ils trouuent quelque vieille muraille, de laquelle le mortier ait esté fait de chaux et de sable, et qu'elle soit tant peu commencée à ruiner, on verra les pigeons tous les iours apres ladite muraille; et les hommes qui viuent sans philosophie disent que les pigeons mangent le sable. Mais c'est vne moquerie : ce seroit l'or potable de pigeons : car il est indigest, et ne faut penser qu'ils cherchent autre chose que la chaux, qui est dans le mortier, à cause de sa salsitude, et s'ils aualent quelque grain de sable, c'est contre leur volonté et intention. Les huistres se nourrissent la plus grand part de sel, et leurs coquilles en sont faites, lesquelles elles mesmes ont basties; et qu'ainsi ne soit, on le void euidemment : par ce que lesdites coquilles estant iettées dans le feu, elles pettent en pareille sorte que le sel commun. Et si le sel a ceste vertu d'esmouuoir les parties genitalles (comme i'ay dit) c'est une chose certaine et bien aprouuée que les huistres causent vne mesme action; qui est attestation de ce que i'ay dit, que les huistres sont nourries la pluspart de sel. Et pour mieux monstrer que le sel n'est pas ennemi des natures vegetatiues, voyons vn peu la maniere de faire des laboureurs Ardennois; en certaines contrées des Ardennes ils coupent du bois en grande quantité, le couchent et arrangent en terre, en sorte qu'il puisse auoir air par dessouz : apres ils mettent vn grand nombre de mottes de terre sur ledit bois, sçauoir est de la terre herbeuse en forme de gasons, puis ils font brusler le bois au dessouz desdittes mottes, en telle sorte que les racines des herbes qui sont en ladite terre sont bruslées, et quand laditte terre et racines ont souffert grand feu, ils l'espandent par le champ comme fumier, puis labourent la terre et y sement du seigle : au lieu qui au parauant n'estoit que bois le seigle s'y treuue fort beau : et font cela de seize ans en seize ans : car ils la laissent reposer seize années, et en quelques endroits six années, et en d'autres que quatre : durant lequel temps la terre n'estant point labourée,

produit du bois aussi grand et espois comme il estoit au parauant ; et autant comme il leur faut de terre pour ensemencer vne année, ils coupent des bois, et font brusler des mottes, comme i'ay desia dit, et consequemment tous les ans, iusques au nombre de seize : et alors recommencent à la premiere piece de terre qu'ils auoyent labourée seize ans au parauant, en laquelle ils trouuent le bois aussi grand comme la premiere fois. I'ay dit cecy pour deux occasions, l'vne par ce que mon propos du sel n'est pas encores finy, et par ce que les laboureurs dudit pays disent, que la terre est eschauffée par ce moyen, et qu'autrement elle ne produiroit rien, à cause que le pays est froid ; surquoy ie di que comme l'eau qui a esté boulie est plus subiecte à geler que l'autre, aussi le feu qu'ils y font, ne cause pas l'accroissement des fruits, ains faut croire que c'est le sel que les arbres, herbages et racines bruslées y ont laissé. L'autre cause est pour donner à connoistre combien sont heureux ceux qui habitent és regions moderées et fertiles, qui produisent tous les ans. Ces pauures gens sont en grand peine quand l'année est pluuieuse, qu'ils ne peuuent brusler leurs bois en la saison conuenable ; en la meilleure de leurs années ils ne cueillent ny vin, ny fruits, ny aucune chose, que du seigle : et en chacun village le pauure a autant de terre que le riche, pour faire son cultiuage. Si le sel estoit ennemy des semences, il est certain que le bois et herbes qu'ils font brusler n'amenderoit point la terre, mais la rendroit inutile : par ce qu'en bruslant lesdits bois, le sel qui est en iceux demeure en la terre (1). Si ie connoissois toutes les vertus des sels, ie penserois faire des choses merueilleuses. Aucuns alchimistes blanchissent le cuiure auecques du sel de Tartare ou autres especes de sel, le sel est fort vtile aux teintures. L'alun, qui est vn sel, attire à soy les couleurs du bresil, de la galle, et autres matieres, pour les donner aux draps, aux cuirs ou soyes, tellement que les teinturiers quelque fois voulant teindre vn drap blanc en rouge, le trempent dans de l'eau d'alun : le sel d'alun estant dissout dans l'eau, sera cause que le drap receura la teinture que l'on luy aura preparée, et vn autre drap qui ne sera point

(1) Il y a une véritable prévision du génie dans cette longue dissertation sur le rôle que jouent les sels dans l'acte de la végétation. La plupart des arguments de Palissy se trouvent confirmés par l'expérience et font aujourd'hui partie des principes de l'agronomie.

trempé en l'eau d'alun ne le pourra faire. Le sel donc est vne chambriere qui oste la couleur à l'vn pour la bailler à l'autre. Aucuns sels endurcissent le fer et le trenchant des armes, en telle sorte que on en coupe du fer comme si c'estoit du bois. Ie ne suis point capable de descrire l'excellence des sels, ny leurs vertus merueilleuses : Toutesfois en parlant des pierres i'en diray quelque chose de ce qui aura esté oublié, aussi que l'on ne sçauroit traiter d'icelles sans parler quelquesfois des sels.

THEORIQUE.

Il y a long temps que tu parles des sels, mais iusques icy tu n'as point dit vn mot de la definition de sel, et toutesfois c'est le principal que d'entendre que c'est que sel.

PRACTIQUE.

Ie n'en sçaurois dire autre chose sinon que le sel est vn corps fixe, palpable, et conneu en son particulier, conseruateur et generateur de toutes choses, et en autruy, comme és bois et en toutes especes de plantes et mineraux. C'est vn corps inconneu et inuisible, comme vn esprit, et toutesfois tenant lieu, et soustenant la chose en laquelle il est enclos, et si iamais il ne sentoit d'humidité, plusieurs choses, où il est enclos, seroyent perpetuelles : comme le sel qui est au bois empescheroit qu'il ne pourriroit iamais : et s'il ne receuoit aucune humidité, il ne s'engendreroit iamais de vers dans ledit bois : Car iamais ne se peut faire de generation sans qu'il y ait vne humeur eschaufée par putrefaction. Si le foin, la paille et choses semblables estant bien seichées, sans receuoir aucune humidité, estoyent gardées en lieu sec, ils seroyent perpetuels par la vertu du sel qui y est. Il y a aucuns sels lesquels estant és lieux secs tiennent la forme qui leur aura esté donnée, et estants mis en lieu humide se reduisent en huile, desquels le Tartare est vn, et le sel de salicor vn autre. Ce point bien entendu peut beaucoup aider à l'intelligence des propos que i'ay tenus en parlant de la generation des metaux : partant il est de besoing que tu entendes bien le tout : par ce que toutes ces matieres sont si bien concatenées ensemble, que l'vne donne intelligence de l'autre.

DV SEL COMMVN.

Theorique.

Ie n'eusse pas pensé qu'il y eust eu tant d'especes de sels, ne qu'ils eussent eu tant de vertus, si tu ne me l'eusses dit : Mais puis que nous sommes sus le propos des sels, deuant que passer outre, ie te prie me faire le discours de la maniere de faire le sel commun, comme il s'en fait aux isles de Xaintonge, et me monstre la figure de la forme comme sont fait les marez salans : car tu le sçais bien, d'autant que ie t'ay ouy dire qu'autrefois tu as esté sur les lieux auec commission de figurer lesdits marez.

Practique.

Ce qui est vray ; ce fut du temps que l'on vouloit eriger la gabelle audit pays. Or puis que tu as enuie d'entendre ces choses, donne moy audience et ie t'en feray volontiers le discours, et puis ie t'en monstreray vne figure.

Premierement, tu dois entendre que d'autant que la mer est presque toute bordée de grands rochers ou de terres plus hautes que non pas la mer, pour faire les marez salans, il a fallu trouuer necessairement quelque plaine plus basse que la mer : Car autrement il eut esté impossible de trouuer moyen de faire du sel à la chaleur du soleil : Et faut croire que si l'on eut trouué en quelque autre partie de la France limitrophe de la mer, lieu propre pour former marez, qu'il y en auroit en plusieurs endroits. Or ce n'est pas assez d'auoir trouué vn platin ou campagne plus basse que la mer : mais il est aussi requis que les terres où l'on veut eriger marez, soyent tenantes, glueuses, ou visqueuses, comme celles dequoy on fait les pots, briques et tuilles. Il y a vn seigneur d'Anuers qui a beaucoup despendu pour faire des marez és pays bas, en la forme et semblance de ceux des isles de Xaintonge : Mais combien qu'il ait trouué assez de lieux bas pour faire venir l'eau

de la mer, ce neantmoins d'autant que la terre n'estoit pas glueuse ny tenante comme celle de Xaintonge, il n'a peu venir au bout de son intention, et sa despence a esté perdue : d'autant que les terres qu'il auoit fait creuser pour former les dits marez estoyent arides et sableuses, qui ne pouuoyent contenir l'eau.

Combien que nos predecesseurs des isles Xaintoniques ayent trouué certains platins, ou lieux bas, limitrophes de la mer, et que les terres du fond ayent esté trouuées naturellement glueuses ou argileuses, cela n'a pas suffi pour paruenir à leur dessein : car il a fallu inuenter une maniere de conroyer ladite terre en la sorte et maniere que ie te diray cy apres.

Si nosdits predecesseurs n'eussent eu vn grand iugement et consideration en formant les marez sallans, ils n'eussent rien fait qui eut valu : ayans donc consideré les platins plus bas que la mer, ils ont trouué qu'il faloit trancher vn canal qui peut amener aisement l'eau de la mer iusques aux lieux pretendus, pour faire le sel. Ayant ainsi creusé certains canaux ils ont fait venir l'eau de la mer iusques à vn grand receptacle qu'ils ont nommé le iard (1), et ayant fait vne ecluse audit iard ils ont fait au bout d'iceluy d'autres grands receptacles, qu'ils ont nommé conches (2), dedans lesquelles ils laissent couler de l'eau du iard en moindre quantité que non pas audit iard, et d'icelles conches ils font passer l'eau dedans le forans par vne tronce de bois percée, qu'ils appellent l'Amezau, lequel est par dessouz le bossis, et d'iceluy forans la font passer par deux bois percez qu'ils appellent les pertuis des poelles, pour entrer dedans certains lieux qu'ils nomment entablements, viresons, et moyens, lesquels sont faits par une telle mesure, que l'eau de laquelle l'on veut faire sel, faut qu'elle tourne et enuironne vn bien long chemin et par diuers degrez, au parauant que l'on la laisse entrer dedans les parquets du quarré destiné à faire le sel. Il faut noter que combien que l'on face passer laditte eau par plusieurs degrez enclos aux receptacles, si est ce que de receptacle en autre l'eau est mise en moindre quantité, decoulant de l'vn à l'autre tousiours en diminuant,

(1) Probablement du mot anglais *yard*, cour, surface de terrain plate et limitée, lequel sans doute est aussi la racine du mot *jardin*.

(2) Réservoirs; de *concha*, coquille.

afin que ladite eau soit bien preparée et eschaufée au parauant qu'elle soit mise dedans les aires salans, ausquels l'on l'a fait congeler en sel, c'est à dire auant que ouuerture luy soit faite pour entrer dedans lesdits aires. Car il y a certaines petites tablettes que l'on hausse pour laisser descouler dedans les aires, l'eau qui vient des viresons et entablements et autres degrez.

Mais pour monstrer qu'elles n'ont pas esté faites sans grand labeur et auec vn bien long temps, il a fallu creuser la quadrature du champ des marez, plus bas que le canal venant de la mer, ni que les iards et conches, afin de donner pente ou inclination és degrez et membres susdits : afin d'amener l'eau iusques à la grande quadrature du champ de marez. Et faut noter qu'en creusant celle grande quadrature il a fallu apporter les terres et vuidanges tout à l'entour de ladite quadrature, laquelle estant mise tout à l'entour, fait vne grande platte forme que l'on appelle bossis, laquelle sert pour mettre de grands monceaux de sel qu'ils appellent vaches de sel ; et quand ce vient en hyuer que la saison de faire sel est passée, ils couurent lesdits monceaux de sel auec des ioncs, lesquels se vendent bien, à cause de leur vtilité. Lesdits bossis seruent aussi pour aller de marez en marez, pour passer les hommes et cheuaux en tous temps : il est requis qu'ils ayent vne grande largeur, par ce que quand quelqu'vn a vendu vne vache de sel ou deux, selon que la distance est longue, pour apporter le sel dedans le nauire, il est requis pour les lieux lointains vn grand nombre de bestes pour porter le sel à bord, et cela se fait auec vne merueilleuse diligence, tellement que l'on diroit qui n'en auroit iamais veu, que ce sont esquadrons qui veulent combatre les vns contre les autres. Il y a gens sur le bord du bateau, qui ne font que vuider les sacs, et vn autre qui marque, et chacune beste ne porte qu'vn sac à la fois, et ceux qui touchent les cheuaux sont communement petits garçons, qui soudain que le cheual est deschargé et le sel vuidé, se iettent de vitesse sur le cheual, et ne cessent de courir la poste iusques à la vache de sel, où il y a autres hommes qui emplissent les sacs et les chargent sur les cheuaux, et estants rechargez lesdits garçons les remeinent en diligence iusques au nauire. Et d'autant que les vns et les autres vont et viennent tous en diligence, il est requis que les bossis ou plattefor-

mes soyent bien larges : car les cheuaux se rencontreroyent l'vn l'autre. Entens maintenant l'industrie de laquelle il a fallu vser pour rendre les marez propres pour garder que la terre ne succe l'eau qui y est mise, pour saller. Quand la grande quadrature a esté creusée et les vuidanges ostées, au parauant que former les voyes et parquetages, ils ont vn nombre de cheuaux et iuments, lesquels ils attachent l'vn à l'autre en quelque sorte, pour les pourmener, puis les mettent dedans icelle grande quadrature, où ils veulent former les marez, il y a vn personnage qui tient le premier cheual d'vne main, et de l'autre main vn fouët, lequel pourmene lesdits cheuaux et iuments en diligence, iusques à tant que la terre de solle soit bien conroyée, et qu'elle puisse tenir l'eau, comme un vaisseau d'airain. Et la terre estant ainsi bien conroyée, ils dressent leurs voyes et parquetages par lignes directes, donnant la pente requise de degré en degré, en telle sorte qu'il n'y a maçon ny geometrien qui la sçeut mieux niueler auec tous les outils de geometrie, qu'ils la niuellent auec de l'eau : car l'eau leur donne à connoistre clairement les lieux plus hauts ou plus bas.

Apres di-ie que la terre est ainsi conroyée, ils forment leurs voyes et parquetages ainsi que si c'estoit de la terre à potier, voyla pourquoy ie t'ay dit ci deuant que ores que l'on peut trouuer des lieux plus bas que la mer, il seroit impossible de dresser marez sallans si la terre n'es naturellement argileuse ou visqueuse comme celle des potiers.

Il y a encores vn grand labeur qu'il a conuenu faire à nos predecesseurs pour dresser les marez; il ne faut point douter que les premiers qui en ont erigé, n'ayent choisi les lieux les plus proches de quelque canal naturel : car s'il n'y auoit point de canal, il seroit difficile d'amener le sel qui se fait sur les marez, iusques au nauire dedans la grande mer, par ce que les grands nauires ne peuuent approcher du bord, à cause de leur grandeur : parquoy ceux qui vendent du sel ameinent des petites barques qui entrent au dedans du platin le plus pres qu'ils peuuent du sel qu'ils auront vendu; ils posent l'ancre, et ainsi l'on apporte ledit sel premierement en la barque, puis l'on meine ladite barque pour descharger dans le nauire : et faut noter que le plus souuent en certains canaux l'on n'y peut entrer que au plein : et pour en sortir, si la mer s'en est al-

lée, il faut attendre qu'elle soit de rechef au plein : Et combien que aucuns canaux ont esté trouués naturels, ce neantmoins il a esté necessaire d'aider à nature, afin que les barques et petits nauires puissent approcher des lieux où l'on fait le sel : et ne faut douter que nos predecesseurs n'ayent aussi esté contraints de former des canaux és lieux où il ne s'en est point trouué de nature : car autrement ils ne pourroyent tirer le sel desdits marez : d'autant que les plates formes sont faites si fort obliques, qu'il semble que c'est vn labyrinte, et ne sçauroit on faire vne lieuë au trauers qu'elle n'en monte à plus de six, à cause des enuironnements qu'il faut faire pour en sortir : et si quelque estranger y estoit enclos, à peine en pourroit il sortir sans conduite, par ce qu'il faut trouuer vn grand nombre de pontages, qu'il faut chercher l'vn à dextre et l'autre à senestre, quelque fois tout au contraire du lieu où l'on veut aller : Car il faut entendre que tout le platin des marez est concaué de canaux, de iards, de conches, ou de champ de marez ; aucuns desdits champs sont quarrez, et autres longs et estroits, d'autres en forme d'esquerre ; afin que toute la terre soit employée en façon de marez : tout ainsi qu'en vne ville les premiers edifians ont pris place communement quarrée à leur commodité, et les derniers ont pris les places et restes des autres, ainsi qu'elles se sont trouuees : le semblable s'est fait és marez, car les premiers ont pris place à leur commodité le plus pres des canaux et de la mer qu'il leur a esté possible, et les derniers venus ont pris les places, non pas telles qu'ils desiroyent, mais ils les ont edifiées quelque fois és lieux bien lointains des canaux et riues de la mer, qui cause que ceux là ne se sont pas tant vendus : d'autant que les frais de l'amenage du sel sont par trop grands.

Autres ont edifié des marez qui sont de peu de valeur, parce que bien souuent l'eau leur defaut au plus grand besoing, d'autant que les canaux, iards et conches ne sont pas assez bas en terre, pour recouurer de l'eau de la mer à leur souhait, et faut icy noter vn poinct singulier, qui est qu'en chacun marez il y a vn canal fait à force d'hommes, pour amener l'eau de la mer dans le iard, et autres canaux comme petites riuieres, qui seruent pour amener les barques entre plusieurs marez, dedans lesquelles on porte le sel au grand nauire, comme i'ay dit vne autre fois : par tel moyen toute la terre

de la vallée des marez est labourée, fossoyée et retranchée pour l'vtilité et seruice dudit sel, et pour ces causes ai-ie dit cy dessus que si vn estranger estoit au milieu des marez, ores qu'il verroit le lieu où il voudroit aller, à peine en pourroit il sortir : d'autant que bien souuent luy faudroit tourner le dos pour chercher les pontages : aussi qu'il n'y a chemin ne voye que seulement les bossis, qui sont erigez par lignes obliques, et n'est possible de trouuer chemin ne voye dans lesdits marez autre que les bossis, lesquels sont haut esleuez, par ce que toutes les vuidanges des champs des marez y ont esté mises, et si l'on y estoit en hyuer l'on verroit tous lesdits champs couuerts d'eau, comme de grands estangs, sans apparoir aucune forme d'iceux. Ce qui a fait que aucuns peintres ayants esté enuoyez és isles pour sçauoir la cause pourquoy il est impossible de passer vne armée au trauers desdits marez, ont esté deceus : d'autant qu'ils y sont allez és saisons que l'eau estoit dedans lesdits marez, et en ont rapporté des figures incertaines. Du temps que l'on vouloit eriger la gabelle au pays de Guienne, le sieur de la Trimouille et le general Boyer, enuoyerent un maistre Charles (peintre fort excellent) sur les isles pour remarquer les passages ; ledit peintre apporta figure certaine et au vray des bourgs et villages : Mais quant est des formes des marez, ce n'estoit que confusion en sa figure : d'autant que pour lors les marez estoyent couuerts d'eau ; et pour mieux te le faire entendre, il faut necessairement qu'apres que les chaleurs sont passées, et qu'il n'y a plus d'apparence de faire du sel, les sauniers, pour la conseruation des marez, ouurent certaines bondes des canaux qui passent par le iard et par ces conches, et laissent entrer l'eau dans lesdits marez iusques à ce que toutes les formes soyent couuertes. Car s'ils laissoyent lesdits marez descouuerts, les gelées les dissiperoyent en telle sorte qu'il les faudroit refaire tous les ans: mais par le moyen de l'eau ils sont conseruez d'vne année à autre.

Et afin que tu entendes mieux que le sel n'est pas vne chose qui se puisse faire aisement et à peu de frais, il conuient noter que l'on n'en peut faire que durant trois ou quatre mois de l'année, pendant les grandes chaleurs. Et pour le premier preparatif du sel, il faut prendre l'eau de la mer au plein de la lune du mois de Mars. Car en ce temps là, la mer est plus

haute et enflée qu'en nulle saison, et lors qu'elle est en sa pleine grandeur, les sauniers desbondent les conduits des canaux et grandes tranchées, pour emplir ce grand receptacle qu'ils appellent iard, lequel faut qu'il contienne autant d'eau qu'il en fait besoing, pour faire le sel iusques à la pleine lune du mois de Iuillet, auquel temps la mer se remet en sa grandeur et hautesse comme celle de Mars, et alors vn chascun saunier se trauaille à remplir le iard : toutesfois quelque labeur et diligence que nos predecesseurs sauniers ayent sçeu faire, si est ce que quand vn esté est fort sec, il y a plusieurs marez qui ne font rien vne partie de l'esté : Car l'eau du iard estant faillie deuant le temps, ils n'ont aucun moyen d'en remettre d'autre, si ce n'est au temps des grandes malignes (qu'ils appellent) qui est lors que la mer est en sa superbe grandeur. Voila pourquoy les marez qui sont pres du port, et qui peuuent auoir de l'eau au plein de toutes les lunes sont beaucoup plus estimez que les autres.

Il faut aussi noter vn poinct qui est, que si durant que l'on fait le sel il aduenoit vne pluye l'espace d'vne nuict ou d'vn iour, mesmes seulement deux heures, l'on ne sçauroit faire de sel de quinze iours aprez : par ce qu'ils faudroit nettoyer tous les marez et oster l'eau d'iceux, aussi bien la salee que la douce, tellement que s'il pleuuoit tous les quinze iours vne fois, l'on ne feroit iamais de sel à la chaleur du Soleil : parquoy faut croire qu'aux regions et contrees pluuieuses et froides, l'on n'y sçauroit faire de sel à la maniere qu'il se fait és isles de Xaintonge, encores qu'ils eussent toutes les autres commoditez cy dessus alleguees.

Il est encores besoing d'entendre qu'auparauant que faire le sel il faut espuiser toute l'eau qui est dans les marez, laquelle y auoit esté mise pour les conseruer en hyuer : ce qui n'est pas vn petit labeur ; et ayant nettoyé tous lesdits marez communement au mois de May, quand le temps vient à s'eschauffer, ils lachent les bondes pour laisser passer telle quantité d'eau qu'ils veulent, laquelle ils font coucher dedans les conches, entablements, moyens et viresons, afin qu'elle se commence à eschaufer, et estant eschaufée, ils la mettent à sobrieté dedans les aires où l'on fait cresmer le sel. Et pour mieux te monstrer encores la despense desdits marez, il faut entendre qu'en chascun champ de marez il y a deux escluses

22.

faites en maniere d'vn pont, lesquelles ne se peuuent faire qu'auec grands despens, à cause de la grandeur du bois : car il faut que les montans viennent du fond et concauité du canal bien profond, et les pieces trauersantes seruent de passer hommes et cheuaux : ils nomment lesdits ponts l'vn la varengne et l'autre le gros mas : par ce qu'il sert aussi à retenir les eaux du iard : Outre lesdits ponts, en chacun marez il y a plusieurs pieces de bois qui sont percées tout du long, pour faire passer les eaux, de degré en degré. En chascun champ de marez, il faut bien vne piece de bois autant longue que le pied d'vn grand arbre, laquelle est percée tout du long, qu'ils appellent l'Amezau, et faut que ledit pied d'arbre soit bien gros, et les autres pieces qui sont moindres sont percées selon leur grosseur. Ie te di ceci afin que tu entendes que les bois des marez estans pourris ou bruslez, les forests de la Guyenne ne sçauroyent suffire pour les refaire. Et n'y a homme ayant veu le labeur de tous les marez de Xaintonge, qui ne iugeast qu'il a fallu plus de despence pour les edifier, qu'il ne faudroit pour faire vne seconde ville de Paris (1).

THEORIQUE.

Voire, mais ceux qui se sont meslez d'escrire par cy deuant, disent que le sel prouient de l'escume de la mer, et mesme vn autheur (qui a escrit, depuis que le sel est si cher, vn petit liure, de l'excellence, dignité et vtilité du sel) l'a ainsi dit, et semblablement a dit que nous serions bien heureux si nous auions vne fontaine d'eau salee en France, comme ils ont en la Lorraine et autres pays.

PRACTIQUE.

Tu peux bien auoir entendu par mon discours, le contraire de leur dire, il n'est pas besoing que i'en repete quelque chose. Et quant à l'aucteur que tu m'as allegué, il n'entend pas bien ce qu'il a mis en son liure, et plusieurs le croyans se pourront abuser : Car quant il y auroit cent fontaines d'eau salee en France, elles ne sçauroyent suffire à la moitié du Royaume. Et qui plus est, quand il y en auroit mille, elles

(1) Cette description des marais salants de Saintonge et des procédés usités à cette époque pour l'extraction du sel est aussi claire qu'exacte et précise. Palissy avait eu l'occasion d'étudier cette matière, ayant été chargé de lever le plan des marais salants par suite de l'édit de François 1er, du mois de mai 1543, qui ordonnait d'y établir les droits de gabelle.

DV SEL COMMVN.

seroyent inutiles. Car où sont les bois pour faire ledit sel ? I'ose bien dire que toutes les forests de France ne sçauroyent faire en cent ans autant de sel de fontaines ou de puits salez qu'il s'en fait en vne seule annee en Xaintonge, à la chaleur du soleil; non pas vne annee, mais seulement depuis la my-May iusques à la my-Septembre. Car ils n'en sçauroyent faire en autre saison. Il y a des puits ou fontaines en Lorraine, desquels l'on fait grande quantité de sel : mais ie te prie considere vn peu la grande despense. La chaudiere où l'on fait bouillir l'eau, a trente pieds de long et autant de large, elle est maçonnee sur vn four qui a deux gueules, et à chacune gueule il y a deux hommes qui ne cessent de ietter bois dans icelles. Il y a vn grand nombre de chariots pour charier le bois, et des hommes pour le mettre pres du four, autres sont au bois pour le couper. L'on tient pour certain que toutes les annees il faut la leuée de mil arpens ou quartiers de bois taillis pour entretenir lesdittes fournaises, et l'ordre est tel qu'il y a quatre mil quartiers de bois destinez pour l'entretenement des fours : et par chascun an l'on en coupe mil quartiers, et au bout de quatre ans les quatre mil quartiers estans coupez, ils recommencent au premier milier qui auoit esté coupé. Or considere si quelqu'vn auoit en France mil quartiers de bois taillis, s'il voudroit bailler la leuée dudit bois pour le prix que pourroit estre vendu le sel qui se feroit de dix mille quartiers, il est certain que le bois vaudroit plus, et s'en trouueroit plus d'argent que du sel. Et combien que le bois ne couste rien au Duc de Lorraine, si est ce que les frais de faire le sel au feu, sont si grands que le sel est trois fois plus cher en Lorraine, que non pas en France. O combien la beatitude de la France est plus grande en cest endroit que celle des autres nations. Et combien qu'en Portugal il s'en face à la chaleur du Soleil, si est ce qu'il n'est pas si naturel que celui de Xaintonge : par ce qu'il a vne acuité si grande et corrosiue, que plusieurs en ayant salé des lards ont trouué des trous et incisions que les gros grains de sel auoyent fait au trauers desdits lards. Quant est de celuy de Lorraine, tant il s'en faut qu'il soit si conseruatif que celuy de Xaintonge, que bien souuent les lards dudit lieu sont tous remplis de vers apres auoir esté salez. Plusieurs Royaumes estrangers, ayant quelque quantité de sel en leur pays, ne laissent pour cela d'en venir querir en France, et

quand ils en ont, ils l'augmentent et accroissent du leur : ceux des Ardennes sçauent tres-bien que le sel de Xaintonge est meilleur que celuy de Lorraine, et pour ces causes ils sont soigneux d'en auoir : ils le connaissent à la couleur et grosseur : car les grains du sel qui est congelé au soleil sont plus gros que de celuy qui est fait au feu, et faut croire que le sel de Xaintonge est aussi blanc que nul autre sçauroit estre : Mais par ce que la terre des marez est noire, ceux qui font le sel ne le peuuent tirer hors des aires sans racler et entremeler quelque peu de terre : ce qui luy oste vne partie de sa blancheur : toutesfois quand les sauniers commencent à faire du sel, ils en font d'aussi blanc que neige, pour seruir à table, et en font des presens à leurs parents et amis, qui sont espars és terres douces. Ils prennent ledit sel blanc tout dessus, auant que de racler iusques au fond, et sans esmouuoir rien de laditte terre. Ce n'est donc pas la faute de l'eau, que le sel de Xaintonge ne soit aussi blanc que celuy des autres pays. Et ne faut plus auoir opinion qu'il s'en face de l'escume de la mer, ainsi que l'on l'a creu iusques auiourd'huy.

Le Sel blanchit toutes choses.

Et donne ton à toutes choses.

Et si fortiffie toutes choses.

Et si est compagnon de toutes natures.

Et si entretient l'amitié entre le masle et la femelle.

Et si aide à la generation de toutes choses animees et vegetatiues.

Il empesche la putrefaction et endurcist toutes choses.

Il aide à la veüe et aux lunettes.

Sans le sel, il seroit impossible de faire aucune espece de verre.

Toutes choses se peuuent vitrifier par sa vertu.

Il donne goust à toutes choses.

Il aide à la voix de toutes choses animées, voire à toutes especes de metaux, et instruments de musique.

DES PIERRES.

Theorique.

Je suis fort aise d'auoir entendu ce discours du sel commun : car ie ne pensois pas qu'il se fît auec tant de labeur, et cela meriteroit bien d'estre mis en lumiere. Car ie croy fermement que nul des Cosmographes n'en ont iamais parlé. Maintenant ie te prie de me parler des pierres : d'autant que tu m'as dit qu'en parlant d'icelles ie connoistrois de beaux secrets. Ie voudrois bien sçauoir que tu en veux dire : car les vns disent qu'elles ont esté formées dés la creation du monde, et les autres disent qu'elles croissent tous les iours.

Practique.

D'autant que ie t'ay veu si fort attaché à l'alchimie, ie suis content de te parler des pierres : car peut estre qu'en parlant de la formation et essence d'icelles, tu pourras te reduire à mon opinion. Ceux qui disent que les pierres sont formées dés la creation du monde errent, et ceux qui disent qu'elles croissent errent aussi. Or il faut que tu rememores ce que i'ay dit plusieurs fois en parlant des fontaines et de l'alchimie, qu'il n'y a nulle chose sous le ciel en repos, et que toutes choses se trauaillent en se formant, et en se deformant tournent bien souuent de nature à autre, et de couleur à autre. S'il estoit ainsi que les pierres eussent esté creées dés la fondation du monde, et qu'il ne s'en fît plus l'on n'en pourroit plus trouuer à present. Considere la grande quantité de pierres qui est consumée tous les iours : vne partie par les gelées qui la font venir menue comme cendres : une autre partie par les fours à chaux : autre partie par les maçons et tailleurs de pierres. C'est chose certaine qu'en faisant vn logis de pierre de taille la moitié s'en ira en poussière à coups de marteau, aussi tu sçais que les cheuaux, chariots et charrettes,

en passant et repassant en dissipent vne grande quantité. Si tu as bien regardé les rochers qui sont le long de la mer, tu as veu comment ses flots impetueux ont ruiné vne bonne partie desdits rochers. D'autre part, le vent d'Est et de Sus, cause vne dissolution du sel qui entretient la pierre en son estre, tellement qu'elles tombent en poussiere : et de là vient qu'aucuns disent que telles pierres sont gelisses ou venteuses. A la vérite les pierres, desquelles l'eau est sortie au parauant que leur decoction fut faite, si estant abreuuées d'eau, la gelée vient là dessus, elles ne faudront à se reduire en poudre : et voila comment les pierres sont suiettes à la dissolution des vents et des gelées. Si tu consideres toutes choses tu connoistras que si les pierres eussent esté faites dés la fondation du monde, et qu'il ne s'en fit plus depuis, il y a long temps que l'on n'en sçauroit trouuer vne seule. Ie ne di pas que Dieu n'ait creé dés le commencement et montaignes et vallées, lesquelles montaignes ne sont causées que des rochers, comme ie t'ay dit en parlant des fontaines.

Theorique.

Et pourquoy m'as tu donc nié que les pierres croissent?

Practique.

Ie te le nie bien encores : car les pierres n'ont point d'ame vegetatiue, mais insensible ; parquoy elles ne peuuent croistre par action vegetatiue : mais par vne augmentation congelatiue (1) ?

Theorique.

Et qu'appelles-tu augmentation congelatiue?

Practique.

C'est vn traict qui te pourra beaucoup servir à connoistre la generation des metaux. I'appelle augmentation congelatiue comme qui ietteroit de la cire fondue sur vne masse de cire desia congelée, et qu'icelle se vint congeler auec ladite masse, laquelle seroit augmentée d'autant que l'addition y auroit esté mise. En cas pareil, les rochers des montaignes sont augmentez par quelque cheute de pluye qui auroit amené auec soy vne matiere pierreuse. Mais la vraye addition dés pierres et la plus certaine, est celle qui se fait és pierres qui sont

(1) La science moderne exprime précisément la même pensée, en d'autres termes, lorsqu'elle pose en principe que les corps organiques s'accroissent par *intussusception* et les corps inorganiques par *juxtaposition*.

encores dans le ventre de la terre. Car tout ainsi que i'ay dit des metaux, qu'ils ne peuuent estre generez hors la matrice de la terre, et qu'il estoit besoing qu'ils fussent enclos dans lieux humides et aqueux, comme se fait la formation de nature humaine : Aussi semblablement les pierres des carrieres ne peuuent estre engendrées sinon és lieux creux et cachez dans la matrice de la terre, et là elles reçoiuent tous les iours vne augmentation congelatiue, et cela se fait par le moyen que i'ay plusieurs fois dit, et qui est le fondement principal de mes arguments : à sçauoir que dèslors que Dieu crea la terre, il la remplit de toutes substances. Or par ce que les substances pierreuses et metalliques sont inconneües parmi la terre, et consequemment parmi les eaux, les pluyes qui passent au trauers des terres prennent les sels qui sont aussi inconnus, lesquels sels ou matieres metalliques sont fluentes et se laissent couler auec les eaux qui entrent dans la terre iusques à ce qu'elles ayent trouué quelque fonds pour s'arrester : et si elles s'arrestent sus vne carriere, ou miniere de pierre, lesdites matieres estant liquides passent au trauers des terres, et ayans trouué lieu pour s'arrester, se viennent à congeler et endurcir et faire vn corps et vne masse auec l'autre pierre. Voila pourquoy ie l'ay dit que les pierres ne croissent point, mais bien qu'elles peuuent augmenter par vne addition congelatiue : et cela fait que toutes carrieres contigues ont les sins, veines et assemblages de trauers, et non point descendantes du haut en bas, qui est vne vraye attestation que la congelation desdites pierres n'a pas esté faitte tout en vn coup : autrement elle ne se pourroit iamais fendre, ains seroit autant dure en l'vn endroit comme en l'autre. Et quand l'on la veut fendre, l'on trouue communement certaines ioinctures que l'on nomme sins, et bien à propos : par ce que c'est la fin d'vne congelation faite en vn temps, suiuant ce que i'ay dit que les congelations des rochers ou carrieres contigues, n'ont pas esté faites tout en vn coup.

THEORIQUE.

Et où est ce que tu as trouué cela par escript, ou bien di moy en quelle escole as tu esté, où tu puisses auoir entendu ce que tu dis?

PRACTIQUE.

Ie n'ay point eu d'autre liure que le ciel et la terre, lequel

est conneu de tous, et est donné à tous de connoistre et lire ce beau liure. Or, ayant leu en iceluy, i'ay consideré les matieres terrestres, par ce que ie n'auois point estudié en l'astrologie pour contempler les astres (1). Et ayant de bien pres regardé les natures, i'ay conneu en la forme de plusieurs pierres, qui estoyent faites comme des glaçons qui pendent aux goutieres des maisons quand il gele, que les pierres estoyent faites et engendrées de quelques matieres liquides et distilantes comme eau; i'ay esté l'espace de dix ans en opinion que les eaux communes se reduisoyent en pierre par quelque vertu congelatiue, et singulierement le cristal, lequel ie ne trouuois en rien different à l'eau commune. Toutesfois comme les sciences se manifestent à ceux qui les cherchent, depuis quelque temps i'ay conneu que le cristal se congeloit dedans l'eau; et ayant trouué plusieurs pieces de cristal formées en pointes de diamants, ie me suis mis à penser qui pourroit estre la cause de ce : et estant en telle resuerie, i'ay consideré le salpestre, lequel estant dissoult dedans l'eau chaude, il se congele au milieu ou aux extremitez du vaisseau où elle aura bouilli : et encores qu'il soit couuert de laditte eau, il ne laisse à se congeler. Par tel moyen i'ay conneu que l'eau qui se congele en pierres, ou metaux n'est pas eau commune. Car si c'estoit eau commune elle se congeleroit egalement par tout, comme elle fait par les gelées. Ainsi donc i'ay conneu par la congelation du salpestre que le cristal ne se congele point sur la superficie, ains au milieu des eaux communes, tellement que toutes pierres portans forme quarrée, triangulaire ou pentagone, sont congelées dedans l'eau. Depuis que ie suis en telle connoissance, i'ay trouué plusieurs mines de fer, d'estain et d'argent, qui auoyent les formes de cristal, qui m'a fait croire que toutes ces choses estoyent congelées dedans l'eau, comme i'ay dit en parlant de l'alchimie (2). Et pour confirmation de ce que ie dis,

(1) Voilà une de ces réponses énergiques qui caractérisent l'homme supérieur. Palissy n'avait aucune littérature acquise, mais il avait l'éloquence naturelle d'un esprit élevé; il n'avait pas étudié les anciens, mais il avait observé la nature; il n'avait pas contemplé les astres, mais scruté les entrailles de la terre.

(2) C'est la première théorie rationnelle qui ait été établie sur la cristallisation. C'était aussi la première fois que l'on observait la forme des cristaux, que l'on assimilait la formation des pierres cristallisées à la cristallisation des sels au milieu d'un liquide, enfin que l'on distinguait la

J'ay veu vn lapidaire (nommé Pierre Seguin) qui auoit trouué vne pierre de cristal au dedans de laquelle il y auoit de l'eau qui n'estoit pas congelée, et dedans ladite eau y auoit vne petite ordure noire qui estoit plus legere que l'eau : car quànd il tournoit la pierre de quelque costé, ladite ordure se tenoit tousiours dessus. Et d'autant que ledit lapidaire l'auoit fait tailler et enchasser en vn anneau, aucuns croyoyent fermement que c'estoit un esprit enclos dedans icelle, ne se doutant du secret de ceste philosophie. Il y auoit vn nommé de Trois rieux, homme curieux et de bon iugement, lequel auoit vne autre pierre de cristal en laquelle y auoit de l'eau enclose comme en la susdite : Mais il fust bien trompé : car l'ayant baillé à vn lapidaire pour tailler vne larme, en la taillant trouua vne petite veine par laquelle l'eau (qui n'estoit pas congelée) s'enfuit. J'ay trouué aussi plusieurs cailloux cornuz, qui estoyent creuz dedans, et auoyent plusieurs pointes comme de diamants : cela m'a fait connoistre que quand lesdits cailloux se formoyent, ils estoyent pleins d'eau, et que depuis l'eau commune s'est exhalée et a laissé la matiere congelatiue en forme d'vn caillou creux. Voila les liures de mon estude.

Theorique.

Et cuides tu que ie croye que l'eau se puisse reduire en pierre ?

Practique.

Je t'ay dit que j'ay esté long temps en ceste opinion. Mais à present ie te di que ce n'est pas l'eau commune, ains vne eau de sel, laquelle tu ne sçaurois distinguer d'auec la commune ; toutesfois elle est fluide et autant candide que l'eau commune. Et de cela j'ay bon tesmoignage : car moy estant à Paris, l'année passée 1575. il y eust vn medecin nommé Monsieur Choynin, duquel la compagnie et frequentation m'estoit vne grande consolation, qui apres m'auoir entendu parler ainsi des natures, et connoissant qu'il estoit amateur de philosophie, ie le priay de venir auec moy dans les carrieres pres sainct Marceau, afin de luy oster toute doute de ce que ie luy auois dit de la generation des pierres. Et iceluy, meu de bon zele et sans espargner sa peine, fit soudain apporter des flambeaux de

cristallisation des sels de la formation de la glace. Il y a dans ce court paragraphe les éléments de toute une révolution dans les idées de l'époque sur cette matière.

cire, et amenant auec luy vn escolier Medecin, nommé Milon, nous allasmes pres d'vne lieüe dans lesdites carrieres, estants conduits par deux carriers : Et là nous vismes ce que long temps au parauant i'auois conneu par les formes des pierres faites comme des glaces pendantes : Aussi que i'auois veu vn nombre de telles pierres, qui auoyent esté apportées de Marseille par le commandement de la Royne, mere du Roy, d'vne cauerne qui s'appelle la Mauue louviere, laquelle a pris son nom par ce que les loups y vont souuent manger les cheures et brebis qu'ils ont desrobees. I'auois aussi veu grande quantité de telles pierres à la grotte de Meudon, qui ont esté apportées des parties maritimes. I'en ay aussi veu és rochers qui sont du long de la riuiere de Loire : Mais quand nous fusmes és carrieres de Paris nous vismes distiller l'eau qui se congeloit en nostre presence. Parquoy tu ne me peux nier ce poinct : car i'ay bon tesmoignage.

THEORIQUE.

Voila vne chose bien estrange de dire qu'il se forme des pierres tous les iours.

PRACTIQUE.

Ie ne dis pas des pierres seulement, mais aussi des metaux, et te dis que le bois et les herbes se peuuent reduire en pierre.

THEORIQUE.

Si tu dis cela, gueres de gens ne le voudront croire, et te conseille de ne tenir iamais vn propos si esloigné de verité.

PRACTIQUE.

I'ay trouué autrefois des asnes comme toy, qui trouuoyent fort estranges mes propos, et crioyent apres moy comme au renard, que bien souuent i'en estois honteux : toutefois ie faisois tousiours mon compte que la science n'a plus grand ennemi que l'ignorance. A present l'on n'a garde de m'en faire rougir : ie suis trop asseuré en mon affaire. Et di que non seulement le bois se peut reduire en pierre, ains aussi le corps de l'homme et de la beste.

THEORIQUE.

Voila vne chose plus qu'estrange, que l'homme, la beste et le bois se puissent reduire en pierre.

PRACTIQUE.

Quant est du bois ie t'en monstreray plus de cent pieces re-

duites en pierre et en cailloux : quant est de l'homme ie n'en ay pas veu ; mais i'ay bon tesmoignage d'vn homme de bien, medecin, qui dit auoir veu dans le cabinet d'vn seigneur, le pied d'vn homme petrifié. Et vn autre medecin m'a asseuré auoir veu la teste d'vn homme aussi petrifiée. Vn Monsieur Iulles, demourant à Paris, m'a asseuré qu'il y a vn prince en Alemagne, lequel a en son cabinet le corps d'vn homme la plus part petrifié. Ie me tiens tout asseuré que si vn corps estoit enterré dans vn lieu où il y eust quelque eau dormante, parmi laquelle y eust de l'eau congelatiue, de laquelle se forme le cristal et autres matieres metalliques et pierreuses, que ledit corps se petrifieroit : par ce que la semence congelatiue est d'vne nature salsitiue, et que le sel du corps de l'homme attireroit à soy la matiere congelatiue, qui est aussi salsitiue, à cause de l'affinité que les especes ont, elles viendroyent à congeler, endurcir et petrifier le corps mort, et cela ie preuue par le bois de hetre, qui est le plus salé, et de quoy l'on fait plus aisément du verre.

THEORIQUE.

Voila encores vn propos plus esloigné de verité que tous les autres, selon mon iugement, et ne crois point que le corps de l'homme se puisse reduire en pierre.

PRACTIQUE.

Ie ne dis pas seulement en pierre, mais ie dis qu'il se peut reduire en metal, et l'homme, et le bois, et les herbes. Et cela se peut faire quand vn homme seroit enterré en quelque lieu aquatique, où la terre seroit pleine d'vne semence de vitriol, ou coperose. Car ladite semence n'est autre chose qu'vn sel qui n'est iamais oysif. Et, comme i'ay desia dit, les sels ont quelque affinité ensemble. Le sel du corps mort estant en la terre fait atraction de l'autre sel, lequel sera d'vn autre genre, et les deux sels ensemble pourront endurcir et reduire le corps de l'homme en matieres metalliques (1) : d'autant que

(1) On voit que Palissy était assez près de la vérité, relativement à la théorie des pétrifications. Il pense que des causes analogues pourraient réussir à pétrifier des os humains ; *mais il n'en a pas vu* : ce qui montre sa bonne foi et son scrupule scientifique. Du reste, il est digne de remarque que dans ce peu de mots il fasse preuve de vues chimiques très-élevées pour son époque ; et qu'il aille même jusqu'à se servir des termes d'*affinité* et d'*attraction*, dont, avant lui, on ne trouve l'emploi nulle part, dans le sens qu'il leur attribue.

la nature du sel nommé coperose, ou vitriol, ne peut faire autre chose que conuertir en airain les choses qu'il treuue au lieu où il fait sa demeurance. Ie te donne ce trait pour vn poinct inuincible et bien asseuré.

Theorique.

Tu le dis que c'est un poinct bien asseuré. Ouy si ie te veux croire. Voila toute l'asseurance que ie sçaurois auoir de toy.

Practique.

Ie ne t'ay pas mis ces poincts en auant sans que i'en feusse bien asseuré. Il y a long temps qu'on m'a asseuré qu'il y a vn personnage de qualité, au pays d'Auuergne, qui a un pal, lequel a esté arraché d'un estang, lequel s'est trouué partie en bois, partie en pierre, et l'autre partie en fer. Sçauoir est, la partie qui estoit dans terre estoit conuertie en fer, et la partie qui estoit dans l'eau conuertie en pierre, et la partie qui restoit hors de l'eau, est encores bois. Quand i'eus entendu vne telle chose, ie me mis en deuoir d'en sçauoir la cause : Et quelque iour en cerchant de la terre argileuse, ie trouuay plusieurs pieces de bois réduites en métal : Et i'apperceu que dedans ladite terre y auoit grande quantité de vitriol : Lors ie conneus que ainsi que le bois se putrifioit en la terre il s'abbreuoit de ceste matiere salsitiue ou vitriolique, qui causa la congelation et transmutation de la nature du bois, en matiere metallique : et par ce que ie sçauois bien que le bois le plus salé estoit le plus prompt à se reduire en pierre, ie mis peine de connoistre de quelle espece de bois estoyent ces pieces metalliques, et le conneus par la forme d'icelle : car ayant considéré qu'autrefois le lieu où ie les auois trouuees, auoit esté planté de vignes, lesquelles auoyent esté arrachées, pour tirer de la terre d'argile et faire des tuilles, ie vis que lesdites pieces de bois metallisees estoyent semblables aux iambes et pieds des vignes qui auoyent esté arrachées dudit lieu. Lors ie ne doutay plus que ce ne fut lesdits pieds de vignes, qui auoyent esté transmuez de bois en metal : non pas par le moyen du feu, comme les alchimistes cherchent à faire, hors la matrice de la terre. Car ie trouuay et contemplay de bien pres que ces choses auoyent esté transmuées dans ladite terre d'argile, qui est de ceste nature froide : dont quelques vns ont dit que pour ceste cause elle restraint le flus de sang

estans mise sus les temples auec du vinaigre. Apres que ie fus bien certain que ladite vigne se congeloit et transmuoit en matiere metallique, par la vertu de la coperose, ie conneus qu'il y auoit encores vne autre cause operante et aidante à ladite coperose : Et tout ainsi que le sel d'vn corps mort estant couuert dans la terre és lieux aqueux peut tirer à soy autres sels par l'affinité qu'ils ont l'vn à l'autre : Aussi les sels de la vigne peuuent auoir aidé à la congelation et transmutation dudit bois, et de cela ie m'en tiens pour tout asseuré, sçachant bien que le sel de la vigne, que l'on nomme tartare, a grande vertu enuers les metaux. Ie sçay que plusieurs alchimistes en blanchissent le cuiure, qui a causé que plusieurs en ont abusé. Aucuns font vn tire-poil dudit tartare, que ie n'ose dire, craignant que tu m'estimes menteur : par ce que la chose semble impossible. Parquoy ayant conneu telles choses à la verité, et en estant bien asseuré, i'ay consideré que i'auois beaucoup employé de temps à la connaissance des terres, pierres, eaux et metaux, et que la vieillesse me presse de multiplier les talens que Dieu m'a donnez, et partant qu'il seroit bon de mettre en lumieres tous ces beaux secrets, pour laisser à la posterité. Mais d'autant que ce sont matieres hautes et connues de peu d'hommes, ie n'ay osé me hazarder, que premierement ie n'eusse senti si les Latins en auoyent plus de connoissance que moy : Et i'estois en grand peine, par ce que ie n'auois iamais veu l'opinion des philosophes, pour sçauoir s'ils auoyent escrit des choses susdictes. l'eusse esté fort aise d'entendre le Latin, et lire les liures desdits philosophes, pour apprendre des vns et contredire aux autres : Et estant en ce debat d'esprit; ie m'auisay de faire mettre des affiches par les carrefours de Paris, afin d'assembler les plus doctes medecins et autres, ausquels ie promettois monstrer en trois leçons tout ce que i'auois conneu des fontaines, pierres, metaux et autres natures. Et afin qu'il ne si trouuast que des plus doctes et des plus curieux, ie mis en mes affiches que nul ni entroit qu'il ne baillast vn escu à l'entrée desdites leçons, et cela faisoy-ie en partie pour voir si par le moyen de mes auditeurs ie pourrois tirer quelque contradiction, qui eust plus d'asseurance de verité que non pas les preuues que ie mettois en auant : sçachant bien que si ie mentois, il y en auroit de Grecs et Latins qui me resisteroyent en face, et qui ne m'espargneroyent point, tant à

23.

cause de l'escu que i'auois pris de chascun, que pour le temps que ie les eusse ameusez : car il y auoit bien peu de mes auditeurs qui n'eussent profité de quelque chose, pendant le temps qu'ils estoyent à mes leçons. Voila pourquoy ie dis que s'ils m'eussent trouué menteur, ils m'eussent bien rembarré : Car i'auois mis par mes affiches que partant que les choses promises en icelles ne fussent veritables, ie leur rendrois le quadruple. Mais graces à mon Dieu, iamais homme ne me contredit d'vn seul mot. Quoy consideré, et voyant que ie ne pouuois auoir de plus fidelles tesmoings, ne plus asseurez en sçauoir qu'iceux, i'ay pris hardiesse de te discourir toutes ces choses bien tesmoignées, afin que tu ne doutes qu'elles ne soyent veritables. Et pour te les rendre encores mieux asseurées, ie te feray icy vn catalogue des gens de bien, honorables et doctissimes, qui ont assisté à mesdites leçons (lesquelles ie fis le caresme de l'an mil cinq cens septante cinq) au moins de ceux desquels ie pouray sçauoir le nom et la qualité : lesquels m'ont asseuré qu'ils seront tousiours prests à rendre tesmoignage de la verité de toutes ces choses, et qu'ils ont veu toutes les pierres minerales et formes monstreuses, lesquelles tu as veuës à mes dernieres leçons de l'an mil cinq cens septante six, lesquelles i'ay continué, afin d'auoir plus grand nombre de tesmoings.

S'ensuit le catalogue desdits tesmoins qui ont veu les choses susdites au parauant l'impression du liure (1).

Et premierement, Maistre François Choisnyn, et Monsieur de la Magdalene, tous deux Medecins de la Royne de Nauarre.

Alexandre de Campege (2), Medecin de Monsieur le Frere du Roy.

Monsieur Milon (3), Medecin.

(1) Voilà un grand nombre d'habiles médecins, plusieurs chirurgiens célèbres, des grands seigneurs, des gentilshommes, des ecclésiastiques en dignité, des gens de loi, etc., réunis par le goût des connaissances. Voilà en un mot, le premier Lycée français ouvert; et c'est un potier de terre qui y préside, qui y donne des leçons, qui s'y fait admirer?... (G.)

(2) Ou plutôt Champier (*Campesius*), l'un des descendants de Symphorien Champier, naturaliste célèbre, médecin des rois Charles VIII et Louis XII, mort à Lyon en 1539.

(3) Devenu premier médecin de Henri IV.

Guillaume Pacard, Medecin de S. Amour, en la Comté de Bourgongne, Diocese de Lyon.

Philibert Gilles, Medecin, natif de Muy, en la Duché de Bourgongne.

Monsieur Drouyn, Medecin, natif de Bretaigne.

Monsieur Clement, Medecin de Dieppe.

Iean du Pont, au Diocese d'Aire, Medecin.

Monsieur Misere, Medecin Poiteuin,

Iean de la Salle, Medecin du Mont de Marsan.

Monsieur de Pena, Medecin.

Monsieur Courtin, Medecin.

Tous ceux cy sus nommez, sont Medecins Doctes.

Monsieur Paré, premier Chirurgien du Roy (1).

Monsieur Richard, aussi Chirurgien du Roy.

Messieurs Paiot et Guerin, Apoticaires à Paris.

Messire Lordin, Marc de Saligny en Bourbonnois, Chevalier de l'Ordre du Roy.

Monsieur d'Albene et l'Abbé d'Albene son frère.

Iacques de Narbonne, presenteur de l'Eglise Cathedrale de Narbonne.

Monsieur de Camas, Gentilhomme Prouençal.

Noble homme Iacques de la Primaudaye, du pays de Vendomois.

La Roche Larier, Gentil homme de Touraine.

Monsieur Bergeron, Aduocat au Parlement de Paris, homme docte et expert aux mathematiques.

Maistre Iean du Clony, Diocese de Renes en Bretaigne, aussi Aduocat en Parlement de Paris.

Brunel de Saint Iacques Bearnois, des Salies, Diocese de Dax, licentié és loix.

Iean Poirier, escolier en droit, Normand.

Monsieur Brachet d'Orleans et Monsieur du Mont.

Maistre Philippe Oliuin, gouuerneur du Seigneur du Chasteau-bresi, homme docte és lettres.

Maistre Bertolome, prieur, homme experimenté és ars.

Maistre Michel Saget, homme de iugement et de bon engin.

Maistre Iean Viret, homme expert aux arts et mathematique.

(1) Ambroise Paré, premier chirurgien de Henri II, de François II, de Charles IX et de Henri III. On sait qu'il était huguenot et qu'il échappa comme Palissy au massacre de la Saint-Barthélemy.

Or i'ay veu autrefois vn liure que Cardan avoit fait imprimer des subtilitez, où il traite de la cause pourquoy il se trouue grand nombre de coquilles petrifiées iusques au sommet des montagnes et mesme dans les rochers : ie fus fort aise de voir vne faute si lourde pour auoir occasion de contredire vn homme tant estimé : d'autre costé i'estois fasché de ce que les liures des autres philosophes n'estoyent traduits en François, comme cestuy là, pour voir si d'auenture i'eusse peu contredire comme ie contredis à Cardan sur le fait des coquilles lapifiées (1).

THEORIQUE.

Et comment? voudrois tu contredire à vn tel sçavant personnage, toy qui n'es rien? Nous sçauons que Cardan est vn medecin fameux, lequel a regenté à Tolette, et qui a composé plusieurs liures en langue Latine : et toy qui n'as que la langue de ta mere, en quoy est ce que tu le voudrois contredire?

PRACTIQUE.

En ce qu'il a dit que les coquilles petrifiées qui estoyent esparses par l'vniuers, estoyent venues de la mer és iours du deluge, lors que les eaux surmonterent les plus hautes montagnes, et comme les eaux couuroyent toute la terre, les poissons de la mer se dilatoyent par tout l'vniuers, et que la mer estant retiree en ses limites, elle laissa les poissons : et les poissons portans coquilles se sont reduits en pierre sans changer de forme. Voila la sentence et l'opinion de monsieur Cardan.

THEORIQUE.

Pour certain voila vne fort belle raison, et ie ne sçauroi croire que la verité ne soit telle.

PRACTIQUE.

Si est ce que tu n'as garde de me faire croire vne telle bauasse. Car il est certain que toutes especes d'ames ont quelque connoissance du courroux de Dieu et des mouuements des astres, foudres et tempestes : et cela se voit tous les iours és

(1) Faujas de Saint-Fond remarque que Jérôme Cardan mourait à Rome la même année où Palissy refutait ses opinions par des démonstrations publiques, à Paris (1575). Des biographes ont prétendu que Cardan s'était laissé mourir de faim pour accomplir ce qu'il avait prédit, qu'il ne passerait pas l'âge de 75 ans.

parties maritimes. Il y a plusieurs especes de volailles qui auparauant les tempestes adueneus en la mer se retirent és riuieres douces en attendant que les tourmentes soyent pacifiées, et apres s'en retournent en la mer comme auparauant. Entre lesquels oyseaux il y en a vn genre qui sont blancs et grands comme pigeons, que l'on appelle goilants (goëlands), qui au temps de tempestes se sçauent retirer és eaux douces. L'on voit communement les porcilles, qui est vn grand poisson, venir és costes de la mer auparauant la tempeste, qui est vn signe qui donne à connoistre aux habitans du pays que la tempeste est prochaine. Et quant est du poisson portant coquille, au temps de la tourmente ils s'attachent contre les rochers en telle sorte que les vagues ne les sçauroyent arracher, et plusieurs autres poissons se cachent au fond de la mer, auquel lieu les vents n'ont aucune puissance d'esbranler ny l'eau ny le poisson. Voila vne preuue suffisante pour nier que les poissons de la mer se soyent espandus par la terre és iours du Deluge. Si Cardanus eust regardé le liure de Genese il eust parlé autrement : car là, Moyse rend tesmoignage qu'és iours du Deluge, les abymes et ventailles du ciel furent ouuertes, et pleut l'espace de quarante iours, lesquelles pluyes et abymes amenerent les eaux sus la terre, et non pas le desbordement de la mer.

THEORIQUE.

Mais d'où voudrois tu donc dire la cause de ces coquilles dedans les pierres, si ce n'est par le moyen que Cardanus a escrit ?

PRACTIQUE.

Si tu auois bien consideré le grand nombre de coquilles petrifiées, qui se trouuent en la terre, tu connoistrois que la terre ne produit gueres moins de poissons portans coquilles, que la mer : comprenant en icelle les riuieres, fontaines et ruisseaux. L'on voit aux estangs et ruisseaux plusieurs especes de moules et autres poissons portants coquilles, que quand lesdites coquilles sont ietées en terre, si en icelle il y a quelque semence salsitiue elles se viendront à petrifier.

THEORIQUE.

Ie ne croiray iamais qu'en la terre se trouue presque autant de poissons portans coquilles que dans la mer, et l'on sçait bien qu'il n'y a endroit en la mer qui n'en soit tout rem-

ply, et que dans la terre ou és riuieres il n'y en peut auoir qu'en certains lieux bien rarement.

PRACTIQUE.

Tu t'abuses de penser que par toutes les parties de la mer, il y ait des poissons portans coquilles : car tout ainsi que la terre produit des plantes qui ne sçauroient venir en vn pays comme en l'autre, ainsi que les orangers, figuiers, palmiers, amandiers, et grenadiers, ne peuuent venir en tous pays : aussi en la mer, il y a certaines contrées où l'on pesche des maquereaux, autres contrées où l'on peche des harans, autres contrées des seiches, autres des maigres, et mesmes nous sommes contrains aller querir des moluës (morues) és terres neuues. Tous poissons portants coquilles se tiennent pres des limites de la terre, et viennent en partie des matieres salsitiues, qui sont amenées des bords de la terre prochaine de la mer. Et encores ne faut penser trouuer desdits poissons par tous les endroits des bordures de la mer. Il faut donc conclure qu'il y a quelques endroits où les semences des poissons peuuent prendre nourriture, et autres non. Tout ainsi comme des vegetatifs. Ie n'entends pas dire qu'il y a à present aussi grand nombre de poissons armez en la terre comme il y eut autre fois. Car pour le certain les bestes et poissons qui sont bons à manger, les hommes les poursuyuent de si pres qu'en fin ils en font perdre la semence. I'ay veu plusieurs ruisseaux où l'on prenoit grand nombre de lamproyons, qu'à present l'on n'y en trouue plus. I'ay veu aussi autres ruisseaux où l'on prenoit des escreuisses par milliers, là où l'on n'en trouue plus. I'ay veu des rivieres où l'on prenoit du saumon, et à present ne s'y en trouue plus. Et que la terre ou riuieres d'icelle ne produisent aussi bien des poissons armez comme la mer, ie le prouue par des coquilles petrifiées, lesquelles on trouue en plusieurs endroits par milliers et millions, desquelles i'ay vn grand nombre qui sont petrifiées, dont la semence en est perdue, pour les auoir trop poursuyuis. Et est vne chose qui se void tous les iours, que les hommes mangent des viandes desquelles anciennement l'on n'en eust mangé pour rien du monde. Et de mon temps i'ay veu qu'il se fut trouué bien peu d'hommes qui eussent voulu manger ny tortues ny grenouilles, et à present ils mangent toutes choses qu'ils n'auoyent accoustumé de manger. I'ay veu aussi

de mon temps qu'ils n'eussent voulu manger les pieds, la teste, ny le ventre d'un mouton, et à present c'est ce qu'ils estiment le meilleur. Parquoy ie maintiens que les poissons armez, et lesquels sont petrifiez en plusieurs carrieres, ont esté engendrez sur lo lieu mesme, pendant que les rochers n'estoyent que de l'eau et de la vase, lesquels depuis ont esté petrifiez auec lesdits poissons, comme tu entendras plus amplement cy apres, en parlant des rochers des Ardennes (1).

THEORIQUE.

Par ce propos tu n'as rien fait contre l'opinion de Cardan : car tu n'as pas dit la cause de la petrification des coquilles.

PRACTIQUE.

Aucunes ont esté iettées en la terre, apres auoir mangé le poisson, et estant en terre, par leur vertu salsitiue ont fait atraction d'vn sel generatif, qui estant ioinct auec celuy de la coquille en quelque lieu aqueux ou humide, l'affinité desdites matieres estants iointes à ce corps mixte ont endurcy et petrifié la masse principalle. Voila la raison, et ne faut pas que tu en cherches d'autres. Et quant est des pierres où il y a plusieurs especes de coquilles, ou bien qu'en vne mesme pierre il y en a grande quantité, d'vn mesme genre, comme celles du fauxbourg sainct Marceau lés Paris, elles là sont formées en la maniere qui s'ensuit, sçauoir est, qu'il y auoit quelque grand receptacle d'eau, auquel estoit vn nombre infini de poissons armez de coquilles, faites en limace piramidale (2). Et lesdits poissons ont esté engendrez dans les eaux dudit receptacle, par vne lente chaleur, soit qu'elle soit prouenue par le soleil au descouuert, ou bien par vne lente chaleur qui se trouue soubs la terre, comme i'ay apperceu estant dans lesdites carrieres. Ie mets ceste difficulté en auant, par ce qu'il y a vne veine de pierre esdites carrieres, laquelle n'est que cinq ou six pieds de profond au dessous de la terre, laquelle veine contient autant que toutes les terres de ceste contrée là, et icelle n'a gueres qu'vn pied et demy d'espoisseur, mais elle

(1) C'est là l'opinion contre laquelle on s'éleva avec tant de légèreté au dix-septième et au dix-huitième siècle; mais que la science a fini par adopter, comme la plus rationnelle et la mieux fondée. Cuvier va jusqu'à regarder ce seul résultat des recherches et des vues ingénieuses de Palissy, comme le premier fondement de la géologie moderne.

(2) Ce sont des bélemnites ou pierres de Lynx.

a grande estendue. La cause que ie pense estre la plus certaine est, qu'il y a eu autrefois quelque grand lac, auquel lesdits poissons estoyent en aussi grand nombre que l'on y trouue leurs coquilles : Et parce que ledit lac estoit remply de quelque semence salsitiue et generatiue, iceluy depuis s'est congelé, à sçauoir l'eau, la terre et les poissons. Tu l'entendras mieux cy apres quand ie te parleray des pierres des deserts des Ardennes. Et voila pourquoy l'on trouue communement és rochers de la mer, de toutes especes de poissons portans coquilles. Il s'ensuit donc que apres que l'eau a deffailly ausdits poissons, et que la terre et vase où ils habitoyent s'est petrifiée par la mesme vertu generatiue des poissons, il se trouue autant de coquilles petrifiees dedans la pierre qui a esté congelee desdits vases, comme il y auoit de poissons en icelle, et la vase et les coquilles ont changé de nature, par vne mesme vertu, et par vne mesme cause efficiente. I'ay prouué ce poinct deuant mes auditeurs, en leur faisant monstre d'vne grande pierre que i'auois fait couper à vn rocher pres de Soubize, ville limitrophe de la mer : Lequel rocher auoit esté autrefois couuert de l'eau de la mer, et au parauant qu'il fut reduit en pierre, il y auoit vn grand nombre de plusieurs especes de poissons armez, lesquels estants morts dedans la vase, apres que la mer a esté retiree de ceste partie là, la vase et les poissons se sont petrifiez. La chose est certaine que la mer s'est retirée de ceste partie là, comme i'ay verifié, du temps qu'il y auoit sedition au pays de Xaintonge, lors qu'on y vouloit eriger la gabelle. Car en ces iours là ie fus commis pour figurer le pays des marez sallans ; et estant en l'isle de Brouë, laquelle fait vne pointe vers le costé de la mer, où il y a encores vne tour ruinee, les habitans du pays m'ont attesté que autrefois ils auoient veu le canal du haure de Brouage venir iusques au pied de ladite tour, et que l'on auoit edifié ladite tour, pour garder d'entrer les pirattes et brigands de mer, qui en temps de guerre venoyent bien souuent rafraichir leurs eaux à vne fontaine qui estoit pres de ladite tour, et ladite tour s'appelle la tour de Brouë à cause de l'isle où elle est assise, laquelle se nomme Brouë, dont le haure de Brouage a pris son nom. Et pour autant qu'il est auiourd'huy impossible d'aller le long du canal pour aprocher de ladite tour, l'on connoist par là que la mer s'est retirée de celle

contree, et qu'elle peut auoir autant gaigné en vn autre endroit : comme ainsi soit, que pres la coste d'Aluert, gueres loing du passage de Maumusson, qui est si fort dangereux, les habitans du pays disent auoir passé autrefois de liesse d'Aluert en l'isle d'Oleron, en ayant mis seulement vne teste de cheual ou de bœuf à vn petit fossé, ou autrement petit bras de mer, qui se ioignoit des deux bouts à la grand mer. Et aujourd'huy les nauires de quelque grandeur qu'elles soyent, passent par là pour le plus court chemin de Bordeaux à la Rochelle, ou en Bretaigne, en Flandres et en Angleterre : et au parauant il falloit tourner alentour de l'isle d'Oleron. Voila vn tesmoignage comment la mer se diminuant d'vne part, accroist d'autre part. Dont i'ay pris tesmoignage que le rocher qui est tout plein de diuerses especes de coquilles a esté autrefois vases marins, produisans poissons. Si aucuns ne le veulent croire, ie leur monstreray ladite pierre, pour couper broche à toutes disputes. Et par ce qu'il se trouue aussi des pierres remplies de coquilles, iusques au sommet des plus hautes montagnes, il ne faut que tu penses que lesdites coquilles soyent formees, comme aucuns disent que nature se iouë à faire quelque chose de nouueau. Quand i'ay eu de bien pres regardé aux formes des pierres, i'ay trouué que nulle d'icelles ne peut prendre forme de coquille ny d'autre animal, si l'animal mesme n'a basti sa forme : parquoy te faut croire qu'il y a eu iusques au plus haut des montaignes des poissons armez et autres, qui se sont engendrez dedans certains cassars ou receptacles d'eau, laquelle eau meslee de terre et d'vn sel congelatif et generatif, le tout s'est reduit en pierre auec l'armure du poisson, laquelle est demeuree en sa forme. Et ne faut pas que tu m'allegues qu'il faudroit donc que l'eau des pluyes eust auec soy quelque substance salsitiue et generatiue, et ne faut point que tu doutes de ce : car si autrement estoit, les crapaux et grenouilles, qui tombent bien souuent auec les pluyes ne pourroient estre engendrez en l'air; d'autre part tu vois souuent des murailles bien hautes, où il y aura des arbrisseaux et herbages, qui n'auront esté produits ny engendrez sinon des semences et humeurs apportees par les pluyes, et si les pluyes n'apportent auec elles quelque substance generatiue, elles ne pourroient aider à l'accroissement des semences, et mesmes les fruits arrousez d'vne eau qui ne fut point salee,

viendroyent soudain en pourriture. C'est la raison, pourquoy ie t'ay dit que le sel est la tenue et mastiq generatif et conseruatif de toutes choses : ie n'ay pas pourtant dit que tous sels fussent poignans et mordicatifs : tu trouueras que toutes coquilles petrifiees sont plus dures que non pas la masse de la pierre où elles sont, et ce pour cause qu'il y a plus de matiere salsitiue. Or combien que par cy deuant i'aye assez desconfit l'opinion de Cardan, sur le fait des pierres monstreuses, si est ce que ie suis deliberé de donner plus amples preuues de mon opinion contraire à la sienne, et ce d'autant qu'il y a bien peu d'hommes qui ne disent auec luy que les coquilles des poissons petrifiez, tant és montagnes qu'és vallees, sont du temps du Deluge, pour à quoy resister et prouuer le contraire ; i'ay fait plusieurs figures de coquilles petrifiées, qui se trouuent par milliers és montagnes des Ardennes, et non seulement des coquilles, ains aussi des poissons, qui ont esté petrifiez auec leurs coquilles. Et pour mieux faire entendre que la mer n'a point amené lesdittes coquilles au temps du Deluge, ie te monstreray presentement la figure d'vn rocher qui est esdites Ardennes, près la ville de Sedan ; auquel rocher et en plusieurs autres, il se trouue des coquilles de toutes les especes figurées en ce papier : depuis le sommet de la montagne iusques au pied d'icelle, combien que ladite montagne soit plus haute que nulle des maisons ny mesme le clocher dudit Sedan, et les habitans dudit lieu coupent iournellement de la pierre de ladite montagne, pour bastir, et en ce faisant il se trouue desdites coquilles aussi bien au plus bas comme au plus haut, voire encloses dedans les pierres les plus contiguës ; ie puis asseurer en auoir veu d'vn genre qui contenoit seize poulces de diametre. Ie demande maintenant à celuy qui tient l'opinion dudit Cardanus, par quelle porte entra la mer pour apporter lesdites coquilles au dedans des rochers les plus contigus ? Ie t'ay cy dessus donné à entendre que lesdits poissons ont esté engendrez au lieu mesme où ils ont changé de nature, tenans la mesme forme qu'ils auoyent estans viuans. Parquoy ie repeteray le mesme propos, disant que dedans les rochers susdits se trouuent plusieurs fosses, concauitez, et receptacles d'eau, qui entrent par les fentes desdits rochers, descendant du haut en bas, et en descendant l'on connoist euidemment qu'elles se petrifient en la forme de

eaux glacées, qui coulent du haut des montagnes en bas. Il faut donc conclure que auparauant que cesdites coquilles fussent petrifiées, les poissons qui les ont formées estoyent viuans dedans l'eau qui reposoit dans les receptacles desdites montagnes, et que depuis l'eau et les poissons se sont petrifiez en vn mesme temps, et de ce ne faut douter. Es montagnes desdites Ardennes se trouue par milliers des moules petrifiées, toutes semblables à celles qui sont viuantes dans la riuiere de Meuse, qui passe pres desdites montagnes. I'ay contemplé autrefois les habitations des huistres de la mer Oceane : mais ie ne vis onques les huistres naturelles ne leurs coquilles en plus grande quantité qu'il s'en trouue en plusieurs des rochers d'Ardenne : lesquelles combien qu'elles soyent petrifiées, si est-ce qu'elles ont esté animées, et cela nous doit faire croire qu'en plusieurs contrées de la terre les eaux sont salées, non si fort comme celles de la mer : mais elles le sont assez pour produire de toutes espèces de poissons armez. Et faut croire ce que i'ay dit cy deuant, que tout ainsi comme la terre produit des arbres et des plantes, d'vne espece en vne contrée, et en l'autre contrée elle en produit d'vne autre espece : et comme aucuns champs produisent de la feuchere, et autres des yebles, et autres chardons et espines : aussi la mer produit des genres de poissons en vn endroit qui ne pourroyent viure en l'autre. Il est certain que les huistres, les moules, auaillons, petoncles et sourdons et toutes especes de burgaulx, qui ont leurs coquilles en façon de limace, toutes ces especes, dy-ie, se tiennent és rochers limitrophes de la mer, ce que les autres especes de poissons ne font pas. Ceux qui vont pescher les moules à trois ou quatre cents lieuës me seront tesmoings de ce que i'ay dit. Et comme les orangers, figuiers, oliuiers et espiceries ne pourroyent viure és pays froids, en cas pareil les poissons ne viuent sinon és lieux là où il a pleu à Dieu de ietter la semence de leur generation et nourriture, comme ainsi soit que i'ay dit cy deuant qu'il a fait des semences des metaux et de tous mineraux, et des vegetatifs. Iusques icy ie n'ay parlé que des coquilles petrifiées, et ainsi que ie cherchois et m'enquerois de toutes parts des lieux où i'en pourrois recouurer pour le tesmoignage de mes conclusions, il me fut dit qu'au pays de Valois, pres d'vn lieu nommé Venteul, il

y auoit grande quantité de coquilles petrifiées, qui me causa me transporter sur ledit lieu, pres d'un hermitage ioignant la montaigne dudit lieu, auquel ie trouuay grand nombre de diuerses especes de coquilles de poissons semblables à celles de la mer Oceane et autres. Car parmi icelles coquilles s'en treuue de pourpres et de bucines de diuerses grandeurs, bien souuent d'aussi longues que les iambes d'un homme, lesquelles coquilles n'ont point esté petrifiées, ains sont encores telles comme elles estoyent quand le poisson estoit dedans; qui te doit faire croire qu'il y a autrefois eu des eaux en ce lieu là, qui produisoyent les poissons qui ont formé les dites coquilles: mais d'autant qu'il y a eu faute d'eau commune et d'eau generatiue, la montagne ne s'est peu lapifier, ains est demeurée en sable, et si ladite montagne se fut petrifiée comme celle des Ardennes et plusieurs autres, lesdites coquilles se fussent aussi petrifiées, et en quelque endroit que la roche eust esté coupée, icelles se fussent trouuées incastrées au dedans d'icelle roche, en pareille forme que tu voids celles des carrieres de sainct Marceau lés Paris. Depuis auoir veu ladite montagne i'ay treuué vne autre montagne, pres la ville de Soissons, où il y a par milliers de diuerses especes de coquilles petrifiées, si pres à pres l'vne de l'autre que l'on ne sçauroit rompre le roc d'icelle montagne en nul endroit, que l'on ne trouue grande quantité desdites coquilles, lesquelles nous rendent tesmoignage que elles ne sont venuës de la mer, ains ont generé sur le lieu, et ont esté petrifiées en mesme temps que la terre et les eaux où elles habitoient furent aussi petrifiées. Quelque temps après que i'eus recouuert plusieurs coquilles et poissons petrifiez, ie fus d'auis de reduire ou mettre en pourtraiture ceux que i'auois trouué lapifiez, pour les distinguer d'auec les vulgaires, desquels l'vsage est à present commun: mais à cause que le temps ne m'a voulu permettre mettre en execution mon dessein lors que i'estois en telle deliberation, ayant differé quelques années le dessein susdit, et ayant tousiours cherché en mon pouuoir de plus en plus les choses petrifiées, enfin i'ay trouué plus d'especes de poissons ou coquilles d'iceux, petrifiées en la terre, que non pas des genres modernes, qui habitent en la mer Oceane. Et combien que i'aye trouué des coquilles petrifiées d'huistres, sourdons, auaillons, iables, moucles, d'alles, couteleux, petoncles, cha-

taignes de mer, escreuices, burgaulx, et de toutes especes de limaces, qui habitent en ladite mer Oceane, si est-ce que i'en ay trouué en plusieurs lieux, tant és terres douces de Xaintonge que des Ardennes, et au pays de Champagne d'aucunes especes, desquelles le genre est hors de nostre connoissance, et ne s'en trouue point qui ne soyent lapifiées : parquoy i'ay osé dire à mes disciples que Monsieur Belon et Rondelet auoyent pris peine à descrire et figurer les poissons qu'ils auoyent trouuez en faisant leur voyage de Venise, et que ie trouuois estrange qu'ils ne s'estoyent estudiez à connoistre les poissons qui ont autrefois habité et generé abondamment en des regions, desquels les pierres où ils ont esté petrifiez en mesme temps qu'elles ont esté congelées, nous seruent à present de registre ou original des formes desdits poissons. Il s'en treuue en la Champagne et aux Ardennes de semblables à quelque espece d'aucuns genres de pourpres, de buccines, et autres grandes limaces, desquels genres ne s'en trouue point en la mer Oceane, et n'en void on sinon par le moyen des Nautonniers, qui en apportent bien souvent des Indes et de la Guinee. Voila pourquoy i'ay conneu qu'en plusieurs et diuers endroits des terres douces il y a eu autrefois habitation et generation desdits poissons, et ce d'autant, comme i'ay dit, qu'il s'en trouue aucuns qui ne sont encores petrifiez, parce qu'ils ne le peuuent auoir esté à cause que la terre où ils viuoyent est encores terre, ou pour mieux dire sable. Mais les autres qui se trouuent dedans les pierres des montagnes se sont petrifiez lors que le lieu où ils habitoyent s'est conglacé, sçauoir est, l'eau et la vase, et tout ce qui y estoit, comme ie t'ay dict tant de fois, pour te le mieux faire entendre. Tu verras en mon cabinet, que i'ay dressé pour cela, plusieurs formes desdits poissons, de ceux qui sont armez : par ce qu'il s'en trouue bien peu d'autres de petrifiez : à cause que les parties plus tendres se putrifient au parauant estre petrifiez : et qu'ainsi ne soit i'ay trouué plusieurs escailles ou armures de locustes et escreuices petrifiées, qui estoyent separées l'vne d'auec l'autre, pour cause de la putrefaction qui estoit suruenue en la chair, auparauant la petrification : toutesfois i'ay trouué aux montagnes des Ardennes de ces grands moules, qui habitent communement es estangs, que le poisson estoit aussi bien petrifié comme la coquille.

Et par ce que nous sommes sur le propos des pierres, il faut poursuyure premierement les formes d'icelles, et en cherchant la cause i'ay trouué que le cristal prend sa forme dedans l'eau, et que autrement il n'y auroit aucunes formes de pointes ny faces, comme l'on void qu'il se trouue audit cristal. Ie trouue aussi que toutes marcassites et mineraux ayant quelque forme pentagone, triangulaire, quadrangulaire, ou hexagone, sont toutes formees au dedans de l'eau, comme i'ay dit cy dessus, qu'il se trouue des pierres de mine de fer formées à pointes. Au dedans des carrieres où l'on tire l'ardoise aux pays d'Ardennes, il se trouue dedans l'eau, parmy les ardoises, vne grande quantité de marcassites quarrées naturellement, formées à quatre quarres, ou faces polies et egales en grandeur, et lesdites marcassites sont de couleur de fer ou de plomb, assez uisantes. I'en ay veu des autres qui ont sept ou huit faces formées naturellement comme les susdites. Il y a vn certain personnage qui m'a asseuré qu'il s'en trouue au pays de Languedoc et de Prouence, que chacune desdites marcassites portoit en soy trente six faces diuisées par esgales parties. Or toutes ces formes ne se font ny ne se peuuent faire sinon dedans l'eau. Nous voyons aussi que le sel qui est congelé dedans l'eau, si on le laisse congeler sans le mouuoir, il prendra quelque forme pentagone ou quadrangulaire; comme i'ay dit du salpestre. Mais quand est des cailloux et autres pierres particulieres, qui n'ont aucune forme diuisée, elles prennent leur forme selon la forme du trou ou receptacle où ce matieres seront arrestées, et où elles se congelent : Et de ce genre de pierre et cailloux, il s'en forme tous les iours : car quand ce vient sur la fin de l'esté, que les herbes, pailles et foins, et autres herbages commencent à pourrir par les champs, les eaux des pluyes ramassent et font decouler le sel vegetatif, qui est esdites pailles et herbes, et en tous vegetatifs qui seront consumez és chaleurs, et estant ainsi dissoult et liquide en la terre, iceluy mesme cause la generation de nouuelles plantes et de pierres. Et ce genre de pierres se font communement selon la grandeur de la matiere, par fois grandes et par fois petites, et par fois aussi menues que le sable selon le peu de matiere qui se presentera. Quant est des grandes pierres contigues i'en ay assez parlé dés le commencement, il y a vne autre espece de pierres desquelles on fait des meules pour

aiguiser toutes especes de tranchans. Si tu regardes de bien pres, et consideres la rudesse de ces pierres, tu trouueras qu'elles estoyent premierement formées en sable, et apres que le sable a demeuré quelque temps en la terre, il est aduenu que par l'action des pluyes, ledit sable s'est embibé d'eaux et sels congelatifs, qui ont rassemblé et ioinct ensemble tous ces petits grains de sable en vne grande pierre, et d'autant que le sable est d'vne eau plus pure que non pas la seconde generation de la pierre, c'est la cause pourquoy il est plus dur que non pas la masse seconde, et de là vient que la dite masse estant plus tendre, se mine et gaste en aiguisant les ferremens : ainsi les grains de sable demeurent tousiours plus hauts, et les concauitez qui sont entre lesdits grains, causent vne aigreur et rudesse à la meule, d'où vient sa puissance et action d'aiguiser les outils. Et ce qui m'a donné connoissance de ces choses est qu'vn iour i'achetay vn plein muy de sablon d'Estampes, et en le tamissant ou sassant ie trouuois plusieurs pierres formées dudit sablon, en telle sorte attachées l'vne à l'autre par la liqueur seconde qui auoit masliqué ledit sable que l'on voyoit euidemment que lesdites pierres estoyent formées dudit sablon. Voila comment de degré en degré ie suis paruenu à la connoissance de ces choses. Il y a vn autre genre de pierres qui ne tiennent aucune forme, ains sont contigues comme les pierres des carrieres, et ce genre là ne peut estre engendré qu'il ne soit pour le moins aussi dur que marbre. Ce sont les pierres qui sont engendrées des terres argileuses lesquelles sont bien souuent reduittes en marbre, iaspe, et en cassidoine, et autres telles pierres dures. Mais parce que i'ay vouloir de traiter à part les duretez, pesanteurs et couleurs, ie garderay ce propos pour en traiter quand le temps se presentera, et poursuiuray à parler des formes, desquelles i'ay bonne connoissance.

Quant est du bois petrifié, il tient sa forme comme aparauant : il y a plusieurs especes de fruicts lesquels estans lapifiez tiennent la mesme forme qu'au parauant : i'ay perdu vne poire petrifiée autant bien formée qu'elle estoit deuant auoir changé sa substance. I'ay encores dans mon cabinet vne pomme de coing, vne figue, et vn naueau petrifiez, tenant la mesme forme qu'ils auoyent auant qu'estre lapifiez. Monsieur Race, Chirurgien fameux et excellent m'a monstré vn cancre tout entier pe-

trifié, il m'a aussi monstré vn poisson petrifié, et plusieurs plantes d'vne certaine herbe, aussi petrifiée. J'ay veu aussi plusieurs chastaignes marines petrifiées sans auoir rien perdu de leur forme. Il y a en la ville d'Angers vn maistre Orfeure, nommé Marc Thomaseau, lequel m'a monstré une fleur reduite en pierre chose fort admirable, d'autant que l'on voit en icelle le dessous et dessus des parties de la fleur les plus tenues et deliées. J'ay trouué vne miniere de terre argileuse en laquelle y a vn nombre infiny de pierres de marcassites metalliques de plusieurs grandeurs, les vnes grandes comme la palme de la main, les autres comme iocondales et testons, lesquelles m'ont instruit en la philosophie beaucoup plus que non pas Aristote : Et c'est d'autant que ie ne puis lire en Aristote et i'ay bien leu ausdites marcasites, et ay entendu par icelles que les matieres generatiues des metaux estoyent fluides, liquides et aqueuses, et cela ay-ie conneu en contemplant leurs formes : d'autant qu'elles sont formées en telle sorte que si quelqu'vn auoit ietté de la cire fondue en bas en assez bonne quantité, et comme la premiere seroit iettée en plus grande abondance que la seconde, et estant iettée tousiours en diminuant le premier ict, en se conglaçant feroit vne forme plus euasée que le second, et le second plus euasée que le tiers, et cela se feroit à cause de la diminution de la matiere. Car ie voyois euidemment dedans lesdites marcassites que les goutes qui tomboyent les dernieres monstroyent vn signe de defaillance de matiere : Cela ne se peut aisément entendre sans voir la chose mesme : parquoy tu la pourras venir voir en mon cabinet. Il y a beaucoup d'autres pierres qui sont formées selon le suiet qu'ils ont pris, comme quelques autres pierres que i'ay veuës que l'on nomme Pierre d'Aigle. Quelque chose que l'on en die, ie croy que ce n'est autre chose qu'vn fruit lapifié, et ce qui ioue dedans est le noyau, qui estant amoindry quand on secoue ladite pierre, ledit noyau frappe des deux costez d'icelle. Voila comment les pierres peuuent auoir diuerses formes par diuers suiets : lesquelles choses nous sont inconnues par faute d'y regarder. Plusieurs m'ont certifié qu'il y a vn lac à Rome nommé Thioli, duquel les eaux qui passent par les riuages d'iceluy s'attachent et congelent contre les herbages et autres choses pendantes sur les bords desdits riuages, j'ay veu plusieurs desdites pierres, qui

ont esté apportées du lac susdit, qui sont fort blanches et belles, à cause des pores et concauitez percées et spongieuses et embrouillees par diuerses formes, que les herbes leur ont causé. Ie feray fin au propos des formes, et parleray de la cause des couleurs.

Il y a un grand nombre de matieres qui causent les couleurs des pierres, et plusieurs d'icelles sont inconnues aux hommes : Toutefois l'experience, qui de tout temps est maistresse des ars, m'a fait connoistre que le fer, le plomb, l'argent et l'antimoine, ne peuuent faire autres couleurs que iaune. Ayant donc vne telle certitude ie puis asseurement dire, que plusieurs pierres iaunes ont pris leurs teintures de l'vn d'iceux mineraux : I'entens quand les eaux passent par des terres esquelles y a de la semence desdits mineraux, ayans apporté auec elles de laditte substance, laquelle aura actionné en la couleur et en la congelation; parce que toutes ces matieres metalliques sont salsitiues, et comme i'ay tant de fois dit, il ne se fait point de congelation sans sel; aussi laditte teinture à esté faite dés le temps de l'essence de la pierre, au parauant que les matières fussent endurcies. Ie comprens entre les pierres iaunes, les pierres rares aussi bien que les communes, comme la Topasse. Ie mets aussi au rang d'icelles le sablon, duquel il se trouue grande quantité de couleur iaune. Voilà l'vne des causes des pierres iaunes. Il y a vne autre cause bien fort certaine et veritable, que les bois qui sont pourriz en terre, ayans rendu par dissolution et putrefaction le sel qui estoit en eux, et que les eaux et les matieres congelatiues (par vne defluxion qui se fait és temps de pluyes, le sel dudit bois amenant auec soy sa teinture) causent la congelation et la couleur de quelque pierre, qui sera formée au premier receptacle, là où telle matiere fluide se viendra reposer : et de ce n'en faut douter, car ie sçay que le verre iaune, que l'on fait en Lorraine, pour les vitriers, n'est fait d'autre chose que d'vn bois pourry, qui est vn tesmoignage de ce que ie dy, que le bois peut teindre le bois en iaune ; si tu as regardé autrefois des ais, ou du plancher et autres pieces, et que le bois soit verd, et qu'ils soyent fraischement siez, s'ils vient à pleuuoir dessus, tu verras que l'eau qui degoute vers la partie pendante sera jaune. Il y a aussi plusieurs especes d'herbes et plantes qui peuuent teindre les matieres des-

quelles les pierres sont formées : entre les autres la paille d'auoine a auec soy vne teinture fort iaune. L'Absinthe Xaintonnique a sa teinture fort iaune : l'on sçait aussi que les teinturiers se servent d'vne herbe qu'ils appellent Gaude, de laquelle ils font leurs iaunes.

Ie ne connois ny plante, ny mineral, ny aucune matiere qui puisse teindre les pierres bleües ou azurées, que le saphre, qui est vne terre minerale, extraite de l'or, argent et cuiure, lequel a bien peu de couleur autre que grise, tirant vn peu sur le violet : toutesfois quand ledit saphre est fait vn corps auecques les matieres vitreuses, il fait vn azur merueilleusement beau : par là peut on connoistre que toutes pierres ayans couleur d'azur, ont pris leur teinture dudit saphre. Et afin que tu ayes asseurance certaine de ce que ie di, considere vn peu les pierres que l'on nomme lapis lazuli, lesquelles sont d'vne couleur d'azur, autant viue qu'il en est point au monde, et parmy lesdites pierres se treuuent plusieurs veines et petites estincelles d'or ; aussi se treuue en plusieurs endroits d'icelle du verd ressemblant au chrysocolla des anciens, que nous appelons auiourd'huy borras (borax). Ceux qui font auiourd'huy ledit borras le font blanc par quelque industrie qu'ils tiennent bien secrette. Le borras des anciens qu'ils nomment chrysocolla, estoit pris és canaux d'eau qui distiloit des minieres de cuiure et de saphre. Et d'autant que ie t'ay dit tant de fois qu'il y auoit du sel és metaux, et que leur congelation estoit faite par la vertu dudit sel, tu as à present à noter ce poinct sur tous les autres, qui est que le chrysocolla ou borras n'estoit autre chose qu'vn sel que les eaux auoyent pris en passant par les minieres d'airain : et les eaux douces des pluyes estant sorties et acheminees hors des minieres ayant attiré ledit sel, s'exaloyent, et s'estant exalees le fixe demeuroit, qui estoit le sel lequel se congeloit le long des canaux exterieurs, là où les eaux l'auoyent amené : estant ainsi congelé on s'en seruoit à souder l'or et l'argent et le cuiure. Or note donc que ce chrysocolla n'estoit verd sinon à l'occasion du sel coperose, qui auoit engendré la miniere de cuiure. Ce n'estoit pas mon propos de parler en cest endroit des couleurs verdes, ains de celles d'azur : mais d'autant que dedans le lapis lazuli, il se trouue du verd, ie ne pouuois eschaper que ie ne parlasse des deux ensemble. Par là tu peux connoistre

que le saphre se prend dedans les minieres d'or et de cuyure : Car s'il n'y auoit de l'or en la miniere dudit saphre, il ne se trouueroit pas dedans le lapis, et s'il n'y auoit du cuiure, il ne s'y trouueroit pas du verd. Voila comment les matieres sont colligées et comment de degré en degré les occasions se presentent de produire tousiours la vertu des sels.

Theorique.

Il me semble que ton propos est fort loing de vérité, et ce d'autant que tu dis que le saphre cause vne tant belle couleur au lapis, et toutesfois tu dis que ledit saphre n'a point la couleur viue ny belle : comment donques se pourroit faire cela ? le saphre pourroit il bien donner ce qu'il n'a point ?

Practique.

Pour certain ton argument est assez bien fondé : toutesfois ie suis bien certain que le verre d'azur se fait de saphre, et sçay bien aussi qu'auparauant qu'il soit fondu auec les matieres vitreuses il n'a point de couleur : Aussi ie sçay bien que l'herbe salicor luy baille sa viue couleur : combien qu'il n'aye nulle couleur, non plus que le sel commun, c'est à dire il le fait fondre ou liquefier auecques le caillou ou sable : et sçay bien aussi que les trois matieres ensemble font vn fort bel azur, ie di apres que les matieres sont liquefiées, et de rechef endurcies, et formées en telles formes des vaisseaux de verre qu'on les veut employer.

Theorique.

I'ay ici deux arguments à te proposer à l'encontre de ton dire, en premier lieu tu dis que le sel de salicor cause de faire deuenir le saphre en couleur d'azur, et puis tu dis que cela se fait à force de feu. Voila donc comment le lapis lazuli ne peut prendre sa couleur par ces deux moyens, d'autant qu'au lieu où ledit lapis est trouué il n'y a ny feu ny salicor.

Practique.

A ce ie respond, que le sel de vitriol fait en la terre, ce que le salicor fait au feu des verriers. Quant à la decoction ce n'est pas chose estrange de voir faire plusieurs decoctions en la matrice de la terre. Car elle se fait en toutes especes de pierres et metaux, et mesmes és terres argileuses, celles qui sont noires en vn temps deuiennent blanches en vn autre temps.

Theorique.

Et veux tu conclure par là qu'il n'y a aucune matiere qui puisse faire la couleur d'azur que le saphre ?

Practique.

Ie n'en connois point d'autre.

Theorique.

Tu n'y entends doncques rien : car on void bien que le lapis et le saphir sont de couleur d'azur bien viue, et toutesfois la Turquoise tire plus sur l'azur que nulle autre couleur : ce neantmoins il y a grande difference : car elle tient vn peu de la couleur verde : d'autre part le saphir a vn corps diafane, et la Turquoise et le lapis ont vn corps tenebreux. Ie prouue par là que ces couleurs differentes ne se peuuent trouuer en vn mesme suiet.

Practique.

Tu t'abuses : car la cause que le saphir est transparent et diafane, c'est parce qu'il a esté formé de matieres aqueuses, pures et nettes mais il n'est pas ainsi du lapis : Car auec les matieres d'iceluy, il y a de la terre entremeslée, laquelle luy rend sa couleur obscure. Aussi ledit lapis en est beaucoup plus foible, comme l'on peut voir qu'il y a plusieurs veines, à l'endroit desquelles il ne peut prendre si beau pollissement a l'vn endroit comme à l'autre : les petites veines d'or et les parties verdes qui y sont rendent tesmoignage que les matieres de son essence estoyent mal entremeslées. Quant est de la Turquoise, il faut prendre le mesme argument, sçauoir est qu'il y a de la terre qui luy rend son corps tenebreux, et ce qui luy cause vn peu de verdeur n'est autre chose que quelque substance de cuiure entre-meslée auec les autres matieres. Voila comment il faut tousiours donner l'honneur de toutes couleurs d'azur au saphre, comme principal fondement, les pierres qui tiennent de couleur de pourpre sont de semblables matieres, sauf qu'il y a quelque espece de matiere rouge, qui fait tourner l'azur en couleur purpurée.

Theorique.

Tu dis ne connoistre aucune matiere qui puisse faire l'azur que le saphre, et toutesfois il y a quelques vns qui en font auec du cuiure.

Practique.

Ce n'est pas selon nature s'ils le font, c'est par accident.

DES PIERRES.

Théorique.

Et comment pourrois tu soustenir qu'il n'y aye que le saphre qui puisse faire l'azur, attendu que nous voyons tant de milliers de fleurs bleuës, et entre les autres la flambe (l'iris), de laquelle on fait de la couleur bleuë ?

Practique.

Tu responds mal a propos : car ie te parle des couleurs des pierres, et tu me responds des couleurs des peintres. Il a bien à dire des couleurs mineralles aux couleurs qui se font d'herbes : Car toutes celles qui se font d'herbes sont de peu de durée, comme le saphran, le verd de vessie, le tournesol, et autres telles couleurs. Mais celles des pierres qui viennent des minieres, ou qui sont faites des metaux calcinez ne peuuent perdre leur couleur.

Theorique.

Quelque beau argumenteur que tu sois, si est ce que tu t'es pris à ce coup, en telle sorte que tu ne te sçaurois iustifier : d'autant que par cy deuant tu m'as dit que les pierres iaunes pouuoyent prendre leur teinture des bois pourris et de diuerses especes d'herbes et à present tu dis tout le contraire.

Practique.

Ce que i'ay dit est bien dit, et ne suis pas prest de m'en desdire. Quand ie t'ay dit que les pierres pouuoyent estre teintes quelquefois de bois pourris et des herbes, ie ne t'ay pas dit que la pierre pouuoit estre teinte apres que les matieres sont endurcies : Mais bien t'ay-ie dit que lors que les matieres sont liquides et fluentes qu'elles peuuent estre teintes de quelque bois ou espece d'herbes, et les matieres apres estants endurcies peuuent retenir lesdites couleurs : et la cause pourquoy elles ne peuuent perdre leur couleur, comme celles des peintres, c'est parce qu'elles sont encloses en la masse, et d'autant que l'aër ny le vent ne peuuent penetrer ladite masse, les couleurs y sont conseruées. Si tu interroges les peintres sur le fait des couleurs qui sont faites d'herbes, ils te diront qu'elles sont suiectes à s'esuenter ; et pour mieux entendre ce fait, considere vn doublet, tu trouueras aucuns lapidaires qui feront de fort belle couleur de ruby et de grenad, de quelque sang de dragon ou autre matiere, et ayant taillé deux pieces de cristal ils en teindront vne de ceste couleur rouge, et puis mastiqueront l'autre dessus icelle, et ainsi ce rouge sera con-

serué en sa beauté entre les deux pierres : autrement il ne pourroit garder sa couleur. En pareille sorte les pierres naturelles gardent leurs couleurs encloses en icelles. J'ay encores à te proposer deux arguments sur ce fait, l'vn est quand ie t'ay dit que les couleurs des pierres se peuuent prendre quelquefois des bois et des plantes, ie ne t'ay pas parlé des fleurs, car les couleurs des fleurs sont de peu de durée, comme l'on voit que les roses, les œillets et autres fleurs perdent leurs couleurs en vn instant ; Mais il n'est pas ainsi des couleurs qui procedent des bois pourris : Car ie t'ay dit cy dessus que le bois pourry sert à faire du verre iaune. C'est autant que si ie disois que la teinture du bois s'est fixée en sa putrefaction et ne se peut perdre pour ceste cause, à l'extreme chaleur du fourneau, chose admirable. Semblablement il y peut auoir plusieurs simples, desquels la teinture se peut fixer. Or voicy à present le second argument qui est fort notable. Si tu me mets en auant que les teintures des vegetatifs ne peuuent estre fixes, ie t'allegueray ce que dessus, que le bois pourry fait le verre iaune. Et partant que tu ne te veuilles contenter d'vne telle preuue, ie te diray qu'entre toutes les pierres de couleur, il s'en trouuera bien peu desquelles la teinture soit fixe. I'ay fait calciner plusieurs fois du marbre noir, des cailloux, et pierres noires, et autres de diuerses couleurs, comme iaspe, cassidoine, et marbre figurez : Mais ie n'en trouuay iamais que les couleurs ne se perdissent au feu : et combien que l'agate et cassidoine ne se peuuent calciner, ains se vitrifient, si est ce qu'estans examinées par le feu, elles perdent toutes leurs couleurs : parquoy il ne faut plus douter que les vegetatifs ne puissent donner quelque couleur en la matiere des pierres, au parauant qu'elles soyent endurcies, comme i'ay dit vne autrefois. Quant est des emeraudes, il ne faut point douter que les couleurs d'icelles ne soyent causées de la coperoze, c'est à dire de quelque eau pure, qui a passé par les minieres du cuiure et de coperoze. Quant est des pierres noires, leur teinture peut estre causée par diuers moyens et de plusieurs sortes. Nous auons plusieurs arbres desquels la teinture est noire, aussi bien comme des noix de galle, entre autres les noires, les aulnes ou vergnes apportent teinture noire ; estant pourris en terre leur teinture peut estre retenue pour seruir quelquefois à la generation des pierres :

pour le moins la terre là où ils pourriront en sera teinte de noir. I'ay aussi plusieurs fois contemplé que les pierres sont bien souuent de la couleur de la terre où elles ont esté engendrées, et celles qui sont dedans les sables sont aussi bien souuent de la couleur des sables où elles sont trouuées : Toutesfois il se trouue bien souuent des pierres blanches dedans les terres noires, et cela vient à cause que les matieres d'où elles ont esté formées, ont changé de couleur en leur decoction, ce qui aduient bien souuent à plusieurs mineraux, et generalement à tous les fruits de la terre, lesquels ont autre couleur à leur maturité que non pas à leur commencement. Quant est des couleurs des marbres figurez, iaspes, porphyres, serpentins, et autres telles especes, leurs couleurs sont causées par diuers egousts d'eau qui tombent du haut de la terre, iusques au lieu où lesdites pierres se forment : les eaux venant de plusieurs et diuers endroits de la terre, en descendant elles apportent auec elles ces diuerses couleurs, qui sont esdittes pierres. Car ainsi qu'une partie de l'eau, en passant, trouuera quelque miniere d'airain ou de copperoze, elle fera des taches verdes sus la pierre, tombant goutte à goutte sus icelle. Autres gouttes tomberont à mesme instant qui passeront par quelques minieres de fer, et tombans (comme i'ay dit) sur le receptacle où laditte pierre se formera, lesdittes gouttes se congeleront en iaune. Autres gouttes porteront autres couleurs diuerses, qui causeront plusieurs figures ausdites pierres.

THEORIQUE.

Si ainsi estoit comme tu dis, les figures seroyent toutes rondes, comme le porphyre : mais quoy, nous voyons aux iaspes, marbres, et pierres mixtes, des figures faites par idees estranges : cela monstre bien qu'elles ne se font pas par vne eau desgouttante, comme tu dis.

PRACTIQUE.

Si tu eusses esté à mes leçons, tu eusses bien conneu que ce que ie te dy est vray : car il y auoit plusieurs hommes vn peu plus sçauans que toy, ce neantmoins ie leur fis connoistre que la verité est telle que ie te dy, et n'y eust iamais homme qui me sçeut contredire. Vray est que pour leur faire entendre mon dire i'en fis vne figure en leur presence. Il est vray que si les gouttes qui tombent du haut en bas se congeloyent

soudain qu'elles sont tombées, elles ne seroyent autre figure que ronde, selon la grosseur de la goutte qui tomberoit : mais d'autant que la matiere qui se conglaçant fait quelques bosses, les matieres qui tombent de plusieurs endroits tout en vn coup, trouuant la place bossuë, sont contraints de se couler en la vallée : et ainsi que trois ou quatre pisseures d'eau diuerses en couleurs, tomberont sur vne bosse ou petite montagne, elles seront contraintes se couler en bas, et en coulant feront chascune d'elles vne veine de la couleur qu'elles apporteront : et outre cela ainsi qu'elles descendront de vitesse, par la violence de leurs descentes, elles s'entremesleront en tournoyant comme deux riuieres, qui se rencontrent, auec ce qu'vne autre descente, ou deux ou trois, se pourront faire tout à vn coup en ce mesme lieu, qui en se combattant ou contrepoussant l'vne l'autre, ne faudront à faire des figures confuses. Quant est du porphyre ou autres pierres qui ont les figures rondes, elles se peuuent faire à la cheute des eaux, comme les gouttes tombent, et en tombant il y a plusieurs petites gouttes qui se separent d'auec les grandes, comme l'on voit audit porphyre. I'ay veu aussi du porphyre qui auoit esté fait par vn autre moyen, qui est que quelque terre sableuse s'estoit congelée, et auec elle le sable qui y estoit, et quand on tailloit ledit porphyre les grains de sable qui estoyent plus blans seruoyent de moucheture. Pour connoistre comment le cassidoine et plusieurs especes de iaspes ont prins leurs couleurs, il faut chercher les terres argileuses, et l'on trouuera que plusieurs d'icelles ont les mesmes couleurs que le cassidoine. Il y en a aussi qui ont des figures semblables à l'agate. Ie laisseray le reste à dire lors que ie parleray d'icelles.

Theorique.

Tu m'as promis cy deuant de me dire la cause pourquoy les pierres sont plus dures les vnes que les autres, tu me ferois plaisir de m'en parler.

Practique.

C'est vn point bien aisé à prouuer : et pour ce faire ne t'enuoyeray sinon és carrieres de Paris, desquelles les pierres sont tendres dessus, enuiron de dix ou douze pieds de profondeur, et lesdites pierres tendres sont appelées moilons à cause qu'elles sont mal condensées : mais au dessouz dudit

moilon il se trouue de la pierre que l'on appelle liais, laquelle est tellement condensée que l'on en peut tirer des pierres de telle grandeur que l'on veut, et sont lesdites pierres fort dures, et en fait on communement des marches pour les escalliers, et aussi l'on en fait des couuertures sus les monuments. Ceste preuue te deuroit suffire : par ce que tu pourras contempler esdittes pierres que la cause pourquoy elles sont plus dures dessous que dessus, n'est autre sinon que les eaux, qui passent au trauers des terres, descendent en bas, et ayant trouué le bas foncé de quelque terre argileuse, au trauers de laquelle les eaux n'ont sçeu passer si promptement comme elles faisoyent en haut, elles ont este arrestées ; et quand le premier lict a esté congelé il a seruy de vaisseau pour retenir les autres eaux, qui descendoyent au trauers des terres, et par ce moyen lesdites pierres ont tousiours eu abondance d'eau, qui a causé qu'elles sont beaucoup plus dures que celles de dessus. Et te faut noter que celles de dessus ne sont tendres sinon par ce que les eaux n'y peuuent demeurer iusques à ce que la congelation soit paracheuée. Et ce defaillement d'eau est pour deux causes principalles, l'vne est celle que i'ay dit, que les eaux descendent tousiours et delaissent la partie haute, l'autre est que la terre est alterée en esté, par la vertu du soleil, et de là vient qu'elle ne peut produire les pierres en leur perfection : et telles pierres superieures se pourroient appeller marcassites, par ce que au dessus des minieres metalliques, et en plusieurs autres lieux, se treuue des metaux imparfaits, que l'on appelle marcassites, à cause de leur imperfection. Et tout ainsi comme les pierres congelées es parties les plus basses et plus aqueuses, sont plus parfaictes que les autres, aussi voit on que les metaux les plus parfaits se treuuent bien souuent dedans les eaux, lesquelles il faut pomper auec grand labeur. Il faut donc tenir pour chose certaine qu'il y a deux causes qui donnent la dureté aux pierres, l'une est abondance d'eau, l'autre est la longue decoction : car plusieurs pierres peuuent estre engendrées d'eau, qui toutesfois ne seront pas dures. Nous en auons vn fort bel exemple aux plastrieres de Montmartre, pres Paris, car parmy icelles il se treuue certaines veines d'vn plastre qu'ils appellent hif, ou miroirs, lequel se fend comme ardoise, aussi tenuë que feuilles de papier, et est aussi clair que verre. Il est comme vne es-

pece de talc ; sa diafanité ou transparence nous donne bien à connoistre que la plus grand part de son essence n'est autre chose que de l'eau : toutesfois il se calcine, et l'on en besongne tout ainsi que de l'autre plastre. Il faut donc conclure par là, que la trop hastiue congelation ne peut souffrir endurcir les pierres : Et cela peut on connoistre és lieux là où ledit plastre se treuue. Car c'est vn pays sableux, et les terres sont alterées, et en ce mesme endroit et ioignant lesdites plastrieres, il y a certains rochers desquels les pierres sont fort legeres, tendres et tenantes à la langue, comme du boliarmeny (bol d'Arménie), et lesdits rochers sont fort mal condensez. Voila comment ie prouue que les pierres ausquelles l'eau defaut trop tost, ne peuuent estre dures. Pour bien connoistre vne pierre qui a eu faute d'eau en sa formation : au pays de Bigorre ne se trouue point de pierres, ains sont tous cailloux durs : le pays est froid et fort pluuieux : et y a grande quantité de riuieres, à cause qu'il est fort prés des montagnes : Parquoy en la formation des pierres dudit pays il n'y peut auoir faute d'eau : aussi sont ils contrains de defaire leurs maçonneries de cailloux, qui ne se peuuent tailler, à cause de leur dureté. Aux Ardennes les terres sont fort sableuses, et leurs pierrieres ne sont d'autres matieres que d'icelles terres : Mais par ce que le pays est fort pluuieux, les pierres sont fort dures, aigres et mal plaisantes : tellement que ceux qui bastissent sont contrains aller querir de la pierre tendre en France, pour tailler leurs iambages de cheminées, croisées, corniches, frises et architraves : car ils ne pourroyent former leurs moulures de la pierre du pays. Les pierriers qui la tirent font tout au contraire de ceux de Paris, car ils ne prennent que le dessus, et quand ils ont osté la moins contiguë, et qu'ils commencent à trouuer celle que les Parisiens nomment liais, ils sont contrains la laisser, à cause qu'elle est trop dure. Les pierrieres dequoy ie parle sont formées d'vne sorte que l'on n'en voit gueres de semblables. Car apres que l'on a trouué vn lict de pierre de l'espesseur d'un pied et demi ou deux pieds, l'on trouue vn autre lict de sable, et toutes les pierres de ladite contrée sont ainsi faites, et le sable qui fait la separation entre les lits des pierres, est aussi dur et aussi bien condensé que la pierre blanche qu'ils vont querir en France, pour tailler leurs fenestrages : ce que ie trouue fort estrange, et ne puis croire autre chose sinon que ledit sa-

ble est commencé à petrifier. Dedans les forests desdites Ardennes il y a vn grand nombre de cailloux de plusieurs grosseurs et couleurs, lesquels se trouuent en plus grande quantité le long des ruisseaux qui passent par les vallées, par ce que les eaux des pluyes qui descendent des montagnes amenent le sel des bois pourris aux ruisseaux desdites vallées, qui est encores vne preuue que les pierres et cailloux ne peuuent estre dures sans qu'il y ait abondance d'eau. Et communement les plus dures se trouuent és pays froids et pluuieux, comme l'on voit par exemples aux monts Pyrenées, où il se trouue de beau marbre. Il s'en trouue aussi à Dynan qui est pays froid et pluuieux. Aux montagnes d'Auuergne il se trouue du cristal, et tout cela ne se fait que par abondance d'eau et de froidure. L'on sçait bien que à Fribourg en Briscot, le beau cristal se trouue és montagnes ausquelles il y a de la nege presque en tout temps : et suyuant ce que i'ay dit du pays de Bigorre, qu'il ne s'y trouue que des cailloux, parce que le pays est pluuieux et froid, l'on peut dire le semblable d'vne grande partie des contrées limitrophes des Ardennes, et principalement sur le chemin allant de Messieres à Anuers : chose plus merueilleuse que i'aye encore veuë. Car le long de la riuiere de Meuse au pays du Liege, ladite riuiere passe entre des montagnes lesquelles sont d'vne merueilleuse hauteur, elles sont formées la plus grande partie de matiere semblable aux cailloux blancs, et autre partie de gris, et afin que tu n'entendes que la montagne soit de diuers cailloux, ie dy qu'vne grande montagne ne sera qu'vn caillou. Et te dy encores qu'il y en a plusieurs qui ne produisent ny arbres ny plantes ; à cause de leur grande dureté elles sont inutiles : par ce que l'on ne les sçauroit couper pour s'en seruir en bastiments, et au dessous d'icelles bien auant souz terre, se trouue des carrieres d'ardoises : semblablement les maisons de Bigorre sont couuertes d'ardoises, comme celles des Ardennes : car elles se prennent communement és pays frais.

THEORIQUE.

Et dy moy ie te prie la cause des pesanteurs diuerses.

PRACTIQUE.

Un homme de bon iugement l'entendra assez par les causes que i'ay dit cy dessus, car la mesme chose qui cause la dureté, cause la pesanteur des pierres : parquoy tu peux co-

noistre que ce n'est autre chose que l'eau : car toutes pierres legeres, comme la craye, et certaines pierres blanches, ne sont legeres sinon à cause que l'eau leur a deffailli en leur formation, et a laissé lesdites pierres spongieuses et pleines de pores. Et qu'ainsi ne soit, prens vne pierre de craye et la mets tremper dans l'eau, apres l'auoir pesée, et estant trempée repèse la, tu trouueras par la pesanteur qu'elle est spongieuse, qui luy a causé boire beaucoup de ladite eau. Si tu mets tremper vn caillou ou quelque piece de cristal, tu trouueras qu'il ne boira pas l'eau comme la pierre legere, car il en a beu son saoul en sa congelation.

Theorique.

Ie te prie de me dire la cause de la fixation des pierres. Car i'en voy aucunes qui sont suiettes à se calciner, et estans calcinées sont plus legeres que elles n'estoient au parauant, et soudain que l'on y met l'eau elles se rendent en poussiere, et autres se blanchissent et candident et liquifient, se tenans tousiours en vne mesme masse.

Practique.

Il y a deux effets qui causent la fixation de plusieurs pierres, l'vn est l'abondance d'eau, et l'autre la longue decoction, et faut noter que toutes pierres qui se calcinent sont imparfaites en leur decoction. Voila en peu de paroles tout ce que ie te peux dire de la fixation des pierres. Il y a quelques contrées ou climats, là où la malice du temps et vents impetueux, gelées et froidures, causent quelque aigreur aux pierres et aux bois, comme nous voyons par les minieres de fer qui sont aux Ardennes és terres du Duc de Bouillon. Car tout ainsi que i'ay dit que les pierres dudit lieu sont aigres, rudes et mal plaisantes, semblablement le fer qui se fait és forges dudit pays est fort aigre, rude et frayable : et non seulement le fer se resent de l'air mal plaisant, mais aussi les bois qui sont és riues et limites des forests sont rudes, durs, suiets à gauchir, mal aisez à mettre en besogne. Aussi les vignes ne peuuent croistre audit pays, par ce qu'il y a bien peu d'esté. Les terres du Duc de Bouillon sont bien pourueuës de mine de fer, mais ladite mine a les grains fort menus, et la faut chercher bas en terre, qui est tousiours confirmation de ce que i'ay dit des metaux, qui ne se peuuent generer par feu. Tout ainsi qu'aucunes plantes et fruicts viennent en une contrée qui ne peu-

uent venir en vne autre, aussi en aucuns climats les pierres ne sont point semblables à celles d'vn autre climat : comme aussi ne sont les terres argileuses.

Theorique.

Tu m'as baillé beaucoup de raisons des formes, couleurs, duretez et pesanteurs des pierres, lesquelles choses m'estoient aisées à entendre, lors que tu en faisois la montre. Mais s'il me falloit à present instruire vn autre de ce que tu m'as monstré, ie serois fort empesché, n'ayant aucunes preuues, comme tu auois, lors que tu faisois les demonstrations : parquoy ie voudrois que tu m'eusses baillé en peu de paroles, quelque belle conclusion, comme tu as fait des metaux et de l'eau generatiue.

Practique.

S'il te souuient des points que ie t'ay enseignez, tu te rememoreras que pour la derniere conclusion de l'effet des pierres, ie prouuois deuant mes auditeurs que la matiere principale de toutes pierres n'estoit autre que l'eau congelatiue, de laquelle le cristal et diamant et toutes pierres diafanes sont composées. Et s'il te souuient, ne te montrois-ie pas certaines pierres d'agate et autres, qui estoyent candides sur la partie superieure, et tenebreuses en la partie inférieure? ne disois-ie pas, auec preuues, que toutes les pierres tenebreuses et coulourées de quelque couleur que ce soit ne sont tenebreuses, ny coulourées, sinon par accident? qui est que les pierres desquelles sont les meules pour aiguiser les ferremens, sont rendues tenebreuses à cause d'vn sable qui est meslé parmy l'eau congelatiue. Autres pierres sont rendues tenebreuses à cause de la terre qui est entre meslee parmy ladite eau; tu peux assez auoir entendu la cause de ce, quand i'ay parlé des couleurs des pierres : et pour te remémorer les preuues que i'ay alleguées en mes leçons, il te faut souuenir de ce que ie te dis lors. Considere le cristal qui est en la roche, et tu connoistras que durant sa congelation la matiere d'iceluy estoit dedans les eaux, comme i'ay dit plusieurs fois : et quand les eaux sont troublées à cause des terres, la terre cherche tousiours le bas comme la lie dans vn poinson de vin : et de là vient que l'eau pure et l'impure se congelent toutes deux : mais la partie superieure sera de cristal pur et net, et l'inferieure sera d'vn cristal trouble.

Autant en est-il comme ie l'ay dit des matieres metalliques, lesquelles apportent tousiours auec elles quelque chose qui cause leur impureté,

DES TERRES D'ARGILE.

Theorique.

Tv as si souuent allegué les terres argileuses, en parlant des fontaines et des pierres, et toutesfois ie n'ay point entendu de toy, que c'est que terre argileuse.

Practique.

I'ay ouy lire quelque liure d'vn autheur, lequel en traitant des pierres, et terres, dit que la terre d'argile a pris son nom d'vn village qui se nomme Argis, et que par ce qu'en ce lieu furent faits les premiers vaisseaux de terre, l'on appelle depuis ce temps là toutes terres bonnes à faire pots, terre d'argile, tout ainsi que l'on appelle le boliarmeny qui se prend en France bolus armenus : combien qu'il ne fut iamais pris en Armenie. Toutefois i'ay depuis entendu par quelques Latins que cela estoit faux, et que toute terre propre à faire vaisseaux s'appelle argile, à cause de son action tenante : et disent qu'argile veut dire terre grasse. Telles opinions m'ont causé double hardiesse d'en parler, car i'ay cõneu par là en partie que les Latins et les Grecs peuuent aussi bien faillir que les François (1). Et qu'ainsi ne soit ils appellent la terre d'argile terre grasse : et tant s'en faut qu'elle soit grasse : car l'on prend de la terre d'argile pour desgraisser, tesmoins les foulons de draps : et aucuns merciers en ont fait

(1) *Argile* vient évidemment du grec ἀργός, blanc, ou plutôt de ἀργιλός, matière blanche.

des trochisques à vendre, pour degraisser. Il est bien certain que la terre d'argile n'a aucune affinité auec les terres grasses, et ne se peut non plus entremesler auec la graisse que fait l'eau auec l'huile. Et ce qui cause que la terre d'argile oste la graisse des draps, la raison n'est autre sinon que la graisse lui est aduersaire. Et tout ainsi comme le chaud chasse l'humide, la terre d'argile chasse la graisse du lieu où elle est la plus forte.

Theorique.

Comment? voudrois tu donc que l'on nommast la terre des potiers sinon terre grasse? car ie sçay bien que le glus, qu'aucuns appellent besq (1), est composé de matieres grasses: aucuns le font de la pelure d'vn arbre que l'on appelle houx: les autres prennent de la graine d'vn certain brandon (le gui) qui croit le plus communement sur les pommiers: laquelle est fort visqueuse. Aussi aucuns appellent ledit brandon besq. Or tous ces deux là sont bons à prendre des oyseaux, et quand on la manie il faut auoir les mains mouillées, autrement elle prendroit aux mains: et toutesfois quand les François et Latins parlent des terres argileuses ils disent que c'est une terre visqueuse, grasse et glueuse: et mesme aucuns ont escrit que la terre d'argile est une terre tenante, glueuse et visqueuse.

Practique.

Par tes propres paroles tu confesses que tous ceux qui parlent ainsi, l'entendent fort mal: par ce qu'il n'y a rien plus contraire anx matieres visqueuses que l'eau. Or la terre argileuse est toute composée de matière acqueuse: parquoy se peuuent lier ensemble. La terre d'argile se dissout dans l'eau, et toutes matieres visqueuses et oleagineuses deuiennent plus dures. Il seroit beaucoup plus conuenable de la nommer terre pasteuse que non pas visqueuse, parce que la farine à faire la paste se destrempe auec l'eau comme la terre d'argile.

Theorique.

Et puis qu'elles sont toutes bonnes à faire vaisseaux, quelle difference y treuues tu?

Practique.

Entre les terres argileuses il y a si grande difference de l'vne à l'autre qu'il est impossible à nul homme de pouuoir

(1) De *viscus*, gui.

raconter la contrarieté qui est en icelles. Aucunes sont sableuses, blanches et fort maigres : et pour ces causes leur faut vn grand feu au parauant qu'elles soyent cuittes au debuoir. Telle espece de terre est fort bonne à faire des creusets : par ce qu'elle endure vn bien grand feu ; il y en a autres especes qui pour cause des substances metalliques qui sont en elles, se ployent et liquifient, quand elles endurent grande chaleur. I'ay veu quelques fours de thuiliers que les arceaux estoyent en telles sortes liquifiez, que les voultes estoyent toutes pleines de formes pendantes comme tu vois les glaçons és goutieres des maisons durant les gelées. Il y en a d'autres especes que quand elles sont cuittes, soit en thuiles ou en briques, il faut que le maistre de l'œuure se donne bien garde de tirer sa besongne du four, quelle ne soit bien refroidie. Et qui plus est, ceux qui en besongnent sont contraints d'estouper tous les aspirals de leurs fourneaux, soudain que leur besongne est cuitte ; par ce que si elle sentoit tant soit peu de vent en refroidissant, les pieces se trouueroyent toutes fendues. Il y en a vne espece à Sauigny en Beauuoisis, que je cuide qu'en France n'y en a point de semblable, car elle endure vn merueilleux feu, sans estre aucunement offensée, et à ce bien là, de se laisser former autant tenue et deliée que nulle des autres : Et quand elle est extremement cuitte elle prend vn petit polissement vitrificatif, qui procede de son corps mesme : Et cela cause que les vaisseaux faits de ladite terre tiennent l'eau fort autant bien que les vaisseaux de verre (1). Il y a autres especes de terres qui sont noires en leur essence, et quand elles sont cuittes elles sont blanches comme papier ; autres especes sont iaunes, et quand elles sont cuittes elles deuiennent rouges. Il y en a aucuns genres qui sont de mauuaise nature : par ce que parmy elles, il y a des petites pierres que quand les vaisseaux sont cuits, les petites pierres qui sont dedans lesdits vaisseaux, sont reduites en chaux et soudain qu'elles sentent l'humidité de l'air se viennent enfler, et font creuer ledit vaisseau à l'endroit où elles sont encloses : et c'est pour cause que lesdites pierres se sont calcinées en cuisant : et par ce moyen plusieurs vaisseaux sont perdus quelque grand labeur que l'on y aye employé. Il y

(1) Il s'agit probablement ici d'un silicate alumineux ; en sorte que Palissy aurait été on ne peut plus rapproché de la découverte de la porcelaine

autres especes de terres qui sont fort bonnes et endurent fort bien le feu : Mais elles sont si vaines et lasches que l'on n'en peut faire aucuns vaisseaux legers, par ce que quand l'on la veut former vn peu haut elle se laisse aller en bas, ne se pouuant soustenir. C'est vne regle generale que toutes terres argileuses, et singulierement les plus fines sont suiettes à peter au feu auparaut qu'elles soyent cuittes : pour ces causes ceux qui en besongnent sont contraints de mettre le feu petit à petit, afin de chasser l'humidité qui est dedans la besongne, tellement que si les pieces que l'on fait cuire sont espaisses, et qu'il y en ait quantité, il faudra tenir le feu quelquefois trois et quatre iours et nuits, et si la besongne est vne fois commencée à eschaufer, et que celuy qui conduira le feu s'endorme, et qu'il laisse refroidir sa besongne, au parauant qu'elle soit cuitte en perfection, il n'y aura nulle faute que l'œuure ne soit perdue. Et par tel accident plusieurs thuilliers ont eu de grandes pertes. Il ne sera pas hors de propos que ie te die vn autre secret fort estrange, qui est que plusieurs chaufourniers ont aussi eu de grandes pertes, par vn accident tout semblable : c'est que depuis que la pierre du four à chaux commence à eschaufer, iusques à auoir sa couleur rouge, et que la flamme aye commencé à passer entre les pierres, si celuy qui conduit le feu se vient à endormir, et qu'en s'eueillant il trouue que la flamme soit abbatue, et la chaleur en partie rabaissée au parauant que la pierre soit calcinée au degré requis ; s'il venoit apres à recommencer à mettre du bois à son fourneau, et qu'il employast tout le bois des forests des Ardennes, il ne luy est plus possible de faire remonter son feu, ne plus reduire sa pierre en chaux, ains a perdu tout ce qu'il y auoit mis. I'en ay conneu plusieurs qui sont deuenus pauures par tels accidens. Ceux qui besongnent impatiemment de l'art de terre, perdent beaucoup bien souuent par leurs impatiences : car s'ils ne chassent l'humeur exalatiue, qui est dedans la terre, petit à petit, et qu'ils veulent mettre le grand feu au parauant qu'elle soit ostée, il n'y a rien plus certain que le chaud et l'humide se rencontrant engendreront vn tonnerre, à cause de leur contrarieté. Car ie sçay que les tonnerres naturels sont engendrez par la mesme cause, sçauoir est le chaud et humide : par ce qu'ils sont contraires, et ne peuuent habiter

ensemble : car le feu (comme le plus fort) trouuant l'humide enclos dedans les parties de la terre, il le veut chasser violemment, comme son ennemy, et l'humide estant pressé de trop pres veut fuir en diligence : mais d'autant que le feu ne luy donne pas le loisir de trouuer les petites portes par où il estoit entré, il est contraint de s'enfuir, et en s'enfuyant il fait creuer et casser les pierres où il est enclos. J'ay veu autrefois que aucuns tailleurs d'images, instruits en l'art de terre par ouyr dire seulement, et assez nouueaux en la connoissance des terres, qu'apres auoir fait quelques images ils les venoyent mettre dedans les fourneaux, pour les cuire, selon qu'ils l'entendoyent : Mais quand ils commençoyent à mettre le grand feu, c'estoit une chose assez plaisante (combien qu'il n'y eut pas à rire pour tous) d'entendre ces images peter et faire vne baterie entr'eux, comme vn grand nombre d'harquebusades et coups de canon, et le pauure maistre bien fasché, comme vn homme à qui on rauiroit son bien : car le iour venu pour desenfourner les images, le four n'estoit pas si tost descouuert qu'il aperceuoit les vns la teste fenduë les autres les bras rompus et les iambes cassées, tellement que le pauure homme ayant tiré ses images estoit bien empesché et auoit bien de la peine à chercher les pieces : car les vnes estoyent aussi petites que mouches, et ne les pouuant rassembler estoit contraint bien souuent faire des nez de drapeau ou autre matiere à sesdites images. Les hommes experimentez en l'art de terre ne besongnent pas ainsi inconsiderement, ains premierement, ils taschent de connoistre le naturel de la terre, et apres l'auoir connue, ils considerent l'espaisseur de la besongne qu'ils veulent faire cuire, ayant connoissance que la plus espaisse est la plus dangereuse à se creuer au feu : Aussi ils se donnent bien garde de la cuire, qu'elle ne soit bien seche. Et quand elle est dedans le four, ils baillent le petit feu plus longuement à la besongne espaisse, que non pas à la tenue : et en donnant le feu petit à petit ils donnent loisir à l'humide de sortir à son aise et sans violence : Et quand le maistre connoist que l'humide a quitté sa place, il donne congé au feu d'entrer auec telle violence que bon luy semblera, et lors il se vient esgayer et entre auec toute liberté, mesme iusques à l'interieur de toutes les parties closes et fermées au dedans des pieces d'ouurages.

DES TERRES D'ARGILE.

formées de ladite terre : et par tel moyen l'on peut connoistre qu'en la terre argileuse y a deux humeurs, l'vne euaporatiue et accidentale, et l'autre fixe et radicale : l'humide et accidentale est suiette à s'euaporer et estant euaporée, la radicale transmue la substance de la terre en pierre : Toutesfois sans que premierement l'humide y besongne, cela ne se pourroit faire : car il faut necessairement que l'humide rassemble toutes les parties, et qu'il serue de mastic pour former toutes sortes d'ouurages.

Il y a aucunes especes de terres ausquelles il ne faut pas tenir longuement le petit feu ; Telles terres sont communement grosses, sableuses et spongieuses, et par ce qu'elles ont les pores ouuerts, l'humide s'exale plus promptement, estant chassé par le feu. Il y a autres terres qui sont si alises, ou si peu poureuses que pour ces causes ceux qui en besongnent sont contraints d'y mettre du sable, pour obuier au long temps qu'il faudroit tenir le petit feu, pour garder de casser la besongne. La cause pourquoy le sable peut faire que la piece endurera plutost le grand feu, que quand la terre sera pure, est qu'il fait diuision des subtiles parties de la terre : et d'autant que sa subtilité la rendroit plus alise et reserrée, le sable luy cause quelques pores par lesquels l'humide s'exale plus promptement pour donner place au feu, son aduersaire. Pour ces causes les potiers de Paris mettent du sable à toutes leurs besongnes. Aupres de Paris il y a de trois sortes de terres argileuses, la plus fine se prend à Gentilly, qui est vn village pres dudit lieu. Mais il y a certains endroits là où parmy ladite terre se trouue grand nombre de marcassites metalliques et sulphurées, qui causent que lesdits potiers n'en veulent point, sinon pour faire de la brique, ou de la tuille. La cause pourquoy ils n'en peuuent point faire de bonne besongne, est parce qu'en cuisant leur ouurage lesdites marcassites rendent vne vapeur noire et puante, laquelle noircit tout l'ouurage qui est couuert de iaune et de verd. Il y a vne autre espece de terre à vn village pres Paris, nommé Chaliot, de laquelle l'on fait la tuille; elle est vn peu plus grosse que celle de Gentilly : il se trouue dedans icelle vn grand nombre de marcassites, qui toutesfois sont d'autre genre que celle de Gentilly. Je te dy ces choses pour te faire mieux entendre que si en si peu de pays il se trouue de diuerses especes de terre,

que cela te soit argument de te faire croire qu'en la grandeur d'vn Royaume il y en peut auoir vn grand nombre de bien differentes. Ie n'ay pas conneu la difference des terres, et leurs diuers effets sans grands frais et labeurs. I'auois quelques fois recouuert (découvert) de la terre du Poitou, et auois trauaillé d'icelle bien l'espace de six mois au parauant que d'auoir ma fournée complete : parce que les vaisseaux que i'auois faits estoyent fort elabourez, et d'assez haut prix. Or en faisant lesdits vaisseaux de la terre de Poitou, i'en fis quelques vns de la terre de Xaintonge, de laquelle i'auois besongné plusieurs années auparauant, et estois assez experimenté au degré du feu qu'il falloit à ladite terre ; et pensant que toutes terres se peusent cuire à vn mesme degré, ie fis cuire ma besongne qui estoit de terre de Poitou parmy celle de terre de Xaintonge, qui me causa vne grande perte : d'autant que la besongne de terre de Xaintonge estant assez cuitte, ie pensois que l'autre le seroit aussi ; mais lors que ie vins à esmailler mes vaisseaux, iceux sentant l'humidité, ce fut vne risée mal plaisante pour moy : parce qu'autant de pieces que l'on esmailloit vindrent à se dissoudre et tomber par pieces, comme feroit vne pierre de chaux trempée dedans l'eau, et toutesfois les vaisseaux de la terre de Xaintonge estoient cuits dans le mesme four, et d'vn mesme degré de chaleur, et en mesme heure que les susdits, et se portoient fort bien. Voilà comment vn homme qui besongne de l'art de terre, est tousjours apprentif à cause des natures inconnuës és diuersitez des terres. Il y a des terres argileuses que combien que elles ayent receu vne cuisson raisonnable, et autant de feu qu'il leur en faut, si est-ce que si les vaisseaux de telle terre sont mouillez, et que l'on les presente deuant le feu, ils se casseront comme s'ils n'estoient pas cuits : ce qui n'aduient point aux autres terres. Il y en a de certaines especes qui sont si visqueuses et si tresfines, qu'elles se laisseront allonger comme vne corde. I'ay veu des femmes besongner d'vne telle terre, qui pour faire des anses de pots, prenoient vne poignée d'icelle, et la tenant par vn bout d'vne main, de l'autre main elles l'allongeoient autant longue qu'elles pouuoient leuer les bras en haut : et quand cela estoit fait elles laissoyent aller vn bout pendant vers le bas sans que ladite terre se rompist, et puis elles les mettoient par monceaux, pour faire leursdites anses. Cela ne se peut

DES TERRES D'ARGILE. 305

pas faire des terres sableuses : parce qu'elles sont toutes courtes et vaines. Il y a autres especes de terres fort malignes : car quand elles sont vn peu trop cuittes elles sont suiettes à se brusler, noircir, et fendiller, et les vaisseaux qui sont dessouz, pressez de la pesanteur de ceux qui sont dessus se ployent et tordent la gueule comme s'ils estoyent d'vne matiere maleable. Il y a des terres argileuses vers les Ardennes, qui sont fort humides ou longues à seicher, dangereuses à brusler, lesquelles tiennent quelque substance de mine de fer. I'en ay trouué quelquefois d'vne espece qui estoit fort nette, subtile et deliée, ayant apparence d'estre fort bonne : tellement que pour l'esperance que i'auois de m'en seruir i'en formay quelques pieces, et le mis au plus chaud du fourneau : mais quand ie vins à chercher mes pieces ie trouuay qu'elles estoyent fondues, et ladite terre auoit coulé le long des cendres, comme plomb fondu. Il se trouue des vaisseaux antiques d'vne terre rouge qui est polie, sans aucun esmail, et aucuns appellent les vaisseaux de ladite terre, vaisseaux de barc. Ie ne sçay pour quelle cause ils les appellent ainsi : mais bien sçay-ie qu'anciennement ils étoyent en grand vsage. Car l'on en trouue grande quantité de pieces rompues aux villes antiques : et plusieurs fois s'en est trouué dans des sepulchres auec des monnoyes des Empereurs qui regnoyent pour lors, et cela se faisoit par quelque ceremonie, qui depuis a esté laissée. Si ie voulois escrire toutes les diuersitez des terres argileuses, ie n'aurois iamais fait : tu en pourras auoir plus grande connoissance en traitant de l'art de terre : parquoy ie n'en parleray plus pour le present (1).

(1) Le traité des *Terres d'argile* était le préambule nécessaire du traité de l'*Art de terre*. Il renferme des préceptes dont la justesse et la clarté se retrouvent à un degré encore supérieur dans le traité suivant, l'un des plus importants et des plus remarquables des œuvres du savant potier.

DE L'ART DE TERRE,

de son vtilité, des esmaux
et du feu.

THEORIQUE.

T u m'as promis cydeuant de m'apprendre l'art de terre : et lors que tu me fis vn si long discours des diuersitez des terres argileuses, ie fus fort resiouy pensant que tu me voulusses monstrer le total dudit art ; mais ie fus tout esbahy qu'au lieu de poursuyure tu me remis à vne autre fois : afin de me faire oublier l'affection que i'ay audit art.

PRACTIQUE.

Cuides tu qu'vn homme de bon iugement vueille ainsi donner les secrets d'vn art, qui aura beaucoup cousté à celuy qui l'aura inuenté ? Quant à moy ie ne suis deliberé de ce faire que ie ne sçache bien souz quel titre.

THEORIQUE.

Il n'y a doncques en toy nulle charité. Si tu veux ainsi tenir ton secret caché, tu le porteras en la fosse, et nul ne s'en ressentira, ainsi ta fin sera maudite : car il est escrit qu'vn chacun selon qu'il a receu des dons de Dieu qu'il en distribue aux autres : par ainsi ie puis conclure que si tu ne me monstres ce que tu sçais de l'art susdit, que tu abuses des dons de Dieu.

PRACTIQUE.

Il n'est pas de mon art, ny des secrets d'iceluy comme de plusieurs autres. Ie sçay bien qu'vn bon remede contre vne peste, ou autre maladie pernicieuse, ne doit estre celé. Les se-

crets de l'agriculture ne doiuent estre celez. Les hazards et dangers des nauigations ne doiuent estre celez. La parole de Dieu ne doit estre celée. Les sciences qui seruent communément à toute la republique ne doyuent estre celées. Mais de mon art de terre et de plusieurs autres arts il n'en est pas ainsi. Il y a plusieurs gentilles inuentions lesquelles sont contaminées et mesprisées pour estre trop communes aux hommes. Aussi plusieurs choses sont exaltées aux maisons des Princes et seigneurs, que si elles estoyent communes l'on en feroit moins d'estime que de vieux chauderons. Ie te prie, considere vn peu les verres, lesquels pour auoir esté trop communs entre les hommes sont deuenuz à vn prix si vil que la plus part de ceux qui les font viuent plus mechaniquement que ne font les crocheteurs de Paris. L'estat est noble, et les hommes qui y besongnent sont nobles (1) : mais plusieurs sont gentilshommes pour exercer ledit art, qui voudroyent estre roturiers et auoir dequoy payer les subsides des Princes. N'est ce pas vn malheur aduenu aux verriers des pays de Perigord, Limosin, Xaintonge, Angoulmois, Gascongne, Bearn et Bigorre? ausquels pays les verres sont mechanizez en telle sorte qu'ils sont venduz et criez par les villages, par ceux mesmes qui crient les vieux drapeaux et la vieille ferraille, tellement que ceux qui les font et ceux qui les vendent trauaillent beaucoup à viure. Considere aussi vn peu les boutons d'esmail (qui est vne inuention tant gentille), lesquels au commencement se vendoient trois francs la douzaine. Or d'autant que ceux qui les inuenterent ne tindrent leur inuention secrete, vn peu de temps apres, la conuoitise du gain, ou l'indigence des personnes fust cause qu'il en fut fait si grande quantité qu'ils furent contrains les donner pour vn sol la douzaine, tellement qu'ils sont venus à tel mespris qu'auiourd'huy les hommes ont honte d'en porter, et disent que ce n'est que pour les belistres, parce qu'ils sont à trop bon marché. As tu pas veu aussi les esmailleurs de Limoges, lesquels par faute d'auoir tenu leur inuen-

(1) L'art du verrier jouissait, en effet, de certaines prérogatives, mais il ne donnait point la noblesse. Toutefois, il était exercé dans plusieurs provinces de France par des gentilshommes qui en conservaient les secrets et ne les transmettaient qu'à des personnes de la même condition. Plusieurs familles du Dauphiné, de la Provence et du Languedoc, qui se disaient nobles, n'avaient d'autres titres que ceux d'une prétendue *noblesse verrière*.

tion secrete, leur art est deuenu si vil qu'il leur est difficile de gaigner leur vie au prix qu'ils donnent leurs œuures. Ie m'asseure auoir veu donner pour trois sols la douzaine des figures d'enseignes que l'on portoit aux bonnets, lesquelles enseignes estoyent si bien labourées et leurs esmaux si bien parfondus sur le cuiure, qu'il n'y auoit nulle peinture si plaisante. Et n'est pas cela seulement adueuu vne fois, mais plus de cent mil, et non seulement esdites enseignes, mais aussi aux esguieres, salieres, et toutes autres especes de vaisseaux, et autres histoires, lesquelles ils se sont aduisez de faire : chose fort à regretter. As tu pas veu aussi combien les Imprimeurs ont endommagé les peintres et pourtrayeurs sçauans? i'ay souuenance d'auoir veu les histoires de nostre Dame imprimées de gros traits, apres l'inuention d'vn Alemand nommé Albert (1), lesquelles histoires vindrent vne fois à tel mespris, à cause de l'abondance qui en fut faite, qu'on donnoit pour deux liars chacune desdites histoires, combien que la pourtraiture fut d'vne belle inuention. Vois tu pas aussi combien la moulerie a fait de dommage à plusieurs sculpteurs sçauans, à cause qu'apres que quelqu'vn d'iceux aura demeuré long temps à faire quelque figure de prince et de princesse, ou quelque autre figure excellente, que si elle vient à tomber entre les mains de quelque mouleur, il en fera si grande quantité que le nom de l'inuenteur ny son œuure ne sera plus connue, et donnera on à vil prix lesdites figures à cause de la diligence que la moulerie a amenée, au grand regret de celuy qui aura taillé la premiere piece. I'ay veu vn tel mespris en la sculpture, à cause de ladite moulerie, que tout le pays de la Gascongne et autres lieux circonuoisins estoyent tous pleins de figures moulées, de terre cuite, lesquelles on portoit vendre par les foyres et marchez, et les donnoit on pour deux liards chascune, dont aduint que du temps que l'on commençoit à porter des ceintures et autres habits à la busque, il y eut vn homme lequel fut emprisonné et eut le fouët, à cause qu'il alloit par toute la ville de Tolouze, auec vne balle pleine de crucifix, criant : crucifix, crucifix à la busque. Tu peux aisément connoistre par ces exemples et par vn millier d'autres semblables, qu'il vaut mieux qu'vn homme ou vn petit nombre facent leur proufit de quel-

(1) Albert Durer, célèbre peintre et graveur de Nuremberg, mort en 1528.

que art en viuant honnestement, que non pas si grand nombre d'hommes, lesquels s'endommageront si fort les vns les autres, qu'ils n'auront pas moyen de viure, sinon en profanant les arts, laissants les choses à demy faites, comme l'on voit communement de tous les arts, desquels le nombre est trop grand. Toutesfois si ie pensois que tu gardasses le secret de mon art aussi precieux comme il le requiert, ie ne ferois difficulté de le l'enseigner.

Theorique.

S'il te plaist de me l'apprendre, ie te promets de le tenir aussi secret qu'homme à qui tu le pourrois enseigner.

Practique.

Ie voudrois faire beaucoup pour toy, et te voudrois auancer d'aussi bon cœur que mon propre enfant : mais ie crains qu'en te monstrant l'art de terre ce soit plutost te reculer que t'auancer. La raison est parce que tu as besoing de deux choses, sans lesquelles il est impossible de rien faire de l'art de terre. La premiere est qu'il faut que tu sois veuillant, agile, portatif et laborieux. Secondement il te faut auoir du bien, pour soustenir les pertes qui suruiennent en exerçant ledit art. Or d'autant que tu as indigence de ces choses ie te conseille de chercher quelque autre moyen de viure, qui soit plus aisé et moins hazardeux.

Theorique.

Ie cuide que ce qui te fait dire ces choses n'est pas pour pitié que tu ayes de moy : Mais c'est qu'il te fache de tenir ta promesse et de me reueler les secrets dudit art. Qu'ainsi ne soit ie sçay que quand premierement tu te mis à chercher ledit art, tu n'auois pas beaucoup de biens, pour supporter les pertes et fautes que tu dis qui peuuent suruenir au labeur dudit art.

Practique.

Tu dis vray, ie n'auois pas beaucoup de biens : Mais i'auois des moyens que tu n'as pas. Car i'auois la pourtraiture. L'on pensoit en nostre pays que ie fusse plus sçauant en l'art de peinture que ie n'estois, qui causoit que i'estois souuent appellé pour faire des figures pour les procés (1). Or quand i'estois

(1) Les figures pour les procés n'étaient que les plans figuratifs de certains lieux, dressés en vertu d'ordonnances judiciaires, pour servir à l'instruction et jugement des procès ; Palissy faisait par là les fonctions d'arpenteur-géomètre juré. (*Note de Gobet.*)

en telles commissions i'estois tresbien payé, aussi ay-ie entretenu long temps la vitrerie, iusques à ce que i'aye esté asseuré pouuoir viure de l'art de terre : aussi en cherchant ledit art i'ay apprins à faire l'alchimie auec les dents, ce qu'il te facheroit beaucoup de faire. Voila comment i'ay eschappé le temps que i'ay employé à chercher ledit art.

Theorique.

Ie sçay que tu as enduré beaucoup de pauuretez et d'ennuis en le cherchant : mais il ne sera pas ainsi de moy : car ce qui t'a fait endurer, ce a esté à cause que tu estois chargé de femme et d'enfans. Or d'autant que au parauant tu n'en auois nulle connoissance, et qu'il te failloit deuiner, par ce aussi que tu ne pouuois laisser ton mesnage pour aller apprendre ledit art en quelque boutique, aussi que tu n'auois moyen d'entretenir aucuns seruiteurs qui te peussent faire quelque chose pour t'amener au chemin de l'art susdit. Tous ces defauts t'ont causé les ennuis et miseres susdites. Mais il ne sera pas ainsi de moy : par ce que suyant ta promesse tu me donneras par escrit tous les moyens d'obuier aux pertes et hazards du feu : aussi les matieres dont tu fais les esmaux et la dose, mesures et composition d'iceux. Ainsi faisant, pourquoy ne feray-ie de belles choses sans estre en danger de rien perdre, attendu que tes pertes me seruiront d'exemple pour me garder et guider en exerçant ledit art?

Practique.

Quand i'aurois employé mille rames de papier pour t'escrire tous les accidens qui me sont suruenuz en cherchant ledit art, tu te dois asseurer que, quelque bon esprit que tu ayes, t'auiendra encores vn millier de fautes, lesquelles ne se peuuent apprendre par lettres, et quand tu les aurois mesme par escrit, tu n'en croiras rien iusques à ce que la pratique t'en aye donné vn millier d'afflictions. Toutesfois afin que tu n'ayes occasion de m'appeller menteur, ie te mettray icy par ordre tous les secrets que i'ay trouué en l'art de terre, ensemble les compositions et diuers effects des esmaux ; aussi te diray les diuersitez des terres argileuses, qui sera vn point lequel il te faudra bien noter. Or afin de mieux te faire entendre ces choses, ie te feray vn discours pris dés le commencement que ie me mis en deuoir de chercher ledit art, et par là tu oras les calamitez que i'ay endurées aupa-

rauant que de paruenir à mon dessein. Ie cuide que quand tu auras bien entendu le tout, il te prendra bien peu d'enuie de te ietter audit art, et m'asseure que d'autant que tu es à present desireux de t'en approcher, d'autant tascheras tu à t'en esloigner : par ce que tu verras que l'on ne peut poursuyure, ny mettre en execution aucune chose, pour la rendre en beauté et perfection, que ce ne soit auec grand et extreme labeur, lequel n'est iamais seul, ains est tousiours accompagné d'un millier d'angoisses.

Theorique.

Ie suis homme naturel comme toy, et puisque les choses t'ont esté possibles sans auoir eu aucun enseigneur, il me sera beaucoup plus aisé quand i'auray obtenu de toy vn entiers discours de toute la maniere de faire, et les moyens par lesquels tu y es paruenu.

Practique.

Suyuant ta requeste, sçaches qu'il y a vingt et cinq ans passez qu'il ne me fut monstré vne coupe de terre, tournee et esmaillee d'vne telle beauté (1), que deslors i'entray en dispute auec ma propre pensée, en me rememorant plusieurs propos, qu'aucuns m'auoient tenus en se mocquant de moy, lors que ie peindois les images. Or voyant que l'on commençoit à les delaisser au pays de mon habitation, aussi que la vitrerie n'auoit pas grande requeste, ie vay penser que si i'auois trouué l'inuention de faire des esmaux ie pourrois faire des vaisseaux de terre et autre chose de belle ordonnance, parce que Dieu m'auoit donné d'entendre quelque chose de la pourtraiture; et deslors, sans auoir esgard que ie n'auois nulle connoissance des terres argileuses, ie me mis à chercher les esmaux, comme vn homme qui taste en tenebres. Sans auoir entendu de quelles matieres se faisoyent lesdits esmaux, ie pilois en ces iours là de toutes les matieres que ie pouuois penser qui pourroyent faire quelque chose, et les ayant pilées et broyées, i'achetois vne quantité de pots de

(1) On peut supposer, quoique rien ne le constate, que cette coupe *émaillée* était d'origine italienne ; soit qu'elle fût le produit des manufactures de Faenza (d'où le mot *faïence*), soit qu'elle remontât à une plus haute antiquité : car on sait que, dès le temps de Porsenna, on connaissait, en Étrurie, l'art de couvrir d'émail les vases de terre. Mais cet art était alors complétement ignoré en France, et ce fut Palissy qui l'y créa.

terre, et apres les auoir mis en pieces, ie mettois des matieres que i'auois broyées dessus icelles, et les ayant marquées, ie mettois en escrit à part les drogues que i'auois mis sus chacunes d'icelles, pour memoire ; puis ayant faict vn fourneau à ma fantasie, ie mettois cuire lesdites pieces pour voir si mes drogues pourroyent faire quelques couleurs de blanc : car ie ne cherchois autre esmail que le blanc : parce que i'auois ouy dire que le blanc estoit le fondement de tous les autres esmaux. Or par ce que ie n'auois iamais veu cuire terre, ny ne sçauois a quel degré de feu ledit esmail se deuoit fondre, il m'estoit impossible de pouuoir rien faire par ce moyen, ores que mes drogues eussent esté bonnes, par ce qu'aucune fois la chose auoit trop chaufé et autrefois trop peu, et quand lesdites matieres estoyent trop peu cuites ou bruslées, ie ne pouuois rien iuger de la cause pourquoy ie ne faisois rien de bon, mais en donnois le blasme aux matieres, combien que quelque fois la chose se fust peut estre trouué bonne, ou pour le moins i'eusse trouué quelque indice pour paruenir à mon intention, si i'eusse peu faire le feu selon que les matieres les requeroyent : Mais encores en ce faisant ie commettois vne faute plus lourde que la susdite : car en mettant les pieces de mes espreuues dedans le fourneau, ie les arrangeois sans consideration ; de sorte que les matieres eussent esté les meilleures du monde et le feu le mieux à propos, il étoit impossible de rien faire de bon. Or m'estant ainsi abuzé plusieurs fois, auec grand frais et labeurs, i'estois tous les iours à piler et broyer nouuelles matieres et construire nouueaux fourneaux, auec grande despence d'argent et consommation de bois et de temps.

Quand i'eus bastelé plusieurs années ainsi imprudemment, auec tristesse et soupirs, à cause que ie ne pouuois paruenir a rien de mon intention, et me souuenant de la despense perduë, ie m'auisay pour obuier à si grande despence d'enuoyer les drogues que ie voulois approuuer à quelque fourneau de potier ; et ayant conclud en mon esprit telle chose, i'achetay de rechef plusieurs vaisseaux de terre, et les ayant rompus en pieces, comme de coustume, i'en couuray trois ou quatre cent pieces d'esmail, et les enuoyay en vne poterie distante d'vne lieue et demie de ma demeurance, auec requeste enuers les potiers qu'il leur pleust permettre cuire lesdittes es-

preuues dedans aucuns de leurs vaisseaux : ce qu'ils faisoyent volontiers ; mais quand ils auoyent cuit leur fournée et qu'ils venoyent à tirer mes espreuues, ie n'en receuois que honte et perte, par ce qu'il ne se trouuoit rien de bon, à cause que le feu desdits potiers n'estoit assez chaut, aussi que mes espreuues n'estoyent enfournées au deuoir requis et selon la science ; et parce que ie n'auois connoissance de la cause pourquoy mes espreuues ne s'estoyent bien trouuées, ie mettois (comme i'ay dit cy dessus) le blasme sus les matieres : de rechef ie faisois nombre de compositions nouuelles, et les envoyay aux mesmes potiers, pour en vser comme dessus : ainsi fis-ie par plusieurs fois, tousiours auec grands frais, perte de temps, confusion et tristesse.

Quand ie vis que ie ne pouuois par ce moyen rien faire de mon intention, ie pris relasche quelque temps, m'occupant à mon art de peinture et de vitrerie (1), et me mis comme en non chaloir de plus chercher les secrets des esmaux, quelques iours apres suruindrent certains commissaires, deputez par le Roy, pour eriger la gabelle au pays de Xaintonge, lesquels m'appellerent pour figurer les isles et pays circonuoisins de tous les marez salans dudit pays. Or apres que ladite commission fut paracheuée et que ie me trouuay muny d'vn peu d'argent ie reprins encores l'affection de poursuyure à la suitte desdits esmaux, et voyant que ie n'auois peu rien faire dans mes fourneaux ny a ceux des potiers susdits, ie rompi environ trois douzaines de pots de terre tous neufs, et ayant broyé grande quantité de diuerses matieres, ie couuray tous les lopins desdits pots desdites drogues couchées auec le pinceau : mais il te faut entendre que de deux ou trois cents pieces, il n'y en auoit que trois de chascune composition : ayant ce fait, ie prins toutes ces pieces et les portay à vne verrerie, afin de voir si mes matieres et compositions se pourroyent trouuer bonnes aux fours desdites verreries. Or d'autant que leurs fourneaux sont plus chauds que ceux des potiers, ayant mis toutes mes espreuues dans lesdits fourneaux, le lendemain que ie les fis tirer, i'apperceus partie de mes compositions qui auoyent commencé à fondre, qui fut cause que ie fus encores d'auantage encouragé de chercher l'esmail blanc, pour lequel i'auois tant trauaillé.

(1) C'est-à-dire, de peinture sur verre.

Touchant des autres couleurs ie ne m'en mettois aucunement en peine; ce peu d'apparence que ie trouuay lors, me fit trauailler pour chercher ledit blanc deux ans outre le temps susdit, durant lesquels deux ans ie ne faisois qu'aller et venir aux verreries prochaines, tendant aux fins de paruenir à mon intention. Dieu voulut qu'ainsi que ie commençois à perdre courage, et que pour le dernier coup ie m'estois transporté à vne verrerie, ayant auec moy vn homme chargé de plus de trois cents sortes d'espreuues, il se trouua vne desdites espreuues qui fut fondue dedans quatre heures apres auoir esté mise au fourneau, laquelle espreuue se trouua blanche et polie de sorte qu'elle me causa vne ioye telle que ie pensois estre deuenu nouuelle creature : Et pensois deslors auoir vne perfection entiere de l'esmail blanc : Mais ie fus fort esloingné de ma pensée : ceste espreuue estoit fort heureuse d'vne part, mais bien mal-heureuse de l'autre, heureuse en ce qu'elle me donna entrée à ce que ie suis paruenu, et mal-heureuse en ce qu'elle n'estoit mise en doze ou mesure requise ; ie fus si grand beste en ces iours là, que soudain que i'eus fait ledit blanc qui estoit singulierement beau, ie me mis à faire des vaisseaux de terre, combien que iamais ie n'eusse conneu terre, et ayant employé l'espace de sept ou huit mois à faire lesdits vaisseaux, ie me prins à eriger vn fourneau semblable à ceux des verriers, lequel ie bastis auec vn labeur indicible: car il falloit que ie maçonnasse tout seul, que ie destrempasse mon mortier, que ie tirasse l'eau pour la destrempe d'iceluy, aussi me failloit moy mesme aller querir la brique sur mon dos, à cause que ie n'auois nul moyen d'entretenir vn seul homme pour m'ayder en cest affaire. Ie fis cuire mes vaisseaux en premiere cuisson : mais quand ce fut à la seconde cuisson, ie receus des tristesses et labeurs tels que nul homme ne voudroit croire. Car en lieu de me reposer de mes labeurs passez, il me fallut trauailler l'espace de plus d'vn mois, nuit et iour, pour broyer les matieres desquelles i'auois fait ce beau blanc au fourneau des verriers; et quand i'eus broyé lesdites matieres i'en couuray les vaisseaux que i'auois faits : ce fait, ie mis le feu dans mon fourneau par deux gueules, ainsi que i'auois veu faire ausdits verriers, ie mis aussi mes vaisseaux dans ledit fourneau pour cuider faire fondre les esmaux que i'auois mis dessus : mais c'estoit vne chose mal-heureuse pour

moy : car combien que ie fusse six iours et six nuits deuant ledit fourneau sans cesser de brusler bois par les deux gueules, il ne fut possible de pouuoir faire fondre ledit esmail, et estois comme vn homme desesperé ; et combien que ie fusse tout estourdi du trauail, ie me vay aduiser que dans mon esmail il y auoit trop peu de la matiere qui deuoit faire fondre les autres, ce que voyant, ie me prins a piler et broyer ladite matiere, sans toutesfois laisser refroidir mon fourneau . par ainsi i'auois double peine, piler, broyer et chaufer ledit fourneau. Quand i'eus ainsi composé mon esmail, ie fus contraint d'aller encores acheter des pots, afin desprouuer ledit esmail: d'autant que i'auois perdu tous les vaisseaux que i'auois faits : et ayant couuert lesdites pieces dudit esmail, ie les mis dans le fourneau, continuant tousiours le feu en sa grandeur : mais sur cela il me suruint vn autre malheur, lequel me donna grande fascherie, qui est que le bois m'ayant failli, ie fus contraint brusler les estapes (étaies) qui soustenoyent les tailles de mon iardin, lesquelles estant bruslées, ie fus contraint brusler les tables et plancher de la maison, afin de faire fondre la seconde composition. l'estois en vne telle angoisse que ie ne sçaurois dire : car i'estois tout tari et deseché à cause du labeur et de la chaleur du fourneau; il y auoit plus d'vn mois que ma chemise n'auoit seiché sur moy, encores pour me consoler on se moquoit de moy, et mesme ceux qui me deuoient secourir alloient crier par la ville que ie faisois brusler le plancher : et par tel moyen l'on me faisoit perdre mon credit, et m'estimoit-on estre fol.

Les autres disoient que ie cherchois à faire la fausse monnoye, qui estoit vn mal qui me faisoit seicher sur les pieds; et m'en allois par les ruës tout baissé, comme vn homme honteux : i'estois endetté en plusieurs lieux, et auois ordinairement deux enfans aux nourrices, ne pouuant payer leurs salaires; personne ne me secouroit : Mais au contraire ils se mocquoyent de moy, en disant : il luy appartient bien de mourir de faim, par ce qu'il delaisse son mestier. Toutes ces nouuelles venoyent à mes aureilles quand ie passois par la ruë; toutesfois il me resta encores quelque esperance, qui m'accourageoit et soustenoit, d'autant que les dernieres espreuues s'estoyent assez bien portées, et deslors en pensois sçauoir assez pour pouuoir gaigner ma vie, combien que i'en fusse

fort esloigné (comme tu entendras ci apres), et ne dois trouuer mauuais si i'en fais vn peu long discours, afin de te rendre plus attentif à ce qui te pourra seruir.

Quand ie me fus reposé vn peu de temps auec regrets de ce que nul n'auoit pitié de moy, ie dis à mon ame, qu'est-ce qui te triste, puis que tu as trouué ce que tu cherchois? trauaille à present et tu rendras honteux tes detracteurs : mais mon esprit disoit d'autre part, tu n'as rien de quoy poursuyure ton affaire ; comment pourras-tu nourrir ta famille et acheter les choses requises pour passer le temps de quatre ou cinq mois qu'il faut auparauant que tu puisses iouir de ton labeur ? Or ainsi que i'estois en telle tristesse et debat d'esprit, l'esperance me donna vn peu de courage, et ayant consideré que ie serois beaucoup long pour faire une fournée toute de ma main, pour abreger et gagner le temps et pour plus soudain faire apparoir le secret que i'auois trouué dudit esmail blanc, ie prins vn potier commun et luy donnay certains pourtraits, afin qu'il me fist des vaisseaux selon mon ordonnance, et tandis qu'il faisoit ces choses ie m'occupois à quelques medailles : mais c'estoit vne chose pitoyable : car i'estois contraint nourrir ledit potier en vne tauerne à credit : parce que ie n'auois nul moyen en ma maison. Quand nous eusmes trauaillé l'espace de six mois, et qu'il falloit cuire la besogne faite, il fallut faire un fourneau et donner congé au potier, auquel par faute d'argent ie fus contraint donner de mes vestemens pour son salaire. Or par ce que ie n'auois point d'estoffes (matériaux) pour eriger mon fourneau, iè me prins à deffaire celuy que i'auois fait à la mode des verriers, afin de me seruir des estoffes de la despoüille d'iceluy. Or par ce que ledit four auoit si fort chaufé l'espace de six iours et nuits, le mortier et la brique dudit four s'estoient liquifiés et vitrifiés de telle sorte, qu'en desmaçonnant i'eus les doigts coupez et incisez en tant d'endroits que ie fus contraint manger mon potage ayant les doigts enuelopez de drapeau. Quand i'eus deffait ledit fourneau, il fallut eriger l'autre qui ne fut pas sans grand peine : d'autant qu'il me falloit aller querir l'eau, le mortier et la pierre, sans aucun ayde et sans aucun repos. Ce fait, ie fis cuire l'œuure susdite en premiere cuisson, et puis par emprunt ou autrement ie trouuay moyen d'auoir des estoffes pour faire des esmaux, pour couurir ladite besogne, s'estant

bien portée en premiere cuisson : mais quand i'eus acheté lesdites estofes il me suruint un labeur qui me cuida faire rendre l'esprit. Car apres que par plusieurs iours ie me fus lassé a piler et calciner mes matieres, il me les conuint broyer sans aucune aide, à vn moulin à bras, auquel il falloit ordinairement deux puissans hommes pour le virer : le desir que i'auois de paruenir a mon entreprinse me faisoit faire des choses que i'eusse estimé impossibles. Quand lesdites couleurs furent broyées, ie couuris tous mes vaisseaux et medailles dudit esmail, puis ayant le tout mis et arrangé dedans le fourneau, ie commençay a faire du feu, pensant retirer de ma fournée trois ou quatre cents liures, et continuay ledit feu iusques à ce que i'eûs quelque indice et esperance que mes esmaux fussent fondus et que ma fournée se portoit bien. Le lendemain quand ie vins à tirer mon œuvre, ayant premierement osté le feu, mes tristesses et douleurs furent augmentées si abondamment que ie perdis toute contenance. Car combien que mes esmaux fussent bons et ma besongne bonne, neantmoins deux accidens estoyent suruenus à ladite fournée, lesquels auoient tout gasté : et afin que tu t'en donnes de garde, ie te diray quels y sont : aussi apres ceux là ie t'en diray un nombre d'autres, afin que mon malheur te serue de bon-heur, et que ma perte te serue de gain. C'est par ce que le mortier dequoy i'auois massonné mon four estoit plain de cailloux, lesquels sentant la vehemence du feu (lors que mes esmaux se commençoient à liquifier) se creuerent en plusieurs pieces, faisans plusieurs pets et tonnerres dans ledit four. Or ainsi que les esclats desdit cailloux sautoient contre ma besongne, l'esmail qui estoit desja liquifié et rendu en matiere glueuse, print lesdits cailloux, et se les attacha par toutes les parties de mes vaisseaux et medailles, qui sans cela se fussent trouuez beaux. Ainsi connoissant que mon fourneau estoit assez chaut, ie le laissay refroidir iusques au lendemain ; lors ie fus si marri que ie ne te sçaurois dire, et non sans cause : car ma fournée me coutoit plus de six vingts escus. I'auois emprunté le bois et les estoffes, et si auois emprunté partie de ma nourriture en faisant laditte besongne. I'auois tenu en esperance mes crediteurs qu'ils seroyent payez de l'argent qui prouiendroit des pieces de ladite fournée, qui fut cause que plusieurs accoururent dès le matin quand ie commençois

à desenfourner. Dont par ce moyen furent redoublées mes tristesses ; d'autant qu'en tirant ladite besongne ie ne receuois que honte et confusion. Car toutes mes pieces estoyent semées de petits morceaux de cailloux, qui estoyent si bien attachez autour desdits vaisseaux, et liez auec l'esmail, que quand on passoit les mains par dessus, lesdits cailloux coupoyent comme rasoirs ; et combien que la besongne fust par ce moyen perdue, toutesfois aucuns en vouloient acheter à vil pris : mais par ce que ce eut esté vn descriement et rabaissement de mon honneur, ie mis en pieces entierement le total de ladite fournée et me couchay de melancholie, non sans cause, car ie n'auois plus de moyen de subuenir à ma famille ; ie n'auois en ma maison que reproches : en lieu de me consoler l'on me donnoit des maledictions : mes voisins qui auoyent entendu cest affaire disoyent que ie n'estois qu'vn fol, et que i'eusse eu plus de huit francs de la besongne que i'auois rompuë, et estoyent toutes ces nouuelles iointes auec mes douleurs.

Quand i'eus demeuré quelque temps au lit, et que i'eus consideré en moy mesme qu'vn homme qui seroit tombé en vn fossé, son deuoir seroit de tascher à se releuer, en cas pareil ie me mis à faire quelques peintures, et par plusieurs moyens ie prins peine de recouurer vn peu d'argent ; puis ie disois en moy-mesme que toutes mes pertes et hazards estoyent passez, et qu'il n'y auoit rien plus qui me peust empescher que ie ne fisse de bonnes pieces : et me prins (comme au parauant) à trauailler audit art. Mais en cuisant vne autre fournée il suruint vn accident duquel ie ne me doutois pas : car la vehemence de la flambe du feu auoit porté quantité de cendres contre mes pieces, de sorte que par tous les endroits ou ladite cendre auoit touché, mes vaisseaux estoyent rudes et mal polis, à cause que l'esmail estant liquifié s'estoit ioint auec lesdites cendres : nonobstant toutes ces pertes ie demeuray en esperance de me remonter par le moyen dudit art : car ie fis faire grand nombre de lanternes de terre à certains potiers pour enfermer mes vaisseaux quand ie les mettois au four : afin que par le moyen desdites lanternes mes vaisseaux fussent garentis de la cendre. L'inuention se trouua bonne, et m'a serui iusques au iourd'huy (1) : Mais ayant obuié

(1) Elle sert encore de nos jours sous le nom de manchons ou de *cazettes*.

DE L'ART DE TERRE.

au hazard de la cendre, il me suruint d'autres fautes et accidens tels, que quand i'auois fait vne fournée, elle se trouuoit trop cuitte, et aucune fois trop peu, et tout perdu par ce moyen. l'estois si nouueau que ie ne pouuois discerner du trop ou du peu; aucunefois ma besongne estoit cuitte sur le deuant et point cuitte à la partie de derriere: l'autre apres que ie voulois obuier à tel accident, ie faisois brusler le derriere et le deuant n'estoit point cuit: aucunefois il estoit cuit à dextre et bruslé à senestre: aucunefois mes esmaux estoyent mis trop clairs, et autrefois trop espais: qui me causoit de grandes pertes: aucunefois que i'auois dedans le four diuerses couleurs d'esmaux, les vns estoyent bruslez premier que les autres fussent fondus. Bref i'ay ainsi bastelé l'espace de quinze ou seize ans; quand i'auois appris à me donner garde d'vn danger, il m'en suruenoit un autre, lequel ie n'eusse iamais pensé. Durant ces temps là ie fis plusieurs fourneaux lesquels m'engendroient de grandes pertes auparauant que i'eusse connoissance du moyen pour les eschauffer également; enfin ie trouuay moyen de faire quelques vaisseaux de diuers esmaux entremeslez en maniere de iaspe: cela m'a nourri quelques ans: mais en me nourrissant de ces choses ie cherchois tousiours à passer plus outre auecques frais et mises, comme tu sçais que ie fais encores à present. Quand i'eus inuenté le moyen de faire des pieces rustiques, ie fus en plus grande peine et en plus d'ennuy qu'auparauant. Car ayant fait vn certain nombre de bassins rustiques (1) et les ayant fait cuire, mes esmaux se trouuoyent les vns beaux et bien fonduz, autres mal fonduz, autres estaient brulez, à cause qu'ils estoient composez de diuerses matieres qui estoient fusibles à diuers degrez; le verd des lezards estoit bruslé premier que la couleur des serpens fut fonduë, aussi la couleur des serpens, escreuices, tortues et cancres, estoit fondue au parauant que le blanc eut receu aucune beauté. Toutes ces fautes m'ont causé vn tel labeur et tristesse d'esprit, qu'auparauant que i'aye eu rendu mes esmaux fusibles à vn mesme degré de feu, i'ay cuidé entrer iusques à la porte du sépulchre: aussi en me trauaillant à tels affaires ie me suis trouué l'espace de plus de

(1) Ce que Palissy appelle *pièces* ou *bassins rustiques* sont les ouvrages sur lesquels il plaçait des reptiles, des poissons, des coquillages en relief, et peints avec leurs couleurs naturelles.

dix ans si fort escoulé en ma personne, qu'il n'y auoit aucune forme n'y apparence de bosse aux bras ny aux iambes : ains estoyent mesdites iambes toutes d'vne venue : de sorte que les liens de quoy i'attachois mes bas de chausses estoyent, soudain que ie cheminois, sur les talons auec le residu de mes chausses. Ie m'allois souuent pourmener dans la prairie de Xaintes, en considerant mes miseres et ennuys : Et sur toutes choses de ce qu'en ma maison mesme ie ne pouuois auoir nulle patience, n'y faire rien qui fut trouué bon. I'estois mesprisé, et mocqué de tous : toutefois ie faisois tousiours quelques vaisseaux de couleurs diuerses, qui me nourrissoient tellement quellement : Mais en ce faisant, la diuersité des terres desquelles ie cuidois m'auancer, me porta plus de dommage en peu temps que tous les accidents du parauant. Car ayant fait plusieurs vaisseaux de diuerses terres, les vnes estoyent bruslées deuant que les autres fussent cuittes : aucunes receuoyent l'esmail et se trouuoyent fort aptes pour cest affaire: les autres me deceuoyent en toutes mes entreprinses. Or par ce que mes esmaux ne venoyent bien en vne mesme chose, i'estois deceu par plusieurs fois : dont ie receuois tousiours ennuis et tristesse. Toutesfois l'esperance que i'auois, me faisoit proceder en mon affaire si virilement que plusieurs fois pour entretenir les personnes qui me venoyent voir ie faisois mes efforts de rire, combien que interieurement ie fusse bien triste.

Ie poursuyuiz mon affaire de telle sorte que ie receuois beaucoup d'argent d'vne partie de ma besongne, qui se trouuoit bien : mais il me suruint vne autre affliction conquatenée auec les susdites, qui est que la chaleur, la gelée, les vents, pluyes et gouttieres, me gastoyent la plus grande part de mon œuure, au parauant qu'elle fut cuitte : tellement qu'il me fallut emprunter charpenterie, lattes, tuilles et cloux, pour m'accommoder. Or bien souuent n'ayant point dequoy bastir, i'estois contraint m'accommoder de liarres (lierres) et autres verdures. Or ainsi que ma puissance s'augmentoit, ie defaisois ce que i'auois fait, et le batissois vn peu mieux; qui faisoit qu'aucuns artisans, comme chaussetiers, cordonniers, sergens et notaires, vn tas de vieilles, tous ceux cy sans auoir esgard que mon art ne se pouuoit exercer sans grand logis, disoyent que ie ne faisois que faire et desfaire, et me blasmoyent de ce qui les deuoit inciter à pitié, attendu que i'estois

contraint d'employer les choses necessaires à ma nourriture, pour eriger les commoditez requises à mon art. Et qui pis est, le motif desdites mocqueries et persecutions sortoit de ceux de ma maison, lesquels estoyent si esloingnez de raison, qu'ils vouloyent que ie fisse la besongne sans outis, chose plus que déraisonnable. Or d'autant plus que la chose estoit déraisonnable, de tant plus l'affliction m'estoit extreme. I'ay esté plusieurs années que n'ayant rien dequoy faire couurir mes fourneaux, i'estois toutes les nuits à la mercy des pluyes et vents, sans auoir aucun secours aide ny consolation, sinon des chatshuants qui chantoyent d'vn costé et les chiens qui hurloyent de l'autre; parfois il se leuoit des vents et tempestes qui souffloyent de telle sorte le dessus et le dessouz de mes fourneaux, que i'estois contraint quitter là tout, auec perte de mon labeur; et me suis trouué plusieurs fois qu'ayant tout quitté, n'ayant rien de sec sur moy, à cause des pluyes qui estoyent tombées, ie m'en allois coucher à la minuit où au point du iour, accoustré de telle sorte comme vn homme que l'on auroit trainé partous les bourbiers de la ville; et en m'en allant ainsi retirer, i'allois bricollant sans chandelle, et tombant d'vn costé et d'autre, comme vn homme qui seroit yure de vin, rempli de grandes tristesses : d'autant qu'apres auoir longuement trauaillé ie voyois mon labeur perdu. Or en me retirant ainsi soüillé et trempé, ie trouuois en ma chambre vne seconde persecution pire que la premiere, qui me fait à present esmerueiller que ie ne suis consumé de tristesse (1).

Theorique.

Pourquoy me cherches tu vne si longue chanson? c'est plutost pour me destourner de mon intention, que non pas pour m'en approcher; tu m'as bien fait cy dessus de beaux discours touchant les fautes qui suruiennent en l'art de terre, mais cela ne me sert que d'espouuantement : car des esmaux tu ne m'en as encores rien dit.

Practique.

Les esmaux dequoy ie fais ma besongne, sont faits d'es-

(1) Ce récit est non-seulement plein d'intérêt, de grandeur, d'éloquence naïve, mais, sous le rapport du style, on peut le regarder comme un des morceaux les plus précieux qui nous soient restés de langue française au seizième siècle. Il brille d'ailleurs par plus d'un genre de mérite, comme nous avons essayé de le montrer dans l'essai historique placé en tête de ce volume.

taing, de plomb, de fer, d'acier, d'antimoine, de saphre, de cuiure, d'arene, de salicort, de cendre grauelée, de litarge, de pierre de Perigord. Voila les propres matieres desquelles ie fais mes esmaux.

Theorique.

Voire, mais ainsi que tu dis tu ne m'apprens rien. Car i'ay entendu cy deuant par tes propos que tu as beaucoup perdu au parauant que d'auoir mis les esmaux en doze asseurée : parquoy tu sçais bien que si tu ne me donnes la doze, ie ne sçaurois que faire de sçauoir les matieres.

Practique.

Les fautes que i'ay faites en mettant mes esmaux en doze, m'ont plus apprins que non pas les choses qui se sont bien trouuées : parquoy ie suis d'aduis que tu trauailles pour chercher laditte doze, aussi bien que i'ay fait, autrement tu aurois trop bon marché de la science, et peut estre que ce seroit la cause de te la faire mespriser : car ie sçay bien qu'il n'y a gens au monde qui facent bon marché des secrets et des arts, sinon ceux ausquels il ne coustent gueres : mais ceux qui les ont pratiquez à grands frais et labeurs ne les donnent ainsi legerement.

Theorique.

Tu me fais trouuer les choses merueilleusement bonnes : si c'estoit quelque grande science, de laquelle on eut grande necessité, tu la ferois bien trouuer bonne : veu que tu estimes si fort vn art mechanique, duquel on se peut passer aisément.

Practique

Voila vn propos par lequel ie connois à present que tu es indigne d'entendre rien du secret dudit art : et puis que tu l'appelles art mechanique tu n'en sçauras plus rien par mon moyen (1). On sçait bien qu'audit art, il y a quelques parties mechaniques, comme de batre la terre : il y en a aucuns qui font des vaisseaux pour le seruice ordinaire des cuisines, sans tenir aucune mesures, ils se peuuent appeller mechaniques : mais quant au gouuernement du feu, il ne doit estre comparé a la mesure des mechaniques. Car il faut que tu sçaches que pour bien conduire vne fournée de besongne, mesmement

(1) On reconnaît le grand artiste à la sainte indignation qui l'anime quand on essaie de ravaler son art.

quand elle est esmaillée, il faut gouuerner le feu par vne philosophie si soingneuse qu'il n'y a si gentil esprit qui n'y soit bien trauaillé, et bien souvent deceu. Quand a la maniere de bien enfourner, il y est requis vne singuliere Geometrie.

Item, tu sçais qu'on fait en plusieurs lieux des vaisseaux de terre qui sont conduits par vne telle Geometrie qu'vn grand vaisseau se soustiendra sur vn petit pied, mesme la terre estant encores molle; appelles-tu cela mechanique? Sçais tu pas bien que les mesures du compas ne se peuvent appeller mechaniques pour estre trop communes, aussi par ce que les ouuriers d'iceux sont pauures ; toutesfois les arts ausquels sont requis compas, reigles, nombres, poids et mesures, ne doyuent estre appellez mechaniques. Et puis qu'ainsi est que tu veux mettre l'art de terre au rang des mechaniques, et que tu n'estimes gueres son vtilité, ie te veux à present faire entendre combien elle est plus grande que ie ne te sçaurois dire. Consideres vn peu combien d'arts seroyent inutiles, voire entierement perdus, sans l'art de terre. Il faudroit que les affineurs d'or et d'argent cessassent, car ils ne sçauroyent rien faire sans fourneaux, ny vaisseaux de terre : d'autant qu'il ne se peut trouuer pierre ny autres matieres qui puissent seruir à fondre les metaux, sinon les vaisseaux de terre.

Item, il faudroit que les verriers cessassent : car ils n'ont aucun moyen pour fondre les matieres de leurs verres sinon en vaisseaux de terre. Les orfeures, fondeurs, et toute fonderie de quelque sorte et espece que ce soit, seroit aneantie et ne s'en trouuera aucune qui se puisse passer de terre. Regarde aussi les forges des mareschaux et serruriers, et tu verras que toutes lesdittes forges sont faites de briques : car si elles estoyent de pierres elles seroyent soudain consommées. Regarde tous les fourneaux, tu trouueras qu'ils sont faits de terre, mesme ceux qui trauaillent de terre font tous leurs fourneaux de terre, comme tuiliers, briquetiers et potiers : bref il ne se trouue pierre, ny mineral, ny autre matiere qui puisse seruir a l'edification d'vn fourneau à verres, ou à chaux, ou autres susdits, qui puisse durer longuement. Tu vois aussi combien les vaisseaux communs de terre sont vtiles à la republique, tu vois aussi combien l'vtilité de la terre est grande pour les couuertures des maisons : tu sçais bien qu'en beaucoup de pays ils ne sçauent que c'est d'ardoise

et n'ont autre couuertures que de tuilles : combien cuides tu que l'vtilité de la terre soit grande, pour conduire les ruisseaux des fontaines? on sçait bien que les eaux qui passent par les tuyaux de terre sont beaucoup meilleures et plus saines que celles qui sont conduittes par canaux de plomb. Combien cuides tu qu'il y a de villes qui sont edifiées de briques, d'autant qu'ils n'ont pas eu moyen de recouvrer de la pierre? Combien cuides tu que nos ancestres ont estimé l'vtilité de l'art de terre? on sçait bien que les Egyptiens et autres nations ont fait construire plusieurs bastiment somptueux, de l'art de terre, il y a eu plusieurs Empereurs et Rois, qui ont fait edifier de grandes Piramides de terre, afin de perpetuer leurs memoires, et aucuns d'eux ont ce fait craignants que leurs Piramides fussent ruinées par feu, si elles eussent esté de pierre. Or sçachans que le feu ne peut rien contre les bastimens de terre cuite, ils les faisoyent edifier de briques, tesmoings les enfans d'Israel, lesquels ont esté merueilleusement opprimez en faisant les briques desdits bastimens. Si ie voulois mettre par escrit toutes les vtilitez de l'art de terre ie n'aurois iamais fait : parquoy ie te laisse à penser en toy mesme le surplus de son vtilité. Quand à son estime, si elle est auiourd'huy mesprisée, ce n'a pas esté de tous temps. Les historiens nous certifient que quand l'art de terre fut inuenté, les vaisseaux de marbre, d'alebastre, cassidoine et de iaspe, furent mis en mespris : mesmes que plusieurs vaisseaux de terre ont esté consacrez pour le seruice des temples.

POVR TROVVER ET CONNOISTRE LA TERRE

nommée Marne, de laquelle l'on fume les champs infertiles, ès pays et regions où elle est connue : chose de grand poids et necessaire à tous ceux qui possedent heritages.

THEORIQUE.

IL me souuient auoir veu vn petit traité que tu fis imprimer durant les premiers troubles, auquel sont contenus plusieurs secrets naturels, et mesme de l'agriculture (1) : toutesfois combien que tu ayes amplement parlé des fumiers, si est ce que tu n'as rien dit de la terre qui s'appelle Marne : bien sçay-ie que tu as promis par ton liure de regarder s'il s'en pourroit trouuer en Xaintonge et autres lieux où ladite terre est encor inconnuë. Ie me suis enquis plusieurs fois si tu aurois composé quelque autre liure où tu eusses parlé de ladite terre : mais ie n'en ay rien trouué : parquoy si tu en as quelque intelligence ou connoissance d'icelle, ne me le cele point : ce ne seroit pas bien fait à toy d'enseuelir vn secret vtile à la République.

PRACTIQUE.

A la verité ie promis par mon liure que tu dis, de chercher de la Marne au pays de Xaintonge, par ce que pour lors i'estois hab'tant audit pays et y pensois finir mes iours; et par ce que audit pays n'est aucune nouuelle de ladite Marne, et que i'en avois veu au pays d'Armaignac, i'eusse esté bien aise de laisser quelque profit ou faire quelque seruice au pays de mon habitation : et pour ces causes me suis efforcé d'auoir ample connoissance de ladite terre : toutesfois quand elle seroit conneüe ou commune aux autres pays comme elle est en la Brye

(1) C'est encore là, bien évidemment, le livre intitulé : RÉCEPTE VÉRITABLE, *imprimé durant les premiers troubles*, et non point la *Déclaration des abus et ignorances des médecins*, dans laquelle il n'est nullement question d'agriculture.

et Champagne ie n'en daignerois parler : parce que les laboureurs qui la mettent en œuure ne se soucient point d'entendre la cause pourquoy elle rend la terre fertile : et combien que la cause ne requiert point estre entendue de tous, si est ce que les medecins et tous physiciens, Philosophes et naturalistes, pourront beaucoup profiter à la lecture des causes et raisons que ie te diray en continuant nostre propos.

Theorique.

Ie te prie en premier lieu entendre de toy que c'est que Marne.

Practique.

La Marne est communement vne terre blanche que l'on tire au dessouz de l'autre terre, et communement l'on fait les fosses pour la tirer en telle forme que l'on fait les puits à tirer les eaux, et au pays où ladite terre est en vsage on la boute dans les champs steriles, en la forme et maniere que l'on boute les fumiers, premierement par petites pilles, et puis il la faut dilater par les champs, comme l'on fait les fumiers, et quand les terres steriles sont fumées de ladite terre, c'est assez pour dix ou douze années : aucuns disent qu'en diverses contrées il n'y faut plus rien mettre de trente années. Aucunes desdites marnes se commencent à trouuer dés l'entrée de la fosse, et poursuyuent la profondeur vn nombre de toises de profond. En d'autres lieux et coutreés il faut creuser plus de quatre ou cinq toises de profond au parauant que trouuer le commencement de la Marne. Voila ce que i'ay peu tirer de ceux qui vsent communement de la Marne. Toutesfois i'ay entendu de quelque personnage que la Marne ne profite de gueres aux champs la premiere année qu'elle y est mise, ce que ie trouue fort estrange.

Theorique.

Pourquoy est ce que tu trouues estrange de ce qu'ils disent que la premiere année que la terre sera marnée elle ne produira rien? si tu auois consideré la cause qui peut actionner la vegetation des fruits tu ne trouuerois estrange vne telle raison : car il n'y a homme en ce monde qui me sçeut faire acroire que la marne puisse aider à la generation, sinon pour cause de la chaleur qui est en elle : comme nous voyons que nulle chose ne peut vegeter en hyuer, et nulle semence ne germeroit iamais, n'estoit la chaleur procedée d'en haut par la

vertu du soleil : combien que le soleil cause la vegetation de toutes choses, si est ce que quand il est trop chaud il deseiche l'humidité, et les vegetatifs ne peuuent prendre accroissement : le soleil donc est la vie et quand il est trop vehement est aussi la mort : en cas pareil, la marne est cause de generation germinatiue ou vegetatiue des plantes, pour cause de la chaleur : mais quand elle est nouuellement tirée il faut croire que sa chaleur est si grande qu'elle brusle les semences. Voila pourquoy la generation des semences qui seront iettées en la terre la premiere année ne peut croistre.

Practique.

A la verité ta raison est fort grande et fort aisée à faire croire à ceux qui n'ont gueres de sentiment des choses naturelles : mais en mon endroit vn tel argument ne trouuera iamais lieu.

Theorique.

Ie t'en bailleray à present vn autre contre lequel tu ne pourras opposer aucun argument legitime, et quand tu voudrois contredire, le moindre laboureur des Ardennes te rendra confus. Il faut necessairement que tu me confesses que la pierre cuite dedans les fournaises ardantes, soit reduite en poussiere par la vehemence du feu, et que l'humidité desdites pierres s'estant exalée, il n'y demeure plus que le terrestre rempli d'vne vertu ignée, et pour ces causes l'on l'appelle chaux : par ce qu'elle est chaude, voire si chaude qu'il est aduenu plusieurs fois que ayant apporté desdites pierres dans des maisons sur de la paille, lesdites maisons ont esté bruslées par le mouuement de certaines gouttieres d'eaux qui sont cheutes en temps de pluye sur ladite chaux : et tout ainsi que les pierres de ladite chaux sont dissoutes par l'humidité qui leur est presentée quand elles sont tirées du four, semblablement en cas pareil les pierres de marne estant tirées de la fosse se viennent a dissoudre et mettre en poussiere comme les pierres de chaux. I'ay encores vn bel argument et preuue suffisante pour conclure ce que i'ay dit, qui est que d'autant que les terres circonuoisines des bois des Ardennes, sont froides à cause des neiges et froidures dudit pays, les laboureurs de certaines contrées ayant indigence de fiens (fumiers), se sont aduisez de fumer les terres de chaux, en cas pareil et forme que l'on a coustume de les engresser de fumiers : et par tel moyen

ils ont rendu les terres fertilles, qui ne produysoient rien auperavant. Puis que la chaux cause vn tel bien par sa chaleur (comme ainsi soit que les laboureurs disent que la chaux eschauffe les terres, et fait germer les semences), puis-ie pas donc par là conclure que la marne ne peut de rien seruir aux champs sinon pour cause de sa chaleur?

PRACTIQUE.

Les raisons qui sont bonnes, comme celle que tu dis, seront tousiours receües pour bonnes, moyennant qu'il n'y en ait point de meilleure que les tiennes : et combien que tes arguments ayent grande apparence de verité, ie te vay bailler des raisons plus veritables que les tiennes, et premierement, quant à ce que tu dis que la terre de marne se dissoult à l'humidité comme la chaux, à ce ie responds qu'ainsi font toutes terres, quand elles sont seiches, et singulierement toutes terres argileuses : et quand à l'autre raison que tu pourrois alleguer, que la marne est aussi blanche comme la chaux, à ce ie responds qu'il y a de la marne grise, noire, iaune, par lesquelles couleurs ie prouue l'argument obiectable.

THEORIQUE.

Ie ne sçay quel obiect tu sçaurois alleguer contre mon dire : car nous sçauons que la cause que le fumier aide à la vegetation des semences, est pour cause de sa chaleur, et si ainsi est du fumier, il est semblable à la marne et à la chaux.

PRACTIQUE.

Tu veux donc dire et conclure que le fumier est chaud?

THEORIQUE.

Et me voudrois tu nier vne chose si euidente? ne sçauons nous pas que l'on fait consommer et reduire les lames de plomb en ceruse dedans les fumiers, à cause de la grande chaleur? ne sçait-on pas bien que plusieurs teintures de soye se font dedans les fumiers chauds? ne sçait on pas bien que plusieurs alchimistes se seruent de fumiers chauds, pour mettre couuer les œufs de leurs essences? il n'y a pas iusques aux pourceaux qui ne rendent tesmoignage de la chaleur des fumiers? car bien souuent les fumiers leur seruent de poilles ou estuues pour s'eschauffer.

PRACTIQUE.

Tout cela est fort mal entendu, et ne fait rien contre moy. Nous sçauons bien que quand le foin et la paille sont humectez

par les eaux, ils se putrifient, et en se putrifiant la putrefaction cause vne grande chaleur és pailles et foins, iusques à ce que la dissolution de l'essence radicalle soit accomplie, et ce fait, le fumier n'a plus de chaleur. Nous sçauons aussi que les pierres de chaux cuites, engendrent vn feu, lequel feu dure en elle iusques à ce qu'elle se soit creuée et puluerisée, et apres la chaleur n'y est plus; nous sçauons aussi que l'eau bouillante est chaude tandis qu'elle est esmeüe ou touchée par le feu, mais apres, estant reposée hors du feu, elle est plus subiette à la gelée que non pas l'eau qui n'aura point chauffé. Nous sçauons aussi que vne playe ou concussion, qui par accident auenu engendrera apostume à la partie offensée, sera plus chaude que de coustume, à cause de l'accident et de la putrefaction qui se fait, comme ie t'ay dit de la paille ou foin, qui s'eschauffe par accident de putrefaction, et non que la chaleur y soit tousiours. Nous sçauons aussi que deux cailloux ou autres matieres dures engendreront (quand elles seront frappées l'vne contre l'autre) des bluettes ou estincelles de feu : ce n'est pas pourtant à dire que les cailloux soyent chauds : mais c'est ce que ie di, que les accidens engendrent des chaleurs extraordinaires : parquoy faut conclure qu'il y a quelque cause autre qui fait germer les semences. Quand i'ay contemplé de bien pres la terre appellée Marne, i'ay trouué que ce n'estoit autre chose que vne sorte de terre argileuse, et si ainsi est, c'est le contraire des raisons que tu as amenées : car nous tenons pour certain que la terre argileuse est froide et seiche, comme tu peux auoir entendu en parlant des metaux et mineraux, en te prouuant que en plusieurs terres argileuses se trouuent des marcassites, mesme du bois metallisé et petrifié; et si la terre de marne estoit chaude, la terre d'argile le seroit aussi, et tout ce que i'aurois escrit en parlant des terres, pierres et metaux, seroit faux. Faut commencer donc par ce bout et en fin conclure que la terre de marne est vne espece d'argile, laquelle ayant demeuré plusieurs années à l'iniure du temps, elle se seroit refroidie ou gelée voire dés la premiere gelée : et ores qu'elle auroit esté chaude en la matrice de la terre elle ne pourroit seruir à eschauffer la terre vne seule année. Autant en di-ie du fumier et de la chaux, il est aisé à conclure puisque la terre est ameilleurée par la marne l'espace de dix ou trente ans, que cela n'est pas causé de chaleur qui soit en

elle : car en tirant la dite marne en plusieurs lieux, il s'en trouue qui ne se peut dissoudre à l'iniure du temps, ny par par les pluyes, iusques à ce que la gelée y ayant besongné, laquelle gelée trouuant les pierres de marne dures comme craye, les fera dissoudre et reduire en poussiere, comme ainsi soit que cela auienne souuent és pierres tendres, lesquelles pierres on appelle iolices (gélisses), desquelles i'ay parlé cy dessus; et pour faire fin à toutes disputes, ie te dis que la marne estoit vne terre au parauant qu'estre marne, que terre argileuse et commencement de pierre de craye à esté premierement marne, et te di encores, que la craye qui est encores en la matrice de la terre deuiendra pierre blanche, et te di encores autre chose qui te faschera plus de croire, qu'en quelque part qu'il y ait des pierres sujettes à calcination, elles ont esté marne auparauant qu'estre pierres : car autrement estans calcinées elles ne pouroyent meilleurer les champs stériles.

Theorique.

Ie ne vis iamais homme plus opiniatre en ses opinions que toy; cuides-tu trouuer des hommes si fols qui veulent croire les propos que tu as mis en auant? tu en trouueras bon nombre qui s'en mocqueront, et t'estimeront destitué de toute raison : de ma part ie me suis deliberé de ne rien croire de ce que tu dis si tu ne me donnes preuues aisées et intelligibles, par lesquelles tu me face croire qu'il y a quelque cause qui ayde à la vegetation des semences, autre que la chaleur qui est en la chaux, Marne et fumiers. Car comme ie t'ay dit, puis que la Marne ne profite gueres aux champs la premiere année, c'est signe comme i'ay dit que la trop grand chaleur qui est en elle empesche son action.

Practique.

Tu t'abuses et n'entens pas ce que tu dis, car ce n'est pas vne chose ordinaire, ny en tous lieux, que la marne fait mieux son deuoir la seconde année et autres suyuantes que la premiere : mais en cest endroit il te faut noter vn point singulier et de grand poids, lequel tu peux auoir entendu par le propos subsequent, qui est que la Marne se reduit en craye ou autre pierre par vne longue decoction, et quand vne marne commence à passer sa decoction, elle s'endurcit en telle sorte que les pluyes ne la peuuent disoudre au deuoir requis, ains

demeure aux champs par petits morceaux sans se liquifier parmi la terre, et aduient par ces causes qu'elle ne peut donner saueur en la terre iusques à ce qu'elle soit disoute et liquifiée, et d'autant que cela ne se peut faire si soudain de la premiere année, les gelées auront causé quelque temps apres la dissolution de ladite marne, qui est ia commencée à putrifier, et estant ainsi disoute et liquifiée, elle aidera à la generation des semences qui luy seront presentées. Voila vn point que tu dois tenir et garder comme chose certaine : cela est fort aisé à connoistre au pays de Valois, Brie et Champagne, auquel pays se trouue de ladite marne abondamment, et encores plus abondamment de la craye, qui autrefois a esté marne et s'est reduite en pierre de craye par sa longue decoction. Tu peux auoir entendu vne partie de ces raisons en mon traité des pierres.

Theorique.

Et ie te demande, si ainsi est que tu dis que la terre de craye estoit premierement marne, la craye pourroit donc seruir de marne moyennant qu'elle fut bien puluerisée ; car s'il est ainsi que tu dis, la mesme vertu qui estoit en la marne est encores en la craye.

Practique.

Tu as fort bien iugé, mais la craye estant lapifiée ne se pourroit dissoudre, et ce ne seroit pas assez de la mettre en poussiere, aussi qu'elle cousteroit trop à pulueriser, et pour vray si les gelées la pouuoient dissoudre elle seruiroit de marne : et pour le tesmoignage de ce que ie dis, ie te renuoiray à ce que i'ay dit cy dessus, que la pierre de chaux estant dissoute par le feu sert de marner ou fumer les terres. Voudrois tu vn plus beau tesmoignage, il te faut encores passer outre et regarder à la cause de la difference des couleurs, qui sont aux marnes. La cause des marnes blanches, procede de sa longue decoction, quand est des noires, il y peut auoir plusieurs causes, dont la principale est, qu'il n'y a pas long temps que les matieres sont commencées à congeler, et telles marnes sont de plus aisée dissolution : ils peuuent aussi auoir de quelque bois pourry ou mineralles qui peuuent auoir taint en noir les matieres. Quant est des iaunes, les mines de fer, de plomb, d'argent et d'antimoine, tous ces mineraux peu-

uent teindre les marnes en iaune : voila pourquoy il s'en trouue de couleurs diuerses.

Theorique.

Et puis que tu dis que la chaleur de la marne, des fumiers, et de la chaux, n'est pas la cause actionale des vegetations seminales, donne-moy donc à entendre par quelle vertu la marne pourroit actionner ces terres infertilles.

Practique.

Quand ie t'ay dit qu'il ne falloit pas attribuer à la chaleur de la marne la vertu generatiue, ie n'ay pas voulu pour cela destituer totalement la marne de la chaleur : mais i'ay voulu par là destruire la folle opinion de ceux qui veulent attribuer le total à la chaleur : ie dis le total interieurement et exterieurement. L'on sçait bien que le sel est chaud interieurement, et pour ces causes l'on dit qu'il ayde à la generation genitale : et toutesfois en temps de froidures tu trouueras le sel autant froid que de l'eau ou des pierres, il faut conclure donc, que sa chaleur ne peut actionner si elle n'est esmuë par vne contre-chaleur, sçauoir est en ce qui consiste le fait seminal, il faut donc philosopher plus loing et regarder à la cause essentielle, esmouuante et operante en ce fait icy, et l'on trouuera quelque chose de caché que les hommes ne peuuent entendre.

Theorique.

Ie te prie, si tu en as quelque connoissance, ne me fais point languir, mais donne moy clairement a entendre ce que tu en penses.

Practique.

Si tu eusses amplement ouuert les aureilles quand tu lisois le subsequent de ce liure, tu eusses aisément entendu ce qui en est : car ie t'ay dit cy deuant qu'il y auoit vn Element cinquiesme, lequel les Philosophes n'ont iamais conneu ; et ce cinquiesme Element, est vne eau generatiue, claire ou candide, subtile, entremeslée parmi les autres eaux indistinguibles, laquelle eau estant apportée auec les eaux communes, elle s'endurcist et se congele auec les choses qui y sont entremeslées, et tout ainsi que les eaux communes montent en haut par l'attraction du Soleil, soit que ce soit par nuées, exalations ou vapeurs, si est-ce que l'eau seconde la-

quelle i'appelle element cinquiesme, est portée auec les autres : et quand les eaux communes viennent à descendre et découler le long des valées, soit par fleuues, riuieres ou sources, ou par pluyes, ie dis qu'en quelque sorte qu'elles descendent, en quelque part qu'elle s'arrestent, il se forme quelque chose, et singulierement par tel moyen les cailloux et pierres et carrieres sont formées, chose bien certaine comme tu peux auoir bien entendu en lisant mon discours des pierres : or venons à present au principal, voyons comment cela se peut faire. Apres que tu auras bien entendu qu'il y a vne eau generatiue et l'autre exalatiue, et comme tu pourras aisément entendre que l'eau congelatiue est generatiue, laquelle i'appelle le cinquiesme element, que quand elle est remuée par l'eau contenuë en quelque receptacle, ou lieu de repos, elle estant en tel repos se viendra à congeler et fera quelque pierre selon la grosseur de la matiere qui y sera arrestée, et portera la forme de son giste; et apres qu'elle sera ainsi congelée, l'eau commune quelquefois sera succée par la terre et descendra plus bas, ou bien sera exalée et s'en yra en vapeurs és nuées, et laissera là sa compagne, parce qu'elle ne la pourra plus porter. Voila vne sentence qui te doit faire entendre qu'aupara-uant que la marne fut marne, c'estoit de la terre dedans laquelle les deux eaux sont entrées et ont reposé quelque temps; et estant en repos, l'eau generatiue ayant trouué son repos s'est venuë à congeler et la vaporatiue a passé outre, ou bien s'est exalée, comme i'ay dit cy dessus, et la terre où l'eau congelatiue s'est arrestée a esté endurcie et conséquemment blanchie par l'effect de ladite eau congelatiue, qui a fait vn corps auec elle; et de là vient que quand la terre est reduite en marne par l'action de l'eau generatiue, la terre qui lors est portée aux champs et qui s'appelle marne, ce n'est pas cela qui rend la terre fructueuse, ains est l'eau congelatiue qui s'est arrestée parmy la terre : laquelle eau estant arrestée à cause comme i'ay dit, endurcit et blanchit la terre, et quand les semences sont iettées sur la terre conuertie en marne, elles ne prennent la substance de la terre pour ayder à leur vegetation, ains se repaissent de l'eau generatiue et congelatiue, que i'appelle le cinquiesme element, et quant les semences par l'espace de plusieurs années ont attiré l'eau generatiue, la terre de marne est inutile comme le marcq de

quelque decoction qui auroit esté faite, autant en est-il du fumier et de la chaux (1).

Theorique.

Tu voudrois donc conclure que les semences vegetatiues succeroyent ce cinquiesme element que tu appelles eau generatiue, comme vn homme qui succeroit de l'eau ou du vin par le trou d'vne bonde, et laisseroit la lie faire son marq au fond du tonneau?

Practique.

Tu dis vray et n'en faut rien douter, mais faut entrer en consideration plus subtile, car les semences vegetatiues ne pourroyent faire attraction de l'eau generatiue, sans qu'elle fut humectée par les eaux communes, et te faut noter que quand les terres sont humectées par les pluyes ou rosée, ou autrement que les vegetatifs prennent de l'eau commune auec la congelatiue ; laquelle eau commune luy empesche la trop hatiue congelation, et de là vient que les frouments et autres semences se tiennent verds iusques à leur maturité, et quand ils sont meurs et que le pied laisse son succement et qu'il n'a plus que faire de nourriture, l'eau exalatiue s'en va et la generatiue demeure : et comme la decoction des plantes se parfait, la couleur aussi change, comme il fait semblablement és pierres et à toutes especes de mineraux, comme ie t'ay dit en mes autres traitez parlant des mineraux, que toute espece de fruits changent de couleur en leur maturité, suyuant quoy ie t'ay tousiours dit, en parlant de l'element cinquiesme,

(1) Ce *cinquième élément*, que Palissy a tant de peine à définir, et auquel il donne tantôt le nom de *Sel*, tantôt celui d'*Eau générative* ou *congélative*, était une pensée de premier ordre, mais qui ne se présentait pas bien nettement à son esprit; et cela ne doit point étonner dans un physicien qui s'était formé lui-même, un chimiste qui, suivant son expression, avait appris la chimie *avec les dents*. On comprend toutefois qu'après avoir réfléchi sur l'acte de la composition et de la décomposition des corps, et n'ayant pu trouver la raison de ces phénomènes dans les idées physiques de son siècle, pas plus que dans les quatre éléments de l'école d'Aristote, il en ait cherché la cause dans une force particulière, un *cinquième élément* qui, selon lui, unissait, séparait les parties des corps ou les maintenait dans leur état et dans leurs formes. On voit qu'il ne s'agissait pas moins que de l'attraction, de l'affinité et de la force vitale, qui se présentaient à Palissy, parfois comme une substance soluble, sapide, colorée, odorante, d'autres fois sous la forme d'un liquide chimique, toujours comme un *élément* particulier, une force occulte, principe de toute action entre les matériaux des corps naturels. Qui oserait assurer que cette pensée instinctive, bien que vague et obscurément exprimée, ait été perdue pour Boyle et pour Newton!

que combien que c'est vne eau, et parmy les autres eaux que c'est celuy qui soustient pailles et foins, et toutes especes d'arbres et plantes, mesme les hommes et les bestes, et t'ay dit mesme que les os de l'homme et de la beste sont endurcis et formez de ceste belle substance generatiue; et comme tu vois qu'au commencement la marne est vne terre tendre et fluante, et puis de là deuient en marne plus dure, et de marne en craye, et de craye en pierre, par la vertu de laquelle eau aussi les os de l'homme et de la beste (qui sont espece de pierre et cassent quand ils sont secs comme pierre) iceux di-ie sont en eau pareille que dessus. Premierement fort tendres, comme ie t'ay dit de la marne, et puis deuiennent durs comme pierre quand ils sont paruenuz à leurs decoction et maturité, et tout ainsi que tu vois que les pierres ou cailloux qui sont generez et formez de ceste eau congelatiue, endurent le feu et ne se peuuent consommer au feu, ains se vitrifient, tu vois aussi que cest element generatif duquel ie t'ay parlé ne peut estre consommé estant aux pailles et aux foins, car si tu brusle de la paille, du foin, ou du bois, toute l'eau commune s'en ira en fumée, mais ceste eau generatiue qui a soustenu, nourri et a creu le foin et la paille, demeurera aux cendres et ne pourra estre consommée, ains se vitrifiera estant és fournaises ardantes, desquelles cendres l'on pourra faire du verre qui sera transparent et candide, comme l'eau generatiue estoit auparauant sa congelation; et si ainsi est des cendres des bois, des pierres qui pour le fait de ceste semence generatiue, souffrent les effects du feu, aussi tu vois semblablement qu'il ny a rien qui resiste plus au feu que les os de plusieurs bestes, comme tu as veu plusieurs fois que i'ay fait brusler des os de pieds de mouton, et quelque grande chaleur qu'il y eut és fournaises, il n'est possible de les consommer par feu, ny semblablement la coquille des œufs; qui te doit faire croire que Dieu à mis un ordre en nature en telle sorte, que les os ont attiré et attirent ordinairement plus abondamment de laditte eau generatiue, que non pas les autres parties; et comme i'ay dit autre part, ne faut douter qu'il n'y en ait vne bonne partie en la prunelle des yeux, et par ce qu'elle est humectée et accompagnée de l'eau exalatiue, cela empesche que ladite prunelle ne se petrifie. Nous auons les miroirs et lunettes qui nous rendent tesmoignage qu'il y a quelque af-

finité enuers les yeux, les lunettes et les miroirs, et ne faut croire que nulle chose peut receuoir policement ny seruir de miroir ou lunettes, si n'estoit par la vertu admirable de ce cinquiesme element, qui lie auec soy les autres matieres, et les rend dures, candides et polissables par les efforts que le souuerain luy a ordonnés. Autre preuue, cuide tu que les poissons armez qui sont en la mer et és estans et riuieres douces, n'ayent quelque connoissance de l'element susdit? et comment pouroyent-ils former leurs coquilles, au milieu des eaux, et que la coquille se vient à endurcir et desecher au milieu de l'humidité, s'ils ne sçauoyent choisir la matiere congelatiue au meilleur des eaux? tu sçais bien que ces grands poupres et bucines ont leurs coquilles autant dures ou plus que pierre, et toutesfois la matiere estoit liquide et à nous incónnuë au parauant que le poisson eut formé sa maison. Il faut pour conclusion venir à ce point comme ie prouue au traité des metaux, que le cristal est formé de ladite eau generatiue au milieu des eaux communes, que ladite semence, ou eau generatiue n'est pas seulement pour seruir à la generation des pierres, mais aussi est substance et generation de toutes choses animées et vegetatiues, selon le cours humain, ensuyuant l'ordre et vertu admirable que Dieu à commandé à nature. Tu as entendu cy deuant qu'il n'y a nulle espece de pierre qui ne soit candide en sa forme principale, et celles qui sont tenebreuses, ne le sont que par accident : parce qu'il y a parmy la matiere, de la terre, du sable qui se congele et endurcit auec elle, et de là vient que la matiere qui au parauant estoit candide se trouue obscure; toutesfois il n'y a pierre si obscure que l'on ne rendit en fin transparente à force de feu, par ce que l'element principal duquel i'ay tant parlé rend les choses fixes et transparentes, comme il est transparent en son estre : cela ne se peut aisement verifier, sinon par les practiques, et la theorique ne sçauroit asseurement parler de ces choses. Ie t'ay mis toutes ces preuues en auant afin que si tu as des terres infertiles tu mettes peine de trouuer de la marne en ton heritage pour fumer les terres steriles, afin qu'elles rendent abondamment des fruits en leur saison, et en ce faisant tu seras vn bon pere de famille, et comme lumiere entre les paresseux, tu seruiras de bon exemple et les voisins mettront peine de suyure tes traces.

Theorique.

Ie te prie me faire ce bien de m'apprendre le moyen de connoistre la marne que tu dis : car si ie sçauoy le moyen de la connoistre ic ne faudroy de m'employer de toutes mes forces, iusques à tant que ie sceusse s'il seroit possible d'en pouuoir trouuer en mon heritage.

Practique.

Ie ne cuide pas que ceux qui premierement ont meilleuré les terres par la marne, qu'ils l'ayent fait par vne theorique imaginatiue : mais i'ay bien pensé que ceux qui ont trouué premierement l'inuention, l'ont trouuée sans la chercher, comme plusieurs autres sçiences se sont offertes d'elles mesmes, comme tu peux penser que la moullerie peut auoir esté inuentée par les pas d'vn homme qui marcha les pieds nuz sur vn sable fin, ou sur de la terre d'argile, en laquelle terre ou sable l'on verra euidamment la forme touchée, rides, flaches, bosses et concauités de la forme de tout le pied : cela, di-ie est suffisant pour auoir premierement inuenté la moullerie et l'imprimerie, suyuant quoy, il est aisé à croire que quand la marne a esté premierement connue, ç'à esté par le moyen de quelque fosse ou tranchée, comme ainsi soit qu'en iettant les vuidanges du profond des fosses au dessus du champ circonuoisin, l'on a trouué que le bled qui estoit semé audit champ, estoit plus gaillart et espoix à l'endroit où les vuidanges des fossez auoyent esté iettées; quoy voyant les proprietaires du champ peuuent auoir prins l'année suyuante de la terre dudit fossé et l'ayant espandue par toutes les parties du champ, ils ont trouué que ladite marne estoit autant bonne et meilleure que fumier. La premiere inuention d'auoir trouué la marne, peut auoir aussi esté trouuée en creusant les puits pour chercher de l'eau, et en quelque lieu est aduenu qu'ayant creusé vn puits bien profond l'on a ietté les vuidanges et espandu par toute la terre circonuoisine de la fosse dudit puits, et apres que le champ a esté labouré et semé, l'on a trouué ce qu'on ne cherchoit pas, qui est que les semences iettées és parties du champ couuert des vuidanges du puits, se sont trouuées espoisses, belles et gaillardes. Voila deux effets qui ont peu aduertir les premiers qui ont vsé de la marne, et l'ose dire et asseurer que l'vn et l'autre sont veritables, et peuuent encores seruir comme d'inuention aux lieux ausquels

la marne ne fut onques vsitée, et te donneray vn argument inuincible, qui est que quelquesfois la marne se treuue dés le commencement, ou bien pres de la superficie de la terre, et descendant tousiours en bas, tirant vers le centre, autre marne ne se peut trouuer que premierement l'on n'aye fait vne fosse de quinze ou vingt pieds ; quelquefois plus de vingtcinq, et ayant trouué le commencement de ladite marne, il la faut tirer comme si on tiroit l'eau d'vn puits auec grand labeur. Voila pourquoy ie t'ay dit et asseuré qu'ayant trouué la marne par cas fortuit en creusant les puits et fosses, que depuis l'inuention estant trouuée l'on a cherché apres si auant és pays où elle est vsitée et conneue. Il faut donc conclure que la marne ne se peut apprendre à trouuer par theorique, non plus que les eaux cachées sans source, et que tout ainsi que les terres argileuses se trouuent quelquefois pres la superficie, et quelquesfois les faut chercher profond, semblablement la terre de marne se trouue, comme ie t'ay dit cy dessus. Si tu veux donc trouuer de la marne ie te conseilleray retenir l'exemple d'vn bon pere de famille Normand, lequel habitant à vne paroisse de Normandie, qui prenoit grand peine à cultiuer ses terres, et ce neantmoins il estoit contraint toutes les années d'aller acheter du bled hors de la paroisse : car toute ladite paroisse estoit infertile, et ne se trouuoit nul qui cueillist du bled pour sa prouision ; et quand il venoit vne cherté, et que les hommes de ladite paroisse alloient acheter du bled en la prochaine ville, les autres paroisses les maudissoient, disans qu'ils estoient cause d'encherir le bled. Il aduint que ce bon pere de famille que ie t'ay dit au commencement s'auança quelque iour de prendre son chapeau plein d'vne terre blanche qu'il trouua dedans vne fosse, et la porta en quelque endroit d'vn champ qu'il auoit semé, et marqua l'endroit où il auoit mis ladite terre, et quand les semences furent accreuës il trouua que le bled estoit espoix, vert et gaillard sans comparaison plus qu'en nul autre partie du champ : quoy voyant le bon homme fuma l'année suyuante tous ses champs de ladite terre, lesquels apporterent des fruits abondamment ; et apres que ses voisins et tous les habitans de ladite paroisse furent aduertiz d'vn tel fait, ils firent diligence de trouuer de ladite terre de marne, et en ayant fumé leurs champs ils recueillirent plus abondamment des fruits que nuls d'autres

paroisses. Voila le moyen de chercher de la marne le plus asseuré que ie sçaurois penser, et pour mieux te donner le moyen de la chercher et connoistre, ie te veux amplement donner à connoistre, que la marne n'est autre chose qu'vne terre reposée vn bien long temps, laquelle a esté tousiours humectée par les eaux qui ont esté retenues en icelle, tellement que toutes les choses petrifiables qui estoyent en elles se sont reduites en terre fine : laquelle terre estant purifiée de toute ordure corruptible, a retenu en elle l'vne des deux eaux, sçauoir est la congelatiue, et icelle eau congelatiue ayant fait vn corps auec laditte terre, la terre s'est par ce moyen endurcie : non si fort que la pierre, combien que ce soit vn commencement de pierre : mais d'autant qu'elle a esté tirée de sa miniere au parauant sa parfaitte decoction, elle se dissout en la descente des pluyes et des gelées, apres qu'elle est tirée du lieu de sa formation : et d'autant qu'elle est pierre imperfaite, elle laisse l'eau qui l'auoit congelée au lieu où elle est dissoute et brisée, et l'eau qui la soustenoit est liquifiée dedans le champ et ramassée, succée et recueillie par les semences qui y sont iettées, comme ie t'ay dit cy dessus : mais d'autant que ce propos est de grand poids i'ay voulu repeter vne mesme chose auec exemple plus intelligible, qui est (pour mieux te le faire entendre) qu'vn lard, ou la chair d'vn porc, ne perdra pas sa forme pour estre salée, et quand elle est est dessalée elle demeure encore en sa forme, comme tu vois ordinairement, que dedans vn pot il y pourrra auoir plusieurs pieces de chairs fraisches, parmy lesquelles et au dedans du pot il y aura vne piece de lard, laquelle donnera saueur à toutes les autres qui seront de chair fraische, aussi que tout le bouillon du pot sera sallé pour le sel qui estoit dedans le lard, toutesfois le lard demeurera en sa forme. Les distillateurs tireront de la canelle la saueur, la senteur et la vertu, sans oster la forme de la canelle : aussi tu peux connoistre par là, que tout ainsi comme le lard n'a pas sallé l'eau du pot par sa vertu, ains pour cause du sel ou il auoit reposé, lequel sel a esté extrait du lard par la vertu de l'eau sans oster la forme du lard : aussi les semences tirent à soy la vertu salsitiue de la marne, qui est ceste eau generatiue, et quand toute la vertu salsitiue à esté attirée par les semences, la marne n'est rien plus qu'vne terre infertile comme l'escorce

de la canelle, apres que l'essence en a esté tirée. Ie te diray encores vn secret qui est que iamais le sel ne pourroit conseruer la chair de porc, ny la conuertir en lard, n'y consequemment les autres chairs, si premierement le sel n'estoit dissout; et si le sel ne faisoit que toucher à l'encontre sans se liquifier, il ne pourroit entrer au dedans, ny empescher la putrefaction. Voila pourquoy tu peux entendre que la marne qui est ia commencée à petrifier, si elle n'est premierement dissoute parmi le champ, les semences n'en pourroyent rien tirer, non plus que feroit vne chair d'vn sel qui ne se pourroit dissoudre ou liquifier. Ie m'efforce tant que ie puis de te faire entendre qu'il n'y a pierre, que si elle se pouuoit dissoudre à la cheutte des pluyes ou gelées, qu'elle ne seruit de fumier aux champs : par ce que toutes pierres sont formées, soustenues et endurcies par le mesme element cinquiesme, lequel accompagne toutes choses depuis le commencement iusques à la fin; et faut que plusieurs choses ne craignent ny le feu, n'y l'eau, n'y aucune iniure du temps, tesmoing les terres argilleuses lesquelles ont esté causées de son action, et demeurent dedans les eaux sans aucun dommage, et estant formées en vaisseaux ou en briques, elles endurent le feu des fournaises, et mesmes les fournaises en sont construites.

Theorique.

Tu m'as dit cy dessus beaucoup de raisons, neantmoins ie ne suis pas satisfait touchant le moyen le plus expedient pour trouuer promptement de ladite terre de marne.

Practique.

Ie ne te puis donner moyen plus expedient que celuy que ie voudrois prendre pour moy : si i'en voulois trouuer en quelque Prouince où l'inuention ne fut encore connue, ie voudrois chercher toutes les terrieres desquelles les potiers, briquetiers et tuilliers, se seruent en leurs œuures, et de chascune terriere i'en voudrois fumer vne portion de mon champ pour voir si la terre seroit ameillourée, puis ie voudrois auoir une tariere bien longue, laquelle tariere auroit au bout de derriere vne douille creuse, en laquelle ie planterois vn baston, auquel y auroit par l'autre bout vn manche au trauers en forme de tariere, et ce fait, i'irois par tous les fossez de mon heritage, ausquels ie planterois ma tariere iusques à la longueur de tout le manche, et l'ayant tirée dehors

du trou, ie regarderois dans la concauité de quelle sorte de terre elle auroit apporté, et l'ayant nettoyée, i'otterois le premier manche et en mettrois vn beaucoup plus long, et remetterois la tariere dedans le trou que i'aurois fait premierement, et percerois la terre plus profond, par le moyen du second manche, et par tel moyen ayant plusieurs manches de diuerses longueurs, l'on pourroit sçauoir qu'elles sont les terres profondes; et non seulement voudroy-ie fouiller dedans les fossez de mes heritages, mais aussi par toutes les parties de mes champs, iusques à ce que i'eusse apporté au bout de ma tariere quelque tesmoignage de ladite marne, et en ayant trouué quelque apparence, lors ie voudrois faire en iceluy endroit vne fosse telle comme qui voudroit faire vn puits.

THEORIQUE.

Voire mais s'il auoit du rocq au desoubs de tes terres, comme l'on voit en plusieurs contrées, que toutes les terres sont foncées de rocher?

PRACTIQUE.

A la verité cela seroit fascheux, toutesfois en plusieurs lieux les pierres sont fort tendres et singulierement quand elles sont encores en la terre : parquoy me semble que vne tariere torciere les percerroit aisément, et apres la torciere on pourroit mettre l'autre tariere, et par tel moyen, on pourroit trouuer des terres de marne, voire des eaux pour faire puits, laquelle bien souuent pourroit monter plus haut que le lieu où la pointe de ta tariere les aura trouuées : et cela se pourra faire moyennant qu'elles viennent de plus haut que le fond du trou que tu auras fait (1).

THEORIQUE.

Ie trouue fort estrange de ce que tu dis, que si le rocq m'empesche de percer la terre, qu'il faut aussi percer le rocq, et si c'est du rocq que ay-ie que faire de le percer, veu que ie cherche de la marne?

PRACTIQUE.

Tu as mal entendu, car nous sçauons qu'en plusieurs lieux les terres sont faites par diuers bans, et en les fossoyant on trouue quelquesfois vn ban de terre, vn autre de sable, vn au-

(1) La découverte des puits artésiens est explicitement renfermée dans ces paroles. (HOEFER, *Hist. de la Chimie.*)

tre de pierre, et vn autre de terre argileuse : et communement les terres sont ainsi faites par bans distinguez. Ie ne te donneray qu'vn exemple pour te seruir de tout ce que ie t'en sçaurois iamais dire : regarde les minieres des terres argileuses qui sont pres de Paris, entre la bourgade d'Auteuil et de Chaliot, et tu verras que pour trouuer la terre d'argile, il faut premierement oster vne grande espesseur de terre, vne autre espesseur de grauier, et puis apres on trouue vne autre espesseur de rocq, et au dessouz dudit rocq, l'on trouue une grande espesseur de terre d'argile, de laquelle l'on fait toute la tuille de Paris et lieux circonuoisins (1). Ce n'est pas en ce lieu seulement qu'il conuient prendre la terre d'argile au dessous des rochers : mais en plusieurs autres lieux. Si tu as bien retenu le discours du traité des pierres, tu as peu entendre que la terre d'argile estant venue en sa perfection, elle a serui de receptacle pour retenir les eaux congelatiues qui ont causé le rocq qui est au dessus.

THEORIQUE.

Nous parlons de trouuer la marne, et tu me parles de la terre d'argile : il me semble que cela vient mal à propos.

PRACTIQUE.

Tu l'entens fort mal, ie t'ay dit cy dessus que l'eau congelatiue n'a pas seulement operé en la terre pour la reduire en marne, ains a aussi operé en la terre d'argile et és pierres et bois, voire en toutes choses generatiues voire iusques és choses animées : cuides tu que la semence generatiue du genre humain et brutal, soit vne eau commune et exalatiue? Ie t'ose dire que tout ainsi comme la semence humaine apporte en soy les os, la chair, et toutes les parties distinctes de la forme humaine, aussi en la semence vegetatiue sont comprins les troncs, les branches, les feuilles, les fleurs, et les fruits, les vertus, les couleurs, les senteurs, et tout cela par vn ordre que l'admirable prouidence de Dieu a commandé ; et ne faut que tu trouues estrange que ie t'allegue les exemples de la terre argileuse, pour te seruir en la marne : car depuis quel-

(1) Le système du sondage des terres, la théorie de la stratification du sol, l'idée primitive des puits artésiens, c'est-à-dire les principaux éléments de la géologie se trouvent réunis dans ces deux pages. C'était la première fois que ces idées étaient exprimées théoriquement, en même temps qu'elles étaient démontrées par la pratique.

que temps i'ay passé par le pays de Valois et Champagne, où i'ay veu plusieurs champs ornez de plusieurs piles de marne, arangées en la forme de pilots de fumier, et comme il pleuuoit sur ladite marne, qui estoit par mottes grandes et petites, i'apperceu qu'elles se venoyent à dissoudre à la cheutte des pluyes : lors ie prins vne de ces mottes, qui estoit ia liquefiée comme paste, et l'ayant petrie entre mes mains i'en fis vn nombre de trochisques, lesquelles ie fis cuire dedans vn grand feu, et estant cuittes, ie trouuay qu'elles s'estoyent endurcies en pareille forme que la terre d'argile : lors ie conneuz que l'vne et l'autre pouuoit faire vne mesme action, sinon en tous lieux, pour le moins en quelque contrée.

THEORIQUE.

Voire mais les terres d'argile sont de diuerses couleurs et plus communement grises, et la marne est blanche : parquoy cela ne se peut accorder.

PRACTIQUE.

A la verité, la marne est communement blanche és pays de Valois, Brye, et Champagne, toutesfois i'ay bon tesmoignage qu'au pays de Flandres et Alemagne, mesme en quelque partie de la France, il y en a de grise, noire et iaune, comme i'ay dit dés le commencement : parquoy ie te conseille de ne t'amuser point à la couleur : car la marne grise ou noire peut deuenir blanche en sa decoction ; et tout ainsi qu'il y a de la marne blanche, aussi il y a des terres argileuses blanches. Il me souuient auoir passé de Partenay, allant à Bresuyre en Poitou, et de Bresuyre vers Thouars, mais en toutes ces contrées, les terres argileuses sont fort blanches, et consequemment les cailloux, lesquels sont en grand nombre audit pays : qui me fait croire que les terres argileuses desdits pays pourroyent aussi seruir de marne, et singulierement celle dequoy les drapiers foulent et desgressent les draps. Mais voyons aussi que les creusets des orfebvres qui sont apportez du pays d'Anjou, d'aupres de Troye, et plusieurs autres lieux, sont faits d'vne terre fort blanche semblable à la marne. En la basse Bourgongne, il y a vn certain village où l'on tire de la terre d'argile toute semblable à la marne, et cuide que ce ne soit autre chose : toutesfois elle endure le feu en telle sorte, que tous les verriers de la plus grande partie des Ardennes, se seruent des vaisseaux faits de ladite terre,

et mesme les verriers d'Anuers qui besonguent de verre de cristalin, sont contrains en enuoyer querir, combien que l'on la vende bien cher, à cause qu'elle dure long temps és fournaises ardantes. I'ay veu creuser vn puits au pays des Ardennes, qu'auant trouuer l'eau, il fallut creuser vne bien grande espesseur de terre, et apres la terre, on trouua vn fond de rocq d'vne grande espesseur, et apres le rocq se trouua d'vne terre d'argile autant blanche que craye, laquelle i'esprouuay, et la trouuay bonne à faire vaisseaux : toutesfois combien qu'elle n'ait esté approuuée si est-ce que ie croy que c'est vne parfaite marne. Si mon estat se pouuoit exercer en peregrinant d'vne part et d'autre, ie pourrois donner plusieurs aduertissements de ces choses, qui seruiroient beaucoup à la republique : toutesfois voila vn chemin ouuert : si tu es homme curieux de ton bien, tu pourras chercher par les moyens que ie t'ay dit; en cherchant tu trouueras les choses plus asseurées que ie ne te les sçaurois dire : car on dit communement qu'il est facile d'adiouter à la chose inuentée; aussi la science se manifeste à ceux qui la cherchent.

Theorique.

Et ne me suffira il pas de chercher la marne au maniment des mains? attendu que la marne est vne terre grasse, comme celle d'argile, et puis que la terre d'argile est connue au maniment des mains : car il y a celuy que s'il manie de la terre d'argile destrempée, qu'il ne dit voila vne terre grasse et visqueuse : aussi les Latins disent que terre d'argile veut dire terre grasse.

Practique.

Tu as fort mal retenu ce que i'en ay escrit au liure des terres : car ie t'ay dit que les Latins et les François abusent du terme, en appellant la terre d'argile terre grasse : car si elle estoit grasse il seroit impossible de la dissoudre par eau ny par gelée : car toutes gresses et viscosités oleagineuses resistent à l'eau, et ne peuuent auoir quelque affinité : ains au contraire, la terre d'argile et la terre de marne chassent toutes taches grasses, visqueuses et oleagineuses : et pour ces causes les foulons les font seruir à degresser les draps.

Theorique.

Ie trouue en quelque endroit de tes propos vne contrarieté assez connue ; car tu m'as dit cy deuant, que mesme les ro-

chers estoient causés de la matiere mesme qui ayde à la generation des semences : et toutesfois i'ay veu des pays que toutes les terres estoient incrustées de rochers et pierres, et les terres qui sont telles ont bien peu de terre sur le rocq, et les semences qui y sont iettées, ne peuuent gueres profiter, ains les bleds demeurent bas, ayant les espics bien petits, par ce que la plante ne peut prendre nourriture sur le rocq.

Practique.

N'as tu pas entendu vn propos que ie t'ay dit, que si le sel ne se venoit à dissoudre, les lards, poissons, et toutes especes de chairs ne pourroient estre salées, si le grain du sel demeuroit en son entier sans se dissoudre et diminuer ? Si le pays qui est ainsi pierreux est de telle nature que les pluyes qui tombent dessus ayent en elles vne si grande quantité d'eau congelatiue, qui tombant d'en haut, fait vne croutte en augmentant les rochers couuerts d'vn peu de terre, cela ne fait rien contre mon propos : car ie t'ay dit que depuis que l'eau est congelée et reduitte en pierre, les semences n'en peuuent tirer aucune liqueur, si la pierre n'est premierement dissoute, comme ie t'ay dit que la chair ne pourroit rien prendre du sel, sinon en tant qu'il se dissout et diminue. Voila vne conclusion toute certaine.

Theorique.

Si est-ce pourtant que i'ay veu plusieurs forests és parties montagneuses, esquelles les arbres sont merueilleux en grandeur, combien que la sole d'iceux n'est que rocq, auec vn bien peu de terre par dessus la superficie des rochers, et les racines desdits arbres sont à trauers et parmi les rochers des montagnes.

Practique.

Si tu eusses bien noté ce que ie t'ay dit en traitant des pierres, tu n'eusses mis vn tel argument en auant : car tu dois entendre que les racines des arbres ne sçauroyent transpercer les rochers. Il te faut donc croire que les arbres auoyent prins racine au parauant que la terre où ils sont fut congelée, et comme les arbres ont prins en leur croissance abondamment de l'eau generatiue, ils en ont distribué aussi bien aux feuilles et aux fruits, comme aux branches et comme aux racines : et par ce que les feuilles et fruits tombent par chacun

au desouz les arbres, ils se viennent à putrifier, et en se putrifiant (comme font les herbes des forests) ils rendent en leur putrefaction l'eau commune et la generatiue parmy la terre, qui est causée parmy des feuilles et fruits : et quelque temps apres, par la vertu du Soleil, l'eau commune se vient à exaler, et la generatiue rend alors en pierre la terre qui a esté causée des feuilles, fruits, et autres plantes des forests : car autrement ce que tu dis ne se pourroit faire : car si tu consideres la racine des arbres tu trouueras qu'il n'y a celuy qui n'aye autant de racine que de branches : car autrement, il ne pourroit endurer le combat qu'il endure par l'iniure des vents. Et si tu voulois contempler la cause pourquoy les arbres ont les racines ainsi tortues, tu trouueras que la cause n'est autre sinon, que comme les hommes cherchent les montagnes, les chemins et sentiers plus aisez, aussi les racines en leur accroissement cherchent les parties de la terre les plus aisées, plus tendres et moins pierreuses ; et s'il y a quelque pierre au deuant de la racine, elle laissera la pierre en son chemin et se tournera à dextre, ou à senestre ; d'autant qu'elle ne pourroit percer les pierres qui sont au chemin.

THEORIQUE.

Et toutesfois les branches des arbres qui n'ont aucun empeschement en l'aër, sont aussi tortues et fourchues comme les racines : si est ce que l'aër n'est non plus dur en vn endroit qu'en l'autre. Il faut necessairement qu'il y aye autre raison que celle que tu dis.

PRACTIQUE.

Quant aux racines, ie t'ay dit verité : mais quant aux branches il y a vne autre cause, qui est que les branches, poussans l'augmentation des gittes, vne chacune cherche la liberté de l'aër, et se dilatent en s'esloignant des autres gittes tant qu'ils peuuent, afin d'auoir l'aër à commandement ; et par vne telle cause, les gittes fuyans le voisinage l'vne de l'autre ne peuuent monter directement, ce que tu peux connoistre par les noyers, poiriers, et pommiers, et plusieurs autres especes d'arbres, qu'en leurs premiere croissance la tige montera directement en haut iusques à ce que la vertu radicale monte abondamment, qui luy cause se fourcher, en poussant plusieurs gittes, comme vne eau desbordée. Ie considere ces raisons en plusieurs exemplaires, premierement en ce que

j'ay veu les chesnes, noyers, chastaigniers, et plusieurs autres especes d'arbres, plantez és lieux champestres, entre lesquels ie n'en ay iamais trouué vn qui montast directement en haut, comme ceux qui sont és forets entourez d'autres arbres qui les empeschent à se dilater de part et d'autre. Ie n'ay iamais aussi trouué que les arbres des forests fussent fertiles abondamment, comme ceux des campagnes, ny aussi que le fruit d'iceux fut sauoureux en telle sorte que ceux qui ont l'air et le soleil à commandement : dont il est aisé a conclure que les arbres des forests qui sont entourez d'autres arbres, ne pouuant iouir du Soleil et de l'aër és parties dextre et senestre, sont contrains monter en haut pour chercher l'aër et le soleil, lequel ils desirent pour leur nourriture et accroissement. Et comme ie cherchois la connoissance de ces causes, ie passay quelquefois par vne forest qui contenoit trois lieues de largeur, et afin de rendre le chemin aisé, l'on auoit coupé, tout au trauers de la forest, les arbres d'vne voye contenant en largeur huit ou dix toises : en passant ladite forest, i'apperceu que tous les arbres qui estoyent à dextre et à senestre de ladite voye, auoyent poussé grand nombre de branches deuers le costé du chemin ; et deuers la partie de la forest, il y en auoit fort peu, qui me donna certaine connoissance que le tronc de l'arbre prenoit son plaisir à pousser les branches vers le chemin, par ce que c'estoit la partie la plus aërée : i'apperçeu aussi que les arbres de la circonference de la forest se iettoyent et courboyent ou s'enclinoient deuers le costé des terres, comme si les autres arbres leur estoyent ennemis : et à la verité bien souuent il y a plusieurs arbres fruitiers tant és iardins que autres lieux qui sont courbez pour cause de l'ombre de leurs voisins, autres arbres desquels ils n'ayment estre accompagnez.

THEORIQUE.

Par tes propos tu veux dire qu'apres que les feuilles, fruicts et branches des arbres et plantes sont pourries elles se peuuent reduire en pierre.

PRACTIQUE.

Ie l'ay dit, et encores plus, comme tu peux auoir entendu au discours des metaux, que non seulement les choses putrifiées se peuuent lapifier, ains se peuuent petrifier au parauant la putrefaction, comme tu as veu par les bois et coquilles, et

t'ose dire encore qu'il n'y a nulle espece de terre qui ne se puisse naturellement petrifier par l'effect du cinquiesme element, duquel i'ay tant parlé cy dessus.

THEORIQUE.

Et le tripollit, qu'est-ce? se peut-il petrifier?

PRACTIQUE.

Non seulement le tripollit, mais aussi l'ocre, le boliarmeni, et tous ces mineraux qui sont lapifiez, comme la sanguine, l'orcane, et la pierre noire : tout cela ne sont que pierres petrifiées dessicatiues et astringentes, comme vne espece de terre sigillée.

THEORIQUE.

Et qu'appelles tu terre sigillée?

PRACTIQUE.

Terre sigillée est autrement appellee terre Lemnie (de Lemnos); aucuns lui attribuent ce nom, à cause du lieu où elle est prinse(1) : et te faut noter que la terre n'est autre chose qu'vne espece de marne ou terre argileuse, laquelle se prend bas en terre, comme sont communement les terres argileuses, et les marnes : l'on dit que ladite terre est fort astringente, et que par son action elle preserue de poison et retient les flux de sang par sa vertu astringente : et pour ces causes les hommes du pays où elle se prend vont par chacun an ouurir la fosse, ou le trou par où ils descendent pour la tirer, et en ayant tiré à leur discretion, ils ferment le trou iusques à l'autre année : et pour cause qu'ils ont tribut de ladite terre. Ils ouurent le trou auec grand pompe, accompagnez de ceremonies. Le pays où ladite terre se prend, est à present occupé par le Turc, qui cause qu'il en prend le profit, et se vent ladite terre par trochisques marquées des armoiries du Turc. Voyla pourquoy l'on l'appelle terre scelée, et me semble que ce seroit mieux dit terre cachetée, et par ce qu'elle est appellée terre marquée, ou cachetée, cela me fait croire qu'elle est molle quand on la tire, comme communement est la terre d'argile : car combien qu'elle soit assez dure et qu'on la porte souuent a grand mottes sur les espaules, si est ce qu'elle est humide, en telle sorte

(1 La *terre sigillée* est une substance alumineuse, mêlée de silice, de chaux, de magnésie et d'oxyde de fer, que l'on employait, en médecine, comme astringente. On la nommait ainsi parce qu'elle arrivait en Europe sous forme de grosses pastilles empreintes d'un sceau (*sigillum*).

quelle se peut aysément cacheter. Venons a present à la cause de son vtilité; d'où est-ce que peut proceder vne telle vertu? Si tu as bien entendu le propos que i'ay dit sur les congelations, tu connoistras que la vertu de ladite terre ne procede, sinon des eaux communes et congelatiues, qui ayans percé a trauers des terres, iusques à ce qu'elles ont trouué quelque rocher pour s'arrester au lieu où les eaux se sont arrestées, la terre subtile et fine qui là estoit, a retenu la vertu de l'eau congelatiue, et là s'est fait vne association et ligature, sçauoir est, la terre et l'eau ont fait vne decoction moderée, et commencement de petrification, et en ce faisant ont laissé courir, descendre ou exaler l'eau commune, et n'est demeuré parmy la terre que l'eau congelatiue qui a perdu en se congelant la couleur et apparence qu'elle auoit au parauant, et a prins la mesme couleur de la terre où elle s'est iointe; et par ce qu'elle n'est encores venue en sa parfaite decoction ou petrification, il est certain qu'estant prinse par la bouche, la vertu de l'eau congelatiue qui est en elle se vient à dissoudre à la chaleur et humidité de l'estomach, et alors les matieres estant liquides, le corps fait son profit de la matiere congelatiue, qui estoit en la terre, et la terre est enuoyée aux excrements selon le cours ordinaire. Voila qui te doit faire croire que ceste eau congelatiue est de nature salsitiue, comme ie t'ay fait entendre cy dessus, que le venin des serpents est guery par la vertu de la saliue, a cause du sel. Ie t'ay allegué cy dessus vne Isle pleine de serpents, aspics et viperes, qui sont en vne Isle appartenant au seigneur de Soubise. Ie t'ay dit aussi que ceux qui sont morduz des chiens enragez sont gueris par l'eau de la mer, et mesme aucuns par le lard vieux, et cela ne se fait que par une vertu salsitiue. Ie t'ay assez donné a entendre (en parlant des sels) que tous sels ne sont pas mordicatifs, ou acres, afin de te faire entendre que ie ne veux pas dire par là, que la vertu salsitiue de la terre sallée soit d'vn sel commun : ains ie veux seulement dire que son action n'est causée que par vne vertu salsitiue.

THEORIQUE.

Ie te prie me dire s'il seroit possible de trouuer en France quelque terre qui fist la mesme action que celle que tu dis : parce qu'en tous tes discours tu ne faits point distinction des matieres qui causent la congelation des pierres, marnes et

terres argileuses; et d'autant que tu attribues à la terre sigillée sa vertu procéder de la mesme cause que les terres, pierres, et marnes de ce pays sont congelées, pourquoy est ce qu'il ne se pourra trouuer en la France des terres qui feront mesme action, veu qu'elles sont causées d'vn mesme subiet? comme i'ay dit.

Practique.

Ie ne te puis alleguer raison contraire, sinon qu'és pays chauds, les fruits ou pour le moins partie d'iceux, sont beaucoup meilleurs qu'és pays froids, comme tu vois qu'és pays de France, depuis qu'on passe Paris, allant vers le Septentrion, on ne peut cueillir pompons, melons, oranges, figues ny oliues, ny beaucoup d'autres especes de fruits, comme on fait és chaudes regions, et mesme les raisins ne peuuent venir en maturité, comme ils font és parties meridionales de la France, Champagne, et Picardie. Tu sçais bien aussi que les espiceries, sucres, ne peuuent prendre accroissement au royaume de France, comme elles font és pays chauds. Tu sçais bien que la casse et toutes gommes odoriferantes sont prises és regions chaudes, mesme la rubarbe et autres simples, seruans à la medecine. Il est assez aisé a croire que le soleil donne quelque vertu plus violente en certaines regions qu'en d'autres, et mesme on voit qu'vne mesme region, vne mesme espece de plante operera merueilleusement plus qu'vne autre, qui sera accreuë en mesme pays. Ie t'ay baillé pour exemple les vignes de la Foye-Moniaut, qui sont entre saint Iehan d'Angely et Nyort, lesquelles vignes apportent du vin qui n'est pas moins estimé qu'hippocras, et bien pres de là, il y a autres vignes desquelles le vin ne vient iamais à parfaite maturité, lequel est moins estimé que celuy des raisinettes sauuages, par là tu peux penser que les terres ne sont semblables en vertu, combien qu'elles se ressemblent en couleur et apparence. Toutesfois ie ne veux par là conclure qu'il n'y puisse auoir en France de ladite terre lemnie, laquelle puisse faire la mesme action que la sigillée; et prendray argument sur ce que les vaisseaux premiers faits furent formez, comme aucuns disent en argis, et depuis tous les autres qui sont formez, on les appelle vaisseaux de terre d'argile; puis que l'on recouure de la terre en tous pays semblable a celle d'argis, aussi il n'est pas difficile de croire qu'il se puisse trouuer de la terre lem-

nie. Ie prendray autre argument plus certain : puis qu'aux Isles de Marennes, et en la Foye-Moniaut, se cueille du vin ayant douceur et bonté d'hippocras, et que sa bonté procede d'vne vertu salsitiue que nous appellons tartare, et qu'és pays de Narbonne et Xaintonge, il se fait du sel commun, et combien que la vertu salsitiue de la terre lemnie ne soit pas de sel commun, si est ce que tout ainsi que comme en quelque partie de la France, les raisins et quelques autres fruits apportent en soy vne douceur autant grande que les dates, figues et autres fruits qui viennent des regions chaudes, i'ay conclud qu'en quelque endroit se pourroit aussi trouuer de la terre lemnie, laquelle feroit la mesme action que celle que on prend en Turquie, de laquelle nous auons parlé. Ie te diray encores vne exemple, tu vois que les anciens ont eu en grand estime le bol d'Armenie, à cause de son action astringente ; et toutesfois depuis que l'vsage en est en France, celuy mesme qui se prend au pays, et combien qu'il se trouue en plusieurs contrées de la France, si est ce qu'on luy baille le mesme nom de celuy d'Armenie, comme tu vois que les Latins l'appellent bolus armenus, en François boliarmeny. Nous en auons encore vne autre espece qui est plus desiccatif que le susdit, duquel les peintres font des crayons à pourtraire, qu'ils appellent pierres sanguines, elle est fort propre pour contrefaire les visages apres le naturel : elle est composée d'vn grain fort subtil. Il y a autre espece de sanguine, qui est fort dure ; à cause de sa dureté, on la peut tailler et pollir comme vne pierre de iaspe ou d'agathe, combien qu'elle ne soit pas si dure : aucuns on fait tailler desdites pierres pour se seruir à brunir ou pollir l'or et autres choses. Si tu consideres bien ladite pierre tu connoistras qu'il n'y a difference aucune des deux especes de sanguine, sinon que l'vne est petrifiée à cause qu'elle a plus receu d'eau congelatiue qui l'a rendue plus pesante et plus dure, et l'autre qui est demeurée tendre, de laquelle on fait des crayons rouges, est demeurée alterée par ce que l'eau luy deffaut au parauant sa parfaitte decoction. Et parce que le commencement de nostre propos a esté seulement de parler de la marne, ie te dis à present qu'en plusieurs lieux la marne peut seruir à faire des crayons blancs à pourtraire en blanc, tout ainsi que la sanguine pourtrait des traits rouges.

Theorique.

Ie trouue icy vne chose fort estrange, qui est de ce que tu contredis à tant de millions d'hommes, tant des passez que des viuants, en ce qu'ils disent tous, et le tiennent pour chose certaine, que la marne et la terre d'argile est grasse, et que les terres sont ameilleurées pour cause de la graisse qui est en la marne : et toy comme opiniatre inueteré, les veux gaigner contre tous.

Practique.

Si tu auois bien consideré le propos que ie t'ay tenu cy dessus en parlant de l'or potable, du restaurant d'or, des graisses et des eaux, tu eusses connu par là, que depuis que les hommes sont abreuuez d'vne opinion fausse, il est difficile de leur arracher de la teste : mesmement à ceux qui se soucient bien peu de considerer les effects de nature. Te souuient-il pas que i'ay assemblé autre fois à Paris, des plus doctes Medecins, Chirurgiens et autres naturalistes, lesquels m'ont tous accordé que les Philosophes, Physiciens, passez et presens, auoient abusé en escriuant du restaurant d'or, de l'or potable, des metaux, des eaux, et des pierres, et en plusieurs autres instances, desquelles tu sçais que i'ay faict lecture, et n'ay iamais trouué homme qui m'ayt contredit : toutesfois il se trouua un Alchimiste, lequel auoit bruit de se tourmenter apres l'augmentation des metaux, pour de là venir à la monnoye. Iceluy, dis-ie, estoit fort mal content de ce que ie parlois de l'or potable, pource qu'il pretendoit potager l'or pour donner teincture à l'argent, ce qui est impossible, sinon seulement sur la superficie pour en abuser : et comme tu sçais que de l'abondance du cœur la langue parle, iceluy passionné de mes propos, attendit que l'assemblée s'en fut allée, et puis me vint dire qu'il sçauoit faire de deux sortes d'or potable. Sa passion auoit causé qu'il auoit mal entendu : car ie ne disois pas que l'or ne se peut rendre potable, car ie sçay plusieurs moyens de le potager, mais ie disois que quand il seroit potagé iamais ne se conuertiroit en la nature humaine, pour luy seruir de restaurant, parce qu'il ne se peut digerer. Et pour reuenir à poursuyure les fauces opinions inueterées sur le fait des terres qu'ils appellent grasses, ie t'allegueray la mesme raison que i'ay dit en parlant des terres argileuses, qui est qu'esdites terres il y a deux eaux : l'vne est commune

et exalatiue, ennemie du feu, l'autre est congelatiue, qui cause que la terre qui n'est que poussiere, se tient en vne masse, et s'endurcit au feu : ie demanderay à tous ces dictionnaires si l'humeur radicale qui ioinct les parties de la terre estoit grasse, pourroit-elle endurer le feu? ne sçayt on pas bien, que toute gresse espesse, oleagineuse brusle au feu, ne sçauons nous pas aussi que les drapiers desgressent leurs draps auec de la terre argileuse, ou de celle de marne ; si elle estoit grasse comment pourroit elle desgresser? Il y a quelques vns qui pour prouuer qu'elle estoit grasse ont dit que plusieurs puits estoient foncez de terre de marne, voulant par là prouuer qu'elle est grasse : mais une telle preuue n'est pas bonne, car nous sçauons que toute espece de terres argileuses tiennent l'eau durant le temps qu'elles sont sousternées, mais estant tirées de leur fosse elles ne pourroyent tenir l'eau, sinon durant le temps qu'elles seroyent molles comme paste : mais apres que lesdites terres sont succées, elles se viennent à dissoudre soudain que l'on les mettra dedans l'eau ; et si elle estoit grasse, comme on dit, iamais elle ne se pourroit dissoudre en l'eau, non plus que le suif, la cire, la poix-raisine et autres choses grasses. Il est bien certain que si tu prend deux pieces de marne, ou de terre argileuse, et que tu ayes deux vaisseaux, que l'vn soit plein d'huile, et l'autre d'eau, et qu'en chacun vaisseau tu mette vne motte de marne, ou terre argileuse, que celle que tu mettras dedans l'huile, ne se dissoudra iamais, mais celle que tu mettras dedans l'eau, se creuera et se dissoudra comme vne pierre de chaux, car nous sçauons que les matieres grasses et oleagineuses sont repugnantes à l'eau, et lesdites terres sont composées de matieres aqueuses, parquoy ils ne peuuent se ioindre ny entremesler : il faut donc que ceux qui appellent les marnes et terres argileuses grasses, qu'ils allent chercher autres raisons que celles qu'ils mettent en auant. S'ils appelloient lesdites terres pateuses, ils parleroyent beaucoup mieux et diroyent verité, car nous sçauons que la farine et l'eau ont telle affinité, que soudain qu'elles sont entremeslées, elles se conuertissent en vn corps pateux. Il les faut donc appeller terres pateuses, et non point grasses ou visqueuses.

THÉORIQUE.

Ie trouue estrange que tu dis, que non seulement les choses

30.

putrifiées se peuuent reduire en pierre, mais aussi aucune chose sans perdre leur forme, comment est il possible que l'eau que tu dis puisse entrer dedans les corps solides, si premierement ne sont molifiées par putrefaction?

PRACTIQUE.

Comment oses tu dire le contraire de ce que i'ay dit, veu qu'en te parlant de l'essence et forme des pierres, ie t'ay monstré plusieurs coquilles reduites en pierre, combien que les coquilles estoyent au parauant autant solides que pourroit estre vn vaisseau de verre, ou de quelque matiere metallique.

THEORIQUE.

Il faudroit donc qu'il n'y eut rien qui ne fut poreux, et si ainsi estoit, les vaisseaux ne pourroient contenir l'eau de quelque matiere que ce soit, et toutesfois l'on voit le contraire.

PRACTIQUE.

Ie ne doute point que toutes choses ne soyent poreuses, mais ces choses qui sont faites des matieres plus condensées ont les pores si subtils que les liqueurs ne peuuent passer à trauers euidemment, sinon par quelque accident : comme tu as veu autrefois que quand ie voulois broyer mes couleurs en hyuer, ie faisois chauffer la molette, et apres l'auoir posée sur le marbre toute chaude, icelle molette pour sa chaleur attiroit de l'eau dudit marbre, combien qu'iceluy marbre eut apparence d'estre bien sec : voila vn argument qui te doit faire croire que le marbre estoit poreux, à trauers desquels pores, la chaleur de la molette faisoit attraction de l'humidité. Autre exemple : tu sçais bien que les forgeurs d'armes et de taillans, quand ils veulent endurcir les armes et taillans, ils les font chauffer tant qu'ils soyent rouges, et puis les mettent froidir dans l'eau ; lors les trenchants des ferrements et armures deuiennent beaucoup plus durs. Ie te demande si le fer ou l'acier, estant ainsi trempé, ne prenoit quelque substance iusques au centre, et par toutes les parties s'ils se pourroyent endurcir par l'action de l'eau? on sçait bien que non : car si le trenchant, ou le harnois ne s'endurcissoit que sur la superficie, cela ne seruiroit de rien. Il faut donc conclure que les armures estans chaudes, sont imbibées, et font attraction de quelque eau, autre que l'exalatiue, laquelle subuient et se

fortifie ; et pour ce monstrer, te faire mieux entendre que les armures ne sont pas fortifiées par les eaux exalatiues, il faut que tu entendes que pour tremper lesdites armures, aucuns ont plusieurs secrets ; aucuns mettront du sel dedans l'eau où ils veulent tremper leurs armures, aucuns mettront des vinaigres, autres mettront des pierres de chaux, autres mettront du verre subtilement broyé, et ne faut que tu doutes que si le verre broyé ne pouuoit seruir à l'endurcissement du fer, ou acier, ie ne dis pas qu'il y puisse seruir estant en verre, mais estant bien broyé, le sel dudit verre se liquifie parmy l'eau commune, et alors les armures qui y sont trempées font leur profit dudit sel liquifié, duquel ils font attraction pour se fortifier et non pas de l'eau commune, car elle ne se peut fixer. Du temps du feu Roy de Nauarre, il partit de Geneue deux orfeures qui porterent en la cour du susdit Roy, vne masse et vn coutelas, au labeur desquels ils auoyent employé l'espace de deux années pour orner et enrichir ou tailler lesdites pieces : et parce qu'elles estoient merueilleuses et de haut prix, ils n'auoyent rien espargné à ce que ladite masse et coutelas fussent forgez de bonnes estoffes, et en cas pareil trempées en certaines eaux qui causerent vne dureté ausdites armes : ie ne sçay si elles furent attrempées par le magnifique Maigret, lequel auoit bruit qu'en cherchant la generation de l'or, ou pierre philosophale, il auoit trouué vne eau qui causoit vne merueilleuse dureté aux armures ; ignorant donc celuy qui auoit fait la trempe, ie suyuray mon propos qui est que le coutelas dont ie parle estoit si bien attrempé que l'on en coupoit les chenets ou landiers de fer, comme l'on eut fait du bois, sans que le coutelas en receut aucun dommage : voila des preuues qui te doiuent assez donner à entendre les propos que ie t'ay dit sur le fait de la marne, que comme les semences ne sont totalement nourries par l'effect des eaux communes, aussi ne sont les metaux. Ie te donneray encores vn bel exemple pour la confirmation de ce que i'ay dit, de ce qui cause la bonté de la marne ; elle cause aussi la congelation des pierres. Il y a certaines forges de fer aux Ardennes, au village de Daigny et Giuonne, autres forges au village de Haraucourt, lesquelles ne sont distantes pour le plus que deux lieuës les vnes des autres, ce neantmoins és forges de Haraucourt ils mettent de la terre blanche qu'ils prennent assez bas en terre, laquelle

ils mettent parmy la mine de fer pour aider à la fonte d'icelle mine, et ceux de Dagny et Giuonne prennent pour la mesme cause de la pierre de laquelle l'on se sert à faire de la chaux, qu'ils appellent pierre de castille, laquelle ils cassent pour aider à la fonte de leurs mines comme i'ay dit. Vois tu pas par là vne preuue evidente, puis que les sels des arbres aident à faire fondre toute chose, qu'il y a vne vertu salsitiue és pierres, et consequemment és terres qui ne sont encores lapifiées comme celle de laquelle l'on se sert à Haraucourt, puis qu'elle fait la mesme action que font les pierres de Dagny et Giuonne.

Theorique.

Il semble que tu te contredis, en ce que tu dis quelquesfois que les pierres sont congelées par la vertu du sel, et puis apres tu dis que c'est vne eau.

Practique.

Il me semble que tu as vne ceruelle bien dure, car il me souuient t'auoir dit au precedent qu'on n'a point accoustumé d'appeller l'eau de la mer sel, combien qu'elle soit sallée : mais bien on l'appelle eau iusques à ce qu'elle soit congelée, et depuis on l'appelle sel ; on n'appelle pas aussi l'eau glacée, auparauant qu'elle soit gelée, mais estant gelée on l'appelle glace : on n'appelle point le lait fromage auparauant sa congelation, semblablement ie ne puis appeler les choses susdites en autre terme qu'en la forme où elles sont alors que i'en ay parlé depuis auoir escrit au precedent. Ie trouue tesmoignage certain contre ceux qui disent que la marne ne profite guere aux champs la premiere année ; il est certain que si fait, autant bien que la suyuante, moyennant qu'elle soit mise aux champs auparauant que l'hyuer aye commencé, parce que la marne ne peut de rien seruir, si elle n'est premierement dissoute par les gelées. I'ay esté aussi aduerty par les habitans de Champagne, de Brie et Picardie, qu'en certains lieux, la marne n'est autre chose que craye, et d'autant qu'en plusieurs contrées desdits pays, il y a faute de pierre, et sont contrains quelquesfois de faire des murailles de craye, quand ils trouuent quelque fosse où elle sera bien condencée et reduite en craye ; cela ne se peut faire en toutes marnieres, parce qu'aucunes ne se peuuent tirer que par petites pieces, et mesme il y en a qui sont encores liquides et bourbeuses. Et

comme i'ay dit au precedent, ne sont toutes blanches, ains y en a de diuerses couleurs. As-tu pas consideré les semences qui estant mises dedans vne phiole pleine d'eau, elles viennent et se promeinent dedans ladite eau, combien que la phiole soit bien scelée? et toutesfois nous tenons pour certain que toutes choses animées ne pourroient viure sans aër, il faut donc que l'eau et la phiole soient tous deux poreux, car autrement ces bestes encloses dedans, ne pourroyent viure. Autant en dis-ie des poissons de la mer, et des riuieres que si l'eau n'auoit quelque pore, les poissons ne pourroient viure. As tu pas consideré que quand le temps est humide, et qu'il aduient quelquefois à plouuoir, ou neiger contre les vitres, qu'elles seront mouillées à trauers, par le dedans és costez de la chambre: cuides tu que le soleil fut passé à trauers des vitres, si elles n'estoyent poreuses. Il est certain que non aussi le feu ne pourroit percer à trauers des pots et chaudieres des metaux, s'il n'y auoit quelques pores, tu vois aussi que combien que la coquille des œufs soit bien condencée, si est-ce qu'estants mises sur la braise il pleure certaines petites gouttes d'eau à trauers de la coquille, procedantes du dedans de l'œuf.

COPPIE DES ESCRITS

Qui sont mis au dessouz des choses merueilleuses que l'auteur de ce liure a preparées, et mises par ordre en son cabinet, pour prouuer toutes les choses contenues en ce liure : par ce qu'aucuns ne voudroyent croire, afin d'asseurer ceux qui voudront prendre la peine de les venir voir en son cabinet, et les ayant veu, s'en iront certains de toutes choses escrites en ce liure.

TOVT ainsi que toutes especes de metaux, et autres matieres fusibles, prenants les formes des creux, ou moules, là où ils sont mis, ou iettez, mesmes estans iettez en terres prennent la forme du lieu où la matiere sera iettée ou versée, semblablement les matieres de toutes especes de pierres, prennent la forme du lieu où la matiere aura esté congelée. Et comme les formes metalliques ne sont connues iusques à ce qu'elles soyent dehors du moule, auquel la matiere aura esté congelée, autant en est il des matieres lapidaires, lesquelles en leur premier essence, sont liquides, fluides, et aqueuses : et afin d'obuier aux calomnies qui pourroyent estre faites par ignorance, ou par malice, n'ayant veu autre chose que mes escrits et plattes figures : pour ces causes, dis-ie, ay mis en ce lieu, en euidence vn grand nombre de pierres par lesquelles tu pourras aisement connoistre estre veritables, les raisons et preuues que i'ay mises au traité des pierres. Et si tu n'es du tout alienné de sens, tu le confesseras apres auoir eu la demonstration des pierres naturelles : lesquelles i'ay figuré en mon liure, parce que tous ceux qui verront le liure, n'auront pas le moyen de voir ces choses naturelles : mais ceux qui les verront en leurs formes naturelles, seront contrains confesser,

qu'il est impossible qu'elles eussent prins les formes qu'elles ont, sans que la matiere eut esté liquide et fluide.

Si tu veux bien entendre ce que dessus, entre au dedans des carrieres, ausquelles l'on aura tiré quantité de pierres, ou autres mineraux. Si lesdites carrieres sont encores demeurées voutées, tu trouueras en la pluspart d'icelles certaines mesches pendantes, et formées par les eaux qui descendent iournellement à trauers des terres, sus les voutes desdits rochers. Et les eaux qui auront coulé en la partie dextre ou senestre, contre les mineraux desdits rochers, te donneront clairement à entendre les preuues que verras cy apres. Par ce que tu connoistras que les eaux, qui se sont congelées depuis que les pierres ont esté tirées desdits rochers, ne sont semblables de couleur, ny de forme, ny de dureté, à celles de la principale carriere.

Aussi, en contemplant ce que dessus, tu connoistras qu'il y a vn nombre infini de pierres, qui ont deux essences; et autres qui ont esté formées par additions, le tout par matieres liquides, comme tu connoistras aisément par les preuues que ie t'ay mises icy par rangs.

Les pierres qui sont congelées en l'air, ne peuuent tenir autre forme que celles que tu vois, lesquelles sont formées, partie d'icelles comme glaces pendues és goutieres.

Et par ce que i'ay dit, que toutes pierres sont diaphanes et transparentes, ou cristalines en leur essence premiere : il te faut doncques entendre, que celles que tu vois icy sont tenebreuses, pour ce que les eaux communes iointes auec l'eau congelatiue, ont amené de la terre, ou sable auec elles, lequel sable ou terre estant congelée auec la matiere cristaline, la rend tenebreuse, mesmes la fait estre de sa couleur, soit sable ou terre ; comme tu peux voir euidemment par ces figures, en considerant les formes d'icelles.

Tu peux aussi iuger par icelles formes rudes et mal plaisantes, que ce neantmoins elles ont esté formées de matieres fluantes, en telle sorte, que tu peux aisement iuger lequel bout estoit en haut ou en bas, comme si c'estoit vne matiere metallique.

Tu peux aussi connoistre par les autres pierres suyuantes qu'elles ont esté formées le plat en bas, et qu'elles ont esté faites à diuerses fois, et par additions congelatiues, et non par

croissance comme aucuns disent : les additions assez sont connues audites pierres.

Tu vois aussi que les pierres de platre, de talque et d'ardoise s'esleuent et se desassemblent par feuillets en la forme d'vn liure : et ce d'autant que les matieres ont tombé à diuerses fois, à trauers des terres, parquoy les congelations estants faites à diuerses fois, ne se peuuent si bien lier comme si la matiere auoit esté congelée tout à vn coup : aussi comme tu vois, il y a quelque fois de la terre, ou sable qui se trouuent entre deux congelations.

Par ces pierres tu peux aisément connoistre qu'elles ont esté formées a plusieurs fois et diuerses congelations adioutées par les matieres distillantes.

Toutes ces especes que tu vois estre remplies de cailloux et diuerses especes de coquilles, ont esté formées dans terre en quelque lieu couuert d'eau, et sont les pierres de double essence : Car les coquilles et cailloux qui sont au dedans d'icelles, estoyent formez au parauant la masse et leur formaion, pour ces causes, est plus pesante et plus dure que non pas la masse. Et quelque temps apres les eaux exalatiues s'en sont fuyes y ayant delaissé l'eau congelatiue. Icelle a lapifié et petrifié les vases ausquelles estoyent les coquilles ou cailloux. Et d'autant que la terre estoit desia alterée pour l'absence des eaux exalatiues, la masse principale se trouue plus tendre et plus legere pour cause du nombre des pores qui sont en ladite masse.

Et ne faut que tu penses que nature ait formé lesdites coquilles sans subiet : Ains te faut croire qu'elles ont esté formées par des poissons animez comme les autres natures brutales, et ne dois nullement croire que ces choses ayent esté faites du temps du deluge : car combien qu'il s'en trouue sur les montagnes steriles d'eau : si est-ce que quand leurs coquilles prindrent leurs formes, il y auoit pour lors de l'eau en laquelle y auoit plusieurs choses animées, lesquelles ont esté retenuës, et se sont trouuées encloses quand le bourbier s'est reduit en pierre : tu l'entendras mieux en poursuyuant la lecture des escriteaux subséquens.

Tu vois icy un grand nombre de bois reduit en pierre, lequel s'est petrifié dedans l'eau comme les coquilles, et ledit bois a esté petrifié en mesme temps que la masse de la

pierre à la laquelle ledit bois est attaché, et le tout n'a point esté fait hors de l'eau, et ne le peut estre.

Tu vois aussi certaines pieces de bois qui ont esté petrifiées dans l'eau congelatiue, de laquelle toutes choses sont commencées, et sans laquelle nulle chose ne peut dire ie suis. Voila pourquoy ie l'ay appellé element cinquiesme, combien qu'il deust estre appellé premier.

Pour te rendre certain que toutes choses sont poreuses, comme i'ay mis en mon liure, considere ce grand nombre de poissons armez de coquilles, lesquelles i'ay mis deuant tes yeux, qui sont à present tous reduis en pierre; et ce par la vertu de l'eau congelatiue, qui a penetré tout au trauers desdites coquilles en les changant de nature en autre, sans leur oster rien de leur forme.

Et à cause que plusieurs sont abreuez d'vne opinion fausse, disant que les coquilles reduites en pierres ont esté apportées au temps du deluge, par toute la terre, voire iusques au sommet des montagnes, i'ay respondu et reprouué vne telle opinion par vn article cy dessus, et afin de mieux verifier les escrits de mon liure, i'ay mis devant tes yeux de toutes les especes de coquilles petrifiées, qui ont esté trouuées, et tirées, entre cent millions d'autres, qui se trouuent iournellement és lieux montueux, et au milieu des rochers des Ardennes : lesquels rochers pleins de poissons armez de coquilles n'ont pas esté faits, ny generez depuis que la montagne a esté faite, ains te faut croire qu'au parauant que la montagne fut de pierres, que ce lieu là, où se trouuent lesdits poissons, estoyent pour lors eaux ou estangs, ou autres receptacles d'eau, où lesdits poissons habitoyent, et prenoyent nourriture. Voila pourquoy tu peux aisément connoistre que i'ay dit verité, quand i'ay dit qu'il y auoit és terres douces aussi bien trois especes d'eaux, comme dans la mer : car autrement les mesmes poissons qui viuent en la mer, et multiplient par habitations l'vn auec l'autre, ils ont semblablement fait és montagnes où les armures desdits poissons se trouuent toutes semblables à celles de la mer.

Et pour confirmation de ce que dessus : Regarde toutes ces especes de poissons que i'ay mis deuant tes yeux, tu en verras vn nombre desquels la semence en est perdue, et mesmes nous ne sçauons à present comment il les faut nommer : mais

cela ne peut empescher qu'il ne soit notoire à tous, que la forme d'iceux ne nous donne claire connoissance qu'ils ont esté autre fois animés, et ces formes ne se peuuent faire nullement, si elles ne sont formées par choses animées.

Il te doit suffire par les articles subsequents, que les preuues sont toutes notoires, que toutes pierres sont en premiere essence de matieres liquides, fluides et cristallines. Semblablement les matieres metalliques sont aussi fluides, aqueuses et cristallines. Et tout ainsi que les pierres tenebreuses le sont pour cause des melanges des terres et sables entremeslez parmi la matiere essencielle, semblablement les metaux ne peuuent aucunement apparoir diaphanes, ou cristalins : ains sont impurs pour cause des matieres entremeslées auec l'essence pure : lesquelles matieres entremeslées rendent le metal impur, aigre et friable : ce qui ne pourroit estre, s'il n'y auoit vne opposition des terres ou sables, ou autres interpositions : et mesmes le souphre est ennemy des metaux apres leur congelation. Parquoy il faut qu'il soit mis hors par les affineurs, au rang des matieres excrementales.

Et pour bien t'inciter à preparer tes aureilles pour ouyr et tes yeux pour regarder, i'ay mis icy certaines pierres et mineraux de toutes especes de metaux, pour te faire entendre vn poinct singulier et de grand poids, qui est tel que par ces pierres metalliques mises deuant tes yeux, tu pourras aisément connoistre que tout autant d'alchimistes qu'il y a et qu'il y a eu par cy deuant, se sont trompés en ce qu'ils ont voulu edifier par le destructeur : d'autant qu'ils ont voulu faire par feu ce qui se fait par eau, et par chaud ce qui se fait par froid : qui m'a causé mettre ces preuues euidentes deuant tes yeux.

Note bien ce petit argument bien prouué par la chose mesme, et regarde bien en toutes minieres metalliques, tu trouueras sur la superficie du metal vn nombre infini de pointes taillées par faces naturellement, comme si elles auoient esté taillées par artifice : dont la plus part d'icelles pointes sont formées des matieres cristallines, ou pour mieux dire, de cristal, qui m'a causé connoistre directement, et m'asseurer que iamais il ne se forma aucunes pointes naturellement hors de l'eau : mais pour choses certaines toutes matieres qui sont congelées dedans les eaux, se trouuent sur la superficie superieure en

forme triangulaire, quadrangulaire, ou pentagone. Ie dis formées par vne nature merueilleuse, et comme il est donné aux vegetatiues de tenir vn ordre certain, comme tu vois que les rosiers et groisiliers se forment des espines picquantes pour leur defence : aussi les matieres metalliques et lapidaires, se forment comme vn harnois, ou corps de cuirasse sur la superficie, en façon de pierres pointuës : comme il est donné à plusieurs poissons de se former plusieurs escailles, ainsi que tu vois aux escreuices et plusieurs autres genres de poissons.

Regarde donc si ie suis menteur, vois-tu pas plusieurs pieces de mines d'or et d'argent qui te monstrent euidemment qu'elles ont esté formées dans l'eau? entre les autres, n'en vois tu pas vne qui est la premiere couche estre de pierre, qui te monstre euidemment que la pierre a esté premierement congelée? et apres tu vois vne autre couche de mine d'argent. Et au troisiesme degré, il y a vne couche de cristal formée par pointes de diamant, et puis que ie te dis, que ces formes pointues taillees à faces, ne se peuuent former hors de l'eau, tu me confesseras doncques, que la mine d'argent qui est en la partie inferieure du cristal, est aussi congelée au dedans de l'eau, comme tu connoistras en continuant la montre de ces choses.

Tu vois aussi par ces autres pierres metalliques, certaines pointes comme celles cy dessus nommées : Et toutesfois en icelles il y a plusieurs especes de metaux : comme or, argent, plomb, et cuyure, lesquelles choses sont aussi impures, à cause des terres sulphurées et autres excrements qui causent rendre les metaux aigres et friables. Et quand lesdits excremens sont dissipez et separez par l'action du feu, lors lesdits metaux sont traitables, et maleables : comme on void par les metaux monnoyez.

Voicy à present vn article qui te doit faire arrester à contempler et croire tout ce que dessus. Regarde l'ardoise que i'ay mis cy-deuant tes yeux, laquelle est remplie de marcassites, formées en façon d'vn dé carré. Il est certain que l'ardoise a esté congelée dedans l'eau, et qu'au parauant sa congelation la matiere metallique qui estoit inconnue au dedans de l'eau, s'est separée de ladite eau : comme l'huile qui n'a nulle affinité auec l'eau ; et la matiere desdites marcassites qui sont formées de matieres metalliques, en se congelant et se diuisant d'auec

l'eau se sont formées par faces pentagones, et ont prins leur couleur en leur congelation. Et faut necessairement que lesdites marcassites ayent esté formées et congelées au parauant la formation de l'ardoise.

Vois-tu pas ces pierres cristallines que i'ay mises icy, pour attestation de la plus rare et difficile demonstration qui soit en mon liure? D'autant combien que lesdites pierres soyent autant claires et cristallines que l'eau pure, si est ce qu'au dedans d'icelles il y a de la matiere metallique, laquelle ne se peut aucunement connoistre dans la masse, sinon que la matiere metallique soit manifestée par l'examen du feu bien chaud, comme tu vois par vne piece de la mesme matiere qui est deuenue en couleur d'argent apres son examen fusible. Et par là tu te dois tenir asseuré et croire fermement, que les metaux sont entremeslez, et inconnus parmy les eaux iusques à leur congelation.

Note doncques que les matieres metalliques sont inconnues parmy la terre, et parmy les eaux, et sont tellement liquides, et subtiles qu'elles penetrent à trauers des corps, ou matieres corporelles, comme fait le soleil à trauers des vitres; car autrement les eaux metalliques ne pourroyent reduire aucune forme en metal, si la forme n'estoit premierement dissipée. Nous voyons toutesfois que plusieurs coquilles de poissons, sont metalliques et changées de substance, pour auoir croupi entre les matieres metalliques, comme tu vois aussi presentement plusieurs pieces de bois qui se sont reduites en metal pour auoir croupi parmy les eaux auxquelles il y auoit des eaux metalliques.

Tu vois euidemment que toutes ces formes de coquilles reduites en pierres, ont esté autrefois poissons viuants, et par ce que de toutes ces especes la memoire et vsage en est perdue, ce neantmoins par les autres especes qui sont en vsage, et sont aussi reduites en pierres, nous pouuons aisément connoistre que nature ne fait rien de telles choses sans subiet comme i'ay dit cy dessus. Et pour ces causes i'ay mis vn parquet à part et du genre que tu vois estre formé en façon de lignes spirales; i'en ay veu vn qui auoit seize pouces de diametre.

I'ay mis ceste pierre deuant tes yeux pour te faire entendre que tout ce que i'ay dit des tremblements de terre contient ve-

rité : car tu vois en ceste pierre les effets de l'air et de l'eau esmeus par le feu : car combien que la pierre soit grande, ce neantmoins elle est formée de bieu peu de matiere : parce que les trois elements l'ont enflée et rendue spongieuse en telle sorte que tu vois, que si la matiere estoit reserrée comme elle estoit au parauant qu'elle fut mise au feu, elle seroit cent fois plus petite qu'elle n'est à present : mais parce qu'elle estoit liquide et bouillante, lors que le feu a esté cause de la tourmenter, elle s'est soudain congelée, et l'air qui la tenoit enflée par le mouuement du feu, a demeuré dedans iusques à present. Et voila pourquoy ladite pierre est si legere qu'elle nage sur les eaux, comme toutes autres choses legeres.

Comme ie t'ay dit que les metaux estoyent inconnus dans les eaux, semblablement sont ils en la terre, au parauant leur congelation : et pour ces causes, ie t'ay mis deuant les yeux ceste grande piece de terre cuite, laquelle estoit formée en la façon d'vn grand vase : mais quand elle a esté touchée par le feu, elle s'est liquifiée, et ployée et entierement perdue sa forme, en telle sorte que si elle eut esté forgée toute chaude, elle se fut estendue sans se casser, comme font les choses maleables. Ne te faut il pas bien croire par là, qu'il y a quelque matiere metallique inconnue parmy la terre, de laquelle on fait ces vaisseaux ? car autrement elle eut plustost cassé, que ployé.

Vois tu bien ces formes de poissons nommez auaillons : ils ont esté trouuez en un champ ioignant les forests des Ardennes : et la partie de la terre où ils ont esté trouuez, est fort creuse sur la superficie : qui m'a fait croire comme dessus, que les eaux s'arrestoyent là anciennement plus qu'en nulle autre partie du champ, et lesdits poissons y estoyent generez et augmentez, et y viuoyent comme s'ils eussent estez en la mer. En la mer Oceane limitrophe de Xaintonge, se trouue grande quantité desdits poissons. Et comme i'ay dit cy dessus, l'eau dudit champ s'est exalée et tarie, et les vases et poissons se sont reduits en pierre, desquels s'en trouue vn nombre infini.

Et en vn autre champ i'ay trouué vn nombre infini de poissons que nous appellons sourdons, desquels les Michelets en enrichissent leurs bonnets ou chappeaux en venant de sainct Michel. Et la cause pourquoy les coquilles ne sont blanches

comme les autres, est par ce qu'il y a de la mine de fer au dedans, et parmy la terre où lesdits poissons estoyent habitants.

Vois-tu pas icy des fruits reduits en pierre, par les mesmes causes que i'ay deduites cy dessus?

Toutes les pierres que tu vois en cest endroit, sont agates, ou cassidoines, qui ont esté autrefois terre d'argile, comme tu verras au parquet suyuant.

Considere vn peu ces mottes de terre lesquelles ont la figure d'agate, ou cassidoine, et tu connoistras qu'elles estoyent preparées à se reduire en pierre, et ne restoit plus que la decoction par laquelle les pierres viennent en perfection.

Regarde vn peu: voicy deux pierres, lesquelles ont retenu la forme des herbes sur lesquelles la matiere est tombée au parauant qu'elles fussent congelées.

Il y a des poissons et autres animaux qui ont des pierres en la teste, lesquelles sont formées de matieres liquides comme les autres.

Par ces pierres cornues qui sont creuses dedans, ie prouue qu'elles ont esté pleines d'eau exalatiue, durant le temps de leur formation.

Ces pierres que tu vois ainsi pleines de trous sont formées des vases de la mer, ausquelles y auoit plusieurs poissons nommez dailles: iceux sont longs comme manches de couteaux, armez de deux coquilles: et quand la vase se reduit en pierre, lesdits poissons sont morts dedans, et la pierre est demeurée percée.

Et pour te monstrer que toutes choses formées dans l'eau, sont par faces et autrement non, Regarde icy la coperose ou vitriol, le salpestre et toutes autres especes de sels, qui sont couuertes d'eau en se congelant.

EXTRAIT DES SENTENCES

principales contenuës au present liure. Le nombre mis à la fin signifie la page : celles qui n'en ont point sont pour la plus part recueillies generalement de tout le discours, sans estre rapportées à certain lieu.

COMBIEN que tous les Philosophes ayent conclud, qu'il n'y a que quatre elements si est ce qu'il y en a vn cinquiesme, sans lequel nulle chose ne pourroit dire ie suis. 215, 217

Iamais homme n'a entendu les effets des eaux, ny du feu. 143

Ceux qui disent que les eaux viennent de la mer, et y retournent s'abusent. 158

Toutes fontaines et fleuues, qui sont formées d'eau douce, ne sont causées que de l'eau des pluyes. 157, 165

Les fonteniers modernes se trompent iournellement, n'entendant point les effets des eaux encloses par tuyaux sousterreins. Les antiques pour ces causes, ont inuenté les aqueducs. 143, 145

Toutes pompes et machines pour esleuer les eaux ne peuuent durer pour cause de la violence. 137

Sans la violence de l'eau esbranslée par le feu, il n'y pourroit auoir aucun tremblement de terre. 150

Il y a deux eaux, l'vne exalatiue et l'autre congelatiue et germinatiue. 216

Comme l'eau seminale de toutes choses animées est differente de l'vrine, aussi l'eau exalatiue est differente à l'eau congelatiue.

Toutes choses humaines sont commencées par matieres aqueuses; mesme les matieres des semences dures ne peuuent generer de rechef que premierement ne soyent liquifiées :

car autrement elles ne pourroyent succer ny faire atraction de ceste matiere congelatiue, laquelle i'appelle element cinquiesme.

Comme toutes especes de plantes, voire toutes choses animées sont en leur premiere essence de matieres liquides, semblablement toutes especes de pierres, metaux et mineraux sont formées de matieres liquides, en leur première essence. 203

Par l'action de l'eau congelatiue les corps de l'homme et de toutes bestes et de toutes plantes se peuuent reduire en pierre. 266

L'on peut faire des fontaines en tous lieux. 168, 174

En la terre argileuse sont deux eaux, l'vne congelatiue, et l'autre exalatiue. 303

La guerison des eaux des bains est incertaine. 153

Les eaux qui sont propres pour les teintures n'ont leur action causée que d'vne salsitude que les eaux ont prise en passant par les terres.

Les effets des eaux qui sont propres pour endurcir et attremper les ferrements, ne procedent que d'vne matiere salsitiue qui est esdites eaux.

Les fontaines artificielles sont meilleures que les naturelles. 174

Il n'y a aucune eau mauuaise de soy. La cause de la mauuaistié de celles qui le sont, procede de la terre du lieu où elles passent. 147

Les eaux des pluyes sont meilleures et plus asseurées que celles des sources. 174

Si la terre n'estoit foncée de pierres, ou de quelque terre argilleuse, on ne trouueroit iamais source pour faire fontaine ou puits. 165, 166

Les figures du cœur du bois qui sont estimées en menuiserie, et les figures qui sont és marbres, iaspes, porphires, agates, cassidoines et toutes autres especes de pierres, ne sont causées que par accident procedant de la descente ou esgout des eaux congelatiues.

Le polissement des pierres dures et compactes, rend tesmoignage qu'elles sont formées de l'eau inconnue : Et comme l'eau represente les Tours, Chasteaux, ou autres bastiments assis aupres de la riuiere, aussi font les pierres polies.

Les metaux polis font le semblable par la vertu de ce cinquiesme susdit.

L'espouuantable masquaret, qui se fait en la riuiere de Dordongne, n'est causé que d'vn air enclos, compressé par les eaux de la Garonne et de la mer, qui entre en la Gironde. 184

Si les fleuues et fontaines des montagnes procedoyent de la mer comme l'on dit, il faudroit necessairement que les eaux se partissent de la mer en quelque endroit où elle fut plus haute que toutes les montagnes, et qu'il y eut vn canal bien clos contenant depuis la haute mer susdite, iusques au sommet des montagnes; que si le canal ne prenoit qu'au bord de la mer, l'eau ne monteroit iamais plus haut que le riuage de la mer : et si le canal qui ameneroit l'eau des fleuues au haut des montagnes se venoit à creuer, il est certain que tout le monde seroit submergé. 160,161

Si l'eau congelatiue n'estoit portée par la commune, elle ne pourroit actionner non plus.

Si toute l'eau de la terre estoit en nature congelatiue, bien-tost la terre se reduiroit en pierre.

Si en l'homme n'y auoit autre eau que la commune ou celle de l'vrine, il ne pourroit iamais engendrer pierre en son corps.

Plusieurs eaux engendrent la pierre à ceux qui en boiuent, à cause que parmy la commune, il y a quantité de l'eau congelatiue.

Comme l'eau claire est propre pour receuoir toutes couleurs, semblablement les terres blanches les peuuent aussi receuoir.

En la mer il y a trois especes d'eaux, la commune, la salée, et la vegetatiue, ou congelatiue.

La verité est contraire et se mocque de la lourdise de plusieurs qui soustiennent que les glaces se forment au fond de la riuiere de Seine. 238

Entre tous les esprits visibles, il n'en est pas vn plus certain que l'eau commune, qui est vn tesmoignage que tous mineraux exalatifs sont composez de matieres aqueuses, et pour ces causes ils sont sublimatoires.

Combien que la terre et la mer produisent iournellement nouuelles creatures, et diuerses plantes, metaux et mineraux,

si est-ce que dès la creation du monde, Dieu mit en la terre toutes les semences qui y sont et seront à iamais : d'autant qu'il est parfait, il n'a rien laissé d'imparfait. 194

Comme toutes senteurs, couleurs et vertus sont inconnues en la terre : aussi toutes matieres lapifiques et metalliques sont confuses et inconnues parmy les eaux et la terre, et ce iusques à ce qu'elles soyent reduites en quelque forme par vne congelation inconnue. 206, 213, 215

Tous ceux qui cherchent à generer les metaux par feu veulent edifier par le destructeur. 196

Comme en toutes les matieres seminales de toutes choses animées, on ne sçauroit distinguer les os et le poil d'auec la chair, semblablement nul homme ne sçauroit connoistre les matieres metalliques auparauant leur formation ou congelation. 213

Si quelqu'vn pouuoit distinguer les couleurs, saueurs, vertus, puis que les plantes sçauent attirer et desbrouiller de la terre, ie dirois qu'il seroit possible à vn tel homme faire de l'or et de l'argent. 212, 222

Les metaux n'ont aucune couleur, ains sont comme eau au parauant leur congelation et decoction. 194

Iamais homme n'a conneu, ny souphre, ny vif-argent, au parauant qu'il eut commencement de generation, non plus qu'on ne sçauroit voir les couleurs et senteurs extraites de la terre par les plantes aromatiques, au parauant que lesdites plantes en eussent fait atraction. 209, 213, 223

Si les matieres metalliques n'estoyent fluides et liquides, il seroit impossible qu'elles peussent actionner les pierres monstreuses que i'ay mis en mon cabinet. 245, 249

Par l'action des matieres metalliques estants encores fluides, les corps de l'homme et de la beste, et poissons, et de toutes especes d'arbres et plantes, se peuuent reduire en metail. 219, 266

L'or se peut potager en diuerses sortes, mais non pas pour seruir de restaurant. 224

Potage l'or en quelque sorte que tu voudras, que si l'estomach du malade à qui tu le donnes est aussi chaud qu'vne fournaise ardante, la chaleur de l'estomach en lieu de departir le potage d'or és membres nutritifs, il le rendra à vn lingot : car autrement l'or ne pourroit estre fixe. 227

Les metaux se peuuent augmenter par art, mais non pas legitimement. 197,200

Antimoine est vn metail imparfait, qui cause vn vomissement par les deux parties de l'homme, à cause de la chaleur naturelle de l'estomach qui le fait exaler : laquelle exalation veneneuse esmeut tous les esprits vitaux. 229

Par plusieurs especes de marcassites, ie prouue tous metaux estre generez de matieres liquides. 206,213,219

Ceux qui ont escript que les metaux croissent aux minieres comme les arbres, n'ont rien entendu et ont parlé contre verité.

Ceux qui disent et ont escript que les esprits inuisibles tuent les hommes dedans les minieres, ont erré.

Autant qu'il y a, et qu'il y a eu d'alchismistes au monde, se sont abusez en ce qu'ils ont pensé retenir les esprits esmeus par le feu és vaisseaux clos et fermez. 220

Quand vn vaisseau de terre, ou quelque metail que ce soit seroit aussi espois qu'vne montagne, et qu'il y ait quelque matiere spirituelle, ou exalatiue au dedans dudit vaisseau, il faut necessairement que ledit vaisseau creue s'il est touché par le feu, sçauoir est si ledit vaisseau n'a quelque trou pour seruir de fuite à la matiere spirituelle ou exalatiue, qui sera au dedans. 220

Il seroit plus aisé a vn Alchimiste de faire tourner en son premier estre, vn œuf pillé, broyé, ou vne chataigne, ou noix pulueriseé, que non pas pouuoir generer les metaux. 204

Comme l'huile dedans l'eau se separe par petits rondeaux : comme aussi fait le suif et toutes especes de gresses ; aussi les matieres lapidaires et metalliques, se sçauent separer des eaux communes. 205,214,216,224

Comme l'air tient lieu et occupe place, semblablement fait le feu dedans les metaux fondus, et pour ces causes le fer fondu et autres metaux rapetissent en se congelant.

Tout ainsi que Dieu a commandé à la superficie de la terre de se trauailler à produire et germer les choses necessaires pour l'homme et pour la beste, il est certain que l'interieur et matrice de la terre en fait le semblable, en produisant plusieurs especes de pierres, metaux et autres mineraux necessaires. 194

Ceux qui disent que les pierres estoyent creées dès le commencement du monde errent, ne l'entendant pas. 261

Et ceux qui disent que les pierres croissent, errent semblablement. 261

Ceux qui pensent que les pierres soyent en leur dureté dès la premiere formation, ne l'entendent pas. 293

Ceux qui disent que les terres et pierres ont prins leur couleur dés leur essence ne l'entendent pas.

Comme les fruits de toutes especes changent de couleur en leur maturité, semblablement les pierres, metaux et autres mineraux, mesme les terres argileuses changent de couleur en leur decoction. 213

La matiere de toutes pierres, tant des communes que des rares et precieuses, est cristaline et diaphane. 264

Toutes pierres coulourées ou tenebreuses ne sont tenebreuses ny coulourées que par accident suruenu à la matiere diaphane auparauant la congelation desdites pierres. 297

Toutes terres argiles sont commencement de pierres. 329

Il n'y a pierre en ce monde, ny aucune chose animée, si elle pouuoit estre dissoute, qui ne peut seruir de fumier ou de marne pour rendre les terres fructueuses.

Ceux qui ont escript que les coquilles qui se trouuent és pierres sont du temps du déluge ont lourdement failly. 272

Comme les os de l'homme luy causent la forme, les pierres causent aussi la forme des montaignes. 165,262

De tant plus que les pierres sont dures, alizes, ou compactes, de tant plus elles reçoiuent beau policement.

S'il n'y auoit des pierres il ne seroit nulle montaigne. 165

Aucunes pierres et rochers sont creux à cause d'vn air enclos à la venue des matieres lapidaires qui ont esté congelées au dessus et portées par l'air enclos.

Aucunes autres pierres et rochers sont creux par l'apposition des terres qui ont empesché que la matiere distilante ne se peut condencer : duquel genre de pierres, les pierres des moulins qui se prennent à la Ferté sous Iouarre, en rendent tesmoignage.

La craye et la marne sont pierres imparfaites, ausquelles l'eau congelatiue a defailly au parauant leur parfaite congelation. 333

Le semblable en est il de toutes pierres tendres et pour cause

de leurs imperfections elles se calcinent ne pouuant resister au feu. 294

Toutes pierres dures le sont par deux effets nécessaires : L'vn qu'elles ayent de l'eau à souhait durant leur congelation et formation : L'autre, qu'elles ne soyent ostées de leur place iusques à la perfection de la congelation. 293

Si le plastre autrement appellé gyp et l'alebastre estoyent laissez en terre ils deuiendroyent pierres dures, moyennant que le fonds de leur situation peut contenir les eaux, et autrement non.

Si la matiere principale de toutes pierres n'estoit d'vne eau candide et transparente il ne seroit iamais diamant, cristal, emeraudes, rubits ny grenats, ny aucunes pierres diaphanes.

Toutes pierres cornues ne le sont que par accident, et se forment en la terre, selon le lieu et forme où la matiere liquide se vient arrester et congeler. 282

Toutes pierres sont formées de matieres fluantes et liquides. 264

Toutes pierres ou metaux formez à faces ou à pointes sont congelez dedans les eaux. 207,264,307

Le nombre de diuerses especes de sels est infiny. 241

Il n'est rien en quoy il n'y ait du sel. 242

Ceux qui disent que le sel commun est ennemy des semences errent. 246

Le sel cause la saueur en toutes les especes de fruits et de plantes. 242,244,260

Le sel qui est en toutes plantes, metaux et mineraux cause la vertu qui est en iceux. 242,244,260

Le sel blanchit toutes choses. 242,244,260

Il donne ton à toutes choses. 244,260

Rend transparent toutes choses. 245

Cause l'action és mirouers et lunettes. 245

Il cause l'amitié et vertu generatiue. 260

Il cause la voix et l'incorruption. 244

Il fait attraction des teintures. 249

Il oste de l'vn pour bailler à l'autre. 249

Et comme il donne ton aux metaux, aussi fait il és chansons ou cantiques faites par les humains, mesme resiouit les humains et les bestes. 244,260

Sans sel il est impossible de faire verre. 244,260

Le sel commun est vn contre venin.

Sans le sel nulle chose ne pourroit prendre policement.

Sans le sel nul ferrement n'auroit force de couper ny mesme s'endurcir. 242,249,260

Il est impossible que la langue trouue saueur en nulle chose si premierement elle n'est dissoute et face attraction de quelque partie du sel qui est en la chose qu'elle atouche. 230

En l'escorce du bois est contenu presque tout le sel de l'arbre. 243

S'il n'y auoit du sel en l'escorce de bois elle ne pourroit conroyer le cuir, ny nettoyer les draps et seroit inutile à la buée. 243

S'il n'y auoit du sel aux pailles et foins, les fumiers ne pourroyent aucunement ameilleurer la terre. 244

Si n'estoit le sel des epiceries les corps embaumez se putrifiroyent. 243

Sans l'effet du sel nulle chose ne sentiroit. 242

La terre sigillée n'a aucune vertu contre le poizon sinon à cause de l'action du sel ou eau congelatiue. 348

Les cendres de toutes especes de bois, arbres et arbustes sont bonnes à faire verres pour cause du sel qui est esdits bois par les foins et pailles. 244

S'il n'y auoit du sel aux pierres, elles estant calcinées ne pourroyent seruir aux conroyeurs pour empescher la putrefaction des cuirs.

Les coquilles des poissons de la mer ne sont fort bonnes à faire chaux, et est attestation de la salsitude qui est en elles.

Le sel des raisins detruit le cuiure, le rendant en vert de gris.

Il y a en toutes choses humaines vn commencement de forme soustenue par le cinquiesme element, et autrement toutes choses naturelles demeureroyent combustées ensemble sans aucune forme. 217

Le nombre de diuerses especes de terre argileuse est indicible. 300

Les effets desdites terres sont merueilleux, voire indicibles. 301

Toutes terres peuuent deuenir argilles.

Ceux qui disent que la terre argileuse est grasse et visqueuse ne l'entendent pas. 298

La mesme matiere qui cause argiler toutes terres, est cela mesme qui cause que la terre de marne fait produire et vegeter les fruits és terres steriles.

Par les moyens mis en ce liure on pourra trouuer de la terre de marne en toutes prouinces.

Toutes choses, quelques compactes ou alizes qu'elles soyent, sont poreuses.

La momie des modernes n'est que charongne. 244

Le plombusti des modernes n'est fait au debuoir.

Les architectes et sculpteurs ne prennent occasion de se glorifier sinon en ce qu'ils sçauent imiter les inuentions des payens, et veulent estre honorez comme inuenteurs.

Les œuures plus vaines des humains sont les plus estimées.

De chose que la langue ne peut faire attraction de saueur, le corps n'en sçauroit prendre nourriture. 230

Comme le corps est suiect à corruption il veut estre nourri de choses corruptibles. 230

S'il n'y auoit du cinquiesme susdit en la prunelle de l'œil les lunettes ne pourroyent ayder à la veüe. 335

Tout ainsi que Dieu a ordonné qu'en chacune semence il y a toutes matieres requises pour la generation des nouuelles auenir, comme dans la semence de l'œuf est comprins le blanc, le iaune et la coquille, et és noyers les noix, la robbe d'icelle, la coquille, l'arbre, fueilles et branches : lesquelles matieres inconnues se font apparoir en leur maturité : semblablement la chair, les os, le sang et toutes les parties de l'homme sont contenues et encloses en vne, et comme Dieu a ordonné de separer les matieres de pierres en dureté, semblablement la matiere des os de l'homme et de la beste sont endurcies, et aussi en partie de la matiere lapidaire : ce que l'on peut veoir par les coquilles des œufs et par les os de pieds des mouton et plusieurs autres bestes, desquelles les os resistent mieux au feu que nulle pierre que l'on puisse trouuer.

Le mitridat des anciens n'estoit composé que de quatre simples. 234

Trois cents tant de simples que les modernes mettent à leur mitridat ne sçauroyent s'accorder : Comme toutes les couleurs d'vn peintre broyé ensemble n'en sçauroyent faire vne belle. 232

Comme aussi vn bouquet de toutes fleurs ne sçauroit sentir si bon qu'vne seule rose. 232

Plusieurs viandes broyées ensemble ne sçauroyent estre si sauoureuses qu'vn chapon seul. 232

Sans l'action de l'humidité nulle chose ne se pourroit corrompre ne putrifier. 250

Dans les sepulchres bien sellez, les corps se tiennent à tousiours en la forme qu'ils y ont esté mis : à cause de l'aër qui est enclos auec eux.

Tous arbres et autres choses vegetatiues monteroyent directement en haut en leur croissement si ce n'estoit les accidens que i'ay mis en ce liure. 347

Comme les fleuues et ruisseaux sont tortus à cause des montagnes, aussi les racines de tous arbres et plantes ne sont boiteuses que à cause de la position des pierres ou des terres qui sont plus dures à percer à vn endroit que non pas en l'autre. 345,346

La terre de marne est ennemie des plantes qui ne sont semées par les laboureurs et ne les veut permettre vegeter parmy les bleds semez.

Le soulfre, la geme, la poix-rasine et le bitumen ne sont autre chose que huiles congelées.

En plusieurs contrées et pays des terres douces lointaines de la mer, mesme aux plus hauts lieux des Ardennes, il y a mesme semence qui est en la mer pour l'essence de toutes especes de poissons, comme ie certifie et le prouue par les coquilles lapifiées qui sont par millions audit pays des Ardennes et en plusieurs autres contrées, que l'on pourra voir en ce liure.

Les vents ne sont causez que par vne compression d'air.

Il y a bien peu de choses en ce monde qui ne se puissent par art rendre transparentes.

La marne est vn fumier naturel et diuin, ennemi de toutes plantes qui viennent d'elles mesmes, et generatiue de toutes semences qui ont esté mises par les laboureurs.

EXPLICATION

DES MOTS PLUS DIFFICILES.

ACRIMONIE, s'entend des choses mordicatiues, qui picquent la langue : comme aucunes especes de sels, comme la couperose, ou vitriol.

Additions, sont les matieres adioustées és pierres et metaux, congelées et attachées à diuerses fois à la premiere masse.

Aigres, sont choses qui se cassent aisément auec vn marteau.

Alizes, sont les choses serrées, comme le caillou, et le pain broyé, auquel n'a esté donné lieu de se leuer, et toutes choses qui sont si bien condencées qu'il n'y a aucuns pores apparents.

Alterées, sont les pierres imparfaites, comme la craye, le plastre, et toutes pierres legeres, ausquelles l'eau a deffailly au parauant leur parfaite decoction.

Amalgame, est appellé par les Alchimistes l'or, quand il est dissout, et entremeslé auec le vif argent.

Antimoine, est vn metal imparfait, commencement de plomb et d'argent.

Appositions, sont les matieres terrestres entremeslées, lesquelles se mettent entre deux congelations des pierres et metaux, et rendent en cest endroit la masse plus tendre et impure.

Aqueducs, sont les conduits d'eau, pour lesquels les antiques faisoyent plusieurs arcades, pour conduire les eaux.

Attraction, s'entend d'attirer la teinture ou la vertu de quelque chose, comme l'eau bouillante attire la couleur du bresil, et l'alun attire la saliue de l'homme.

Bitumen, est vne espece de poix, de laquelle on gresse les nauires pour resister à la pourriture : et combien qu'aucuns

en vsent de certaine mixtion, comme de iesme, graisse et poix-rasine, si est-ce qu'il s'en trouue de naturel en diuerses contrées.

Calciner, se dit de toutes choses qui se rendent en chaux ou en poussiere par l'action du feu.

Circonference, est la ligne qui est à l'entour d'vne figure ronde ou quarrée, et de toute figure.

Concasser, se dit des choses pillées grossement.

Concatenées, se dit des choses liées, enchainées l'vne à l'autre.

Congeler, se dit de toutes choses qui s'endurcissent apres la fonte : comme les eaux s'endurcissent au froid.

Decoction, s'entend des metaux paruenus à leur perfection : comme aussi les pierres quand elles sont endurcies en perfection : comme les coquilles des noix.

Diaphane, s'entend de toutes choses claires, au trauers desquelles on void les choses qui se presentent deuant les yeux.

Dilater, se dit des choses qui s'espandent d'vn costé et d'autre : comme les riuieres debordées, les arbres et plantes, comme on voit les citrouilles et concombres.

Dissoudre, se dit des choses qui perdent leurs formes : comme la glace et les neiges, quand elles sentent la douceur du temps.

Esmail, est vne pierre artificielle composée de plusieurs matieres.

Esmailler, se dit des choses qui sont peintes d'esmail liquifié ou fondu sur la besongne.

Spirale, est vne ligne faite par voute en vironnant, en forme de la coquille d'vne limace.

Esprits, ou matieres spirituelles, s'entendent l'argent vif, et toutes choses qui s'esleuent en haut à la chaleur : comme l'eau d'vn linge mouillé.

Euaporer, se dit des choses liquides, que l'on fait monter en haut par l'action du feu.

Fixes, sont choses qui endurent le feu iusques à la fonte : comme fait le verre, l'or, l'argent, et autre metal.

Fossiles, sont les matieres minerales pour lesquelles recouurer faut creuser la terre.

Frangible, se dit des matieres aigres et cassables.

Fusibles, sont les choses qui se liquifient ou se fondent à la chaleur du feu : comme le plomb, l'estain, et autres metaux.

Imbiber, se dit de choses qui pour leur alteration succent quelques matieres liquides.

Incliner, nous appellons inclination quand les vaisseaux sont pendants d'vn costé, pour tirer la liqueur de quelque chose, pour laisser le marc au fond du vaisseau.

Lamines, sont petites tablettes de plomb ou autre metal qui ont esté forgées pour calciner, ou employer à autres ouurages.

Lapifier ou petrifier, se dit des choses qui en premiere essence estoyent terre, ou eau, ou bois, qui se sont reduittes en pierre.

Liquides, se dit de toutes choses qui sont claires comme eau, ou comme le verre dedans la fournaise.

L'ocre iaune, est vne semence et commencement de fer, et en fin se rend en fer, quand il est suffisamment abreuué et nourri par les eaux, aussi tu vois que le fer rouillé retourne en couleur d'ocre.

Luter, les distillateurs et ceux qui font l'eau forte appellent lut la terre de laquelle ils reuestent et couurent leurs vaisseaux de verre, affin qu'ils resistent au feu, ce qu'autrement ne pourroyent faire.

Maleables sont les choses qui endurent le marteau sans aucune fraction : comme fait l'or, l'argent, et autres metaux domptables.

Marcassites, sont metaux imparfaits. Les matieres d'iceux se forment quelquefois en façon quarrée comme vn dé, quand elles sont congelées et formées dedans les eaux.

Marne, est vn fumier naturel, qui se prend en mine, et quelquefois bien bas en terre, comme les carrieres de pierres et metaux.

Mordicatiues, sont appellees les choses qui picquent la langue, quasi iusques à l'inciser.

Obliques, sont lignes tortues.

Oleagineuses, sont choses qui tiennent la nature de l'huile, et s'accordent auec icelle : comme fait la cire, soulphre, poix-rasine et plusieurs autres choses.

Peintures et teintures, sont differentes : par ce que les teintures

sont toutes diaphanes, n'ayant aucun corps : et donnent couleur à l'interieur comme à l'exterieur : ce que les peintures ne peuuent faire, à cause qu'elles ont vn corps.

Pentagones, sont figures à cinq coings, Hexagones qui en ont six, Heptagones qui en ont sept, et ainsi des autres.

Petrifier, se dit des choses qui ont esté formèes en bois, ou en coquilles, ou autres vegetatifs, en premiere essence, et depuis se sont reduites en pierres.

Pyramides, sont les figures pointues par enhaut, à l'imitation ou semblance du feu, sur lequel on a prins le mot de Pyramide.

Quadrangle, est vne forme quarrée, et s'appelle quadrangle à cause des quatre coings.

Salsitiue ou salsitiues, sont les choses qui picquent la langue, comme le sel, l'alun et les pierres calcinées.

Saphre, est vne terre qui se prend és mines d'or, laquelle est terre fixe autant comme l'or mesme, et d'icelle on fait vne couleur d'azur, en esmail.

Sel commun, est celuy que nous mangeons ordinairement lequel on distingue des autres : par ce qu'il y en a de plusieurs especes.

Souffleuses, sont les choses qui ne veulent receuoir les fontes des metaux, comme terre, sable poreux, qui retiennent l'air enclos, lequel empesche que les metaux ne prennent nettement la forme des choses qui sont mises dedans.

Sousterreines, sont les choses qui sont souz terre, comme les canaux, par lesquels on fait venir les fontaines.

Sublimer, se dit des choses qui s'esleuent et s'en vont en haut en fumée, quand elles sont touchées par le feu.

Sulphurées, sont toutes matieres tenant du souphre : comme font les metaux et toutes especes de marcassites.

Superficies, s'entendent les choses qui enuironnent à l'entour quelque masse ronde, ou quarrée, ou d'autre forme, comme qui auroit doré quelque piece d'argent, et que la dorure ne fust que par le dessus.

Tenebreuses, sont les pierres ausquelles l'on ne peut rien voir au trauers, comme on fait au cristal et au verre.

Terrestres, sont les matieres qui ne se peuuent exaler, ou sublimer par l'action du feu.

Triangle, est vne figure à trois coings.

Trochisques, sont figures rondes comme pilules et puis faittes plattes par vne compression faite sur la partie superieure.

Varenne, est vne terre communement de couleur rousse (qui tient quelque peu de la nature argileuse) de laquelle on fait des moules pour toutes especes de fontes, et pour bastir les fourneaux et pour luter les vaisseaux de verre.

Visqueux, vaut autant à dire comme gluant.

Vitrifier, se dit des choses qui prennent polissement et lustre de verre quand elles sont asprement chauffées dedans les fournaises.

FIN.

APPENDICE.

AVERTISSEMENT DE L'ÉDITEUR.

Voici l'opuscule que les éditeurs de 1777 se sont efforcés d'attribuer à Bernard Palissy et qu'ils ont regardé comme son premier ouvrage. Bien que nous soyons loin de partager leur opinion, nous avons réimprimé textuellement cet écrit, afin que notre édition ne parût pas moins complète que la précédente; mais nous avons dû y joindre en même temps les motifs de nos doutes sur son authenticité.

La recherche que firent Gobet et Faujas de Saint-Fond de cet opuscule était fondée sur une phrase insérée par Bernard Palissy, à la fin de son ouvrage intitulé Recepte véritable, etc. : « Si je connois ce mien second livre être approuvé, je mettray en lumière le troisième livre que je feray ci-après, lequel traitera... de diverses espèces de terres, tant des argileuses que des autres; aussi sera parlé de la marne qui sert à fumer les autres terres, » etc.

C'est uniquement sur cette expression de *second livre* que les deux savants éditeurs se mirent en quête de découvrir le *premier livre* que Palissy semblait avoir désigné. Des recherches laborieuses finirent par placer dans leurs mains l'ouvrage suivant, dont nous devons faire connaître le sujet, en rappelant à quelle occasion il fut composé.

Un médecin de Fontenay-le-Comte, en Poitou, Sébastien Colin, auteur de quelques traductions et dissertations peu connues, avait publié une diatribe violente et d'assez mauvais goût, sous ce titre : *Declaration des abus et tromperies que font les apothicaires; fort utile à ung chascun studieux et curieux de sa santé;* par Me Lisset-Benancio (anagramme de Sébastien Colin). Tours, 1553; in-16. Ce petit livre, réimprimé

à Rouen et à Lyon, suscita une réponse ayant pour titre : *Declaration des abus et ignorances des medecins; œuvre très-utile et proufitable à un chascun studieux et curieux de sa santé;* composé par Pierre Braillier, marchand apothicaire de Lyon; in–16. L'épître dédicatoire est datée du 1ᵉʳ janvier 1557.

C'est dans ce dernier pamphlet que Faujas de Saint-Fond et Gobet ont voulu voir le premier ouvrage de Bernard Palissy; aussi l'ont-ils inséré dans leur édition, précédé d'une dissertation bibliographique dans laquelle leur opinion se fondait sur des conjectures plus ou moins spécieuses, ainsi que sur une certaine conformité entre les caractères, les vignettes du livre intitulé *Recepte véritable* et les mêmes signes typographiques de la *Declaration des abus et ignorances des medecins*. Voici, à notre tour, sur quels arguments nous nous appuyons pour émettre une opinion tout à fait contraire.

Commençons par dire que ces expressions de Palissy, « ce mien *second* livre, » peuvent s'expliquer en ce sens que la *Recepte véritable* est divisée, dans l'édition originale, non en quatre traités, comme l'ont fait sans raison les éditeurs de 1777, mais en deux parties seulement. La première renferme tout ce qui se rapporte à l'histoire naturelle, à l'agriculture, ainsi que la description du *jardin délectable*, le tout sans distinction de chapitres ni de paragraphes; la seconde partie, qui est tout à fait détachée de la première, commence un *recto* de page et a pour titre : DE LA VILLE DE FORTERESSE. C'est à la fin de cette *seconde* partie que se trouve la phrase « si je connois ce mien *second* livre être approuvé, » etc. Or on sait qu'il n'est pas rare, chez les anciens auteurs, de voir confondre le mot *livre* avec ceux de *chapitre* ou de *traité*. Voilà, ce me semble, l'explication la plus naturelle et la plus simple des expressions de Palissy.

Gobet et Faujas tirent un nouvel argument de ce que dit Palissy, dans ses *Discours admirables*, au traité des sels (voy. p. 245), ainsi qu'au traité de la marne (p. 225), savoir, que le petit livre qu'il rappelle fut imprimé *dès les premiers troubles*. Or on sait que les premiers troubles religieux du milieu du seizième siècle ne commencèrent réellement qu'en 1562, au massacre de Vassi, à la surprise d'Orléans par le prince de Condé, et qu'ils se terminèrent en 1563, après la bataille de Dreux.

Au traité de *l'Or potable* (p. 224), Palissy cite le livre dans lequel il a déjà montré que l'or ne peut servir de restaurant. La *Recepte véritable* contient en effet une dissertation à ce sujet (p. 54-57), où l'on trouve les mêmes arguments que dans le traité spécial de 1580. A la vérité, il est aussi question d'or potable dans la *Declaration des abus et ignorances des medecins*, mais non dans les mêmes termes, ni en se fondant sur des raisonnements semblables, comme le prétend Gobet. Du reste, cette opinion était également professée par Sébastien Colin dans la diatribe à laquelle répondait Pierre Braillier; les arguments que l'auteur y fait valoir se rapportent même mieux que ceux de Pierre Braillier aux arguments de Palissy : et qu'y aurait-il d'étonnant que ce dernier, ayant adopté une opinion qui lui paraissait fondée, l'eût reproduite quelques années plus tard, en lui donnant plus de force et de développement ?

Quant à la prétendue conformité des signes et des caractères typographiques que les précédents éditeurs ont cru remarquer entre le livre de Pierre Braillier et le premier ouvrage authentique de Bernard Palissy, on sait combien les éditions de cette époque offraient de points de ressemblance, alors que la gravure et la fonderie typographiques ne comptaient encore qu'un très-petit nombre d'ateliers.

Mais ce n'est pas seulement à ces remarques que l'on doit s'arrêter pour établir que l'ouvrage que Gobet et Faujas attribuent à Palissy n'est point sorti de sa plume. Il est évident pour tout homme qui a étudié cet auteur que ce n'est là ni son langage, ni sa logique, ni sa manière vive, serrée, pleine de verve et de couleur. Le ton général de l'écrit est lâche, diffus, redondant. C'est sans aucun doute l'ouvrage d'un homme du métier, car il en connaît trop bien tous les détails. Palissy était chimiste, mais nullement apothicaire, et à peine est-il question de chimie dans la réponse de Pierre Braillier. Tout au plus pourrait-on croire que le véritable auteur en ait fourni le fond à Palissy; mais ce dernier était-il homme à écrire pour un autre sur des matières qui lui étaient en partie étrangères? Si l'on y réfléchit davantage, on voit que cette époque de 1557 coïncide précisément à celle où il était le plus occupé de la recherche de ses émaux, où il eut le plus à lutter contre les difficultés de son art, contre l'in-

gratitude de la fortune; l'époque où, lancé dans la controverse religieuse, il s'associait avec d'autres artisans pour fonder à Saintes la nouvelle église; et comment supposer que de si nombreuses, de si graves préoccupations lui eussent permis de s'occuper de Sébastien Colin, et de répondre à un pamphlet qui, du reste, n'avait aucunement trait à ce qui l'intéressait le plus? Quant à l'opuscule en lui-même, on ne peut s'empêcher de remarquer qu'indépendamment de la faiblesse du style et des raisonnements, la physique en est souvent fausse et contradictoire. L'auteur parle des quatre éléments d'Aristote et des quatre humeurs qui y correspondent, suivant la doctrine de Galien; il compare le microcosme au macrocosme, conformément aux idées de Pythagore, que Palissy ne connaissait point, ou qu'il n'eût sans doute pas adoptées s'il en eut eu connaissance. Il se moque des médecins qui ne savent ni le latin ni le grec, ce qui, à ses yeux, n'eût certes pas été un crime. Il contredit, comme doctrine, toutes les idées de Palissy sur la physique générale et la géologie, sur la formation des pierres et l'origine des métaux; enfin, cet écrit eût été opposé comme forme, à sa manière d'argumenter toujours pleine de force et de logique, comme au ton habituel de sa discussion, toujours grave, sérieux et réservé. Ajoutons que c'eût été le seul dans lequel il eût négligé la forme de dialogue, qui donne partout à son argumentation tant d'intérêt et de mouvement.

Quoi qu'il en soit, cet ouvrage fût-il sorti de la plume de Bernard Palissy, il faut reconnaître que la gloire de cet homme de génie en serait peu augmentée, et que, comme œuvre scientifique, il eût ajouté peu de chose aux lumières de l'époque où il fut composé.

DECLARATION
DES ABUS ET IGNORANCES
DES MEDECINS.

ŒUVRE TRÈS-UTILE ET PROUFITABLE A UN CHACUN STUDIEUX ET CURIEUX DE SA SANTÉ,

Composé par Pierre Braillier, marchand apothicaire de Lyon; pour réponce contre Lisset Benancio, medecin.

AU LECTEUR.

Si ie n'allegue nul autheur,
Mais seule vraye experience;
Diras-tu mon liure menteur,
Ou qu'il en ait quelque apparence?
 Tout homme de bonne science
Le lisant iugera fort bien
Que ce qu'ay mis en euidence
Est veritable, et faict pour bien.

P. G.

A L'AUTEUR.

Les Anciens ont fort parlé d'Apis,
Et d'Esculape experts en Médecine.
La mort du tout ne les a assoupis,
Car seulement, le corps elle ruine ;
Mais leur sçauoir, bruit immortel s'assigne,
Or qui voudra voir ton art tout exprès,
Il cognoistra que nature divine,
Les sus nommés te fait suyure de près.

UN AMY A L'AUTEUR.

Les Médecins ne seront par raison
Si grandement de ton liure offencez,
Comme ont esté par lourde desraison
Les Pharmatis outragez et blessez,
Premierement, mais non pas trop froissez.
Benancio son salaire reçoit,
Benancio ha bien ici assez
De payement : ou mon sens me deçoit.

A NOBLE SEIGNEUR

CLAUDE DE GOUFFIER,

COMTE DE CARUASZ ET DE MAULEURIER, SEIGNEUR
DE BOYSI ET GRAND ESCUYER DE FRANCE.

ONSEIGNEUR, Pour la grande beniuolence que de vostre bonne grace m'auez monstrée par le passé, iointe à celle vertueuse noblesse qui est en vous, ie vous adresse ce mien petit Traicté, afin de vous donner quelque recreation, comme i'espere et desire : car par iceluy cognoistrez que certain Medecin satyrique, sous vn non emprunté et forgé nouuellement (ainsi qu'il peut sembler y auisant de près) s'est legerement ingeré de blasmer et vilipender l'estat de la Pharmatie, auquel Dieu m'a appellé, estat, certes, non moins vtile et necessaire que le sien, duquel s'il a abusé, il ne s'ensuit pas qu'il doiue si desordonnement escrire que les Apoticaires abusent du leur. Car si aucuns abus y a, ils procederoyent principalement des Medecins mesmes, comme i'ay amplement deduit et declaré par ce present Traicté, ce que vous plaira voir et cognoistre par ce discours. En quoy ie n'entens blasmer sinon ceux qui le meritent, et qui seroyent semblables à notre susdit Reuerend Medecin. Aussi n'ay pas voulu laisser passer sous silence les fautes des imperits et imprudens Apoticaires, mesme afin que

ie me montrasse, non par affection particuliere, estre incité à luy respondre, ains (comme disoit iadis vn sçauant et sage personnage) me suis voulu monstrer seulement, et sincerement amy de verité. Surquoy faisant fin à la presente Espitre, vous priray m'excuser, et mon petit ouurage : suppliant le Createur pour vous, Monseigneur, qu'il vous maintienne en prospérité.

De Lyon, ce premier de Janvier 1557.

ESPITRE AU LECTEUR.

Tu ne seras point scandalisé, Amy Lecteur, si nous n'obseruons la loy de nostre Seigneur Iesus Christ, qui nous commande rendre bien pour mal, pardonner à tout le monde, mesme à ceux qui nous ont offencé, et offencent : encores que soit sans cause, raison et vérité. Et nous défend prendre vengeance l'vn de l'autre, et aussi de nous iniurier l'vn l'autre, comme faict Lisset Benancio en son liure intitulé, *Les Abus et tromperies que font les Apoticaires*, les denigrant, outrageant à toute outrance, sans sçauoir qu'il dit, et sans considerer que ce qu'il en a escrit est faux et ne contient verité, de chose qu'il dit, ains a faict son liure par grand enuie qu'il a contre les Apoticaires, pour ce qu'ils n'en tiennent conte, et qu'ils ne luy font gaigner argent comme ils font à quelques autres, à cause que c'est quelque pauure fol opiniastre et ignorant. Vous connoistrez facilement, si vous lisez son liure, la grand affection et mal talent qu'il a contre les Apoticaires de Poitou, Aniou et Touraine. Ie m'esbays bien que iceux ne luy ont respondu : il faut bien qu'il ayent crainte de lui, ou qu'ils n'en veulent tenir conte non plus que d'vn fol, ou qu'ils soyent tels qu'il les nomme, à sçauoir ignorans et indoctes.

Il dit qu'ils sont incorrigibles, et que par charité les a voulu admonester, et faict admonester par ses amis : qui est bien au contraire, car au lieu de les admonester et corriger secretement, il les a timpanisez et scandalisez, blasmez et iniuriez par ses escritures, qui se vendent et crient publiquement par toutes les villes de France. Parquoy tu ne trouueras estrange, si ie me suis ingeré à respondre aux grandes iniures et blasmes que ce venerable Lisset a escrit contre les Apoticaires, tant pour soustenir ceux de ma qualité, que pour remonstrer que

ce qu'il dit est faux, et ne contient verité (comme i'ay dit) et aussi que les abus de quoy il nous charge, ne viennent de nous, mais d'eux-mesmes, si abus y a. Ie ne pourrois endurer voir deuant mes yeux denigrer et vilipender vn si noble estat comme celui de la Pharmatie que ie n'estime moins que la Medecine et Chirurgie.

L'autre partie de la rancune et haine qu'il a conçeu contre les Apoticaires, c'est à cause qu'ils practiquent et pansent les malades sans luy, se y sentant fort interessé, sans considerer que par charité il faut aider aux pauures qui n'ont de quoy payer le Medecin, non-seulement pour achepter une poulle pour se substanter : car il ne faut pas attendre que la plus grand part des Medecins de maintenant les aillent visiter s'ils n'en pensent estre payez, et deussent-ils mourir tout quant et quant. Parquoy ne deuons estre blasmez si à ceux nous administrons la medecine sans eux : car il en mourroit beaucoup si n'estoit ce peu d'aide et secours que nous leur baillons, dequoy de la plus grand part n'en avons iamais rien, et y perdons temps et drogues, et eux qui n'y fournissent que leur peine, n'y retourneront iamais s'ils ne sont payez. Il fait excuse disant que les Apoticaires practiquent sans eux pour gaigner dauantage, qui est au contraire, car là où le Medecin ordonne, l'Apoticaire y a plus de prouffit de la moitié, et est mieux payé et a moins de peine. Ils se peuuent bien plaindre et gruser, disant que les Apoticaires se font incontinent riches en suruendant leurs drogues, qui est bien à rebours : car de tous les estats de ce monde, c'est le plus mal payé, le plus suiet et le plus mal estimé.

Ie ne m'esbays pas si ceux qui l'exercent se meslent d'autre vacation : car la leur est tant anichilée, et tant mise au bas par les Medecins et Chirurgiens, que les pauures Apoticaires n'y trouuent nul prouffit, et semble aux malades qu'ils les doivent panser et soliciter gratis, pour leurs beaux yeux : disant (quand ils sont gueris), que m'auez vous baillé? des herbes : et voila comme les pauures Apoticaires sont payez.

Quant au Medecin, il est payé contant, ou s'il n'est payé il n'y retournera plus, encores qu'il n'y fournit rien que sa peine, et l'Apoticaire fournit de sa peine beaucoup plus que le Medecin : car il faut qu'il applique tout, et dauantage fournit ses drogues, son temps, et de ses seruiteurs, et quelquefois

n'a rien de tout, et perd son temps, peines et drogues : qui est fort mal parti, et considéré. Car si le peuple sçauoit que c'est que l'estat de la Pharmatie quand il est bien fait, il en feroit beaucoup plus de compte, car l'on ne sçauroit payer vn Apoticaire faisant son deuoir : i'entens quand il est sçauant et bon simplicite. Tu n'as garde trouuer de bons Medecins ny Chirurgiens si tu n'as de bons Apoticaires : car c'est l'Apoticaire qui tient tout, et s'il est beste, les deux autres estats sont bestes comme luy : car il ne peuuent rien sans luy, et par son ignorance leue l'intention du Medecin et Chirurgien. Lisset a fort bien parlé, quand il a dict que les Apoticaires vendent la vertu des plantes et drogues que Dieu nous baille gratis, sans cultiuer, ce qu'ils ne doiuent faire, et dit que c'est grandement offencé enuers Dieu. Ie luy voudrois bien prier de prendre la peine, à lui et aux autres, d'aller chercher les herbes, fleurs, racines, et semences, gommes, fruicts, et autres : et icelles conseruer et garder auec grand soin et diligence, payer louage des maisons, gages de seruiteurs, les nourrir, achepter les drogues qui viennent de pays lointains, à grandes sommes d'argent contant, et puis les bailler gratis : et ils trouueroyent combien leur faudroit d'argent, mais ils s'en garderont bien. Comment bailleront-ils leurs drogues pour rien, quand seulement ne veulent pas fournir vne simple visite sans estre payez, et vendent leurs presences et paroles? Encore que leur visite et ordonnance sert plutôt quelquefois à faire mal que bien. Et les pauures Apoticaires faut qu'ils fournissent toutes ces belles choses à credit, et quelquefois à iamais rien auoir, et perdre leurs peines et vacations. N'est-ce pas la briganderie que escrit Lisset contre les Apoticaires? N'est-ce pas la volerie qu'il dit qu'ils font aux malades, quand ils les pansent sans eux, vendant leurs compositions outre la raison.

Ie vous laisse à penser si pour taster le poulx d'vn malade, et ordonner vn simple Iullep ils font conscience prendre vn escu, ou deux testons, et l'Apoticaire en aura bien deux sols, ou six blancs à grand difficulté : qui est plus grand voleur l'Apoticaire ou le Medecin? Il me souuient auoir pansé vn homme de qualité, qui estoit malade d'vne fieure double tierce, et fut malade enuiron vn mois, le Medecin ne ordonna iamais que Iulleps, et vne simple Medecine purgative, et

cousta de Medecin pour ordonner ces beaux lulleps et vne medecine, trente escus sol, et la partie que ie luy portay ne monta que à cinq liures, et si luy auois fourny du sucre et autres marchandises Latines, et quelle briganderie est-ce là? Encores que tout ce que le Medecin auoit ordonné ne seruit de rien : car le patient se voyant ainsi affronté, luy donna congé, et n'y fit rien plus, et nature le guerit à chef de temps après : et qui ne l'eust point mediciné, il eust esté plutost gueri qu'il ne fut.

Ne trouues-tu pas vne grande ignorance et peu de iugement aux Medecins de promettre à vn patient qu'ils le gueriront en sept ou huit iours, mais cependant le tiendront vn mois ou deux? N'est-ce pas bien prognostiqué à eux qui portent le nom et titre de Medecin; ce qui est faux, et n'en est rien : car celuy qui est, et veut estre appellé Medecin, doit faire l'action d'vn Medecin, ce est guerir toutes maladies, promettre la vie ou prononcer la mort : mais bonne partie des Medecins de maintenant sont tant parfaits en leur estat que à grand peine oseroyent-ils asseurer la vie à vn malade d'vne simple fieure tierce, et n'oseroyent asseurer la guerir. Parquoy ie dis qu'ils ne sont pas Medecins : car le Medecin ne doit estre appellé Medecin s'il ne guerit toutes maladies. Ils me respondront que les maladies qui sont plus fortes que nature, et qui conuainquent nature, sont incurables; voire, pour ce qu'ils ne sçauent pas les curer : car si Dieu a donné les maladies, il a donné les remedes pour les guerir, mais ils leur sont incogneus, et ne les sçauent pas. Dequoy sont-ils doncques Medecins? Des maladies qui se gueriroyent sans eux; encores quelquefois y font-ils plus de mal et nuisance que de bien. Leur estude est de grand valeur et efficace, mais ie ne sçay à quoy, ne qu'ils ont iamais estudié.

Ie croy qu'ils ont le plus estudié à faire la mine : car à cela ils sont plus sçauans qu'en perfection de medecine; et à bon droit se doiuent plutost appeller freres mineus que Medecins : car c'est la plus grande perfection qu'ils ayent. S'ils auoyent perfection en autres, concernant la medecine, ils le montreroyent, mais il faut doncques qu'ils confessent que la medecine est imparfaite, et n'y a nulle perfection, Dieu en a tiré l'eschelle à luy : parquoy tout est à l'aventure. Ils appellent les maladies incurables pour ce qu'ils ne les sçauent pas gue-

rir. Ils veulent estre appellez Medecins, et ne font nul acte de medecin.

Mettez entre leurs mains vn hydropic, vn asmatic, un epiletic, vn apopletic, vn etic, une peste, s'ils les gueriront, ouy de beaux. Ie ne sçay à quoy ils ont estudié : s'ils auoyent seulement appliqué leur estude à guerir l'vne de ces maladies (qu'ils disent quasi incurables), ils deuroyent estre appellez Medecins de cette maladie : mais ils n'en sçauroyent guerir vne. I'ay veu guerir de la peste, i'ay veu guerir d'hidropics, d'asmatics, elles ne sont pas doncques incurables, sinon à ceux qui ne les sçauent curer, mais ils ne se soussient de les guerir aucunement : c'est tout vn, mais que les testons viennent, viue ou meure le patient s'il veut.

Et ne trouues-tu pas abuser grandement, de prendre l'argent d'vn pauure patient, lui promettant lui oster sa maladie, et tu n'en as point de certaineté? Et si toy même en estois frappé, tu ne t'en sçaurois guerir.

Ie cognois beaucoup de Medecins qui sont frappez et affligez de certaines maladies, desquelles ils ne se peuuent guerir, les vns de gouttes artetiques, les autres de gouttes migraines : les autres de colliques venteuses, les autres de nephresie, les autres de frenesie, et tant d'autres, et ne s'en sçauent guerir, et sont contrains endurer et garder leurs maladies par force, et ne laissent pas d'en panser les autres. Regarde quelle perfection est en leur estat : et se ingerent blasmer les autres, comme la Pharmatie qui est vn art parfait, et le leur est imparfait : car tu peux cognoistre que tout ce qu'ils font est à l'auenture, sans perfection : voyant qu'ils ne se peuuent guerir eux-mesmes des maladies dequoy ils sont frappez. Si ie voulois escrire les grands et enormes abus et tromperies que i'ay veu faire aux Medecins, il y auroit grand volume, et n'escrirois que choses veritables : et quelquefois si les Apoticaires n'estoyent plus sages et prudens que les Medecins à mitiger leurs ordonnances, ils en mettroyent beaucoup à la renuerse : car ils ne sçauent pas la moitié de la force et acrimonie des medicamens qu'ils ordonnent. Il dit que les Apoticaires sophistiquent leurs drogues et medicamens, et en a fort bien escrit à son honneur, et en sera fort bien estimé entre gens doctes et sçauans, qui cognoistront par ces escritures que ce

qu'il dit est fort veritable, et est bien possible de faire ce qu'il en dit.

Il n'y a si petit apprenty en la Pharmatie qui ne iuge qu'il n'est qu'vne beste, et ne vit oncques medicamens. Parquoy il est à presumer qu'il dit ainsi verité des autres choses, et qu'il n'est qu'vn menteur, et que foy ne doit estre adioustée en ses dits. Car il a fait son liure par grand haine et malueillance qu'il a contre les Apoticaires, pour ce qu'ils ne l'appellent pas en leurs practiques, et ne luy font gaigner argent, dequoy il est enragé: puis dit par son excuse qu'il a fait son liure par charité. Tu me diras: qui t'a meu luy respondre, voyant qu'il ne te blasme, ny ceux de ta patrie? Ie te dis que ie ignore qu'il soit du pays d'Aniou, Poitou ou Touraine: mais ie doute plutost que ce soit quelque Medecin de Lyon ou des enuirons, qui auroit changé son nom, et ce seroit nommé ainsi, et donner la charge aux Apoticaires de ce pays, pour blasmer ceux de ma patrie, et ainsi pour crainte que ceux de Lyon ne luy fissent response: car ie ne cogneus iamais Medecin qui eust nom Lisset; c'est vn nom qui est sot et rare, et croy que le maistre est sot et rare comme son nom, si maistre y a; et aussi que ie me suis fort scandalisé lisant vn liure si satyrique et iniurieux contre les Apoticaires, ne contenant verité: lequel liure se vend publiquement dans Lyon, et si plutost fust venu en ma notice, plutost luy eusse respondu.

Icy ne sont blasmez les doctes et sçauans, et afin de n'estre prolixe, ie prieray à Dieu très-affectueusement qu'il nous donne la grace de si bien exercer nos estats et vacations en quoy luy a pleu nous appeller, que ce soit à sa louange et gloire, afin que n'ayons iuste occasion nous blasmer et iniurier les vns les autres, au grand preiudice et moquerie des facultez.

DECLARATION
DES ABUS ET IGNORANCES
DES MEDECINS.

Le grand Dieu eternel, qui tout a fait et creé sous sa main, a orné la terre de beaux arbres, arbustes, herbes, plantes, pierres et metaux. Puis il a creé les animaux, rationaux et non rationaux, comme bestes, oyseaux, et poissons : mais par sus tout l'homme est rational, à qui il a donné vne raison qui participe aux Anges, et par cette raison l'a fait maistre sus tous autres animaux. Car sans la raison il seroit beste moindre que les brutes, et par cette raison l'a fait à sa semblance, et luy a donné cognoissance des astres, des maladies, des herbes, des plantes, des pierres et metaux, le tout pour son vsage et service.

Puis il a donné aux vns la science plus qu'aux autres ; aussi des biens de terres aux vns plus qu'aux autres. Et à ceux à qui il a donné la science, il n'a pas donné la richesse, à ceux à qui il a donné la richesse, il n'a pas donné la science, à celle fin que l'vn serue à l'autre ; et a si bien dispersé ses graces, que nul ne peut repugner contre luy, et se doit chascun contenter de ce peu qu'il luy a pleu donner en son estat et vacation, où il luy a pleu l'appeller. Et pour ce qu'il a donné si brieue vie à l'homme, il n'est possible qu'il puisse comprendre beaucoup de choses, et ne peut pas grandement estre parfait en son estat, comme en la medecine specialement, qui est vn art fort long à comprendre, et la vie est fort brieue, parquoy perfection n'est en medecine : car auant que l'homme ait la cognoissance des maladies qui sont diuerses, et qui se chan-

gent tous les iours, aussi les complections des hommes semblablement se changent, puis des herbes, plantes, metaux, pierres, animaux et autres ; et auant qu'il sache la vertu et faculté de tout pour s'en seruir en ce que concerne la medecine, il a long temps à estudier ; puis auant qu'il les puisse composer et ordonner, il a bien à philosopher.

Premier doit considerer le Medecin, auant que ordonner, l'acrimonie de la maladie, la force d'icelle, la force et l'aage de son malade, la temperature et habitude d'iceluy, la qualité et temperature du temps ; puis doit sçauoir et cognoistre la vertu et faculté de son medicament, pour la guerir : et ayant tout bien cogneu et consideré, encores est-il bien empesché, et quelquefois ne peut venir à ses fins.

Ie te donne à penser si les Medecins de maintenant, quand ils vont voir leurs malades, ont en recommandation toutes ces choses ; il s'en faut beaucoup. Ils ont bien en recommandation le teston, mais de guerir ne s'en soussient pas grandement ; guerisse le patient s'il peut, mais qu'ils ayent leurs mains pleines, c'est assez ; aussi font-ils de belles cures à rebours. Et ne sçauroit estre autrement : car s'ils vont chez le malade, ils n'ont pas le loisir de le regarder, de tenir le poulx, voir l'vrine, qu'ils tendent la main pour auoir le salaire et s'en aller ; et puis en iront voir cinq ou six ; puis iront chez l'Apoticaire ordonner, escriuant quelquefois l'ordonnance de l'vn pour l'autre, ne se souuenant de la maladie de leurs patiens.

Et voila les paoures malades bien seruis, et à propos, là où le Medecin deuroit demeurer vne heure pour le moins à interroger son malade, pour preuoir les incidens qui suruiennent toutes les heures, pour y obuier, ils ne font qu'entrer et sortir, prendre argent et à Dieu. Si tu prends garde aux Medecins de maintenant tu trouueras que ce n'est rien qu'auarice, et ne se soussient que d'auoir argent, guerisse ou meure le patient s'il veut.

Car ils n'ont point d'honneur deuant leurs yeux, ny aucune honte non plus que beste. Ils nous peuuent bien appeler mangeurs d'hommes, ils en ont grand raison. Ie te donne à penser qui pille ou mange mieux le patient, le Medecin ou l'Apoticaire ? Ie ne vis iamais en practique où ie fusse, que le Medecin n'eust deux fois autant d'argent, sans rien fournir que sa peine, que moy qui fournissois tout, et auois plus de peine et

de soin du malade deux fois que le Medecin, et quelquefois suis venu de practique et le plus souuent que ie n'apportois qu'vn beau credo, et le Medecin estoit payé tout contant : voila comment nous les destruisons et mangeons. Maistre Lisset dit que nous abusons en nos eaux distillées, vieilles et corrompues, mais c'est bien au contraire : car c'est eux-mesmes, comme ie diray cy-après.

Il a escrit la maniere de les distiller en alambics de verre, qui ne vaut gueres mieux que distiller en plomb, et toutes deux ne valent rien : et si tu estois vn bon distillateur, et que tu eusses bien frequenté la distillation, tu dirois auec moy, que toutes eaux sublimées et distillées, soit en plomb, verre ou cornue sont de nulle valeur, reserué l'eau forte, dont les orfeures usent.

Qui est la cause que nous les distillons en cette maniere : est-elle venue de nous? En sommes nous les inuenteurs? Non : c'est eux, et c'est doncques eux qui en abusent, et non pas nous. Regarde tous nos vieils dispensaires, et tu trouueras la maniere de distiller à la vieille mode, et nous l'auons tousiours obserué et gardé. A quoy tient-il qu'ils ne nous ont apprins la vraye maniere de distiller? Il tient qu'ils n'en sçauent et n'en sçeurent iamais rien. Si est-ce que c'est le principal de la Medecine, que sçauoir bien distiller, mais nos Medecins s'en passent bien, et n'en veulent point d'autres; et qui leur en voudroit bailler de parfaites distillées, ils n'en voudroyent point, car elles ne sont à leur vsage : mais plutost des distillées en nos alambics de plomb ou de verre, n'ayant nulle odeur, ny saueur de l'herbe ou drogue dont elles sont extraites.

Si tu eusses bien experimenté et fabriqué la distillation, tu eusses cogneu que les eaux distillées ne valent non plus que eau de puits ou fontaine : car en telle distillation ne monte que la simple eau terrestre, n'ayant goust ny saueur non plus que eau de puits, sinon du feu qui la pousse. Et si tu en veux sçauoir la vraye experience, prends vne liure d'eau et vne liure de sel, et les fais bouillir ensemble, tu trouueras l'eau bien salée : fais-là distiller en plomb ou verre, comme tu voudras et tu trouueras ton eau aussi douce comme elle estoit auant que la fisses bouillir au sel. Ainsi est-il de toutes autres choses comme herbes, fleurs, racines, semences et autres, rien

ne se leue que la simple eau terrestre, sans odeur, saueur ny vertu que bien peu (1).

Tu me diras que l'eau rose tient beaucoup de l'odeur de la rose. Ie te dis que la rose tient plus de la vertu aërée que nulle autre herbe ny plante, qui est la cause que l'eau retient quelque peu de l'odeur. Mais si tu la distillois comme il la faut distiller, tu trouuerois bien vne autre odeur que n'est celle qui est distillée en plomb ou en verre, car si tu en auois frotté tes mains ou ta barbe (si tu en as) l'odeur n'en sortiroit de trois ou quatre iours. Et si tu veux cognoistre l'eau bien distillée, il faut qu'elle ait l'odeur, saueur et force du suiet dont elle est extraite, et qu'elle ne tienne rien de la violence du feu. Et estant ainsi tu iugeras que ton eau est bien distillée, et tient partie de la vertu de son suiet. Les Medecins qui ordonnent les eaux, cuidant auoir la vertu entiere du medicament, sont bien bestes, et dignes de mener paistre; car il faut entendre que toutes herbes, plantes, pierres et metaux, sont engendrez des quatre eslemens celestes, et semblablement l'homme et tous autres animaux, et ont en chascun corps quatre eslemens terrestres, à sçauoir quatre humeurs consonans au celeste, qui est le feu, l'eau, l'air, la terre. Aussi le petit monde qui est l'homme, est composé de quatre humeurs qui sont la colere pour le feu, le flegme pour l'eau, le sang pour l'air, et la colere noire (que nous disons melancolique) pour la terre. Semblablement toutes herbes et plantes, pierres et metaux, sont composez de quatre eslemens, humeurs ou essences, à sçauoir l'eau pour l'eau, l'huile pour le feu, le sel pour l'air, et la forme pour la terre (2). Et chascun de ces eslemens tient sa part de la vertu du corps où ils sont implantez l'vn plus que l'autre; parquoy tu es bien abusé si pour faire boire de l'eau d'vne herbe aux malades, tu penses auoir toute la vertu de l'herbe dont est extraite l'eau. Tu n'en as point en

(1) Un argument aussi mal fondé et si évidemment contraire à l'expérience, ne peut appartenir à un homme comme Palissy.

(2) On ne peut s'empêcher de remarquer ici que l'auteur se montre partisan de la doctrine de Galien sur les éléments et les humeurs qui leur correspondent; et, plus loin, de celle de Pythagore sur le macrocosme et le microcosme. Or ces doctrines, si elles n'étaient pas totalement ignorées de Palissy, qui n'avait pas lu les anciens, ne devaient au moins trouver nul crédit auprès d'un homme qui se faisait honneur de n'admettre aucune opinion sur la foi des maîtres, et sans l'avoir vérifiée par lui-même.

la maniere que nous auons esté enseignez par les Medecins à distiller : mais encores qu'elle fust distillée en toute perfection, tu n'en aurois que bien peu : car l'eslement de l'eau de quelle herbe que ce soit, soit chaude ou froide, est tousiours eau. Ie ne dis pas quand elle est bien distillée, que elle ne tienne de la vertu, mais moins que l'huile de la moitié, et moins que le sel du quart, et cela tu cognoistras, si tu goustes lesdits eslemens, à l'odeur, saueur et force.

Ie voudrois bien prier vn Medecin qu'il m'enseignast à extraire les quatre eslemens ou essence d'vne herbe ou plante, pierres ou metaux, et les rendre chascun à part, sans y adiouster ou diminuer, qui est le principal point de la Medecine. Il ne faut point attendre cela d'eux, car ils n'y sçauent rien du tout, et n'en veulent rien sçauoir, et ne veulent que leur vieille mode, qui est fausse, et ne vaut rien ; mais ce leur est tout vn, seulement qu'argent vienne : aussi leurs cures vont le plus souvent à rebours.

N'est-ce pas vne grande ignorance à eux, qui deuroyent estudier aux choses exquises et necessaires, chasser toutes erreurs, s'enquerir des choses bien faites, et les choses mal faites et abusiues, les reformer afin que leurs operations en fussent meilleures, et que les malades ne fussent en danger ? et la meilleure ordonnance qu'ils ayent, c'est vn Iullep à vn pauure malade, ayant l'estomac debile et desuoyé, auquel Iullep entre quatre onces d'eau, distillées à la maniere antique (ne sentant que le plomb et feu qui vaudroit mieux eau de puits ou fontaines) auec vne once ou deux de sirop le matin pour conforter ce pauure estomac, et voila le meilleur remede qu'ils ayent.

Et si ie disois à vn Medecin ; i'ai de l'eau distillée parfaitement, il me diroit : gardez-vous bien y en mettre, car ils ne sçauent que c'est, et n'est point escrit en leurs liures. Et combien nous en ont-ils fait faire d'abus par leurs ordonnances le temps passé ? Comme prendre vn medicament l'vn pour l'autre, à cause qu'ils n'auoyent point estudié en Grec, et seulement ne le sçauoyent pas lire ; et puis disoyent que les Apoticaires failloyent et qu'ils n'auoyent pas bien fait leurs ordonnances, quand leurs operations ne venoyent à propos, et s'excusoyent sur les pauures Apoticaires, encores auiourd'huy font le semblable.

Ne trouues-tu pas vn grand abus et ignorance aux Medecins, faire tenir vn pauure malade enfermé dans vne chambre, les fenestres bouchées, le lit bouché, et defendre luy donner air? Ià que le pauure patient ne peut aspirer ny auoir son haleine à cause de la maladie, que à grand peine ; et tu la luy rends pour le bien enfermer et clore ? Regarde comment tu abuses, premier tu luy oste l'aspiration, et le rends plus melancolique que ne fait sa maladie, auec les mauuaises odeurs qui ne s'en peuuent exaler, qui luy penetrent le cerueau et le rendent plus malade de beaucoup : et si tu me confesses que l'air aide à la vertu expulsiue, et que nuls animaux ayant poumons ne peuuent viure sans air, doncques l'homme quelque sain et allegre qu'il soit, ne peut viure sans air, et estant malade encores moins ; parquoy ie dis que tu abuses de defendre l'air aux malades quand il est beau, et quand il n'est trop froid ny trop humide, ou venteux. Ie ne dis pas que si le patient a mal de teste ou qu'il le craigne, qu'il ne luy soit osté, non pas le faire mourir à petit feu par ton ignorance.

Ie te voudrois demander qui t'enfermeroit seulement six iours en vne chambre sans air, toy sain, et non malade, (comme tu enfermes les malades) si tu le trouuerois bon, et si tu pourrois viure comme tu fais à l'air.

Vn autre abus inueteré dont les Medecins de maintenant vsent communement, et mesme nostre Maistre Lisset, qui dit que c'est très-mal operé bailler à boire à vn febricitant de fieure continue ou ëgue, et que le boire augmente la colere. Les fieures continues et ëgues alterent bien fort les malades qui en sont frappez : et que leur ordonneras-tu pour leur estancher la soif, eux qui sont en feu continuel auec la siccité qui cause l'alteration, et tu luy defens le boire de l'eau et autre potion.

Ie te dis que l'eau est froide et humide et ne peut engendrer ny augmenter la colere, qui est chaude et seiche : car elle luy est toute contraire. Et pour leuer la chaleur et siccité, il me semble (sous correction) qu'il luy faut bailler froid et humide, car toutes alterations sont procedées de chaleur et seichent ; parquoy l'eau qui est contraire à la chaleur et siccité, peut estancher la soif, et ne la peut-on estancher autrement.

Ie ne dis pas qu'il soit raisonnable de bailler à boire à vn

febricitant toutes les fois qu'il en demandera, car il en demanderoit trop souuent; et luy en bailler peu et souuent ne sert que l'inflammer dauantage, mais bien luy en bailler vne fois ou deux assez abondamment au lieu de luy en bailler cinq ou six fois. Alors tu luy esteindras cette grande chaleur, siccité et acrimonie; et aussi tu luy defendras le foye et les intestins, à qui cette grande chaleur et inflammation nuit beaucoup; et ce faisant ne le feras mourir martyr, à faute de boire, comme tu as de coustume. Et si tu as esgard à ton patient qui a la langue noire, les dents et les leures, tu considereras qu'il y a grande chaleur au foye et estomac; parquoy tu luy concederas le boire raisonnable, sans le faire languir et mourir à petit feu : mais aucuns Medecins de maintenant prennent si bien garde à leurs malades, et espeluchent si bien les matieres, qu'ils n'oseroyent conceder outre ce que leurs liures en ont dit, sans donner aucun allegement à leurs patiens, et deussent-ils mourir, ce qu'ils font la pluspart à faute de les soulager; mais c'est tout vn au Medecin, pourueu qu'il ait argent.

Ie trouue vne grande philosophie aux Medecins de maintenant, qui ordonnent l'eau bouillie à leurs patiens, disant que l'eau bouillie par l'ebullition du feu, se rend plus vnctueuse, perd sa froideur et viuacité, ce qui est faux, sinon que l'on la fist boire chaude ou tiede, et ce faisant perdroit sa viuacité actuelle, mais non potentielle : car quand tu l'aurois fait bouillir trois iours, laisse là puis refroidir, elle retourne comme elle fut, et n'y aura plus ny moins : sinon qu'elle print quelque goust estrange de fumée, ou du vase où elle auroit esté bouillie : car tu te peux bien asseurer que ce sera tousiours eau, comme elle fut, froide et humide, si tu la laisses refroidir; parquoy tu es bien abusé faire bouillir l'eau simple pour la faire plus proufitable aux malades. Ie t'asseure bien qu'elle vaut moins, car en bouillant le plus subtil s'en va, et demeure le plus terrestre et le plus gros; parquoy il seroit bien meilleur la faire boire sans bouillir, que la bouillir.

Si tu estois bon philosophe tu sçaurois que les eslemens ne se destruisent l'vn l'autre, et n'ont puissance l'vn sur l'autre sinon que l'vn soit plus fort que l'autre, à sçauoir en plus grande quantité; comme si l'eau est en plus grande quantité que le feu, elle le chasse ou pousse, et se rend actiue et rend le feu passif; au semblable quand le feu est en plus grande

quantité que l'eau, il pousse et chasse l'eau en se rendant actif et rendant l'eau passiue; mais la destruire, consommer ou changer sa complexion, il n'en est rien : car rien ne se perd en ce monde ; les eslemens ne augmentent ny diminuent, ny se transmuent l'vn l'autre, chascun fait son action.

S'il estoit ainsi que le feu consommast l'eau et la transmuast, et que l'eau consommast le feu ou le transmuast, il y a longtemps que nous eussions faute d'eau ou de feu, ou bien que Dieu augmentast ou diminuast l'astre à mesure que les eslemens augmenteroyent ou diminueroyent. Ie ne dis pas que chascun n'ait son temps et force vne fois l'vn plus que l'autre : comme en hyuer la terre, au printemps l'air, en esté le feu ou soleil, en automne l'eau, et ont chascun leur regne en leurs temps; comme au petit monde les humeurs ayant semblable action comme les eslemens.

Ie ne dis pas que faire bouillir en eau quelque medicament, comme orge, rigalisse ou autre, ne soit bon, car le medicament cuit ou putrifié en eau, s'il est chaud, rend l'eau moins froide, y laissant de sa vertu selon la quantité que tu y mets. Et si tu y fais bouillir orge ou autre medicament nutritif, la rendras nutritiue comme aux potages de chair, ou autres, et semblablement auras de la vertu des herbes et plantes que tu y feras cuire, quelque portion et non toute ; mais si y aura-t-il tousiours de l'eau qui fera son action par dedans. Ie ne te donneray aucune autorité que la vraye experience; et si tu la veux sçauoir, prens vn grand materac ou phiole, et y mets deux onces d'eau bien pesées, puis le bouche du verre mesme, que rien n'en puisse aspirer, et que nuls porres du verre ne soyent ouuerts, puis tiens-la sur le feu tant que tu voudras, et la fais rougir au feu si bon te semble, et tant de drachmes que tu en consommeras, ie t'en donneray autant de cent escus, et l'y tinsses-tu deux ans comme i'ay fait. Et ayant ce experimenté, cognoistras que les eslemens ne consomment ny destruisent l'vn l'autre; et si tu n'en veux faire l'experience, i'en fais iuge de mon dire toutes gens de sçauoir et bons philosophes qui en diront la verité, et d'autres choses que ie diray cy-après, sans alleguer autheur : car ie ne veux escrire la cognoissance des maladies, ny la maniere de les curer; mais ie veux escrire les abus et ignorances de plusieurs Medecins en la cognoissance des medicamens et cure des mala-

dies, et le danger où ils mettent leurs malades, par leur grand betise et nonsçauance, cuidant auoir la vertu d'vn medicament par vn moyen dont il n'est possible, comme des huiles qui se vsent auiourd'huy en la pharmatie, qui est vn grand abus, et ne l'ont encores cogneu nos Medecins, et encores pullulent.

Les Medecins diront que c'est nous qui le faisons et l'auons inuenté, qui est bien au contraire : car si tu cherches les vieux dispensaires et les nouueaux, tu trouueras la maniere de faire lesdites huiles, escrite ià passé cent ans, qui est si très-fausse et abusiue, que vn asne y mordroit : et si en vsent encores auiourd'huy, c'est qu'ils ordonnent communement huile de menthe, absinthe, rue et autres qui sont faites desdites fleurs, fruits et autres, auec huile d'oliue, pensant auoir la vertu desdites herbes en l'huile d'oliue qui est chose impossible : car ce sont toutes choses contraires, comme le feu et l'eau.

Tu es bien abusé de penser incorporer les eslemens aqueux et liquides auec les eslemens de nature oleagineuse et crasse ; tu assemblerois et incorporerois aussi-tost le feu et l'eau comme tu ferois entrer la vertu d'vne herbe ou plante en huile ou gresse, et l'experience te le monstre euidemment. Regarde vne huile où tu auras bouilli force herbes ou fleurs, et la fais en la meilleure mode que tu sçauras, et tu trouueras que ton huile ne tient du goust ou saueur de son suiet, et moins de l'odeur ; parquoy tu peux iuger que la vertu n'y est pas demeurée, et n'en tient rien.

Autre experience ; prens de l'huile laquelle tu voudras, et de l'eau, et tasche de les incorporer ensemble, et y fais tout ce que tu sçauras et pourras, et si tu les incorpores simples, sans y rien adiouster, qu'ils ne se separent d'ensemble, ie payeray ce que tu voudras ; et à cela tu peux cognoistre qu'ils ne sont de semblable nature, mais differente et contraire ; parquoy tu ne peux ioindre les facultez et vertus ensemble.

Autre experience ; prens vn simple tel que tu voudras, et le distille, et tu verras que le feu chasse l'eau la premiere : car il fait tousiours son action à son contraire, et puis à son semblable qui est l'huile, à part et non iamais ensemble, qui te monstre bien que l'huile et l'eau ne sont de semblable vertu, mais bien contraire : car toutes huiles tiennent plus du feu que des autres eslemens, et fust l'herbe froide dont l'huile

seroit extraite, et aussi iamais ne se peuuent incorporer, encores qu'ils soyent extraits d'un mesme corps engendré et nourry ensemble par nature. Dauantage si tu prens lesdites herbes ou fleurs qui auront esté bouillies et presque toutes bruslées en huile d'oliues et que tu les distilles et en tires l'huile du propre corps d'icelles sans y rien adiouster, tu en tireras vne huile qui aura autre odeur que celle que tu as fait par ton ebullition aqueuse : car elle aura la propre odeur, saueur et force que son suiet mesme ; que si tu en mesles demi-once en vne liure d'huile d'oliues, elle te rendra telle odeur à ladite huile qu'il semblera que toute l'huile soit extraite du mesme medicament. Or regarde si pour bouillir tes herbes elles laissent leur vertu dans l'huile ou gresse où tu les as bouillies. Par cela tu peux cognoistre facilement qu'il n'y a rien du tout, veu que si grande quantité d'herbes ne peut pas bailler l'odeur que fait demi-once qui a esté extraite à part.

Ie ne pense point que les bons autheurs ayent escrit la maniere de faire les huiles autrement que par la vraye distillation, non pas celles brouilleries qui sont escrites en nos dispensaires, qui ont esté escrits de quelque vieux resueur : car il est facile de tirer l'huile de tous les vegetans sans y adiouter, et en vaudroit mieux vne once que dix liures faites par decoction en huile d'oliues.

Si tu auois veu de l'huile extraite ou tirée d'vne herbe, fleur ou racine, tu dirois c'est le vray : car si tu en auois tasté le gros d'vn cul d'espingle en ta bouche, il te seroit aduis que toute l'herbe ou fleur fust en ta bouche auec semblable force. Et si tu en auois frotté tes mains ou ta barbe, l'odeur n'en partiroit de deux iours, et celles-là sont les vraies huiles, et les autres ne sont qu'abus inueterez, dequoy les Medecins sont autheurs qui nous les ont apprins à faire en cette sorte, et ne veulent vser encore auiourd'huy que de celles-là, et qui leur en voudroit bailler des parfaites, ils n'en voudroyent point : car ils ne les sçauent pas ordonner, ils n'en virent iamais, et ne sçauent la force et subtilité d'icelles, et seroyent trompez en faisant plutost mal que bien à ceux à qui ils les ordonneroyent ; parquoy ie suis d'aduis qu'ils se tiennent à leurs vieilles paste et mode de faire inutile, à celle fin que s'ils ne font pas de bien, qu'ils ne facent point de mal.

Lisset dit que nous baillons du *quid pro quo* en leurs ordonnances, ce qui est vray : n'est-ce bailler vn *quid pro quo* à vn malade, luy bailler de l'huile d'oliues, pour huile de menthe, sauge ou autre? N'est-ce pas abuser le patient qu'il pense refroidir vn membre par l'huile rosat ou violat ou autre? Et il y a de l'huile d'oliues qui est chaude et acre : tu aurois beau bouillir herbes froides dans l'huile auant que lui oster son naturel, qui est chaud et acre, non pas seulement luy diminuer : car l'herbe n'est pas de semblable nature, mais contraire, qui empesche que les vertus ne se peuuent ioindre ensemble; et maistre Lisset dit que nous sommes imperits et faisons mourir les malades par nostre imperitie.

Ie vous laisse à penser si eux-mesmes ne sont imperits, ne sçachant que c'est qu'ils ordonnent, ny moins donner raison comme les compositions peuuent rendre leurs vertus suiuant leurs intentions, comme tu vois des huiles : le semblable est des autres choses.

Si ie voulois escrire combien i'ay veu mourir d'hommes par leurs imperities et ignorances! comme les vns pour s'amuser à iullepter pendant la maladie augmentoit, et la nature diminuoit tant que le malade mouroit; d'autres que pour ordonner la diette trop extresme, debilitoit tant la chaleur naturelle, que le patient tomboit en conuulsion de ses membres, et mouroit; d'autres pour auoir ordonné des dormitoires (sans auoir esgard si les malades estoyent chargez de fluxions) qui dorment encores, et tant d'autres qu'ils ont faits et font tous les iours, qui seroit tant long à reciter, que l'on en feroit vne Bible! Et de tels Medecins en a grande quantité en l'Europe, Asie et Afrique : de ce que Lisset escrit contre eux et contre les Chirurgiens, ie n'y responds rien, ie suis de son costé en cela.

Il dit que l'estat de la Pharmatie est plus douteux qu'il ne fut iamais, à cause que les Apoticaires se meslent d'autre estat et vacation que la leur; ie luy respond que les Medecins en font bien dauantage, car ils se meslent, les vns de prester à vsure l'argent qu'ils ont gaigné iniustement des pauures malades; les autres de faire marchandise, comme faire faire veloux; les autres à iouer toute la nuit aux cartes et dez; les autres à chercher les femmes enceintes, et leur aller taster le ventre pour sçauoir si elles feront fils ou fille, pour gager des-

sus, et voila leurs estudes. Et ne faut penser que l'estude du Medecin soit autre que à l'auarice; parquoy la medecine est plus douteuse que la pharmatie : car l'art de la pharmatie se peut faire parfaitement, ce que ne fait la medecine; car elle est imparfaite, et n'y eut iamais perfection n'y aura, l'experience le montre à l'œil.

Tu verras des Medecins frappez de certaines maladies, desquelles ils ne s'en peuuent guerir, et sont contraints languir et enfin mourir; les vns sont affligez de goutes artetiques, les autres de goutes migraines, les autres de coliques, les autres de nephretiques, les autres sont frenetiques, et ne s'en peuuent guerir, et en pensent guerir tous les autres tous les iours qui en sont malades comme eux. Regarde quel abus et quelle perfection y a en leur art; s'il y auoit perfection ils se gueriroyent les premiers, mais ils ne peuuent guerir eux ny les autres, et blasment les Apoticaires qui pancent les malades sans eux.

Ie te dis que si l'Apoticaire est sçauant et bon simpliciste, il le peut faire aussi seurement que le Medecin : car il a intelligence et cognoissance des medicamens, qui est le principal : car de ieunesse et frequentation il est nourry auec eux, et sçait quelle force et temperature ils ont, et en quelle action ils font mieux que le Medecin, ioint qu'il a veu et retenu les grandes fautes que les Medecins ont fait et font en la cure des maladies dont il se peut garder : car il est tousiours plus prochain du malade, que le Medecin, pour ce qu'il faut qu'il applique l'ordonnance, et s'il est homme de bon esprit et iugement, qui le gardera retenir le bon, et laisser le mauuais? Ie t'asseure que les Medecins sont tant estonnez du moindre incident qui suruient en leurs practiques, qu'ils ne sçauent que dire; quelquefois ils diront il est mort, qu'il guerira; quelquefois ils diront qu'il guerira, qu'il mourra incontinent.

Combien de fois me suis-ie trouué auec le Medecin aller voir des malades, le soir dire à leurs parens : il se portera bien et guerira bientost pour certain, que le matin nous le trouuions mort sur la table? Plusieurs fois cela m'est aduenu auec les Medecins qui estoyent les mieux famez, dont ie me esbaysois fort. Et si un Apoticaire pance vn pauure homme sans leurs ordonnances, il en sera blasmé, et s'il meurt, l'on dira : l'Apoticaire l'a tué par son ignorance; que ne dit-on

doncques ainsi des Medecins quand leurs malades meurent entre leurs mains? l'espere voir le temps que le peuple cognoistra que c'est que le Medecin, et dequoy il sert, et aussi l'Apoticaire.

Notre maistre Lisset nous blasme, disant que nous faisons vser beaucoup de drogues aux malades pour auoir plus d'argent; c'est bien au contraire, car l'Apoticaire sçauant se gardera bien de bailler aux malades chose dequoy il ne soit asseuré par experience, et qu'il n'en cognoisse bien la faculté; et ne fera pas comme font beaucoup de Medecins qui ordonnent des receptes confuses, à sçauoir grands triacles (thériaque), grand quantité de drogues, pour dire qu'ils sont fort sçauans, là où deux ou trois ayant bons respects à la maladie, feroyent plus que tous ces grands triacles. Et qui examineroit le Medecin qui les ordonne, il se trouueroit bien empesché de dire la faculté de la moitié, et trouueroit sa recepte confuse : car il est impossible que tant de drogues puissent faire vne fermentation ayant respect à la maladie, qu'il n'y en ait quelqu'vne qui nuise et qui repugne, et qui ait quelque vertu oculte qui ne vient à propos. Parquoy ie trouue sage vn operateur qui use de peu de medicamens, bien cogneus et experimentez, mesme de ceux qui croissent deuant luy, sans aller chercher les lointains qui sont nourris les vns en pays chaud, les autres en pays maritimes qui ne sont consonans à nostre nature, qui n'est engendrée ni nourrie en ces pays.

Tu peux pancer et mediciner les corps nez au pays de France, des herbes et plantes qui sont nées audit pays, sans en aller chercher au pays lointains et sera plus seurement : car les medicamens nez et nourris sous le climat où sont nez et nourris les corps, proufitent beaucoup plus ausdits corps que ceux qui sont nez sous autre climat. Experience : regarde si ceux des Indes et autres pays se medecinent des medicamens qui croissent en nostre climat, et nous nous medecinons bien des leurs, et qui en est la cause? Nos imperits de Medecins; pour ce que Galien, Hippocrates et Auicenne en ont escrit de ce qu'ils ont veu par experience en leur pays et climat, tant des medicamens que des corps, et s'ils eussent esté en France nourris, ils eussent escrit des medicamens nez et nourris sous le climat de France, et n'eussent point eu la peine de les aller chercher si loing.

Tu ne me sçaurois faire croire qu'vn médicament né en pays chaud et maritime, ne serue mieux à ceux de son climat, que à ceux d'vn autre climat froid ; si tu cherches bien les herbes chaudes en France, comme les Indiens et Arabes ont en leurs pays, tu les y trouueras, mais non tant chaudes, ny tant acres, aussi ne nous seruiroyent-elles pas bien : pour ce que nos corps ne les pourroyent endurer, ny nostre nature n'en pourroit si bien faire son proufit comme de celles qui croissent deuant nos yeux, et en nostre region et climat, qui quelquefois ne sont encores que trop fortes, violentes, et acres, sans en aller chercher plus loing de plus fortes, et plus acres, mesmes qui nous enuoyent le plus souuent l'vn pour l'autre, se moquant de nous, comme de nostre espodion (ivoire) bruslé.

Ie voudrois bien demander à nos Medecins s'ils sçauroyent bien discerner vn os mis en cendres, si c'est de l'os de la iambe de l'Elephant, ou autre animal : ouy de beaux. Et tant d'autres que ie ne veux citer.

Si le Medecin estoit docte et bon operateur, il n'vseroit iamais, ny feroit vser par la bouche de drogues lointaines, que du rhubarbe, agarit et aloës, pour ce que cela est cogneu et experimenté par nous.

Ie te voudrois bien demander quelle vertu prens-tu en l'espode bruslé, en la corne de cerf bruslée ? Penses-tu que nature puisse alterer et transmuer en sang cette cendre si aride ?

Si tu me dis, ie la baille pour deseicher quelque humeur dans l'estomac, ie te responds qu'il en faudroit grande quantité pour deseicher, et tu n'en ordonne qu'vne drachme pour le plus, qui ne sçauroit deseicher grande humidité.

Parquoi mets cela au rang des abus, et n'en vse plus pour ton honneur : car tout cela ne sert que d'empesche dans l'estomac : tout ainsi comme des metaux que nos Medecins veulent que l'estomac debille, transmue, et sanguifie, comme l'or et l'argent.

Ie te dis que l'or est si parfait et si fixe, qu'il ne craint eslement qui soit, celeste ou terrestre : rien ne le peut alterer, rien ne le peut transmuer : il demeure tousiours en son entier, et tu luy veux faire rendre sa vertu dans l'estomac de l'homme debille. Tu es bien abusé, non pas dans l'estomac de l'Austruche. I'ay veu faire des petites pelotes d'or, pesant chascune douze grains ; et les faire manger auec du pain à vn Gal (coq) :

pour ce qu'il a vn Docteur qui a escrit que le Gal le destruit et digere : nous luy en fismes manger vingt et quatre, lesquelles il nous rendit comme nous les luy auions baillées, sans estre en rien diminuées, et eusmes nostre pois autant pesant qu'il en auoit mangé.

I'ay veu tenir l'or au feu par l'espace de quarante-huit heures sans estre diminué d'vn seul grain ; regarde comme la diminuera vn estomac debille, comme te restaurera-t-il le cœur, si l'estomac ne le transmue? Comment te resiouyra-t-il les esprits? Si fera, et ie te le diray : car tu ne sçais pas, et croy que les autheurs qui en ont escrit, l'ont ainsi entendu.

Si tu voyois deux ou trois mille escus sur ta table, ou dans tes coffres, ne serois-tu pas plus ioyeux que s'il n'y en auoit point, et que tu en deusses? Ouy, de la belle moitié. Il te restauroit le cœur, les esprits et la veue exterieurement, mais non interieurement ; et ne desplaise à nostre autheur qui a ordonné le Diacameron en nostre dispensaire, où il ordonne limature d'or et d'argent, disant que la composition est tant souueraine, qu'elle reduit l'homme de vie à mort, dis-ie de mort à vie ; et ie t'asseure que c'est des meilleurs abus de nostre pharmatie, entretenus par les doctes Medecins.

Si ie voulois dire que l'or ne fust restauratif, i'aurois bien menty : car par l'or on a chapons, perdrix, cailles, phaisans et toutes choses qui sont bonnes pour resiouir et restaurer l'homme, comme maisons, chasteaux, terres, possessions qui resiouissent l'homme exterieurement, et non interieurement : comme de le manger en substance, que nos Medecins ordonnent. I'aimerois mieux si i'estois malade auoir perdu vn escu que d'en auoir mangé vn autre en quelque sauce que le Medecin me le sçeust mettre : car il ne sert en l'estomac que de chose estrange, et d'empesche : et si ie l'auois en ma bourse, il ne me sçauroit empescher. Ainsi en est-il des pierreries ou fragmens que les Medecins ordonnent à manger aux malades pour restaurer et conforter le cœur, le cerueau et les esprits.

Lisset peut bien dire que nous en abusons en baillant du verre broyé pour lesdites pierres. Asseure toy que autant vaut l'vn que l'autre, et autant rend de faculté en l'estomac l'vn que l'autre.

Si tu cognoissois que c'est que ces pierres, tu iugerois que autant seruent elles que les metaux, et non plus : car elles

sont aussi difficilles à transmuer et sanguifier que l'or ou l'argent, car la perfection de la pierre est en sa dureté, et plus elle est dure, et plus lucide et transparante elle est, et aussi plus rebelle à cuire et digerer à vn estomac debille, à qui communement les Medecins les ordonnent, et moins se peut sanguifier, et ne peut seruir en l'estomac que d'empesche, à cause de sa pesanteur et frigidité, rendant l'estomac inutile de son action au lieu de le restaurer et conforter.

Ie te voudrois demander si vn bon chapon bien cuit et pressé, le suc ne restaureroit pas mieux qu'vne pierre bien dure, fust-elle la plus precieuse de ce monde? Penses-tu restaurer et conforter les corps des choses dures et indigestibles? Penses-tu que nature puisse alterer vne pierre et vn metal? Tu t'abuses et abuses les pauures malades à qui tu les ordonnes : car toutes choses que nature peut alterer, elle en a fait son proufit, et ce qu'elle ne peut alterer, l'altere, la conuaint et endommage, luy faisant grand mal, la rendant tant debille que le patient ne peut quasi aspirer, et les causes sont ces choses estranges, abusiues et mal inventées. Il faudroit beaucoup manger de pierres pour faire et engendrer vne once de sang; aussi faudroit-il beaucoup en manger pour consommer vne once d'humidité. Si l'intention du Medecin estoit telle, et toutesfois il en ordonne bien peu; parquoy ie dis que c'est vn des premiers abus de Medecine.

Tu chercheras autre nourrissement pour restaurer, que pierres : car les pierres ne restaurent que exterieurement, comme quand elles sont belles, bien orientales, bien colorées, bien lucides et transparantes : et pour leur beauté conforte la veue, l'esprit, à celuy à qui elles sont; mesmes quand elles sont de grand prix, et bien parfaites. Les pierres sont engendrées par congelation, les metaux par desiccation. Il faut long temps auant qu'elles soyent en leur perfection : plusieurs disent qu'elles sont creées dès le commencement du monde : tant plus dures sont-elles, et plus de temps faut pour attirer leurs vertus à nostre pauure estomac debille, qui n'a la puissance de digerer vn coulis, ou bouillon, qui est presque digeré à force de cuire, et voila les belles ordonnances de nos Medecins.

Tu me diras, Galien, Hyppocrates, Auicenne l'ont escrit : ie te respons qu'ils ont bien escrit d'autres choses qui ne ser-

uent de rien non plus que cela, et ont bien failly en plusieurs choses; tu ne te deuois pas tant fier à eux que tu n'en fisses quelque experience. Prens quelques pierres que tu voudras, et les fais distiller ou brusler, ou en tires les quatre eslemens, et tu verras quelle peine tu y auras, et combien tu en tireras. Il faudroit beaucoup de saphirs, rubis, iacinthes, esmeraudes et autres pour tirer vne once d'huile, et pour tirer demi-once de sel. Ie ne voudrois pas estre obligé de rendre vne once d'huile de ces pierres pour cent escus sol... Regarde quel abus voila aux Medecins qui n'en ordonnent que demie drachme ou vne drachme : autant rendent-elles de vertu dans l'estomac, comme elles te rendent d'odeur et saueur sur la langue, et les broye tant subtiles que tu voudras; d'autant plus ie m'esbays des Docteurs qui en ont escrit sans les auoir experimentées.

Ie me ris encores mieux des Medecins qui les ordonnent en onguent, comme le corail et autres, appliquez sur l'estomac, et veulent qu'ils entrent par les pores, ablués d'huile ou gresse; vne chose dure et pesante, que iamais ne laisse sa vertu, à cause de sa grande dureté, pour chose que l'on luy face. Et encores qu'il est ablué de gresse ou huile qui est bastante de l'empescher, s'il estoit prest à rendre sa vertu ; et veux-tu qu'il entre par les pores subtilement : tu as bel attendre.

Ie m'esbays que tu n'as mieux experimenté les abus qui ont tant regné et regnent encores. Lisset se peut bien moquer des Apoticaires qui appliquent les retentifs sur le ventre pour restraindre le flux; et les Medecins ordonnent les pierres sur l'estomac qui n'ont nulle asperité, odeur, saueur, ny force. Si les y ordonnent-ils pour restraindre et conforter ; et qui est plus ignorant, est-ce pas le Medecin et plus imperit? Tu me diras, tu parles contre le proufit de la Pharmatie, et ie te dis que ie suis amy de verité, et que i'aime mieux que cet abus soit osté qui encherit grandement les compositions où entrent ces belles pierres precieuses, tant pour les pauures que pour les riches, qui ne seruent que d'empesche, et que les proufits ne soyent pas si grands, afin que le peuple ne soit tant abusé : car auiourd'huy nos Medecins ordonnent fort de ces belles compositions pierreuses ou restaurans, qui sont cuits au bain marie, composés d'vn vieux chapon de dix ou huit ans, dur,

aride et gouteux, qui meurt de vieillesse, ethic, sans chair, ny suc; et iceux nos Medecins font chercher pour restaurer les corps debilles et destituez de nature : et le chapon qui est destitué de nature, et qui n'a nul nourrissement ny chaleur naturelle, peut bien restaurer vn malade debille et destitué de chaleur naturelle. Nonobstant, si en faut-il auoir, et ne veulent point de ieunes, tendres, gras et chauds, ayant bon suc et bon nourrissement; ceux-là ne valent rien à restaurer, mais bien les vieux ethics durs comme pierres.

Ie cuide que l'on cherche tous les moyens d'abreger les heures aux malades : i'en fais iuges tous les frians qui disent : jeune chair et vieux poisson; ie ne sçay où ils ont trouvé ces resueries. Vn homme qui n'auroit iamais estudié en medecine, et ne sçauroit rien de la qualité des choses, iugeroit qu'vn bon ieune chapon, gras et tendre, vaut trop mieux qu'vn vieux, sec et maigre, dur et gouteux, et que le ieune a plus de substance que le vieux; ils me diront que le vieux est plus chaud que le ieune, ce qui est faux : car toute chose près de sa natiuité a plus de chaleur que la chose vieille et loing de sa maturité. Regardes le par toy-mesme, si tu as tant de chaleur que quand tu estois ieune : si tu veux dire ouy, tu rendras les hommes immortels par vieillesse, ce que tu ne sçaurois faire : car tout homme et tous animaux ont toute leur chaleur à leur naissance, et va tousiours diminuant iusques à la fin, et en diminuant nous fait changer de couleur tous les iours; nous transmuant à mesure qu'elle se perd, à sçauoir là où nous estions rouge, nous fait venir blesmes; la barbe que nous auions rousse ou noire la fait venir blanche : là où nous estions forts et roides, nous fait demeurer flacs et debilles; ne pouuant plus tendre nos nerfs, n'ayant plus de suc, ny d'humidité radicale, destituez de chair, estant presque éthics; et la cause est que nous n'auons plus cette chaleur qui nous faisoit auoir nourrissement de toutes choses; ainsi est-il de tous autres animaux. Parquoy si tu me veux croire, tu n'vseras plus de vieux animaux pour restaurer les corps vieux et debilles, et ne prendras plus ce qui a besoin d'estre restauré, pour restaurer les destituez et debilles.

Il me souuient auoir ouy dire à vn Medecin que le vin vieux estoit plus chaud que le nouueau, et ie luy demanday ou le vin prend sa chaleur; il me dit, en la tine ou vaisseau

où l'on le fait; et ie luy respondis qu'il auoit sa chaleur auant que y estre mis, et nous accordasmes à cela. Puis ie luy demanday où prend le vin cette chaleur acquise que vous dites en enuieillissant, veu qu'il est subtil et s'euapore tous les iours. Le pauure homme ne me sçeut donner autre raison, sinon qu'il attiroit; et ie luy dis qu'il le falloit doncques tenir au soleil, et non en la caue.

Il y a des grandes sophisteries entre ces Medecins, ils ont mis de toutes choses le char deuant les bœufs, mais auiourd'huy ne peuuent plus faire croire leurs abus et ignorance, dire que le vin vieux est plus chaud et plus fumeux, ayant plus d'asperité et force que le vin nouueau; ie t'en vais donner vraye experience.

Prens vn barraut ou mesure de vin vieux, le meilleur que tu pourras trouuer, et semblable mesure de vin nouueau, qui soit bon et purifié, et les fais distiller par vne serpentine, ayant ses reuolutions, et tu trouueras que le vin nouueau te rendra plus d'eau ardente que le vin vieux d'vn bon tiers, et à cela tu cognoistras que le vin nouueau a plus de chaleur et asperité que le vin vieux, contre le dire de tous les vieux resueurs. Ie ne dis pas qu'vn vin vieux ne soit plus proufitable au corps et plus temperé que le nouueau : car il ne penetre le ceruau comme fait le nouueau; mais pour dire qu'il soit plus chaud, il n'en est rien.

Regarde l'ignorance des Medecins et leurs bonnes experiences, qui cherchent les choses froides, arides, sans nourrissement, comme pierres dures, chapons vieux et ethics pour faire restaurans pour les corps debilles et destituez de chaleur naturelle, et sont ordonnez de si bon goust lesdits restaurans, qu'vn homme bien sain et alegre, aimeroit mieux ne iamais manger que prendre de ces beaux restaurans aborrissant à nature, à cause de leur mauuais goust. Regarde comme les malades debilles et desgoustez, en peuuent estre restaurez; car il faut que ce qui restaure soit plaisant et alegre à nature; encores ont-ils trouué une autre maniere de restaurer, fort abusiue, que notre Maistre Lisset approuue très-bonne, c'est qu'ils font distiller la chair d'vn chapon, perdrix, cailles ou autres, en eau, puis ils y mettent du sucre et canelle, pour faire boire ladite eau à leurs malades, pensant leur donner telle substance que s'ils auoient fait manger lesdites chairs à

leurs malades, qui est bien au contraire : car il ne distillera que l'eau pure, comme ie t'ay ia baillé l'experience de l'eau salée, et n'aura nulle odeur ou saueur, sinon de la chair qui bruslera au cul de l'alambic, qui fera que l'eau sentira l'alambic et le bruslé, et rien autre; et le bon et le substantiel demeurera et ne montera point; et le Medecin fera boire de cette eau à son malade pensant le restaurer, qui ne vaut non plus que eau de puits, n'a odeur que d'eau et de feu.

Experience, prens vn chapon ieune et non vieux, et vne perdrix, ou autre que tu voudras, et le fais bien cuire, et tu trouueras en la decoction ou bouillon vne grande odeur, si tu l'odores, et vne grande saueur si tu le goustes, tellement que tu iugeras que cela est bastant pour restaurer. Fais le distiller, puis prends de l'eau et en goustes, et tu la trouueras insipide, sans goust, ny odeur que du bruslé, comme i'ay ia dit; lors tu iugeras que ton restaurant n'est bon, et ne peut rendre bon suc au corps debile, à qui tu l'ordonnes pour faire bon sang, pour restaurer ny fortifier les esprits de nature.

Ie ne veux pas dire que le sucre et canelle, quand ils y en ordonnent, n'y seruent plus que toutes les chairs distillées qu'ils y sçauroyent mettre : car il vaudroit mieux l'odeur des potages desdites chairs, que l'eau qui en sort; et vaudroit mieux eau de fontaine que icelle eau ayant mauuaise odeur; et voila les restaurans de nos ignorans Medecins.

Si tu veux faire vn bon restaurant facile à distribuer, et transmuer, par tout le corps, fais cuire chapons, poulles, ieunes, non vieux, et autres que tu voudras, puis le presse fort bien dans vne presse, tant que les os rendent leurs moelles, puis en fais vne gelée bien claire et de bon goust, et tu auras toute la substance de la chair, sans distiller; et si y adiousteras tel medicament que tu voudras, dont tu auras la substance, et n'empescheras l'estomac de ton patient, ains le restaureras, sans aborrition, comme font les autres restaurans susdits, aborrisant aux sains et alegres, mais le prendra plaisamment, et ne luy coustera que d'aualler, et aura la substance et vertu de tout ce que tu y auras mis, comme i'ay dit.

Maistre Lisset recite l'argument qu'il fit à l'Apoticaire qui disoit que le rhubarbe attiroit du cerueau, et Lisset luy demanda, à sçauoir si les drogues qui ont vertu d'attirer du cerueau, doiuent estre legeres ou pesantes : l'Apoticaire luy

respond qu'elles doiuent estre legeres ; et Lisset luy dit pourquoy il prenoit le rhubarbe, veu que le bon rhubarbe se doit eslire le plus pesant ; ie responds icy à nostre Maistre Lisset que l'Apoticaire luy auoit mieux respondu que ledit Lisset ne luy auoit demandé : car s'il n'est la plus grande beste du monde, pour attirer du cerueau en toutes les compositions il y a du rhubarbe : et si le rhubarbe est de substance pesante, si est-il de vertu subtile ; et s'il n'estoit de vertu subtile, il ne purgeroit pas la colere. L'aloes est bien de substance pesante, si attire-t-il du cerueau mesme, et en vsons en toutes nos pillules : voila vn bel argument pour escrire et faire imprimer.

Il dit bien vray que nature guerit les maladies, car ce ne sont pas les Medecins : parce qu'ils ne cognoissent les maladies, nature ny medicamens ; n'est-ce pas bien cogneu la vertu et faculté des medicamens qu'ils ont tenus, eux et les Chirurgiens, l'argent vif ou mercure, froid au quart degré, qui est au contraire ; il est bien froid actuellement, mais chaud potentiellement, et n'y a metal que luy qui soit subtil, et qui entre dans les pores, de tant qu'il y en a.

Ie suis esbay que les Medecins et Chirurgiens n'y ont prins garde, mesme l'experience le leur a tousiours monstré deuant les yeux. Y a-t-il Medecin ny Chirurgien qui sçeust inflammer le foye et l'estomac, par onguent qu'il sçache faire à vn verollé, luy donner mal de gorge sans argent vif, ny moins qu'ils puisse guerir cette maladie qui est vne lepre froide, sans argent vif, qui est le principal medicament, et celuy qui fait plus d'action en cette maladie, qui comme par sa grande chaleur fait ulcerer la gorge, les leures, les genciues, fait branler les dents comme vn clauier d'orgues. Et s'il estoit froid, feroit-il toutes ces actions, donneroit-il telles inflammations, causeroit-il faire suer ? Tu me diras, ce n'est pas luy seul qui enflamme et donne mal de gorge.

Ie te vais conter vne experience veritable d'vn ieune homme qui vne fois vint à moy, et me pria luy donner secours à certaine maladie : c'estoit qu'il auoit force morpions, et ne pouuoit durer ; ie luy fis vn petit liniment où ie mis vne once de pommade qui est faite de gresse de chevreaux, de pommes et d'eau rose, et tout cela est froid : ie y mis vne dragme d'argent vif, et le tout incorporé, luy en fis frotter les genitoires,

cet onguent luy donna telle chaleur et inflammation que le pauure homme cuida brusler toute la nuit, et le matin tira toute la peau de ses genitoires comme vne bourse, si bien l'argent vif l'auoit bruslé. Tu ne sçaurois dire que ce fust autre que l'argent vif : car tout le reste estoit froid ; et si tu penses que ie sois menteur, esprouue la recepte sur toy, et s'il ne t'en prent ainsi, ie payeray ce que tu voudras : car ie suis asseuré de mon experience. Ie luy chassay fort bien les morpions, aussi il ne s'en mescontenta pas ; nonobstant, les Medecins et Chirurgiens le tiennent pour froid, et en vsent à refroidir.

Ils s'abusent bien, car d'autant que tu penses qu'il soit froid, il est chaud, et qui pis est, ne meurt iamais en quelque lieu où il soit appliqué, fut-il mis au feu : car le feu n'a nulle puissance sur luy, que de le chasser : car il est si subtil, que incontinent qu'il sent le feu, il s'en va en fumée. Mais il ne diminue en rien, et rien ne s'en perd, si non que l'on y mesle du souphre pour en faire du cinabre, ou bien que tu le voulusses sublimer ; mais encores baille moy du cinabre et sublimé, et i'en tireray d'argent vif, non pas tout. Et ne faut plus que tu sois ignorant de dire qu'il est froid : car il est chaud sans difficulté ; tu me diras que les Autheurs l'ont escrit froid, disant que les choses graues et pesantes de leur substance sont froides, et les legeres lucides et transparantes, en leur substance sont chaudes. Si tu as bien leu Mesué, tu trouueras qu'il ne faut auoir esgard à la pesanteur, ny à la legereté, c'est qu'il est ainsi et n'en sçauroit donner raison.

Regarde les herbes qui sont les plus froides (comme le iusquiame) croissent en lieux les plus chauds et se y nourrissent. Les chaudes et seiches en l'eau, comme les cressons ; puis il y en croist des froides et seiches, comme les capillaires : parquoy tu ne sçaurois iuger qui est la cause, sinon que Dieu a donné ses vertu si occultement que l'homme ne les peut comprendre. Et pour sçauoir quelle vertu elles ont il les faut experimenter par experience.

I'approuue le camphre chaud, ce qu'il est encores que les Medecins et Chirurgiens l'ordonnent pour refroidir contre tous leurs autheurs. Premierement il est fort leger, lucide, transparant et de forte odeur, tellement que son odeur esmeut le cerueau ; il est de substance subtile, les choses froides ne

sont point subtiles, et leur odeur ne penetre le cerueau. Dauantage il a conuenance auec le feu, et brusle mieux que l'huile ou gommes; s'il estoit froid, il repugneroit au feu son contraire : mais au contraire, le feu s'y prend sitost qu'il le touche; s'il étoit froid comme le salpestre, il brusleroit auec bruit et repugneroit : mais il brusle lentement sans mener aucun vent, et l'eau ne l'en peut garder : car il brusle en l'eau; dauantage, quand il est meslé auec la poudre à canon, où il y a du salpestre, il fait la poudre fort violente, à cause du froid et du chaud, qui est le salpestre et le camphre, et s'il étoient tous deux froids, ils seroyent longs à brusler : car le souphre est long à brusler, et n'auroit pas tant de vigueur, force, ny violence; parquoy i'approuue le camphre chaud par toutes ces raisons : et quant à l'experience, ie ne vis onques refroidir inflammation par camphre : et n'estoient les autres medicamens froids que les Medecins et Chirurgiens ordonnent pour accompagner le camphre, iamais il ne refroidiroit les parties enflammées; mais au contraire, reschaufferoit au lieu de refroidir; et si tu en veux autre experience, esprouue le seul, et tu trouueras qu'il est chaud.

Notre Maistre Lisset dit que les Sandaux sont chauds à cause de leur odeur violente, et dit que icelle odeur leur est baillée par les Apoticaires. Veritablement il a bien parlé, et à son honneur, et a beaucoup veu de Sandaux. Il n'y a si petit apprentif en la Pharmatie, qui ne iuge que c'est vn ignorant du tout : car il ne seroit possible de bailler odeur à vne piece de bois comme il dit, qui ne coutast à l'Apoticaire plus de deux escus sans le temps perdu, et le sandal blanc et citrin ne couste que huit sols la liure. Ne seroit-il pas bien de loisir qui s'y amuseroit, gaigneroit-il pas bien sa vie? Encores n'est-il possible de le faire.

Il dit aussi que les Apoticaires font tremper de bons girofles pour donner odeur aux vieux. Ne seroit-il pas bien de loisir aussi l'Apoticaire qui s'amuseroit à bouillir vne liure de girofles bons, pour donner odeur à vne liure de vieux et pourris? Maistre Lisset ne sçait pas et n'a pas experimenté que les girofles bouillis ou trempez en eau ne valent rien, et fussent-ils les meilleurs du monde, auant bouillir ou tremper : car ils ne se peuuent si bien desseicher qu'ils ne donnent bien à cognoistre qu'ils ont esté mouillez : car ils regrignent ou regril-

lent comme vn cuir, et là où ils doiuent estre gros, charnus et secs, ils se montrent comme cuir bruslé tous entortillez ; et n'y a homme qui en sçeust vendre ne qui en voulust acheter : car ils sont difformes.

Ie crois que celuy qui luy a donné à entendre ces belles folies, se moquoit de luy, et c'est bien moquerie dire que l'on peut bailler odeur au bois ; mais s'il eust dit que ordonner du bois en onguent ne sert de rien, non plus que des pierres, il eust dit vérité, et ne se fust pas moustré asne comme il est, et les autres qui l'ordonnent ; car le bois n'est pas si subtil, tant soit-il puluerisé, qu'il puisse penetrer par les pores : et est difficile que nature le puisse tant eschauffer qu'elle en sçeust tirer la vertu, à cause de sa dureté et siccité. Ioint qu'ils l'ordonnent auec huiles et gresses qui le garderoyent rendre ses facultez s'il estoit prest à les rendre. Mais sans huile ny gresse le bois ne sert de rien, appliqué exterieurement, sinon a eschauffer et faire des couleurs, comme bresil, sandal et autres. Et voila de belles ignorances des Medecins de maintenant, qui vsent du bois et pierres sur les estomacs, pensant faire entrer la vertu desdites choses par les pores.

Ie ne dis pas si tu mets du bois en decoction, et la faire prendre par la bouche, ou en fomenter quelque partie où tu la voudrois appliquer bien chaude, que la decoction ne soit bonne, et qu'elle ne tienne quelque peu de la vertu du bois : mais si tu en sçauois tirer l'huile parfaite, tu en ferois de belles operations ; sa substance dure ne t'y empescheroit, et entreroit par les pores, à cause de sa subtilité, et seroit sans abuser et tromper les malades, comme font les Medecins.

Ie trouue vne grande sottise aux Medecins ordonner torrefier le rhubarbe, mirabolans et autres, voyant qu'ils sont si secs : car le rhubarbe s'il n'est sec tombera en putrefaction incontinent, et ne se pourra garder, ny les autres ; et pour les garder, faut qu'ils soyent secs, et les Medecins les font deseicher dauantage de peur de faillir ; pour ce qu'ils ont leu en leurs autheurs qui ont escrit du rhubarbe, et mirabolans qui croissent en leur pays, et les ont tous recens. Aussi les ordonnent-ils seicher, pour ce qu'ils ont trop d'humidité estant verds ou recens ; et nous n'en auons point que de secs, car l'on ne les sçauroit apporter recens, et nos Medecins de par-deça les ordonnent seicher qui est vne grande folie : car incontinent les

font rehumecter en la mesme decoction en quoy ils les font vser.

S'ils les faisoyent prendre secs, ie dirois qu'ils auroyent intention de imbiber quelque humeur dans l'estomac, ou restraindre plus amplement : mais font torrefier le rhubarbe et autres, et quant et quant auec vne decoction en font faire vn potus. Et dequoy a serui le torrefier? Car estant en la decoction se renfle comme deuant et mieux. Si tu me dis, ie le fais seicher pour luy oster sa subtilité, ie te responds que quand elle seroit à demi-bruslée, elle n'en perdroit rien, et n'est que folie torrefier le rhubarbe, mirabolans et autres, pour faire prendre en potus auec eau et decoction. Mais c'est vne vieille coustume entre les Medecins qui n'oseroyent auoir ordonné du rhubarbe et mirabolans à vn flux de ventre, s'ils ne les ordonnent torrefiez : autrement seroyent appellez bestes et auroyent grandement failli.

Maistre Lisset nous a grandement chargez de sophistication : mesmes en celuy de l'ambre gris, disant que nous l'adulterons et augmentons de certaines drogues, ce que n'est vray ; mais il n'a pas dit que c'est que ambre, et luy est à pardonner, à luy et aux autres, car ils ne sçauent que c'est.

Ie m'esbays comme nos Medecins n'ont mieux estudié pour cognoistre les grands abus, et iceux repudier, corriger et chasser pour ne abuser le peuple ; et ils l'ont par leur ignorance laissé regner et pulluler depuis ie ne sçais combien de temps, sans l'auoir cogneu. C'est la plus belle sophistication et la plus chere qui soit en nostre Pharmatie. Ie n'ay point leu ny peu sçauoir à la verité que c'est que ambre, sinon sophistication, comme ie diray.

L'vn dit que c'est le sperme de la baleine, que la mer iette sur le riuage, et puis est englouty et mangé de certains renards marins : puis est prinse la fiente desdits renards, et dit-on que cela est le vray ambre, et y en a de deux sortes, à sçauoir celuy qui est failly par le sophisticateur, qui est mol comme sauon noir, et on dit celuy estre qui n'a passé par le ventre du renard, et l'autre qui est dur est celuy qui a passé par le ventre du renard. Voila de belles baliuernes, et t'y fie si tu veux.

Les autres ont dit que c'est l'espume de mer, que par force de flotter contre quelque rocher, s'est engendré et endurcy

en vn germe, que autres disent estre vray ambre gris, ce qui est faux; les autres ont dit que c'est la fiente d'vn certain poisson que la mer iette sur le sablon, qui est amassé et apporté pour ambre gris.

Il me souuient auoir trouué vn bec d'vn poisson et vne pierre d'ambre qui resembloit le bec d'vn petit oyseau qui est frequent en ce pays, qui se nomme vn gros bec, autrement ne se nomme, et celuy qui auoit vendu l'ambre, soustenoit que c'estoit le bec d'vn poisson que l'autre poisson auoit mangé.

Or deuinez que c'est, et le quel est de ces trois, et si tu ne le sçais, ie t'en vais dire mon opinion : c'est vne belle misture et sophistication qui nous est enuoyée par les Turcs et Arabes, qui nous la font payer plus que l'or, et s'en moquent, et nos Medecins qui n'ont eu le sens et entendement de sçauoir que c'est, nous contraignent acheter ce bel abus à grand coust, pour en conforter et restaurer les malades, qui possible est contraire, et ainsi en abusent les pauures gens, auec grands coustanges.

Maistre Lisset s'est fort bien ingeré de nous vouloir parler des choses rares, que nous ne pouuons auoir ny recouurer qu'à grand frais et peines, comme la vraye terre sigillée, le balsamon, le myrre, le rheon, l'amomon, et le vray Cinamomon et tant d'autres. Il est venu trop tard pour nous enseigner cela, et autres choses : car feu Monsieur Symphorien Champier nous en a desbandez les yeux, il y a passé vingt-cinq ans, par son liure intitulé, *Le Miroir des Apoticaires*, et Lisset nous le veut ramener, et pense que nous l'ayons oublié. Celuy ne nous a iniurié comme Lisset, ains remonstré affablement. Aussi auoit-il plus de sens d'esprit et sçauoir que Lisset. Il l'a monstré par ces escritures, car il ne nous accuse estre les inuenteurs d'abus, et n'en dit rien aussi; qui est-ce qui nous a apprins à abuser (si abus il y a)? N'est-ce pas les Medecins? S'ils parlent contre nous, ils parlent contre eux : car c'est eux qui sont les autheurs. Regarde nos vieux antidotes, et tu verras la maniere comme nous auons esté enseignez et apprins; puis se pensent bien excuser, disant, que c'est nous qui faisons les abus qu'ils nous ont apprins.

Maistre Lisset dit que les herbes siluestres qui croissent sans cultiuer, sont de plus grande vertu que celles qui sont

cultiuées, ce qui est faux; et si tu n'es asne, tu trouueras que les chardons qui sont viandes d'asnes, cultiuez sont plus sauoureux, plus grands en herbe, racine et semence, et plus plaisans à manger que ceux qui croissent par les montaignes, et champestres non cultiuez. Semblablement si tu regarde les herbes et plantes, commes les especes d'antibes et autres, si l'agriculture ne leur donne double saueur, double corps, et au lieu d'estre seiches et arides, sont douces et amiables. Et si tu veux dire qu'elles n'ayent double vertu, ie te dis que pour le moins elles en ont plus que celles qui croissent sans cultiuer; et si tu veux sçauoir l'experience, regarde vn arbre ou fructice qui n'ait point esté enté, et vn de mesme fruict qui ait esté enté, et taste des deux fruicts, et tu verras lequel est le meilleur, et lequel a plus attiré de la uertu aërée.

Autre : prens des raisins, des lambrucs qui croissent sans cultiuer, et de ceux de vigne qui est cultiuée, et en fais du vin, et gouste dudit vin, et tu trouueras que celuy qui est fait sans cultiuer, ne sent que l'eau et l'acerbe; et celuy qui est cultiué, est de bon goust, et plus chaud deux fois que celuy de lambrucs; parquoy tu peux iuger que le vin de sa nature est chaud, et ne perd sa chaleur pour l'agriculture, ains l'augmente de la moitié. Par ce moyen ie conclus que toutes choses cultiuées croissent en corps et vertu de moitié plus que les champestres, et non cultiuées, et sont plus odorantes vertes et seiches.

Quelle erreur trouue Lisset à l'Apoticaire prendre les herbes seiches au lieu des vertes? Les Medecins pensent-ils qu'vne herbe prise en son temps bien deseichée, soit moindre qu'vne verte et recente? Ie dis que la seiche ne perd rien de sa vertu pour estre seichée; elle ne perd que l'eau terrestre dequoy elle a esté nourrie en la terre; mais de son eau eslementaire elle n'en perd rien, mesme que si ie voulois auoir la vraie eau, moy et tous les bons distillateurs, il la faudroit faire seicher ou prendre de la seiche.

Autre : si tu en veux sçauoir l'experience, prens vne poignée d'herbe seiche de laquelle que tu voudras, et vne poignée de verte, et les faits bouillir à part, et autant l'vne que l'autre, puis prens la decoction des deux, et en taste et l'odore, et tu trouueras que la decoction de toute herbe qui est seiche est plus odorante et plus forte que celle de la verte;

36.

parquoy tu iugeras que l'herbe seiche ne perd rien de sa vertu pour estre seichée.

Si nous voulons auoir l'huile ou autre eslement d'vne herbe par distillation, nous la faut faire seicher. Ie ne dis pas qu'il ne se puisse faire sans seicher. Or ie voudrois demander aux Medecins, qui fait la plus grande faute en automne ou hyuer, le Medecin qui ordonne l'herbe verte ou l'Apoticaire qui luy en baille de seiche. Ie dis que le Medecin erre grandement d'ordonner l'herbe verte hors son temps : car l'herbe cueillie en son temps qui est Auril et May, quand la vertu est aux caules ou tiges, et feuilles, a plus de vertu seiche que n'a la recente quand la vertu est en la fleur ou semence, ou quand la vertu est retournée en la racine, qui est en automne ou en hyuer. Tu ne peux auoir la vertu des herbes aux feuilles si elle est en la racine. Aussi tu ne la peux auoir en la racine quand elle est aux feuilles, et au semblable tu ne la peux auoir en la fleur si elle est en la semence, aussi en la semence si elle est en la fleur.

Chascune chose a son temps, et doit estre cueillie et amassée en son temps si tu ne veux grandement errer; parquoy ie dis que l'Apoticaire qui diligemment amasse et se fournit d'herbes, racines, fleurs et semences en leurs temps, et les fait seicher pour en seruir en l'ordonnance du Medecin seiches, fait beaucoup mieux que les bailler vertes, encores que le Medecin l'ordonne hors du temps des feuilles; comme en automne ou en hyuer, encore que l'on les puisse trouuer : car nos Medecins en temps d'hyuer ou automne font chercher les herbes recentes, qui ont passé leur temps, et laissent les seiches qui ont esté prinses et amassées au temps de leur vertu, qu'il en vaut mieux vne poignée qu'vn plein sac de recentes de ce temps-là, et sont encores en cette ignorance.

Maistre Lisset est fort empesché sçauoir que c'est que turbith que nous usons auiourd'huy en la Pharmatie; pour te dire que c'est, ce n'est le taptia que tu dis, qui se trouue en la Romaigne, c'est l'esula maior qui se trouue au Royaume de Naples, et en autres lieux, et nous est apportée des Venitiens et autres Nations, fort chere. Ie te monstreray d'esula maior aussi belle, charneuse et laticineuse comme celle qui nous est apportée des Neapolitains, qu'ils appellent turbith.

I'ay experimenté l'esula maior de ce pays, que i'ay trouuée

plus laxatiue sans errosion que n'est celle qui nous est apportée pour turbith, et aussi belle, et si laticineuse : car la gomme que tu vois aux deux bouts n'est autre que le laict qui sort quand tu la coupe fresche, qui se seiche là, et par les fentes quand tu la fends fresche comme i'ay dit, et t'asseure qu'elle n'est point si maligne, ny si venimeuse que celle qui est apportée pour turbith.

Ie me tairay de parler de l'election des drogues, aussi de leurs vertus : car ie n'ay deliberé responde que contre les abus et ignorances des Medecins, tels que Maistre Lisset : car i'espere auec le temps escrire des médicamens, ensemble de la distillation plus amplement. Encores que Lisset dise que les Apoticaires ne sont aucunement grammariens, et ne sçauroyent estudier; parquoy la medecine est en grand danger. Ie trouueray Apoticaires qui parleront aussi seurement de la medecine en François, que beaucoup de Medecins ne sçauroyent respondre en Latin. Il est plus facile estudier chascun en sa langue, que d'emprunter les langages des estranges pour estudier.

Gallien a escrit en sa langue, et n'a pas emprunté le langage d'vne autre region pour faire ses liures; aussi Hyppocrates, Auicenne, chascun a escrit et estudié en sa langue. Les Apoticaires de France peuuent estudier en François sans aller emprunter les langues Latines, ny celles des Alemans : car tout ce qui concerne la Pharmatie est traduit en François; parquoy ils se peuuent faire sçauans, sans estre Latins, ni Grammariens, contre le dire de Maistre Lisset, et mieux que les Medecins : car leurs liures sont en Grec et Latin fort elegans, et la moitié des Medecins n'entendent Grec ny guerres Latin; parquoy ils ne sçauent qu'ils estudient, et les pauures malades sont en grand danger sous leurs mains : car ils nous medecinent à la mode des Grecs et Arabes, et des drogues des Grecs et Arabes; et nous ne sommes Grecs ny Arabes, et moins de leur complection, ny nez, ny nourris en leur climat qui est tout contraire au nostre : car leur pays et climat est plus chaud deux fois que le nostre, et leurs medicamens plus forts et plus egus, et plus veneneux que les nostres. Nonobstant, nos Medecins s'en seruent à mediquer nos corps, aussi nous mettent-ils en grand danger, qui est grand betise à ceux qui pourroyent bien trouuer des medicamens en France pour

medeciner ceux de France, sans en aller chercher en ces pays maritimes qui sont du tout contraires à nous; mais ils n'ont cognoissance ny intelligence aux medicamens non plus que bestes, et n'oseroyent entreprendre d'experimenter autre que ce qu'ils ont leu en leurs liures, et pour ce qu'ils vilipendent l'estat de Pharmatie, ie dis que iamais ne fut et ne sera bon Medecin, s'il n'a esté Apoticaire, et qu'il n'ait frequenté l'herbolage et les drogues pour connoistre la force, saueur, vertu et acrimonie, les auoir veu composer pour seurement en ordonner après, et ne faire comme celuy qui me demanda dernierement si i'auois du sirop d'absinthe Romain, et ie luy dis que ouy.

Il me dit qu'il auoit plus de vertu à conforter l'estomac que l'absinthe Pontic, et en va ordonner pour boire en l'eau bouillie, et à la cueillier, à vne ieune Damoiselle, sans regarder l'amertume qui est si grande, que quand la ieune Damoiselle en tasta, cuida creuer de vomir, et rua fiole, sirop et verre par terre. Et si le Medecin eust veu faire le sirop et en eust tasté, il se fut bien gardé d'en ordonner pour boire en eau, car il est trop plaisant : et s'il se fust trouué près de la Damoiselle quand elle gousta du sirop, elle luy eust ietté par la teste ; ainsi font-ils des autres choses, pour ce qu'ils ne virent iamais rien faire des compositions qu'ils ordonnent, et ne sçauent si elles sont aigres ou douces, vertes ou blanches.

Ie ne dis pas qu'il n'y ait des Apoticaires veaux et asnes, ne sachant rien de leur estat ; ie n'escris pas pour soustenir ceux-là, mais plutost les voudrois vilipender, et monstrer au doigt que de les soustenir : car c'est grande conscience à vn Apoticaire de se mesler de distribuer la medecine, et n'a la cognoissance des medicamens, et plus grande conscience au Medecin qui ordonne quand il a cognoissance que l'Apoticaire est vne beste.

Mais auiourd'huy les Medecins iront plûtost ordonner chez vn Apoticaire ignorant que chez vn sçauant : car l'ignorant luy leuera le bonnet tant de fois qu'il parlera, fera grandes reuerences, donnera presens, trouuera tout bon, ne contredira en rien, et deust le Medecin tourner tout sens dessus dessous, ce que ne fera vn docte Apoticaire : car il ne peut endurer vne chose mal faite deuant les yeux, qu'il ne repugne ; aussi les Medecins ne cherchent pas ceux-là, et se garderont bien

y aller s'ils peuuent, mais plutost les detracteront pour pousser en auant leurs semblables. Aussi vous trouuerez ces asnes d'Apoticaires plus riches que les sçauans, à cause de ce que i'ay dit, et qu'ils endurent tout, et mesme de leurs seruiteurs : car ils n'oseroyent rien commander à leurs seruiteurs, mais au contraire leurs seruiteurs leur commandent, et faut qu'ils endurent pour ce qu'ils ont peur d'estre appellez asnes par leurs seruiteurs.

Et voila pourquoy la medecine est mal faite par ces veaux : car si vn seruiteur fait mal vne composition, le maistre ne l'ose reprendre; car il ne sait pas. Voila qui fait les seruiteurs arrogans, à cause qu'on endure d'eux, qui ne sont que veaux, et les maistres veaux en sont cause. Il seroit bon que l'estat fust iuré, et que nul n'exerçast la Pharmatie qu'il ne fust examiné, vieux et ieunes : car il y a de grands asnes d'Apoticaires en France, et aussi y en a-t-il de sçauans.

Mais pour chasser cette vermine qui fait tant de maux, et qui deshonore l'estat, seroit bien fait de leur faire faire vn examen, pour sçauoir s'ils sont capables auant que se mesler d'administrer la medecine. Mais qui les poursuiura? Les Medecins? Non : car ils ont si grand peur que l'on ne les contraigne d'eux corriger les premiers, et se graduer, qu'ils se garderont bien rien entreprendre contre les Apoticaires, ce qui seroit bien raisonnable; car il y a tant de gens qui viuent de cet estat, et n'en sçauent rien, que c'est chose horrible. Aussi seroit-il bien raisonnable que les Medecins fussent passez Docteurs auant que les laisser practiquer, et leur faire faire approbation de leur estude : car le premier qui vient est Medecin passé. I'ay veu dans Lyon venir plusieurs qui se disoyent Medecins, qui en leur vie n'auoyent ordonné recepte.

Ie te monstreray par les receptes qui sont escrites de leurs mains, qu'il n'y a si petit Apoticaire (fust-il apprentif) qui ne iuge qu'ils n'en auoyent iamais ordonné autant, et si auoyent grand bruit, et gaignoyent force argent, en abusant le pauure peuple; et voila qui est la cause des grands abus qui se font, et mesmes les Chirurgiens qui se meslent de la Pharmatie et Medecine, qui est chose impossible : car le Chirurgien a tant à estudier en son estat, qu'il ne faut point qu'il en cherche d'autre : auant qu'il fut sçauant Medecin, et sçauant Chirurgien et Apoticaire, il luy faudroit trois aages, encores n'en

pourroit-il venir à bout et luy suffiroit bien sçauoir mediocrement la chirurgie.

Ie voudrois trouuer vn Chirurgien qui osast asseurer guerir vne maladie, et en donner raison, ie l'estimerois bien. Ils diront bien qu'ils la gueriront, si autre accident n'y vient ; mais de preuoir l'accident, pas rien. Quand tout est dit c'est comme des Medecins, ils sçauent bien faire la mine, rien autre, pouruu qu'ils soyent bien braues, de l'argent gaigné aux paures gens, en les abusant, c'est tout vn, aussi tout est à l'aventure.

I'ay veu vn Chirurgien asseurer guerir vne petite playe à la cheuille du pied, dans quatre iours, n'en faisant grand conte, et le patient mourut en six iours, et la cause de mort fut la douleur de l'vlcere qui causa la fieure continue, et le veau ne luy sçeut iamais leuer la douleur, et s'il estoit fort braue et bien velouté, et tant d'autres que i'ay veu faire deuant mes yeux. Parquoy il suffiroit bien au Medecin faire sa Medecine, au Chirurgien, la Chirurgie, encores en seroyent-ils bien empeschez, sans comprendre sur les autres estats, et seroit bien assez que chascun sçeust donner raison de ce qu'il fait ; mais leurs raisons sont tant minces, que les imperits aujourd'hui leur font grand honte.

I'ay veu dans Lyon vn Courdonnier et vn cousturier qui n'auoyent iamais estudié en medecine, ny en chirurgie, se mesler de practiquer et guerir les maladies que les Medecins et Chirurgiens auoyent desesperez et abandonnez. N'est-ce pas vne grande honte à eux ; et ils entreprennent l'vn sur l'autre, et de tout ne sçauent rien, et ne sont certains de rien ; parquoy il seroit bien meilleur laisser toutes autres faciendes pour estudier en la medecine et chirurgie, à fin de confondre tous ces imperits, guerir les maladies et satisfaire si bien que les cousturiers et courdonniers n'emportassent l'honneur qu'ils doivent auoir, et ne se fascher si vn plus sçauant et experimenté que eux y entreprenne ; qui est grand honte, sans s'amuser à blasmer l'vn l'autre par escrit, qui est vne grande moquerie entre les sçauans et doctes. Ie pense bien que Lisset n'a reçeu grand honneur d'auoir ainsi vilipendé et iniurié les Apoticaires.

Quant à moy, la response que ie lui en fais, c'est pour ce qu'il blasme sans raison et ne dit verité : car ce qu'il dit des

sophistications, n'est possible le faire, et donne faux à entendre au peuple ignare, cuidant mettre à neant l'art d'Apoticaire, ce qu'il ne sçauroit faire, mais plutost l'honorer et se deshonorer soy-mesme entre les sauans, qui cognoissent bien que ce qu'il a escrit est par enuie et haine qu'il a contre les Apoticaires.

I'ay protesté ne blasmer les doctes et sçauans, ny aussi ie ne veux laisser blasmer l'estat, et ceux de l'estat où Dieu m'a appelié. Ie n'ay point escrit par enuie que i'aye contre Lisset : car ie ne le cogneus iamais ; mais plutost ie douterois que ce soit quelque Medecin qui a changé son nom pour nous blasmer, en chargeant ceux d'Aniou et Poitou, craignant auoir la response de ceux de Lyon.

Si est-ce que i'ay cogneu des Apoticaires de Tours, Aniou et Poitou, qui estoyent sçauans, et m'esbays comme ils ont enduré ces iniures, sans luy respondre. Il ne faut pas qu'il s'excusent d'auoir faute de matiere, car il y a tant d'abus en la medecine que les Medecins ont fait et font tous les iours, que qui voudroit chercher en trouueroit pour amplir vne rame de papier.

Quant à moy, ie m'en tais pour le present. Il est temps que ie face fin à ma response, te laissant à penser (Amy Lecteur) si les Medecins ont grand raison de blasmer les Apoticaires après qu'ils les ont introduits et enseignez à faire les choses de quoy ils les accusent d'abuser, et c'est eux qui abusent, comme ie t'ay monstré cy dessus, et sont ignorans des abus qu'ils font, et en vsent encores auiourd'huy.

Ie n'ay voulu escrire tout ce que i'en sçay, à cause de la moquerie du peuple ; mais i'ay escrit les plus euidens qu'ils ordonnent tous les iours. Ie n'ay escrit certains abus de medecine qui ne consistent en la Pharmatie, esperant auec le temps le tout mettre en lumiere et euidence. Te suppliant, Amy Lecteur, nous auoir pour excusez, si nous n'auons dit chose digne de toy, te promettant auant long-temps auec l'ayde de Dieu, chose meilleure : et à Dieu.

<div style="text-align:center">FIN.</div>

TABLE ALPHABÉTIQUE

DES MATIÈRES.

Absinthe pontique, 428.
— santonique, 247, 285.
Abus (des) et ignorances des médecins, 399.
Addition congélative, 263.
Affinage, 209.
Affinité, 208, 267, 268.
Agathe, 297, 366.
Agriculture, 16.
Agriculture, combien on a tort de la dédaigner, 85 et suiv.
Aimant, 210, 211.
Air, 185, 186.
Aix (eaux d'), 152, 155.
Album Rhazis, 41.
Alchimie (de l') et des métaux, 190.
Alchimie, permise à certaines personnes, 200.
Alchimistes, 55, 193, 211.
Alchimistes, défi que leur porte Palissy, 201.
Alun, 242, 249.
Ambre, 211.
Ambre gris, 423.
Ammonites, 37.
Animaux pétrifiés, 266.
Antimoine, 229.
Aplomb, 92.
Apothicaires, 393, suiv.
Appendice, 383.
Aqueducs des anciens, 143.
— de Nismes, 145.
— de Rome, 146.
— de Xaintes, 144.
— de Saint-Cloud, 146.
Arabes (médecins), 427.

Arbres fruitiers, 31.
Arc-en-ciel, 204.
Arcadie (fontaine d'), 148.
Architecture végétale, 67.
Ardennes, 154, 206, 248, 278, 294, 327.
Ardoises, 206, 295.
Argile (terres d'), 298.
Aristote, 158, 283.
Arnaud de Villeneuve, 191.
Arrosement, 79.
Arts mécaniques, 322.
Astrolabe, 92.
Attraction, 203, 210, 267.
Augmentation congélative, 262.
Avertissement de l'éditeur, au sujet de l'appendice, 385.
Avicennes, 427.
Azur, 286.

Bacchus, 169.
Bagnères, 150, 152.
Bancs de pierres, 39.
Bassins rustiques, 319.
Bec-d'Ambez, 187.
Besecq (Gui), 299.
Bitume, 148.
Blanc Rhazis, 41.
Blés des marais salans, 246.
Bois, son utilité et son emploi, 89, 182.
Bois pétrifié, 283.
Bolus armeni, 294, 351.
Borax, 242, 286.
Braillier (Pierre), 386.

37

Branches des arbres; causes de leurs formes, 346.
Brouage (le), 183, 276.
Buccin, 118.

Cabinet d'histoire naturelle de Palissy, 358.
Calcidoine, 51, 292.
Camphre, 420.
Canelle, 243, 418.
Cancres, 160.
Cardan (Jérôme), 271, 277.
Carrières, 238, 265, 292.
Cassidoine, 292.
Cauteretz, 150.
Cérès, 169.
Céruse, 41.
Chaillot (terre de), 303.
Champier (Symphorien), 424.
Chapons, 416.
Chardons, 425.
Charente, 13, 185.
Chaudes-Aigues, 152.
Chaudron, 151, 205.
Chaux, 41. 327.
Chirurgiens, 429.
Chrysocolle, 286.
Cinabre, 420.
Cinnamomum, 424.
Cinquième élément, 215, 332.
Cité de refuge, 82.
Citernes, 142.
Colin (Sébastien), 386.
Colonnes faites d'arbres, 65.
Compas, 91.
Confrontations du Jardin délectable, 80.
Congélation (cristallisation) des minéraux, 46, 196.
Coquillages, 71, 204, 206, 274.
Coquilles fossiles, 37, 219, 272.
Cornes d'Ammon, 37.
Corps animaux conservés par le sel, 22.
Couches des pierres, 39.
Couleurs formées par les minéraux, 284.
Couleurs végétales, 289.
Coupe des bois, 25.
Couperose, 242, 267.
Coupe de terre émaillée, 311.
Cours d'histoire naturelle professé par Palissy, 269, 352.

Craie, 296, 331.
Cresson, 420.
Creusets, 300.
Cristal, 48, 205, 216, 268, 281, 295.
Cristaux (forme des), 264.
Criste marine, 247.
Ctésinus; trait rapporté par Pline, 16.
Culture de la terre dans les Ardennes, 248.

Daigny (forges de), 355.
Déclaration des abus et ignorances des médecins, 389.
Diamant, 52, 216.
Discours admirables de la nature des eaux et fontaines, etc., 127.
Dordogne, 184, suiv.
Drogues composées, 232.
Durer (Albert), 308.

Eau bouillie, 405.
— congélative, 216, 297.
— exhalative, 216, 302, 334.
— végétative, 216.
— de roses, 402.
Eaux et fontaines (traité des), 136.
Eaux distillées, 401.
Eaux encloses; leur force, 143, 144.
Eaux de fontaines, ne viennent pas de la mer, 158.
Eaux incrustantes, 284.
Eaux de pluies, alimentent les fontaines, 162, 165.
Eaux minérales; leurs propriétés médicales sont incertaines, 153, 154.
Eaux thermales de Cauterets, de Bagnères, d'Aix, 149 et suiv.
Eaux de Spa, 154.
Ebénisterie (bois propres à l'), 28.
Ecobuage, 248.
Ecorce des bois, 243.
Ecriteaux placés au-dessous des échantillons de son cabinet, 358.
Eléments, 402.
Elément cinquième, 215, 332.
Email (boutons d'), 307.
— de Limoges, 308.
Emaux (composition des), 311, 322.

DES MATIÈRES.

Embaumements égyptiens, 243.
Emeraude, 52, 290.
Enderces, 20.
Engrais, 245.
Eolipyle, 152.
Equerre, 92.
— (fausse), 92.
Espode brûlé, 412.
Esprits, 220.
Esula major, 426.
Explication des termes difficiles, 377.
Ezéchiel (sentence d'), 82.

Fayan (hêtre), 49.
Feu, destructeur de l'eau, 196.
Fiévreux, 405.
Flambe (Iris), 288.
Fontaines naturelles, 143.
Fontaines; causes des qualités de leurs eaux, 147.
Fontaines; leur origine, 42.
Fontaines d'Arcadie, citées par Pline, 148.
Fontaines artificielles, 157, 170.
— salées, 258.
Fontaines salées de Béarn et de Lorraine, 155.
Forêts; leur destruction, 88.
Forteresse (ville de), 113.
Fourneaux, 151.
Fragments précieux, 51.
Fruits pétrifiés, 283.
Fumiers (théorie des), 17, 23, 24, 244, 328.

Gabelle établie en Saintonge, 313.
Galien, 427.
Garonne, 185.
Gaude, 285.
Géber, 191.
Gélisses (pierres), 34, 262.
Géodes, 45, 265.
Gentilly, 303.
Girofles, 421.
Gironne (forges de), 355.
Glaces. 236.
Gomme, 209.
Grecs (médecins), 427.
Grole (corbeau), 88.
Grotte rustique exécutée pour le Connétable, 3.
Gypse, 233.

Hamelin (Philibert), 105.
Hérisson, 87.
— de mer, 117.
Hêtre, 49.
Hippocrate, 427.
Histoire de l'établissement à Saintes de l'église réformée, 99.
Hommeaux (ormes), 63.
Huile de pétrole, 148.
Huiles médicamenteuses, 407.
Huîtres, 160.
Humeurs qui correspondent aux éléments, 402.

Ingratitude, 6.

Jardin délectable, 57.
Jaspe, 51, 291.
Jayet, 211.
Jean de Meun, 191.
Jérémie (sentence de), 8, 12.
Julep, 403.
Jusquiame, 420.

Laboureurs qui dédaignent leur condition, 86.
Lambrucs, 425.
Lapis lazuli, 286.
Latins (philosophes), 161, 205, 269.
Lecteur (épître au), 10.
Lessive, 242.
Limaces, 115.
Lisset Benancio, 386.
Livre des philosophes de Palissy, 151, 264.
Liste des auditeurs de son cours, 270.
Lits des pierres, 39.

Maigues, 236.
Marais salants, 252.
Marcassites, 46, 206, 213.
Marcassites cristallisées, 281 et suiv.
Mares, 141.
Marées, 161.
Marne, 326.
Mascaret, 184.
Matières propres à faire les émaux, 322.
Mathieu (sentence de saint), 14.
Maumusson, 276.

Meaux (puits de), 140.
Médecins, 55, 140, 399 et suiv.
Médecin aux urines de Poitou, 228.
Médicaments composés, 232.
Mer (limites de la), 158.
Mercure, 195.
Merle (marne), 326.
Métaux (traité des) et alchimie, 190.
Métaux; leur génération, 209.
Métaux; ne peuvent être engendrés par le feu, 196.
Minéraux (formation des), 210.
Mines de fer, 206 296.
— de sel de Pologne, 155.
Mirobolans, 422.
Mithridate, 231.
Moellons, 293.
Momie, 22.
Monde (petit), 402, 406.
Monnoyeurs (faux), 209.
Montagnes; les rochers forment leur charpente, 31, 165.
Montagnes artificielles, 170.
Montmartre (plâtrières de), 293.
Montmorency (maréchal de) (épître dédicatoire au), 3.
Montmorency (Anne de) (épître au connétable duc de), 8.
Monts Pyrénées, 164, 196.
Murailles, 34.

Neptune, 169.
Neptunisme, 212, 217.
Nitre, 42, 205.
Niveau, 92.
— des eaux, 161.
Nuées, 164.

Océan, 276.
Œufs couvés, 193.
Or potable, 53, 224, 413.
Orgues à vent, 69.
Ormes, 63.
Oursins, 38.
Outils propres à la géométrie et à l'agriculture, 91.

Pal, paux, 25.
Paracelse, 227, 229.
Paré (Ambroise), 271.
Pêche, 160.

Pesanteur des pierres, 295.
Pétrification des coquilles, 275.
Pétrifications, 49, 218, 266.
Pharmacie, 390 et suiv.
Pièces rustiques, 319.
Pierres; leur formation, 35, 262.
— d'aigle, 284.
— de liais, 293.
— précieuses, 51, 414.
Pierre philosophale, 191, 201, 214.
Philosophie, 10, 15, 25, 30, 209.
Plantes vertes ou sèches, 425.
Plâtre, 233, 293.
Plomb calciné, 50.
Pluies de grenouilles, 277.
Poissons armés, 115, 204, 274.
Poissons pétrifiés ou métallisés, 219.
Pompes, 137.
Ponts (Antoine de) (épître à), 129.
Pont du Gard, 143.
Poreux (corps), 354.
Porphyre, 291.
Pourpre, 118.
Priapus, 169.
Protestantisme à Saintes (histoire de l'établissement du), 99.
Puits (eaux des), 139.
Puits salés de Béarn et de Lorraine, 155.
Puits salés de Saintonge, 168.
Pyrénées, 164, 196.

Quid pro quo, 409.

Racines des arbres, 346.
Raisins, 425.
Recepte véritable, etc., 1.
Règle, 91.
Reine-mère (épître à la), 6.
Renard, 86, 87.
Rêve de Palissy, 83.
Rochers du jardin délectable, 73.
Rochers, charpente des montagnes, 31, 165.
Roman de la Rose, 191.
Rhubarbe, 419, 422.

Salicor, 242, 250, 287.
Sal alkali, 242.
Salpêtre, 42, 45, 205.
Santaux, 421.
Saphir, 52, 285, 380.

Saphre, 52.
Saveurs, 53, 230.
Sauterelle (fausse équerre), 92.
Sel; définition, 242, 250.
— dans les fumiers, 18.
— dans les plantes, 19.
Sel dans les pierres et les métaux, 33.
Sel ammoniac, 242.
Sel de tartre, 20, 242, 249, 268.
— commun, 251.
Sel commun n'empêche pas la végétation, 246.
Sel commun; ses propriétés, 260.
Sel gemme, 242.
Sels divers, 22, 241, 244.
Sentences principales extraites des ouvrages de Palissy, 367.
Serpentine, 291.
Sins des pierres, 39, 263.
Sirop d'absinthe, 428.
Sleidan (Jean), 140.
Sondage des terres, 340.
Soubise, 276.
Soufre, 209.
Sources naturelles, 157.
— des plaines, 166.
Spa (eaux de), 154.
Stalactites, 47, 265.
Stratification du sol, 342.
Sublimé, 242.
Sympathie, 208.

Taille des arbres, 25.
Tan, 243.
Thapsie, 426.
Tarbes, 153.
Tarière, 340.
Tartre (sel de), 20.

Teinturiers, 249.
Térébenthine, 209.
Terre (de l'art de), 306.
Terre (de l'art de), son importance et son utilité, 323.
Terre sigillée, 348, 424.
Terres à briques, 300.
— à creusets, 300.
— argileuses, 302 et suiv.
— sulfurées, enflammées, 156.
— salées de Saintonge, 247.
Tête d'un homme (mesure de la), 93.
Thériaque, 231.
Thioli (Tivoli) (lac de), 284.
Topaze, 51, 285.
Torréfaction, 422.
Transmutation, 214.
Tremblements de terre, 150 et suiv.
Trempe du fer, 250, 354, 355.
Tuf, 215.
Turbith, 426.
Turquoise, 52, 287.
Tuyaux engorgés, 143.

Urines (médecin aux), 228.

Vapeur (force de la), 143, 145.
Verre, 44, 50, 156.
Verriers, 307.
Vers, 247.
Vignes des marais salants, 246.
Ville de forteresse (de la), 113.
Vin vieux ou nouveau, 417.
Vitrerie, 311.
Vitriol, 22, 242, 267.
Vitruve, 39, 65.
Volcans, 156.
Volière, 77.

FIN.

2892

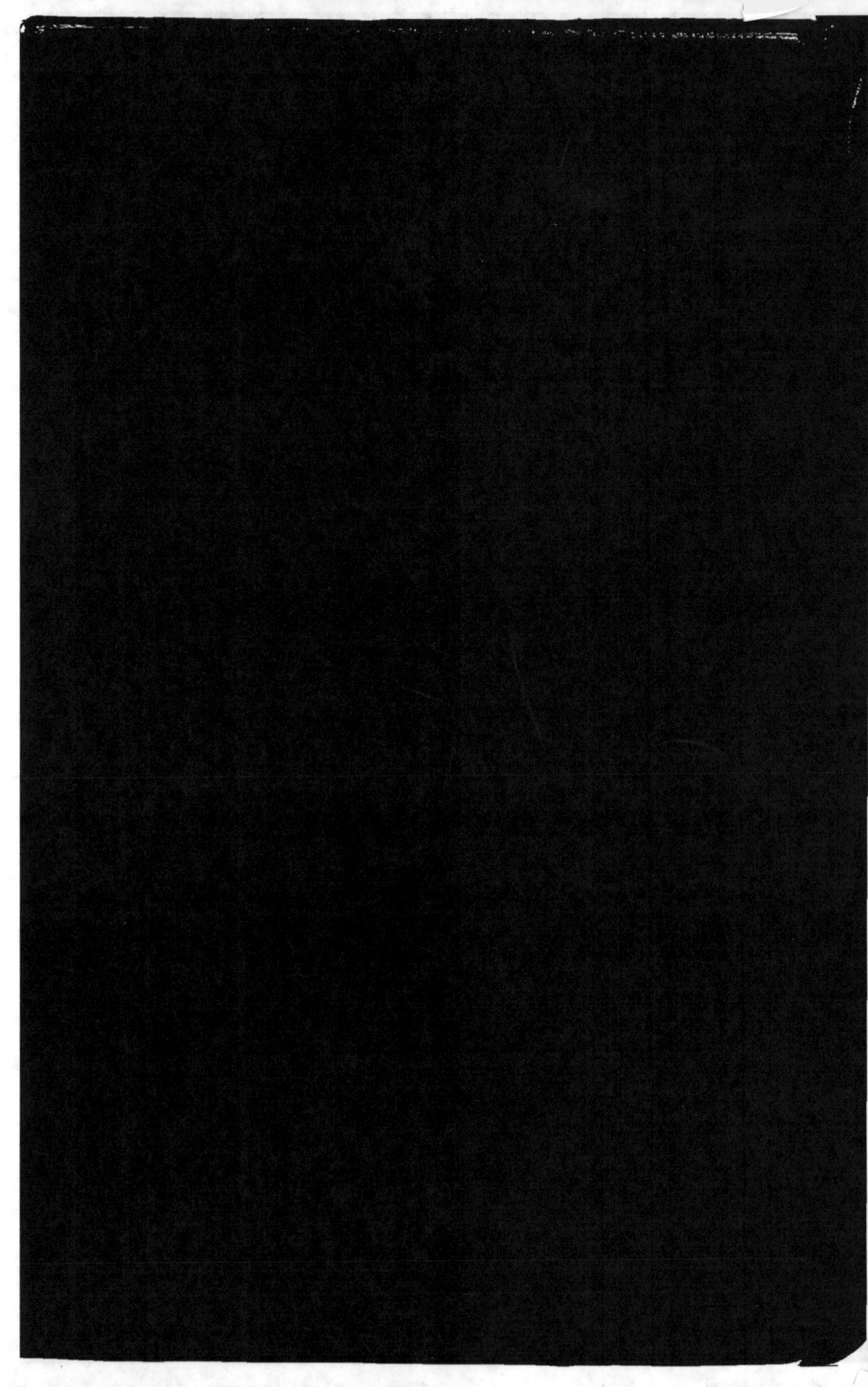